The
Bookseller
of Florence

Also by Ross King

The
Bookseller
of Florence

The Story of the Manuscripts
That Illuminated the Renaissance

ROSS KING

Atlantic Monthly Press
New York

FIRST EDITION

Printed in Canada

First Grove Atlantic hardcover edition: April 2021

Library of Congress Cataloging-in-Publication data is available for this title.

ISBN 978-0-8021-5852-9
eISBN 978-0-8021-5853-6

Atlantic Monthly Press
an imprint of Grove Atlantic
154 West 14th Street
New York, NY 10011

Distributed by Publishers Group West

groveatlantic.com

21 22 23 24 10 9 8 7 6 5 4 3 2 1

For Simonetta Brandolini d'Adda

All evil is born from ignorance. Yet writers have illuminated the world, chasing away the darkness.

—Vespasiano da Bisticci

Contents

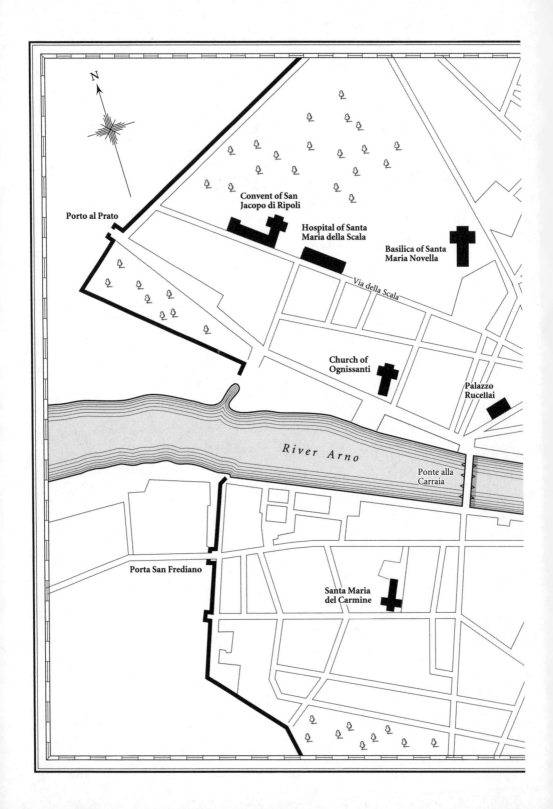

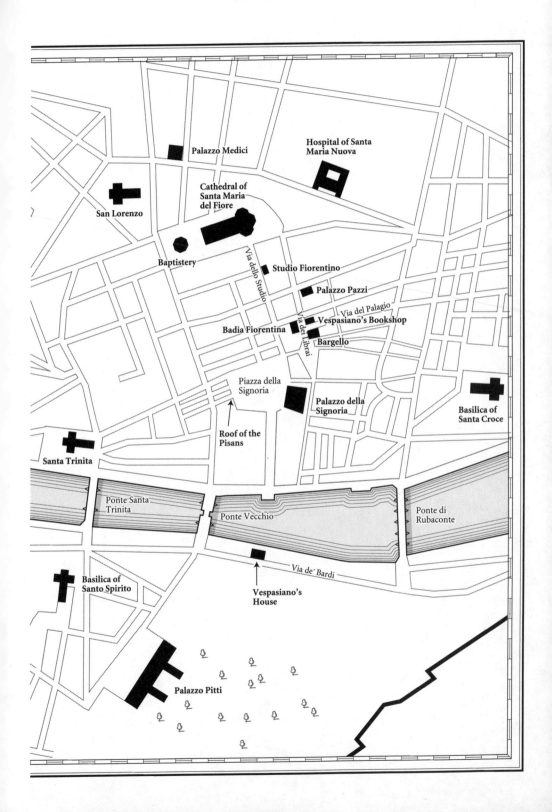

Palazzo Medici

Hospital of Santa
Maria Nuova

Cathedral of
Santa Maria
del Fiore

San Lorenzo

Baptistery

Via dello Studio

Studio Fiorentino

Palazzo Pazzi

Via del Palagio

Vespasiano's Bookshop

Badia Fiorentina

Via dei Librai

Bargello

Piazza della
Signoria

Palazzo della
Signoria

Roof of the
Pisans

Basilica of
Santa Croce

Santa Trinita

Ponte Santa
Trinita

Ponte Vecchio

Ponte di
Rubaconte

Basilica of
Santo Spirito

Via de' Bardi

Vespasiano's
House

Palazzo Pitti

The
Bookseller
of Florence

Chapter 1

The Street of Booksellers

The Street of Booksellers, Via dei Librai, ran through the heart of Florence, midway between the town hall to the south and the cathedral to the north. In the 1430s the street was home to an assortment of tailors and cloth merchants, as well as a barrel maker, a barber, a butcher, a baker, a cheesemonger, several notaries, a manuscript illuminator, two painters who shared a workshop, and a *pianellaio*—a maker of slippers. It took its name, however, from the shops of the many booksellers and stationers, known as *cartolai*, scattered along its narrow stretch.

In those days the Street of Booksellers was home to eight *cartolai*. They took their name from the fact that they sold paper (*carta*) of various sizes and qualities, which they procured from nearby papermills. They also stocked parchment, made from the skin of calves or goats and prepared by parchment makers, many of whose workshops—with their hides festering in wooden vats—could be found in neighboring streets. But *cartolai* offered far more extensive services than just selling paper and parchment: they produced and sold manuscripts. Customers could buy secondhand volumes from them or hire them to have a manuscript copied by a scribe, bound in leather or board, and, if they wished, illuminated—decorated with illustrations or designs in paint and gold leaf. *Cartolai* were at the very center of Florence's manuscript trade, serving as booksellers, binders, stationers, illustrators, and publishers. An enterprising *cartolaio* might deal with everyone from scribes and miniaturists to parchment makers and goldbeaters, and sometimes even with authors themselves.

Bookmaking was a trade in which, like wool and banking, the Florentines excelled. The *cartolai* found a buoyant local market because many people in Florence purchased books. In Florence,

more than anywhere else, large numbers of people could read and write, as many as seven in every ten adults. The literacy levels of other European cities, by contrast, languished at less than 25 percent.[1] In 1420 the possessions of a dyer in Florence included works by Dante, a poem by Dante's contemporary Cecco d'Ascoli, and the poetry of Ovid.[2] These works were in the local Tuscan dialect, the *lingua Fiorentina*, rather than Latin, but it was still an impressive library for someone who worked in one of Florence's more menial industries. Even many girls in Florence were taught to read and write despite the warnings from monks and other moralists. A wool merchant once boasted that his two sisters could read and write "as well as any man."[3]

One of the larger bookshops stood toward the north end of the Street of Booksellers, at its intersection with Via del Palagio, where the grim wall of the palace of Florence's chief magistrate faced the elegant facade of an abbey known as the Badia. Since 1430 Michele Guarducci, the proprietor, had rented the premises from the abbey's monks for fifteen florins* per year plus a pound of candlewax.[4] His shop consisted of two rooms, with one door facing the entrance of the Badia and the other, on the south side, opening onto Via del Palagio and a view, looking up, of the robust and fearsome tower of the Palazzo del Podestà, the chief magistrate's palace, today the Museo Nazionale del Bargello.[5] Each morning many of Florence's most brilliant minds gathered on the corner beside this palazzo, only a few steps from Guarducci's shop, to discuss philosophy and literature. Florence was celebrated in those days for its writers, especially for its literary scholars and philosophers (from *philosophos*, "lover of wisdom"): men who expertly sifted and scrutinized the accumulated wisdom of the ages, especially the works of the ancient Greeks and Romans. Many of these texts, lost for centuries, had recently been rediscovered by Florentines such as Poggio Bracciolini, who, amid much rejoicing, had recovered long-lost works by Roman writers such as Cicero and Lucretius.

*The florin was a gold coin, first minted in Florence in 1252, weighing 3.536 grams. The silver coinage in Florence was the soldo, which steadily decreased in value against the florin. At the beginning of the fifteenth century a florin was worth seventy-five soldi; by 1500, one hundred and forty. Milan, Venice and Rome each had their own gold coin, the ducat, of equivalent weight and value to the florin.

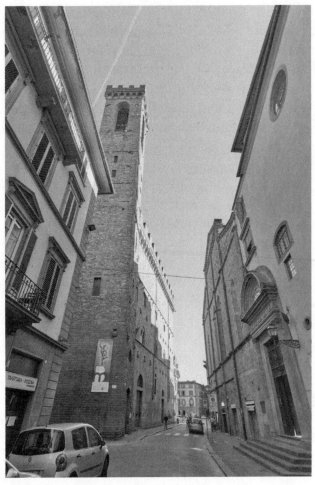

The "Street of Booksellers," today part of Via del Proconsolo. The Bargello, with its tower, is on the left, and the entrance to the Badia is on the right.

Poggio was one of the lovers of wisdom who gathered on the street corner beside Guarducci's shop. Though he and his friends naturally browsed the shops of the *cartolai* in search of manuscripts, few of them, in the early 1430s, might have found much to tempt them in Guarducci's premises. He kept a talented illustrator on staff, but his lease described him as *cartolaio e legatore*, "stationer and bookbinder,"[6] and he specialized not in obscure and enticing Greek and Latin works but, rather, in the humbler trade of binding manuscripts. Besides paper and parchment, his shop was therefore well supplied

with clasps, studs, wooden boards, hammers, and nails, as well as piles of calfskin and velvet. The barking of hammers, the coughing of saws—such were the sounds greeting anyone who entered his shop.

Things were about to change. In 1433 Guarducci hired a new assistant, an eleven-year-old boy named Vespasiano da Bisticci. So began Vespasiano's long and astounding career as a maker of books and a merchant of knowledge. Soon Florence's men of letters would be gathering inside the bookshop, not outside on the street corner. For in the world of the *cartolai*, of parchment and quills, of scribes hunched over writing desks, of elegant libraries with hefty, portentous tomes chained to benches, Vespasiano was destined to become what one lover of wisdom called *rei de li librari del mondo*—"king of the world's booksellers."[7]

No birth record has survived, but most likely Vespasiano was born in 1422, a couple of years after Filippo Brunelleschi began the herculean task of raising the cupola—the largest dome ever constructed—over the cathedral of Santa Maria del Fiore.[8] His family took their name from Santa Lucia a Bisticci, a hamlet that clung to the slopes of a rugged hill ten miles southeast of Florence. Filippo da Bisticci, his father, known as Pippo, worked, like so many others in Florence, in the wool trade. Pippo divided his time between a house he rented in the city and a rural property five miles to the southeast, near the village of Antella, a hilltop farm that produced wheat, barley, beans, figs, wine, and olives. In 1404 Pippo became betrothed to a ten-year-old girl named Mattea Balducci, who would eventually bear six children, four boys and two girls. Vespasiano was the fourth child, and his unusual, imperial forename (there was only one other Vespasiano in Florence in the 1420s) seems to indicate that from an early age he had been marked out by his parents for great things.

The death of Pippo early in 1426 jeopardized the future of Vespasiano, then four, and his siblings. Mattea was left with five children, none over the age of fifteen, and a sixth on the way. She was also left with debts of 250 florins, 86 of which Pippo owed to the Medici, one of Florence's wealthiest families. These were significant sums, considering that the highest-paid employees of wool shops earned,

at best, 100 florins per year, with most taking home fewer than 50 florins.[9] Mattea made a series of forced moves to cheaper lodgings in Florence while she unsuccessfully attempted to settle her husband's debts. In 1433 the creditors, one of them her latest landlord, seized plots of land at the farm in Antella.

Vespasiano began his schooling a year or two after his father's death. As many as 70 or 80 percent of boys in Florence attended school—a much higher rate than in other European cities.[10] Between the ages of six and eleven Vespasiano would have attended one of the primary schools informally known as a *botteghuzza*, or little workshop. The first book he ever read was probably a *Santacroce*: a humble pamphlet whose pages were made from the cheap parchment taken from the skin of a goat's neck. From this book he would have learned his ABCs and to read in the Tuscan dialect, known as the "vulgar tongue," from the Latin *vulgus*, meaning "the common people" or, more unkindly, "the rabble." Another of his books might have been a *Babuino*, whose name came from *baboon*—a reference to the fact that students learned to read by "aping" their teachers. The constant need for these books to equip Florence's hundreds of schoolboys meant a brisk and continuous business for the *cartolai*.[11]

Around the age of eleven, students continuing their education left the *botteghuzza* for either a grammar school, where they studied Latin literature to prepare for a career in law or the Church, or an abacus school, which emphasized the sort of numeracy important for the careers of Florence's merchants. Had his father not died leaving large debts, and had his mother not found herself with numerous children to feed, Vespasiano would surely have gone to a grammar school and spent four years immersed in Latin literature, followed, perhaps, by further studies at a university.

Fate, though, had other things in store. In about 1433, the year of his family's most dire misery, Vespasiano closed his schoolbooks and, at the tender age of eleven, went to work. He did not enter the wool trade like his father but instead set off for the Street of Booksellers.

Bookbinding would have been one of the first tasks learned by the young Vespasiano in Michele Guarducci's bookshop. This was the final

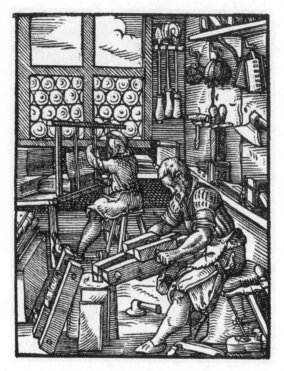

Jost Amman's woodcut of bookbinders from
The Book of Trades by Hans Sachs (1568).

step in the production of a volume, the methodical process of placing the dozens or even hundreds of sheets of parchment, laboriously copied by the scribe, into their proper order, stitching them together with leather thongs on a sewing frame, and then, to protect them, fixing them between wooden boards. Depending on the wishes of the client, the boards might be covered with leather, and the leather decorated with metal bosses or tooled patterns. And depending on the book's value and destination—if it was intended for a library in a monastery, or perhaps for the pulpit of a church, or anywhere it could fall victim to a light-fingered predator—a metal chain might be attached so the volume could be tethered to a shelf or lectern.

These operations called for strength, patience, and precision. The sawn boards of beech needed to be shaped with an ax or saw and then planed, and the leaves of parchment pierced with a sharp

gimlet, their edges aligned, and, to prevent them from bellying out-
ward, tapped into place with a block hammer. Little wonder that a
depiction of bookbinders, done more than a century later, shows two
burly men with muscular forearms at work amid an orderly array of
rasps, axes, bow-saws, hammers, clamps, sewing frames, and leather-
working tools.

Vespasiano was evidently adept at such work. He would later be-
come known for, among other things, the quality of his bindings,
some of which, for the most precious volumes, he covered in red vel-
vet. Equally important to Guarducci, no doubt, was the fact that his
new apprentice seems to have been an engaging personality who
could charm the customers. Further, he possessed a curiosity and a
desire to learn, not just about bindings and chains but about what
was inside the volumes themselves. He quickly came to share with
Guarducci's clients interests that were not merely commercial.

Indeed, within a few years of arriving in the Street of Booksell-
ers, Vespasiano was rubbing shoulders with, and evidently making a
favorable impression on, some of the most important people in Flor-
ence and beyond: the lovers of wisdom who gathered on the street
corner outside. He had the good fortune to start work with Guarducci
in the years when certain political events brought many distinguished
visitors to the city. He was fortunate, too, that these were the years
when ancient manuscripts, lost for centuries, were being rediscov-
ered, and when popes and princes began putting together vast li-
braries in which their books served not merely as beautiful ornaments
to flatter their vanity but as repositories of valuable wisdom from
which others could learn.

Florence's scribes, scholars, and booksellers were at the fore-
front of a revolution in knowledge. The Florentine Renaissance
conjures images of beautiful frescoes and altarpieces, of snow-white
marble statues in sinewy poses, of the swelling burnt-orange dome
of the city's cathedral—all the handiwork of the city's brilliant artists
and architects. But equally if not more important for the centuries
to follow were the city's lovers of wisdom, what a later observer would
call Florence's "wise and valorous men" from whom the city "derives all
its splendor."[12] These men were manuscript hunters, teachers, scribes,

scholars, librarians, notaries, priests, and booksellers—bookworms who blew the dust off a thousand years of history and tried to imagine and to forge a different world: one of patriotic service, of friendship and loyalty, of refined pleasures, of wisdom and right conduct, of justice, heroism, and political freedom; a world in which a life in a better society could be lived in the fullest and most satisfying way possible.

One of the first people to take an interest in Vespasiano, to draw him into this charmed circle of wise and valorous men, was a cardinal named Giuliano Cesarini. Vespasiano would have been about sixteen when the two of them met in Michele Guarducci's bookshop.

Cardinal Cesarini was a distinguished scholar and teacher, a former law professor at the prestigious university in Padua. Though he came from a noble and ancient Roman family, Cesarini had suffered poverty in his student days. He had been forced to copy out his own textbooks because he could not afford to buy them and, when he served as tutor to the sons of a wealthy family, had collected the stubs of candles after their splendid banquets in order to prolong his studies into the evening—for the acquisition of knowledge in those days required not just books but also a good supply of candles to read by.

Cesarini was always on the lookout, therefore, for students whose intellectual abilities were inversely proportional to their financial means. He evidently spotted in Vespasiano an able and enthusiastic pupil, and an intimacy grew between them—the one an adolescent working for a bookbinder, the other a forty-year-old cardinal who had traveled all across Europe, from Oxford to Krakow, on business for the pope. One day he made the young man a tempting offer: he would foot the bill for Vespasiano's studies to become a priest. He gave him fifteen days to decide and, after the elapsed time, came for his answer. "I told him I did not wish to become a priest," Vespasiano later recalled. The cardinal was magnanimous in defeat. "He responded that if he could ever help me," Vespasiano wrote, "he would do so."[13]

Cardinal Cesarini proved unable to fulfill his promise, because a few years later he would die in battle against the Turks in eastern

Bulgaria. His remains were never recovered from the battlefield beside the Black Sea, but his funeral oration was preached before the pope in Rome by his friend, the scribe and scholar Poggio Bracciolini, who worked in the Roman Curia, the papal bureaucracy. Poggio may have been the one who brought the cardinal into Guarducci's shop and first introduced him to Vespasiano. He was from the country, the son of a spice merchant in a village thirty miles southeast of Florence, but he always signed his name "Poggio Florentinus," proudly identifying himself with the city to which, in about 1400, at the age of twenty, with only a few coins in his pocket, he had moved for his studies. He had finished his training as a notary, worked briefly as a scribe, then gone to Rome to find employment in the Curia. Here he worked, unhappily and for little pay, dreaming of a life "free from the bustle of civilization," with plenty of leisure for writing books and, even more, for collecting them.[14]

Another regular visitor to the shop in those early days was Poggio's friend Niccolò Niccoli who, like Cardinal Cesarini, was always eager to help young students of modest means. Vespasiano met him as early as 1433 or 1434, when Niccoli was in his late sixties, a fat, handsome, fastidious man who dressed in a long plum-colored robe. He invited the young bookseller to dine at his house, impressing him with its beautiful furnishings: marble statues, antique vases, mosaic tables, ancient inscriptions, a map of the world, paintings by distinguished masters. "No house in Florence," an awestruck Vespasiano later exclaimed, "was so beautifully decorated."[15]

Niccoli's company must have been exhilarating for the young Vespasiano. Poggio called him "the most learned citizen of Florence"[16]—a title for which there was much competition. He was one of the wonders of the city: Vespasiano later claimed that whenever visitors came to Florence, "they did not believe they had seen the city until they came to Niccolò's house," which stood a stone's throw from the cathedral, near the church of San Lorenzo.[17] He was friends with Brunelleschi, by then close to completing his massive cupola, and, like Brunelleschi, took an interest in ancient architecture. He clambered over the ruins of baths and amphitheaters, rolling up his sleeves to measure the proportions of columns or to count the steps of a temple. He was also on intimate terms with the sculptors

Donatello and Lorenzo Ghiberti. "He never married," Vespasiano later wrote, "so as not to be hindered in his studies," though for thirty years he kept a spirited mistress named Benvenuta "to serve his needs."[18] He had stolen her from one of his five younger brothers, who exacted an ancient and appalling form of chastisement: she was stripped naked and publicly whipped in the piazza. The episode did nothing to restore Niccoli's relations with his brothers, already strained due to his habit of selling off family investments (his father had been a prosperous wool merchant) to fund the purchase of manuscripts.

Niccoli's finest and proudest possession was his library. He was, as a friend noted approvingly, a "glutton for books."[19] He owned some eight hundred manuscripts, one of the largest and most valuable collections in Europe. Niccoli had assembled his manuscripts, he claimed, "with great diligence and industry since adolescence,"[20] that is, from the time he had stopped working in his father's wool business and devoted himself to studious pursuits. Among the volumes were more than one hundred Greek manuscripts, some five hundred years old. He owned works by Plato and Aristotle, copies of both *The Iliad* and *The Odyssey*, the comedies of Aristophanes, and the tragedies of Euripides and Aeschylus. His collection of Latin works was much larger, encompassing thirty-four volumes of Saint Augustine alone, as well as sixteen volumes of the Holy Scriptures. Among his manuscripts were ancient treatises on geography, law, astronomy, architecture, medicine, and on the care of horses and cattle. He owned manuscripts written in Armenian and Arabic, as well as a volume of Slavonic hymns.

Nowhere in Niccoli's library, however, was there a single work in Italian, the "vulgar tongue," which he found excruciatingly offensive. Even the works of Dante were forbidden, for Niccoli considered the pages of the *Divine Comedy* to be fit only for wrapping fish and cuts of meat. Almost as atrocious, he believed, was anything composed in Latin in the past thousand years—because the glorious language of Cicero, so redolent of the best of Roman civilization, had deteriorated thanks to the fumbling quills and uncouth tongues of Christian scribes and writers. He had started writing a

An example of Niccolò Niccoli's distinctive,
forward-slanting script.

book on correct Latin spelling for the edification of the young but
never managed to finish it because, as Vespasiano noted, "so exqui-
site was his genius that he could never satisfy himself."[21]

Many other things upset Niccoli's delicate sensibilities. Medieval
scribes were guilty of writing in a crabbed script with angular, com-
pressed, and often overlapping letters—a style that was not only un-
attractive but also, even for dedicated readers, all but illegible. Just
as he wished to recapture the gloriously pristine Latin of Cicero, and
just as he hoped architecture would return to the elegant and orderly
simplicities of ancient Roman buildings, so too Niccoli hoped to de-
vise what Poggio, who shared similar aims, referred to as "a script
which recalls antiquity"[22]—a neat and decorous sort of handwriting
of the sort used, the pair of them believed, by the ancient Romans.
A number of the manuscripts in his library, such as works by Cicero,

Lucretius, and Aulus Gellius, Niccoli had copied out in his own distinctive, forward-slanting handwriting. In these manuscripts he proved himself, Vespasiano wrote, "a most beautiful scribe."[23]

Sitting at Niccoli's table, eating from porcelain dishes and drinking from a crystal glass on a tablecloth of the purest white, listening to the master talk about Brunelleschi or debate with the other guests over whether Plato was a greater philosopher than Aristotle, and then exulting with his host over the precious volumes in the library . . . the young Vespasiano must have realized that in the space of only a year or two he had entered a blessed, glittering company. It was, he later sighed, *questo secolo aureo*—"this golden age."[24]

Vespasiano would write those words many decades later, long after the deaths of Niccoli, Poggio, and the other lovers of wisdom who first introduced him to the wonders of ancient manuscripts. During this golden age he had also witnessed the achievements of Florence's painters, sculptors, and architects, men such as Brunelleschi and Donatello, "whose works," he wrote, "are there for all of us to see."[25] Yet he had also watched from his bookshop over the decades as momentous changes overtook Florence: political plots, assassinations, plagues, wars, invasions, and, outside the door of the bookshop itself, gruesome murders and abominable acts of "excessive cruelty."[26] All of these terrible scourges would turn the magical realm of his imagined Florence into what he despairingly called "the land of oblivion."[27]

Then, too, had come the changes and innovations within Vespasiano's own profession: the production and transmission of knowledge. While the king of the world's booksellers was at the height of his powers, producing for popes and princes lavish manuscripts in pen and ink, decorated in gold and silver, on the north side of the Alps, on the banks of the Rhine, a German goldsmith named Johannes Gutenberg began impressing paper with metallic letters, transforming books from script to print, from the ancient craft of a scribe hunched over parchment to a mechanical process of founding and stamping, of reproducing volumes of knowledge by the hundreds and thousands. A new and different age was about to begin.

Chapter 2

The Pure Radiance of the Past

Many Florentines besides Vespasiano regarded their city as enjoying a golden age. "I am delighted to have been born in this fortunate time," wrote a poet whose birth coincided with Vespasiano's first years in the Street of Booksellers.[1] Everyone agreed that Florence was beautiful, wealthy, and filled with people of astounding talent. "The splendor of this city is so remarkable," wrote a friend of Niccolò Niccoli, "that no eloquence could begin to describe it."[2] Even so, that did not stop many Florentines from offering enthusiastic descriptions. They extolled its churches and palaces, its clean streets, its four stone bridges crossing the tawny sweep of the Arno, and its formidable circuit of turreted walls pierced by fifteen gates and topped by eighty towers. They praised the prosperous countryside that lay beyond these walls, with its productive farms and, dotting the breezy, vine-clad hillsides, hundreds of elegant villas. "No one could ever tire of such a sight," concluded Niccoli's friend. "The whole region could rightly be considered a paradise whose beauty and joyful harmony are unparalleled anywhere in the world."[3]

Credit for such wonders went to the Florentines themselves. Their particular genius owed much, many believed, to their illustrious ancestors, the ancient Romans, who had founded the city in around 80 BC. Dante, in about 1305, had called Florence "*la bellissima e famosissima figlia di Roma*" ("the most beautiful and most famous daughter of Rome").[4] A few traces of the city's Roman origins remained, such as the ruins of aqueducts, arches, and theaters, as well as, supposedly, the baptistery (which the Florentines mistakenly believed to be an ancient temple of Mars repurposed by the early

Christians). However, Florence was not actually as rich in Roman ruins as many other places in Italy, and the Florentines could have argued that the legacy of the Romans persisted more conspicuously in their own recent accomplishments than in any random and collapsing blocks of stone.

These accomplishments were widely celebrated. Florence's bankers and wool merchants, with their offices and agents spread throughout the world, from London to Constantinople, brought untold wealth into the city. This wealth paid for the many palaces and churches, for the statues and frescoes that adorned them, and even for their magnificent cathedral over which Brunelleschi's dome was taking shape. Filippo Brunelleschi was a typical example of the sort of all-conquering genius that the Florentines seemed effortlessly able to produce, whether in architecture, sculpture, painting, or literature. "Nowadays," wrote one proud Florentine, surveying the city's artistic landscape, "we see innumerable arts flourishing which have been absent from Italy for ten centuries"—that is, since the fall of the Roman Empire. "O men of ancient times," he concluded, "the Golden Age is inferior to the time in which we now live."[5]

In our own age, in the popular mind, a different term is used to describe Florence's Golden Age of the fifteenth century. A century after Vespasiano's birth, Italian writers began using the word *rinascita* to express this extraordinary efflorescence of culture, seeing the advances in arts and letters as a "rebirth" of classical antiquity, a recovery and revival of the aesthetic and moral values of the ancient Romans and, beyond them, the ancient Greeks. In the nineteenth century this compulsion to recover a deeper and richer past received a more famous and enduring name when in 1855 the historian Jules Michelet called it "La Renaissance." This French term to describe an Italian phenomenon might have been forgotten had it not been adopted in an enormously influential book published in Basel in 1860: Jacob Burckhardt's *Die Kultur der Renaissance in Italien*, translated into English in 1878 as *The Civilization of the Renaissance in Italy*.

Burckhardt was a Swiss professor of history who had spent the winter of 1847–48 in Rome. While there he read a book published from an old manuscript recently discovered by an Italian cardinal in the Vatican Library and first printed in 1839 as *Vitæ CIII Virorum*

Illustrium, or *The Lives of 103 Illustrious Men.* The author of this
work, according to the volume's editor, was Vespasiano Fiorentino—
"Vespasiano the Florentine"—about whom, in 1839, almost nothing
was known. The work contained biographies of famous men (and
one woman) from the fifteenth century: everyone from popes, kings,
dukes, cardinals, and bishops to assorted scholars and writers, includ-
ing Niccoli and Poggio. What these illustrious figures had in com-
mon was that Vespasiano knew them all. Many, indeed, had been his
close friends and long-term customers. He claimed that, possessing
"a good deal of information" about them, he produced their biogra-
phies "so their fame might not perish."[6]

The rediscovery of Vespasiano's manuscript, with its celebration
of Florence's Golden Age, was to have momentous consequences.
Burckhardt had arrived in Rome to update a two-volume handbook
of art history written by his former professor Franz Kugler. But a read-
ing of this series of biographies quickly turned his interests and at-
tention from the visual arts to the vibrant intellectual life depicted
in Vespasiano's pages: from paintings and statues to manuscripts and
libraries. The journey through the century, with this well-connected,
name-dropping bookseller as a guide, proved exhilarating. Vespa-
siano was, Burckhardt declared, "an authority of the first order for
Florentine culture in the fifteenth century,"[7] his expertise having
been gained from a knowledge of virtually everyone of political or
cultural importance over a period of more than fifty years. Burck-
hardt was captivated and inspired by this depiction of a world of
princes, philosophers, and prelates who built magnificent libraries
and collected or commissioned manuscripts of Latin and Greek clas-
sics that had been lost or ignored for centuries. Vespasiano's writ-
ings helped him trace the intellectual developments and achievements
of the fifteenth century, a "revival of antiquity," as he called it, that
"achieved the conquest of the western world."[8]

Burckhardt's treatise achieved a conquest of its own. It became
one of the most celebrated works of history ever written, offering (as
a modern historian writes) "one of the most compelling and creative
theses in the history of modern historiography, virtually creating the
"idea of the Renaissance."[9] This brilliant thesis—now much debated—
owed a huge amount to the discovery of Vespasiano's long-lost

writings, which Burckhardt later claimed had been "infinitely important" to him.[10]

Vespasiano's biographies were crucial, therefore, to the formation of one of history's most famous and endearing (if sometimes misleading) narratives: how the rediscovery of ancient books refreshed and "rebirthed" a disoriented and moribund civilization. However familiar the story in its general outlines—and however in need of nuance and refinement—the reanimation of antiquity during the fifteenth century raises many questions. Under what circumstances was the wisdom of the ancient world lost? By what means, and from what sources, was it recovered? Why should Christian scholars have wished to recover pagan writings in the first place? And how did Vespasiano, a young man from humble origins with poor prospects and an apparently limited education, become so crucial to this story?

For Jules Michelet, the Middle Ages had been "the age of despair."[11] His horror at what he believed were the dismal and savage centuries that came after the fall of the Roman Empire in AD 476 echoed the intense revulsion, centuries earlier, of the poet and scholar Petrarch. Born in 1304 in Arezzo, into a family banished from Florence a few years earlier, Petrarch would become known, hundreds of years later, as "the first modern man."[12] He seems "modern" not so much because he looked forward but, ironically, because he cast his gaze backward, a thousand years and more into the past, to the writers of antiquity. His love of ancient literature dated from his boyhood. Under his bed he kept a collection of Latin classics that his father, when he discovered them, angrily tossed into the fire—"like heretical books," as Petrarch later recalled. However, seeing his son so distraught, Petrarch senior "thereupon quickly grabbed two books, already nearly burned by the fire, and, holding a Virgil in his right hand and Cicero's *Rhetoric* in his left, handed both to me."[13]

Petrarch would devote the rest of his life to salvaging what remained of the classics. He was an inveterate traveler who, during the 1330s, shuttled back and forth across France and Italy, and through Flanders, Brabant, and the Rhineland. If on these journeys he happened to see a monastery, he would stop and visit its library, hoping to

unearth some treasures among
the spiderweb-shrouded shelves.
He made a number of startling
discoveries, adding to his col-
lection of manuscripts by un-
covering long-lost copies of
works by authors such as Ci-
cero, the writer he claimed to
admire "as much or even more
than all whoever wrote a line
in any nation."[14] The recovery
of these texts formed part
of his hopeful project to re-
store to the world the glories
of Rome extinguished by the
"Dark Ages"—a phrase he is
credited with coining to de-
scribe the centuries following
the collapse of the Roman
Empire.[15]

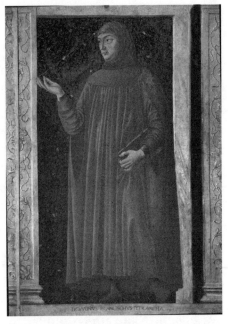

Petrarch (1304–1374): poet, scholar,
traveler, manuscript hunter.

 The centuries after the collapse of the Roman Empire had not
actually been as unremittingly gloomy as Petrarch (and many after
him, like Michelet) maintained. Historians now agree that, relatively
speaking, the years 1000 to 1300 in Europe—the period traditionally
called the "High Middle Ages"—were prosperous and productive.
The Viking and Magyar raids had ended, the population grew, new
villages and towns appeared, as did universities in cities such as Bo-
logna, Padua, Salamanca, and Oxford. Greek treatises on science—
by Ptolemy, Hippocrates, Euclid—reached the West, translated into
Latin; so too did all of Aristotle's surviving works. Great cathedrals
rose into the skies above Paris, Chartres, and Reims, in the latter of
which Gerbert of Aurillac, the future Pope Sylvester II, assembled a
great library of classical authors. These beautiful new churches with
their pointed arches and stained glass windows, so different in ap-
pearance from the tumbledown ruins of antiquity, were built in a style
known as *opus modernum,* or "modern work." Indeed, by the thirteenth
century people had begun referring to themselves and their activities

as "modern"—a recognition that their civilization had developed a unique and original style.[16]

The windmill and the watermill were invented during these centuries, as were the heavy plough, the horse collar, the horseshoe, and the three-field system of crop rotation. These innovations gave liftoff to the "first European industrial revolution" (as the historian Fernand Braudel called it)[17] and ensured the ever-growing population—which almost doubled during the High Middle Ages from thirty-eight to seventy-four million—could be fed. Trade and commerce were aided by the invention of double entry bookkeeping and international letters of credit. Administration and record-keeping became more efficient after papermaking reached Spain in the eleventh century, France in the twelfth, and Italy in the thirteenth. Even the weather cooperated: this was the period known to climatologists as the "Medieval Warm Period," when temperatures in the Northern Hemisphere averaged higher than in the centuries before and after—similar, in fact, to those of the late twentieth century.[18]

Petrarch's cheerless view of recent history was no doubt shaped by the fact that he lived in what one historian famously called "the calamitous fourteenth century."[19] Around the time of Petrarch's birth in the early 1300s, the upward curve of progress and prosperity was suddenly arrested. The climate changed: the weather grew colder and stormier as what climatologists call the "Little Ice Age" took hold.[20] The glaciers advanced, torrential rains fell, crops failed, and people starved to death—some four thousand people in Florence alone during a famine in 1347. Economic hardship followed the collapse of the two great Florentine banking houses, the Peruzzi in 1343 and the Bardi in 1346, after the king of England, Edward III, failed to repay vast sums of money borrowed to prosecute his costly war against France. This war stretched out endlessly, as the name historians later gave to it, the Hundred Years' War, dramatically attests. Its battles and sieges were interrupted by regular outbreaks of the plague: not just during the Black Death of 1348, which wiped out at least a third of Europe's population, but again in the years 1363, 1374, 1383, 1389, and 1400.

The age was characterized by what a historian, in a classic study, called "the violent tenor of life."[21] Violence was random and wanton. In 1343, the public prosecutor in Florence was killed and dismembered by a mob that carried his body parts through the streets on lances and swords—"and there were those so cruel, so bestial in their anger, and full of such hatred," recorded an astonished chronicler, "that they ate the raw flesh."[22] In France, during a peasant revolt in 1358, a knight was roasted on a spit, his burned flesh then fed to his wife and children. In Florence came the Tumult of the Ciompi, in which thousands of poor clothworkers rioted in 1378. They burned down the palaces of the wealthy, caught and butchered the hangman, and set up their own gallows to hang the *popolani grassi*—the fat cats.

The Church could offer no solutions to this sorry state of affairs because the papacy was a failing institution. In 1309 the pope, a Frenchman, Clement V, decamped from Rome to Avignon. The new seat of the papacy became, in Petrarch's view, "Babylon on the fierce banks of the Rhône," filled with vice and corruption. "In the heaping up of all evils you are not only great, you are the greatest, you are immense," Petrarch wrote of the Avignon papacy. "You are the mother of fornicators and the abomination of the earth, the impious mother of detestable offspring."[23] When, after almost seventy years and a half-dozen popes, the papacy finally returned to Rome, a rival pope appeared in Avignon. By 1410 three men claimed to be pope, including a former pirate named Baldassarre Cossa, who supposedly seduced three hundred widows, virgins, and nuns, along with, for good measure, his brother's wife.

Rome, meanwhile, had fallen into dereliction. Wolves roamed the streets in such numbers that anyone who killed one could claim a reward. People went about armed, and a law needed to be enacted, with a heavy fine, to stop them from shooting arrows at each other or throwing rocks through stained glass windows of the churches. A law was even needed, with an even bigger fine, against stuffing shit inside someone else's mouth. Petrarch, on a visit to the Eternal City in 1337, was appalled by everything he saw. "Peace is exiled," he lamented. "Civil and external warfare rages; dwellings are prostrate; walls are toppling; churches are falling; sacred things are perishing;

laws are trodden underfoot; justice is abused; the unhappy people mourn and wail."[24]

Yet this violent, decaying city held clues to a better world. In the early 1370s, one of Petrarch's friends, Giovanni Dondi, an astronomer from Padua, went to Rome and was struck by what he saw. He noted in a letter that certain "sensitive persons" were eagerly looking for and inspecting Rome's beautiful antiquities. Anyone who looked at these ancient statues and reliefs—which he noted commanded high prices on the market—was amazed by their quality and by the "natural genius" of the ancient artists who had created them. The ancients, Dondi was forced to admit, had been far superior than the moderns at making art and architecture. Further, the ancient Romans had more, too, in the way of such desirable qualities as justice, courage, temperance, and prudence. "Our minds are of inferior quality," he glumly concluded.[25]

Petrarch had long believed, however, that the glory of Rome could be reborn. He concluded his 1339 poem *Africa* with an optimistic note for the future. For him there was little hope, he believed, for it was his unhappy fate to live "amid varied and confusing storms," amid the calamities of his doomed times. But a better age would surely follow. "This sleep of forgetfulness will not last for ever," he wrote. "When the darkness has been dispersed, our grandsons will walk again in the pure radiance of the past."[26]

Niccolò Niccoli was, figuratively speaking, one of Petrarch's grandsons, and he, too, dearly wished to bask in the radiance of the past. The secret to a cultural revival was, he believed, a creative imitation of ancient models. Like Petrarch, he was haunted by the thought of all the ancient knowledge lost to the world due to what one of his and Vespasiano's friends sorrowfully called "the indifference of our ancestors."[27] The actions that Niccoli and his friends would take to rediscover and disseminate this lost wisdom—some of them in tandem with Vespasiano—would result in Italy, and Florence in particular, assuming the cultural leadership of Europe.

One day during Holy Week around the year 1400 Niccoli had gathered with some friends at his elegant home. One of his guests

was Leonardo Bruni, a literary scholar and translator who would later write up the conversation of that day. Bruni was destined to become one of the most celebrated and influential of all of Florence's lovers of wisdom. He had been born about 1370 in Arezzo, the birthplace of Petrarch, whose portrait, which he saw as a child, inspired his own passion for literature. He moved to Florence in the 1390s to study law but soon switched to Greek, quickly becoming proficient enough to translate Aristotle into Latin. In terms of the number of his manuscripts in circulation across Eu-

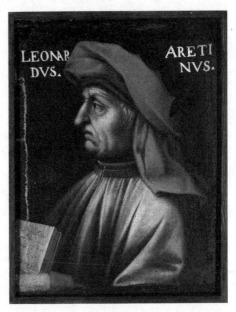

Leonardo Bruni (c.1370–1444): "He achieved what no one else had done for a thousand years."

rope, Bruni would become the bestselling author of the fifteenth century.[28] So deeply did he come to be revered for his learning that Vespasiano once witnessed the endearing spectacle of the king of Spain's envoy kneeling before him. "He was so eloquent and learned," wrote Vespasiano, "that he achieved what no one else had done for a thousand years."[29] Such, Vespasiano believed, was the quality of Leonardo Bruni: the most erudite and accomplished man since the fall of Rome.

In 1427 Bruni would become the chancellor of Florence, a post that made him the republic's most senior civil servant, the official in charge of the team of bureaucrats administering the government's policies and paperwork. Though a native of Arezzo, Bruni was a great champion for Florence. He believed the greatness of the city was such that, as he told Niccoli on that afternoon during Holy Week, it was ideally suited to launch a revival of learning through disciplines such as grammar and rhetoric. Niccoli, however, was less optimistic about a revival of learning, in Florence or anywhere else, for the simple

reason that the kind of knowledge necessary for this revival was missing—lost or destroyed. As proof he began enumerating these terrible losses. Where were the masterpieces of Varro, Sallust, and Pliny the Elder? Where were the lost books on the history of Rome by Livy? So many great philosophers and poets were nothing more than ghosts occasionally glimpsed in fragments of parchment or in secondhand quotations cribbed from dubious sources.

One of Niccoli's favorite books was *Attic Nights*, a wonderful grab bag of history, philosophy, law, grammar, and literary criticism written in the second century AD by a Roman named Aulus Gellius, who called his work "a kind of literary storehouse."[30] Niccoli's copy of *Attic Nights* was fragmentary, but even so it contained snippets from many classical works that, apart from a few fleeting citations in other ancient texts, were completely unknown—a treatise by Cicero, *On the Republic*, among them. Such, Niccoli realized, was his and his friends' feeble grasp of so much ancient learning: rare and tantalizing sightings caught almost by chance in the pages of other works that were themselves defective or incomplete.

The measure of these incalculable losses was the Roman writer Marcus Varro, Julius Caesar's librarian and perhaps the most knowledgeable man in the ancient world. He had written hundreds of books covering virtually all areas of human thought and endeavor. Gellius casually mentioned or quoted from a dizzying array of Varro's titles: *On the Arts, On Farming, On the Antiquities of Man, On the Duties of a Husband, On Bringing Up Children*, and *Hebdomades* (which concerned, Gellius explained, "the many varied excellencies and powers of the number seven").[31] Nothing of this encyclopedic learning survived apart from a single treatise on Latin (dedicated to Cicero) discovered in a Benedictine monastery in the 1350s by the Florentine writer Giovanni Boccaccio. The story of this recovery was a sad fable of the sorry state of learning in the "age of despair." Boccaccio found the Varro manuscript, an eleventh-century copy, in a doorless library that had weeds growing in the windows and a thick rime of dust covering the books. Many of the manuscripts were badly mutilated: the illustrations in their margins had been pitilessly pruned because to earn extra money the monks, according to Boccaccio, tore out "whole handfuls of leaves" to make books for children and cut

off strips of parchment to make amulets to sell to women.[32] Mounting an urgent rescue mission, Boccaccio pilfered the Varro manuscript from the library and spirited it back to Florence, where it merged into his own collection.

Even more significant was the loss of the most comprehensive handbook on rhetoric—the art of making persuasive speeches—composed in ancient Rome: Quintilian's *Institutio Oratoria*. Rhetoric had been an essential feature of Roman life and culture. It occupied the central place in the educational curriculum, and the skill of speaking effectively was prized as much as battlefield heroics. Persuasive oratory was essential in the Senate, at funerals, and at other state occasions, as well as in criminal trials, which were popular events held before huge crowds in the Forum (hence "forensic" oratory)—one of the stages on which Cicero shone so brightly. Quintilian had been the most renowned teacher of rhetoric in Imperial Rome. His twenty-year career (roughly between AD 70 and 90) saw him tutor future men of letters and budding statesmen, including the heirs of Emperor Domitian. The poet Martial celebrated him as the "supreme controller of the wayward youth"—an indication of how successful he was in using education to shape the behavior of young Romans.[33] So great was Quintilian's esteem that he claimed a Roman bookseller named Trypho began pressing him "every day, with great insistence," to spread his wisdom more widely.[34] He duly assented, partly because, as he lamented, several bootleg editions of his lectures, scribbled down by slaves, had begun circulating under his name.

Quintilian's massive text, produced in Rome in around AD 90, was a handbook for parents and teachers both. Spanning twelve volumes, it offered detailed instructions not only on how to teach children to read, write, and speak properly, but also on the best way to turn them into healthy, happy, and virtuous adults. For instance, he strongly disapproved of flogging children because, as he pointed out, the pain, fear, and shame of a beating often produced disastrous results, depressing the child's spirits and causing him "to shun and loathe the light of day."[35] Practical advice on how to deliver speeches took up the bulk of the text: everything from how to commit passages to memory (he recommended a system of relevant symbols) to how to train and maintain the voice (bodily massages with oil were

prescribed). His students were intended to become a caste of capable citizens and inspired political leaders, men who were, as he hoped, "fit for the management of public and private business."[36] Above all, he wished to create what he called the *vir bonus dicendi peritus,* the "good man skilled in speaking"[37]—someone who was both articulate and virtuous, and who used his oratorical powers for the good of his society.

The full extent of Quintilian's sound precepts had long since been lost. Most people in the "Dark Ages" had demonstrated scant interest in his work. As Cicero had pointed out, rhetoric only flourished among free people in societies in which decisions were taken by "assemblies of men."[38] Recommendations about how to deliver effective speeches or develop virtuous habits possessed little relevance in the hierarchical feudal societies and agricultural economies that followed the fall of the Roman Empire—political communities in which power was exercised by princes and bishops, not by elected leaders needing to win the hearts and minds of their fellow citizens through rousing speeches or laudable actions. The result was that none of the copies used in Roman schools during Quintilian's time seemed to have survived. The *Institutio Oratoria* existed only in mutilated manuscripts, hundreds of years old, that lacked large chunks of text.

Interest in Quintilian was roused, however, with the migration of the population into cities and the rise of the merchant class. Lessons in rhetoric suddenly became desirable and applicable in city-states such as Florence that were governed by men of business who needed to deliver speeches and cast votes, and who lived together in political communities governed by consent rather than force. Florence was a republic ruled by its people, not a dukedom or princedom where the people lived under the reign of a tyrant. "There are thousands of men who administer our republic," one Florentine politician proudly declared in the 1390s.[39] Indeed, some six thousand men (out of a total population of some forty thousand people) were eligible for election to the republic's various administrative offices and to staff its advisory bodies and special commissions—all lively forums for speeches, discussion, and debate. The records of these meetings reveal strong differences of opinion finally being resolved,

through the persuasions of oratory, into agreement and consent. "But at last everyone agreed," reported the minutes after one exchange of speeches in 1401.[40]

The value of a treatise on speechmaking was obvious in such a political landscape. "For what can be better than to be master of the emotions," asked one Florentine politician, "to bend your auditor to go wherever you might want, and to bring him back from that place, filled with gratitude and love."[41] Over the years, a rumor of a complete manuscript of Quintilian was enough to quicken the pulses of scholars. But this fabled copy never emerged. When Petrarch got his hands on the fragments of a manuscript of the *Institutio Oratoria*, he wrote an enthusiastic letter to the long-dead Quintilian celebrating his good fortune but lamenting that his new friend was *discerptus et lacer*—"torn and mangled."[42] Boccaccio likewise owned a Quintilian, but the manuscript was, as the inventory of his library stated, *incompletus*.[43] Decades later, the search continued. Leonardo Bruni claimed that, after some lost works by Cicero, Quintilian's work was "mourned beyond all others."[44]

Classical texts and ideas were therefore valuable because they could be applied to concrete political and social problems. If the works of the ancient Greeks and Romans could be found, and if these works were then properly studied and understood, they might teach modern Italians how better to educate their children, how to write more inspiring speeches, how to rule themselves more wisely and temperately, how to conduct more judicious and successful wars—in short, how to create a safer and more stable society than the one in which, for the past few centuries, they had been living.

Perhaps, as Niccoli hoped, Quintilian and others were indeed still out there, still waiting to be rediscovered. Perhaps the revival of learning could take place after all, the ignorance dispelled by the radiant glow of the past.

The loss of so many ancient books could be blamed on something more than the apathy of feudal lords and the negligence and greed of unscrupulous monks. It could be blamed, too, on circumstances beyond the inevitable and indiscriminate destruction of floods and

fires, or the pernicious appetites of mice, warble flies, and book-worms. All these things played their part, but there was another reason so few texts survived, and that was technology: how books were made.

The Greeks and Romans did not write their books on supports such as paper or parchment.[45] Instead, they experimented with palm leaves, tree bark, wax tablets, and even sheets of lead before turning to papyrus, a reed that grew in the swamps of Egypt, and that the Egyptians, naturally, had used for their own documents. The Greek word for this plant was *byblos* (βύβλος), after the Phoenician port city of Byblos (on the coast of what is now Lebanon) from which the Greeks imported their papyrus. The name of the city and the plant are inscribed in their word for a book, *biblion* (βιβλίον), which is the root of "bibliography," "bibliophile," and "bible." The Romans followed the Greeks in using this reed, but they named their books not after papyrus, as they called the plant—a Latin term from which the word "paper" descends—but rather after its bark or pellicle, the *liber*. From this Latin term came words such as "library" and "librarian," along with the word for "book" in Italian and Spanish (*libro*), in French (*livre*), and in Irish (*leabhar*).

Papyrus was originally used for firewood and chewing gum, as well as for making forks, spoons, and bowls, sails and ropes for boats that navigated the Nile, and even the hulls of the boats themselves. Pliny the Elder, writing in his *Natural History* in the seventies AD, gave credit for the use of papyrus as a writing support to Alexander the Great in about 332 BC, around the time he founded Alexandria. Pliny described the process of how the pellicles—the *libri*—were woven into a lattice on a board wetted with muddy Nile water, which acted as a glue. The sheet was put in a press to be flattened, then it was dried in the sun, after which irregularities could be sanded down with a shell. Various grades were available in ancient Rome, including one called "amphitheater paper," named for the place of its manufacture, the amphitheater of Alexandria. To flatter the vanity of Emperor Augustus, the highest grade was known as "Augustan" (the second best was "Livia," named in honor of his wife).

These papyrus sheets were not folded and bound together like the pages in a book. Instead, they were connected end to end to

form one long scroll, which was then attached and rolled onto two staffs, one at each end. The finished product, ready to be written on or read, rolled or unrolled, was called a *volumen*, from the Latin *volvere*, meaning "to turn" or "roll," and from which we get the word "volume." The reader unrolled the book one column at a time, meanwhile rolling onto the other staff the text already read. Knowledge was therefore gained by the act of unfurling a long scroll some nine or ten inches high and, once unrolled, perhaps thirty feet wide. All the libraries of the ancient world, such as that of the Ptolemies in Alexandria or the one founded in the first century BC by Asinius Pollio on the Aventine Hill in Rome, would have been filled with these great spools of learning.

This format was familiar throughout the Mediterranean world. However, competition between ancient libraries soon brought forth a new technology. Sometime after 200 BC one of the Ptolemies, usually identified as Ptolemy V Epiphanes, banned the export of papyrus from Egypt in order to foil the ruler of Pergamum, Eumenes II, who was hoping to create a library even grander than the one in Alexandria. Forced to find a substitute for the choked-off supply of papyrus, the Pergamene ruler (whose domains were in what is now western Turkey) hit upon the expedient of animal skins. The resultant product took its name from his city, with the Latin name for parchment, *pergamenum*, carrying the echo of its supposed origins. This story about the papyrus embargo, first told by Julius Caesar's librarian, the prolific Marcus Varro, may well be a complete fabrication. Parthian documents from before this time (ones written in what is now northeastern Iran) were composed on animal skins, as were some of the texts of the ancient Hebrews (including most of the Dead Sea Scrolls). The animal skins used at Pergamum were, however, specially treated—tanned, limed, scraped, and stretched—to create a smoother, thinner, and more durable writing surface compared to other skins.[46]

Parchment never caught on among the ancient Romans, perhaps because it always carried the connotation of an inferior substitute. Even so, by the last quarter of the first century AD, parchment could be found in certain Roman bookshops, not rolled up in scrolls (although some early experiments with parchment reveal

this format) but rather cut into small rectangles and fastened together. The Latin verb "to fasten" was *pangere*, from which, via the Latin *pagina*, the word "page" descends. Suddenly it was possible to read a document by turning pages of parchment rather than unspooling a roll of papyrus.

The Roman poet Martial was a convert to this new technology. In the mid-eighties AD he wrote an epigram that advertised his own works in this new format: "You who want my little books to keep you company wherever you may be and desire their companionship on a long journey, buy these, that parchment compresses in small pages." The benefit of these works, Martial believed, was their small size and handiness for travel. Even *The Iliad* and *The Odyssey* had been produced in this way, "stored in many layers of skin." In order to save his curious readers from "stray wandering all over town" in search of these little pocket books, he helpfully provided an address: that of Secundus, a former slave whose stall stood behind the Temple of Peace.[47]

Despite Martial's enthusiasm, this new format did not prove a popular success, and the papyrus scroll would remain the chosen vehicle for classical literature through the fall of Rome in the fifth century. But if the pagans spurned this new technology, it was embraced by another culture: the followers of Christ. The early Christians readily adopted these rectangular leaves rather than long scrolls. They may have favored this format because of their more limited access to papyrus and because of such advantages as durability, pagination (which made finding passages of text much easier), and efficient use of material, since the scribe could write on both sides. In any case, the *biblion* or *liber* then gained a new name: "codex." The Romans had sometimes used wax-coated boards, bound with leather thongs, for disposable writings such as notes, accounts, and the first drafts of literary compositions. One of these stacks of wax-coated wood was called a *caudex*, literally a "tree trunk." When the medium changed from wood to parchment, the word mutated into "codex," or, in plural, "codices."

The parchment codex was to become, with the advent of Christianity, the preferred format for recording and preserving knowledge. Fathers of the Church, such as Saint Jerome and Saint Augustine,

used both papyrus and parchment, but Jerome in one of his letters described how, in the library in Caesarea, on the Mediterranean coast some forty miles west of Nazareth, two priests were replacing old and decaying rolls of papyrus by transcribing their contents onto parchment. This process of conversion must have been happening all over the Mediterranean as codices supplanted scrolls. When, in 331, Emperor Constantine ordered fifty Bibles to be copied out for the churches in his new capital, Constantinople, he stipulated that they were to be "written on prepared parchment" and "in a convenient, portable form." As a result, he was presented not with papyrus scrolls but with "magnificent and elaborately bound volumes."[48] (The sole survivor of this commission, known as the *Codex Vaticanus*, made from more than eight hundred leaves of parchment, is now the oldest extant copy of the Bible.)

Christianity therefore brought about not only a change in moral and aesthetic values but also one in the technology of knowledge. Both of these changes imperiled the chances of ancient knowledge surviving into future centuries. Papyrus was highly perishable: one Roman poet wrote regretfully of "the bookworm which bores through papyrus," while another, Martial, humorously recounted how his scrolls were both eaten by cockroaches and recycled as wrappers for olives and fish.[49] For a Latin work from ancient Rome to survive the next few centuries and beyond, it therefore needed to be transferred to parchment. But this conversion from roll to codex was reliant on the early Christians—the people who made the codices—deeming the writings of their pagan predecessors worthy of preservation and study.

Many Christian voices had been raised against the pagans. The theologian Tertullian, who converted from paganism to Christianity in Carthage in around AD 200, pointedly demanded of his fellow Christians: "What has Athens to do with Jerusalem?"[50] Even more emphatic was the rejection by Saint Jerome. In about 373 he set off on a journey across Asia Minor to Jerusalem, taking with him a number of the pagan works he had studied in Rome, and reading with great delight the works of Cicero and Plautus, compared to whose polished Latin the style of the Old Testament struck him as crude and distasteful. Falling ill en route, he experienced a vision in which he was hauled before the throne of God to account for himself and, after

protesting that he was a Christian, received the withering rebuke that he followed Cicero rather than Christ. He next imagined himself being scourged with a lash and tortured with fire.

By no means were all early Christians hostile to the Latin or Greek classics. For every Tertullian, there was a Clement of Alexandria, who, writing in around AD 200, regarded pagan philosophy as what he called the "handmaid" of theology. Philosophy, he wrote, served the Greeks as a "preparation" for the Christian faith, "paving the way for him who is perfected in Christ."[51] Likewise, Saint Augustine noted that although heathen writers such as Plato were, to be sure, filled with strange fancies contrary to Christian teaching, they also wrote much that was in harmony with the faith. Indeed, in *On True Religion,* written in about 390, several years after his conversion to Christianity at the age of thirty-two, Augustine claimed that Plato and Socrates, were they alive in the fourth century, would be good Christians.

A Christian who made use of pagan works was, Saint Augustine believed, like the children of Israel who looted the Egyptian temples, making off with precious vessels of gold and silver that were then piously repurposed. Even Saint Jerome eventually softened his stance, taking heart from Deuteronomy 21:10–14, which explained what to do if, when victorious in battle against the enemy, one saw among the captives a beautiful woman and experienced "a desire unto her." All one needed to do, the Bible stated, was to shave her head, clip her nails, strip her naked, and let her "bewail her father and her mother a full month," after which it would be safe and acceptable to marry her. Such, for Jerome, was the kind of decontamination or quarantining that the classics called for: once carefully clipped and sanitized, they would be fit for Christian consumption.

A thousand years after Jerome and Augustine, when Christianity no longer waged its fierce combat against pagan culture, the ancient Greek and Roman writers posed much less of an existential threat. Medieval heretics such as the Cathars, the Lollards, and the Hussites, and even witches, caused the ecclesiastical authorities far greater alarm. Compared to the Cathar belief that much of the Bible had been written by Satan, gentle reflections from the ancient world on how a man could acquire wisdom or live a virtuous life

scarcely seemed worth the bonfire. The heretics were persecuted and, in some cases, slaughtered en masse, whereas the fate of most classical writers was benign neglect. True, shrill voices occasionally rose against them, as in 1405 when a Dominican friar in Florence urged Christians to keep away from classical literature. "Not only are the books of the pagans not to be read," he thundered, "but they are by public decree to be burned."[52] But no public decree was passed in 1405, and no manuscripts were burned. The friar was mocked for his poor grammar, and Niccoli and his friends continued their studies hindered only by their lack of books.

Chapter 3

Wondrous Treasures

One day in 1431, several years before he met Vespasiano, Niccolò Niccoli wrote out, in his stylish, tilted script, a list of sought-after books that he sent to Cardinal Cesarini. The cardinal had been dispatched by the pope, Martin V, on a legation that extended across Germany, Bohemia, Hungary, and Poland. Niccoli never traveled himself. He had long planned a trip to Constantinople, but Poggio, who had traveled a great deal himself, warned Niccoli that he was much too finicky and intolerant to cope with the discomforts and inconveniences of travel. He was fussy about his diet, and the sound of a mouse squeaking or a donkey braying was enough to disconcert him. One of his friends, a monk, was obliged to have his robes beaten and brushed before entering Niccoli's presence. "He could not stand hearing or seeing anything unpleasant," wrote a friend.[1] And so, in the end, Niccoli did not budge from his sumptuous Florentine lodgings. If, however, one of his friends set off on a journey, especially one that took him across the Alps, he was quick to offer urgent suggestions about where to go and what to do—for he was convinced that many ancient manuscripts remained to be discovered in the dim and musty fastnesses of French and German monasteries.

Cardinal Cesarini therefore embarked on his papal mission armed with the list of books that Niccoli hoped might be found. Included were the names of works by Cicero, Tacitus, and Suetonius, together with the places where in recent years exciting rediscoveries had been made, such as the Benedictine abbey at Hersfeld, in the middle of Germany.[2]

Many ancient manuscripts had been recovered in the two decades before Vespasiano's birth, a good number of them in France,

Germany, and the Swiss cantons. As one of Niccoli's young protégés succinctly put it back in 1416, "In Germany there are many monasteries with libraries full of Latin books."[3] Indeed, the lost classics were most likely to be found in these northern monasteries, in lands often disparaged by the Italians as barbaric. Niccoli therefore had good reason to relish the prospect of a friend finding new tomes after crossing the Alps. He was, however, disappointed in his wish to have Cesarini search for lost masterpieces. Though he traveled

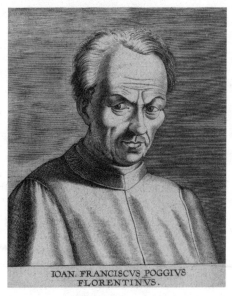

IOAN. FRANCISCVS POGGIVS FLORENTINVS.

The manuscript hunter Poggio Bracciolini (1380–1459).

widely over the next year or two, the cardinal proved far too busy to make arduous detours into the German hinterlands in search of musty and neglected volumes. Many years earlier, however, Niccoli had enjoyed the tremendous success of Poggio.

Years later, Poggio would tell the story of his incredible adventure to Vespasiano, who related it in the biography he wrote of this intrepid manuscript hunter. Vespasiano may first have heard the story over dinner at Niccoli's house or on the corner outside the bookshop—a tale to thrill the blood.

In the autumn of 1414, Poggio had arrived with his employer, Pope John XXIII, in the city of Constance, in southern Germany, where, a few weeks later, they were joined by Leonardo Bruni. Elected in 1410, John, the former pirate and notorious seducer Baldassare Cossa, was one of the three rival claimants to the throne of Saint Peter. He had convened a Council on the shores of Lake Constance to settle this vexing issue, as well as to deal with heretics such as the Hussites, followers of the Bohemian theologian Jan Hus, who wished to reform the Church. The problem of the Hussites was harshly addressed with the burning of Hus's books and then, for good measure,

Hus himself. The difficulty of multiple, competing popes was solved less to John's satisfaction, since he found himself deposed. After a violent tantrum in which, according to Vespasiano, he tried to throw a priest out the window, the now ex-pope was obliged to flee Constance in disguise. He hid with Bruni in an abbey where, Vespasiano claims, they survived by eating rotten pears.[4]

Poggio remained in Constance but, with his employer so unceremoniously dethroned, found the leisure to make his way to the baths at Baden to treat his rheumatism. Here, as he informed Niccoli in a letter, he delighted himself by observing the women, both old and young, entering the water while "displaying their private parts and their buttocks to the onlookers."[5] Niccoli had weightier aspirations for his friend's sojourn. As Vespasiano wrote, "He was urged by Niccoli and by many other scholars to search the monasteries for the many books in Latin that had been lost."[6] Poggio left the baths of Baden for the Benedictine abbey of Saint Gall, twenty-five miles southeast of Constance, founded some seven hundred years earlier on the site of the shrine of an Irish monk. Here he would make his remarkable discovery.

If the book of the Christians was the parchment codex, the means of its reproduction and transmission had been at places such as Saint Gall. After the fall of the Roman Empire, the Church had been the bastion of books and literacy. For many centuries, books were almost exclusively part of the ecclesiastical world. The business of producing and preserving manuscripts was conducted by monks hunched over parchment dutifully copying texts (often borrowed from other monasteries) for their libraries. Sometimes a monastery set aside for its scribes a special room called a scriptorium, though more often the monks simply copied work in their cells or in the open air of the cloisters.

The classical civilization of the Mediterranean was most faithfully preserved not in sunny Italy—which between the fifth and the eighth centuries was ravaged by barbarian invasions—but, rather, in distant northern lands, among the mists of Ireland, the moorlands of Northumbria, and the forests of Germany. "All the learned men

on this side of the sea fled," wrote an observer in Gaul during the invasions, "and in districts beyond the sea, that is to say, in Ireland."[7] Latin learning was enthusiastically pursued in Irish monastic foundations, culminating in the remarkable figure of Columbanus, born in the province of Leinster in about 560. His legend relates that his mother, while pregnant, dreamed of a brilliant sun emerging from her bosom to illuminate the darkness of the world. When her child was born, she prepared him for this task by seeing to it that he received a well-rounded education in grammar, rhetoric, and geometry, as well as in the Holy Scriptures. In about 590 he and twelve followers crossed the English Channel to the Brittany coast and then went on to found monasteries with scriptoria near Luxeuil in Burgundy and at Bobbio in northern Italy. Other monasteries developed as offshoots at Fontaines and Corbie. The abbey of Saint Gall—the object of Poggio's quest—was founded on the site of the shrine that held the relics of one of Columbanus's twelve companions.

Next to cross the Channel to set up monastic foundations had been Anglo-Saxon missionaries, such as Willibrord (who began working among the Frisians from the 690s) and Boniface (who arrived in Utrecht in 716). The latter wrote that he had come "to enlighten the dark corners of the Germanic peoples."[8] They came armed with supplies of books and, like Columbanus and his companions, a distinctive script later known as "insular" ("from an island") because of its origins in Ireland, Scotland, and England. The Anglo-Saxon missionaries brought something else with them: the conviction that a well-equipped library was essential to ecclesiastical study. A good supply of books was vital to the task, according to Boniface, of impressing piety and reverence on the "carnally minded" Germans.[9]

Many decades later came Alcuin of York. Around 780, when he was about forty years old and possessed a reputation as an erudite and effective teacher, Alcuin met Charlemagne, King of the Franks and conqueror of the dreaded Lombards. So began the great "Carolingian Revival," with Charlemagne zealously promoting literary studies and Alcuin serving as a kind of minister of education. Though Charlemagne was illiterate himself (he kept a slate under his pillow in a vain attempt to learn his letters), he had a great respect for scholarship and wisdom. He built up the royal library with new acquisitions,

oversaw the production of manuscripts on subjects ranging from theology and history to the natural sciences, and encouraged both monasteries and private individuals to acquire books. In doing so, he and his scribes preserved for future centuries many works that would otherwise surely have perished. Around seven thousand manuscripts survive from the Carolingian Age, a period running from the end of the 700s to the end of the 800s.[10] Many of these manuscripts were copied from ones already hundreds of years old—those done during the papyrus-to-parchment changeover of the fourth and fifth centuries. Not only were these reams of knowledge preserved and multiplied after Charlemagne's scribes rendered them in their elegant script, but also, thanks to the monastery libraries, they found new places of refuge in what had been the "barbarian" lands of northern Europe.

Suddenly, five hundred years before Petrarch's manuscript hunting in the middle of the 1300s, it became possible to dream of the rebirth of the ancient world. As a poet enthused around 805, "Our times are transformed into the civilization of Antiquity. / Golden Rome is reborn and restored anew to the world!"[11] Claims about the rebirth of "Golden Rome" had been boldly underscored a few years earlier, on Christmas Day in the year 800, in the basilica of Saint Peter, in Rome, when Pope Leo III proclaimed Charlemagne's new title: "Charles Augustus, crowned by God, great and powerful Emperor of the Romans."

This revival of ancient learning would continue beyond the deaths of Alcuin in 804 and Charlemagne in 814, spreading across what became known as the Holy Roman Empire, and thriving in monasteries and schools in places such as Liège, Corbie, Hersfeld, Fulda, and, of course, Saint Gall. In the latter alone there were, by 830, one hundred monks busily copying manuscripts. Among the treasures of the library were books so ancient that they had been copied not on parchment or even papyrus but, rather, on tree bark.[12]

The splendor of this rejuvenated empire was not to endure. Charlemagne's magnificent library was dispersed following his death, as his heirs fell victim to infighting, civil discord, and barbarian onslaughts. Within a few decades, the abbot at the monastery of Corbie, where a beautiful and legible script had developed, bemoaned the

loss of "such a glorious realm" through "the hideous evils done by savages" and "the wars fought without pity between our own peoples, amid pillaging and plundering, sedition and fraud." As Charlemagne's grandson Nithard morosely observed, "Once there was abundance and happiness everywhere, now everywhere there is want and sadness."[13] The manuscripts of the classics, so recently copied and cherished, began moldering on library shelves, awaiting the arrival, centuries later, of enthusiasts such as Petrarch and Poggio.

Poggio arrived at the Abbey of Saint Gall in the summer of 1416. He was accompanied by two young friends, both accomplished Greek scholars and fellow members of the Roman Curia, Cencio Rustici and Bartolomeo Aragazzi. They made their journey in a state of high anticipation, having heard that the library was stocked with great numbers of books. As Rustici later wrote, they were hoping to lay their hands on works by Cicero, Varro, and Livy, "and other great men of learning, which seem to have completely vanished."[14]

The library at Saint Gall quickly yielded some interesting volumes despite its disorderly state. Poggio later described to Vespasiano how he found a volume containing six speeches by Cicero "in a heap of scrap paper destined for the rubbish." Among the shelves they also discovered works such as Vitruvius's *Ten Books on Architecture* and a manuscript of the Roman poet Valerius Flaccus's unfinished epic, *Argonautica*—"all works of the greatest importance," according to Vespasiano.[15] None of the works, however important or interesting, was unknown to the young men. At least two copies of Vitruvius, for example, could be found in Florence, including one owned by Giovanni Boccaccio that was stored with the rest of his manuscripts—a collection of some 160 codices—in the monastic library at Santo Spirito.

Only when the three men left the library and went into the tower of the abbey's church, where further books were stored, or rather, as Poggio noted, kept prisoner in a gloomy dungeon, did they make their great discovery. At first they were appalled by the sight that greeted them: the books were horribly neglected and the tower both infested with insects and filthy with dust, mold, and soot. The three of them burst into tears at the sight, reflecting bitterly on this barbarous

treatment of the Latin classics. The abbot and monks were, Rustici fulminated, the "damned dregs of humanity"—though he was forced to admit that the Italians, too, had shamefully mistreated their magnificent heritage. However, sorrow soon turned to disbelief and joy when they discovered among these sorry ruins the book that had been sought for more than five centuries: a complete copy of Quintilian's *Institutio Oratoria.*

Poggio tried to acquire this precious volume from the monks, recognizing that Quintilian "could not much longer have endured the filth of that prison, the squalor of the place, and the savage cruelty of his keepers." When the abbot refused, Poggio spent the next thirty-two days hastily copying out the entire text. Many years later he would show this manuscript to Vespasiano who, by then a connoisseur of such things, admired the "beautiful letters."[16]

Poggio's discovery of Quintilian in Saint Gall was widely celebrated, indeed epoch-making. Having learned of this discovery, Bruni and Niccoli urged Poggio to leave all else aside and send a copy of the manuscript to Florence. "Oh wondrous treasure!" enthused Bruni. "Oh unexpected joy! Shall I see you, Marcus Fabius, whole and undamaged, and how much will you mean to me now?"[17] In 1417 Poggio received a letter from a friend, a wealthy scholar from Venice named Francesco Barbaro, who praised him for bringing such a wise man back to life. Thanks to Poggio's discoveries, Barbaro rejoiced, "our descendants will be able to live well and honorably." The wisdom of these ancients, once studied and applied, would now "bring the human race more benefit" because such book learning would bring advantages "not only to private concerns but to cities, nations and finally to all mankind." He fondly imagined that one day someone holding the "highest power of government" would be steeped in these classical works, with happy consequences for humanity. In Barbaro's opinion, Poggio had done a great service to both government and society at large: his discoveries would enhance "the public good."[18]

Following his discovery of Quintilian, Poggio took himself off the following year to places such as Langres in France, Cologne in Ger-

many, and Einsiedeln in the Swiss cantons. He went to the famous abbey at Fulda, where, six centuries before, a team of forty monks had worked to copy codices brought from England by Anglo-Saxon missionaries. He went to Reichenau, where, a century after that, another team of monks had copied the codices transcribed by the monks in Fulda. In these and other libraries he made further discoveries, including the partial copy of Lucretius's *On the Nature of Things*—unseen by scholars for more than five hundred years—and eight previously unknown speeches of Cicero.

All of these works Poggio copied and sent to Bruni and Niccoli in Florence. The city was becoming renowned more than anywhere else in Europe as a place where ancient manuscripts were collected, where the classics were studied, preserved, and esteemed. Thus, by the time Vespasiano was born in 1422, all of this ancient knowledge, after its migrations around Europe, after flowing back and forth across the Channel and the Alps, after finding refuge in monasteries where new codices were produced, and after centuries of eclipse and neglect, of disintegration and loss, was finally coming to Florence.

"How much the men of letters of our age owe these men," Vespasiano later wrote of Poggio and his friends, "who shone such a light."[19] When he went to work in Michele Guarducci's bookshop it was therefore possible, thanks to men like Niccoli and Poggio, to dream of the rebirth of the ancient world, this time on the banks of the Arno.

Chapter 4

Athens on the Arno

In the summer of 1434, soon after Vespasiano began work in the Street of Booksellers, a distinguished visitor came to Florence. He arrived on the eve of Florence's biggest annual celebration, the Feast of San Giovanni, when people donned masks, lit bonfires, and watched jousts, parades, a horse race, and gory fights between wild animals. This year the scenes were even more festive, for the visitor was Pope Eugenius IV. Vespasiano was among the crowd that turned out to see him. He later described how His Holiness was greeted on the road from Pisa and escorted into Florence by its finest citizens, who treated him "with all the ecclesiastical pomp due to a pope."[1]

Little more than three years had passed since Gabriele Condulmer, a tall, fifty-one-year-old Venetian nobleman, was elected pope, taking the name Eugenius IV. But despite the grandeur of his office and the pageantry of his entry, Eugenius was now a homeless fugitive. When he was a young man a hermit had predicted that he would become pope, and that as pope he would know much trouble.[2] Both prophecies were, as it happened, amply fulfilled.

The Council of Constance, which had completed its sessions in 1417, finally solved the problem of the multiple popes. Besides deposing John XXIII, it had accepted the abdication of another claimant, Gregory XII, and dismissed the claims of the third, the Avignonese pretender Benedict XIII (who, however, stubbornly continued to appoint cardinals and steadfastly maintained, until his death in 1423, that he was the true pope). In November 1417 the Council had elected a new pontiff, a Roman cardinal named Oddone Colonna, who took the name Martin V. In September 1420, following a twenty-month sojourn in Florence, he moved to Rome.

Pope Martin came from a family of powerful Roman barons. For centuries the Colonna, in rivalry with other ancient families such as the Orsini and the Frangipane, had fought for control over Rome. They entrenched themselves in fortresses and towers, built on the remains of ancient baths and temples, from which they pursued bloody vendettas against one other. The Colonna naturally enjoyed great power and privileges while their kinsman reigned as pope: Martin generously exempted their huge estates from taxation and showered them with civic and ecclesiastical offices. Meanwhile he forsook the Vatican for the greater comforts of the Colonna palace near Trajan's Forum.

Martin died from a fit of apoplexy in the family palace in February 1431. He was replaced by Eugenius, whose election, though unanimous among the cardinals, had not gone down well with much of the rest of Rome, whose people were, in Vespasiano's opinion, "wayward and unruly."[3] Battle lines were drawn when Eugenius sided with the Colonna's old enemies, the Orsini. He revoked the Colonna's privileges and accused them of having embezzled funds intended for a holy war against the Turks. When the authorities uncovered a Colonna plot to murder the pope, more than two hundred people went on trial: some were sent to prison, others to the gallows, and the Colonna were excommunicated. Three years later, at the end of May 1434, with the Colonna still stirring up trouble and the Roman people discontented by his incompetent prosecution of an unpopular war against Milan, Eugenius was forced to flee the city. Disguised as a monk, he set off down the Tiber by boat, traveling only a short distance before the spectacle of a monk escorted by four crossbowmen raised suspicions. Boats set off in pursuit. The pope cowered beneath a leather shield as rocks, spears, and arrows rained down on the skiff, which nearly capsized beside the basilica of Saint Paul Outside the Walls. After an anxious fifteen-mile chase downriver, Eugenius finally reached the port of Ostia and the safety of a vessel waiting to take him up the coast for refuge in the friendlier environs of Florence.

Eugenius would remain in Florence for much of the next decade, ruling as pope in sumptuous lodgings prepared for him in the

Dominican convent of Santa Maria Novella. His ejection from Rome was to have important consequences for Vespasiano's career. Pious and unworldly, the pope was not a learned man. However, the Florentine residence of the papacy meant, crucially, that the Roman Curia also came to town—the papal bureaucracy staffed by highly educated diplomats, scribes, scholars, and experts in Latin, such as Poggio Bracciolini.

Poggio welcomed the chance to return to Florence after his long absence. Following his triumphant discoveries in Saint Gall and elsewhere in 1416 and 1417, he had left the Curia to spend five unhappy years in England as secretary to Henry Beaufort, the Bishop of Winchester. Here he was bedeviled by a lack of money, the uncouth habits of the natives—"men given over to gluttony and lust"[4]—and persistent hemorrhoids. He returned to work in the Roman Curia in 1423, his one consolation for his English adventures being a collection of funny stories about the English with which he later amused friends. "He found much to condemn in their way of life," noted Vespasiano, who met him soon after this return to Florence in 1434.[5]

Vespasiano's reliable customer Andrew Holes (c.1395–1470) (center): an exception to the drunken, gluttonous *inglesi*.

Another distinguished refugee from Rome arriving in Florence at this time was an exception among the drunken, gluttonous *inglesi*: a young man named Andrew Holes. An Oxford graduate, Holes had arrived in Italy in 1431, when he was in his mid-thirties, to serve as the English ambassador to the pope. For the next dozen years he would remain in Italy, mainly in Florence, where he began living, as Vespasiano approvingly noted, *alla italiana*, shunning the greedy habits of his countrymen: he ate only a single course at mealtime and

remained sober. The dinners he hosted in Florence were feasts for the mind rather than the belly, attended by learned men who debated philosophical propositions. His spare time was spent in prayer and reading the books that he hired scribes to copy for him—"a vast number of books," according to Vespasiano.[6] He would become, not surprisingly, a regular visitor to the Street of Booksellers and a close friend of Vespasiano, who called him "Andrea Ols."

With so many of these lovers of wisdom gathering in Florence, the stage was set for lively discussions. At the dinners hosted by Niccoli or Holes, in debates on the street corner outside the bookshop— the adolescent Vespasiano was busily absorbing knowledge and stories, making important connections, and, crucially, impressing his interlocutors with his intellect and abilities as he feasted on their scraps of wisdom.

One mystery about Vespasiano is how he would come to possess such a vast store of knowledge and expertise despite his brief and somewhat rudimentary education. His five years in school must have equipped him with very little Latin. After mastering his ABCs, he would have been introduced to a book variously known as a *Donato, Donatus,* or *Donadello,* a Latin grammar based on that composed by Aelius Donatus, the teacher of Saint Jerome. Only at a grammar school, however, entered at the age of eleven, did students truly begin to tackle the complexities of Latin grammar and the works of ancient writers. Students who left school at eleven, like Vespasiano, could recognize and pronounce many Latin words but not actually understand their meanings. For the most part their schooling consisted of reading works in the "vulgar tongue," especially works on heroic moments in Florentine history meant to inculcate moral discipline and patriotic devotion. The contract for one teacher summed up the level and purpose of the literacy acquired in the *botteghuzza* by boys like Vespasiano: the tutor was to offer instruction such that his pupils "might know how to read and write all letters and accounts and what shall be adequate to serving in the shops of artisans."[7]

Though destined to work in the shop of an artisan, Vespasiano continued his education until his proficiency soon extended well

beyond letters and accounts. Some of his learning took place, quite literally, in the street—on the corner outside Guarducci's shop. Another gathering spot could be found on the west side of the Piazza della Signoria, beneath the Tettoia dei Pisani, the Roof of the Pisans.* Built by hundreds of Pisans captured at the Battle of Cascina in 1364, this space, offering shelter from the sun and rain as well as a view of the whole piazza, drew together informal groups of philosophers and scholars. Under the roof one could listen as scholars discussed the finer points of Latin grammar and Greek translation. Giannozzo Manetti, a renowned diplomat and scholar of Hebrew and Greek who, according to Vespasiano, "adorned the city" with his brilliance, perfected his Latin in these debates, ultimately coming to speak it as well as he spoke his mother tongue.[8] Vespasiano came to know Manetti well. His adulation for and familiarity with the older man has led to speculation that Manetti served as his tutor in the 1430s, and that Vespasiano's career owed much to the guidance and intellectual virtuosity of this brilliant multilinguist who knew by heart the entirety of both Saint Augustine's *City of God* and Aristotle's *Nicomachean Ethics*.[9]

Another tutor was Niccolò Niccoli, the treasures of whose library offered Vespasiano his first exposure to classical manuscripts. Niccoli hosted what might be called a book club or reading group. Vespasiano later described how Niccoli liked to invite young men to his home and, as each arrived, hand him a book from his library and say, "Go and read." The young men, "as many as ten or twelve of them," would sit engrossed until Niccoli urged them to lay down their manuscripts; he then asked each to describe what he had read. "Many worthy discussions followed," Vespasiano fondly recalled of this stimulating little reading group—one of several in which, over the years, he would participate.[10]

Other opportunities for learning also presented themselves in the Florence of Vespasiano's youth. Among them was the local uni-

* These public spaces were decidedly masculine. An archbishop of Florence (and future saint), Antonino Pierozzi, was adamant that women should not go "leaping about the piazza." Women were even discouraged from standing in their own doorways or appearing at the window. They should only be seen in the street, the archbishop claimed, when on their way to church—suitably chaperoned, of course.

versity, the Studio Fiorentino. Vespasiano never enrolled at the Studio, which occupied a modest building in a narrow street on the south side of the cathedral, only a three-minute walk from Guarducci's bookshop. However, he came to know some of the professors well, and a few years after he began work in the shop a friend in the countryside wrote asking him for news of Florence, specifically what was happening in the Studio.[11] The professors often gave public lectures in order, as Vespasiano later wrote, "to satisfy the appetite for literature" among the Florentines.[12] He described how one professor in the 1430s, Francesco Filelfo, lectured to crowds in their hundreds, and how another, Carlo Marsuppini, "the most well-read man in Florence," delivered a lecture in which, in a jaw-dropping display of erudition, he quoted from every known Greek and Roman writer. "It was a wonderful sight to behold," Vespasiano later enthused, proudly placing himself among the throng of eager auditors.[13]

Lectures such as those by Filelfo or Marsuppini, with their deep knowledge of Greek as well as Latin authors, could have been heard in few other places in Europe. Florence's university was unique. It was neither ancient nor prestigious like those in Bologna (founded in 1088), in Paris (1200), or in Padua (1222), celebrated respectively for law, theology, and medicine. The Studio Fiorentino had opened its doors only in 1348—the year, ominously, of the Black Death. So unstable were its finances during its early decades that closure was a constant threat. Throughout the decade of the 1370s it had been staffed by a single professor. However, its fortunes soon began to turn thanks to generous support from several wealthy bankers and the appointment of a succession of brilliant professors, the first of whom, hired in 1397, had been Manuel

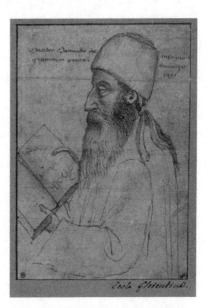

The Greek scholar and teacher
Manuel Chrysoloras
(c.1350–1415).

Chrysoloras, a learned nobleman and diplomat enticed away from Constantinople to teach the students Greek.

It was not true, as was so often said, that no one in the West spoke Greek before 1400. It was more the case that the supply of Greek texts and teachers exceeded the demand until scholars in the West, following Petrarch, became interested in the precious heritage of antiquity. Resources had always been at hand. Tens of thousands of Greeks had come to the Italian peninsula over the centuries, whether as refugees fleeing Muslim conquests in Syria and Sicily, as merchants doing business in Venice and Pisa, or as craftsmen overseeing mosaics in Florence. Some two hundred monasteries could be found in southern Italy where the ceremonies were performed in Greek. The library in the court at Naples held Greek manuscripts, as did, in even more copious numbers, the abbey of San Nicola di Casole, near Otranto in the heel of Italy. This abbey was home to learned monks happy to teach Greek to anyone who wished to learn. One local scholar reported that they offered "food, a teacher and hospitality, all without asking for compensation."[14] Giannozzo Manetti took his own approach to learning the language: he invited two Greeks to come live in his house and offer him a fully immersive experience by speaking to him only in their mother tongue.

For many scholars in the West, though, Greek was still an unintelligible language. When copyists came upon a Greek word or phrase in a manuscript—as they often did in the works of, say, Cicero, whose letters alone have 850 Greek words and phrases[15]—they would unabashedly write: "*Graecum est—non legitur*" ("It is Greek—it cannot be read"). Much to his regret, Petrarch was unable to read either the sixteen dialogues of Plato that he owned or the codex of Homer given to him in 1354 by a Byzantine envoy. "Alas, I am deaf to you and you are mute to me," he sighed over the latter manuscript, in which he got no further than learning to decipher the capital letters.[16]

Expert knowledge of Greek would be what distinguished many scholars in the fifteenth century from their predecessors in the Middle Ages. This mastery owed virtually everything to the Studio Fiorentino and its appointment of Manuel Chrysoloras. The "pure radiance of the past" began to glimmer anew with his arrival in the city on February 2, 1397, as he quickly assembled under his tutelage a

group of brilliant and eager students who included Niccoli, Poggio, and Leonardo Bruni. Though Chrysoloras stayed for only three years, other experts in Greek succeeded him—Guarino da Verona, Giovanni Aurispa, and Francesco Filelfo—all of whom had spent time honing their language skills and collecting Greek manuscripts in Constantinople. In 1423, in a famous episode, Aurispa had returned to Italy with 238 manuscripts, some of which he sold his clothing to purchase—"something for which," he later reported, "I feel neither shame nor regret." Thanks to these professors, Florence quickly became what Bruni called "the new Athens on the Arno."[17]

Filelfo, in particular, took Florence by storm. Hired to teach at the Studio in 1429, he was a dazzling thirty-year-old prodigy from Tolentino, 150 miles southeast of Florence. He arrived in town sporting a Greek-style beard and accompanied by a beautiful and aristocratic Greek wife: the legacies, along with his perfect fluency in Greek, of seven years spent in Constantinople. According to Vespasiano, the sons of all of Florence's most influential citizens flocked to his lectures on Latin authors such as Cicero and Livy, and Greeks such as Thucydides and Xenophon. Filelfo conducted more informal lessons in his house, which stood on the south side of the Arno in Via dei Ramaglianti, and which featured his library of precious manuscripts. These volumes had been transported to Florence by a team of six pack mules paid for by Niccoli.

Filelfo's time in Florence ended with the glint of a blade and splashes of blood. However generous, Niccoli could also be spiteful and jealous. Even friends such as Poggio complained that he was "crotchety and bad tempered," and Manetti that he possessed "a kind of frank and free-wheeling license in censuring others."[18] Niccoli and Filelfo soon fell out due to the former's jealousy of the latter's acclaim and his abhorrence of the young professor's titanic self-regard ("I am praised to the skies," Filelfo boasted, "my name is on everyone's lips").[19] As Vespasiano later observed of Filelfo, "He possessed great genius but little self-control."[20] As relations declined, Filelfo circulated venomous diatribes accusing Niccoli and Poggio of drunkenness, sodomy, and ignorance of Greek. Poggio retorted with a poisonous series of invectives depicting Filelfo as a rapist, an adulterer, and a pedophile who seduced his mother-in-law and maintained

a stable of male prostitutes. "You stinking billy-goat," he frothed, "you horned monster, you malevolent vituperator, father of lies and author of chaos." He suggested that Filelfo's time would be better spent directing his attacks "against those who debauch your wife."[21] One day as Filelfo left his house in a narrow street on the south side of the Arno a thug stepped from the shadows and with "perilous and terrifying thrust"—as Filelfo later described it—slashed him across the face.[22]

Filelfo would bear the scar for the rest of his life. But he and Greek letters in Florence both survived the assault. Vespasiano later viewed the quarrels and altercations involving the fiery Filelfo with a philosophical shrug: "Such was the disdain felt for him." But at least Filelfo had been part of what Vespasiano called the "rich harvest" brought forth by the arrival in Florence of Manuel Chrysoloras.[23]

The violent passions raised in Florence's literary circles likewise troubled the political arena. Barely had the pope established himself in Santa Maria Novella than, in October of 1434, another sudden arrival caused much excitement: the return from exile of Cosimo de' Medici.

Just as the Colonna and Orsini vied for control of Rome, a number of wealthy and powerful families had, for the previous few decades, vied for control of Florence. Most were old merchant families such as the Albizzi, the Rucellai, and the Strozzi. Florence was a republic ruled by, as one of its politicians boasted, "thousands of men." But power resided, in actual fact, with a small circle of these wealthy families. Only some 10 percent of the many citizens eligible for office ever actually found themselves selected for service thanks to a clever manipulation of the voting system, which involved the drawing of names from pouches—a kind of lottery in which, mysteriously, a few names were drawn repeatedly, others not at all.

By the 1420s one of the less prominent clans, the Medici, began emerging as a force to be reckoned with. Originally from a rural stronghold in the Mugello, a mountainous region to the north of Florence, the Medici were supposedly descended from a knight of Charlemagne's who fought the Lombards and drove a giant out

of Tuscany.[24] If this valiant knight in fact existed, many of his descendants proved less illustrious. In the 1300s, with many having migrated into Florence, they became known for small-time moneylending and violent disorder: five members of the family were convicted of murder between 1343 and 1360, while in 1373 a sixth, Cosimo's great-grandfather Chiarissimo, was accused of killing a peasant but beat the charge for lack of evidence. They took to attacking each other, too, and in 1377 a certain Niccolò de' Medici was murdered by his uncle.

The Medici played little part in Florentine politics until 1378, when Salvestro de' Medici, the murdered Niccolò's father, supported the rebellion of the so-called Ciompi, the poorest of the clothworkers, who briefly took control of the government and celebrated him as their savior. Two decades later, the foray into politics of Salvestro's distant cousin Antonio ended less happily when he was beheaded for conspiring to murder the leader of a rival family, the Albizzi. Another botched plot in 1400 got the entire family banned from public office for twenty years. During these two decades of political exile, Giovanni di Bicci de' Medici, a model of prudence and restraint compared to so many of his feckless and homicidal ancestors, began building up the family wealth through concerns in banking and wool. By the time Giovanni died in 1429, leaving his affairs in the capable hands of his two sons, Cosimo and Lorenzo, the upstart Medici rivalled in wealth and influence older and more established families such as the Albizzi.

Thanks to some deft maneuverings, in fact, not to mention his vast wealth, by the early 1430s Cosimo, then in his early forties, held sway over Florence's communal finances and foreign policy. The Albizzi prepared their retaliation. According to Vespasiano, in 1433 Niccolò Niccoli warned Cosimo, his close friend, that a bad year was in store. His evidence came from a friar to whom he loaned Greek manuscripts, a man who lived in a pious community in the mountains near Lucca and, Vespasiano claimed, possessed "the God-given gift to predict the future." This prophet informed Niccoli, who duly warned Cosimo, that either death or exile beckoned.[25]

The latter won out, though only barely. In 1433 Rinaldo degli Albizzi accused Cosimo of bribing officials, interfering with elections,

and prolonging the unpopular and expensive war against the neigh-
boring city of Lucca in order to fill his coffers by making profitable
loans to the republic. When a government unsympathetic to the
Medici was elected in September 1433, Cosimo found himself de-
tained at Rinaldo's behest and imprisoned in the tower of the Palazzo
della Signoria. Here he was held for a month as his enemies clamored
for his execution. Only cash bribes to selected members of the
government ensured his release and—in fulfilment of the friar's
prophecy—his exile to Venice.

Cosimo's many friends stayed loyal to him during his exile in
Venice. Vespasiano watched Niccoli send a letter to the exiled Cosimo
while defiantly proclaiming to the messenger, loud enough for all to
hear: "Give this letter to Cosimo, and tell him I say that so many
mistakes are made every day in this city that a book wouldn't suffice
to describe them."[26] Niccoli was far from Cosimo's only friend who
stayed loyal. The rulers in places such as Perugia and Bologna offered
him sympathy and assistance, no doubt in recognition of crucial loans
made in the past. In Venice, to whose government he had likewise
loaned large sums, he was received like a visiting prince, "with such
honor and good will," he happily reported, "that it would be impos-
sible to describe."[27]

Meanwhile, in Florence it became obvious that the new masters
of the city had, as Vespasiano put it, "no idea how to govern."[28] Within
a year, a pro-Medici government was elected, calling for the return
of Cosimo and panicking Rinaldo, who, in a desperate bid to main-
tain power, assembled a thousand-strong mob of supporters. He was
dissuaded from violent action partly by Pope Eugenius but mostly by
the fact that his troops were outnumbered by supporters of Cosimo.
These included "a huge multitude of wild and fierce peasants" who,
under the command of Cosimo's distant cousin Papi, poured into the
city from the Mugello.[29] Now, suddenly, it was Rinaldo's turn to flee
into exile, along with more than five hundred others.

Cosimo returned to the family stronghold of palaces clustered along
Via Larga, north of the church of San Lorenzo. For the next three
decades he would dominate the republic's political and cultural life.

Florence was still a republic in name. However, Cosimo maintained tight control over political affairs by lavishing patronage, by advancing or impeding careers, and by manipulating the taxes in such a way as to impoverish his opponents. He also perfected the rigging of elections to public office through the careful oversight of the officials in charge of the ballots and pouches—the old ploy ensuring that, though many were called, very few were actually chosen. Cosimo himself remained mostly in the background, deftly and almost invisibly fingering the levers of power. "He did everything he could," Vespasiano observed, "to conceal his authority over the city. He did everything discreetly and with the utmost caution."[30]

Vespasiano came to know Cosimo extremely well. His biography of the great man—one of the longest in his collection—is peppered with expressions of casual intimacy such as "when I was with him," "when I was in his room," and "I have heard Cosimo say." To Vespasiano we owe the images of Cosimo playing games of chess and rising early in the morning to spend two hours pruning his grapevines.[31] The pair probably first met thanks to Niccolò Niccoli. However, Vespasiano's family had done business with the Medici in the 1420s, when his father, Pippo, worked as a subcontractor in the Medici wool business. Pippo owed the family eighty-six florins at his death. By 1431 this debt had been lowered to sixty-five florins, and then two years later, in 1433, the year Vespasiano began work in the Street of Booksellers, it was paid in full.

How precisely the impoverished Bisticci family managed to clear this debt remains a mystery. Years later Vespasiano would write of his relationship to the Medici that he was *allevato in casa vostra*—"raised in your house."[32] The statement should not be taken literally, but clearly Vespasiano had close links to the powerful clan from a young age. One scholar has speculated that Vespasiano and some of the other Bisticci children were put to work in the Medici wool business; another, that Cosimo personally intervened to help the family.[33] The latter is certainly a possibility. Vespasiano later wrote that Cosimo showed the greatest generosity to "those who busy themselves with books," since he knew they were often "poor in possessions but rich in virtue."[34] An example was Cosimo's treatment of Giovanni Aurispa, who sold his clothing in Constantinople to pay for Greek manuscripts:

Cosimo gave him fifty florins to defray the cost of shipping the codices to Italy and a decade later found him work as the secretary to Pope Eugenius. The young Vespasiano may likewise have encountered at first hand some of Cosimo's liberality toward needy bookworms.

However the two first met, Cosimo, like so many others, was evidently struck by the young man's intelligence and aptitude, and he would soon entrust Vespasiano with important missions. Despite the difference in age and social standing, the pair proved compatible, perhaps in part because Cosimo's enthusiastic but haphazard exposure to ancient literature mirrored Vespasiano's own. Since Cosimo's studies had been aimed at furthering his banking career, his classical learning was largely the result of informal discussions with friends. According to Vespasiano, he first studied Latin literature with a scholar and politician named Roberto de' Rossi, who offered lessons in his home to groups of well-born young men. Afterward, like Vespasiano, he participated in debates with friends such as Bruni, Niccoli, and Poggio.

The results of these informal studies were impressive. Cosimo came to possess a good knowledge of Latin—"more than one would expect," Vespasiano claimed, "in a great citizen burdened with the affairs of state."[35] His interests and expertise ranged over a formidable territory. "He was so universal in his knowledge," wrote Vespasiano, "that he could talk to anyone," whether about agriculture, astrology, medicine, philosophy, or theology.[36] He owned a library of more than seventy volumes—nothing compared to Niccoli's, to be sure, but a substantial collection in an age when the average cardinal owned fifty manuscripts and the library of the average German monastery contained only sixty.[37] A number of his manuscripts had been specially copied for him in beautiful handwriting by one of the finest scribes of the age, Giovanni Aretino. The scribe who copied a manuscript of the Roman philosopher Seneca for him concluded his labors with a personal message: *Lege feliciter suavissime Cosma*—"Happy reading, sweetest Cosimo."

Despite the urgent demands of running a bank with branches all across Europe, and despite involving himself in the messy political machinations necessary to safeguard his position as the unofficial ruler of Florence, Cosimo was perhaps never happier than when reading philosophy.

Niccolò Niccoli died early in 1437, at the age of seventy-one. Vespasiano included a long biography of him in his lives of illustrious men. So detailed is his description of Niccoli's final hours—the great man reposing on a carpet on the floor, at his own request, while a group of friends knelt around him, weeping—that we can imagine Vespasiano at the vigil, though he could have been no more than fifteen at the time. Niccoli was an eccentric and irascible character, but Vespasiano considered him a heroic figure worthy of emulation and commemoration. "Consider the life and habits of Niccolò Niccoli," he implored in his biography, "a great example to all the world."[38]

Niccoli's death raised the question of what would become of his immense library of eight hundred manuscripts. Two earlier collectors, Petrarch and Coluccio Salutati, a mentor of Leonardo Bruni and longtime chancellor of Florence until his death in 1406, had been foiled in their attempts to keep their libraries together after their deaths. Petrarch owned at least two hundred codices, while the collection of Salutati numbered an astonishing six hundred. Petrarch had donated his books to the Republic of Venice in exchange for the use of a palazzo, but the agreement fell apart when he moved to Arquà, some forty miles southwest, taking many of the books with him. The volumes left behind in Venice were sorely neglected, left to molder in the basilica of San Marco, while most of those in Arquà were seized in 1388 by the Duke of Milan, kept in a library in Pavia, and then eventually scattered around Europe. Salutati's library was likewise dispersed after his death, though many of his codices ended up in the libraries of Cosimo de' Medici and, in even greater numbers, of Niccoli himself. Others, in time, would pass through Vespasiano's hands.

Niccoli had been determined that the same fate should not befall his own magnificent collection. He wanted his manuscripts not only kept safely together but also made available to the public as a common good. In making his extraordinary library available to all interested scholars, he was only continuing what he practiced during his lifetime, since at his death no fewer than two hundred manuscripts were on loan to various of his friends.

The choice of where to deposit the collection Niccoli left to six-
teen trustees, among whom were Poggio, Bruni, and Cosimo de'
Medici. An appropriate institution obviously needed to be found and
then properly equipped with furniture in a suitable space. In 1438
plans were afoot to have his manuscripts transferred to the Franciscan
basilica of Santa Croce, on the eastern edge of the city. In 1423 a fire
caused by a careless friar had badly damaged the basilica's library,
causing the government to allocate 2,000 florins from the public purse
for its reconstruction. A few years later, in 1426, a wealthy butcher
named Michele di Guardino left 200 more florins for the refurbish-
ment of this library, along with a number of his own manuscripts to be
displayed on sixty wooden benches—a generous gesture that earned
his heirs the right to have the family coat of arms, a rampant bull,
frescoed on the library's outside wall. In 1438 Michele's guild, the ex-
ecutor of his will, made more of his funds available, this time to outfit
Santa Croce's library for the reception of Niccoli's collection. How-
ever, the precious manuscripts never arrived at Santa Croce. A differ-
ent patron intervened, and another institution was to become the
beneficiary of Niccoli's treasures.

The eventual fate of Niccoli's books rested on a conversation held in
Florence about a year before his death. The story is one of the most
famous in Vespasiano's collection, and one he undoubtedly heard
from Cosimo de' Medici himself.

One day in 1436 Cosimo went to visit Pope Eugenius. The pope
was still in Florence, lodged in Santa Maria Novella, from which he
had emerged on only a single occasion since his arrival two years
earlier: the consecration of the high altar of the cathedral of Santa
Maria del Fiore, adorned by Brunelleschi's newly completed dome.
On that memorable day in March 1436, His Holiness, sparing no
pomp, put off his usual clothes of scratchy wool, dressed himself in
full pontificals, donned his tiara, and then processed with seven car-
dinals, thirty-one bishops, and other dignitaries, including ambassa-
dors from the king of France and the Holy Roman Emperor, along
an elevated, drapery-festooned wooden walkway, ten feet high and
almost a third of a mile long. A massive crowd of two hundred thou-

sand people had come from near and far to celebrate Brunelleschi's achievement. It was "a marvellous sight to behold," reported Vespasiano, and we can imagine him, then a fourteen-year-old, among the throng.[39]

Cosimo was enjoying tremendous power and prestige at this time. He was also, of course, exceedingly rich, amassing a fortune, according to one observer, "as even Croesus could scarcely have owned."[40] While in the not so distant past a wealthy man such as Cosimo might, on moral grounds, have needed to disguise his extravagant spending, a new attitude toward riches and worldly goods had recently begun taking shape in Florence: nothing less than a revolution in attitudes toward money and spending brought about by a reading of the ancients, whose writings acknowledged values other than strictly Christian ones.

Was it better for a man to be rich or poor? For many centuries the Church had preached the virtue of poverty. The Bible taught that money was the root of all evil, that it was impossible to serve both God and mammon, and that it was easier for a camel to pass through the eye of a needle than for a rich man to enter into the kingdom of God. Saint Augustine wrote that business was an evil and Saint Jerome that a merchant could seldom if ever please the Lord. Saint Francis, who renounced his paternal inheritance, had been fulsome in his praise of Lady Poverty: "You surpass all other virtues," the saint declared. "Nothing can be a virtue without you."[41] A fresco on the vault in the Lower Church of the basilica of San Francesco in Assisi, painted by a follower of Giotto in the first half of the 1300s, depicts Francis taking Lady Poverty as his bride, placing a ring on her finger as Christ calmly presides over the ceremony.

Leonardo Bruni begged to differ with this dismissive view of earthly goods. He argued that nothing could be a virtue without money, and that virtue, in fact, depended on money. Bruni's friend and mentor Coluccio Salutati had already praised merchants, extolling them as "a most honest breed of men whose activities beautify cities and make available to everyone the bounties of nature."[42] Now Bruni was inspired to similar views by some of the works he translated from Greek into Latin. One of them was a treatise on economics that he (and everyone else at the time) mistakenly believed to have been

written by Aristotle (it was probably composed by one of his students, now known as the "Pseudo-Aristotle"). In this text, which described the best way to manage a household or estate, Bruni found justification for the idea that riches did not impede or inhibit virtue but, on the contrary, offered ample opportunities for its exercise. "It is the opinion of wise men," wrote Bruni, "that such enhancement of fortune is not blameworthy if it does not harm anyone. For riches can serve as an aid to such virtues as magnanimity and liberality, and they are useful to the republic."[43] Worldly goods could become instruments of virtue. After all, everything from charities to governments depended on men making large sums of money that they could then redistribute for the good of society.

Wealth was therefore essential for the health and well-being of the city or state. Indeed, Florence had become beautiful and powerful thanks to the riches of her merchants. The city's magnificent churches and their decorations, the protective circuit of city walls, the great towers, the beautiful palaces and other noble buildings, the handsome streets and spacious squares—all were the testament not only to the skill of Florence's artists and architects but also to the resources, both financial and intellectual, of its merchants.

Bruni's translation and commentary quickly became one of the most popular and influential treatises of the century: more than 230 manuscripts still survive of the many copies made in the decades that followed. Bruni found further ammunition when he produced a new translation of Aristotle's *Nicomachean Ethics*, a work that treated the expenditure of great wealth as a virtue. Aristotle praised the "magnificent man" who spent his money lavishly but appropriately (as opposed to the "vulgar man" with his "tasteless display on unimportant occasions"). "The magnificent man," wrote Aristotle, "is an artist in expenditure: he can discern what is suitable, and spend great sums with good taste."[44] Bruni therefore wrote warmly of the virtue of "magnificence"—of making "vast and great expenditures" by sponsoring such things as new theaters, jousting matches, and public banquets.[45]

Cosimo owned a manuscript of Bruni's translation of the *Nicomachean Ethics* (another of his manuscript bestsellers, with 285 fifteenth-century copies still surviving). Assurances that his exorbitant splurges could be counted as a virtue rather than a vice no doubt brought

comfort to him as he luxuriated in his palace in Florence and his castles and villas in the countryside.

Even so, certain matters weighed heavily on Cosimo's conscience. He was made uneasy, Vespasiano claimed, by the questionable origins of his vast fortune, much of which had been "acquired through dubious means,"[46] as Vespasiano cautiously put it—that is, by lending money at interest. Earning money through trade or honest toil was one thing, usury quite another. Aristotle could be of no help here, having declared interest contrary to nature since it involved money coming from money rather than from the sweat of the brow. Roman law had fixed modest rates of interest, though Christians, following Christ's injunction to lend without expecting anything in return, frowned on making any sort of profit at all from money. Over the centuries the Church had condemned the charging of interest, especially if it meant the rich profiting from the misfortunes of the poor. By the Middle Ages the denunciation was enshrined in canon law, which strictly forbade usury. In 1311, in fact, the Council of Vienne deemed that anyone who defended usury should be punished as a heretic. Around the same time, Dante placed usurers in the third ditch of the Seventh Circle of Hell, a barren desert where they sat weeping in a shower of flames, their moneybags suspended round their necks.

Cosimo was therefore understandably concerned for the fate of his soul. As Vespasiano wrote, "Hoping to lift this weight from his shoulders, he conferred with Pope Eugenius, who was then in Florence, regarding how he might unburden his conscience."[47] The pope informed him that a donation to the Church of 10,000 florins would suffice. It was hardly a novel solution: for the previous two centuries men of great wealth had salved their consciences and safeguarded their fates in the hereafter by making charitable donations and undertaking other good works of the sort singled out by Bruni as examples of putting wealth in the service of virtue—using their ill-gotten gains to pay for the founding and decoration of chapels, churches, and convents, and thereby expiating sins such as usury. In Padua, Enrico Scrovegni, whose grandfather and father had both been wealthy

usurers, endowed the Scrovegni Chapel (frescoed by Giotto between 1303 and 1305 with funds from Enrico) "for the salvation of my ancestors."[48] (The tactic, according to Dante, failed: Enrico's father, Rinaldo, was one of the usurers cowering in the Seventh Circle of Hell.)

Eugenius proposed that Cosimo lavish 10,000 florins on a monastery—and he knew exactly the one. The pope had only just evicted a small band of Silvestrine monks from the convent of San Marco, conveniently close to Cosimo's palaces in Via Larga. The Silvestrines founded this monastery in 1290, though recently the small handful of brothers inside the dilapidated buildings had earned themselves a reputation for high living and low morals, carrying on "without poverty and without chastity."[49] Eugenius kicked out the Silvestrines and gave the site to a more devout band, Dominicans from the convent of San Domenico in Fiesole, in the hills just north of Florence. The Dominicans arrived at their new convent to discover that the Silvestrines, in an act that did nothing to burnish their reputation, had stripped the premises of furnishings and set fire to parts of the buildings. The new residents were forced to build themselves wooden huts in which to live.

Cosimo was easily convinced by Eugenius to come to their rescue. He spent enormous sums on the monastery—far in excess of the 10,000 florins suggested by the pope. He engaged the architect Michelozzo Michelozzi to build dormitories, a church, a sacristy, and a cloisters, and to have them decorated with frescoes. Cosimo's generosity extended to paying for the tunics of novices, as well as for bread, salt, medicine, and, on feast days, extra portions of fish, eggs, and wine for the friars. He had a beautiful garden laid out for them according to his own design. He even persuaded Michelozzo to build him a double cell inside the upstairs dormitories, to which he could repair for periodic spells of spiritual contemplation.

Michelozzo had been engaged around the same time to rebuild the library damaged by fire at Santa Croce—the library chosen to house Niccolò Niccoli's manuscripts. Not long after work began at San Marco, Cosimo appears to have decided to give Michelozzo one more commission, and to give the Dominicans, besides their dormitories, tunics, and extra helpings of fish, one more charitable gift: a public library.

Chapter 5

Wise Men from the East

If the arrival in Florence of the Roman Curia had been a great boon to booksellers, five years later, in 1439, when Vespasiano was seventeen years old, the *cartolai* in the Street of Booksellers suddenly found their shops filled with dozens of even more brilliant and discerning customers, or what Vespasiano called "learned men from all over Italy and beyond."[1] Russians, Armenians, Bulgarians, Ethiopians, and Mesopotamians were among those who arrived. The majority of these distinguished scholars came, however, from Constantinople—exotic figures whose elegant robes, thick beards, and dignified bearing must have made them look to the Florentines like biblical prophets or Greek sages.

Constantinople had been founded by the first Christian emperor, Constantine, more than a thousand years earlier as the "New Rome." Constantine chose for the site of his new capital the ancient Greek colony of Byzantion (latinized to "Byzantium"), which occupied a strategic location on the Bosporus strait. Though the Roman Empire in the West fell in 476, the Empire continued in the East, with Constantine's unbroken chain of successors down through the centuries all bearing the title "Emperor of the Romans." And if Constantinople carried on, in name at least, the grandeur that was Rome, it likewise bore the legacy of ancient Greece. This Greek heritage was obvious to anyone who visited Constantinople: the local population spoke Greek, and the city served as an enormous repository of ancient Greek culture and learning. By the Middle Ages scholars in Constantinople had embarked on a quest to retrieve and preserve the classics of ancient Greek literature, showing such conscientious rigor that virtually all of the Greek classics as we know them have

come down to us thanks to Byzantine manuscripts copied in the
eighth and ninth centuries.

In 1439 the Eastern Roman Empire was in grave danger of dis-
integrating. Its domains were rapidly shrinking, ravaged by plague,
civil war, and, most of all, the conquests of the Ottoman Turks. By
the 1390s the Sultan Bayezid I, known as the "Thunderbolt," was in
control of virtually all of what had been the Empire's glorious realm.
He even besieged Constantinople itself in 1390. A few years later, after
the Byzantine emperor, Manuel II Palaeologus, appealed to the
West for help, a 16,000-strong army of crusader knights from France,
Burgundy, England, Croatia, Wallachia, Transylvania, and Hungary
clattered eastward, boasting that if the heavens fell they would hold
them aloft on their spears. Their dream of liberating the ancient em-
pire ended at the Battle of Nicopolis, where the Thunderbolt's army
destroyed them. Bayezid then began noisily making known his ambi-
tion to feed his horse from a bushel of oats on the steps of Saint Peter's
in Rome, a plan curtailed due to his long and agonizing fit of gout.

The ensuing decades witnessed further battles and encroach-
ments by the Turks. The Thunderbolt's grandson Murad II besieged
Constantinople in the summer of 1422, before ravaging the Pelopon-
nesus in 1423 and capturing Thessalonica in 1430. Manuel's son,
John VIII, who came to the throne in 1425, realized that, once again,
the only hope for salvation lay with a Crusade from the West. This
vital mission was what brought him and his massive entourage to Flor-
ence in 1439.

The official reason for the arrival of these distinguished visitors
was a Council of the Church, a coming together of the highest offi-
cials from both the Greek and the Latin Churches. As Vespasiano suc-
cinctly summed up the situation, "The Greek Church had for a long
time been divided from the Roman, and so Pope Eugenius wanted
the Greeks to come to Italy for the sake of a union."[2] Indeed, the two
halves of Christianity, the Latin West and Greek East, had frequently
been divided over the previous thousand years. Rifts had come about
due to their different languages and divergent ritual practices, such
as the wearing of beards in the East (which to the Latins smacked of
Judaism) and the use of unleavened bread in the West (which to the
Greeks smacked of Judaism). Conflicting hierarchies also intruded,

for the pope claimed supremacy over the patriarchs in Constantinople, Antioch, Jerusalem, and Alexandria, who failed to accept this hierarchy. The final split came in 1054, when Pope Leo IX and Michael Keroularios, the Patriarch of Constantinople, excommunicated each other. Various attempts were made to bring the two halves back together, but certain theological sticking points—especially whether the Holy Spirit proceeded from both the Father and the Son (as the Latins maintained) or simply from the Father (as the Greeks held)—meant they came to nothing.

Now, hoping for military aid from the princes of the Latin West, the Byzantines were ready to chance another attempt at union. They arrived in Italy early in 1438 for meetings in Ferrara: a party of some seven hundred bishops, monks, scholars, and their slaves. Matters became ever more pressing when, in Ferrara, the emperor received word that the Turks were preparing to unleash on Constantinople a fleet of 150 ships and an army of 150,000 men. Even so, little progress was made before an outbreak of plague in Ferrara and then the blandishments of Cosimo de' Medici, who offered free accommodation as well as 4,000 florins to finance the move, brought the Council to Florence.

John VIII Palaeologus appeared in Florence with his retinue in the middle of February 1439, during Carnival. He made a splendid sight, a handsome man with a Greek beard, damask robes, and a hat adorned with a ruby that, as one observer marveled, was "bigger than a pigeon's egg."[3] His exotic apparel included a scimitar, a bow, and a quiver of arrows. Vespasiano called him the "Emperor of

John VIII Palaeologus (1392–1448): the beleaguered ruler whom Vespasiano called "Emperor of Constantinople."

Constantinople," which aptly described his shrunken and imperiled domains.

The emperor was greeted at the gates of Florence by numerous dignitaries, then escorted into the city beneath a great canopy and treated to an oration in Greek by Leonardo Bruni. The stately ceremony turned into a mad dash for shelter when the heavens opened. The onlookers scattered from the rooftops and balconies while the emperor's company hastily made its way over the streaming cobbles to the resplendent palazzo earmarked for his use, handily vacant after Cosimo exiled its owner, a wealthy merchant, in 1434. The storm was only the first of the bad omens, which also included the appearance of two shooting stars and the incessant whining of the emperor's dog.

The visitors were suitably impressed with their surroundings. A Russian in the entourage of Isidore, the Metropolitan of Kiev, declared the "famous city of Florence" the most impressive of all those through which he had passed on his journey into Italy.[4] Besides being able to admire the palaces, churches, and, of course, the new dome of the magnificent cathedral, the visitors were treated during their stay to spectacular displays of Florentine ingenuity. Filippo Brunelleschi thrilled audiences with high-wire trickery in pageants staged in the churches of Santissima Annunziata and Santa Maria del Carmine. The Russian bishop Abraham of Souzdal described the "great and marvellous spectacle" of the *Assumption of the Virgin* in the former, in which children playing angels floated overhead, rotating around a painted and candlelit vision of heaven—"a happy spectacle of inexpressible beauty." The performance of the *Ascension of Christ* in Santa Maria del Carmine was even more wonderful, with a young actor playing Christ whisked into the heavens, where God the Father awaited, "apparently floating in mid-air," surrounded by flute-playing angels and a multitude of burning lights. Abraham had witnessed something, he wrote breathlessly, "the likes of which has never been seen."[5]

All of this Abraham of Souzdal said he witnessed in "the famous city of Florence," a phrase that recurs in the visitors' reminiscences. A well-traveled young diplomat from Spain, nearing the end of a three-year tour that took him to Rome, Venice, Jerusalem, Cairo, and Constantinople, claimed he spent his days in Florence "marvelling at the city, which is one of the most wonderful in Christendom, won-

derful alike in size, as in wealth and government." He admired the clean and orderly streets, the delightful houses, the churches and monasteries, the bell tower "adorned almost to the top with marble statues," and the hospitals, "unequalled in the world." He was lost in wonder at the political system, in which people were elected by lots, "and the lot may fall on shoemaker or nobleman alike, but nevertheless the government could not be bettered." He concluded that the Florentines were, indeed, a special people: "In what will so wise a people not do well?"[6]

Another thing about the Florentines impressed and perhaps surprised some of the visitors. The Byzantine philosopher and theologian Gennadios Scholarios, an expert on Aristotle, wrote to his students of a new development: "Generations of Italians, whom we once regarded as barbarians, are now applying themselves to scholarly studies."[7]

If the visitors to Florence in 1439 found the city extraordinary, these exotic guests in turn made deep impressions on their hosts. The forty-six-year-old emperor in particular, the brim of whose remarkable hat thrust forward like the prow of a ship, bewitched the Florentines. In due course he and his headgear would be commemorated in various medals and paintings, including *The Flagellation of Christ* by Piero della Francesca.

The emperor was a voracious reader. He devoured works of military strategy but also, on a daily basis, those of Plato and Aristotle. His father, whom he had succeeded in 1425, believed no good would come of this love of philosophy and literature: "I am afraid the decline of this house may come from his poems and arguments."[8] Yet in 1439 men of letters were essential to the salvation of the Byzantine Empire. The emperor brought with him the finest philosophers and scholars, men who would argue against the Latins and, with their books and their ideas, leave an even more vivid legacy than the emperor's hat.

These wise men had already made their presence felt in Ferrara. In the spring of 1438, the leader of the Latins, Cardinal Cesarini, began hosting banquets in Ferrara to which he invited the most

esteemed members of the Byzantine delegation. Among them were
George Gemistos Pletho and his former student, Basilios Bessarion.
The conversation drifted naturally from the theological debates about
Purgatory and the Trinity to philosophical matters concerning Plato
and Aristotle.

Pletho was a beguiling figure. He was in his eighties when he
arrived in Italy, a native of Constantinople who was supposedly in Fer-
rara as an advisor to the emperor. However, he did not worry himself
overmuch about doctrinal matters, for he was at heart a pagan rather
than a Christian. He believed that the God who "presides over all real-
ity, and whose divinity transcends everything," was none other than
Zeus.[9] He concerned himself with a spiritual rebirth that he believed
would come about when both Christ and Muhammad faded away and
all nations of the world came to heed instead the true theology—that
of Plato. His passion for Plato was such that he even tinkered with
his own name, turning his surname Γεμιστός ("Gemistos," meaning
"full") into its synonym Πλήθων ("Pletho," meaning "abundant")—a
cognomen pleasingly homonymous with "Plato." And indeed, he
seemed to be Plato reborn, like a time traveler from the Golden Age
of Athens.

If he was a time traveler, Pletho had smuggled something with
him from across the centuries. On the evening of one of the dinners
in Ferrara, if not earlier, Cardinal Cesarini was no doubt made aware
of one of the manuscripts in Pletho's possession, a treasure of which
Cesarini's late friend Niccolò Niccoli could barely have dared to
dream: the complete works of Plato.[10]

Plato's writings were taking much longer to arrive in the West than
those of Aristotle. All of the latter's surviving texts had been trans-
lated into Latin by the middle of the 1200s. Some, such as his *Nicom-
achean Ethics*, had even been translated into Italian, an indication of
his smooth assimilation into Western education and culture. There
had been, it is true, a few initial problems and objections. Certain of
Aristotle's teachings, especially his arguments against the soul's im-
mortality, directly contradicted the Christian faith. At regular points
throughout the thirteenth century various of his propositions (such

as the one that God could create neither a void nor an infinite universe) were banned at the universities in Paris, Toulouse, and Oxford. But the condemnations proved toothless, and by the middle of the century these universities and others were teaching his work on everything from metaphysics to medicine. In the 1240s his works were eagerly devoured by a brilliant young nobleman from southern Italy then studying at the university in Paris: Thomas Aquinas. A Dominican theologian and future saint, Aquinas became a devoted follower of Aristotle, whom he called simply "The Philosopher."

Aquinas had deftly and subtly reconciled Aristotle's philosophy with the Bible. "If we find something there that is in harmony with the faith, we will take it," he declared, "but anything that contradicts Catholic doctrine we will refute."[11] He discovered far more to accept than refute. He enlisted Aristotle to provide firm philosophical underpinnings for Christian doctrine, mobilizing his thought to argue for the nature of the soul, the mystery of the Trinity, and the existence of angels. Thanks in no small part to Aquinas and the universities, Aristotle achieved enormous intellectual authority in Western Europe. In about 1305, Dante called him the "supreme philosopher" who "holds universal sway in teaching everywhere" and whose doctrines "may almost be called universal opinion."[12] By 1367 Petrarch objected to this unchallenged authority, complaining about those "so captivated by their love of the mere name 'Aristotle' that they call it a sacrilege to pronounce any opinion that differs from his on any matter."[13] Or as a Florentine scholar lamented almost a century later, "The whole world has been seized by the Aristotelians."[14]

Plato, on the other hand, had been more absent and elusive throughout the Middle Ages. His works were by no means entirely forgotten.[15] Medieval scholars were familiar with aspects of his thought not only from pagan writers, such as Cicero and Seneca, but also thanks to Christian sources, including Saint Jerome and Saint Augustine. A portrait of Socrates, Plato's mentor and the protagonist of his dialogues, even appeared on the facade of the cathedral in Chartres. However, none of Plato's works was taught in the universities, and although he left behind thirty-six dialogues, the only one of his works known in the West until the 1100s (and in fragmentary form at that) was the *Timaeus*, in a Latin translation by none other than

Cicero, along with a second translation, also fragmentary, done several centuries later by a philosopher named Calcidius, about whom almost nothing is known (including for whom he made his translation). By 1397, when Manuel Chrysoloras arrived in Florence, the total was still lamentably low, with only two dialogues, the *Meno* and the *Phaedo*, translated in their entirety, along with chunks of the *Parmenides*.

Scholars in the West knew from the many ancient sources that Plato's writings were far more copious than merely these few dialogues. His body of work was miraculously intact thanks to the ancient Greeks and their Byzantine successors. The oldest surviving manuscripts were copied in Constantinople in the late ninth century, at least four by a single scribe.[16] One of these Byzantine codices came into the possession of Petrarch, the first substantial collection of Plato's dialogues to arrive in the West. The manuscript was incomplete, since Petrarch's copy was only the second half of a two-volume edition. Even so, it contained many of Plato's writings unknown in the West, including *The Republic*. Yet Petrarch, much to his dismay, was barely able to read a word of it. After his death it disappeared into a library in Pavia, and there it remained, uncopied and untranslated.

The arrival of Chrysoloras in Florence meant the mysteries of Plato came gradually to be unlocked. Besides composing a Greek grammar for the aid of his students, Chrysoloras began a translation of *The Republic*. His pupils translated ten more dialogues into Latin, with Leonardo Bruni alone contributing the *Gorgias*, the *Crito*, and the *Phaedrus*. He also produced a new and superior translation of the *Phaedo*, as well as the *Apology*, the speech that Socrates supposedly made in his own defense at his trial for a charge of impiety in 399 BC (in which he famously declared that "the unexamined life is not fit for a man to live").[17]

Even with the increased access to these texts, barriers to an understanding of Plato remained, because neither Chrysoloras nor Bruni was an expert in his philosophy. The translation of *The Republic*, completed in 1402, was riddled with errors and omissions, while Bruni struggled with terminology and the finer details. Some assistance came to hand thanks to one of Chrysoloras's former students translating another work. In 1433 the Camaldolese monk Ambrogio Traversari completed, at the behest of Cosimo de' Medici, the first

complete translation into Latin of Diogenes Laertius's *Lives of the Philosophers*, a biographical collection written in Greek in the third century AD and brought in manuscript to Florence from Constantinople in 1416. Plato featured prominently in the work, for Diogenes regarded Plato as the greatest of all philosophers, one whose doctrines should be exalted above all others. His biography of Plato, once translated by Traversari, offered Florentines a comprehensive (if somewhat erratic) account of Platonic philosophy. Besides summarizing Plato's thought, Diogenes offered a wealth of gossipy biographical information such as the fact that Plato was an accomplished wrestler whose real name was Aristocles, but his wrestling master nicknamed him Plato, meaning "broad-shouldered," because of his robust physique. Formerly a murky figure lurking in the philosophical hinterlands, the great philosopher for the first time stepped forward and assumed human form.

Traversari, who dedicated his translation to Cosimo, was among the Florentines gathered in Ferrara for the Council. He attended the banquets hosted by Cardinal Cesarini, writing enthusiastically to a friend of the "remarkable volumes" he had seen in Ferrara, including "a volume of Plato containing all his works, beautifully written."[18] Cosimo, too, was present at Cesarini's banquets, since he served as the Florentine ambassador to Ferrara from the end of January to the beginning of June in 1438. He was captivated not merely by the Plato codex—which he became determined to acquire—but equally by George Gemistos Pletho himself, upon whose "fervid lips," as a friend later wrote, he hung as the Byzantine magus held forth "like another Plato" on the Platonic mysteries.[19] Even before he left Ferrara in the early summer of 1438, Cosimo had probably decided to bring the Council and its glittering intellects with their mouthwatering libraries to Florence, a change of location that the appearance of the plague in Ferrara and the depleted coffers of the Byzantines fortuitously made possible.

So it was that the emperor and his entourage arrived in Florence armed with Greek scholars and their manuscripts—the weapons to be deployed in the doctrinal disputes with the Latins. Cardinal

Plato and Aristotle as depicted by Raphael in
The School of Athens in the Vatican.

Cesarini, who arranged the logistics of the move, once again played the part of host, inviting George Gemistos Pletho to his palazzo in Florence for private lectures on Plato and Aristotle, and in particular on why, in Pletho's opinion, Plato was superior to Aristotle. Pletho composed for the edification of this group of Florentines a short treatise on their key differences, *De differentiis Platonis et Aristotelis.*

The differences between Plato and Aristotle had already been much debated. The argument stretched back to ancient Greece, where Aristotle had criticized and corrected Plato, the teacher with whom he began to study in 367 BC, when he was seventeen and Plato around sixty. The Academy had been open for some twenty years and *The Republic* completed for almost a decade by the time Aristotle arrived in Athens from his home in northern Greece, where he received some instruction in biology from his father, who had served as doctor to the grandfather of Alexander the Great. Though Aristotle remained with Plato for the

next twenty years, something of their combative relationship is reflected in Diogenes Laertius's story of how Plato once complained: "Aristotle spurns me, as colts kick out at the mother who bore them."[20]

Aristotle certainly found much to critique in his old teacher.[21] In the *Politics* he found fault with Plato's *Republic*, in *On the Soul* he disputed Plato's view that souls could exist apart from bodies, and in the *Physics* he attacked Plato's conceptions of time and eternity. The most famous difference between Plato and Aristotle was over the theory of Forms, the abstract universal essences that, according to Plato, are imitated by transitory things. A beautiful object, for instance, gains its beauty by emulating or "participating in" the Form of Beauty. The natural world we perceive through our senses is, for Plato, a defective and incomplete version of this more perfect and timeless realm in the same way that (in the famous metaphor from Book 7 of *The Republic*) the images seen by the prisoners shackled in their cave are the shadows of the real objects for which the prisoners, in their ignorance, mistake them.

Soon after Plato's death, Aristotle attacked the theory in *On Philosophy*, later expanding his criticism in his *Metaphysics*. He denied that a form could exist without matter, and the realm of Forms possessed, he believed, no objective validity. Plato put forth nothing but words—what Aristotle disparaged as "empty phrases and poetical metaphors."[22] Reacting against Plato's idealism, he advanced an approach to knowledge that was more scientific and empirical, and that concentrated on particulars rather than universals.

Despite his lower philosophical profile, Plato had found certain advocates in the West. Petrarch had been an early champion, noting that authors such as Cicero and Saint Augustine gave him precedence over Aristotle. As Petrarch put it: "More men praise Aristotle; better ones, Plato."[23] He saw in the tentative and open explorations of the dialogue form (or what he knew of it) a welcome opposition to what he regarded as the rigid formality of Aristotelian logic. Niccolò Niccoli, too, became a great proponent of Plato, whom he believed (similarly, on the evidence of Cicero and Saint Augustine) the more sophisticated philosopher of the pair.

Another advocate for Plato was Ambrogio Traversari, the translator of Diogenes Laertius. At first Traversari had been reluctant to translate this collection of biographies of pagan philosophers, only doing so at the eager insistence of Cosimo. However, the experience proved revelatory: Traversari discovered to his relief that "all the more notable philosophers" were "largely in agreement with Christian truth."[24] From Diogenes's biography of Plato, Traversari took away certain key facts that underlined the great philosopher's parallels and harmonies with Christianity: chastity, piety, and an ascetic lifestyle. Moreover, according to Diogenes, Plato possessed the aura of divinity: his mother, Perictione, a descendant of the sea god Poseidon, gave birth to him while still a virgin. Diogenes learned this story from the eulogy delivered at Plato's funeral by his nephew Speusippus, who described how Plato's father had tried to force himself on the beautiful Perictione, "then in her bloom," but failed in the attempt. Apollo appeared to him in a dream, "whereupon he left her unmolested until her child was born." Diogenes observed the happy coincidence that Plato was born on the seventh day of the month Thargelion—Apollo's birthday.[25]

Leonardo Bruni, too, initially favored Plato, likewise finding his philosophy in concord with Christian themes. The first of his Platonic translations, the *Phaedo*, completed in about 1405, he pointedly entitled *De immortalitate animae* because it offered sophisticated arguments for the immortality of the soul. For good measure, he dedicated the translation to Pope Innocent VII. He then, in 1409, dedicated his translation of *Gorgias*—in the preface to which he happily observed that the writings of Plato "appear in conformity with our faith"[26]—to John XXIII, the "antipope." However, Plato may have received few benefits from association with so worldly a prelate.

Bruni's Platonic flirtation was not to last. Ironically for someone who did so much to introduce Plato's work to readers in the West, he eventually deserted his earlier position, coming down on the side of Aristotle and concentrating on translations of his works instead. Bruni took umbrage when Traversari's translation of Diogenes Laertius introduced a distinctly unflattering portrait of Aristotle: someone with a lisp, skinny legs, and beady eyes who became the lover of the tyrant of Atarneus, a eunuch and former slave named Hermias.

Diogenes claimed that Aristotle was indicted for impiety over this relationship but, to escape prosecution, killed himself with poison. "This then was an easy way of vanquishing unjust calumnies," Diogenes observed, his pen dripping with sarcasm.[27]

Bruni gallantly leapt to the defense of Aristotle with a biography of his own that refuted (or simply ignored) Diogenes's scurrilous claims.[28] He believed Aristotle to be a superior guide for how people could live together in a civilized society. Plato, on the other hand, he regarded a dangerous thinker, someone who espoused "opinions utterly abhorrent to our customs and ways of living."[29] Bruni was especially perturbed by the proposal, put forth in Book 5 of *The Republic*, that "women shall all be the common property of all the men: none shall live with any man privately. Their children too shall be held in common and no parent will know his or her offspring, nor any child his or her parent."[30] After he criticized Chrysoloras's rendering of Plato's *Republic* as "ineptly translated,"[31] Bruni was asked to produce a version of his own. He flatly refused: the text contained too many ideas, he believed, that were repellent to Western morals.

Leonardo Bruni was not the first to entertain such doubts about Plato. Despite Saint Augustine's famous claim in *The City of God* that the Platonists of his time were, of all the pagan philosophers, the closest to the Christians, and despite Ambrogio Traversari's conviction that Plato's philosophy was "largely in agreement with Christian truth," suspicions of immorality and heresy had long swirled around Plato's writings. The first dialogues to be translated in full, the *Meno* and the *Phaedo*, were not much studied because of glaring theological transgressions: the former assumed the preexistence of the soul before birth while the latter denied the resurrection of the body. Other of Plato's works, such as the *Phaedrus*, *Lysis*, and *Charmides*, alluded to homosexual feelings and attachments, while in various dialogues Socrates boasted that he paid heed to a *daemon*—a claim that resulted in his trial on a charge of "bringing in novel deities" and his subsequent appointment with a cup of hemlock.[32]

Homosexuality and heresy aside, Plato was a surprising philosopher to appeal to Florentines, who had long boasted of their

dedication to political liberty and popular government. Plato had been an aristocratic snob sharply at odds with the democratic culture of Athens. Born into a family of oligarchs, he was the nephew of Critias, whom his contemporary Xenophon called the most thieving, violent, and murderous of the ruling council of "Thirty Tyrants" who came to power following the overthrow of the Athenian constitution. After Critias and his cronies (including another of Plato's uncles, Charmides) took control of Athens in 403 BC, an eight-month reign of terror followed, in which thousands perished. Plato became disillusioned with this rule but also with the return to power of the democrats, who in 399 BC put Socrates to death, ostensibly for introducing new gods and corrupting the youth of Athens, but more probably because of his connections with Critias and Charmides. More suspicious than ever of popular government, Plato came to regard politics as the playing out of uncontrolled and irrational passions.

Plato's response to the decline of Athens was quite different from Florentine ideals of participatory citizenship and patriotic civic engagement. His remedy was a retreat from the political world and a self-imposed exile from Athens. He hoped to escape from the ignorance and confusion of the vulgar, imprisoned as they were by their senses, by means of an ascent to the changeless and eternal realm of Ideas—a journey *The Republic* calls the "upward journey of the soul."[33] Such an act was possible only for the few who had been properly educated and then prepared for the task by such practices as sharing wives, children, and property in common (the prescriptions that so appalled Bruni and then, in the twentieth century, anti-communists horrified by the abolition of private property).[34] He also called for the rule of a philosopher, defined as someone who loves "to observe the truth"—someone, the philosopher-king (or, indeed, the philosopher-queen), who could unite wisdom and power, and therefore recognize and properly administer justice. But such people, Plato believed, were "few and far between."[35]

Whatever problems or dilemmas Plato may have presented, with the arrival in Florence of Pletho and his former pupil Basilios Bessarion— if anything, an even more formidable intellect—the philosopher

found new and powerful champions. Plato was about to emerge from the shadow of Aristotle, whose captious comments on his master had hitherto framed much of the debate. Pletho's *De differentiis Platonis et Aristotelis* gave a stout defense of Plato (especially his theory of Forms) through a brutal scrutiny of Aristotle's criticisms. Pletho rebuked Aristotle for the pride that made him fail to acknowledge his intellectual debts and the ambition that led him to break away from the Academy and found a new school while Plato was still alive. He accused him of sophistry—of using a multitude of obscure words to confuse the unwary. He was effective, Pletho admitted, when he turned his attention to things such as oysters and embryos, but this keen vision for minutiae was like that of a bat that was blind in the clear light of day.[36]

Pletho, a neo-pagan, had an ulterior motive in pitting Plato against Aristotle. As an opponent of the proposed union between the Latins and the Greeks, he hoped to demolish the intellectual edifice of the Roman Catholic Church, which he quite rightly recognized had been raised, thanks to Aquinas and others, on Aristotelian foundations. Upending the traditional philosophical hierarchy, he depicted Aristotle as an atheist while stressing Plato's piety. He pointed out that for Aristotle the Prime Mover—the primary cause of all motion in the universe—existed in only one celestial sphere, which undermined the Christian idea of a god who dwells in all things. He rebutted Aristotle's attack on Forms by saying it was tantamount to denying the existence of eternal substances. Finally, Aristotle may have paid lip service to various divinities, but, Pletho claimed, he was ultimately an atheist. Plato, on the other hand, understood God as "the universal sovereign existing over all things . . . the originator of originators, the creator of creators."[37]

Few people outside a small circle of scholars could read Pletho's little treatise, which he composed in Greek. However, he expounded these shockingly radical views in the private lessons conducted in Cardinal Cesarini's palazzo, where Traversari or other Greek speakers translated them for the benefit of auditors such as Cosimo. Pletho's dismantling of Aristotle—and by extension his rattling of the foundations of medieval Christian belief systems—marked the beginning of a long and exhilarating process. Though he himself treated the

appeal to authority as an unconvincing argument, Aristotle had come
to be treated, ironically, as an ultimate and unimpeachable author-
ity. He held, as Dante claimed, "universal sway," his arguments ex-
ploited to discount and disprove those of any other sources. The
destruction of appeals to Aristotle's authority is usually dated to 1632,
when Galileo in his *Dialogue Concerning the Two Chief World Systems* par-
odies a philosopher who, despite stark anatomical evidence that
nerves radiate from the brain, chooses to accept Aristotle's opinion
about their origins. "You have made me see this matter so plainly and
palpably," the philosopher tells an anatomist over an opened cadaver,
"that if Aristotle's text were not contrary to it, stating clearly that the
nerves originate in the heart, I should be forced to admit it to be
true."[38]

Yet some two centuries earlier, in both his manuscripts and his
lessons in Cardinal Cesarini's palazzo, Pletho aggressively attacked
the philosopher whose works had become such an unquestionable
authority—the intellectual prop for western Christendom. The way
was beginning to open on a more unbounded exploration of philo-
sophical questions and possibilities that would leave deep and indel-
ible imprints across the cultural terrain.

History has failed to record who attended the private lectures
in Cardinal Cesarini's palazzo. A Greek scholar of Aristotle (and
hence a bitter enemy of Pletho) claimed—no doubt unfairly—that
Pletho was surrounded in Florence by "men who know as much about
philosophy as he knows about dancing,"[39] that is, very little indeed.
Vespasiano may have been one of these philosophical neophytes. Ce-
sarini knew him by this time, and it would have been natural for him
to introduce the young man, in whose education and welfare he had
interested himself, to this revered teacher. On the other hand, no-
where in his writings does Vespasiano mention Pletho, a strange omis-
sion if he had met the bearded Byzantine sage, who would surely
have made a powerful impression.

Vespasiano did make the acquaintance of someone else who
came to the Council of Florence, a distinguished scholar and eccle-
siastic, Piero Donati, the archbishop of Padua. Vespasiano later de-
scribed Donati as "a Venetian gentleman well-versed in civil and
canon law, and in humanistic studies." Moreover, he possessed what

Vespasiano called "a huge collection of books."[40] Archbishop Donati was indeed a passionate bibliophile, with a collection of more than three hundred manuscripts, one of the largest and finest private collections in Europe. His travels through Germany and Switzerland on behalf of the pope had resulted in various new discoveries, such as, in the cathedral library of Speyer, a Carolingian manuscript of ancient geographical writings that a scribe named Terence had copied for him. He probably first met the young Vespasiano in the Street of Booksellers, introduced by friends and fellow bookworms such as Poggio Bracciolini. He would become, in the next few years, an important early client of the young bookseller.

In the summer of 1439, the delegates from the East straggled out of Florence for their return voyages home. The shooting stars and whining dog had proved accurate auguries: little good came of the Council of Florence, at least as far as the union of East and West was concerned.

To be sure, on July 5 a Decree of Union was signed, and on July 6, after a solemn Mass in the cathedral of Santa Maria del Fiore, Cardinal Cesarini read out the papal bull *Laetentur caeli*, echoed in Greek by Basilios Bessarion. "Let the heavens rejoice," they declared, "and the earth exult." But many of the Byzantines declined to celebrate, refusing to take communion with the Host of unleavened bread. Their delegation remained deeply and acrimoniously split, with those in favor of union led by the formidable Bessarion and those opposed led by another former student of Pletho, Markos Eugenikos, Metropolitan of Ephesus. Tragedy intervened when, on June 10, the seventy-nine-year-old Patriarch of Constantinople, Joseph II, who had been in ill health, died in his quarters in the basilica of Santa Maria Novella. His last act had been to write out a will in which he proclaimed his agreement "to everything held and taught by the Catholic and Apostolic Church of our Lord Jesus Christ, the senior Rome," including the authority of the pope.[41]

For a young bookseller such as Vespasiano, the Council of Florence must have been exhilarating for reasons beyond the exotic dress and beards of many of the participants, and even the signing of the

Decree of Union. Books were revealed during these months of debate to be much more than merely adornments to princely libraries or pleasing distractions from the cares of everyday life. On the contrary, vital religious and political matters, indeed the fates of nations, rested on these repositories of ancient wisdom. Seldom had leaves of parchment been pored over with such anxious scrutiny and expert attention. This gathering of so many scholars laden with hefty manuscripts and well versed in different languages meant the authority of ancient sources could be checked and challenged, the accuracy of translations probed. The scholars at the Council pointed out how much depended on interpretation, on how one read Greek words or phrases in certain passages, and on how these were defined and then translated into Latin. Different manuscripts of the same work could be compared and contrasted, making it possible to judge which ones were truly ancient and which merely recent copies, which could be trusted and which might have been accidentally corrupted or deliberately tampered with.

Locating the best ancient sources was the key to winning the theological arguments. In advance of the Council the Latins had dispatched the Dominican theologian John of Ragusa to Constantinople to find Greek manuscripts with which to confirm quotations and bolster their positions. He purchased some books—including beautifully illuminated works from the eleventh and twelfth centuries—while others he had copied by a Byzantine monk. Meanwhile the ships bringing the Byzantine delegation to Italy had been loaded with a library of manuscripts acquired by Nicholas of Cusa (a former pupil of Cardinal Cesarini). He had likewise scoured the markets and monasteries of Constantinople. Brought as evidence to Florence, many of these works were translated by Ambrogio Traversari into Latin.

Traversari was a conscientious scholar. When he made his translation of Diogenes Laertius—a project that took him the better part of a decade, from 1424 until 1433—he was careful to compare two Greek codices of the work. When he concluded that neither was especially trustworthy, he arranged for a third to be sent to him, a fourteenth-century Byzantine manuscript. This sort of parchment-sifting and nuanced approach to translation would become vital during the debates in Florence. When, for example, one of the Latin

delegates, a Dominican theologian named Giovanni da Montenero, produced a passage from Traversari's translation of Epiphanius of Salamis arguing the Latin position that the Holy Spirit proceeded from both the Father and the Son, Mark Eugenikos objected. He claimed that Traversari's translation was faulty, the byproduct of a corrupt manuscript blighted by erroneous interpolations.[42]

The Latins proved equally adept at spotting errors and appealing to the authority of ancient and more authentic texts. When in another session Giovanni da Montenero presented a passage from Saint Basil's *Against Eunomius* that likewise seemed to prove the Latin argument about the Holy Spirit, Eugenikos again protested. He allowed that a few manuscripts of *Against Eunomius* circulating in both Florence and Constantinople did include that particular passage, but the words in question were the result, he claimed, of deliberate tampering by the Latins. "Very likely this passage was purposely spoiled," Eugenikos declared, "by some defender of your doctrine." In Constantinople, he claimed, there could be found a thousand copies "in which neither the meaning nor the words of the Holy Fathers are changed."[43] This time Giovanni da Montenero was able to rise to an impressive defense: the manuscript from which he quoted was, he pointed out, six hundred years old—dating from long before the split between the Latins and the Greeks—and it had only lately been brought from Constantinople. Its authority as the true argument of Saint Basil was unimpeachable.

Giovanni da Montenero's manuscript and his argument soon won over Bessarion, always sympathetic (unlike Pletho) to the idea of union. Bessarion believed the key to reconciliation could be found in a proper appreciation of Plato. For Plato, of course, there existed beyond the realm of ordinary sense-experience the world of Forms, for which outward, earthly appearances—including symbols such as language itself—were mere and meager representations. Words were simply incapable of accurately describing or illustrating this divine realm. The logic and reason of the Aristotelians occupied its true home only in the sphere of sense-experience—in what Pletho had nonchalantly dismissed as the world of oysters and embryos. The Aristotelian philosophy on which western Christianity depended therefore offered a misguided point of departure in any quest for

inexpressible truths and eternal verities. The clumsy wordings of dog-
mas, liturgies, creeds: such things were mere shadow puppets on the
wall of the Platonic cave; debates framed by Aristotelian philosophy
could never hope to approach or capture their proper forms.

On the other hand, Plato's philosophy, with its belief in a unity
embracing scattered differences, offered a more promising chance
to find a concord between the Greeks and the Latins. Bessarion and
Traversari duly worked out a compromise on the fraught question of
the Procession of the Holy Spirit. They came up with the argument
that since the saints in both the East and West had been inspired by
the same Holy Spirit, it scarcely mattered whether this Holy Spirit
proceeded from both the Father and the Son or simply from the
Father. It was, after all, merely a matter of semantics—of whether one
believed that "from" (εκ) and "through" (διά) meant the same thing.
As Bessarion put it in the context of another dispute, the two parties
"agreed in substance and differed only in words."[44]

Eugenikos, however, repudiated the compromise and declined
to put his signature on the Decree of Union. Not all the Greeks
proved so intransigent, but in some cases the Byzantines who did sign
the decree were received with hostility when they returned home. In
Russia the prominent unionist, Isidore of Kiev, a former student of
Pletho, received an especially harsh reception. He entered Moscow
behind a Latin cross and—in a rather undiplomatic gesture—
dragging a hardline anti-unionist monk behind him in chains. The
grand duke of Moscow, Vasily II, who opposed the union, promptly
clapped Isidore in prison as a heretic and a corruptor of souls.

As for Pletho himself, he had left Florence in the middle of June,
following the funeral of Joseph II. Left behind, though, was a manu-
script of the complete works of Plato. It was copied in the hand of
the scribe and scholar Christophorus Persona, a Williamite hermit
who had been born in Rome in 1416 but traveled extensively in
Greece, becoming so fluent that even the Greeks took him for a na-
tive. It remains unclear whether this manuscript—written in Greek—
was the original copy Pletho brought to Italy or whether it was copied
from his manuscript by Christophorus, who served in the party of
Isidore of Kiev. What is certain, however, is that by the summer of
1439 it was in the possession of Cosimo de' Medici.

Chapter 6

Vespasiano Mangiadore

One day a few years after the Council of Florence, in a Benedictine abbey in Arezzo, forty-five miles southeast of Florence, a monk wrote to a friend outlining his plans for the copying of a manuscript. The monk, Girolamo Aliotti, the abbot of Santa Flora, was a friend of Poggio Bracciolini and other lovers of wisdom in Florence. He entertained scholarly pretensions of his own, producing and collecting manuscripts, including volumes of the copious letters that he penned to these distinguished humanists. However, he often found himself frustrated in his task of compiling manuscripts, since he complained that in Arezzo he was unable to find any good booksellers. He also lamented the poor spelling of the local scribes and the dire quality of their handwriting.[1]

Aliotti explained to his friend that he was planning to commission a new manuscript of an ancient work—a copy of one of the most remarkable writings ever produced in ancient Rome: Pliny the Elder's *Natural History*. Born in AD 23, Pliny embodied the Roman virtue of duty to the state, having served as a cavalry officer, a naval commander, and a high-ranking public official. He was also a formidable scholar whose numerous commitments did not prevent him from undertaking wide-ranging scholarly and scientific research. According to his nephew, Pliny the Younger, he combined "a penetrating intellect with amazing powers of concentration and the capacity to manage with the minimum of sleep."[2] All his spare time he devoted to his studies, rising before dawn and having works read to him during his meals and as he was rubbed and dried following his bath. The results of his unstinting industry were writings on everything from grammar and rhetoric to the technique of throwing a javelin from

horseback. "Any one of your life-long devotees of literature, if put alongside my uncle," boasted Pliny the Younger, "would blush to feel themselves thus enslaved to sleep and idleness."[3]

This brilliant and prolific career ended amid the flame, ash, and poisonous vapors of ancient Rome's greatest natural disaster. In August AD 79, after spotting from his home at Misenum a curious cloud that looked like an umbrella pine rising above Mount Vesuvius, Pliny was prompted by what his nephew called his "scholarly acumen" to sail across the Gulf of Naples for a closer look. The cloud proved to be the eruption of Vesuvius, and, after landing on the beach at Stabiae, four miles south of Pompeii, Pliny was asphyxiated by toxic fumes.[4]

Over the centuries, all of Pliny's works were lost except for the greatest and most ambitious of them, his *Natural History*, a vast encyclopedia of ancient learning that featured no fewer than, as the author himself boasted, twenty thousand facts—what he called "matters interesting to relate or entertaining to read."[5] Included among them were tales of strange people in faraway lands, such as a tribe of one-legged men "who move in jumps with surprising speed," and the "umbrella-foot" people, who shade themselves in hot weather by lying on their backs and sticking their giant feet in the air.[6] He also offered such practical advice as treating hydrophobia by eating a dog's head and improving oral hygiene by scraping one's gums with the fangs of a snake and using ground-up mummies for toothpaste. Women wishing to maintain firm breasts were encouraged to smear them with a mixture of goose grease and spiderwebs. Gray hair could be prevented with ashes of earthworms, and unwanted body hair removed with a depilatory made from goat's milk, bat's brain, and hedgehog gall.

How seriously readers took these eye-of-newt and toe-of-frog prescriptions is an open question. However, the work enjoyed a huge appeal. By the middle of the 1400s some two hundred manuscript versions were circulating throughout Europe, the oldest dating back to the ninth century. Since books were not mass produced, each of these two hundred manuscripts was slightly different from the others, the product of an individual scribe at a particular point in time copy-

ing out the product of another individual scribe, and so forth. Manuscripts were often unreliable because of the errors and inaccuracies introduced over the centuries and then compounded as one flawed manuscript begat an even worse version. Scribes were usually blamed for the mistakes. Scholars frequently denounced their ignorance and incompetence, bemoaning the kind of lackluster skills that so frustrated Aliotti. Petrarch complained that, so sloppy were the scribes of his day, and so full of errors were the manuscripts they produced, "an author would not recognize his own work."[7]

It was all too easy for errors in transcription to creep into manuscripts. To produce new copies, scribes needed to decipher handwriting that was sometimes several hundred years old and in a style very different from the one they knew. Scribes at Charlemagne's court had trouble making out the handwriting of Irish and Anglo-Saxon monks, confusing *r* and *n*, *r* and *p*, and *n* and *p*. They had to cope with possibly eccentric abbreviations and word divisions. Equally confusing was the scribal shorthand: *per* ("through"), *pro* ("for"), and *prae* ("before") were all represented by symbols—a lowercase *p* with subtly varying diacritical marks—that looked suspiciously alike. And it was all too easy for even the most conscientious scribe to miss a sentence or even an entire paragraph if his eye accidentally dropped to a word or phrase further down the page (or on the opposing column) similar or identical to a word or phrase he had just copied— the inadvertent eye-skip known as "parablepsis." Little wonder that a prayer for scribes in Charlemagne's time urged them to "take care . . . lest their hands make mistakes . . . May their pens fly along the correct path."[8]

Some convents exerted a stringent quality control on manuscript production. Unhappy consequences befell clumsy or inattentive monks in the famous scriptorium at the Basilian monastery of San Nicola di Casole, down in the heel of Italy. Anyone failing to treat the Greek manuscripts with proper care, or making careless mistakes while copying out a text, faced a stiff punishment: the rulebook called for 130 μετανοίας ("repentances")—groveling acts of prostration meant to show humiliation. The rules also stated: "If, due to a fit of anger, he breaks his pen, thirty repentances." An even worse fate

awaited a monk who failed to use the proper calligraphic hand: he was excommunicated for two days.[9]

Some universities ensured the integrity of the manuscripts used in their classrooms by means of the *stationarius*, a licensed vendor who served as a custodian of manuscripts. The university would approve a copy, known as the *exemplarium*, that the *stationarius* then rented out for short periods, unbound and in small sections, for copying by scribes or students, who were obliged to return it before receiving their next section to copy. Since more than one person could be working on any given manuscript, the system sped up the process of copying and led to the rapid multiplication of (hopefully error-free) university textbooks. This regulatory practice developed in the 1200s in Bologna, where the term *stationarius* was first used—the name a reference to the fact that the seller was not some itinerant peddler wandering the streets with his stock of paper but, rather, a merchant who was "stationary," with a shop in a fixed location, licensed by the university.

The only other system of inspection and cross-checking involved the voluntary efforts of various determined scholars. The most diligent scholars consulted as many manuscripts of a work as possible in an attempt to identify the corruptions and eliminate them from a new version of a manuscript. In ancient times, no less an authority than Aristotle made corrections in a copy of *The Iliad* for Alexander the Great (who fondly kept the precious scroll under his pillow, beside his dagger). Saint Augustine once spent an entire day with his son and two pupils checking and revising a manuscript of Book 1 of Virgil's *Aeneid*, then another week on the next three books. Monks in the Middle Ages often marked a manuscript with their own seal of approval: *Legi* ("I read it") or *Emendabi semel deo gratis* ("I corrected this once, thanks be to God"). The job was considered important enough that the tomb of a German abbot named Williram, who died in the eleventh century, was proudly inscribed: *Correxi libros* ("I corrected books").[10]

Aliotti was determined that his manuscript of Pliny's *Natural History* should be as free as possible from error. What he needed to find to produce his copy was, therefore, the exemplar—the Pliny manuscript that scholars agreed was the most trustworthy and authoritative,

the least contaminated by scribal errors and incompetent editorial interference.

Aliotti knew exactly where to look for assistance in this difficult task. "Our Vespasiano," he wrote to his friend in 1446, "is the best guide for such things."[11]

Vespasiano noster qui est optimus huius rei explorator. The phrase is startling. Abbot Aliotti wrote this letter in 1446, when Vespasiano was still in his mid-twenties. Clearly the young man had grown enormously in reputation since starting work in the Street of Booksellers a dozen years earlier. No longer was he merely toiling in Michele Guarducci's back room with a bow saw and a hammer or sewing together leaves of parchment. He had become, even at such a young age, and even in a city with as many renowned scholars as Florence, a recognized expert on the manuscripts of ancient authors.

Vespasiano's expertise in ancient authors also encompassed Plato and Aristotle by this time. In that same year a scholar sojourning in the countryside outside Florence returned a manuscript of Leonardo Bruni's translation of Plato's *Phaedo* and asked him to find an exemplar for the *Timaeus*.[12] And in 1446, for a price of five florins, Vespasiano sold a secondhand manuscript of Bruni's translation of Aristotle's *Nicomachean Ethics* to a Frenchman, a scholarly thirty-four-year-old monk named Jean Jouffroy. Five florins was a decent sum considering a small house could be rented on the outskirts of Florence for only a couple of florins a year, and the annual salary of an errand boy in a shop—as Vespasiano had been only a decade or so earlier—was as little as four florins.[13]

How precisely Vespasiano acquired his remarkable skills in such a relatively short space of time remains something of a mystery. The various manuscripts of Pliny's *Natural History* available to him would have been tremendously difficult to compare and assess for quality. Vespasiano could have seen, at best, only a handful of the two hundred or so survivors (a few years later a well-connected and well-resourced Florentine scholar was able to investigate a total of five Pliny manuscripts).[14] Even a small sample would have featured numerous variations between and among copies.

Vespasiano's expertise must have been hard won. He needed to learn as much as possible about ancient authors—to know his Pliny from his Plutarch, and Pliny the Elder from Pliny the Younger. Knowledge of the quality and whereabouts of manuscripts required him to gain access to a vast array of collections. While Poggio and Giovanni Aurispa had searched the convents of Germany and Constantinople, Vespasiano's manuscript hunting kept him much closer to home but entailed the same degrees of persistent detective work and emollient cajolery. Niccolò Niccoli's collection was undoubtedly available to him, both before and after Niccoli's death. By the mid-1440s he also managed to get access to manuscripts from two other prestigious collections, those of Coluccio Salutati and Leonardo Bruni, the latter of whom died in 1444. The heirs of both estates allowed Vespasiano— in what must have been a great coup for such a young man—to sell manuscripts on their behalf.[15]

Another superb collection at his disposal was found in the Badia, the Benedictine abbey in the Street of Booksellers, directly across from the bookshop. The Badia possessed not only a scriptorium but also a fine library that stocked some 280 volumes of the Greek and Latin classics. These works had come into the abbey thanks to the donation of a collector named Antonio Corbinelli.[16] A former student of Manuel Chrysoloras, Corbinelli had been friends with collectors and scholars such as Niccoli and Poggio. His death in the summer of 1425 was much lamented. However, the bequest of his books to the monks infuriated Poggio, who believed the "two-legged donkeys" in the Badia far too ignorant to read, let alone comprehend, these precious volumes. The bequest had been "a stupid thing to do," he bitterly complained, a sorry consecration of the volumes "to dust and worms."[17] The precious collection did not molder in the abbey, for over the years the monks would provide Vespasiano with a ready supply of exemplars.

Vespasiano possessed other resources, including his large network of friends—scholars whose expertise he could tap for advice about manuscripts and their whereabouts. Then, too, he may have consulted the other bookshops along the Street of Booksellers. Two of the most important booksellers after Vespasiano were both nearby:

Zanobi di Mariano, who likewise rented his premises from the Badia, and Piero Bettucci, a former partner of Michele Guarducci whose shop literally stood next door, and who, over the years, had sold classical manuscripts to both Niccoli and Poggio. Finally, although Guarducci specialized in binding books, his influence on Vespasiano should not be discounted, and he probably proved a worthy mentor for book acquisition.

Such was Vespasiano's particular ability that clients now sought him, rather than Guarducci, for advice about manuscripts. His first known independent sale had come in 1442, when he was barely twenty years old. His commission had been to find (or perhaps to produce anew) a manuscript for Piero Donati, the archbishop of Padua, the esteemed scholar with the "huge collection of books" whom he had met at the Council of Florence.

The book the archbishop commissioned from Vespasiano was Petrus Comestor's *Historia Scholastica*, a popular compendium of biblical stories originally composed in about 1170 for students at the cathedral school of Notre-Dame in Paris. "Comestor" was the author's nickname, Latin for glutton. In France he was known as "Pierre *le Mangeur*" and in Italy as "Pietro *Mangiadore*"—Peter the Devourer—a reference to his voracious appetite for books. He was known for his great erudition, for devouring and digesting not only the Bible but also a staggeringly impressive number of other sources as well, including many Hebrew texts.

Archbishop Donati wanted a manuscript of the *Historia Scholastica* for the edification of future students at the university he was planning to found in Padua, the *Domus Sapientie*, or House of Wisdom, where twenty pupils would be instructed in canon law. It is unclear if Vespasiano simply found a secondhand edition for the archbishop or if, after buying the parchment and hiring a scribe, he produced an entirely new manuscript. The archbishop's book has been lost, probably due to unseemly circumstances surrounding his death, related by Vespasiano with much regret. He described how, several years after this commission, the plague came to Padua and the archbishop, who owned a "delightful property" outside the city, hastily repaired there with many of his possessions. Here, despite his precautions, he

too caught the plague. As he lay dying, his household—his retinue of relations and servants—took the opportunity to pillage all his belongings.[18]

Like Comestor, Vespasiano, too, was a *mangiadore*, a devourer of books. More work came for him soon after his commission from the archbishop. Late in 1442 he made the acquaintance of another important collector, William Grey, a twenty-eight-year-old Oxford graduate who had recently been furthering his education in Cologne, studying logic, philosophy, and theology. The university in Cologne specialized in what a later scholar deplored as "syllogistic tricks and the quibbles of dialectics"—the logic of Aristotle, in other words. Authors such as Virgil and Cicero were, he wrote (in the crass anti-Semitic language of the day), "despised as much as a Jew loathes pork."[19] After matriculating in 1442, Grey therefore decided to learn something of humanistic studies by crossing the Alps and descending into Italy, "which," Vespasiano wrote, "he knew to be the best place for such pursuits."[20]

The journey did not promise to be an easy one. Vespasiano wrote that Grey was "of the royal house," that is, related to King Henry VI of England. Grey's step-grandmother had been Joan Beaufort, the illegitimate daughter of John of Gaunt, the great-grandfather of Henry VI. Grey came on his mother's side from both the earls of Westmorland, one of the most powerful families in the north of England, and the dukes of Buckingham, equally influential in the south. His father's family, meanwhile, was descended from, as the papal register declared of his uncle the Bishop of London, a "noble race of earls and barons."[21] That distinguished lineage failed to save Grey's father, Sir Thomas, who was hanged, drawn, quartered, and beheaded in 1415 for plotting against King Henry V. Shakespeare's *Henry V* would feature a doleful Sir Thomas repenting this "damnèd enterprise" as he is frog-marched to his doom.

Grey therefore grew up fatherless but enormously wealthy. In 1437, at the age of twenty-two, following his Oxford degree, he was ordained as a priest by the bishop of Salisbury, who also happened to be his uncle. His years of European study and travel then beck-

oned. In Cologne he lived in a grand style, maintaining an entourage of servants and horses. This reputation for riches—and perhaps rumors of his kinship with the king of England—caused problems and anxieties when he decided the time had come to leave for Italy. He knew that many ruffians in Cologne were eagerly on the alert for his departure so they could attack him on the open road, and either rob him or hold him for ransom. Grey therefore hit on a crafty plan. Feigning illness, he summoned a doctor to pay professional visits to his lodgings. After several days of these consultations, and after news of his illness was bruited about the town, he and a companion sneaked from the house dressed as Irish pilgrims, complete with cloaks and staves, and made their way anonymously from the city. For the next eight days the doctor continued paying his visits to Grey's empty lodgings, pretending to treat the fading patient as Grey and his friend put a safe distance between themselves and their would-be assailants. "And by this prudent plan," wrote Vespasiano, "Guglielmo Graim preserved himself."

Guglielmo Graim—as Vespasiano called him—related this story to Vespasiano personally. He too was a devourer of books. He began collecting manuscripts while a student at Oxford, purchasing from the city's booksellers monastic manuscripts from the twelfth and thirteenth centuries that had come onto the market through channels both lawful and otherwise. In Cologne he had continued adding to his impressive collection of books, even keeping among his extensive household a scribe named Richard Bole who copied out works for him. Grey arrived in Florence with the plan of purchasing books to take to Padua for his humanistic studies. And he knew exactly how to go about putting together this collection. "Arriving in Florence, he sent for me," wrote Vespasiano.

Grey may have learned about Vespasiano from a fellow Englishman, Andrew Holes, the diplomat and bibliophile at the court of Eugenius IV who was in the process of putting together his own collection. In any case, such was Vespasiano's reputation by 1442 that even an Englishman freshly arrived in Italy knew of him. And such was his reputation, too, that he soon attracted the attention of another client, one even wealthier and more powerful than either Archbishop Donati or William Grey.

Seven years after Cosimo de' Medici's anxious conversation with Pope Eugenius about wealth "acquired through dubious means," the convent of San Marco, funded by Cosimo, was nearly finished. The new convent was consecrated in January 1443, on the Feast of the Epiphany, presided over by Eugenius (who had still not found Rome safe enough to return) and attended by a host of other religious and civic dignitaries. No longer were the Dominicans obliged to accommodate themselves in the dilapidated shacks from which the Silvestrines had been evicted. The architect Michelozzo had built them an attractive church, spacious cloisters, a large chapter room, and a long refectory. There was even a special room in which a barber could ply his trade, tonsuring the friars' heads. Up one flight of stairs was the dormitory. More than forty cells were at the friars' disposal, to be used for prayer, study, sleep, and, on certain special occasions, self-flagellation.

The bills for everything were met by Cosimo, including those for an altarpiece featuring a Madonna and Child on a golden throne surrounded by saints and angels. Dozens of frescoes decorated the chapter room, the cloisters, the corridors, and the cells. All of these beautiful works had been painted by a resident friar, Guido di Pietro, who, after taking the Dominican habit at the age of twenty-one, assumed the name Fra Giovanni. A "wholly modest and pious man," as one of his fellow friars called him, Fra Giovanni wept, according to legend, as he painted scenes of the Crucifixion such as the magnificent vision in the chapter room.[22] Giovanni is better known to history as the "Angelic Brother," Fra Angelico.

On that day in early 1443, the only thing remaining to be built at San Marco was the library. Two years earlier the trustees of Niccolò Niccoli's will agreed that the Dominican convent should become the repository of his hundreds of precious Greek and Latin codices. Here they could be used not only by the friars but also, in keeping with Niccoli's wishes, by anyone eager for education. As Poggio had declared in his funeral oration for Niccoli, these hundreds of manuscripts would be of great benefit to the public, since "what could be more splendid, more pleasing, more adapted to humanistic study, more useful to the commune, if a public library could be made, or

contrived, capable of becoming a kind of excellent office of elo-
quence and of all the other good arts?"[23] The library would become,
in other words, a seat of ancient learning—the rich fund of knowl-
edge that, as Bruni believed, would allow Florence to leave all other
cities behind.

The dream of creating a library encompassing the world's finest wis-
dom, and then making it available to the public—or, at least, the male
half of the public—was an ancient one. Cosimo and his friends were
inspired in their efforts by the many accounts they read of ancient
libraries. In their copies of Plutarch they learned how, after being re-
lieved of his command in 66 BC, the philosophy-loving Roman gen-
eral Lucullus put together a large collection of books and made them
available to all, so that ordinary Romans "spent the day with one an-
other, in glad escape from their other occupations."[24] From Sueto-
nius they knew that Julius Caesar, a decade or two after Lucullus,
planned to do something similar, tasking Varro with amassing a col-
lection of Greek and Roman texts for public use. Though this library
was never constructed, from Pliny the Elder's *Natural History* they
learned how, in 39 BC, five years after Caesar's death, the statesman
and historian Asinius Pollio finally realized this dream. According to
Pliny, by founding a library in the Atrium of Liberty on the Aventine
Hill, Pollio "made works of genius the property of the public"[25]—
precisely the ambition of Cosimo, Niccoli, and their friends.

Ancient Rome had ultimately boasted more than twenty public
libraries. They were dotted around its hills and forums, housed in
temples, palaces, and porticoes, even in the baths. "Whatever men
of old or the present day have conceived in their learned hearts," the
poet Ovid happily observed, "lies open to be inspected by those who
would read."[26] How the Florentine humanists must have sighed with
pleasure, or perhaps gritted their teeth in envy, when they read Mar-
cus Aurelius's description of how he lounged on his sofa reading
works of Cato borrowed from the library in the Temple of Apollo on
the Palatine Hill, or when they read Aulus Gellius's casual references
in *Attic Nights* to how he used to relax with friends in the library
founded by Domitian in the palace of Tiberius, or how he finally

located a work by Lucius Aelius in the library founded by Vespasian in the Temple of Peace.

Gellius tells an anecdote that indicates the ease of accessing information in ancient Rome. On a visit to Tibur, in the hills outside the city, he met a man who told him that water from melting snow—which Gellius had been quaffing to refresh himself—was bad for the health. When Gellius questioned how he knew this fact, the man simply went to the local public library, housed in the Temple of Hercules and "well supplied with books," from which he borrowed a volume of Aristotle that, as he proceeded to show Gellius, clearly explained that meltwater was unwholesome for human beings. "And so I for my part immediately declared war upon snow," Gellius reported.[27]

The Florentines were determined to create one of these sorts of public libraries for themselves. To that end, Cosimo had taken possession of Niccoli's codices soon after his death, carting them the short distance from Niccoli's house near the church of San Lorenzo for safekeeping in his own palazzo. In 1441 he purchased the volumes outright from Niccoli's estate by undertaking to pay his debts, which amounted to the hefty sum of 700 florins. Donating them to San Marco, Cosimo committed himself to paying for the binding of the manuscripts, along with building the library in which they would be housed.

Once again, Michelozzo was put to work, and by 1444 the space was complete: a magnificent reading room some fifty yards long and twelve yards wide. Sunlight slanted through twenty-four deep-silled windows, those on the west side overlooking a garden designed by Cosimo himself. The walls were painted green in imitation of the Carystean marble with which—as Cosimo and his friends knew from reading Isidore of Seville's *Etymologies*—the ancients had clad the walls of their libraries because the color green refreshed weary eyes. A marble plaque on the wall declared that the new library of San Marco held the collection of Niccolò Niccoli, preserved through the extraordinary generosity of Cosimo de' Medici. Each codex was carefully inscribed *Ex hereditate doctissimi viri Nicolai de Nicholis Florentia*—"the legacy of the most learned man, Niccolò Niccoli of Florence."

Manuscripts in monasteries and other institutions were not kept, as they are today, on bookshelves lining the walls but rather in cabi-

nets or cupboards called *armaria*, or sometimes on long tables or benches. The codices were stored flat, not upright, and if they were particularly valuable they might be secured to the tables with chains. Readers moved around the room according to which manuscripts they wished to consult, going to the books rather than having the volumes brought to them. By the 1380s the library of the Franciscans in Assisi had featured eighteen benches holding 170 volumes, both chained and unchained. Another 520 manuscripts were kept in eleven cabinets.[28]

Niccoli's books in San Marco occupied two rows of desks, sixty-four in all, that looked like pews, and that, together with the long central aisle and the elegant stone columns bearing semicircular arches, gave the library the appearance of a church. The surfaces of the desks were tilted like lecterns for the convenience of the readers. Shelves were provided beneath to hold the volumes when not in use, and under these shelves, also for comfort and ease, were footrests. Certain of the volumes could be borrowed on six-month loans, but if any of the manuscripts were lost, the friars were obliged to replace them within the year. If the friars were to prove such careless or incompetent custodians that they lost more than fifty florins' worth of books in any given year—as few, depending on their value, as two or three codices—Cosimo would consider moving the entire collection elsewhere.[29]

The library of San Marco was a space of serenity and ease, filled with the gentle crackle of parchment and the scratching of quills. There would also have been the spicy tang of wood, since all the desks were made from cypress, which was recommended for libraries because its fragrant scent helped mask the stink of the codices. After all, no matter how elegant the script or how beautiful the illuminations and bindings, the pages had been made from the hides of dead beasts.

Only four hundred books—one half of Niccoli's collection—appeared on the shelves when the library opened in 1444. Many volumes were still out on loan to the friends with whom Niccoli had so generously shared them, and over the years the trustees had passed others

around. Some had been sent by request to Rome, while still others, perhaps sixty or seventy, needed to be sold to provide dowries for Niccoli's niece as well as his maidservant, as stipulated in his testament.[30] Cosimo consulted Niccoli's catalogue and carefully hunted down the errant volumes, bringing them back into the collection if possible and, if not, having copies of them made. Gradually Niccoli's manuscripts were restored and took their places on the cypress benches.

Cosimo, though, could not help but notice some serious gaps in the collection. Commentaries on the Scriptures, books on canon law, the works of Thomas Aquinas: Niccoli had not collected many of these works. "So Cosimo decided," wrote Vespasiano, "to add to the library everything that was missing."[31] Cosimo was determined, that is, to make the library of San Marco an exemplary collection of all branches of knowledge. He therefore turned to a friend, Tommaso Parentucelli, asking him to draw up a list of all of the works necessary for such a library—a library that would serve not just the Dominicans but, of course, the public as well.

Parentucelli was happy to oblige. He was yet another brilliantly pulsing star in the intellectual firmament, a priest who, after studies in Bologna, first came to Florence in the early 1420s to tutor the sons of wealthy Florentines. His brilliant mind and endearing personality meant he quickly excited the attentions of his superiors, and he came to serve both the high-powered bishop of Bologna and Pope Martin V. In Rome he and his friends would gather in the open air near the Vatican for literary conversation. Whenever he was in Florence he could be found riding a mule through the streets on his way to debate happily with scholars such as Poggio and Leonardo Bruni under the Roof of the Pisans or outside Michele Guarducci's bookshop.

Parentucelli's erudition was legendary. According to Vespasiano, he knew the entire Bible by heart. He had studied the writings of all the Church Fathers, "and there were few writers in Greek or Latin, in any discipline, whose works he did not know." He was a passionate bibliophile, bringing back manuscripts from his expeditions on behalf of first Martin and then Eugenius to England, France, Germany, and Switzerland. His own library was formidable in its range and quality. "He possessed books on every subject," wrote Vespasiano,

noting that Parentucelli hired only the best scribes and illumina-tors, always paying them handsomely.[32] He also bought books second-hand. His collection included a fourteenth-century manuscript of medieval philosophy once owned by Coluccio Salutati. Parentucelli wrote in the flyleaf that he acquired it from Salutati's heirs *per manum Vespasiani*—"through the hand of Vespasiano."[33]

Parentucelli duly compiled for Cosimo a list of works with which, he felt, a great library should be stocked. Cosimo therefore realized that, in order to make his library complete, he would need to buy many more manuscripts. Vespasiano's precocious abilities as "the best guide" for finding the ancient manuscripts meant that, at the age of twenty-three, he entered the service of Cosimo de' Medici.

At the end of 1445, as winter gripped the Tuscan hills, Vespasiano departed for Lucca, forty-five miles to the west of Florence. His bona fides declared him the *procuratore*, or agent, of Cosimo de' Medici.[34] This position was bound to open doors, and he was welcomed into the finest home in Lucca, that of Michele Guinigi. The forty-year-old Guinigi came from a family of wealthy silk merchants and bankers whose operations stretched as far as Flanders, France, and England. He possessed, among his riches, a respectable library of books. Many were inherited from his cousin Paolo, who had ruled Lucca between 1400 and 1430, and who had purchased his manuscripts from a local dealer who doubled as an apothecary.[35] Besides his beautiful palazzo and various farms in the countryside, Michele was also owner of the most famous landmark in Lucca: a tower from whose parapet oak trees sprouted.

This book-buying excursion proved successful. From the Fran-ciscan friars at the local convent Vespasiano purchased forty-nine manuscripts for 250 florins. Included among his purchases were nu-merous glosses and commentaries on the Holy Scriptures. However, not all the books from the Lucca expedition went to San Marco's library: Vespasiano, on his own initiative, purchased some fifteen books in Lucca for himself, no doubt to sell from Guarducci's shop—a sign of his innovative commercial strategy. At least two of these manu-scripts, works by Cicero, he bought from Guinigi himself.

Besides helping to stock the library in San Marco, Vespasiano received another commission from Cosimo. Most of the codices were to be secured to their desks by chains attached to iron rails, preventing readers from making off with the valuable volumes. Vespasiano was given the task of attaching the chains to the books, and also of binding them. Such work may have been physical and artisanal rather than intellectual, but Vespasiano appears to have taken pleasure in producing luxurious bindings for clients, and in turning manuscripts into beautiful artifacts. He disagreed with Seneca the Younger, who condemned collectors for caring more about the outsides of books than their contents, and for using books "not as the tools of learning, but as decorations for the dining-room." Petrarch had likewise criticized collectors who hoarded manuscripts as ornaments for their homes. "There are those who decorate their rooms with furniture devised to decorate their minds," he sniffed, "and they use books as they use Corinthian vases."[36] For Vespasiano, however, a beautiful manuscript could both furnish the mind and adorn a room.

Vespasiano must have enjoyed foraging among the desks and shelves of the library in the convent of San Francesco in Lucca, looking for manuscripts to purchase, or studying volumes of Cicero and other authors in Guinigi's fine collection. But by this time he was already immersed in other enterprises, ones that must have been equally if not more satisfying.

The English diplomat Andrew Holes had returned to England in 1444, following a dozen years in Italy. During his sojourn he had put together a manuscript collection so large that, according to Vespasiano, he was forced to send the books to England on board a ship. His successor as King Henry VI's representative at the Roman Curia was the other expatriate English bibliophile, William Grey. Following his visit to Florence in 1442, Grey had pursued his humanistic studies in Padua, receiving his doctorate in divinity in September 1445, a few weeks before his appointment as the king's proctor. He then left Padua for Rome, to which Pope Eugenius had at last returned in 1443 after having finally judged it safe to chance his pres-

ence among the unruly Roman mob. But first of all, Grey stopped in Florence on important business.

Like Holes, Grey wanted copies of the works of Cicero, having commissioned a collection from Vespasiano during his first visit to Florence. Cicero was the Latin author most admired by early Christians such as Saint Jerome and Saint Augustine and then, a thousand years later, by Petrarch, who had esteemed him, because of his elegant prose style, "as much or even more" than all other writers. Cicero had been a high-ranking Roman statesman, a successful lawyer, and a prolific writer on subjects ranging from rhetoric to politics and philosophy. The rediscovery of many of his speeches, letters, and other writings in the 1300s and early 1400s had enthused and inspired several generations of scholars. The influence was particularly strong in Florence, where Coluccio Salutati, due to his admiration for and emulation of Cicero's style, became known as *Ciceronis simia* ("Cicero's monkey")—a term intended to be flattering because Salutati and his friends regarded the Latin of Cicero to be of the highest possible standard.[37]

Born in 106 BC, in a town seventy miles southeast of Rome, Marcus Tullius Cicero took his surname, according to the biographer Plutarch, from an ancestor with a dent in his nose that looked like the cleft in a chickpea (*cicer* in Latin). Cicero's brilliance showed itself early: adults flocked to his school to witness his astonishing classroom performances. Arriving in Rome as an adolescent, he studied under two forensic orators, skilled advocates whom he watched and assisted as they pleaded in the Forum or spoke in the Senate; he also penned poetry. Then in 91 BC, still only fifteen, he began military service, which saw him promoted within a decade to the command of an army. He quickly proved himself a brilliant orator after returning to the Roman courts, but when he was twenty-seven political events in Rome obliged him to interrupt his burgeoning career and spend two years abroad, including six months in Athens (like all educated Romans, he spoke fluent Greek). Finally, in 75 BC, at the age of thirty-one, he launched his public career as a *quaestor*, a high-ranking position that automatically granted him a lifelong membership in the Roman Senate. A swift ascent through a series of judicial

offices culminated in his election as consul, or chief magistrate, in 63 BC.

Cicero's close involvement in the politics of the Roman Republic saw him heaped with honors, including the title *Pater Patriae*, "father of the fatherland." It also earned him powerful enemies. His public service was punctuated by periods of prudent retreat, during which he composed books, such as, in the mid-fifties, after he fled to Greece, his famous *De Oratore* (a dialogue on the training of an orator) and his *On the Republic*. A decade later, during another enforced interval prior to Julius Caesar's assassination in 44 BC, he wrote works including *Brutus* and the *Orator*.

Cicero was neither involved in the plot against Caesar nor present in the Senate when the deed was done. However, two days later he spoke in favor of a general amnesty. Quickly emerging as a champion of the Republic, he attacked Mark Antony in a series of fourteen speeches (his "Philippics") and tried to win the nineteen-year-old Octavian—the future Emperor Augustus—to his side. His famous rhetoric, however, failed him. In November 43 BC he was executed on orders of Antony, his head and right hand afterward exposed in the Forum, the scene of so many of his oratorical triumphs. Antony's wife, Fulvia, took her own special vengeance. "And Fulvia took the head into her hands," reported the historian Cassius Dio, "before it was removed, and after abusing it spitefully and spitting upon it, set it on her knees, opened the mouth, and pulled out the tongue, which she pierced with the pins that she used for her hair, at the same time uttering many brutal jests."[38]

Cicero's legacy for more than a thousand years after his death was sharply at odds with the vigorous political engagement that got him killed.[39] Throughout the Middle Ages, when only a few of his works were known or read, and when knights and monks, in any case, paid little heed to treatises on republican political affairs, Cicero came to be regarded—thanks to misquotations and misunderstandings—as a representative of the contemplative rather than the active life. This view of Cicero was shattered in 1345, when Petrarch discovered a manuscript of Cicero's letters to his friend Atticus in the library in Verona. These private letters revealed how Cicero did not pursue a quiet life on his country estate, meditating on eternal veri-

ties, but rather involved himself in "useless quarrels" (as a disappointed Petrarch put it) in pursuit of the "false splendor" of worldly glory. "Oh, would that you had never aspired to the consul's insignia or to triumphs!" wailed Petrarch, the author of *On the Solitary Life*, who preferred to live his own life far from the madding crowd.[40]

While this commitment to an active life shocked and disappointed Petrarch, the scholars who came after him, such as Salutati and Leonardo Bruni—both of whom, as chancellors of Florence, were deeply immersed in politics—applauded Cicero's public service and patriotic fervor. In 1415 Bruni wrote a biography of Cicero, which he entitled *Cicero Novus*, revealing and celebrating the "new Cicero," a scholar who was at the same time a man of robust political action. Then, six years later, a complete copy of Cicero's rhetorical writings, including *Brutus*, lost for many centuries, was discovered in Lodi in northern Italy. (The manuscript of *Brutus* mysteriously disappeared in 1425, but not before a number of copies—at least three of which still survive—were made from it.) After almost fifteen hundred years, in the Republic of Florence, Cicero began speaking to a new age: one finally eager to pay heed to his advice about speechmaking and civic conduct in urban centers where decisions were taken by "assemblies of men."

This, then, was the Cicero that Vespasiano was reproducing for clients such as Andrew Holes and William Grey, the latter of whom, he noted approvingly, wished to assemble "a very worthy library" of ancient books.[41] Cicero's writings were essential for this collection—hence Grey's stopover in Florence to visit the Street of Booksellers and check on the progress of his manuscripts. A *cartolaio* with Vespasiano's resources could have found various secondhand Cicero manuscripts without much trouble, but a man with Grey's extensive means could afford to commission an entirely new manuscript. And not only Cicero: he also wanted a copy of Pliny the Elder's *Natural History* as well as one of that other essential humanist treatise, Quintilian's *Institutio Oratoria*.

By the autumn of 1445 Vespasiano had completed the first volume or two of what was destined to become a five-volume set of

Cicero's works. One of them, Cicero's writings on rhetoric, bore on its final page an inscription by Ser Antonio di Mario, the scribe hired by Vespasiano to copy the text. Ser Antonio announced in block capitals, alternating in red and black, that he completed the work in Florence on the twelfth of November in 1445.[42]

Vespasiano's friend Poggio called the English "those barbarians," among whom there were "very few lovers of literature."[43] However, the pair of Englishmen, Holes and Grey, provided Vespasiano with many of his first commissions, and their orders and purchases helped to establish his reputation. More than that, they appear to have inspired Vespasiano's business model—that of producing deluxe manuscripts of the Latin classics for wealthy and learned clients.

Chapter 7

Antique Letters

Producing new manuscripts of Cicero's writings was clearly a more laborious and involved enterprise than combing the sleepy shelves of Franciscan libraries for neglected codices. The word "manuscript" comes from the Latin *manu scriptus,* "written by hand," but any manuscript was the product of much more work than simply the writing of a single hand. It was a months- or even years-long, multistep process calling for the expertise of a series of tradesmen and specialist craftsmen, from parchment makers to scribes, miniaturists, goldbeaters, and even apothecaries, carpenters, and blacksmiths.

The essential first step was finding the exemplar: the text, as reliable as possible, from which the scribe would work. It is no coincidence that on his excursion to Lucca in 1445 Vespasiano purchased two copies of Cicero from Michele Guinigi. His sharp eyes no doubt spotted that these manuscripts would be excellent texts to compare with those volumes he was preparing for Grey.

Vespasiano occasionally produced works on paper, of which, like all *cartolai,* he carried ready supplies. For the most part, though, his clients expected him to use parchment. *Cartolai* carried stocks of parchment, which was made from the skin of sheep or goats, and sometimes also from donkeys. The most beautiful and expensive material on which to write was calfskin, or vellum, the word "vellum" coming (like the word "veal") from *vitulus,* Latin for "calf" (*vitello* in Italian). The younger the calf, the finer and whiter the skin; uterine vellum, from aborted or stillborn calves, was the finest and whitest of all—but also, because of its rarity, infrequently used.

The supply of hides for parchment was always dependent on the dietary preferences of the local population. The appetite in Italy for

goats (one recipe book offered advice on how to spit-roast, boil, or stew them, how to cook their eyes, ears, lungs, and testicles, and how to make pies from their heads)[1] meant that manuscripts in Italy were often made from goatskin. This reliance of the book industry on the palate of the locals is reflected in the lament by a thirteenth-century Patriarch of Cyprus, Gregory II, that not until after Lent, when people began eating meat again, would he be able to get the hides required for a manuscript of Demosthenes. For hundreds of years, the transmission of knowledge had depended on carnivorous appetites and good animal husbandry. Large volumes with hundreds of pages required the skins of many animals. One goat was often needed for each page of parchment in a large liturgical book such as an antiphonary, while a Bible might take the skins of more than two hundred animals—an entire herd of goats or flock of sheep.

Parchment makers in Florence were, like the *cartolai*, clustered around the Badia in the Street of Booksellers. To purchase their hides they needed to visit the butchers on the Ponte Vecchio. In 1422, for reasons of hygiene, the government ordered the city's butchers to move their operations into the shops on the bridge, already occupied by tanners, fish sellers, and beltmakers. From here the butchers could happily pour blood and other slops straight into the Arno, rather than, as before, befouling the city's streets. The parchment makers, in competition with the tanners, would try to get the best hides from the butchers, those with the fewest nicks, cuts, and scars, and the least number of bites from ticks and flies.

The process of making parchment was scarcely less foul-smelling than the work of the tanners, who used both urine and dung to cure their hides. The parchment makers would cart their heap of skins back to their premises, smear them with a corrosive quicklime, fold them lengthwise, then put them into a vat to ferment. After a week or two, the hides would be fished from the vat, bathed in limewater, and then attached with pegs to wooden frames and stretched tight as the remaining hair and flesh was scraped away with a crescent-shaped knife. Still taut on the frame, they would be rubbed with chalk or bone dust and scrubbed with a pumice stone, or perhaps

the bone of a cuttlefish. Then they were rubbed and scrubbed again and again, until the surface of both sides was smooth and pale, though sheepskin always yielded a yellowish cast and goatskin a slightly gray one. The skin was then cut from the frame in a neat rectangle. The rectangular shape of books (through the Middle Ages codices generally had a width-to-height ratio of 2:3) was in many respects determined by the shape of the animal skins once they had been trimmed of their extremities.[2] These outer scraps served to make glues, while other offcuts, such as the skin from the shoulders, neck, and flanks, with their coarser grain and more awkward shape, might be used as cheap parchment for children's books such as the *Santacroce.*

The next operation involved paring away the skin with another sharp tool, reducing it to roughly half of its original thickness. The parchment maker had to be careful neither to tear the skin nor to create an uneven thickness. Parchment for large, luxurious manuscripts was scraped less so it remained robust enough to carry the decorations. Even so, these pages were reduced to a thickness of 0.1 millimeter, or $\frac{1}{250}$ of an inch. At this point any flaws in the skin, from the bites of insects or the gashes of old wounds, could leave the surface with small oval perforations around which the scribe would have to work. The defective quality of the parchment—if it was too rough, greasy, or brittle—was one of the many things about which scribes complained in their manuscripts. "The parchment is hairy," griped one medieval scribe.[3]

The large rectangle of parchment was then cut into four or eight pieces. Parchment was sold in various sizes according to the type of book for which it was destined. One of the largest sizes was used for antiphonaries, which needed to be read simultaneously from a distance by many pairs of eyes—those of choir members. Their pages were often two feet high by more than a foot wide, with the staves (the horizontal lines on which the musical notes appear) drawn almost two inches high. The pages of parchment used by Vespasiano for his edition of Cicero for William Grey were fourteen inches high by ten inches wide, the size known as *foglio comune*, or common sheet.

Parchment in Florence was usually sold in quires made up of five sheets folded in half to make ten leaves, which, inscribed on both sides, gave twenty pages of text. One of these quires of *foglio comune*

could cost as much as ten soldi.[4] Given that his manuscript of Cicero's rhetorical writings required 125 leaves, or more than a dozen quires, the parchment for this volume alone must have cost Vespasiano roughly one and a half florins. This sum was a significant outlay—roughly a month's rent on the shop in the Street of Booksellers. And the most expensive labor and materials were yet to come.

Having supplied himself with parchment, Vespasiano was ready to hire a scribe. Monks in the Badia, across from Vespasiano's shop, still worked as scribes. So too did the Franciscan nuns at the convent of Santa Brigida del Paradiso, the Benedictine nuns in Santissima Annunziata della Murate, and indeed the nuns at some five other convents scattered in and around Florence. However, the manuscripts they produced were liturgical in nature—breviaries, lectionaries, missals, and so forth. In Florence, as in much of the rest of Europe, the scribes who copied secular works such as the Latin classics were not found in the scriptoria of abbeys and convents but rather in the shops of notaries and the studies of assorted scholars who might otherwise work as secretaries to wealthy men or tutors to their sons. Notaries made ideal scribes because their profession called on them to prepare contracts and other documents in Latin, on parchment, in a legible handwriting. There was no shortage of them either, because notaries were the most numerous profession in Florence in the first half of the fifteenth century[5]—and many of their shops lined the Street of Booksellers and Via del Palagio.

Most of the scribes employed over the years by Vespasiano, such as Ser Antonio di Mario, were indeed notaries (all of whom used the honorific "ser," rather as "Esq." is added after a lawyer's name). Many notaries topped up their incomes by copying manuscripts part-time in their shops or homes, but others, such as Ser Antonio, abandoned the notarial profession altogether and worked full-time as scribes, often quite lucratively. Indeed, the scribe represented a bookseller's greatest expense, taking up as much as two-thirds of a manuscript's production cost, at least twice as much as the parchment.[6] They were generally paid by the quire, earning a fixed sum for every ten leaves

of parchment, or twenty pages copied front and back. The average fee was around thirty or forty soldi per quire,[7] at which rate Ser Antonio would have been paid more than five florins for his work on the Cicero manuscript for William Grey. Copying ten or twelve such manuscripts per year would allow a scribe to bask in more than tolerable comfort.

Scribes often needed to work quickly and prolifically due to the demands of the patron, the time limit imposed by whoever lent the exemplar, and their own financial needs. One of the most impressive scribal feats in Florence was that of a copyist in the middle of the 1300s who produced—over the course of some twenty years— what became known to legend as the *gruppo del Cento*, or "the Group of One Hundred": one hundred manuscripts of Dante's *Divine Comedy*, the proceeds of which provided dowries for the scribe's numerous daughters. The offspring of his daughters' marriages called themselves *dei Centi*, "of the Hundred," proudly taking their surname from the pen-pushing efforts of their grandfather.[8]

Many other remarkable scribal feats are on record. One copyist working in Florence managed to complete a quire (that is, twenty pages front and back) every two days.[9] Poggio worked at double that speed when he produced his complete Quintilian in thirty-two days, turning out a quire each day. He once copied out 152 pages of a work in twelve days, and in 1425 he promised to provide Niccolò Niccoli with a new manuscript of Lucretius's *On the Nature of Things* in only two weeks, although in the end the job took a month. One of the quickest quills belonged to a scribe named Giovanmarco Cinico, who once copied 1,270 pages of Pliny's *Natural History* in 120 days, and in a beautiful and legible hand. He signed himself, appropriately enough, as Velex—"Speedy."[10]

We have no record of how long Ser Antonio took to copy the 250 pages of the manuscript for William Grey. But he generally worked both swiftly and prolifically. He completed a manuscript of Virgil in April 1445, only seven months before signing the Cicero for Vespasiano. In the previous twelve months he had copied out two

manuscripts of Leonardo Bruni's *History of Florence*, a massive tome that stretched to 300 leaves of parchment, or 600 pages.* In one year he managed to copy at least seven manuscripts, including one of Bruni's translations of a Platonic dialogue.[11]

In selecting Ser Antonio, Vespasiano had wisely chosen for this important early commission a talented and capable veteran with almost thirty years of experience. His beautiful handwriting graced the manuscripts of many important and cherished works: Gellius's *Attic Nights*, Plutarch's *Lives*, Varro's *On the Latin Language*, Bruni's translations of both Plato and Aristotle, along with many others. He copied manuscripts for the finest collections in Florence. He was, in fact, Cosimo de' Medici's favorite scribe, including at the end of his transcriptions affectionate salutations such as "Happy reading, sweetest Cosimo."

Such comments Ser Antonio always placed at the end, in what has come to be known as the colophon. The word "colophon" derives from the Greek κορυφή, meaning hilltop or summit, but at some point it took on a metaphorical sense of a finishing touch or crowning stroke: ancient Greek philosophers spoke of "putting a colophon" on an argument. We can appreciate how a scribe, having copied hundreds of pages of a manuscript, may well have felt he had scaled a summit, and the term was adopted for the designs, flourishes, and slogans often added by scribes to the ends of their manuscripts.[12] The scribe who copied part of Aquinas's massive *Summa Theologica* ended with a cry of exhausted triumph: "Here ends the second part of the work of Brother Thomas Aquinas of the Dominican Order, incredibly long, verbose and tedious for the scribe. Thank God, thank God, and again thank God!"[13] At other times scribes addressed future readers, cautioning them to be careful with the manuscript: "I beseech you, my friend, when you are reading my book, to keep your hands behind your back, for fear you should do mischief to the text by some sudden movement."[14] Scribes often asked readers to pray for their

*After his death in 1444, Bruni was interred in the basilica of Santa Croce with an elegant funerary monument showing him reclining with a manuscript on his chest—a copy of his *History of Florence*.

souls. A humorous variation on this convention appeared in a manuscript copied by a Florentine nun named Sara. "Let whoever reads this devout life pray God for me, poor Sister Sara," she began, before adding, "And if you don't I'll strangle you when I'm dead."[15]

For his colophons, Ser Antonio used a compass to draw a circle around whose 360 degrees he would put his name and the date, sometimes also recording an ongoing event. He began his long career in the summer of 1417, when he ended a manuscript with the observation that he had been "laboring during the plague in Tuscany." One of his other manuscripts, signed in May 1426, states that Florence was bravely fighting the "tyranny of the duke of Milan, who was waging an unlawful and unjust war."[16]

Vespasiano prepared the parchment for Ser Antonio by ruling it with lines, both horizontally and, to justify the text, vertically at the margins. This task would have been among the first he learned from Michele Guarducci. *Cartolai* pricked the margins with a needle or a pinwheel, often pushing the point through as much as a quire at a time. The operation required a certain amount of physical strength (and no doubt sometimes resulted in minor injuries). The small perforations indicated where exactly the horizontal lines should be drawn or, less often, scored with a stylus. The point of pricking a quire at a time was to make sure the spacing was uniform on all of the pages. Ser Antonio's Cicero manuscript features thirty-six lines of text on each page, with the guidelines in pale ink still faintly visible. The job of ruling the parchment was a tediously repetitive one, but it had the obvious importance of ensuring evenly spaced lines and a text that ran undeviatingly across the pages. As in Florentine architecture, so in Florentine manuscripts, beauty lay in simplicity, regularity, and symmetry.

With his parchment awaiting him, Ser Antonio takes a seat at his desk. His writing surface, sloped at an angle of around thirty degrees, holds the exemplar, the blank quire, and two inkhorns fitted into holes. To remove any grease from the page, he sprinkles it with chalk or bone dust, the latter made (as one manual advised) by incinerating the leg

or shoulder of a sheep and then grinding the ashes on a porphyry slab. Then, to remove the excess dust, he brushes the surface with a hare's foot.[17]

Next comes the preparation of the vital instrument of his labors: his quill, made from one of the flight feathers of a goose (the word pen derives from the Latin *penna*, "feather"). He has already carefully trimmed the barbs from the shaft, which is seasoned to the right hardness, but still supple. He cuts its tip to a point and then, to make the nib more pliable and help the flow of ink, makes a short incision along its length. These procedures he will repeat numerous times a day, his quill slowly growing shorter as he pares it away.

Next Ser Antonio dips the quill into one of the two inkhorns. One holds black ink, the other red. The main ingredients for the former are wine and the barks and saps from various trees, including oak galls, the small, tannin-rich lumps that grow on the twigs of oak trees where gallflies lay their eggs. One Italian recipe for black ink advised taking four ounces of crushed galls and mixing them with a bottle of strong white wine, pomegranate rinds, bark from a mountain ash, the root of a walnut tree, and gum arabic—the sap from an acacia tree. These ingredients were left in the sun and stirred every few hours. Into this concoction were added, after a week, a few ounces of "Roman vitriol," or copper sulphate. The mixture then sat a few days longer and was regularly stirred. Then it was placed over the fire and boiled "for the space of one *miserere*"—as long as it took to recite the nineteen verses of Psalm 51. Next the bubbling black liquor was cooled, strained through linen, and left to sit in the sun for two more days. "If you then put in it a little rock alum it will make it much brighter," the recipe claimed, "and it will be good and perfect writing ink."[18]

Ser Antonio bought his supply of black ink from either a *cartolaio* (who also sold goosequill pens) or one of Florence's monasteries. On a scrap of paper or parchment, making a short doodle, he tests out both the nib and his red ink. He can make red ink himself by mixing egg white and gum arabic with cinnabar, a reddish stone found in Tuscany and purchased, already ground, from the local apothecary. Another dip in the inkhorn and he hovers over the blank page, its buoyant surface pressed down with the knife he holds in his

Ser Antonio di Mario's "Table of Contents" for one of the
Cicero manuscripts commissioned by William Grey.

left hand. His middle finger is farther down the shaft than his index:
the better to control the nib. He holds his quill at a right angle to
the surface of the parchment: the better for the ink to flow from nib
to page.

After a quick check of the exemplar, Ser Antonio brings the nib
down to the surface—he is writing on the smoother, flesh side—and
makes his first stroke. Three short movements, three quick changes
of angle and pressure. Without lifting the pen he makes a swift feint
to the right, a slower and heavier downward stroke, then a slight re-
lease of pressure and another feathery, horizontal feint before the
nib is lifted clear: the letter *I*, its downstroke topped and tailed by
tiny serifs.

Ser Antonio continues in block capitals, still in red: IN HOC
CODICE CONTINENTUR. "This book contains . . ." He is pronounc-
ing the words aloud as he writes, the better to remember them as his

eyes move back and forth from the copy text to his parchment. "Three fingers hold the pen," wrote one scribe, "two eyes see the words, one tongue speaks them, and the whole body labors."[19]

Ser Antonio works his way down the page, providing the table of contents in red ink. It is a roll call of some of Cicero's most famous and influential works, such as *Letters to Atticus*, rediscovered by Petrarch in Verona in 1345, and the *Orator* and *Brutus*, both rediscovered more recently in Lodi. Vespasiano probably acquired the exemplars for Ser Antonio from Cosimo de' Medici, who had copies made for himself in the 1420s. He may also have found them in the library of San Marco, for in 1423 Niccoli copied out both the *Orator* and *Brutus* in his distinctive script.

Ser Antonio completes the contents page and moves on to the next. The quire has been arranged by Vespasiano such that this facing page, the first of the text proper, is also the smoother, flesh side. Flesh sides always face flesh; hair sides always face hair (these are slightly rougher, often lightly stippled from the follicles). Ser Antonio trims a new quill, this time cutting a finer point, then dips the nib into the black ink. After another pen trial he begins writing. The first text is the *Rhetorica ad Herennium*, in which Cicero gives his friend Gaius Herennius lessons on how to make a speech. It was a treatise much loved by the humanists in Florence, where a successful speech depended on the ability to use logic and reason to persuade others, to "bend your auditor to go wherever you might want."

Ser Antonio begins copying out Cicero's words, not in block capitals but in a smaller hand, an elegant, legible script of which he is one of the earliest and most talented pioneers. This so-called humanist script is a gift that the scribes of Florence bequeathed to the world, one no less important than the rediscovery of the works of Cicero or Quintilian, or the perspective grids of Brunelleschi and paintings of Masaccio—a gift that the manuscript expert Albert Derolez has called "one of the great creations of the human mind."[20]

Vespasiano began producing manuscripts a short time after a reform in handwriting took place. In the previous century, Petrarch had been highly critical of scribes not only because so many of them were, in

An example of Gothic script: "designed for something other than reading."

his opinion, deplorably slapdash in their attention to detail, but also because he found their handwriting almost impossible to read. Their script may have looked attractive from a distance, but close up, as one tried to read them, the letters and words crowded tightly together in a tangled mass of tiny characters that quickly fatigued both eyes and brain. It was as if, Petrarch lamented, this sort of script "had been designed for something other than reading."[21]

This style of handwriting developed in northern France in the middle of the 1100s, the same place and time as did what we know today as Gothic architecture. Today we know this script, like the architecture, as Gothic. By the fourteenth century it was called *litterae modernae*—"modern letters"—in the same way that the pointed arches of Gothic architecture were known as *opus modernum*, or "modern work." Over the following two centuries, aided by the rise of the universities, Gothic script spread across Europe, producing a number of variants, such as *textura* (also known as *textualis*), whose name came from the Latin *texere*, "to weave," because the compressed letters looked as if they had been woven together—indeed the entire page often looked like an embroidered tapestry.

These medieval scripts shared basic features. Scribes used a slit, broad-nibbed quill to create their letters through a combination of

thick and thin strokes. Abbreviations were common, and ligatures linked letters together with "feet" (what today are called serifs) at their bottoms. Round shapes became lozenges. Letters were compressed at their sides so that height (as in Gothic architecture) was emphasized over width. Some letter combinations, such as *pp* and *db*, were even fused together, a trait that paleographers call "biting." Petrarch claimed these letters looked like they were riding piggyback on one another.

One problem with reading this script was that many letters looked almost identical. For example, there was no dot above the letter *i*, and so two *i*'s placed side by side were indistinguishable from a *u*, until scribes started putting short dashes above the double *i*'s—the ancestors of our dotted *i*. Nonetheless, letters such as *i*, *u*, *m*, and *n* remained extremely hard to differentiate. To avoid such problems, English scribes sometimes changed certain spellings, substituting an *o* for the vertical strokes in letters such as *i* and *u*: *wimen* became *women*, *munk* became *monk*.

By the 1300s Italian scribes were experimenting with more legible hands for the benefit of an expanding book market that included readers of secular texts such as Dante's *Divine Comedy*, the most copied manuscript of the fourteenth century. Also, the arrival of paper—the first papermill opened in Italy in the 1260s—led to simpler and more informal styles of handwriting because the smoother surface allowed for a more rapid transcription in which the scribe did not need to lift pen from page.

Petrarch was the most vocal proponent of manuscripts with a greater legibility: a good handwriting, he claimed, needed to be clear and simple. As it happened, he knew just such a script. He wrote to his friend Boccaccio describing a manuscript of Saint Augustine whose script showed "majesty, harmony and sober decoration."[22] This manuscript had been copied three hundred years earlier in the script that we know today as Carolingian because of its origins in the scriptoria of Charlemagne, who needed a uniform alphabet that could easily be read by people across his far-flung empire. The rounded and separated characters of Carolingian script flourished throughout Europe between the 800s (when it first appeared at the abbey of Corbie in northern France) and the 1100s (when it was replaced by

The "antique letters" of Carolingian script.

Gothic script, the more "modern" style). Ancient classics copied four or five centuries earlier in monasteries such as Saint Gall or Fulda were written in a script that was not only older than Gothic lettering but, to Petrarch and his followers, clearer, more beautiful, and closer to what they imagined the ancient Romans would have used.

The remote ancestor of this lucid and elegant style does appear to have been a cursive script used by the ancient Romans, for the Carolingian scribes were copying texts written out hundreds of years earlier. Petrarch and the humanists who came after him had no clue what ancient Roman book hands actually looked like: the perishability of Roman writing materials such as wax tablets and papyrus meant that none of these writings had come down to them. But the grace and clarity of the Carolingian script seemed to match the "beautifully precise and legible" handwriting of Atticus that Cicero so admired.[23] Poggio and Coluccio Salutati both referred to the Carolingian

Poggio Bracciolini's "antique" style of handwriting.

style as *litterae antiquae,* "antique letters"—as opposed to the "modern" style that we know as Gothic.

Petrarch and Salutati both tinkered with their own script, experimenting with rounded, well-spaced letters. Neither reproduced the Carolingian style themselves, but in the 1390s, as his eyes dimmed, Salutati began commissioning manuscripts in imitation of Carolingian lettering. Scholars have linked him to at least forty scribes working in Florence.[24] A particularly important year seems to have been 1397, the year Manuel Chrysoloras arrived in the city. In that year Niccoli first experimented with *litterae antiquae* script in a copy he made of Lactantius's *Divine Institutions.* That same year an anonymous scribe—known to scholars only as the "Copyist of 1397"—worked on several manuscripts, including copies of Cicero and Lucan, in a similarly experimental style.

This new approach differed from Gothic, or black letter, script because the scribe's hand moved more quickly over the parchment without making distinctions between thick strokes and hair strokes and, as far as possible, without lifting the quill, which was trimmed to a finer point than the thick nib used for Gothic script. Letters were rounded rather than angular, and the overall appearance of the written page went from a solid block of character-crammed text to a

more evenly spaced grouping of letters running from one margin to another.

This new script became more elegantly and consistently "antique" under the quill of Poggio, specifically in a series of manuscripts—the comedies of Plautus, Cicero's *De Oratore*, and works by Propertius and Saint Augustine—that he copied for Niccoli at some point between 1400 and 1403.[25] Just as Brunelleschi's simple and elegant semicircular arches would soon replace pointed Gothic arches in churches, so too the rounded contours and evenly spaced calligraphy of Poggio and other scribes gradually began supplanting the spikes and serrations of Gothic script.

This transformation was the work of several decades, initially in Florence and then elsewhere around Italy. Scribes first of all needed to be taught how to write in these "antique letters." Poggio appears to have taken the lead as a teacher. In the 1420s he wrote letters from Rome to Niccoli describing his frustrations with the task of imposing his new alphabet, or what he called "the old style." In 1425 he hired a secretary from Naples, "to whom I have taught the old style of writing with great effort." This scribe proved woefully unreliable, "the filthiest sort of man with the worst possible habits . . . He is the very dregs of the earth . . . He is so careless, frivolous, and quarrelsome." Things went no better with another scribe he began training two years later, "a copyist of uneducated intelligence and peasant habits." He spent four months tutoring him, but "day by day he becomes stupider. And so I yell, I thunder, I scold, I upbraid; but he has ears full of pitch. He is leaden, a blockhead, wooden, a donkey, and whatever can be mentioned that is duller and clumsier. Damn him." Little wonder that Poggio confessed a year later that his manuscripts were produced in "an atmosphere of hostility."[26]

Despite these difficulties, by 1413, thanks to the efforts of Poggio and his friends, almost one hundred manuscripts had been copied in versions of this new style—the majority in Florence, by Florentine scribes, or for Florentine patrons.[27] Moreover, the majority were copies of the Latin and Greek texts in which the Florentine humanists were so enthusiastically steeping themselves: an "ancient"

script befitted these ancient texts. Seneca, Virgil, Ptolemy, and, of course, Cicero—all were copied in antique letters. Cicero was the most prolifically copied of all, with more than twenty different manuscripts appearing in this script by 1413. Great authors from antiquity were presented in an elegant script that deliberately and appropriately evoked classical antiquity, and that would ultimately become known, because of its link with the texts of the "study of humanity," as humanistic script.

Cosimo de' Medici's 1418 inventory of his books proudly declared which ones in the collection were copied in antique letters. A later Medici inventory would describe this style with a striking and apparently contradictory phrase: *lectera anticha nuova*, "new antique letters."[28] This old-new, new-old crossover, where old things were made new again, made a fitting parable for what was happening in Cosimo's Florence.

Chapter 8

Friends in High Places

Thanks to the efforts of Vespasiano, by the mid-1440s Michele Guarducci's premises had become one of the most famous shops in Florence. No physical description survives, but the shop probably featured a signboard above one or both doors and, in good weather, a display of books on a table or bench out front protected by a canvas awning.[1] Two large, intercommunicating rooms were found within. One was for the display of books and manuscripts as well as stock such as ink, paper, parchment, Latin grammars, and blank account books. Customers could seat themselves at desks and, if they wished, leaf through the manuscripts—giving the shop the air of a library or reading room. The other room, opening onto the view of the forbidding Palace of Justice, was used for storage as well as for binding manuscripts and fitting them with chains. With its sawdust and sweat, its rasping tools and jangling chains, this space must have looked and sounded like the workshop of a carpenter or cooper.

By the 1440s the bookshop had become a gathering place for Florence's intellectual luminaries. Philosophical and literary discussions now took place not *sul canto del palagio* but inside the corner shop itself as visitors filed through the doors not merely to purchase manuscripts of Cicero or Pliny but also to hear or participate in learned philosophical discussions about them. One visitor claimed the shop was "redolent of philosophy."[2] Another described how he often saw illustrious scholars "gathered together in the bookshop of our Vespasiano, surrounded by a throng of young men and admirably disputing great things."[3] The modest premises had become a reading room, a debating society, a classroom for eager young students, and even—thanks to Vespasiano's close connections to

high-powered men such as Cardinal Cesarini and Cosimo de' Medici—a place to learn the latest gossip about political events. One friend, while away from Florence, claimed he could picture Vespasiano moving about the city and "collecting all the daily happenings."[4] As another put it in 1448: "If there's any news, our Vespasiano will know about it."[5]

A year before that, in the late winter of 1447, talk in the bookshop would have been of the death in Rome, from what Vespasiano called "a grave infirmity," of Pope Eugenius IV.[6] Given that the pope had spent half of his sixteen-year-long pontificate in Florence and enjoyed a close personal friendship with Cosimo, his death might have marked a downturn in Florentine fortunes. Eleven days after his death, however, the cardinals who gathered in Rome to elect his successor chose Tommaso Parentucelli, who assumed the name Nicholas V. Parentucelli was the great scholar, bibliophile, and friend of Cosimo who drew up the list of books with which to stock the library of San Marco. He was also a friend of Vespasiano and many other Florentine bookworms such as Poggio Bracciolini. Indeed, Tommaso had been one of those scholars "admirably disputing great things" in Vespasiano's bookshop whenever ecclesiastical business brought him to Florence.

Many years later Vespasiano wrote a biography of Tommaso, one peppered with affectionate anecdotes and reverential personal reflections. In 1446 the twenty-four-year-old bookseller even served, by his own account, as the intermediary between Tommaso and Cosimo when Pope Eugenius dispatched Tommaso, then Bishop of Bologna, as an ambassador to Germany. Tommaso got as far as Florence before realizing his slender means made the journey impossible. "The first words he spoke to me in Florence," wrote Vespasiano, "were that Eugenius was poor, and he himself even poorer." He therefore asked Vespasiano to approach Cosimo regarding the matter of putting at his disposal a (rather lavish) per diem of one hundred florins, which Cosimo was happy to provide. Vespasiano then breakfasted with Tommaso on the morning of his departure for Germany, noting that, as it was Lent, Tommaso ate nothing and only drank two small bottles of wine, one red and the other white, both well diluted with water. "This information I provide," Vespasiano pointedly remarked, "for

the malevolent and envious people who have slandered him regarding his drinking."[7]

Vespasiano had therefore become an intimate of the reigning pope. Tommaso's elevation to the papacy meant Vespasiano went to Rome in the spring of 1447, his first known visit to the city. He was greeted warmly by Nicholas after appearing at the weekly public audience. The new pope immediately spotted him in the crowded chamber. "He called to me in a loud voice,

Pope Nicholas V (Tommaso Parentucelli): the bell-ringing priest who became pope.

saying I was most welcome but must have patience because he wanted to see me alone." Afterward a footman conducted Vespasiano into the pope's private apartments, into a candle-lit room whose balcony overlooked a garden. The pope joked with Vespasiano that the people of Florence must be astounded that a simple bell-ringing priest had become pope. Equally astonishing, perhaps, was the fact that a fatherless boy from the hills outside Florence was now friends with the pope.

Nicholas informed Vespasiano that in honor of past kindnesses— such as the per diem of one hundred florins—he intended to make Cosimo his banker. Moreover, he told Vespasiano that he should ask for whatever he desired. "But lacking experience," Vespasiano reported, "I asked for nothing." One favor he did ask, however, was for the pope to do something for a friend, a priest named Piero Strozzi who worked as a scribe. Nicholas was happy to oblige. When the benefice of Ripoli, outside Florence, fell vacant, the pope, true to his word, made Piero the parish priest.[8]

Nicholas invited Vespasiano to spend the night in the papal apartments, apologizing for their sorry state by explaining that, in time-honored fashion, Eugenius's entourage had ransacked the palace following his death, stealing even the beds. "He told me many other things," Vespasiano modestly reflected in his biography, "which

I shall omit to tell in case it appears I am writing not about Pope Nicholas but about myself."[9]

The Rome visited by Vespasiano in 1447 must have seemed decrepit and impoverished in comparison to Florence. A few years earlier, Poggio had surveyed the ruins of the city from the Capitoline Hill. "This spectacle of the world," he glumly observed, "how it is fallen!" The ancient temples were roofless, overgrown with thickets and brambles; their stone had been scavenged for buildings as far away as Westminster Abbey and the cathedral at Aachen. Pigs and water buffalo roamed the ruins of the Forum. The Senate had become a dunghill. The stupendous buildings of antiquity lay "prostrate, naked and broken," wrote Poggio, "like the limbs of a mighty giant."[10]

To be sure, some of the old grandeur remained, such as the Baths of Caracalla, the Pantheon—long since turned into a church—and assorted columns and triumphal arches. Then, too, there was the Colosseum. An old saying went back to the time of the Venerable Bede: "As long as the Colosseum stands, Rome shall stand; when the Colosseum falls, Rome will fall; when Rome falls, the world will fall."[11] The Roman people seemed sorely neglectful of this vital harbinger of the world's fate. It was used as a limestone quarry, as an open-air market, and, in the case of the Frangipane and Annibaldi clans, as a fortified palace from which to wage violent feuds against their enemies.

Poggio and Niccolò Niccoli had attempted to rescue the literary remains of classical antiquity. Now its physical ruins were to be salvaged and preserved as Pope Nicholas determined to restore Rome to something of its former glory. The crumbling city walls, the ramshackle monuments, the dingy streets: all would be repaired. He planned to bolster the banks of the Tiber, woefully prone to flooding. Waters from a rehabilitated Aqua Virgo would spurt and plash in a new fountain. The piazza across the river from the Castel Sant' Angelo—itself destined for a major renovation—would be revamped. Most ambitious of all, the architect Leon Battista Alberti was charged with building a new wing for the Vatican Palace and a new tribune for the 1,100-year-old basilica of Saint Peter, which in 1436 a visitor to Rome found "very poor and in bad condition and dirty, and in

many places in ruins."[12] As palace engineer, Bernardo Rossellino was given the task of laying out beautiful, spacious streets in the Borgo, the squalid neighborhood beside Saint Peter's.

Nicholas also had other plans for the adornment of Rome. His legacy would include books as well as buildings—the only two things, he once told Vespasiano, on which he wished to spend money. "The world's greatest scholars came to the papal court," wrote Vespasiano, "many summoned by the pope, who wished them to reside there."[13] To aid their studies, Nicholas began collecting manuscripts for a library in hopes that Rome would become a center of humanistic learning. He informed one of his other friends, Enoch of Ascoli, that he wanted to make sure that "for the common convenience of scholars we may have a library of all books in both Latin and Greek."[14] Nicholas therefore had Latin and Greek manuscripts hunted down, sparing no expense. He collected not only theological works such as the writings of the Church Fathers but also the writings of the ancient Greeks, including *The Iliad* by Homer, histories by Herodotus and Thucydides, and the works of Plato. Scribes were hired to copy manuscripts, translators to turn them from Greek or Hebrew into Latin. All were handsomely paid. Guarino da Verona was rewarded with the enormous sum of 1,500 florins to translate Strabo—an author recently introduced to the West by Pletho—from Greek into Latin.

Nicholas appointed a librarian to take custody of these volumes, a humanist scholar from Arezzo named Giovanni Tortelli, who had spent two years learning Greek in Constantinople in the 1430s. The library was to be housed in two rooms in the Vatican Palace formerly used as a granary. Tortelli began by compiling a catalogue, an inventory that would ultimately encompass more than one thousand entries. Vespasiano was exaggerating only a little when he wrote that Nicholas was amassing the largest collection of books since Ptolemy put together the library in Alexandria.[15]

Back in Florence, Vespasiano remained busy with the library of San Marco. Within a few weeks of his trip to Rome, he was arranging for a scribe, a Dominican friar from Santa Maria Novella, to copy a manuscript. He was also overseeing the binding of the San Marco

Gherardo del Ciriagio's script in one of the Cicero manuscripts
commissioned by William Grey.

collection, including sets of huge choir books. And in the summer of
1447 he completed further volumes for William Grey's collection.
Though Grey was not as distinguished a scholar as Nicholas V, he too
was a bibliophile on the ecclesiastical fast track. In the full course of
time he would become, thanks to Nicholas's efforts, the bishop of Ely.

Vespasiano deployed several other copyists besides Ser Antonio
di Mario to work on the manuscripts for Grey. One of them com-
pleted a collection of Cicero's speeches at the end of September 1447,
signing off: *scriptus fuit per me Gherardum Cerasium civem et notarium
Florentinum*—"written by me, Gherardo del Ciriagio, Florentine citi-
zen and notary." The son of a silk dyer, Gherardo was in his mid-
thirties by the time he copied this Cicero in his beautiful humanistic
hand. He appears to have been Vespasiano's discovery, but so expert
and so elegant is his work that it is impossible to believe this manu-

script was his maiden effort. He would become the finest scribe of his generation, his calligraphic grace an invaluable and frequent resource for Vespasiano.

This manuscript of Cicero was an alluring artifact not merely because of Gherardo's script. The pages of most manuscripts were illustrated with artwork such as decorated capital letters at the start of a chapter, ornate borders or other intricate patterns, coats of arms representing the owner, and paintings done in miniature. These latter might involve portraits or scenes relevant to the text on the page, especially religious scenes in the case of liturgical works such as breviaries, graduals, missals, and antiphonaries. Great skill and creativity were called for: the illuminator needed to fit into a few square inches of parchment what a frescoist, telling the same stories, was able to develop across the walls and vault of an entire chapel.

These illustrations were always added to the manuscript—to spaces left blank on the page—after the scribe completed his copying. Sometimes detailed descriptions of the pictures desired by the client were set down in written documents. When a miniaturist named Zanobi Strozzi (a frequent collaborator of Fra Angelico) received a commission to decorate two antiphonaries for the Cathedral of Florence, the officials provided him with a point-by-point summary of the work expected, from the angel appearing to Zacharias in the temple to "the foliage around the story of the beheading of Saint Reparata."[16] Alternatively, instructions for the illustrations might be marked by the scribe in the spaces reserved for them. On occasion, if for some reason the leaf was never illustrated, these directions remain legible: "Here let the King of Scotland be painted," wrote a scribe in the middle of a space left blank in one manuscript. Or in another: "Here a man kills two lions and a man."[17] On one page in Gherardo's Cicero manuscript a tiny M was inked in the margin to mark the spot where the miniaturist was to paint his decorated capital M—which he did, forgetting, however, to erase the direction.

Giovanni Boccaccio claimed that many of the ancient manuscripts he saw in the 1350s in the dust-mantled, weed-infested library at Monte Cassino had been mutilated, their decorative borders trimmed

from the parchment to provide charms that the monks sold to women. At some point in their history all five volumes of the Cicero prepared by Vespasiano for William Grey suffered the same indignities as these and so many other illuminated manuscripts: someone cut out many of the illustrations, presumably after Grey bequeathed them to the library (whose construction he helped to fund) at Balliol, his old Oxford college. From the surviving evidence it seems clear that the first page of each Cicero manuscript was given an elaborate decorative border surrounding Grey's coat of arms, while new chapters and sections featured embellished oversize capitals. Virtually all of the borders were excised by the vandals, but the vestiges reveal winged *putti* blowing horns or aiming their bows and arrows at golden birds.

The artists who decorated manuscripts are often known to history only by monikers invented by art historians, such as "Master of the Brussels Initials" or "Master of the Codex Squarcialupi." The names of the artists hired by Vespasiano for Grey's manuscripts are likewise lost to history. However, there was no shortage for him to choose from. Florence was gifted with brilliant illuminators, including many connected to the famous scriptorium at the Camaldolese convent of Santa Maria degli Angeli, home for many years to Ambrogio Traversari. It was little more than a ten-minute walk from Vespasiano's shop and a favorite haunt of his humanist friends. Fra Angelico most likely originally trained there as an illuminator.

Manuscript illuminators needed to master the skill of painting in miniature on parchment, an apprenticeship that might take as many as eight or ten years. They either trained under monks in convent scriptoria or else apprenticed in the workshops of illuminators. Many learned to work on a larger scale too: Fra Angelico painted altarpieces and monumental frescoes as well as miniatures. All called for different skills, techniques, and materials: frescoes for rapid brushwork and a head for heights, illumination for a steady hand and endless patience. Frescoists painted with brushes made from hogs' bristles, which could withstand the corrosive action of the lime plaster. Miniaturists used much finer and more delicate ones made from the tail hair of ermines and squirrels. The tails were bought from a furrier, the hairs then plucked and boiled in water before being fitted into the hollow shaft of a flight feather from—depending on the

size of brush desired—a vulture, a goose, a hen, or a dove; a thread of waxed silk bound it tightly together. A sliver from a stick of maple or chestnut was slid inside the quill for support, while the hairs were trimmed to size and, if the brush was to be used for laying gold leaf, rubbed on a porphyry slab for softening. To keep the moths from eating the hairs, one handbook advised steeping them in chalk or kneaded clay when not in use.[18]

Having received the quires of inscribed parchment either from the *cartolaio* or directly from the scribe, the illuminator went to work. He (or she, since many nuns in Florence also worked as illuminators) would first make an underdrawing in silverpoint, using a silver stylus obtained from a jeweler to trace the design in the space reserved for it on the parchment. Drawn across the surface of the parchment, slightly roughened with chalk, the stylus left behind deposits of silver, which oxidized and turned a greyish brown. Once satisfied with the design, the artist might enhance the silverpoint by inking over the lines with a quill pen.

The first color to be added was always gold. The artist would buy gold leaf from one of Florence's thirty *battilori*, or goldbeaters, skilled artisans who also made gold and silver thread for the textile industry. Goldbeaters placed gold pieces such as a ducat or florin between successive layers of parchment and "goldbeaters' skin"—membranes made from ox intestines. Protected in these skins, the gold was struck on a slab for hours on end with hammers weighing some fifteen pounds. Gold is so malleable that a goldbeater was able to hammer an ounce—a nugget the size of a sugar cube—until its thickness was reduced to $\frac{1}{300,000}$ of an inch and its surface area expanded to more than 140 square feet.

Adding such a lightweight, flyaway material to the parchment was a delicate operation. A cough or sneeze, or a puff of wind, could send the leaf into aerobatic motion. "Hold thy breath while fastening the gold leaf," one monk warned his apprentices, "otherwise thou wilt blow it away and may hunt for it afterward."[19] Vespasiano's illuminators, like artists working with gold leaf today, probably rubbed their brushes in their hair, creating a static electric charge to keep the flakes of gold leaf under control. The illuminator then breathed onto the parchment before brushing his flake onto a ground of gesso.

Added wherever the gold was to be laid, gesso was an adhesive made from a mixture of chalk and beaten egg whites to which was added a pinch of an unctuous, rust-colored clay from Armenia known as red bole. Sometimes honey was also added to the mixture. Once applied, the gesso was allowed to dry over the course of a day or two, after which the artist gave it a polish with a tool known as a dog's tooth— so named because it consisted of a tooth, often canine, or otherwise a smooth stone, attached to a handle. The humidity in the illumina-tor's breath restored moisture to the gesso and therefore its adhe-sive quality. Once he fixed the gold leaf in place, he burnished its surface with the dog's tooth to smooth out creases and wrinkles in order to make it reflect and shine—to make it "illuminate" the page.

Gold was not the most expensive color used in manuscript il-lumination. Even more precious was the beautiful blue known as "ul-tramarine," made from lapis lazuli, a semiprecious gemstone coming from "beyond the sea" (*oltremare*)—from the forbidding terrain of the Hindu Kush mountains in northeast Afghanistan, where it had been mined for thousands of years and, as early as the sixth or seventh century AD, used in cave paintings. Ultramarine was, as a painter's handbook written in Florence in about 1400 enthused, "noble, beau-tiful, and perfect beyond all other colors." An ounce could cost as much as eight florins, half of Michele Guarducci's annual rent on his shop. One of the best sources for the ground pigment was the Ge-suati friars at the monastery of San Giusto alle Mure, just outside the walls on the northeast corner of Florence. However, the painter's handbook maintained that women were more skilled at its manufac-ture than men because they "are more patient and their hands are more delicate."[20]

Manufacturing ultramarine was a time-consuming process. The hard stone was heated in a fire, cooled rapidly in water, and then ground in a bronze mortar before the powder was sifted through a strainer and mixed with careful measures of pine resin, wax, and lin-seed oil. The resulting paste was kneaded in a glazed earthenware basin over the course of the next few days until the blue was ready for extraction, a process accomplished by mixing the paste with lye, an alkaline solution made from the ashes of beechwood. This mix-ture was kneaded with a pair of sticks—"exactly in the manner that

you would knead dough," according to a handbook—until the lye turned a bright blue. The blue-tinged lye was then poured into another basin and the kneading and decanting performed repeatedly until the paste no longer tinged the lye, which was then drained, leaving behind the bright-blue residue. "When dry, put it into a skin or purse," the handbook instructed, "and rejoice in it, for it is good and perfect."[21]

A cheaper blue was azurite, also made from a ground-up stone, albeit one more readily accessible, since its principal sources were in Hungary and Armenia. Still another blue pigment was smalt, made by grinding glass containing cobalt into powder shards. Coming from the German *kobold*, meaning "goblin," the word "cobalt" invokes the mischievous demons supposedly lurking in the ore, which was poisonous and caused the miners to fall ill.[22]

Scarcely less expensive than ultramarine was saffron, which produced a yellow color. The stigmas of more than four thousand crocuses were required to produce a single ounce.[23] The best saffron came from Persia, but supplies could also be found in Spain, Sicily, and—after a pilgrim returning from the Holy Land smuggled a crocus bulb into England in his hollowed-out staff—in the town in eastern England that became known as Saffron Walden. An alternative was orpiment, or sulfide of arsenic, a vibrant lemon yellow that had the disadvantage, like smalt, of being highly poisonous. "Beware of letting it soil your mouth," the painter's handbook cautioned, "lest you harm yourself."[24] Another poisonous but widely used pigment was lead white, manufactured by sprinkling lead shavings in a bowl of vinegar and then, once the fumes died down, collecting the whitish deposit. Its noxious qualities were known since the time of Pliny the Elder, but it was far and away the best white available, infinitely superior to an alternative made from the ash of charred chicken bones.

Another lead-based pigment, likewise poisonous, was minium, or red lead, used by scribes and illuminators for lettering important words or phrases. The task of "rubricating" was often performed by a specialized scribe known as the "rubricator" or, in Italian, as the *miniatore* (from the Latin *miniare*, "to color red"). The process of painting these letters in minium was called *miniatura*. Since Latin words such

as *minuo, minimus, minor,* and *minus* all denote something diminished in size, the terms *miniatore* and *miniatura* eventually lost their association with the color red and came to mean painting anything small in scale. By Vespasiano's time, contracts with illuminators referred to them as *miniatori* and the work they performed as *miniatura.* They became miniaturists, painters of small scenes, rather than simply painters in red ink.

The decoration of manuscripts was sometimes split between the artist who painted the miniature scenes and the one who added the decorative borders. The margins of manuscripts might be enriched with fruits, flowers, birds, butterflies, angels, bow-and-arrow toting cupids, and whimsical images of animals. In the Middle Ages these borders became a kind of wild textual hinterland populated by figures that were both frightening and amusing. Medieval illuminators delighted in the same sort of drolleries as the medieval sculptors who carved leering gargoyles and bare-bum misericords—the cheeky grotesques that made a self-righteous Saint Bernard of Clairvaux demand: "What excuse can there be for these ridiculous monstrosities in the cloisters where the monks do their reading?"[25]

Saint Bernard was one of the few people to make a fuss. Even a manuscript as superlative as the *Très Riches Heures,* done for Jean de Berry around 1412 to 1416, did not shy away from depicting a giant snail besieging a castle and a pig playing the bagpipes. Medieval marginalia freely depicted a topsy-turvy world of role reversal in which rabbits pursue the hunter, mice hogtie the cat, and, in one memorable image, a nun plucks penises from a tree and puts them in her basket. One page of the Macclesfield Psalter presents, in the section on the prayers for the dead, a naked man urinating into a pot obligingly held by a bare-bottomed monster. No bodily function was overlooked. A book of hours copied for a woman in northeast France in the 1320s included among its biblical verses and list of feast days more than a hundred images of men and monkeys defecating or otherwise exposing their bottoms.

The artists of the Middle Ages took pleasure in this pairing of the sacred and the profane—in grafting gargoyles onto cathedrals or

adorning prayer books with arse-trumpets and killer rabbits. But change was afoot by the early 1400s. Just as the grimacing monsters disappeared from the waterspouts of churches, so too the earthy and irreverent caprices faded from the margins of books. In Italy they were never deployed with quite the same gleeful fervor as in northern Europe. Certainly these curious frolics were nowhere to be found in the manuscripts copied for Niccolò Niccoli by Poggio and other scribes. Niccoli and his humanist friends favored a more dignified and elegant design, one less florid and frivolous, with fewer visual distractions. Their redesign of the manuscript page, like their new script, emphasized clarity and simplicity. In illustration as in architecture, the Florentines valued lucidity, restraint, and rational order.

The Florentine redesign of the page also had something to do with economy. These humanist manuscripts were created at virtually the same time that a number of books of hours were gorgeously and expensively illuminated in France and the Low Countries for patrons such as Jean de Boucicaut, a chivalrous knight, and the Duc de Berry, the uncle of the king of France. The *Très Riches Heures* features two thousand initials accentuated with gold leaf and borders of ultramarine blue festooned with foliage and populated with cupids, bears, swans, and angels. Such costly and exquisite splendor belonged to the courts of northern Europe, with their crowned heads and caparisoned horses (even the Rebel Angels in the *Très Riches Heures* are shown as knights in armor). So extravagant a volume would have seemed out of place in the commercial world of the practical merchants, bankers, and politicians of republican Florence. The Latin classics rediscovered by Poggio and his friends were not produced in manuscript, initially at least, for chivalrous knights and princely patrons. Rather, they were destined for the collections of men who were, for the most part, of relatively modest means—for lovers of wisdom who actually wished to read them, not to possess them as ostentatious trophies flattering their vanity and declaring their wealth and taste.

Florentine illuminators accordingly offered a new and more chaste style of decoration, one based on what they believed was an "antique" vine-stem pattern. Twisting grapevines were often used to illuminate borders (the word "vignette" comes from these patterns scrolling along the margins of medieval manuscripts). But what

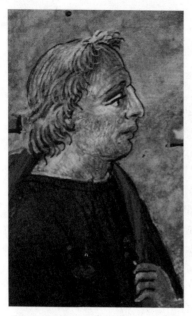

Vespasiano da Bisticci, painted
by Attavante Attavanti.

characterizes the borders and deco-
rated initials in fifteenth-century Flo-
rentine manuscripts of the Latin
classics—and in Vespasiano's manu-
scripts for William Grey—is a partic-
ular variation known as *bianchi girari*.
The name might be translated as
"white twists" or "white curlicues,"
but in English it has become known
as white vine-stem decoration.

These decorations in Vespasia-
no's manuscripts for William Grey en-
circle the capital letters, done in gold
leaf, at the start of each new section.
In many manuscripts, these opening
letters served as recognizable head-
ings, rather like chapter numbers,
and they were therefore enlarged—
sometimes, as in Grey's manuscripts
of Cicero, to the height of nine or ten lines of text—and enriched
with decoration. After adding the gold leaf, Vespasiano's illuminator
surrounded the letter with a rectangle of lapis lazuli onto which dots
were added, like stars, in yellow pigment. Then the "vine stems" were
added, delicate tendrils, leaves, and other vegetal forms, painted in
lead white, that clambered up the letter like ivy on a trellis, encircling
and entwining.

Thanks to one of these miniaturists we have the only known
likeness of Vespasiano, a profile portrait done later in his life in one
of his manuscripts. The artist had only about one and a half square
inches in which to work, and Vespasiano therefore makes a modest
cameo tucked inside a capital *E*. The painter nonetheless manages to
conjure a vivid image of the bookseller: a man with a Roman nose, a
heavy, creased brow, full lips, and a weak chin. He looks morose; and
his hooded eyes gaze worriedly toward the lines of script moving sin-
uously across the parchment—his mournful expression that of a man
who by then, three decades hence, had seen things that in these early
days, during this golden age, he could scarcely have imagined.

Chapter 9

The Fall of Greece

Michele Guarducci died in February 1452, after Vespasiano had worked with him for almost twenty years. Very little changed in the bookshop. Several years earlier, Guarducci had made Vespasiano a partner: he now owned a 37.5 percent share in the shop.[1] The remainder was now owned by Guarducci's two sons, who, like their father, seemed content to let Vespasiano serve as the guiding spirit thanks to his connections with Cosimo de' Medici, Pope Nicholas V, and so many eminent scholars both in Florence and abroad. Vespasiano continued paying the landlords, the monks across the street in the Badia, fifteen florins per year plus the pound of wax. He took on an assistant named Jacopo di Niccolò—the first of many young men who would pass through the shop.[2] The next few years were to prove especially successful as further commissions came from important collectors in Florence, Rome, and Naples.

The year after Guarducci's death, in the summer of 1453, Vespasiano became involved in the formation of a particularly important collection. He was approached for help by one of the world's greatest scholars: a fifty-year-old man with a monk's hood, a bulbous nose, and a long beard. The visitor was looking for an exemplar of Ptolemy's *Geography* from which to make a manuscript copy.

Basilios Bessarion had grown enormously in power and reputation since his leading role at the Council of Florence fourteen years earlier. Following the Decree of Union in the summer of 1439 he returned to Constantinople and searched the monasteries for further manuscripts in hopes of finding evidence with which to clinch the argument for the union against the many naysayers among the Greeks. At the end of 1439, frustrated by the continued hostility of

the Byzantines to the union with the Latins, he returned to the friend-
lier environs of Italy. Grateful for his efforts on behalf of the Church,
Pope Eugenius made him a cardinal, despite which he still wore his
monk's habit and beard, the latter in defiance of a canon law declar-
ing that any cleric wearing a beard was to be shorn, if necessary by
force. Otherwise he settled into the opulent lifestyle of one of the
Princes of the Church. He built himself a grand house in Rome, in
the shadow of Trajan's Column, and also, for the hot summer months,
a beautiful villa on the Appian Way featuring a frescoed loggia and a
garden with orange trees and a well. Among his entourage he main-
tained brilliant young scholars such as Niccolò Perotti, a one-time
protégé of William Grey.

Cardinal Bessarion was, as Vespasiano noted, "a man of great
authority in the Church."[3] He was determined to use his consider-
able powers for two purposes: to end the division between the Greeks
and the Latins and to bring about a crusade against the Turks. The
two enterprises were closely linked. As he had pointed out during the
Council of Florence, the gravity of the Turkish threat to Constanti-
nople meant the only way for the Greeks to survive, as both a nation
and as Christians, was to unite with their Western brothers, who
shared with them, he believed, the one true faith. By 1452 he ap-
peared to have achieved some success in both areas, for in Decem-
ber of that year the Decree of Union was finally proclaimed in the
churches of Constantinople in return for a promise from the princes
of Europe of military aid against the Turks.

Cardinal Bessarion already possessed an impressive library. How-
ever, in the summer of 1453 he began collecting with urgency and
special purpose. He planned to assemble one of the finest libraries
of Greek manuscripts in Europe—what he hoped would be nothing
less than a transcript of Greek civilization itself. It was this mission
that brought him to Vespasiano's door.

Cardinal Bessarion was prompted to begin collecting manuscripts by
an event whose details he learned only weeks before he contacted
Vespasiano in the summer of 1453: in early July news reached Italy
of the capture of Constantinople by the Ottoman Turks.

The twenty-one-year-old sultan, Mehmed II, had achieved an Islamic ambition that dated back eight hundred years, from the time the Arabs first besieged Constantinople. The prize of capturing the capital of the Byzantine Empire had eluded Mehmed's great-grandfather, Bayezid the Thunderbolt, in 1390, as well as his uncle Musa, who attacked the city in 1411. It had evaded his father, Murad II, whose enormous army appeared beneath the walls in June of 1422, bolstered by assurances from prophets and astrologers that Constantinople would fall in that year. However, on that occasion, as the Turks prepared to scale the walls after a two-month siege, a woman dressed in purple suddenly appeared on the battlements. The Turks took fright and abandoned their attack. The Virgin Mary had miraculously delivered the city.

No woman in purple appeared on the battlements on the morning of May 29, 1453. This time, instead, the oracles and auguries favored the sultan. Following a fifty-three-day siege, the Turkish cannons, firing shot weighing 1,200 pounds, finally breached the walls of the city, and Mehmed unleashed his janissaries, his elite unit of fighters, who quickly overran the defenses. The emperor Constantine XI (younger brother of John VIII, who died in 1448) was "killed by the impious Turks," Vespasiano later wrote, "and his head was placed on a lance and carried about for all to see," while "the unhappy citizens and their wives died the most horrible deaths."[4]

Some two thousand inhabitants were slaughtered, a quarter of the city's remaining population. Their corpses were thrown into the Bosporus, where the disembodied heads bobbed, as a Venetian noted with a vivid metaphor, "as melons float through canals."[5] Terrified survivors huddled for refuge inside the church of Hagia Sophia, putting their faith in a prophecy claiming that when the Turks entered Constantinople they would get only as far as the hundred-foot-high column in the square in front of the church before an angel descended from heaven, sword in hand, to drive them away. But, like the woman in purple, the sword-bearing angel failed to appear. The janissaries smashed through the four-inch-thick wooden door and hauled everyone off into captivity. Later one pro-union Greek cleric bitterly reflected that, had an angel actually appeared and offered to exterminate the Turks on condition that the sheltering Greeks

consent to the union with the Latins, they would have spurned their deliverance. Indeed, so vehemently was the Decree of Union opposed by some Byzantines that they had claimed to prefer the Turkish turban to the Latin miter.[6]

Mehmed gave his troops permission to plunder Constantinople for three days so long as they preserved its buildings and monuments intact. Houses, shops, and monasteries were duly ransacked, icons destroyed, churches robbed of chalices, crosses, and reliquaries. Even tombs were opened in ghoulish expectation of handsome booty. That of the Venetian doge Enrico Dandolo, who had sacked Constantinople 250 years earlier, disappointed the looters when it was found to contain nothing but his bones, which were then tossed into the street to be gnawed by dogs.

Manuscripts were also among the casualties. A Byzantine scholar and historian, Michael Critobulus, witnessed books in flames or trampled underfoot after the gemstones had been gouged from their bindings. Included among them were ecclesiastical works as well as books by Plato and Aristotle. The first thought of a number of Italians, when news reached them, had been for the fate of this great literary heritage—for "the countless books, as yet unknown to the Latins," as the poet and diplomat Enea Silvio Piccolomini despaired in a letter to Pope Nicholas V on July 12. "Alas, how many names of great men will now perish! Here is a second death for Homer and for Plato too. Where are we now to seek the philosophers' and the poets' works of genius? The fount of the Muses has been destroyed."[7]

Three days later, the pope received an even more alarming letter from a humanist scholar in Crete, Lauro Quirini, a friend of Cardinal Bessarion. No fewer than 120,000 manuscripts, he claimed, had been destroyed in the sack, a devastating loss. "The name of Greece is blotted out," Quirini despaired. "That literature has perished which illuminated all the globe, which gave us the laws of salvation, holy philosophy and the other good arts by which human life is embellished." It had been viciously rubbed out by a "rude and barbarous race . . . filled with treachery and fraud."[8]

Cardinal Bessarion was deeply disturbed by the cultural implications of what he called, tellingly, "the fall of Greece."[9] In the middle of July, within days of learning the news, he wrote to Francesco Foscari, the doge of Venice, urging him to join with other Christians in taking up arms against the Turks, who, he claimed, would next try to capture not only the Greek islands but also all those lands whose shores were washed by the Adriatic, including Italy itself.

In their conquest of the Holy Land, the Muslims had taken the homeland of Christ; now, with the capture of Constantinople—the center of Greek culture for more than a thousand years—they held the domains of Plato and Aristotle. The classical world so beloved by Bessarion and his friends in Florence had been, he believed, violently extinguished by a tribe of barbarians. The Ottoman Turks were for him the scourge of the civilized world, the equivalents of the Persians who had menaced the ancient Greeks some two thousand years earlier. The modern Europeans, like the ancient Greeks, represented the civilized world of the West, the Ottomans and ancient Persians, by contrast, the barbarism of the East.[10]

The Ottoman Turks saw things quite differently, though likewise from a long historical viewpoint. They believed themselves descendants of the Trojans, whose name was given by Virgil (though not by Homer) as the *Teucri*, a name easy enough to identify with the Turks (*Turci* in Latin, *Turchi* in Italian). The conquest of the Byzantine Empire was therefore a rematch of the Trojan War, the long-overdue revenge of the Trojans against the Greeks. This identification was emphasized by Mehmed II in a letter to Pope Nicholas V in which he stated his intention "to restore Troy and avenge the blood of Hector."[11] An eyewitness to the conquest claimed that Mehmed had "exterminated the exterminators of magnificent Troy."[12]

Piccolomini, the learned humanist diplomat, could not bear to let this parallel stand. He claimed the Turks were descended, rather, from the Scythians, a tribe of nomadic warriors from Siberia whose name in Italian (*scytico*) was synonymous with "barbarian" (the term used by the Greeks to refer to the people whose languages sounded to them like nothing more than "bar, bar, bar"). Pliny the Elder in his *Natural History* had described "the Cannibal Scythians who eat

human bodies." Piccolomini was in no doubt that they were one and the same people, confidently declaring: "The Turks are Scythian barbarians, a cruel, ignominious, lustful people who eat those things which others abhor, like the meat of mares, wolves, vultures and aborted foetuses."[13]

Piccolomini's attack on Islam in general and the Turks in particular was typical of his age. The culture and customs of the Islamic world were little understood or appreciated in the West. The hostility was thanks in part to the dubious reports of pilgrims returning from the Holy Land, to preachers and politicians slavering for a new crusade, and to outrageously defamatory stories such as the "Legend of Mohammed," which described how the Prophet came to a bad end, eaten alive by a herd of swine after falling into a drunken stupor (a denigrating explanation for the Islamic strictures against both alcohol and pork).[14] The vilification by Piccolomini, a future pope, was astonishing in its furious scurrility: the Prophet was a philandering heretic who "advanced his fortunes by seducing a rich widow," became head of a band of brigands, and recruited primitive people to his cult by using "magic spells and tricks," and by giving sanction "to sex in all sorts of unspeakable combinations."[15] Piccolomini's vitriol dated from after the conquest of Constantinople, but it followed on from decades, if not centuries, of like-minded calumnies.

Such denunciations conveniently ignored the fact that Islam had produced one of the most advanced civilizations in the Mediterranean since the ancient Romans. The monasteries in the West had not been the only places to nourish and preserve the intellectual heritage of antiquity. In the decades around the year 800, as Charlemagne and Alcuin promoted the so-called Carolingian Revival, in the East the "Islamic Golden Age" was beginning under the Abbasid caliphs.[16] In their imperial capital, Baghdad, successive caliphs gathered Greek, Sanskrit, Persian, and Syriac writings in a vast storehouse of manuscripts that became known as the Bayt al-Hikma, or House of Wisdom. Teams of scholars translated the writings into Arabic, wrote commentaries on them, and composed their own learned treatises on astronomy, physics, medicine, and optics. This diligent recovery of the texts of classical antiquity, along with an emphasis on secularism and individualism, means that scholars have been able to

dub this period the "Renaissance of Islam."[17] This fruitful resuscitation and proliferation of ancient wisdom spread onto the Iberian peninsula, where many of these Arabic translations and commentaries found their way to the Muslim-ruled *taifa* of Toledo, a vibrant cosmopolitan center of Islamic, Jewish, and Christian scholarship. The Caliphate of Córdoba represented another remarkable intellectual center. Not only could it boast seventy libraries, but one in the Alcázar, founded by the caliph Al-Hakam II, who died in 976, was said by its librarian, a eunuch named Bakiya, to hold four hundred thousand volumes. The caliph's grandson sold the entire collection for 40,000 dinars—the value of a hundred horses.[18]

Tall and robust, bold and resolute, Mehmed II seldom smiled and, according to one European visitor, inspired terror rather than reverence.[19] Grisly rumors swirled around him, such as the one that he ripped open the bellies of fourteen pageboys to discover who ate his melon. The melon was a fiction, but another story was true: he drowned his eight-month old stepbrother, Little Ahmed, in his bath and then enacted a "law of fratricide" stating that whoever seized the throne should put his brothers to death "in the interest of the world order."[20]

Yet Mehmed was also a man of culture and learning. Each morning he received instruction from a trio of philosophers, one who spoke to him in Arabic, the other two, both Italians, in Latin and Greek. He understood Persian and Slavonic as well, and even penned lyric poetry in Turkish under the *nom de plume* "Avni"—a kindlier moniker, meaning "helper" or "protector," than the one ("the Conqueror") by which history has come to know him.

Mehmed was said to have wept when he saw the devastation of Constantinople: "What a city we have given over to pillage and desolation!"[21] Appalled by the destruction, he called a halt to the three days of looting on the first night. The historic buildings of the city he treated with the utmost respect. He preserved both the name of Hagia Sophia (which became known as Ayasofya) and the city itself, which was still officially called Constantinople, though it also became popularly known as Istanbul (from the Greek *eis ten polin*, meaning

"to the city"). He preserved intact the beautiful Christian mosaics of Hagia Sophia—Virgin Mary, Christ Child, and all—and he once sharply rebuked his librarian for using a precious Christian relic, the Stone of the Nativity, as a step stool. Mehmed collected and preserved the relics and Byzantine sculpture in the Imperial Palace, including the porphyry sarcophagi from the Church of the Holy Apostles. When a mulberry tree threatened the Serpent Column in the Hippodrome, Mehmed had its roots cauterized. It is true that he unceremoniously removed from its column outside Hagia Sophia the twenty-seven-foot-high statue of Justinian, a bronze colossus showing the emperor on horseback clutching an orb in one hand and with the other pointing threateningly toward the East, land of the barbarians. But Mehmed had the statue toppled only because his astrologers explained that it was bad luck—though it had signally failed the sultan's hapless opponents cowering inside Hagia Sophia on the morning of May 29.

One of the treasures of Constantinople that Mehmed appears to have preserved as best he could was the library—or what remained of it—in the Imperial Palace. A Spanish ambassador to Constantinople some fifteen years earlier, Pero Tafur, described this library as having "many books and ancient writings and histories," all arranged on marble tables inside a loggia on the palace's ground floor.[22] Tafur gave no indication of the magnitude of the collection nor did he tantalize with any detailed account of its contents. However, the library of the Byzantine emperors would have been a mere shadow of its former magnificence, for it possessed a long and tragic history. Constantine founded a library as one of the facilities of his palace soon after he transferred his government to the city in 330, and by the time of his death seven years later it held almost seven thousand works. His son Constantius II arranged a series of rooms to house the collection, which he further endowed with books. By the 370s Emperor Valens had set to work seven *antiquarii,* or copyists of old texts, four Greek and three Latin. One of their tasks was to transfer the contents of papyrus rolls into parchment codices.

The collection of the Imperial Library had grown to some 120,000 volumes by the middle of the fifth century, making it one of the finest repositories of Greek and Latin writings ever assembled.

But in 475 a fire consumed much of Constantinople, including virtually the entire library. The collection was slowly restocked over the next few centuries, but by 726, when fire struck again, it still held fewer than seven thousand volumes. More books were lost in the decades that followed due to iconoclastic frenzy, when Emperor Leo III, inspired by biblical passages forbidding "graven images," ordered the destruction of all manuscripts with images—among them, supposedly, the poems of Homer written in gold letters and a manuscript of the Gospels bound in gold plates decorated with jewels. Over the next few centuries, lacking an adequate supply of manuscripts of their own to conduct their political and ecclesiastical affairs, the emperors were forced to make do with books from the city's monastic libraries. Early in the tenth century, Emperor Constantine VII, a scholar in his own right, began shoring up the collection by purchasing books from all over the world. However, a hideous fate again intervened: in 1204 the library was devastated during the Fourth Crusade. Later in the century what remained of the collection was reconstituted in a wing of the Imperial Palace, where Tafur saw it in 1437.

What books may have been held in this collection, as well as how many were destroyed by looters in 1453, are matters of conjecture.[23] Isidore of Seville did not specify from which collections the manuscripts were pillaged and destroyed, and his claim about the loss of 120,000 manuscripts is almost certainly excessive, aimed at stoking outrage. Cardinal Bessarion merely spoke vaguely, without giving numbers or authors, of the loss of "many beautiful memorials of those god-like men of long ago."[24]

To be sure, many manuscripts were lost during this time, both in the Imperial Library and from the city's monasteries. However, Mehmed himself would never have sanctioned or tolerated the destruction of Greek, Roman, or Christian manuscripts. A bibliophile in his own right, he would ultimately put together a library of some eight thousand books. It included works in Arabic, Persian, and both Ottoman and Chagatai Turkish, as well as Arabic translations of works such as Ptolemy's *Geology* and George Gemistos Pletho's writings on Plato. His multilingual catalogue even featured a work entitled *Risala fi bayan madinat Filorindin,* or "Treatise on the City of Florence"—no doubt a translation of one of Leonardo Bruni's works. If the figure of

eight thousand books can be trusted, Mehmed's would have been, in the second half of the 1400s, the world's largest collection.[25]

Mehmed was not a dispassionate collector like Niccolò Niccoli, interested in timeworn volumes for their own sake. Far from it: unabashed political aspirations lurked behind his literary interests, which offered him models and inspiration. "He enjoys nothing better," reported one visitor, "than to study the geography of the world and the science of military matters."[26] History interested him most of all. With his tutors he devoured the Greek histories of Herodotus and the Roman histories of Livy, as well as more recent chronicles about the popes, emperors, and kings of Europe. His favorite book was Quintus Curtius's *Histories of Alexander the Great*, composed in the first century AD. He wished to emulate Alexander's conquests and, indeed, to surpass them. As one of Mehmed's chroniclers noted, the sultan "overran the whole world in his calculations and resolved to rule it in emulation of the Alexanders and Pompeys and Caesars and kings and generals of their sort."[27]

Like his great-grandfather, the Thunderbolt, who had hoped to feed his horse on the steps of Saint Peter's, Mehmed added to his many titles—Supreme Emperor, King of Kings, Sultan of the Two Continents and the Two Seas—that of "Kayser-i Rum," Caesar of Rome. His Venetian doctor claimed Mehmed possessed a large map of Europe that he avidly scrutinized, paying particular attention, ominously, to the geography of Italy, and "where the pope and the emperor have their seats."[28]

In the West, the Ottoman conquest was seen as a punishment from God for the failure to unify the Greek and Latin Churches. Among certain Greeks in the East, it was a chastisement for their having embraced the heresies of the Latin Church—for the conquest had come mere months after the Decree of Union was finally proclaimed in Constantinople.

Still others regarded Mehmed's victory as a brutal lesson for the Christians who had fought among themselves rather than uniting to counter the Turkish threat. The Christian powers of Europe had indeed been diligently at war with one other over the previous year or

two: the French against the English, the German princes bickering among themselves, a rebellion in Burgundy, civil war in Navarre, the usual faction and dissension in Genoa, and Venice and the king of Naples in league against Florence and the Duke of Milan in an indecisive and ruinously expensive contest. The catastrophe of Constantinople was, as Pope Nicholas V sorrowfully observed, the "shame of Christendom."[29] He identified Mehmed with the Beast of the Apocalypse from the Book of Revelation. For Isidore of Kiev, meanwhile, the young sultan was the forerunner of the Antichrist.[30]

Vespasiano shared these feelings of doom, and of the Christians having brought this punishment upon their heads through their shortcomings and failures. He believed the advances made by the Turks—those "cruellest of barbarians"[31]—to be the result of political and moral failings on the part of the Christians both Latin and Greek. He later offered a narrative of the lead-up to the conquest in which the Byzantine emperor, "oppressed by the Turks," appealed to "the pope and all the powers in Italy and beyond," only to be met with scorn and disinterest. "They scoffed at him and held him in no esteem, and the five hundred soldiers, who might have saved him, never moved." The emperor then turned to his own people, explaining that he had expended his reserves trying to protect their city, but that if they now opened their own purses and helped him, "I will save this land for you and your children, as well as for myself. If you fail to do it, our final destruction awaits." But the "good gentlemen" of Constantinople refused because of their avarice, and so the Turks rampaged through the city, the emperor lost his head, the citizens were killed, and their homes sacked. "Those who remained," Vespasiano claimed, "were sold to the Jews." He summed up this history of Constantinople with a stern lesson: "So it ends for the stubborn, disobedient sinners who refuse to believe."[32]

Chapter 10

The Miraculous Man

The capture of Constantinople by the Turks in 1453 was an epoch-making event noticed the world over. Something else happened that year, manifested in a small, postcard-size scrap of paper, that attracted far less attention but would mark an equally if not more significant event: one that forever changed how knowledge was spread.

After its brief appearance in 1453 this piece of paper disappeared for centuries until, in 1892, it came into the possession of a certain Eduard Beck, a bank clerk in Mainz. Herr Beck accidentally discovered the scrap in the city's university archives, where a long-ago bookbinder had repurposed it to make a pasteboard container for old documents. This "unfathomable leaf," as a medieval scholar, Professor Edward Schröder, called it in 1904,[1] featured rhyming lines of German on both front and back, with further couplets excised from the top and bottom when the page was trimmed. The sixteen lines on the front encouraged the reader to indulge in faith and good works, while fourteen on the back described the Last Judgment, for which reason Dr. Schröder christened the leaf *Fragment vom Weltgericht* ("Fragment of the Last Judgment").

More clues about the paper were discovered a few years later, in 1908. A German folklorist named Karl Reuschel pointed out that the lines of text actually came from a fourteenth-century prophetic poem called the *Sibyllenbuch* ("Book of the Sibyls"), known through more than forty surviving manuscript copies. This poem recounts a version of the Legend of the True Cross in which a branch from the Tree of Life, planted on Adam's grave by his son Seth, grows into a mighty tree whose lumber is used by King Solomon to make a bridge across a stream and then, in keeping with its providential destiny, the Cross

on which the Savior is crucified. The poem concludes with a series of hazily coded prophecies concerning future events relevant to the politics of the Holy Roman Empire, with various unnamed princes battling for power in the run-up to the Last Judgment. It concludes with the lines of verse discovered on the scrap of paper in 1892.

Much debate surrounds the author of the *Sibyllenbuch*, which from internal evidence seems to date from the 1360s. The leaf discovered in the Mainz archives was one part, presumably, of a small booklet that, if it included all of the *Sibyllenbuch*, must have run to some sixteen pages. The work would have been unremarkable apart from the fact that anyone seeing it in 1453 must have been struck by its odd and slightly alien appearance. Though the letters were formed in the Gothic script familiar in northern Europe, they lacked the harmony and precision of the work of an average scribe. Individual letters, though conscientiously formed, sometimes rose wonkily above the line, while others dropped slightly below, almost as if the calligrapher had been sitting in a moving vehicle on a bumpy road. Some letters were a deep black, others very faint. There were, however, artistic flourishes, since all of the capital letters had been rubricated—touched up with dashes of red ink.

The copy of the *Sibyllenbuch* from which the leaf comes was not copied by a scribe but, rather, produced by the printing press in Mainz newly invented and operated by Johannes Gutenberg. It is one of the earliest pages from his press—one of the very first things he produced as he experimented in secret with his new invention, making the scrap of paper one of the oldest surviving texts printed with movable type.

One of the next works Gutenberg produced, a year or so later, using the same type, was more obviously topical in nature, directly and emphatically addressing the "Turkish question." His *Türkenkalender*, or "Turk's Calendar," printed in December 1454, was a piece of anti-Ottoman propaganda: an astrological poem about the Turkish threat masquerading as a calendar for the year 1455. Entitled *Eyn Manung der Cristenheit widder die Durken* ("An Exhortation to Christendom against the Turks"), this nine-page pamphlet issued thirteen urgent appeals—one for each new moon of 1455—to thirteen different leaders, from Pope Nicholas V and Emperor Frederick III to various dukes, archbishops, and even the King of Inkerman (whose

domains were in the Crimea). All were exhorted to take up arms and launch themselves in a mighty crusade. Amid the gloom and doom the calendar managed to pass along greetings to its readers: *Eyn gut selig nuwe Jar*—"Have a happy and blessed New Year." It ended with a prayer to the Lord, beseeching him to drive the Turk from Constantinople and to make sure that none were left alive anywhere in Greece, Asia, and Europe.

The Turks provided Gutenberg with one more piece of business—or, rather, with many thousands of pieces of business. In May 1452 Pope Nicholas V had announced a general indulgence for anyone donating money for the defense of Cyprus against incursions from the Turks. Priests were dispatched across Europe to proclaim the indulgence, to gather the contributions, and to hand out "Letters of Indulgence"—written decrees exempting the bearers from punishment in the afterlife for various of their sins. These documents, often distributed *en masse*, were laboriously copied by scribes whose wages dented the profits from the sales. Archbishop Diether of Mainz, in charge of organizing the collection in his city, either turned to Gutenberg or else was approached by him. Gutenberg may have realized how his new invention could provide, more quickly and cheaply than Mainz's scribes, large numbers of these identical documents. Fifty examples survive, all printed on parchment, but his workshop may have produced as many as ten thousand copies.[2]

One wonders what Margarethe Kremer, who purchased her Letter of Indulgence in Erfurt, 150 miles from Mainz, on October 22, 1454, made of this new style of document. In any case, this document about the fate of her soul in the hereafter marks the oldest extant example of printing from movable type explicitly bearing a date.

Gutenberg was no doubt using these small documents to earn money to keep his press running as well as to perfect his new method of producing books. But he was also at work on something else. In the same month that Margarethe Kremer purchased her indulgence, the diplomat Enea Silvio Piccolomini—the man who despaired over the loss of "countless books" in Constantinople—arrived in Frankfurt am Main. He had come to drum up German support for a crusade against the Turks, but while in Frankfurt he took the opportunity to visit the city's fair. While there he saw something so intriguing—

especially to a learned bibliophile—that he immediately wrote to a friend in Rome, telling about the remarkable wares offered for sale by a "miraculous man."[3]

This "miraculous man"—Johannes Gensfleisch zur Laden zum Gutenberg—was nearing sixty years of age. He had been born in Mainz, a town on the banks of the Rhine River with a population of six thousand, sometime in the mid- to late 1390s. Little is known about his early life, or, for that matter, about his middle or later years either. He moved 110 miles upstream along the Rhine to Strasbourg sometime around the late 1420s, probably as an exile following municipal disorders in Mainz that pitted the middle-class guildsmen against the upper class, to which Gutenberg's family belonged. A good deal of what is known about him comes from his various legal scrapes. In the first of these, in 1437, he was sued for a breach of his promise to marry a woman named Ennelin zu der Yserin Tür (Ennelin of the Iron Gate); he was also sued for defamation by one of her witnesses, a shoemaker whom Gutenberg called "a miserable wretch who lived by lying and cheating." Gutenberg was forced to pay the shoemaker compensation for the slander but appears to have avoided marriage to Ennelin.[4] By this time he was a member of Strasbourg's guild of goldsmiths, supporting himself by polishing gemstones and, together with a partner named Hans Riffe, manufacturing pilgrims' mirrors in anticipation of the crowds coming to view the famous and sacred relics exposed every seven years at Aachen, such as the swaddling clothes of Jesus and the robe of the Virgin. These mirrors were

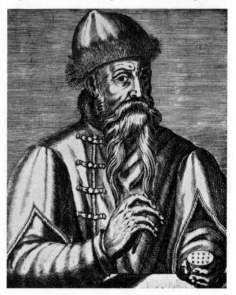

The "miraculous man,"
Johannes Gutenberg.

used by pilgrims according to the religious practice of the day, capturing and "retaining" the divine reflection of these holy relics, after which they were proudly worn on the return journey as badges.

Alas for Gutenberg and Riffe, the pilgrimage was postponed (possibly because of the plague) from 1439 to 1440, leaving them with a storehouse of unsold stock. However, the manufacture of mirrors may have led Gutenberg to experiments in metallurgy, stamping, and the processes of mechanical reproduction by which a single template might produce an unlimited number of copies.[5] He appears to have taken on other partners and made investigations into printing during these Strasbourg years, but the nature and upshot of his attempts remain shrouded in mystery, in part because of his quite understandable insistence on secrecy.

Documents uncovered in a medieval tower in Strasbourg in 1745 by an archivist named Johann Heinrich Barth suggest Gutenberg's involvement in a mysterious enterprise that went beyond polishing gems and making mirrors. In 1439 he was sued by the brothers of a deceased business partner, Andreas Dritzehen. The brothers alleged that Andreas, who died on Christmas Day in 1438, had sunk a large chunk of his property in one of Gutenberg's projects in expectation of a large return. The brothers believed that as Dritzehen's heirs they ought to be admitted to the partnership or else reimbursed the sum invested by their brother. Gutenberg in the meantime sent a servant into Andreas's house to dismantle a mysterious machine—"so that no one can see what it is"—and retrieve the components. Twenty-six witnesses came forward on behalf of the two brothers, fourteen for Gutenberg. None of the witnesses whose testimony survives either knew or divulged the purpose of the mysterious machine, apart from the final one, a goldsmith named Hans Dünne. He testified that over the previous two or three years he had received from Gutenberg about one hundred gulden* "for work connected with printing." The court ultimately ordered Gutenberg to pay an outstanding balance of fifteen gulden to the brothers and then have "nothing whatever to do" with them.[6]

*The gulden was a gold coin that, like the florin or the ducat, had a weight of around 3.5 grams (0.123459 ounces).

Gutenberg's next ten years are difficult to trace, but by 1448 he was back in Mainz, refining his invention. In August 1450 he entered into a business partnership with Johann Fust, a wealthy goldsmith and banker who undertook to loan him, at 6 percent interest, the sum of 800 gulden—enough, in those days, to buy 100 oxen[7]— so that he could begin manufacturing tools and type. In 1452 Fust began paying him, in addition, 300 gulden per year for wages, rent, parchment, paper, and ink for a joint enterprise specified as *Werke der Bücker* ("work on the books"). The partnership lasted some four or five years before breaking down, acrimoniously and litigiously, around the time that Piccolomini visited the book fair in Frankfurt in October 1454.

What Piccolomini saw at the fair were quires of printed text serving as samples of a soon-to-be-released edition of a printed Bible. "I saw not complete Bibles," he wrote to his friend in Rome, "but several quires of different books, exceedingly clean and correct in their script, and without error, which Your Excellency could read effortlessly without glasses." His friend, a cardinal, requested a copy, but Piccolomini reported that despite a print run of something between 158 and 180 copies (he was given both figures) one of these books would be impossible to acquire because "ready buyers had all been found before the volumes were finished."[8]

These volumes, of which forty-nine survive either whole or in part, are more than 1,200 printed pages in length. They are known to historians of print as "B42," reflecting the fact that each page has forty-two lines of text. They are more popularly known as the *Gutenberg Bible*.

The fair at which Enea Silvio Piccolomini met the "miraculous man"— presumably Gutenberg himself—was the largest in Europe. Only twenty-five miles from Mainz, the Frankfurt Fair attracted traders and commodities from England to the Balkans and beyond. Wine came over the Alps from Italy, glass from Bohemia, cloth from France and England, black pepper, nutmeg, cloves, cinnamon, and ginger from the lands of the East. Later in the fifteenth century an African elephant even made its appearance.[9]

ambulauitq; cu deo & non apparuit: quia tulit eum dns. Vixit quoq; ma-thusalam centuoctogintasepte anis: et genuit lamech. Et vixit mathusala postq; genuit lamech septigentisocto-gintaduobz annis: & genuit filios et filias. Et facti sut omnes dies mathu-sale nongentisexagintanoue anni: et mortu9 est. Vixit aut lamech centum-octogintaduobus anis et genuit filiu: vocauitq; nomen ei9 noe dicens. Iste consolabit nos ab operibz et laboribz manuu nostraru & terra: cui maledixit domin9. Vixitq; lamech postq; genuit noe quingentisnonagintaquinq; anis: et genuit filios et filias. Et facti sunt omnes dies lamech septingentiseptua-ginta septem anni: & mortuus e. Noe vero cum quingentoz esset annoz: ge-nuit sem-et cham-et iaphet. Capit vi. Cumq; cepissent homines multi-plicari sup terram-& filias procreasset. Videntes filii dei filias hoiu qp essent pulcre: acceperut sibi vxores ex omibus quas elegerat. Dixitq; deus. Non pmanebit spirit9 meus in hoie in eternu: quia caro e. Eruntq; dies illi9 centuuiginti annoru. Gigantes aut erat sup terra in diebz illis. Postq; eni ingressi sunt filii dei ad filias hoiu-illeq; genuerut: isti sut potetes a seclo: viri famosi. Videns aut de9 qp multa malicia hoim esset i terra: & cucta cogi-tatio cordis intenta esset ad malum omni tpe: penituit eu qp hoiem fecisset in terra. Et pcauens in futur9-& tactus dolore cordis intrinsec9: delebo inqt hoiem que creaui a facie terre-ab hoie usq; ad aiantia: a reptili usq; ad vo-lucres celi. Penitet enim me fecisse eos. Noe vero inuenit gracia coram dno. Hee sunt generationes noe. Noe vir

iustus atq; pfect9 fuit-i generationibz suis: cu deo ambulauit: & genuit tres filios-sem-cham-& iaphet. Corrupta est aute terra cora dno: & repleta e ini-quitate. Cunq; vidisset de9 terra esse corrupta: ois quippe caro corruperat via sua sup terra: dixit ad noe. Finis vniuerse carnis venit cora me. Repleta e terra iniqtate a facie eoz: & ego disper-dam eos cu terra. Fac tibi archam de lignis leuigatis. Mansiunculas in archa facies: & bitumie linies intrinse9 et extrinse9: & sic facies eam. Trecentoru cubitoz erit longitudo arche-quinqua-ginta cubitoz latitudo: et triginta cu-bitoz altitudo illius. Fenestra i archa facies: et i cubito osumabis sumitate eius. Ostiu aut arche pones ex latere deorsum. Cenacula & tristega facies in ea. Ecce ego adducam aqs diluuii super terra ut interficia omne carne in qua spiritu9 vite est subter celu: & vniuersa que in terra sut cosumentu. Ponamq; fedus meu tecum: et ingredieris archa tu et filii tui-vxor tua-et vxores filioz tuoz tecum: & ex cunctis aiantibz vniuerse carnis bina induces i archa ut viuat tecu masculini sex9 & feminini. De vo-lucribz iuxta genus suu-& de iumentis i genere suo: & ex omni reptili terre-secdu gen9 suu-bina de omnibz ingredient tecu: ut possint viuere. Tolles igit tecu ex omnibz escis que mandi possunt-et comportabis apud te: et erunt tam tibi qua illis in cibum. Fecit igit noe omnia que preceperat illi deus. Capit vii. Dixitq; dns ad eu. Ingredere tu et omnis domus tua in archa. Te eni vidi iustu cora me in generatione hac. Ex omnibz animantibus mudis tolles septena et septena-masculum & femina: de animatibz vero immudis

A page from Gutenberg's 42-line Bible.

Books were also exhibited and traded at the Frankfurt Fair. The glory days of booksellers and publishers cramming the Buchstraße ("Book Street") behind the church of Saint Leonhard were still, in 1454, two decades hence; but the stalls in the Römerplatz and in streets stretching down to the banks of the Main displayed the wares of papermakers, bookbinders, illuminators, and woodcut artists. Manuscripts were also available. In 1370 a cleric from the Netherlands, Geert Groote, was able to find at the Frankfurt Fair the manuscripts he needed to start his center for copyists, the Brethren of Common Life, where he employed impoverished young scholars as scribes.

Visitors to the Frankfurt Fair could also have bought a kind of book quite different from one penned on paper or parchment by a scribe—that is, a block book. Woodblocks had been used for many centuries for imprinting designs on textiles, but the paper mills established in Europe by the end of the 1300s (the first in German lands began production in Nuremberg in 1390) made available to craftsmen trained in carving in relief on blocks of wood a relatively inexpensive medium on which to multiply their designs. Prints, playing cards, and picture-books all were produced by artisans from designs carved in relief, and in reverse, on blocks of wood and then inked and impressed on paper. The picture-books produced through woodblock printing were usually biblical in subject matter. Often hand-colored, they might run to sixty or eighty pages, and they sometimes featured short passages from the Bible as captions. Since the illiterate could understand the pictures if not read the captions, this kind of little block book came to be known as a *Biblia Pauperum*, or "Poor Man's Bible," though often they were beautifully produced and well beyond the means of the illiterate poor.

Woodblock prints were hardly a remarkable invention. The ancient Assyrians had used much the same technology in 3500 BC by rolling engraved hematite cylinders in wet clay. It has been claimed that on the scale of human ingenuity, the invention of printmaking should rank "somewhere below the discovery of how to make a soufflé"[10]—and yet, at the same time, its consequences were profound not merely for art but also for the proliferation and exchange of ideas.

Curiously, around 1450 there was a sudden explosion in this medium such that of the more than five thousand woodblock prints that

survive from the fifteenth century, only fifty or sixty can be dated from before the middle of the century.[11] Demand must have driven this accelerated production. This demand is often seen as coming from what one historian has called "the ordinary citizen"[12]—urban craftsmen and the illiterate poor at whom copies of the "Poor Man's Bible" were supposedly aimed. However, evidence suggests that the audience for these printed books and images was not so much illiterate peasants or humble craftsmen but, rather, those from the middle and upper echelons of society—the same sort of people who bought manuscript books.

The limitations of block books are obvious: a book of forty printed pages required forty different woodcuts. A volume such as Gutenberg's 1454 Bible would have needed a separate woodblock for each of its 1,282 pages, and each page would have required the woodcarver to produce, on average, some 2,500 letters. Printing from woodblocks was therefore impractical for anything but short treatises, playing cards, and the religious woodcuts sold to pilgrims at shrines all over Europe—a lucrative revenue stream for anyone in this line of trade.

Gutenberg took a different approach to the technique of printing pages of text. Instead of using a single solid block of letters carved in wood, he composed each page from multiple separate letters cast in metal and painstakingly arranged into syllables, words, and sentences like the segments of a 2,500-piece puzzle. Once the characters were inked and their impressions taken—perhaps 180 times, as in the case of the 1454 Bible—the page would be unlocked and the letters sorted and then reused for the following page. His prefabricated letters are therefore known as movable type, and the clarity of the printed image was improved by the fact that they were cast in metal rather than carved in wood.

Gutenberg was far from the first to have such an idea or to experiment with this technique. The Chinese were printing from movable characters made from fire-hardened clay by the middle of the eleventh century, when a blacksmith and alchemist named Pi Shêng locked his porcelain characters into position by setting them into a tray of wax and resin that he first heated to soften and then, once all had been "typeset," hardened by cooling. Then, in the middle of the

1300s, a Chinese writer named Wang Chêng described books printed from movable characters carved out of wood. Metal type appears to have been the particular invention of the Koreans, who as early as the 1200s began producing bronze type by means of sand-casting. This process involved carving the characters (in reverse) on cubes of beechwood, then taking impressions of them in sand "taken from the shore of the sea where the reeds grow" (as a manual instructed). Bronze was melted and then poured into these negative impressions. Once the bronze cooled, any imperfections were filed away and the characters fitted together into a bamboo frame, ready to be inked and printed, then reused for other pages. The technique received support from the royal treasury in around 1400, when King Taejong established a type foundry so books could be produced for the use of Confucian scholars. Some hundred thousand characters were cast within a few months, and in 1409 the Heungdeoksa Temple in Cheongju produced *Edifying Treatise of the Buddhist Patriarchs*, the oldest surviving work printed in movable type.[13]

If Gutenberg did not invent movable metal type, his contribution to printing was to take advantage of Europe's better supply of metals (thanks to its mines) and superior casting technology. He created his letters by means of a punch, a steel shaft some two and a half inches long onto one end of which the character was cut in relief and in reverse, so that a capital E, for example, appeared as Ǝ. Punch-cutting was a delicate task that called for precise carving in miniature as the craftsman laboriously cut and shaved into the hard metal the elegant figures that scribes could produce with a few strokes of their quills. The cut end was then hammered into a bed of malleable copper, leaving behind an indentation that revealed the letter the right way round (E). This small bar of copper impressed with the letter was known as the matrix, a word etymologically related to the Latin *mater* ("mother") and coming from the Latin word for womb (*matrix*)—an indication that this small cavity was the place in which a letter was generated and from which it was born. The matrix was then fitted into a mold and the letter-shaped cavity filled with Gutenberg's special combination of molten lead, tin, and antimony. The piece of type

emerged, once again, like the figure on the punch, in relief and in reverse (Ⴉ). Gutenberg's new metal separated well from the mold, efficiently received the ink, then released it cleanly and clearly onto the paper.

This process of casting type was repeated hundreds of times, since Gutenberg needed 290 punches and matrices to create his alphabet—forty-seven capital letters and sixty-three lowercase letters (with each case stocked in excess of the twenty-four letters of the Latin alphabet because the same letter was reproduced in different sizes and widths so the lines could be fully justified). He also needed ninety-two abbreviations; eighty-three ligatures, or combinations of fused letters; and five punctuation marks.[14] Then, because the letter *i*, for example, could easily appear five hundred times on a single page, each of his matrices was used to cast hundreds of letters, making sure all of them were readily available when the letter-puzzle of his page was carefully fitted together.

This Gothic alphabet was designed for Gutenberg by Peter Schöffer, a scribe who had been trained in Paris. Schöffer must have marveled as his careful Gothic squiggles were carved into steel, turned inside out, reproduced in their hundreds, and then, presented in mirror image to the page, impressed in crisp black marks.

Gutenberg's relationship with Johann Fust broke down sometime late in 1454, bare weeks after Enea Silvio Piccolomini saw the Bibles on show at the Frankfurt Fair. In the following year Fust took Gutenberg to court in Mainz to obtain the repayment of 2,020 gulden—the original 800 gulden along with a subsequent loan of 800 more, plus interest. The tactic was harsh and even dishonest, given that under the terms of their agreement only 800 gulden plus interest was meant to be repaid. The case was heard in a secular tribunal by the Archbishop of Mainz. The details are hazy. The only evidence related to the case is a notarial document from November 1455, which merely summarizes events after the fact. Also, neither Gutenberg nor Fust was eager to make public the nature of their enterprise. The upshot was that Gutenberg was required to repay Fust some 1,000 to 1,250 gulden and also, it seems, to hand over some of his fonts and presses. Much

of Gutenberg's equipment ended up in Fust's possession, which may well have been the banker's aim in bringing the suit. He immediately set up his own printing operation with Peter Schöffer, the scribe who had designed Gutenberg's 290 letters and punctuation marks. The two men then began planning a new publication.

It is a paradox that the man who revolutionized communication seems to have communicated so little about himself. Nothing is known about Gutenberg's motives—about why, in the 1430s, he should have begun his experiments with movable type, or what led him to conclude that a new method of producing manuscripts was not only possible but also necessary and desirable. Book production, in many ways, seemed in little need of reform. Manuscript technology had endured with minimal deviation since the roll-to-codex switchover a thousand years earlier.

Even so, a number of important shifts did occur through the course of the Middle Ages and into the fifteenth century. Significantly more manuscripts were produced in each ensuing century after the year 1000 as, during the "High Middle Ages," readership expanded across Europe. The major consumers of manuscripts were no longer in rural communities—in the monasteries and other religious institutions—but instead in the new and growing urban centers with their increasingly literate populations and, in some cases, universities. Historians have estimated that while 212,000 new manuscripts were copied across Western Europe in the eleventh century, the number rose enormously in the next century to 768,000. The tally of new manuscripts then jumped to 1.7 million in the 1200s, due in no small part to the rise of the universities. Indeed, more manuscripts were produced in the thirteenth century than in the previous seven hundred years put together. Some half a million of these manuscripts were copied in France alone during the 1200s, the vast majority no doubt in Paris. Then, despite the horrors of the Black Death, the Papal Schism, and the Hundred Years' War, numbers jumped to 2.7 million in the 1300s, with France (564,000) overtaken by Italy (880,000). One statistical study has found that over the course of the fourteenth century manuscript production in Italy increased

by 326 percent. During the fifteenth century, almost five million manuscripts—handwritten codices, not printed books—would be produced; Italy was once more by some distance the largest producer. Further, manuscript production across Western Europe increased some 40 percent each decade between the 1420s and the 1450s.[15]

Not only did ever more manuscripts appear during these centuries; they also grew larger and longer as universities demanded complete texts for students and scholars rather than slender collections of excerpts. This dramatically increasing demand for manuscripts meant scribes needed to work ever more swiftly. Their task was made arduous by the fact that some of the most important and popular works of the Middle Ages were extremely long: Dante's *Divine Comedy* ran to 14,233 lines of verse, *The Romance of the Rose* to more than 20,000. Thomas Aquinas's colossal *Summa Theologica* came in at around 900,000 words (taking up more than 5,000 pages in a modern five-volume Latin-English bilingual edition). We can only feel sympathy for the exhausted fourteenth-century scribe who signed off with exasperated relief: "Thank God, thank God, and again thank God!"

Another change in the production of manuscript books was that by the turn of the fifteenth century, at least partly to cope with the surging demand, their support began to change—from parchment to paper. Paper was not a new technology; it had been invented in China sometime during the Western Han dynasty (206 BC to AD 9). Ancient papermakers in China and then, in the centuries that followed, in Japan and Korea, strained mashed-up mulberry bark, rattan, chopped-up fishing nets, and even seaweed through a mesh of bamboo to create a support for writing and drawing. Muslims adopted paper in the eighth century, after learning the technique, according to legend, from Chinese prisoners captured in battle on the banks of the Talas River near Samarkand in 751. Whether the story is true or not, Samarkand, on the Silk Road in modern-day Uzbekistan, did become an important center of papermaking. Muslims substituted as their raw materials rags and hemp from old ropes, and invented water-powered trip-hammers to break up the fibers. Paper spread through the Middle East and the Mediterranean along with Islam, and by the 1100s production reached Muslim-controlled Spain, where

the Jews also adopted it, albeit reserving parchment for their sacred texts. Muslims, by contrast, began using paper even for copies of the Koran.

The Christians in northern Europe regarded this new product with suspicion. When Peter the Venerable, a Benedictine abbot, encountered paper during a visit to Spain in about 1142, he remarked disdainfully that the Jews wrote their books on a material made, not from animal skins or marsh plants, but from "scraps of old rags or even viler stuff."[16] A shortage of rags did indeed mean that papermakers in the Islamic world were occasionally forced to resort to ghoulish measures. Around the time of Peter's pilgrimage, a diarist in Egypt reported that the pyramids had been raided for mummy swaddling from which to make paper.

Other concerns in the West involved paper's durability. In the first half of the twelfth century, due to fears about the degradation of paper, Roger II of Sicily began renewing on parchment the charters written by his father on paper only a decade or two earlier. Roger's nephew, the Holy Roman Emperor Frederick II, entertained similar anxieties. In 1231 he decreed that all public documents for the Kingdom of the Two Sicilies should be inscribed on parchment "so that they may bear testimony to future times and not risk destruction through age."[17] These worries about paper's deterioration were unfounded, since rags ground under pressure in a mill resulted in long, unbroken fibers that offered a strong and supple product.

During the thirteenth century this "parchment of rags," imported from Spain, increasingly came to be used by notaries and ecclesiastical officials in Italy and elsewhere in the Christian West. By the 1260s a hydraulic paper mill had been established in Italy at Fabriano. How the technology was transmitted to Italy remains unclear, but Islamic assistance or influence lingers in the Italian derivations from Arabic terminology (the Italian *risma*, or "ream," comes from the Arabic *razmah*). Fabriano's mills soon proved so efficient that by the 1280s eight papermakers were plying their trade, and by the fourteenth century the town could produce a million sheets of paper a year. Its high-quality product was exported around the Mediterranean, including into the Islamic world. A number of Korans were even copied on paper watermarked with crosses and other Christian

symbols—a vexing situation that ultimately led, in 1409, to a *fatwa* on the use of European paper.[18]

Papermakers needed pure, fast-flowing water to power their mills. "The clearer the water," one treatise advised, "the better and more beautiful the paper."[19] They also needed vast quantities of rags. Papermakers came to enjoy an abundant supply thanks to a change in fashion in the 1200s, when the population of Europe began moving out of the countryside and into towns and cities. Since people in towns lived in greater proximity to one another, mixing more frequently with the opposite sex, they abandoned the peasant habit of wearing nothing under their breeches and leggings. As a result townspeople began wearing undergarments made from flax and hemp, increasing the quantity of worn-out clothes they sold to the ragpickers who traveled door to door. Social niceties from urbanization therefore meant papermakers came to enjoy a plentiful supply of raw materials.[20]

Tragedy during the fourteenth century also brought a huge supply of rags onto the market. During the ravages of the Black Death in 1348, cities such as Florence forbade the sale of victims' garments and bedding, which were supposed to be incinerated. However, such strictures were often ignored, and huge amounts of surplus clothing suddenly became available in the wake of the deaths of an estimated fifty million people across Europe. The wardrobes of the dead were, in the years that followed, turned into books.[21]

The Black Death affected the book industry in another way. The plague wiped out vast numbers of livestock—the source of parchment—not only indirectly because the disease claimed the herdsmen but directly, too, because animals died from the bubonic plague. In England, cattle "in numbers beyond reckoning" were reported dead in a single field.[22] Livestock suffered from a variety of epidemics throughout the 1300s, as anthrax, rinderpest, and other diseases decimated sheep, goats, and cattle. The populations of flocks and herds in some areas fell by as much as 70 percent. Given that these livestock shortages coincided with a surfeit of rags, we might be tempted to ponder the role played by disease as well as the fashion for underwear in the parchment-to-paper switchover.

This move from parchment to paper accelerated, coincidentally or not, in the decades following the Black Death. During the 1300s, two-thirds of manuscripts in Europe were made from parchment and only one-third from paper. In the following century, only 28 percent were written on parchment and 72 percent on paper.[23] This dramatic reversal echoes the papyrus-to-parchment transition of the fourth and fifth centuries. Vespasiano, however, rowed against this current since many of the manuscripts he produced were, as high-end deluxe items, written on parchment. Though he stocked and sold paper like all *cartolai*, he ensured that the bespoke codices for clients such as Andrew Holes and William Grey were copied in the old-fashioned way, on the skins of animals.

Holes and Grey were independently wealthy, able to afford the price of parchment manuscripts, but many other readers were not. One of paper's greatest attractions was its price: one-sixth or less than that of parchment. Works printed on paper by presses would therefore be considerably cheaper than those copied on parchment by scribes. Enea Silvio Piccolomini did not say at what price the "miraculous man" was selling his wares in Frankfurt, but copies of his Bibles cost five times less than ones written by scribes. Knowledge was about to get much cheaper and much more plentiful.

Chapter 11

The Decades of the King

In October 1454 a young scholar in Bologna named Niccolò Perotti wrote to Vespasiano with a request for books. The two men knew each other well. Perotti had been a bright but impecunious fifteen-year-old student of Greek when, in Ferrara in the mid-1440s, he met William Grey, a fellow classmate. Grey took him into his household and then brought him to Florence and, according to Vespasiano, "generously gave him money to buy books for his studies," the majority of which came from Vespasiano.[1] Perotti's star had been ascendant ever since. In 1447, while still an adolescent, he transferred his services to Cardinal Bessarion in Rome and then, four years later, thanks to Bessarion's help, became a professor of rhetoric at the university in Bologna.

Perotti continued to use Vespasiano as his bookseller. He was a finicky and importunate client. In the summer of 1453 he had written from Bologna, addressing Vespasiano as "dearest brother," sending him eighteen florins, and requesting a copy of a collection of letters (probably those of Cicero). He stressed that the manuscript should be beautifully bound in black leather and embossed "as magnificently as possible." As he urged Vespasiano: "If you ever bind a book properly, let it be this one. But above all I beg you to do it quickly, because I am greatly in need of it." He went on to vent his exasperation that another book ordered from Vespasiano, a copy of Tiberius Claudius Donatus's commentary on Virgil, recently unearthed in a French monastery by Jean Jouffroy, was not yet ready. He also requested a list of all the known translations of Plutarch's *Lives*—the sort of dizzying exercise in manuscript collation at which Vespasiano was the recognized expert. Finally, he asked Vespasiano to find a scribe to copy out two more manuscripts, one on music and

the other on geometry. Once again, speed was of the essence: "If I could have them as soon as possible I would be most grateful."[2]

This tetchy and demanding letter from Perotti encapsulates all of Vespasiano's talents and abilities: to find scribes, to bind books, to tap a vast array of sources to locate the best copies of manuscripts on everything from ancient history to music and geometry—and to deal patiently and efficiently with the most exacting clients. His reputation for quality productions was such that scribes now added his name to the flyleaves of the manuscripts they copied: VESPASIANUS LIBRARIUS FLORENTINUS VENDIDIT. "Sold by Vespasiano, Florentine bookseller."[3] Purchasers of his books likewise recorded the provenance of their manuscripts. Around the time he was dealing with Perotti, Vespasiano sold an Italian translation of the Roman philosopher Seneca the Younger's *Consolations* to Niccolò da Meleto, a Florentine merchant who worked in Bologna. On the inside of his manuscript's front cover Niccolò, like a good merchant, recorded details of the sale: "Niccolò di Piero da Meleto bought this in Florence from Vespasiano *cartolaio*, September 1455. Cost: 2½ florins."[4]

In 1454 Niccolò Perotti gave Vespasiano another difficult assignment: a manuscript for the pope. The commission had to do with Nicholas V's ambitious desire to acquire for the Vatican Library new and improved Latin translations of *The Iliad* and *The Odyssey*. A translation of Homer's masterpieces into Latin was a tall order indeed: *The Odyssey* ran to some twelve thousand lines, *The Iliad* to almost sixteen thousand.

These two great epics were first recited in the eighth century BC by (as ancient tradition held) a blind poet named Homer. Little about Homer is known for certain.[5] The Emperor Hadrian, who reigned from AD 117 to 138, once asked the Delphic Sibyl for information about him, but she could vouchsafe little more than the fact (disputed by other sources) that Homer was born on the island of Ithaca. Various ancient writers, some dating back to the sixth century BC, did not hesitate to provide fanciful and compelling biographical details, such as the story that Homer's mother was a nymph and his father the River Meles in Smyrna, after which he got his birth name: Melesigenes. As a

young man he embarked on seafaring adventures before an eye ailment during a stopover on Ithaca ended his career as a mariner. He went blind—his most famous biographical attribute—but learned from friendly locals the story of Odysseus. Poverty and hardship followed until a cobbler in Neonteichos, thirty miles north of Smyrna, took pity on the blind vagabond. Melesigenes began making ends meet by reciting poems and hymns to the gods, first in the cobbler's shop and later, as his audiences grew, beneath a poplar tree (a famous Neonteichos tourist attraction in ancient times). He eventually became known as Homer, after the Aeolian word for the blind, *homêroi*.

An itinerant life ensued as Homer traveled from town to town, island to island, declaiming his verses and earning such renown that he was given expensive gifts, commemorated in bronze statues, and honored with sacrifices. His death came in old age. The Delphic Sibyl once warned him that he would die on the island of Ios, and that he should beware riddles posed by small boys. En route to Thebes for a music festival, Homer came ashore on Ios, where he asked some fisher boys about their catch. "We have what we did not find," they replied, "and what we found we left behind." Unable to solve the riddle (the boys had been delousing themselves), Homer suddenly remembered the sibyl's prophecy, slipped in the mud, and died. He already had his epitaph prepared:

> Here the earth conceals that sacred head,
> adorner of warrior heroes, the godly Homer.[6]

The survival of Homer's epics across more than two thousand years of history was little short of miraculous. Various other epic poems from around the same period—on topics such as the voyage of the *Argo* and the heroic deeds of Hercules and Theseus—either disappeared entirely or survived only in fragments and commentaries. Like these poems, some likewise said to be Homer's, *The Iliad* and *The Odyssey* formed part of a vibrant oral tradition: they were sung by bards, initially by Homer himself, until at some later point (possibly during Homer's lifetime) they were committed to more permanent form when the written word came to ancient Greece—an event that

a scholar of the period has called "a thunder-clap in human history."[7] Down through the centuries the epics descended, first on papyrus (the oldest surviving one comes from the third century BC) and then in parchment codices, including that owned by Petrarch and another brought back from Constantinople by Giovanni Aurispa. The finest of all the surviving manuscripts—a tenth-century codex of *The Iliad* known today as "Venetus A"—at some point came into the possession of Cardinal Bessarion.

Men of wisdom in the fifteenth century did not doubt the greatness of Homer. They could read Quintilian's praise: "Does not Homer transcend the limits of human talent in his words, his thoughts, his figures, and the disposition of his whole work?"[8] From Pliny the Elder's *Natural History* they knew that Alexander the Great had called Homer's epics "the most precious achievement of the mind of man," and that Pliny himself believed "no genius has ever existed who was more successful than Homer."[9] And yet, frustratingly, despite the efforts in the field of Greek studies by Manuel Chrysoloras and his students, only a minority of scholars in the West could cope with the Greek text. The sole complete Latin translation was a version done in Florence in the 1360s, at the behest of Petrarch and Boccaccio, by a Calabrian named Leontio Pilato. Thanks to Boccaccio, Pilato became a professor of Greek at the Studio Fiorentino, where he lectured for two years while translating Homer into Latin. Alas, the translations he produced were, according to Coluccio Salutati, "barbarous and unsophisticated"[10]—rather like Pilato himself, whom Petrarch found disgusting in his personal habits and irksome in his temperament. His translation was filled with howlers. So bad was his understanding of Homeric Greek that instead of describing Athena as "daughter of Zeus, who bears the aegis"—a goatskin shield—he envisaged Athena milking a goat.

For decades afterward, scholars and translators had dreamed of a Homer rendered into more elegant and accurate Latin. The finest Greek scholars in Italy—many of them former students of Chrysoloras—had risen valiantly to the challenge only to beat hasty retreats before the heavy barrage of Homer's splendid hexameters. Leonardo Bruni translated nothing more than a few speeches from Book 9 of *The Iliad*—"purely for my enjoyment," he modestly noted.

One of Bruni's protégés, Lorenzo Valla, got no further than Book 16 in a prose translation before handing the task over to one of his pupils, who glumly concluded that no one had ever managed to translate "this most eloquent poet with any elegance and not made him almost childish." Another scholar struggled with his own translation of *The Iliad*, but despite disparaging Pilato's work ("nothing more absurd could be imagined"), his effort merely proved an uninspired touch-up of Pilato that earned him a charge of plagiarism from Francesco Filelfo.[11]

Undeterred by these failures, Nicholas had been casting around for a translator since becoming pope in 1447. He approached a poet and scholar of Greek named Basinio da Parma, who, by means of a long and eloquent poem, turned him down on grounds of the insuperable difficulties. He next approached Carlo Marsuppini, who felt he could hardly refuse the pope despite the fact that he had become chancellor of Florence, a busy and important post requiring him and his team of notaries to draft all of the government's diplomatic correspondence (a task he took incredibly seriously: his letters take the form of treatises, larded as they are with classical erudition). Undertaking the job in a gloomy state of mind, Marsuppini got no further than Book 1, plus the famous speeches in Book 9, before dying in April 1453.[12] The task was then undertaken by Filelfo, lured to Rome from Milan (to which he had gone following his incendiary performances in Florence twenty years earlier) with the promise of a fat stipend and a big house.

Perotti's request for a copy of Homer probably concerned the abortive effort of Marsuppini. His demand was made with his typical urgency. "For the love of God," he told Vespasiano, "if you ever wished to please me, now is the time." He gave strict instructions, once again, about the binding—"glued down and covered in leather"—and stressed the need to dispatch it posthaste. Incredibly, he wanted the manuscript in his hands within ten days of ordering it, a time frame that suggests he needed a copy of the extracts produced by either Bruni or Marsuppini, which could perhaps have been used toward the translation desired by the pope.[13]

Vespasiano was busy with many other customers besides the importunate Perotti. In the decade since Girolamo Aliotti, the monk in Arezzo, praised him as the "best guide" for finding and producing manuscripts, his clients had become diverse and widespread. He did work for the library of a church in Bologna and a convent in Ferrara. He produced books for the archbishop of Florence, Antonino, which the archbishop (a future saint) donated as alms to a convent in Fiesole. For the Milanese ambassador to Florence he found a Quintilian. For the Florentine government, for a price of fifty florins, he produced a beautiful manuscript of Leonardo Bruni's history of Florence. He provided a monastery outside Florence with the parchment for an antiphonary. He found and then dispatched a number of law books to a friend in Rome. And such was his renown that he began dealing with one of the most powerful men in Italy: King Alfonso of Aragon and Naples, known as Alfonso the Magnanimous.[14]

Alfonso had succeeded his father as King of Aragon (in modern-day northeast Spain) at the age of twenty in 1416. More than a quarter of a century later, in 1442, he added the Kingdom of Naples to his domains when, after a long siege, he and his troops sneaked into the city through a subterranean aqueduct and put flight to the rival claimant, René I of Anjou. Alfonso thereafter ruled over vast lands that stretched halfway up the Italian peninsula, from the tip of the boot's toe in Calabria to the heart of the Apennines in Abruzzo. Over the next decade his territorial ambitions meant Alfonso offered a constant threat to Florence. His troops invaded Tuscany on various occasions, besieging castles and plundering property in an attempt to gain a foothold on the Tuscan coast from which his ships could patrol the sea lanes across to Corsica, yet another of his possessions. Early in 1455, his aggressions finally came to an end when, somewhat belatedly and reluctantly, he added his signature to the Treaty of Lodi. Through this treaty, signed by the other parties in April 1454, the major powers on the Italian peninsula—the republics of Florence and Venice, the duchy of Milan, the kingdom of Naples, and the papacy—resolved to preserve the peace. The pact was inspired not by their newfound respect for each other's borders and domains (over which for the previous three decades they had unrelentingly squandered blood and treasure) so much as by their empty coffers and

the ominous ruminations of Mehmed the Conqueror as he cast his eyes westward.

A portrait medallion of King Alfonso, designed by Pisanello and struck in 1449, shows a handsome man with a pudding-bowl haircut and an aquiline nose; he wears a suit of armor over his chain mail. Alfonso, though, was much more than a warrior king. Enea Silvio Piccolomini noted with admiration that Alfonso was "never without his books" even in his army camp because he took his library with him on military expeditions, storing the volumes in a tent pitched alongside his own.[15] If his soldiers came across any books while pillaging a city, they fought one another for the honor of presenting the loot to Alfonso, for nothing could give him greater pleasure. One military expedition turned into a pilgrimage when he halted to pay his respects at the birthplace of the poet Ovid. On another occasion, while besieging Gaeta, on the coast midway between Naples and Rome, he ordered his engineers to stop using stones from Cicero's villa as projectiles: better his weapons remained inactive, he believed, than the home of so important and celebrated a writer should be destroyed.

King Alfonso liked to claim, in a paraphrase of Plato, that "kings ought to be learned men themselves, or at least lovers of learned men."[16] His nickname, Il Magnanimo, owed much to his generous literary patronage. His personal emblem was an open book, while his punning motto was *Liber sum* (which meant both "I am free" and "I am a book"). He was determined to make his court in Naples a leading center of the new humanistic learning. One of his resident scholars claimed Alfonso was "a patron and friend of letters without peer. Whoever took such care and pains in acquiring books?"[17] He sponsored an academy of learning that gathered in an open colonnade overlooking Via dei Tribunali. He moved the royal library into a spacious room in the Castelnuovo commanding views of the Bay of Naples. Here his copyists—said to be the best-paid scribes in the world[18]—were set to work producing beautiful manuscripts. They inscribed their parchment not in the usual handwriting of southern Italy, an ancient script known as Beneventan, but rather in the clear new Florentine style pioneered by Poggio and reproduced in so many of Vespasiano's manuscripts. He commissioned volumes from poets and philosophers. His blandishments had failed to attract

Leonardo Bruni to Naples, but many other luminaries adorned his court—"a crowd of scholars," according to Vespasiano, "distinguished in every field."[19] He was able to lure them because, as Vespasiano pointed out, he lavished 20,000 florins per year on their keep. He was a superlative example of what Aristotle called "an artist in expenditure."

King Alfonso's favorite author was the Roman historian Titus Livius, or Livy. According to Vespasiano, the king loved to have one of his resident scholars read Livy aloud to him and his troops during their military campaigns. "It made a worthy sight," wrote Vespasiano.[20] In 1451, Alfonso's ambassador to Venice, Antonio Beccadelli, managed to convince the local authorities in Padua to exhume Livy's skeleton from the tomb where in 1413, amid much jubilant civic pride, it was believed to have been discovered in a lead coffin. The Paduans were pleased to do so, and even acceded to Beccadelli's request for a bone to present to Alfonso as a relic. Alfonso gratefully received the precious gift of a bone from Livy's right arm, which he venerated like that of a saint, though a scholar with superior abilities in deciphering Latin inscriptions later spoiled the fun by proving that the celebrated bones from which this relic came were actually those of a freed Roman slave.[21]

The skeleton may have been spurious, but King Alfonso's enthusiasm for Livy and his works was genuine enough. Livy's monumental history of the Roman people, *Ab Urbe Condita Libri* (literally, "Books from the Foundation of the City"), was one of the greatest works ever produced in the ancient world. A desire for a copy of this masterpiece of historiography and storytelling was what led Alfonso to engage the services of Vespasiano.

Born in Padua (Patavium) in 59 BC, Livy began composing his history of the Roman people around 27 BC. An evaluation of the Roman Republic must have seemed appropriate for the times. In 27 BC the Senate granted the thirty-six-year-old Octavian, the great-nephew of Julius Caesar, the title of *augustus* ("revered one"), effectively ending the 500-year-old republic and establishing the Roman Empire. As Livy wrote, his history traced "the achievements of the Roman

people from the foundation of the city" to his own time, that is, from Aeneas fleeing Troy to the decade before Christ—"above seven hundred years," he proudly declared. In doing so he offered a complete and exhaustive history of "the deeds of the foremost people of the world."[22]

Asinius Pollio, another historian, referring to Livy's origins in Padua, snobbishly mocked what he called his *patavinitas*—provincialism. What exactly Pollio meant is unclear, though Livy may have spoken Latin with a rustic accent (as did his contemporary, the poet Virgil, who came from a village near Mantua). However, the genius of Livy's writing style, his flair for dramatic narrative, and the brilliant sweep of his imagination all refute charges of a defective education or backwater mentality. His account in Book 21 of Hannibal crossing the Alps, in particular, is a master class in scene setting and storytelling.

Livy won tremendous fame and respect as his magnum opus, on which he spent some forty years, became among the most popular works in the ancient world. His celebrity was such that, according to Pliny the Younger, a certain Spaniard was "so stirred by the famous name of Livy that he came from his far corner of the earth to have one look at him and then went back again."[23] Livy may even have saved the life of the younger Pliny because, absorbed in *Ab Urbe Condita* when the cloud appeared over Vesuvius, the young man declined to accompany his uncle, Pliny the Elder, on his fatal trip to take a closer look. One of Livy's few critics proved to be Caligula, the mad emperor who reigned from AD 37 to 41. According to his biographer, Suetonius, Caligula had Livy's books removed from the imperial libraries after denouncing him as a "verbose and careless historian." Livy was in good company: Caligula regarded Virgil as "a man of no literary talent," and he expressed his desire to destroy the works of Homer.[24]

Though his writings survived the rampages of Caligula, Livy was one of those ancient authors the loss of whose works had been so bitterly regretted by Niccolò Niccoli. His history of Rome stretched to 142 books, each running to some fifteen thousand words, which meant the entire work (the product, Livy noted, of "infinite labor") must have encompassed some two million words—more than two and

a half times the size of the Bible. Little wonder that Martial wrote of "vast Livy, for whom complete my library does not have room."[25] This gargantuan size made Livy's history vulnerable: only 35 of the 142 books survive in more or less complete form (books 1–10 and 21–45). Nevertheless, even with only a quarter of its books extant, *Ab Urbe Condita Libri* is the longest Latin work to survive from antiquity.

One obvious problem for the work's survival was that it had been far too large to fit onto a single scroll or even, following the papyrus-to-parchment transition of the fourth and fifth centuries, into a single codex (which called for some five thousand pages). Scribes managed to cope with the unwieldy immensity of the work in the same way they dealt with many long works, such as those of Homer or Aristotle: they divided them into units of five or ten books, known respectively as "pentades" and "decades." The work still existed in its entirety around the year 400, when an aristocratic Roman statesman named Symmachus promised a friend a gift of the complete works of Livy. This copy (most likely a set of papyrus scrolls) has not survived, but most if not all of Livy's 142 books probably made the change from papyrus to parchment as, during the following centuries, numerous manuscripts were copied from Symmachus's rolls.

So began Livy's perilous descent through the centuries. Other copies were subsequently produced from these manuscripts as the Livian family tree thrust out its branches—branches that the vicissitudes of time and chance remorselessly pruned away. The usual recyclings and humiliations befell the text. Pope Gregory the Great probably did not, as legend claimed, burn copies of Livy as part of a campaign against pagan writings. However, a millennium after the papyrus-to-parchment transition, some 75 percent of Livy's masterpiece had disappeared forever.

Prices for manuscripts of Livy's history of Rome were incredibly high, not least because of the labor and materials that went into their production. Antonio Beccadelli was forced to sell a farm in order to buy a copy, while Poggio managed to purchase a villa in Florence on the proceeds—120 florins—of copying out a manuscript.[26] King Alfonso, according to legend, almost paid a higher price for his own copy. In 1436 Cosimo de' Medici sent him a manuscript of *Ab Urbe Condita* as a gift. Since Florence at that time was in a league

with Venice and Milan opposing Alfonso's claim to the throne of Naples, the king's physicians warned him the codex might be poisoned. Such was Alfonso's passion for ancient learning that he was willing to risk death to read the manuscript, even making notes in the margins—with no ill effects.[27]

By the time he put his signature on the Treaty of Lodi, Alfonso was in search of a new manuscript of Livy, evidently deeming the one gifted by Cosimo inadequate. Indeed, one of his marginal notes observed that Book 38, among other sections, was missing from the Fourth Decade. Anxious to own a more complete edition, in 1444 he enlisted a scholar at his court, Bartolomeo Facio, to emend this "poison" manuscript. But a decade later, after Facio's plodding efforts were disparaged by scholars, Alfonso turned to Vespasiano, commissioning an entirely new set of manuscripts—which would be among his most beautiful productions.

Serving as intermediary between Vespasiano and King Alfonso for this commission was an enterprising forty-one-year-old merchant named Bartolomeo Serragli.[28] He came from a family that had been banished from Florence in 1444 "for the good of the peace and for the preservation of Florence's liberty"—for having crossed the Medici, in other words. In 1451 Bartolomeo returned, absolved of blame and back in the good graces of the Medici. Within a year or two he began lucrative dealings in paintings, sculpture, and other luxury goods. He became, in effect, one of the world's first art dealers. At a time when virtually all art was produced on special commission from patrons—from churches, monasteries, and civic bodies requiring site-specific frescoes or altarpieces—Serragli indulged in a much more speculative venture of arranging for paintings or sculptures that he then sold, usually abroad, or of serving as an agent between artists and their wealthy patrons. He specialized in selling Florentine luxury goods to rich clients in Rome and the Kingdom of Naples, and in bringing back antiquities and other prizes from the South to Florentine clients, especially the Medici.

Serragli therefore combined two distinctively Florentine traits: an eye for art and a nose for business. He dealt in everything from chess

sets, mirrors, jewelry boxes, and tarot cards, to sculpture by renowned Florentine masters such as Donatello. For Cosimo de' Medici's son Giovanni he scoured Rome for antique marble statues. For King Alfonso he hunted down gold brocades and other luxury fabrics in Florence. He arranged for the sculptor Desiderio da Settignano to carve twelve portraits of Roman emperors for Alfonso, and for Donatello to cast an enormous bronze equestrian group for the Castelnuovo in Naples. He helped Donatello acquire 1,000 pounds of copper and bronze, along with the 26,679 pounds of charcoal needed to melt it in a furnace. He provided painters with barrels of white lead and sculptors with the plaster from which they made their casts. He even, on one occasion, supplied Cosimo's other son, Piero, who suffered badly from gout, with *confetti*, or candied pills, to ease his pain.

By the early 1450s Serragli was also dealing in manuscripts. It was natural that Vespasiano—a man capable of producing opulent merchandise to satisfy discriminating international clients—should have come to his attention. Serragli worked with Vespasiano as early as October 1453, when he paid him for two manuscripts, the titles of which he failed to specify. Further transactions followed in August and September 1454: an indication that Serragli viewed Vespasiano's distinctive Florentine manuscripts as commodities that were as desirable on the export market as silk fabrics and terracotta Madonnas.

In January 1455 Serragli advanced Vespasiano 50 florins on behalf of King Alfonso. Vespasiano would ultimately receive a total of 160 florins for producing the Livy, making his version even more expensive than the manuscript sold by Poggio. In fact, Vespasiano produced three codices for Alfonso: one each for the First, Third, and Fourth Decades (all ten books of the Second Decade are lost). In his accounts Serragli began calling this three-volume set the "Deche del Re"—the "Decades of the King."

Vespasiano needed to pay his team of scribes and miniaturists from the 160 florins he earned for the three Livy manuscripts. As the scribe for this important commission he selected one of his favorites, Piero Strozzi, the priest who, thanks to Vespasiano's plea to Pope Nicholas, served the tiny parish of Ripoli outside the walls of Florence.

Vespasiano gave him plenty of work over the years, and Piero would ultimately copy more than seventy manuscripts (though in keeping with priestly humility he signed only five of them). Vespasiano held him in enormous regard: Piero was, he claimed, "the most beautiful scribe of his age and the best corrector."[29]

Vespasiano was equally scrupulous in his choice of the illustrator. Serragli's accounts show that Vespasiano paid "Francesco d'Antonio *miniatore*" for his services. A twenty-two-year-old at the outset of what would be a prolific career as a talented and highly inventive illuminator, Francesco di Antonio del Chierico originally trained as a goldsmith, but by 1455 he had dedicated himself to manuscript decoration, training under and collaborating with the celebrated painter and illuminator Zanobi Strozzi, a distant kinsman of Piero. A protégé of Fra Angelico, Zanobi had done work for both the library of San Marco and the Badia, and he must have been the one who introduced Vespasiano to his talented young collaborator. Vespasiano's choice of Francesco for such an important task reveals both his faith in the young man's abilities and his knack for spotting fresh talent. He was amply rewarded. Francesco executed designs updated to the achievements of Florentine artists such as Masaccio, Fra Angelico, and Filippo Lippi: realistic landscapes and figures captured with a lively spirit of observation, full of movement, expression, and narrative freshness.

One of Francesco's illustrations was particularly inventive—a title page. A historian of the printed book has recently argued that the "dynamic of innovation" inherent in printing allowed such radical changes as "the appearance of the title page, which had not existed in the world of the manuscript."[30] It is true that title pages were rarely found in manuscripts. Instead, they almost always began with the "incipit"—that is, with HIC INCIPIT ("here begins"), or often simply INCIPIT, inscribed in capital letters on the opening page. The incipit was therefore set off from the rest of the text, announcing the work that followed but encompassing no more than a few lines at the top of the first page. Economy is sometimes given by historians as the reason for this lack of title pages: scribes and collectors had no wish to waste parchment. However, the budgets of many collectors could easily have stretched to an extra leaf of parchment, and in any

case many manuscripts feature wide margins that represented a much greater "waste."[31]

However, title pages did appear "in the world of the manuscript." In fact, manuscripts showed a "dynamic of innovation" no less than printed books, especially in the fifteenth century when the humanists introduced a novel style of script and a new way of composing a page, both of which were adopted by printers. And in fact it was not printers but rather Vespasiano and his artists who pioneered the title page that printers would later copy. This evolution from incipit to title page has its origins in a twelfth-century manuscript that Vespasiano found himself studying. In 1448 he was called upon to repair one of the codices in the library of San Marco, a copy of Flavius Josephus's *Antiquities of the Jews* transcribed in Tuscany some three hundred years earlier. Since some of the pages were damaged or lost, Vespasiano set his trusty scribe Ser Antonio di Mario to work recopying these missing chunks of the text, which were then integrated into the volume.[32]

Vespasiano must have been struck by certain details in this codex as, like a patient on an operating table, it was taken apart in his workshop and then, following the removal of the mutilated pages and the transplant of parchment, sewn carefully back together. Not only was it decorated with beautiful white vine-stem initials and written in the "antique letters" imitated by Poggio and his followers; its front flyleaf featured the author and title in large capitals framed by a rectangular border: INCIPIT PREPHATIO FLAVII IOSEPHI IUDAICÆ ANTIQUITATIS. The incipit had expanded, migrated from the top of the manuscript's first page, and come to occupy the verso facing the opening page.

What was old became new again: Vespasiano clearly decided that for his deluxe editions, beginning with the "Decades of the King," he would reserve a page for his illuminator, Francesco del Chierico, to create this kind of simple but attractive announcement of author and title—an example of his own spirit of dynamic innovation.

Vespasiano's connections with King Alfonso meant he began branching out his trade by exporting books to Naples.[33] He evidently believed

that, with its erudite ruler and lively court, the Kingdom of Naples could become a booming market for the classics. Rather than Serragli, however, he used as his agent a Florentine merchant active in Naples, a somewhat shady character named Piero da San Gimignano. In 1457 Piero transported twenty volumes on their 350-mile journey south and undertook to sell them on Vespasiano's behalf, in exchange for a 10 percent commission. Worth hundreds of florins altogether, these manuscripts were a risky venture on the open roads and then in the piazzas of Naples. Piero himself was a risk too, already under a cloud with another employer, a Florentine merchant he failed to reimburse after selling a large quantity of silk drapes in Naples.

The prices of some of the books carted to Naples, such as a manuscript of Ptolemy's *Geography* "with beautiful pictures" valued at fifty florins, or a Missal "*grande bellissimo*" at fifty-five florins, suggest that Vespasiano was taking aim at the affluent end of the Neapolitan market. He was also targeting the humanists in Naples and no doubt hoping—through this display of his wares—for further business from King Alfonso himself.[34] All of the works apart from the lavish Missal and a "*bellissimo*" book of hours (seemingly a bargain at only eleven florins) were Greek and Latin classics, among them three manuscripts of Cicero, two of Julius Caesar's *Gallic Wars,* Sallust's *The Jugurthine War,* Niccolò Perotti's Latin translation of Polybius's *Histories,* Bruni's translation of Aristotle's *Nicomachean Ethics*—an exemplary roll call of "humane letters," all of them inscribed in the "new antique letters" of Vespasiano's scribes.

Vespasiano was exporting the advanced culture of humanist Florence abroad, sowing its seeds in fertile Neapolitan soil, where they could be nurtured by its enlightened Aragonese ruler, King Alfonso. The episode reveals Vespasiano's innovative approach to selling books—a bold, speculative attitude that by the middle of the century was feeding a growing appetite for humane letters far beyond the walls of Florence.

More was at stake for Vespasiano in this enterprise, however, than merely the commercial value of his manuscripts. From his earliest days in the Street of Booksellers, he had engaged with the ideas in the books he purveyed. His youthful studies in Niccolò Niccoli's book group, his attendance at the lectures of Carlo Marsuppini in

the Studio or participation in conversations beneath the Roof of the Pisans: such intellectual recreations reveal his devotion to humanist ideals of forging a better world through a study of the ancients. The manuscripts he sold offered what he later called "lessons for our own times." He wrote that many people, through their ignorance, lived in "great darkness," but that the wisdom of the ancients could dispel this gloom. We therefore owed much to "experts in letters, because everything we know, we learn from them." He quoted Saint Jerome's praise that learned men were like stars in the heavens, and the prophet Daniel's that they shine like the sun. "All evil is born from ignorance," he wrote. "Yet writers have illuminated the world, chasing away the darkness, especially those authors from ancient times."[35] These lessons, these radiant beams of light, were what Vespasiano hoped his manuscripts might spread across the stricken terrain of his own age.

Chapter 12

A Destiny of Dignity and Excellence

Pope Nicholas V died in Rome on March 24, 1455, at the age of fifty-seven. His death was deeply mourned by fellow humanists and friends such as Vespasiano, who lamented the passing of "the light and ornament of the Church and of his own time."[1]

During the seven years of his pontificate Nicholas used his resources to employ and protect scholars, scribes, and translators, and to enhance the collection of the pontifical library. The library's collection had grown enormously: estimates ranged from a thousand manuscripts (the guess of the archbishop of Florence) to three thousand (that of Enea Silvio Piccolomini), and even to five thousand (that of Vespasiano and various other sources).[2] Regardless, in a few short years this library became, thanks in part to Vespasiano, one of the largest and finest in the world, making Rome a center of culture and learning for the first time in more than a millennium.

Nicholas must have viewed his thousands of manuscripts with a certain wistfulness. His final years, according to Vespasiano, were unhappy ones as, under the cares of office, he became "the most miserable of men." He suffered badly from gout and "intense bodily pains" for which the only respite he found was singing hymns and reciting prayers. To his friends he confessed his poignant wish to resign the papacy and return to his old life as Tommaso Parentucelli—to go back to the days when he would arrive on a mule to discuss philosophy with his friends in the Street of Booksellers.[3]

Vespasiano reports that on his deathbed Nicholas appealed to God to send a shepherd to preserve and enlarge the Christian flock. That

shepherd arrived some two weeks later when the cardinals assembled in the Apostolic Palace for their conclave. Cardinal Bessarion was a strong candidate, so heavily tipped, with eight of the fifteen cardinals declaring for him, that some of them began approaching him for favors even before the final scrutiny. Indeed, Vespasiano reports that Bessarion was "pope for one night" because so high was his reputation among his peers that even his opponents, as they retired to bed, said to each other: "He will be pope, there's nothing we can do. Tomorrow, after the vote, we shall make the proclamation."[4] Bessarion would have made a fitting successor to Nicholas, no doubt using the papacy to promote his ambitions to unify Christendom, liberate Constantinople, and further humanistic studies. However, a last-minute challenge arose to his candidacy. He was vehemently opposed by a French cardinal who indignantly exclaimed: "So we'll give the Latin Church to a Greek pope, will we? . . . Bessarion hasn't even shaved his beard, and he's going to be our head?"[5] If the French cardinal's words are to be believed, Bessarion's long beard cost him the throne of Saint Peter.

Instead of Bessarion, the cardinals elected a seventy-seven-year-old Spaniard, Alfonso de Borja, who was installed as Pope Calixtus III. The election of this pious law professor caused some disquiet in Italy because of his links to his namesake, King Alfonso of Naples. Borja's skills as a diplomat and administrator had so impressed Alfonso that the king appointed him his secretary and then, in 1432, his principal advisor, and finally, in 1436, the tutor and guardian of his thirteen-year-old illegitimate son and heir, Ferrante. The Florentines, Milanese, and Venetians worried that, with the reigning pope now his close ally, King Alfonso would repudiate the Treaty of Lodi— the peace among Italy's major powers, to which he had added his signature only months earlier—and resume his aggressive territorial ambitions. As a Milanese ambassador wrote to the Venetians, the King of Naples might now become "more arrogant than ever."[6]

The humanists in the Roman Curia likewise had reason for unease. There was little chance that Calixtus, despite his contacts with the court of King Alfonso, would continue Nicholas's lavish patronage. His narrow legal education gave him scant sympathy for the humane letters of the scholars in the Curia, whom he was content to

ignore. When his audit of the Vatican coffers discovered that the papacy was some 70,000 florins in debt, he promptly canceled Nicholas's urban renovations, reduced his household expenditures, and began selling off many of the furnishings. At the dinner table one evening he spotted a golden salt cellar. "Take it away, take it away!" he commanded. "Use it against the Turk. Earthenware is good enough for me!"[7] His former master, King Alfonso, took the opportunity to acquire large quantities of gold and silver plate, gilt amphorae, a wine cooler, trays for sweetmeats, and other samples of the papal family silver.

An even worse fate, according to Vespasiano, befell the books collected by Nicholas. He claimed that when Calixtus first saw the collection of hundreds of books in their beautiful bindings of scarlet velvet with silver clasps he was astonished, "for he had never seen books bound in anything but rags." This was a reference to books written on paper (common among the Muslims and Jews in the pope's native Spain) rather than on parchment. Instead of praising Nicholas for his culture and wisdom, the new pope bitterly observed: "I now see how he squandered the assets of the Church." According to Vespasiano, Calixtus proceeded to "throw away" some of the books, while hundreds of others he gave to a cardinal, Isidore of Kiev, who, since he was "old and senile," allowed them to fall into the hands of servants and hangers-on who sold them for a fraction of their worth. "Such is the fate of precious things," Vespasiano glumly remarked, "that fall into the hands of those who fail to appreciate them."[8]

Calixtus had little interest, to be sure, in Nicholas's Greek and Latin manuscripts. However, Vespasiano's account was a distortion of events. The new pope did give orders to remove the metals and precious stones from the bindings of Nicholas's manuscripts, seeing them as an unnecessary extravagance that could be sold to fund worthy causes. But he did not dispose of the books as Vespasiano claimed, and most of the manuscripts collected by Nicholas are still in the Vatican Library, to which, in time, Calixtus bequeathed his own legal manuscripts.

Nor was Calixtus responsible for another deed forever linked to his name. After the new pope failed to value his literary talents, one of the humanists staffing the Curia, Bartolomeo Platina, spread

a story that has dogged Calixtus ever since, especially among astronomers and scientists who have used it as evidence for what they see as the credulous fancies of a benighted pope and his backward Church. In 1456, so the story goes, Calixtus excommunicated a comet (the one later christened Halley's Comet) and ordered church bells around the world to be rung every day at noon as an intercession against its pernicious influence. In fact, no such bull of excommunication was ever published, and the church bells were to be rung not against the comet but as a daily reminder to Christians of the threat of the Turks and the necessity of a crusade.[9]

A crusade against the Turks was Calixtus's most urgent and abiding concern. "The Pope," wrote an observer from Verona, "speaks and thinks of nothing but the crusade."[10] Calixtus swore a solemn vow to "the Holy Trinity, Father, Son, and Holy Ghost, to the Ever-Virgin Mother of God, to the Holy Apostles Peter and Paul, and to all the heavenly host," that he would do everything in his power, even sacrifice his life, to reconquer Constantinople. The city had been captured and destroyed, he declared in his vow, by the Sultan Mehmed II, "the son of the devil and the enemy of our Crucified Redeemer."[11] Scribes copied out the text of this holy oath, which was then sent to cities all over Christendom.

If Calixtus spared no money for manuscripts, he found plenty for ships. A month after his election he spent 200,000 ducats putting together a fleet, chartering galleys from the Catalans, and turning the quays along the Tiber into a busy shipyard. Sculptors who under Nicholas V had carved statues now made stone cannon balls—760 of them, plus another 9,000 smaller balls for handguns. The Vatican coffers paid for hundreds of crossbows, arrows, coats of mail, lances, swords, and pickaxes. The fleet of galleys set sail in September 1455, but rather than making its way to eastern waters to do battle with Mehmed's formidable navy, Calixtus's mighty fleet spent the autumn and winter in random acts of piracy against Venetian and Genoese ships in the waters off Sicily. Calixtus removed the commanders for these attacks on fellow Christians and for what he indignantly called "many other unspeakable acts."[12]

Other preparations for a crusade were in the meantime set in motion. Cardinals and ambassadors scurried around France,

England, and Hungary, and as far as Scotland, trying to raise troops and rouse enthusiasm. Sellers of indulgences and collectors of tithes fanned out across Europe to raise funds; so too did impostors who gulled "devout and ignorant people" into handing over their money.[13] Preachers exhorted their flocks to contribute to the defense of Christendom and, if possible, to join the crusade. In Florence, a Dominican friar named Giovanni da Napoli inspired six thousand people to march in processions through the streets dressed in white with red crosses on their chests "to intimate their readiness to become soldiers of the faith."[14]

In Naples, King Alfonso made ready to take the Cross, a ceremony in which in the presence of papal officials and the assembled Neapolitan nobility he would take a solemn vow to embark on a crusade. But when the day came for him to swear this holy oath he spotted in the wording certain legal niceties—"fine points and riddles" as well as "quibbles and cavils" and "tight knots . . . of canon law"— that gave him cold feet and persuaded him to call everything off.[15] Only the diplomatic intervention of Giannozzo Manetti, who negotiated with Calixtus from Naples, where he had joined Alfonso's court, managed to salvage the situation some weeks later. On November 1, 1455, All Saint's Day, Alfonso was finally invested with the Cross.

The man who rescued the crusade, Giannozzo Manetti, then fifty-nine years old, was the close friend and mentor of Vespasiano. For many years he had been at the heart of Florence's humanist movement, one of the men who gathered in Vespasiano's bookshop, "admirably disputing great things." The son of one of Florence's wealthiest merchants, he had studied alongside Tommaso Parentucelli, whose secretary he later became and for whom, when Tommaso became pope, he made translations from both Greek and Hebrew. He was a dedicated scholar, sleeping no more than five hours a night in order to devote more time to his studies. Like his friends Poggio and Leonardo Bruni, he was also a busy civic official, serving Florence numerous times as an ambassador to Venice, Genoa, Milan, Naples, and Rome. He took up the thankless post of governor of various Florentine dependencies such as Pistoia and Scarperia, where, as

Vespasiano observed, he "found everything in great disorder and full of deadly feuds."[16]

Manetti's greatest claim to fame was his treatise *On the Dignity and Excellence of Man,* which he completed in 1452 and dedicated to King Alfonso of Naples. The tribute was a rare diplomatic misstep on Manetti's part, because Alfonso was at war with Florence at the time, leading to mutterings in Florence of Manetti's treason. Vespasiano prudently waited until 1455 and the Treaty of Lodi before producing a copy of the

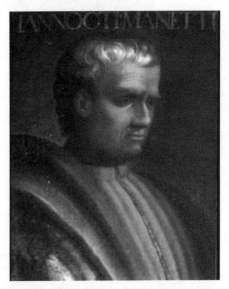

Giannozzo Manetti (1396–1459): scholar, businessman, diplomat, writer.

manuscript. As with the "Decades of the King," the manuscript was elegantly and expertly produced, featuring the "new antique letters" and white vine-stem decorations in which Vespasiano had come to specialize.

Manetti's treatise in many ways captured the spirit of the men who gathered in Vespasiano's shop and under the Roof of the Pisans. He was writing a response to a famous work composed in 1195 by a young nobleman, a cardinal named Giovanni Lotario, who three years later became Pope Innocent III. Cardinal Lotario's treatise, *On the Misery of the Human Condition,* put forth a bleak view of our life on earth. "Man has been formed of dust, clay, ashes and, a thing far more vile, of the filthy sperm," wrote Lotario. If such are our beginnings, our end, he noted, is even worse, for man is destined to become "the food of voracious, consuming worms," a "putrid mass that eternally emits a most horrible stench."[17] Manetti succinctly summarized what he called this "whole sorry work": Lotario offered a catalogue of human afflictions and excretions, from "sputum, streams of urine, mounds of excrement," to the brevity of life, the certainty of death, and "the many kinds of torments and the various other ills of this sort that afflict the human body."

Lotario was enlarging on the Christian idea that, because they decay and pass, we should not cherish earthly things but, rather, lay up our treasure in heaven. This theme stretched from Ecclesiastes ("Vanity of vanities, all is vanity") and Saint Augustine ("By what flood of eloquence can we suffice to detail and explain the miseries of this life?") through to Thomas à Kempis ("All pleasures on earth are either empty or foul").[18] Eternal life in heaven was what counted. Worldly things were contemptible, life on earth an ordeal of misery and suffering.

Manetti admitted that the flesh was certainly heir to all of the complaints listed in Lotario's gut-churning catalogue. But he opposed Lotario's earthly misery with visions of happiness and pleasure, showing that life on earth could be something more than a brief, brutal passage through a vale of tears. He suggested that, besides suffering from afflictions in our everyday life, we also enjoy many kinds of pleasure. In his view, scarcely any human action did not give "at least some little pleasure," and indeed the external senses often provoke "deep and intense pleasure." He countered Lotario's dire inventory of worldly afflictions with his own list of earthly delights: looking at beautiful bodies, listening to "sounds and symphonies and even more delightful things," smelling the scent of flowers, tasting "sweet and succulent viands," and even touching "the softest substances." (One of Manetti's various companies dealt in fine fabrics.) He brought in Aristotle, an author whom he had translated, as a witness for the defense, for in the tenth book of the *Nicomachean Ethics* Aristotle had written, as Manetti pointed out, that "men ought necessarily to find enjoyment while they are living."

To Manetti, all of these "pleasures and delectations" meant that rather than despairing over our earthly sufferings we ought to rejoice in the soothing and agreeable consolations on offer. Manetti's advice was, to be sure, that of a wealthy and educated Florentine who could afford to eat and dress well, even copiously and luxuriantly, and to while away the hours exulting over paintings in his well-appointed palazzo or listening to the soothing strains of the *lira da braccio* at his villa in the country. But if his treatise at times evokes a velvet-clad aesthete, it is nonetheless a sincere and unapologetic celebration of the

beauties and delights of art, nature, and the human intellect—and of a life on earth lived to the full.

Manetti was influenced by his readings of the ancients, generously citing in his defense authors such as Cicero as well as Aristotle. But he was clearly inspired, too, by his home city of Florence. God had created the world in six days, but since then humanity was responsible for discovering and adorning it. He used the frescoes of Giotto ("the best painter of his time"), the cupola of Brunelleschi ("the greatest architect of our age"), and the cast-bronze baptistery doors of Lorenzo Ghiberti ("the preeminent sculptor of our day") as evidence not only of pleasurable sights but of the divinity of the human mind—the excellence to which humanity, at its best, could rise. He concluded with a resounding endorsement of humanity as having "a nature and a destiny of dignity and excellence." Life on earth was to be celebrated and enjoyed, not disdained and grimly endured in hopes of its sole bonus, relief and respite in the afterlife.

According to a French historian writing in 1929, the Italian Renaissance was "the Middle Ages without God."[19] A century later, few historians would accept this formulation, and to understand Giannozzo Manetti's devotion to humane letters and earthly delights as remotely skeptical or anti-Christian would be a mistake. "Renaissance man remained a Christian, even a pious one," the historian Richard Trexler has cautioned.[20] Like other unabashed enthusiasts for the ancient world before him, such as Petrarch and Niccolò Niccoli, Manetti was a devout Christian for whom pagan teachings were meant to supplement Christian learning in order to reform and redeem a world contaminated by ambition, corruption, and self-interest. All of them believed that, while Christian teachings safeguarded the soul, the classical authors could rescue and improve civil society and grant pleasure to our earthly life. These pagan authors could also create better Christians, for the newly discovered and applied Greco-Roman learning was intended to reinforce the truths revealed in Christ.[21] It is telling that Manetti committed to memory not just Aristotle's *Nicomachean Ethics* but also Saint Augustine's *City of God*.

Manetti was able to celebrate human values and the nobility and wonders of the intellect without questioning the importance of religion. Far from being irreligious, he was an aggressively militant Christian, and one of the greatest biblical scholars of the century. At the request of Pope Nicholas V he did a new translation of the New Testament—the first since that of Saint Jerome a thousand years earlier—and only Nicholas's death put a stop to his translation of the Old Testament. He wrote an encyclopedic defense of Christianity called *Adversus Iudaeos et Gentes*, and so determined was he to convince the Jews to embrace the Christian faith that he learned Hebrew for the purpose of refuting and converting them. His Christian orthodoxy was unimpeachable. As Vespasiano noted, during a feast hosted in Florence by Andrew Holes, Manetti staunchly maintained in an argument with his fellow humanists that the precepts of Christianity were as true as the proposition that a triangle has three sides.[22] The dignity and excellence of the Renaissance mind was such that it could hold in a graceful equilibrium both the wisdom of the pagans and the doctrines of the Christians.

A year after completing his treatise, Giannozzo Manetti needed to cleave more closely than ever to both his religious faith and his cheerful prescription of sensuous pleasures as a balm to earthly woes. In 1453 he fled into self-imposed exile, leaving all of his possessions behind. His life served as an example, Vespasiano claimed, of how a man, no matter how successful, could suffer terrible reverses and suddenly lose everything he held dear—exactly the message, ironically, that Giovanni Lotario had wished to emphasize in his treatise on the misery of life.

The reason for Manetti's flight was a simple one: Vespasiano claimed he received "an unbearable tax bill" of 166,000 florins.[23] Lurking behind this crippling tax assessment was, Vespasiano believed, someone with "great authority over all the city": Cosimo de' Medici. Cosimo, it was said, used taxes rather than daggers to rid himself of his enemies. Indeed, the officials on the tax commission did his bidding, ruining his political opponents through eyewatering assessments. As a chronicler later wrote, the Medici did not permit a

fair and fixed method of taxation, but rather imposed taxes on individuals "according to their pleasure."[24]

Manetti became the most conspicuous victim of this abuse of power. For many years he had maintained cordial relations with the Medici, but his personal friendship with King Alfonso, along with his support for a Florentine political alliance with Venice rather than Milan, appears to have damaged his reputation with the regime.[25] Unwilling or unable to pay his crushing new taxes, he left Florence, going first to the court of Nicholas V in Rome and then, following the pope's death, to that of Alfonso. Nicholas and Alfonso both, in turn, paid him a pension, permitting him to eke out a few earthly delights. While living in Naples he wrote to Vespasiano to find him some manuscripts on canon and civil law "at a reasonable price." He also requested a copy of Cicero's *Letters to Atticus*.[26] His pleasure in exile would be found fingering pages of ancient wisdom.

Twenty years after he returned from exile, Cosimo de' Medici still ruled over Florence, as Vespasiano put it, "discreetly, with the utmost caution." His two sons, Piero and Giovanni, had been carefully groomed to take over from him. Piero, the eldest, born in 1416, was destined for politics whereas Giovanni, five years younger, was tipped to run the family bank. Cosimo made sure that both received excellent educations aimed at turning them into wise and effective leaders in both politics and commerce.

Both boys showed early interests in cultural pursuits. Giovanni was enrolled in the Guild of Bankers at the tender age of five, but he displayed less enthusiasm for the business of making money than for classical learning and the fine arts. According to a friend, he delighted in "books, ancient gems, musical instruments, and other cultivated activities."[27] He played musical instruments and penned poetry. He spent his stint at the Rome branch of the Medici bank in the 1440s happily amassing an enviable collection of ancient Roman statues and medallions.

Piero, too, became a passionate collector, maintaining his artifacts—ceramics, cameos, gems, Flemish tapestries—in a special study into which, crippled by gout, he would be carried in order to

ease his pains by (in an illustration of Manetti's thesis) feasting his eyes on objects of great beauty. Besides its precious artifacts, Piero's study also contained more than a hundred manuscripts. He began collecting them around 1440, in his mid-twenties, partly inspired by his father and partly in competition with Giovanni, likewise a manuscript hunter. Between them, the siblings put together in the palazzo they shared with their father one of the finest private libraries in Italy. Piero kept his books chained to benches in his beloved *studietto*, their rich bindings color-coded for ease of identification: blue for theology, yellow for grammar, violet for poetry, red for history, white for philosophy. He began keeping an inventory of this collection in 1456, complete with a description of which manuscripts were in humanistic script ("new antique letters") and which in Gothic, or what his scribe variously called *lectera moderna* and *licteris novis*— "modern letters." There is little question which style of script Piero preferred: over the years he weeded out copies of Seneca, Terence, and Cicero composed in "modern" Gothic script and replaced them with ones in "antique letters."[28]

Vespasiano acted as bookseller to both brothers. He arranged beautifully illuminated manuscripts for Piero as early as 1451, and by the mid-1450s he had his two finest scribes, Piero Strozzi and Gherardo del Ciriagio, working for Piero on such important commissions as Pliny's *Natural History*, Plutarch's *Parallel Lives*, and Livy's *Ab Urbe Condita*. He kept Piero apprised of his progress with a series of reports, one of which optimistically concluded: "And then we shall have finished all the books, by the grace of God."[29] For Giovanni, at this same time, Gherardo was also working on manuscripts of Cicero, Seneca, Catullus, and the Latin poet Tibullus. All of these manuscripts were executed in "new antique letters," and some of them, like the "Decades of the King," featured Vespasiano's latest innovation: title pages.

Piero added something else to the manuscripts in his collection. The final page of his manuscripts always featured an ex libris: LIBER PETRI DE MEDICS. COS. FIL ("The book of Piero de' Medici, son of Cosimo"). Poignantly, as more manuscripts were added to his library, the hand inscribing this ex libris steadily deteriorated, becoming cramped, blotchy, and feeble. This decline suggests that Piero

himself, known as *Il Gottoso* (The Gouty), was writing the bookplates, since manual infirmity due to painfully swollen joints is a debilitating effect of the gout from which he suffered so terribly that at times he could move nothing but his tongue.[30]

Little came of Pope Calixtus's crusade, which fell victim to competing interests, mutual animosities, lingering feuds, and outright battles. As Enea Silvio Piccolomini reported, "A new whirlwind arose to torment that sinful land"[31]—the ambitious Umbrian warlord Jacopo Piccinino. The Treaty of Lodi began to fray at the edges thanks to the determined efforts of Piccinino, for whom peace was bad for business. He had been the highest-paid soldier of fortune in Italy, having signed up to fight for the Venetians in 1453 for an unheard-of annual salary of 120,000 ducats. Concerned about losing this lucrative business thanks to the unaccustomed peace, and eager to carve out a principality for himself, he moved into Sienese territory, stirring up trouble by seizing four castles. After his forces were quickly repelled by the troops of the pope and the duke of Milan in 1455, he beat a swift retreat to Castiglione, a town on the coast, where he hid himself away, "living only on wild plums."[32]

Matters may have rested there but for the fact that Castiglione was in territories controlled by King Alfonso, who remained grateful to Piccinino for his help in conquering Naples in 1442. Calixtus excommunicated Piccinino, regretting that he had spent 70,000 ducats—"which would have been better expended against the Turks," as he lamented[33]—dealing with the pesky soldier of fortune, who, breaking out of Castiglione, even tried to set fire to Calixtus's fleet of ships. However, Piccinino was aided and abetted by King Alfonso, who was plotting to use his forces to attack Sigismondo Malatesta, lord of Rimini, one of the few Italian potentates not signed on to the Treaty of Lodi. So poor did Alfonso's relations become with the pope, his old advisor, that he banished from the kingdom all of Calixtus's relatives, the Borjas, better known to the Italians as the Borgias.

Chapter 13

The Spirit of Plato

Around the time Vespasiano reached his fortieth birthday in 1462, a humanist in Milan wrote that the most beautifully made books came from Florence. "There is one Vespasiano there," he wrote, "an excellent bookseller, with expert knowledge of both books and scribes, to whom all of Italy and foreigners as well resort when they want to find elegant books for sale."[1] According to one of his scribes, Vespasiano was *princeps omnium librariorum florentinorum* (prince of Florentine booksellers). One client simply declared him *rei de li librari del mondo*— king of the world's booksellers.[2]

Recent clients of Vespasiano included János Csezmiczei, a Hungarian poet and scholar better known as Janus Pannonius. He first came to Florence in 1458 at the age of twenty-four, drawn, Vespasiano claimed, by "the city's many illustrious men." The first Florentine he wished to meet was Vespasiano, "because he knew I could introduce him to all the learned men." Vespasiano already knew Pannonius by reputation. "Are you indeed the Hungarian?" he asked in wonder at the square-jawed, serious-looking youth who was already famous for his scholarly brilliance. ("He was also famous," Vespasiano noted, "for never having slept with a woman.") Vespasiano duly presented Pannonius to distinguished citizens such as Poggio and Cosimo de' Medici, the latter of whom found the young man's company a "great pleasure" and pledged to do all he could for him.[3] Vespasiano served Pannonius in another capacity, since he spent many hours in the bookshop, engrossed in Vespasiano's manuscripts, many of which he bought for the library he was planning back in Hungary.

Another customer was an Englishman, John Tiptoft, the duke of Worcester. An Oxford graduate, Tiptoft passed through Italy for

the first time in 1458, at the age of thirty-one, while on a pilgrimage to the Holy Land. Over the course of a long sojourn he studied at the university in Padua, translated works by Cicero into English, traveled to Rome with the express purpose of seeing the Vatican Library, and moved Pope Pius to tears with a beautiful oration in Latin. He returned to Italy two years later, making his way to Florence—and to Vespasiano's bookshop—with the aim of stocking the University of Oxford's library with a choice collection of the Latin classics.

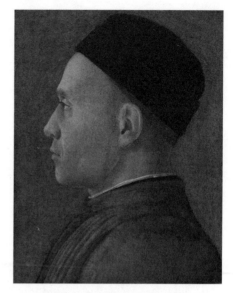

The "young Hungarian," Janus Pannonius (1434–1472).

He acquired what Vespasiano called "a goodly number," many from Vespasiano himself, who knew him as Messer Giovanni di Worcestri.[4]

Tiptoft had a passionate desire, as another Italian friend noted, to "adorn England with handsome monuments of books."[5] But his subsequent political career proved a huge disappointment to Vespasiano. The accession in the summer of 1461 of King Edward IV, a Yorkist, took Tiptoft back to England, which, as Vespasiano observed, "was not in a peaceful state," divided (in what came to be known as the Wars of the Roses) between the rival claims of the houses of Lancaster and York. As constable of England, Tiptoft became notorious for his brutal vengeance against the Lancastrians, earning a well-deserved reputation as "that horrible beheader of men."[6] He once had twenty men hanged, drawn, and quartered, their butchered remains impaled upside down on spikes. As deputy governor of Ireland, he executed his predecessor, the Earl of Desmond, on a charge of treason and, for good measure, had Desmond's two infant sons put to death. "So many great men know not how to control themselves," Vespasiano observed sorrowfully of his friend. When the Lancastrians gained the upper hand, Tiptoft was captured (disguised as a shepherd and hiding in a tree) and then marched to the executioner's

block on Tower Hill. As a friend in England noted, "The axe then did at one blow cut off more learning than was left in the heads of all the surviving nobility."[7]

Vespasiano now lived in a grand residence on the south side of the Arno, near the Ponte Vecchio, a fifteen-minute walk from the Street of Booksellers. The eldest of his three brothers, Jacopo, the medical doctor, had purchased the house from a member of the Bardi family, wealthy bankers who at one point owned more than twenty homes in the neighborhood. The street had once been among the poorest in Florence, known as Via Pidigliosa, a corruption of *pidocchioso* ("lousy"). Then the Bardi moved into the area and built a series of palaces. Lousy Street became Via de' Bardi.

Jacopo da Bisticci had become rich and successful as a physician. Some nine years older than Vespasiano, he originally trained as a goldsmith but switched to medicine in the 1440s, his sudden career change perhaps inspired by his friendship with a famous Florentine physician with the resonant name Galileo de' Galilei Buonaiuti.[8] Jacopo soon became even more renowned than his mentor: a Venetian called him "the supreme monarch of medicine . . . so courted by all the nobles, lords and princes of Italy as if he had been the oracle of Apollo."[9] Among his patients was Malatesta Novello, the feudal lord of Cesena, whom he treated for an embolism in his leg so Malatesta could get back to the business of soldiering. Malatesta also happened to be one of Vespasiano's many customers.[10]

Another brother was also a high achiever. Filippo, the youngest Bisticci, born after his father's death, had become a Franciscan friar whose piety and erudition would soon see him elevated to become guardian of the convent of La Verna, the sacred place where in 1224 Saint Francis had received the stigmata. The other Bisticci brother, Lionardo, three years older than Vespasiano, seems to have accomplished considerably less than his talented siblings: *Lionardo non fa nulla,* his tax declaration once frankly declared—"Lionardo does nothing."[11]

Several generations of the family shared the house on Via de' Bardi, including the long-widowed Mona Mattea, now in her sixties,

her days of crippling debts, cheap lodgings, and seized possessions far in the past. Also in residence was Jacopo's wife, Andrea, who had married into the family in 1440 when she was twelve. She and Jacopo had a son, Lorenzantonio, still a schoolboy. Two slaves provided domestic assistance, one a man, a Moor named Sismundo, and another a woman whom Jacopo had purchased for thirty-two florins: less than the price of one of Vespasiano's finer manuscripts. Jacopo's tax return called her *una schiava tartara, trista*—literally, "a Tartar slave, sad," although property inventories often used the word *triste* to indicate something old or worn out, and so Jacopo may have been referring to her usefulness rather than her demeanor.[12] Slaves could be traded or purchased in Florence only if (as the city's rulers decreed in 1366) they were "of infidel origin," for slavery was deemed to be the infidel's just reward. Sismundo and the Tartar (from central Russia) would have been Christian converts because the statutes of cities such as Florence insisted on the baptism of slaves ("like baptizing oxen," sniffed one Florentine writer and politician).[13] They could be kept as slaves even after baptism, since becoming a Christian did not in itself lead to emancipation. Slaves, it was held, did not possess free will, and slavery was, as a Florentine archbishop once confidently declared, "instituted by divine law."[14]

Despite having reached their forties, Vespasiano and Lionardo remained unmarried. This status by no means made them unusual in Florence, where almost one in five men remained single, in part because men outnumbered women in the city: roughly 120 men for every 100 women.[15] Vespasiano held firm views (as we shall see) on the role and conduct of women in general and wives in particular. He may have possessed the disdain for marriage expressed by scholars such as Boccaccio, who believed Dante's marriage led to his ruin, or Niccolò Niccoli, who thought a wife (but evidently not his mistress, Benvenuta) an impediment to study. Poggio had initially opposed marriage on similar grounds, though he happily fathered various illegitimate children. In 1436, however, at the age of fifty-six, he wed an eighteen-year-old of, as he boasted, "exceptional beauty."[16] He came to enjoy married life so much that the following year he wrote a treatise, *On Whether an Old Man Should Marry*. His answer was enthusiastically in the affirmative.

Besides the house in Via de' Bardi, the Bisticci family owned other houses in Florence, including (according to their tax declaration) "a house with a garden for our own use" near the Porta San Giorgio, a ten-minute walk uphill from Via de' Bardi.[17] Another they rented out to tenants. They still owned the farm at Antella, a few miles outside the city, having long ago purchased back the plots seized by creditors following the death of Pippo. Vespasiano often retreated to this property during the heat of the summer or to escape the plague that visited Florence every two or three years.[18] He could have traveled on the back of either a mule or a horse: the family owned two of each.

Sometimes Vespasiano escaped the heat and pestilence at grander country homes, where he and his friends gathered for literary and philosophical discussions of the sort pioneered years earlier by Niccolò Niccoli. Twice a year a scholar and diplomat named Franco Sacchetti hosted three-day retreats at his sumptuous villa outside Florence, to which he invited what Vespasiano called "ten or twelve literary gentlemen, the finest in the city." After reeling off the members of this distinguished party—a roll call of well-educated young men, the upper crust of Florentine literary society—Vespasiano did not hesitate to mention another regular participant: "I, a humble scribe, was included in this group of worthy men." He took pains to point out that at these gatherings "no harmful gambling took place, as happens in so many other villas."[19]

Few gatherings of worthy men took place without Vespasiano present. He was also invited to an even more exclusive group, one that gathered at the Castello di Montegufoni, an imposing twelfth-century stronghold that consisted of seven houses on a hill encircled by a thick wall. This sturdy complex was owned by the illustrious family of two of his closest friends, the brothers Piero and Donato Acciaiuoli.

Piero and Donato were among those who gathered at Franco Sacchetti's villa. They came from, as Vespasiano proudly noted, "one of the noblest families in the city."[20] He was awed by the great wealth and exotic history of the Acciaiuoli. Their surname suggests that at

a distant point in the past some members had been metalworkers (*acciaio* means steel). For the past 150 years, however, their illustrious ancestors had been bankers, counselors to kings, and lords of Corinth, Thebes, and Athens (the family still owned a stately fortress on the Acropolis). Piero and Donato's father died when they were infants, after which their mother, Maddalena, married Felice Brancacci, the wealthy merchant who commissioned Masaccio and Masolino to paint the fresco cycle (later, much admired by Michelangelo) in the family chapel in Santa Maria del Carmine. In 1434 Brancacci was exiled for his anti-Medici activities, but Maddalena stayed in Florence with the boys and took charge of their education, making certain they were beneficiaries of the new humanist culture. Vespasiano's friendship with Donato became especially strong. Donato sometimes addressed him in letters as "*Vespasiano mio dolcissimo*"—my sweetest Vespasiano.

Like Vespasiano's bookshop or Sacchetti's villa, the Castello di Montefugoni hosted serious philosophical discussions. Besides Vespasiano and the Acciaiuoli brothers, other guests included Giannozzo Manetti, who was related by marriage to Piero and Donato. Their exchanges roamed over a wide range of subjects. One of them was very topical: the link between the plague and the dirty streets of Florence. The causal relation between civic hygiene and disease was much debated in the middle of the fifteenth century.[21] If not seen (as it still was by some) as an act of a wrathful God, the plague was usually explained by "corruption theory": the quality of air in a city or neighborhood became toxic due to the wind, the proximity of a swamp or other unhealthy terrain, or a failure to bury the dead promptly. The authorities took measures such as cleaning the streets, collecting rubbish, flushing the sewers, and speedily disposing of corpses. A new theory, however, had recently been ventured by a doctor from Parma who claimed the plague was spread not by noxious air but through contagion, that is, from person-to-person contact, especially among the poor. If they subscribed to this latest theory, Vespasiano and his friends fled not Florence's pernicious emanations but its poor inhabitants—what a doctor from Padua called "squalid, public, or sordid people such as butchers, meat sellers, innkeepers, bakers, grocers and the like."[22]

Other debates at the Castello di Montefugoni covered less practical matters. One involved who came first, Moses or Homer; another, the fate in the afterlife of babies who died unbaptized. This latter subject witnessed Vespasiano arguing against Manetti. The latter took the Church's position that Original Sin was congenital, that the lust of the parents at the moment of conception was passed to the child, and that the baptism of infants was therefore necessary for their salvation. Vespasiano, on the other hand, believed that since God was just, He would not punish children for the sins of their parents. The disagreement was amicable, though Vespasiano clearly did not give ground even beneath the authority of the Church and the crushing weight of Manetti's erudition. A few months later Manetti wrote to Vespasiano praising his eagerness to learn and his interest in theological matters. He hoped, he claimed, to further discuss the issue of infant baptism with him.[23]

The great passion of the Acciaiuoli brothers was for Greek philosophy. However, despite the arrival of Byzantine émigrés in Italy following the conquest of Constantinople, Greek studies in Florence were on a downward slope. In the early 1440s a Byzantine scholar named George of Trebizond briefly taught at the Studio, besides offering, Vespasiano claimed, private lectures in his home. Vespasiano no doubt attended both the private and public lectures, and George was, furthermore, one of the scholars who gathered for debates in his bookshop. He proved a great success at the Studio. "No one in Florence was more useful for teaching," Vespasiano reported.[24] But George soon left Florence for a more lucrative post in the Roman Curia. Cardinal Bessarion and Niccolò Perotti had likewise been lost to Rome, while Florence's golden generation of Greek scholars and translators—Bruni, Traversari, Marsuppini—all were dead.

Eager for tuition and discussion, Vespasiano and various friends, including Piero and Donato, began yet another literary group. They gathered at the Florentine palazzo of a wealthy young patrician, Alamanno Rinuccini, one of George of Trebizond's former students in the Studio and a member of Sacchetti's circle of literary gentlemen. The group called themselves the "Accademia" in imitation of the famous school founded by Plato on the outskirts of Athens. But this little academy of learning still needed a teacher, and so in 1456, with

the help of Cosimo de' Medici, they lured to Florence a scholar named John Argyropoulos. He became known to Vespasiano as "Messer Giovanni."

Little is known about John Argyropoulos's early life and career, even about when he was born (probably around 1405) or when he first came to Italy (probably around 1441).[25] He seems to have worked as a schoolmaster in Constantinople before moving to Padua to study philosophy and medicine, earning money by copying manuscripts and then, in 1444, matriculating with a doctorate in philosophy. He returned to Constantinople to lecture at the school attached to a hospital, where he was recognized by his students as an expert on the "throbbing of inflamed parts."[26] With the Ottoman conquest in 1453 he returned to Italy, becoming part of the diaspora of Greek scholars.

Argyropoulos began lecturing on Aristotle at the Studio, bringing, according to Vespasiano, "the greatest benefit to the citizens."[27] Vespasiano and the Acciaiuoli brothers were among those who benefited, even receiving private tutoring from Argyropoulos. When plague broke out in 1457, Piero and Donato installed Vespasiano in the Castello di Montegufoni and Argyropoulos in a nearby villa. Here the three Florentines visited Messer Giovanni twice daily for philosophical discussions and, according to Vespasiano, provided him and his family with "all the necessities of life."[28] This hospitality was welcome because the Studio, in the midst of one of its usual financial crises, had so far failed to pay Argyropoulos any of his salary.

The informal philosophical discussions continued when the group returned to Florence. Vespasiano participated as a regular and enthusiastic member, as did, for a time, John Tiptoft. On one occasion when Donato Acciaiuoli was away from town on a diplomatic mission, a young friend of Vespasiano named Pierfilippo Pandolfini wrote to Donato, telling him of a remarkable Sunday afternoon visit that he and Vespasiano made to Messer Giovanni's home. After finding him reading Greek philosophy to friends, they followed in his wake as he strolled through Florence—an imitation of how Aristotle taught as he ambled through the *peripatoi*, or covered walkways,

of the Lyceum (from which came the name of his followers, the Peripatetics).* The company ended up at the church of Santissima Annunziata, where they sat around a well in the garden, still discussing philosophy.

Pierfilippo did not say so, but given the course of the conversation the company clearly discussed the incident for which the church was famous. In 1252 a monk named Bartolomeo was working on a fresco of the Annunciation, showing the Archangel Gabriel announcing to the Virgin Mary the glad tidings that she would conceive the Son of God. Bartolomeo struggled with his composition, unable to capture the rare beauty of the Virgin. After falling into a fitful sleep, he awoke to discover that his painting had been expertly completed with a ravishingly beautiful image of Mary—the handiwork, clearly, of an angel.

The result of this miraculous portrait was that Santissima Annunziata became a shrine at which pilgrims began leaving votive offerings as thanks for healings, answered prayers, and future protection. Many shrines in Italy were served by local pharmacies selling anonymous wax limbs or other body parts for pilgrims to leave behind as pious bequests. Santissima Annunziata, on the other hand, specialized in full-size wax portraits. Grateful pilgrims could commission from the workshop run by the Benintendi family lifelike effigies dressed in their own clothing and accessorized with hats and ornaments. In 1441 the warrior Erasmo da Narni, known as Gattamelata (Honey Cat), paid to have himself depicted on a wax horse, while the wax avatar of another soldier of fortune, Pippo Spano, was kitted out in full battle gear. These statues had become so numerous by the middle of the 1400s—they swarmed up the nave, down the side aisles, into the upper galleries, and some even hung from the ceiling— that they endangered the structural integrity of the building. As for the miraculous image itself, Piero de' Medici had recently hired Michelozzo to construct a tabernacle for its protection.[29]

*Another Greek school of philosophy also took its name from an architectural feature: the group who congregated for lectures in a mural-covered porch (*stoa poikilê*) in the Agora at Athens became known as Stoics.

The Annunciation became a topic of conversation for Messer Giovanni and his students when, by happy coincidence, a learned scholar emerged from the Annunziata church. He and Messer Giovanni soon began discussing the nature of angels. Angels existed—everyone knew that—and the question under consideration was whether Gabriel's voice, when he addressed the Virgin Mary, had been spiritual or corporeal.

Whether or not angels possessed physical bodies was a subject much discussed over the centuries. Saint Augustine, Origen, Gregory the Great, Bernard of Clairvaux, Saint Bonaventure—all had maintained that angels did possess physical bodies because only the Father, the Son, and the Holy Spirit could exist without material substance. Aquinas argued the contrary view. Known as *Doctor angelicus* (Angelic Doctor), he spent much time in *Summa Theologica*, composed between 1265 and his death in 1274, discussing the nature and activities of angels and, in doing so, offering the sort of complex and abstruse demonstrations that centuries later, in 1638, the Oxford scholar William Chillingworth would mock as debates about "whether a million angels might not sit upon a needle's point."[30] For Aquinas, angels were wholly spiritual beings. "The angels have not bodies naturally united to them," he declared. This spiritual nature meant that when they spoke (as the Holy Scripture clearly described them doing) they gave only "a semblance of speech, in so far as they fashion sounds in the air like to human voices."[31]

Messer Giovanni's opinion was called for that Sunday afternoon because, as in so many other places, Aquinas used Aristotle's metaphysical framework to defend his position. The scholar at Santissima Annunziata no doubt relished the opportunity to hear an expert on Aristotle explicate Aquinas's position on angelic bodies. The results were evidently impressive. "Oh Donato, I wish you had been there," Pierfilippo wrote. "Argyropoulos's great stature both as philosopher and theologian was plainly revealed."[32]

Argyropoulos's position at the Studio was specifically to teach Aristotle. Donato Acciaiuoli's assiduous notes, scribbled in class and then copied neatly back at home, possibly in consultation with Messer Giovanni himself, show that he lectured on the *Nicomachean Ethics,*

the *Physics,* and *On the Soul,* and that on feast days he gave readings from the *Politics.* He soon began flirting with scandal, for during his lectures he was audacious enough to correct Leonardo Bruni's translations and offer his own. As he put it, he started "to make a more elegant translation of some treatises by Aristotle" so that the great philosopher would finally appear "in the form in which he wished to appear."[33] Such denigration of the great man did not go unnoticed, and Argyropoulos was quickly warned by Francesco Filelfo—who knew much about the degrading savagery into which scholarship could descend—that he best be careful since people had started murmuring against him.[34] Such quibbling about Bruni's translations aside, Argyropoulos's lectures were a triumph. "Now for the first time," enthused one of his students, "I have begun to admire Aristotle as the prince of philosophers."[35]

In Florence, however, this prince of philosophers was about to be dethroned. Argyropoulos had been encouraged in his efforts by Cosimo de' Medici, who provided him with a house on Via Larga, not far from his own palazzo. Cosimo was repaid for his generosity by becoming the dedicatee of Argyropoulos's Latin translation of Aristotle's *On the Soul,* done in about 1460. Following his Aristotelian studies, however, Cosimo discovered that he wished to study philosophy more deeply—to go back beyond Aristotle to learn "the inner secrets of wisdom itself." As luck would have it, wrote a scholar of the day, help was at hand since "the spirit of Plato, who had dwelt in Byzantium since antiquity," had come "flying to Italy and, in particular, to Cosimo."[36]

For more than twenty years Cosimo de' Medici had kept possession of the manuscript of the complete works of Plato acquired during the Council of Florence in 1439. This codex, still untranslated, was among the most valuable of all those in the family palazzo on Via Larga. To give a sense of its worth, a number of years later a Byzantine codex of Plato's works, and not even a complete set of the dialogues at that, would be sold in Milan to a Bohemian nobleman for 2,000 florins.[37] It was a huge sum considering the annual salary of the Florentine chancellor was 300 florins.

Cosimo's codex was all the more valuable to him, no doubt, because of its connection to the legendary Byzantine sage George Gemistos Pletho, on the words from whose "fervid lips" he had hung during philosophical discussions in Florence. At some point Cosimo loaned the codex to Cardinal Bessarion for a copy to be made as part of his mission to rescue and preserve Greek culture. Vespasiano would have been a natural choice as intermediary between the two men, although no evidence survives. Otherwise the codex remained chained in Cosimo's library, its cover groaning open, its leaves turning in raspy whispers, whenever Cosimo showed it off to a reverent audience of scholars and visiting dignitaries.

Like Petrarch with his Homer manuscript, Cosimo was unable to read his precious codex. Translations of Plato had proceeded only fitfully in the decades since the Council of Florence, and fewer than half of the thirty-six dialogues had been translated into Latin. By 1462 Cosimo had found a translator for his codex: the son of his favorite physician. Recognizing his brilliance years earlier, Cosimo had begun preparing him "while still a boy" as the future translator of the Plato codex, educating him "from that day forth" in preparation for the monumental task.[38]

That, at least, was the story later told by this prodigy himself, a short, yellow-haired, hunchbacked scholar named Marsilio Ficino. If Ficino's story may be doubted, his unique brilliance cannot.

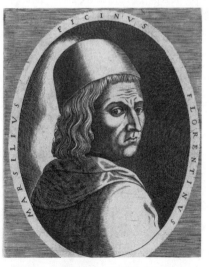

Ficino had been born in October 1433 in Figline Valdarno, a village on the banks of the Arno some twenty miles southeast of Florence. His birth coincided, he explained, with a nefarious conjunction of planets—Saturn in the house of Aquarius—that gave him a gloomy temperament and bouts of severe depression. His

Marsilio Ficino (1433–1499): doctor and philosopher, healer of bodies and souls.

father was a respected physician at Santa Maria Nuova, the hospital near Florence's cathedral, where he specialized in treating fractured skulls, a lamentably common injury in Florence due to the many violent street brawls that plagued the city. He experimented with remedies such as an unguent made from bear fat, myrrh, almonds, and turpentine. "It works miraculously," another doctor happily reported of this concoction.[39] He became, along with Jacopo da Bisticci, one of the most sought-after doctors in Florence, treating members of many of the city's richest families, including the Medici.

Marsilio studied grammar in his tiny hometown before arriving in Florence in the 1440s to study medicine. He would have read authors such as Galen and Hippocrates, studied anatomy, and witnessed the dissections of cadavers—two per year, one male and one female, each an executed criminal. Ficino had enormous respect for the medical profession, later writing that "it is impossible to discover any branch of learning more excellent."[40] But during his medical studies he found himself introduced to large chunks of the old-fashioned hair-splitting Aristotelian logic. On the other hand, he found in works such as Leonardo Bruni's translations of Plato a much more honest and agreeable philosophy, one that was, he believed, "liberal and pleasant . . . and worthy of a learned and noble man."[41] If Aristotle would help him, as a doctor, to heal bodies, with Plato he would become a healer of souls.

No evidence suggests that Ficino was, as he later claimed, talent-spotted as a callow youth by Cosimo, then taken under his wing and carefully primed for his providential mission of restoring Plato's wisdom to the world. Rather, at the age of about twenty he abandoned medicine and began working as a tutor to a member of the wealthy Pazzi banking family. By the second half of the 1450s, dedicating himself to philosophy and letters, he began churning out treatises: works in Latin on economics, pleasure, magnificence, and justice, and works in Italian (the *volgare*) on the appetite, divine fury, and comfort for parents whose children have died (the infant mortality rate in Florence was almost 25 percent).[42] In 1456, building on his interests in Plato, he wrote a work called *Institutiones ad Platonicam Disciplinam* ("Exercises in Platonic Instruction"). Then in 1457, the better to read his beloved Plato's works in the original, he began studying Greek.

At this point Ficino suffered a spiritual crisis of a sort virtually unknown to Florentine humanists: he became worried that the study of pagan philosophers such as Plato might imperil his soul. "Tarry not in turning yourself back to the knowledge of God," one of his friends, a future bishop, advised him, "and leave Plato and others of his sort behind."[43]

Plato had been in especially bad odor around the time of Ficino's crisis in the late 1450s. Decades after Leonardo Bruni found certain aspects of Plato "repugnant to our customs," suspicions of turpitude still clung to the dialogues. Ficino's misgivings coincided with Mehmed II's avowed admiration for Plato: visiting Athens in 1458 following its capture by his forces two years earlier, the sultan made a point of pitching his tent in an olive grove near the Academy. Ficino's misgivings also coincided with a polemic by George of Trebizond, who, like Bruni, had worked on translations of Plato only to turn away in revulsion. A reading of the *Gorgias* as a young man convinced George that Plato was "an enemy of all good things," a monster of "ingratitude, impudence, and wicked impiety."[44] In 1458, alarmed that Plato's malicious ideas were taking hold in the West, he composed a treatise entitled *Comparatio Philosophorum Platonis et Aristotelis* ("A Comparison of the Philosophers Plato and Aristotle"). A modern scholar has called this work "among the most remarkable mixtures of learning and lunacy ever penned."[45] Plato was responsible, in George's eyes, for the fall of the Roman Empire, whose collapse was due to "depraved Platonic hedonism." Further, Plato was behind all of the heresies within the Church as well as being answerable, George maintained, for the rise of Islam. Mohammed was nothing other than a "second Plato," having been contaminated with this "perverse philosophy" by a monk expelled from Alexandria because of his hedonistic Platonic ideas. Now Plato was spreading his deadly tentacles into the West, thanks to the efforts of George Gemistos Pletho, "the apostle of a revived paganism"—a claim that, unlike the others, at least had some basis in truth. Soon, George predicted, a "fourth Plato" would make himself known, undermining Christianity with his evil creed of hedonistic pleasure. George's modern biographer speculates that this fourth Plato was either the Antichrist or Cardinal Bessarion.[46]

George's attack may have been an absurd and alarmist carica-
ture, but the charges were serious enough to rouse Cardinal Bessar-
ion to begin composing a vigorous defense of Plato, which in due
course he would send to Ficino. Help for Ficino also came from an-
other quarter. Hoping to divert the young man from Plato, the arch-
bishop of Florence, a friend of his father, pressed into his hands a
work by Thomas Aquinas, *Summa contra Gentiles*. This may have been
the moment when Ficino's destiny revealed itself to him. For just as
Aquinas had spent his life laboring to reconcile the writings of Aristo-
tle with the doctrines of Christianity, Ficino would take it upon himself
to do the same for Plato. As he would later write with typical mod-
esty: "We have been chosen for this work by divine Providence."[47]

Chapter 14

Uomini da Bene e Letterati

It is a day early in 1462. Vespasiano receives a summons to the palazzo in Via Larga from which, due to his crippling and painful gout, the seventy-three-year-old Cosimo de' Medici seldom stirs. The walk from the bookshop takes him no longer than ten minutes, a stroll bringing him north along the Street of Booksellers and Via dei Balestrieri before, as the narrow street gapes onto a broad piazza, the cathedral rears its massive bulk before him. Walking along the building's southern flank he passes, on his left, the narrow street leading to the Studio Fiorentino. On his right soars the marble-clad bell tower designed almost 130 years earlier by Giotto, its bells observing the hours with sonorous gaiety.

A right turn at the base of the tower brings Vespasiano into the space between the octagonal baptistery and facade of the cathedral—a spot known as the *paradiso* because of the bodies buried there during the Middle Ages. To his left, the baptistery's gilded bronze doors gleam in the winter sunshine while, on his right, statues of the Four Evangelists, each clutching a book, flank the cathedral's entrance. From this point, though still more than two hundred paces distant, the Palazzo Medici can already be seen, turned at a slight angle to the approaching street like a great ship heaving ponderously into dock.

This immense palace was begun in 1446 by Michelozzo after Cosimo bought the properties surrounding the sprawling complex of family homes on Via Larga and, according to legend, rejected a plan by Filippo Brunelleschi as too extravagant and therefore likely to inspire envy (Brunelleschi reportedly responded by angrily smashing his model).[1] Michelozzo's palazzo is certainly spectacular enough. In

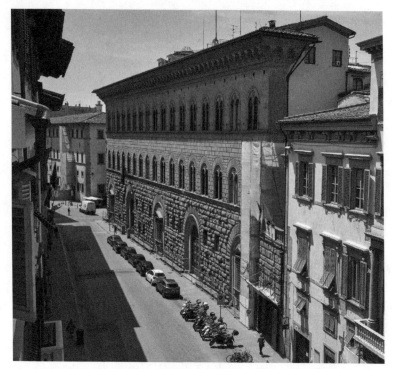

The Palazzo Medici-Riccardi: "the most finished and ornate
that the world has ever had."

1459, a few years after its completion, a visitor from Milan extolled
its splendors. "Everyone is agreed," he wrote, "that this house is the
most finished and ornate that the world has ever had or may have
now, and that it is without comparison." The Palazzo Medici was sim-
ply, he claimed, an "earthly paradise."[2]

Vespasiano is admitted to this paradise through a grand portal
in the fortress-like facade of buff-colored stone, then enters an ar-
caded central courtyard in the center of which Donatello's nude
and androgynous young David, cast in bronze, muses over the sev-
ered head of Goliath. Beyond lies a serenely beautiful courtyard gar-
den planted with laurel, myrtle, and box hedges; orange trees stand
in pots. A fountain in the center of the garden features a second Do-
natello bronze: another decapitation scene, this one showing a sword-
wielding Judith about to deliver the coup de grâce to the seated,
drunken Holofernes.

Ushered up a flight of stone steps, Vespasiano reaches the *piano nobile*, the "noble floor" of the palazzo. He has climbed these steps many times over the decades, for meetings with both Cosimo and his sons. More recently he has come for discussions with John Argyropoulos. Messer Giovanni, as Vespasiano will later record, often visits Cosimo "with certain of his scholars." Topics of discussion include the immortality of the soul and "other philosophical and theological matters."[3]

Even so, no matter how many times Vespasiano visits, the palazzo can never fail to dazzle and delight. The salons and chambers are, as a visitor remarked, designed with "admirable mastery": decorations in gold and marble, inlaid wood, paintings done "by the most accomplished and perfect masters." Tapestries, silverware, alabaster and porphyry carvings, the ceiling in the grand salon frescoed with a starry sky: each room is like an opened treasure chest. There are, besides, "bookcases without number." Here Vespasiano might pause in his progress, detained amid the marvels of the palace by the sight of what a poet, praising the many adornments, called a collection of "highly ornate books."[4] A good many of them, especially those owned by Piero and Giovanni, have been produced and bound by Vespasiano. And manuscripts, unsurprisingly, are the reason for Vespasiano's latest summons to the Palazzo Medici. Cosimo has found a new task for him.

Some ten years earlier a scholar declared the "celebrated monastery of San Marco" to possess "a library surpassing all others now in Italy."[5] By the early 1460s Vespasiano was still doing sporadic jobs at the convent: binding and repairing volumes, hiring scribes for the friars, supplying quires of ruled goatskin parchment. But his work was mostly completed as the cypress shelves in the reading room were now furnished with more than a thousand volumes. Though these manuscripts were available to the public, strict lending conditions applied: the friars were able to loan books only if they first asked permission from Cosimo. Any friar who allowed volumes to leave the premises without Cosimo's express consent was, as the Dominicans informed Vespasiano, "under penalty of excommunication."[6]

Cosimo was not yet finished with the lavish patronage of religious institutions that, so he hoped, would settle his considerable debt to God. Altogether he would spend the staggering sum of some 600,000 florins on buildings and charities.[7] By the early 1460s his latest project was the rebuilding and enlargement of a monastic complex in Fiesole, a forty-five-minute walk uphill from Florence's northernmost gate. Fiesole had once been an important Etruscan settlement, but in recent decades its heights had become a favorite haunt for wealthy Florentines, who built on the gentle slope of the hillside, among the cypress and ilex, beautiful villas with spectacular views of the city and what one poet, gazing down from Fiesole, called "the curves of the long Arno."[8] In the 1450s Cosimo's son Giovanni had built himself a villa here that featured a terraced garden cut into the slopes—"a fine place," a contemporary called it, "where he could seek refreshment when he wanted to take the country air."[9]

Cosimo had already funded the upkeep of some caves and a cluster of buildings in Fiesole that for the past century had housed a colony of hermits. Now he turned his attention to the Badia Fiesolana, an abbey dating back to the eleventh century and occupied since 1440 by Augustinians. Cosimo undertook to refurbish the twelfth-century chapel, along with the loggia, chapterhouse, cloister, dormitory, and sacristy; the latter he adorned with hangings and chalices. He also built a spacious guest apartment for himself on the ground floor, conveniently near the refectory. No expenses were spared after work started in 1456. Vespasiano claimed that when Cosimo was presented with annual accounts for both the Badia and another of his charitable projects, the church of San Lorenzo, that revealed how officials at the Badia had spent 7,000 florins while those in charge of San Lorenzo only 5,000, he replied: "Those at San Lorenzo deserve great blame, since it shows they haven't done much work. Those at the Badia are to be praised."[10] Once again, Cosimo was proving himself to be "an artist in expenditure."

On the top floor of the sprawling new complex, with windows overlooking the cloister, would be a library. Cosimo envisaged that this collection would serve not only the resident Augustinians but also, as at San Marco, the wider community of scholars, or what Cosimo called *uomini da bene e letterati*—"good and learned men"—who

would be given access to texts of humanist learning. A collection of manuscripts was therefore required.

A portrait of Cosimo painted by Benozzo Gozzoli in 1459, in a fresco in the Palazzo Medici's private chapel, depicted him as a white-haired man with a tight mouth and solemn, careworn features. To Vespasiano, who had known him for some thirty years, he must have appeared, by the 1460s, a diminished figure. The previous few years had been blighted for him by the death in 1459 of his beloved grandson Cosimino, Giovanni's five-year-old son. He was growing more and more taciturn, often spending hours, according to Vespasiano, "doing nothing but thinking." When his wife, Contessina, asked why he remained so quiet, he replied that just as she spent a fortnight preparing for a sojourn in the countryside, he too was making ready for an impending voyage—a much longer one from this world to the next.[11]

On that day in 1462, however, Cosimo was all business: an old man in a hurry. As Vespasiano wrote, he feared death would claim him before his various projects were complete. He therefore emphasized the need for all possible haste as he explained his plans for the abbey in Fiesole and its library. "What plan," he demanded of Vespasiano, "have you for furnishing this library with books?" Vespasiano explained that it would be impossible to find all the necessary manuscripts secondhand; new ones would need to be transcribed. Cosimo then asked if Vespasiano would be willing to take charge. "I told him I would be happy to."[12]

The project presented a challenge even to someone with Vespasiano's resources. Unlike at San Marco, where the library was endowed with hundreds of Niccoli's books, at the abbey Vespasiano would be starting from scratch. He used as his guide Tommaso Parentucelli's list of books drawn up for San Marco, with its mixture of religious and classical works. Thanks to Cosimo's generosity and his desire for speed, Vespasiano was able to put together a large team. "He left everything to me," Vespasiano later boasted. "I hired forty-five scribes and completed two hundred manuscripts in twenty-two months."[13]

At this rate, each of Vespasiano's scribes would have completed four or five manuscripts, each manuscript taking some five months

of work (though some scribes must have done much more work than others). Almost forty of these scribes have been identified, lending credence to Vespasiano's claim about the size of his workforce.[14] One of the more intriguing was a hermit named Fra Girolamo da Matelica, who lived in one of the caves on the hillside in Fiesole. Vespasiano claimed that Fra Girolamo was "a man of the most holy life," but he was also one of the erudite, well-educated scribes in whom Vespasiano specialized. Fra Girolamo had studied theology and philosophy for seven years in Paris, working as a scribe at the abbey of Saint-Germain-des-Prés before returning across the Alps and taking up his hermit's life in Fiesole. In 1460 he composed *De Vita Solitaria* ("On the Solitary Life"), which praised the "holy liberty" of the hermit. Some two years later, Vespasiano arrived at his cave with a sheaf of parchment and a request for a manuscript.[15]

Scribes such as Fra Girolamo were not the only ones to work on these manuscripts. Many of the codices were illuminated, requiring Vespasiano to find artists as well as copyists. At least nine of them were illustrated by an anonymous artist known only, thanks to his plump cherubs, as the "Master of the Pear-Shaped Putti."[16]

Vespasiano did not actually supply, as he later claimed, all two hundred manuscripts for the abbey's library in Fiesole. Cosimo acquired around twenty of them through another Florentine bookseller, Zanobi di Mariano.[17] Even so, Vespasiano was clearly the guiding spirit and prime mover behind this collection. Moreover, the speed with which he assembled his team and produced scores of manuscripts reveals his tremendous capabilities, as well as how swiftly and effectively knowledge could be transmitted, even with only an inkhorn and a goosequill.

Vespasiano began work for Cosimo at the abbey's library in Fiesole around the time he completed one of his most important assignments: a deluxe manuscript of a new biography of Charlemagne composed by his friend Donato Acciaiuoli. The recipient was the new king of France, King Louis XI.

Charlemagne was an important link between Florence and France. The "divine Charlemagne . . . ornament and light of the

world" (as Donato's biography called him) was not merely the illustrious ancestor of the French royal house; he had also, according to legend, refounded Florence following its decimation by the Goths in the sixth century. As Donato's biography asserted, Charlemagne restored the city of Florence to its former glory. "He returned the whole nobility dispersed amongst the neighboring towns to the city, girded it with new walls, and adorned it with churches." More than that, Charlemagne gave Florence its laws and its liberties; he was the reason, wrote Donato, "that we live free, that we have magistrates, laws and a city."[18]

Donato's manuscript celebrating Charlemagne, *Vita Caroli Magni*, therefore seemed the perfect gift for King Louis, crowned in the summer of 1461 following the protracted death of his father, Charles VII. For this important job, Vespasiano selected one of his best scribes, Piero Strozzi, as well as his finest illuminator, Francesco del Chierico. Francesco produced beautiful vine-stem borders as well as a title page featuring a putto holding up, Atlas-like, a gold-trimmed circular frame announcing the manuscript's title and author. "His Majesty the king," reported one of the Florentines who witnessed the presentation of the volume at the court in Tours, "was very grateful and accepted it with kind words."[19]

The manuscript had been transported to France by Donato's father-in-law, Piero de' Pazzi, the Florentine ambassador to France. The Pazzi were one of the most distinguished families in Florence. They could trace their ancestors back to Pazzo Pazzi, a soldier who in 1099 was the first man over the walls of Jerusalem during the First Crusade (an act of impetuous bravery possibly inspired by his name: *pazzo* means "crazy"). Their family symbol, a pair of dolphins frolicking back-to-back, could be seen in various locations around Florence, including on their palazzo a few steps away from Vespasiano's bookshop.

Vespasiano had known Piero de' Pazzi, then forty-five years old, for many years. Not only were they neighbors, but Piero had been one of his regular clients. His patronage was due to the timely intervention many years earlier of Niccolò Niccoli, who had a chance encounter with the young Piero—in those days, according to Vespasiano, "a handsome youth much given to the pleasures of the

world"—in the Street of Booksellers. Niccoli asked the young man
his name, to which Piero replied that he was the son of Andrea de'
Pazzi. When Niccoli asked what Piero intended to do with his life,
Piero replied with laid-back candor: "I plan to have lots of fun." Nic-
coli then scolded him, saying it was a shame that the son of such a
distinguished family should neglect his studies for pleasure-seeking.
Once the flower of his youth had passed he would find himself with
nothing, whereas if he studied Latin he would earn much esteem.
"Messer Piero, hearing what Niccolò said, knew it to be true," wrote
Vespasiano.

So began Piero de' Pazzi's career in humane letters. Niccoli
found him a Greek and Latin tutor, who came to live in the Pazzi
mansion. Piero, meanwhile, "gave up lechery and the pleasures of the
flesh." Such was his devotion to his studies that he learned Virgil's
Aeneid by heart: all 9,896 lines of dactylic hexameter. Over the next
three decades he put together a fine library, spending large sums of
money, Vespasiano approvingly reported, "on books, on scribes, and
on illuminators."[20]

The dedicatee of the *Vita Caroli Magni,* King Louis XI of France, was
a cunning and unscrupulous monarch. He was mocked for his clothes
and his funny hats, accused of having poisoned both his father and
his brother. He became known because of his webs of deceit and in-
trigue as *l'universelle araignée,* "the universal spider." His ascent to the
throne in the summer of 1461 posed a potential threat to the pre-
carious equilibrium achieved seven years earlier by the Treaty of Lodi.
Louis supported the Angevin claim to the Kingdom of Naples, that
of René of Anjou, who had been deposed in 1442 by Alfonso the
Magnanimous.

For almost two centuries the right to rule over Sicily and the
Kingdom of Naples had been disputed by the house of Anjou (French)
and the house of Aragon (Spanish). The Angevins were a cadet branch
of the Capetian house of France (named after Hugh Capet, king of
the Franks from 987 to 996). The first Angevin ruler in Italy had been
the French-born Charles I, Count of Anjou, the son of King Louis VIII
of France and the brother of Louis IX (later canonized as Saint Louis).

In 1266 Charles of Anjou captured the Kingdom of Sicily and the southern reaches of Italy, including Naples, from Manfred, a member of the house of Hohenstaufen (German). Since Manfred's daughter, Constance, had married the king of Aragon, a contest ensued between the Angevins and Aragonese for the right to reign over Naples and Sicily.

Angevin claims to the Kingdom of Naples had recently become an issue to trouble the fragile peace of the Italian peninsula. King Alfonso had died in June 1458 after naming as his heir his illegitimate son Ferdinand, known as Ferrante, then thirty-five years old. Alfonso's foe, Pope Calixtus, refused to acknowledge Ferrante's right of succession despite the fact that Ferrante had once been his pupil. "This boy who is nothing," he fumed, "calls himself king without our permission."[21] Like Louis XI, the pope supported the Angevin claim to Naples. However, he also contemplated the possibility of giving the kingdom, a papal fiefdom, to his twenty-six-year-old nephew, Pedro de Borja—though in his more fanciful and ambitious moments Calixtus toyed with the idea of making Pedro the new Byzantine emperor once the crusade drove the Turks from Constantinople.

This crusade was not progressing at all convincingly despite much bloodthirsty speechmaking. The new Florentine chancellor, Benedetto Accolti, urged the Christian powers "to take from the hands of the infidel the most noble city of Byzantium and to force the barbarian enemies who threaten Christians to retreat"—barbarians who, he added for good measure, "worship abominable and accursed demons."[22] But most Florentine merchants remained ambivalent about the prospect of faraway battles, partly because of the taxes a crusade would entail, and partly because they had no desire to see their commercial rivals, the Venetians, benefit from the restoration of their trading privileges and territorial possessions in the East. Some Florentine merchants were, in fact, trying to court the sultan, allying themselves with Mehmed against the Venetians, exchanging intelligence with him on the movements of galleys, and calling themselves his "friends and well-wishers."[23]

If the Christian princes in the West were, at best, half-hearted about a crusade, they were all too happy, as one bishop ruefully declared, "to wrangle with each other, and to turn against their own

flesh the weapons which ought to be directed against the Turks."[24] Battle lines were therefore drawn over the disputed succession in Naples. Cosimo de' Medici and Francesco Sforza, the duke of Milan, both supported Ferrante's claim in opposition to the promotion of the Angevins by the pope and Louis XI. Ferrante's prospects had brightened when Calixtus, never in the best of health, died at the age of seventy-nine in August 1458. He was replaced by a pope more sympathetic to Ferrante's cause, Enea Silvio Piccolomini, the poet, diplomat, and humanist who had been appointed Cardinal of Siena less than two years earlier. Cardinal Piccolomini had been denounced in the conclave by a French cardinal who bewailed his "devotion to the heathen Muses. Shall we raise a poet to the Chair of Saint Peter," he asked, "and let the Church be governed on pagan principles?"[25] Despite the efforts of a group of pro-French cardinals who gathered to scheme in the more insalubrious recesses of the Vatican, the majority of their colleagues responded in the affirmative. The new pope assumed the name Pius II. "It was well their conspiracy was made in the latrines," he wrote of his opponents. "Their plots will go down the drain!"[26]

King Ferrante was still far from secure in his kingdom. In 1459 Jean of Anjou, the thirty-three-year-old son of the deposed Angevin pretender, René, had begun a military campaign to recapture Naples. Jean hired the warlord Jacopo Piccinino, using funds provided from the bank of one of the most faithful and influential members of the pro-Angevin cause in Italy: Piero de' Pazzi.

The rivalry over Naples between the Angevins and the Aragonese therefore divided Florence itself, with the Pazzi squared off against the Medici. The Pazzi were longtime supporters of the Angevins, since Piero's father, Andrea, had hosted René in his villa outside Florence following his expulsion from Naples in 1442. Piero made the deposed monarch godfather to one of his sons, Renato, named in his honor; and he decorated his villa with a monumental terracotta plaque featuring René's coat-of-arms quartered with Pazzi dolphins. Piero became an "intimate friend" and "constant companion," according to Vespasiano, of René's son Jean. In fact, in 1460 the flags and standards for Piccinino's military campaign on Jean's behalf had been prepared in Piero's palazzo in Florence. "It is impossible to deny

that this family is greatly devoted to the house of Anjou," wrote Donato Acciaiuoli regarding his father-in-law.[27]

Piero de' Pazzi even appears to have been involved in an Angevin-inspired assassination attempt against King Ferrante. In the spring of 1460 Piero told Vespasiano: "Within a fortnight Jean of Anjou will be King of Naples without any opposition."[28] This prophecy came close to fulfilment. Before a fortnight passed Ferrante was approached by representatives of three of his enemies in Naples, pro-Angevin barons who claimed they wished to meet with him, beg for clemency, and support his claim against Jean of Anjou. Despite sensible warnings from what Vespasiano called "serious and prudent" counselors, Ferrante rode off to meet them. "The three barons knelt on the ground before him as a sign of reverence, and asked for forgiveness," Vespasiano later wrote. "The king held out his hand, whereupon one of them leapt forward with his knife and tried to seize the reins of his horse and stab him." Ferrante escaped unharmed thanks to his expert horsemanship, wheeling away from danger, his squadron of cavalry—wisely kept a half bowshot away—riding to the rescue.

Vespasiano was appalled by this failed conspiracy. Ferrante was becoming almost as reliable a customer as his father. He even referred to Vespasiano as a "dear gentleman devoted to our cause."[29] After learning of the attempt on Ferrante's life, Vespasiano went immediately to Piero de' Pazzi. "Messer Piero," he told him frankly, "this is a faithless way to win a kingdom, and such is not the custom of the royal house of France. Winning on the battlefield by force of arms deserves praise and commendation. But to resort to such treason? No!" He concluded with an ominous message to his friend: "Almighty God does not allow such things to go unpunished."[30]

The Angevins, however, would not rest—and it would not be the last time a Pazzi involved himself in an assassination plot.

Piero de' Pazzi was a friend of Cosimo de' Medici and, after a recent Medici-Pazzi marriage, father-in-law to Cosimo's son Piero, who had married one of his eight daughters. But his active support for the Angevin cause drove a wedge between the Pazzi and the Medici, for

Cosimo was determined to block Pazzi aid for Jean of Anjou. When funds he expected from Florence failed to appear, René knew whom to blame. However, René wrote to his son that he was in touch with Florentine exiles as well as malcontents within Florence itself who were, he enthused, "hot to transform the regime."[31] René was thinking of exiles such as the Strozzi in Padua (banished by Cosimo in 1434) as well as, in Florence, members of the Pazzi clan, including the Acciaiuoli.

Vespasiano was caught between these competing interests. He had enjoyed the patronage of King Alfonso. His reputation as a supporter of Alfonso, and then of Ferrante, was such that a poet would refer to his bookshop as having "Aragonese doors" whose threshold was not to be crossed by the "Gallic crowd"—that is, by supporters of the House of Anjou.[32] Vespasiano came to know various Neapolitan ambassadors to Florence, sometimes visiting them soon after their arrival in the city. He was friends, furthermore, with Aragonese allies and partisans such as Giannozzo Manetti (to whom Alfonso gave sanctuary at his court in 1455) and Cosimo de' Medici. Another of his regular clients was Alessandro Sforza, ruler of Pesaro, who in 1462 had left his magnificent library, well-stocked by Vespasiano, to fight on Ferrante's behalf in the Kingdom of Naples.

Such connections with the King of Naples and his supporters led an ambassador from Ferrara to report that Vespasiano was *tutto ferandino*, that is, all for Ferrante.[33] It was a mark of Vespasiano's eminence and influence that an ambassador should find the political convictions of a bookseller worth reporting to his masters.

The situation was, however, more complicated. For all of these Aragonese connections, Vespasiano also had a foot in the Angevin camp. He was a close friend of both Piero de' Pazzi and, even more, the Acciaiuoli brothers. Vespasiano therefore needed to perform a delicate balancing act with his friends and patrons, so many of whom, as Italy's delicate equilibrium began to tip, were becoming each other's bitter and dangerous enemies.

Chapter 15

Hermes the Thrice-Greatest

Vespasiano was not the only one who received a summons to the Palazzo Medici in 1462. In early September of that year Marsilio Ficino, then twenty-eight years old, was deep in the Tuscan countryside at San Leo a Celle. The hamlet was a two-hour walk west from Figline Valdarno (itself almost twenty miles southeast of Florence) along a dusty trail that skirted vineyards and fields of grain punctuated with cypresses and turkey oaks before bending northward and meandering between the flanks of forested hills. The house owned by his father sat where the road ended, the forest thickened, and the hills reared: an isolated place, good for philosophizing.

Ficino took up a harp, or what he called his "Orphic lyre," and began playing and singing to lift his spirits. Music, he believed, could drive away melancholy, especially the black bile to which scholars in particular were prone. His public performances of melodic strumming and enraptured chanting were soon to become legendary. As he plucked at the strings with his "melodious fingers," he worked himself into a frenzy, singing a hymn in a voice that, like the divine voice of Orpheus himself, could enchant African lions and move mountains in the Caucasus—or so one of his listeners would later claim.[1]

On that late summer day in 1462, as Ficino worked himself into a trance and addressed the cosmos as "the guardian and watchman of all things," a knock came at the door and a letter arrived from his father in Florence concerning a plan of Cosimo de' Medici. Ficino believed that music could be used to call down planetary influences, and that is precisely what his performance of his "Orphic rite"

appeared to have done: his supplication to the cosmos brought forth a welcome message from another "watchman of all things"—its near namesake, Cosimo. The letter explained that Cosimo had taken an interest in the young man's studies, that he would generously provide for him, and that he was giving him "those Platonic volumes" to translate—the manuscript of the complete works of Plato.[2]

Such was Cosimo's generosity toward the virtuous and erudite "Messer Marsiglio" that he bought him a house in Florence, as Vespasiano later recounted, "to save him from the extremes of poverty."[3] However, Ficino did not actually start work on the Platonic volumes in the autumn of 1462. Increasingly ill and infirm, and aware that the end was nigh, Cosimo changed his mind soon after handing over the precious Plato codex. Instead, since time was of the essence, he suddenly ordered Ficino to set Plato aside and begin work translating a different codex, one he was even more eager to read—one in which, as Ficino realized, were to be found "all precepts of life, all principles of nature, all mysteries of theology."[4]

Cardinal Bessarion was not the only collector in Italy hunting manuscripts in the East. Cosimo, too, had put his agents to work, and in about 1460 one of them, a monk named Leonardo da Pistoia, brought back from a monastery in Macedonia a codex containing the long-lost *Corpus Hermeticum*. This manuscript contained the ancient wisdom of the Egyptian sage Hermes Trismegistus (Hermes the Thrice-Greatest) who, it was believed, had lived around the time of Moses. Hermes had been mentioned by early Christian writers such as Saint Augustine, who knew one of his writings from a Latin paraphrase, a dialogue called *Asclepius*. However, no one had seen the fourteen treatises discovered in Macedonia for at least a thousand years. Cosimo decided he needed them translated into Latin before the Plato codex because he wished to trace knowledge back to its primordial sources. As he knew from his manuscript of Diogenes Laertius, Plato had gone to Egypt to learn from "those who interpreted the will of the gods." According to Diogenes, while there he fell ill and was cured of his malady by priests who treated him with seawater.[5]

Ficino was no doubt as eager as Cosimo to read this treatise, even though Hermes Trismegistus was theologically suspect in some quarters—even more so than Plato.[6] *Asclepius* described the religion of the ancient Egyptians with particular reference to how magic spells could be used to make idols come to life. Such a topic caused Saint Augustine to note uneasily that Hermes looked rather too kindly upon the "delusive contrivances" of demons and idols.[7] In the Middle Ages he was known as an expert on alchemy and magic. Authorities such as the Dominican Albertus Magnus (the teacher in Paris of Thomas Aquinas) warned against experimenting with his diabolical spells. Others, however, had viewed Hermes in a more positive light. In *The Divine Institutes*, composed early in the fourth century, the Christian author Lactantius hailed him as a prophet or precursor of Christianity.

Ficino would stick closely to this appraisal by Lactantius. The preface to his translation of the fourteen Hermetic texts—which he called *A Book on the Power and Wisdom of God, Whose Title Is Pimander*— borrowed heavily from the biography offered by Lactantius, which in turn took details from no less an authority than Cicero in *On the Nature of the Gods*. Cicero described Hermes as a hero who killed the many-eyed giant Argus and fled to Egypt, where he went by the name Thoth, gave the Egyptians their laws and their letters, and then, after his death, was revered as a god and honored with numerous temples. How much of this mythical account Ficino actually believed is an open question, though the words of Cicero and Lactantius carried a great deal of weight. The important thing for Ficino was that Hermes Trismegistus assumed an important role among ancient theologians. He called Hermes "the first author of theology," for Hermes was "the first to discuss, with great wisdom, the majesty of God." After him, Ficino believed, came an illustrious roll call of other ancient writers and thinkers, all building on this wisdom, from Orpheus, "who gained second rank among the ancient theologians," down through Moses, Pythagoras, and Philolaus, "who was the teacher of our divine Plato."[8]

A single theology, that is, had supposedly trickled intact down the centuries from Hermes Trismegistus to Plato and then into Christianity, which was merely the latest outflow in a theological stream whose waters could be traced back to Hermes. Ficino claimed that

Hermes foresaw the birth of Christ, the Resurrection, and the Last
Judgment. Indeed, the spiritual orthodoxy of the *Corpus Hermeticum*
appeared buttressed by the fact that many of its phrases and doctrines—
such as the account of Creation and the description of baptism—
could be found in the Bible.

We now know that, as the French Protestant scholar Isaac Casau-
bon demonstrated in 1614, the entire *Corpus Hermeticum* was actually
composed around the year AD 300—a thousand years later than
people in the fifteenth century believed. Ficino was not to know that,
however, and Cosimo's manuscript produced a wondrous effect on
him. He found in the Hermetic writings a topic to enthrall and pre-
occupy him for the rest of his career: the place of man in relation
to God.

The relationship of man to God was usually described in terms
of difference and distance. Even though the first chapter of Genesis
declared that "God created man in His own image," Christianity,
because of the Fall of Man, opened an unbridgeable chasm between
the two. In 1215 the Lateran Council was explicit: "Between the cre-
ator and the creature there cannot be found so great a similarity that
there could not be found a greater dissimilarity."[9] However, the Her-
metic writings downplayed the dissimilarity and narrowed the dis-
tance, exalting man such that he became a kind of god on earth.
"What a great miracle is Man," Hermes exults at one point, "a being
worthy of reverence and honor. For he goes into the nature of a god
as though he were himself a god."[10]

Giannozzo Manetti had praised this godlike creature a decade
earlier in his *On the Dignity and Excellence of Man*. Indeed, he even cited
Hermes Trismegistus and the dialogue *Asclepius* to bolster his argu-
ment. Ficino would further develop the idea of the excellence and
dignity of man. He believed man's imaginative powers made him a
creator in his own right: a godlike poet, architect, painter, and musi-
cian. Thanks to Hermes Trismegistus, Ficino could take the fallen
creature of the Middle Ages, derided as worthless, miserable, and de-
based, and raise him aloft onto a pedestal where his glorious cre-
ations could be worshipped and praised.

Ficino completed his translation of the *Corpus Hermeticum* by
the spring of 1463. He dedicated it to Cosimo, who, he flatteringly

claimed, resembled Hermes Trismegistus in his wisdom, holiness, and power. He earned for his efforts another house, this one a farm in the country at Careggi, near Cosimo's own country villa. He then turned, at long last, to the Platonic codex given to him eight months earlier.

As Ficino started work on translating Plato, Cardinal Bessarion was still composing his defense of the philosopher against the insulting slanders by George of Trebizond. Bessarion claimed he was "burning the midnight oil" in an attempt to complete the work.[11] However, in the spring of 1463, more practical matters intervened. In April, as he luxuriated in the mineral baths at Viterbo, recuperating from an attack of kidney stones, he found himself appointed bishop of Negroponte, a Venetian possession in Greece. Pope Pius II (the former Enea Silvio Piccolomini) also made him the papal legate to Venice. Following the fall of yet another Venetian territory to the Turks, the fortress of Argos in the Peloponnese, the Venetian ambassador to the Curia had announced to Pius the welcome news that the Republic was finally prepared to fight the Turks. Bessarion was charged with convincing the Venetians to honor their pledge by assuring them of the pope's financial support.

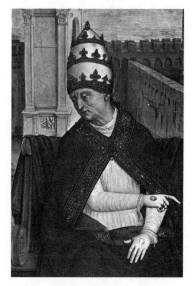

Pope Pius was a humanist of irreproachable credentials. He had been inspired to study humane letters, pursued in both Siena and Florence, by the teachings of Francesco Filelfo. As a young man he composed love poetry and racy stories (such as *Historia de duobus amantibus,* or "Tale of Two Lovers"), winning such renown that Frederick III, the Holy Roman Emperor, crowned him poet laureate. He traveled widely across Europe, writing entertaining journals

Pope Pius II (Enea Silvio Piccolomini): a humanist on the throne of Saint Peter.

that described adventures with compliant maidens in England. His writings extolled the beauty of the Italian landscape, especially that of the countryside of his beloved Val d'Orcia, near Siena. He found endless fascination in the ruins of the ancient civilization that studded the Italian peninsula. He sought out the labyrinth at Chiusi mentioned by Pliny the Elder, Virgil's villa at Mincio, Hadrian's at Tivoli, and the traces of the ancient Roman roads and aqueducts. He took ordination somewhat belatedly, after fathering illegitimate children in places as far-flung as Strasbourg and Scotland. "Truly, it is an enormous pleasure for me that my seed was fruitful," he wrote, unrepentant.[12]

Pius did not permit his elevation to the papacy to curb his intellectual and literary activities. Soon after his election he began writing *Historia Rerum Ubique Gestarum Locorumque Descriptio* ("Description of Places and Achievements Throughout History"). In this ambitious epic he hoped to narrate the histories of all the peoples of the world— across Europe, Africa, and Asia—creating a historical and geographical encyclopedia. But he also addressed himself, as pope, to more urgent geographical matters. Indeed, this worldly, learned, and well-traveled pope was dedicated to the mission that defined his age. It was, as he declared, "to call the peoples of Christendom to a crusade against the Turks."[13]

One of Pius's first acts as pope had therefore been to convene a Congress in Mantua in 1459 to bring the crown princes of Europe together and instill in them a sense of purpose to rid Christian lands of what a speaker in Mantua, the female humanist scholar Isotta Nogarola, called the "savage nation" of "infidels" and "blasphemers of the Lord."[14] Despite the usual inflammatory rhetoric, little had been done by anyone. Early in 1462 Pius had lamented to his cardinals that "we are neglecting the common weal because since our return from Mantua we have neither done nor said anything toward repulsing the Turks."[15] Meanwhile, that summer Mehmed captured the island of Lesbos, whose lord, Niccolò Gattilusio, surrendered on condition that the Turks spared "the heads and the possessions" of the inhabitants. Mehmed honored his part of the bargain, after a fashion: he left their property untouched but sawed four hundred of the islanders in half—their heads still attached.[16]

In the summer of 1463, Cardinal Bessarion arrived in Venice, where he received a princely welcome. After a week of negotiations, the Venetians assured him that they were ready to break diplomatic ties with the Turks. A month later, at the end of August, a crusade was announced in Saint Mark's Square. Then, in September, a bull arrived from the pope declaring that he personally would lead the crusade. It was an audacious vow from a frail and prematurely aged fifty-eight-year-old man of letters who suffered from gout, kidney stones, a chronic cough, and a "moist brain" (the latter of which called for visits to the baths at Petriolo, where warm waters from a hosepipe were poured over his head). Further, his feet had been badly frostbitten three decades earlier during a barefoot pilgrimage through the snow in Scotland, requiring him to sit down even when he celebrated Mass. But he was defiant. "We shall take our stand on the tall deck of a ship," he proclaimed.[17] When Mehmed learned of this vow, he courteously offered to spare the infirm pope the arduous journey by coming to Rome to do battle there.

While Pius prepared to embark on a crusade, the prows of war galleys sliced the waters of the Adriatic as the Venetians fulfilled their part of the bargain. They picked as commander of their land forces a soldier of fortune from Ferrara, Bertoldo d'Este, who quickly recaptured Argos and then besieged Corinth before, in November, he was killed by a rock to the head. To replace him the Venetians chose a cruel and ambitious warlord, the forty-six-year-old Sigismondo Malatesta. He was an ironic and, for Pius, unwelcome choice to lead a crusade. Pius called him the "prince of wickedness," having excommunicated him on Christmas Day in 1460 and, two years later, burned him in effigy in Rome. "He raped Christian nuns and Jewish ladies alike," Pius claimed. "Boys and girls who resisted him he would either murder or torture in terrible ways." He was, quite simply, "the worst of all men who have ever lived or ever will live."[18] But on the Wolf of Rimini, as he was known, rested Christian hopes for driving back the Turks.

A battle-hardened warrior with three decades of violence and treachery behind him, Malatesta made a good start to his campaign, landing with his infantry and crossbowmen in the Peloponnese in the spring of 1464 and inflicting brutal punishment on the Turks. He

even occupied the city of Mistra, notable as the place where in 1452, at the age of ninety-seven, George Gemistos Pletho had died. Famine and a counterattack by the Turks soon checked Malatesta's relentless vigor and forced his retreat from the peninsula. However, he returned to Italy with a precious souvenir: the remains of the great Pletho, which he exhumed in Mistra and then interred like a holy relic in the church in Rimini known as the Malatesta Temple—a building that Pius complained was "less a Christian sanctuary than a temple where heathens might worship the devil."[19]

Pope Pius took the cross in a ceremony in the basilica of Saint Peter on June 18, 1464. Then, commending his gray head and feeble body to God, he set off on the 180-mile journey to Ancona, on the Adriatic coast, where his own band of crusaders was mustering for the expedition against the Turks. He was accompanied by a few doughty cardinals, including Bessarion, who believed Constantinople would at last be liberated. Progress was ponderously slow, first upstream in boats along the Tiber, then a geriatric parade through the scorching countryside, six or seven miles a day, as the pope's health failed and the plague spread through Italy. Pius finally reached the sparkling waters of the Adriatic to find only two Venetian galleys in the port rather than the promised forty. As he awaited the arrival of the rest of the fleet he was forced to order prayers to placate the brawls of the ill-disciplined bands of crusaders, mostly French and Spanish, who had arrived in the city to join the expedition. Food and fresh water ran short. Soon the ranks of crusaders thinned as they deserted or died of pestilence.

With the Venetian fleet still nowhere in sight, Pius finally boarded a galley at the end of July, but rather than taking up his post "on the tall deck," he was quickly carried back to dry land, where for two weeks, in a palace on the hill of San Ciriaco, he lay feverish and weak, clearly dying. On August 14, the eve of the Feast of the Assumption, the end came, both of Pius's life and of his crusade. The Venetian doge, learning of the pope's death, gave orders for the Venetian war galleys to be disarmed.

As Pope Pius II swayed and jolted painfully across Italy on his ill-starred crusade, Cosimo de' Medici had been at his beautiful villa in Careggi, an hour's mule-ride north of his palace in Florence. He had been ill since May, struggling to urinate and suffering from a rash and fever. The younger of his two sons, Giovanni, had died the previous autumn at the age of forty-two. The grieving Cosimo spent much time in silence, according to Vespasiano, lost in his thoughts or else listening to someone read to him from Aristotle's *Nicomachean Ethics*: not the 1417 Latin translation by Leonardo Bruni but the one recently done by Donato Acciaiuoli, revised by John Argyropoulos, and prepared in manuscript by Vespasiano. "This emended text," Vespasiano added as a proud but pedantic aside to his biography of Cosimo, "is the version that everyone now uses."[20]

Cosimo was able to listen attentively to other works, likewise newly translated. Almost two years after Cosimo gave him the manuscript of Plato, Marsilio Ficino had finally translated ten of the dialogues.[21] In the third week of July, Cosimo urged him to come to Careggi "as soon as possible," and to bring with him Plato's dialogue *Philebus*, "which I think you have by now translated into Latin, as you promised." He also requested that Ficino bring his Orphic lyre. Over the next few days, Ficino strummed his harp for Cosimo and read Plato aloud from various of his new translations. The last one Cosimo heard was the *Philebus*, in which Socrates, arguing against the hedonistic Philebus, declared that "wisdom and thought and memory and their kindred, right opinion and true reasonings, are better and more excellent than pleasure."[22] At which point, as Ficino wrote, Cosimo "was recalled from this shadow of life and approached the heavenly light."[23]

At Cosimo's bedside as he passed from the shadow of life was his grandson, the son of Piero, a fifteen-year-old boy named Lorenzo.

Chapter 16

A Divine Way of Writing

The papal conclave assembled in the Roman heat in August 1464, in a chapel in the Vatican whose doors and windows were walled up to concentrate the cardinals' minds on the matter at hand. They quickly selected the nobleman known as the "Cardinal of Venice": Pietro Barbo, the forty-seven-year-old nephew of Pope Eugenius IV. After toying with several possibilities—including Formosus ("handsome"), from which wiser heads dissuaded him—the new pope assumed the name Paul II.

Cardinal Barbo had not been known for his love of books and learning. He collected coins, gems, and antiquities but showed no interest in history or the ancient world beyond these glittering trinkets of the past. He had been a lackluster student with little aptitude or regard for humane letters despite the fact that, as the nephew of Eugenius, he spent much time in Florence during the humanist heyday of the 1430s, where one of his teachers had been George of Trebizond. His disdain for scholars manifested itself when in one of his first acts as pope he fired many clerks from their posts in the papal chancery—including (as one of these casualties, Bartolomeo Platina, pointed out) "poets and orators, who were as great ornaments to the court as the court was honor to them." Platina* was a former mercenary soldier who had fought under the command of both Francesco Sforza and Niccolò Piccinino. Not one to take his dismissal lying down, Platina led a rebellion against the pope, agitating outside

*Platina was born Bartolomeo Sacchi but adopted his humanist appellation from the Latin name (Platina) of his birthplace, Piadena, near Cremona. His preferred version was Platyna—though no historians have so far obliged him with this spelling.

the Vatican with his fellow clerks for twenty consecutive nights and writing a letter calling for a general council to reform the Church. Paul responded by tossing Platina into prison and keeping him in chains "in the middle of winter, without any fire," as Platina complained, "and in a high tower, which was exposed to all the winds that blew, for four months together."[1] Platina should have counted himself lucky: one courtier reported that His Holiness considered having the troublesome humanist beheaded.

Around the time that Paul II became pope, a curiosity appeared in Rome. Among the earliest witnesses were a scholar named Leonardo Dati, an alumnus of the Studio Fiorentino, and his friend and fellow humanist Leon Battista Alberti. One day found the pair strolling in the gardens of the Vatican. "In our usual way," Alberti wrote, "we were discussing literary matters." The conversation soon turned to an invention that had piqued their interest and was, it seems, the talk of Rome—some in favor, some against. Alberti and Dati, as it happened, were in favor. Alberti wrote that they "very warmly approved of the German inventor" who had made it possible, "by making certain imprints of letters," for three men to make two hundred copies of a text in one hundred days.[2]

Alberti probably knew of the German inventor as the "miraculous man" encountered at the Frankfurt Fair in 1454 by Enea Silvio Piccolomini. He and Dati may even have seen one of these miraculous inventions, or samples of its products, with their own eyes. For, after a decade as a closely guarded secret on the banks of the Rhine, the printing press had arrived in Italy.

"Mainz, wicked of old," Pope Pius II had once called the city on the Rhine, echoing an old slogan.[3] In his eyes the city's iniquity had suddenly revived in 1459 thanks to bitter internal strife and opposition to the papacy.

The Holy Roman Empire was every bit as convulsed as Italy by factions and intermittent bouts of violence. The men who wielded power—the dukes, margraves, and archbishops—fell into two camps: those who supported the papacy and those who favored its reform through a general council such as the one held in Constance some

four decades earlier. The reformers protested that, as one high-ranking Mainz ecclesiastic put it, the Church "can take our money away from us in its own fashion, as though we were barbarians," and that the once-great Holy Roman Empire "is now reduced to poverty, servitude and paying tribute."[4]

Matters came to a head with the death in 1459 of the reforming Archbishop of Mainz—"an ignorant man," in Pius's opinion, "debauched by lust and dissipation."[5] His replacement turned out to be, in Pius's view, even worse: Diether von Isenburg-Büdingen, whom the pope regarded as a corrupt and treacherous man with an unquenchable lust for power. Archbishop Diether pursued a reformist agenda, refusing financial demands such as handing over to Rome one-tenth of all revenues from the archdiocese (which Pius claimed would go to a crusade) and paying the "pallium fee," the sum due to the Church for the sash-like vestment worn by archbishops over their shoulders—a fee which, in the case of Diether, Pius had doubled. Diether also called for a general council of the Church, lamenting that "the whole German nation" was burdened by the whims and demands of the papal court at Rome.[6] Naturally furious at this affront to his authority, Pius took his revenge by deposing Diether and appointing a rival archbishop, Adolf II von Nassau. Diether refused the deposition order, staying in Mainz and maintaining the support of the majority of the people through such popular measures as abolishing the tax exemptions and other privileges enjoyed by the clergy.

As various German princes and ecclesiastics rallied to the side of either Diether or Adolf, a series of broadsides appeared in Mainz, produced by the printing house run for the previous five years by Johann Fust and Peter Schöffer. Fust and Schöffer printed notices from both sides of the dispute, including the papal bull deposing Diether, a manifesto issued by Diether in response, and a reply to the manifesto by Adolf. Those who commissioned these broadsides were determined to win the hearts and minds of the people by flooding the streets with their polemics. To the usual implements of warfare— battle axes, swords, lances, and cannons—a deadly new weapon, the printed word, had suddenly been added.

The older weapons were still serviceable, of course, and they would ultimately settle the dispute. In October 1462, three thousand

soldiers supporting Adolf's claim, including four hundred Swiss mercenaries, entered Mainz and slaughtered four hundred of Diether's supporters (Diether himself managed to escape over the city wall). Adolf's men then rounded up eight hundred other citizens and, under a close guard, marched them out of the city, and forced them into exile. Fust and Schöffer, despite their even-handed propagandizing, were among these eight hundred exiles. So too was the proprietor of the other printing press in Mainz, Johannes Gutenberg.

Gutenberg had continued to operate his sole remaining set of type in the years following his legal dispute with Fust. Despite reduced financial and technological resources, he and his assistants managed to produce a series of calendars, a bull of Calixtus III calling for a crusade, and a prayer to be distributed among local churches and stuck on their walls for worshippers to memorize (the only surviving copy, in Munich, features a peg hole at the top). His main business, though, was printing the Latin grammar of Aelius Donatus—a work destined for children's classrooms.

These works must have seemed trifling to Gutenberg in comparison with his great masterpiece, his 1454 Bible. They would have seemed even more so following the printing in 1457 by Fust and Schöffer of their magnificent collection of the Psalms, the book now known, through ten surviving copies, as the *Mainz Psalter*. Printed in both red and black ink, and with two-color woodcuts, it was a technological and visual wonder, commissioned for use in the city's churches and possibly designed by Gutenberg before his 1455 legal setback. It featured a colophon at the end praising the "magnificent capital letters" produced "by an artificial process of printing and producing characters without any use of a pen." The colophon also named Fust and Schöffer and gave the date of publication as the eve of the Assumption in 1457.

Gutenberg's financial woes and legal predicaments had continued to bedevil him. In 1458 he defaulted on interest payments on a loan, perhaps because in that same year he and his assistants began work on two ambitious new projects: a Latin dictionary called the *Catholicon* that would run to 755 pages; and a Bible with 36 lines per

page that because of its larger type would take up 1,768 pages, almost 500 more than the 42-line *Gutenberg Bible*. This latter work is known as the *Bamberg Bible* because the paper on which it was printed, as well as the provenance of surviving copies, suggest that it was produced not in Mainz but 150 miles to the east in Bamberg, a day's journey north of Nuremberg.

After decades dedicated to keeping his invention a closely guarded secret, by the late 1450s Gutenberg was apparently content to see his former assistants and apprentices spread printing far and wide. One of his assistants, Heinrich Keffer, seems to have gone to Bamberg, while another, Heinrich Eggestein, who probably worked on the *Gutenberg Bible*, began operating a printing press in Strasbourg in 1458 with Johannes Mentelin (known in French as Jean Mentel). Later in the same year the French king Charles VII sent Nicolas Jenson, master of the Royal Mint at Tours, to visit "Jehan Guthemberg, Chevalier" in Mainz and report back on this new mechanical method of producing books. Gutenberg must have welcomed him, for Jenson certainly learned from someone, probably Gutenberg himself, the secrets of movable type.

The slaughter of so many people in the streets of Mainz in October 1462, followed by the exile of eight hundred more, is often seen as the catalyst for the spread of printing beyond the Rhine Valley— for an exodus of printers, the workshop assistants of both Gutenberg and Fust, who made their separate ways across Germany, into France and, ultimately, over the Alps to seek their fortunes in the lucrative Italian market. As a Carthusian monk in Cologne wrote, "printers of books multiplied across the land."[7]

Gutenberg, Fust, and Schöffer, along with their assistants, all were exiled from Mainz, it is true. But Fust and Schöffer were soon able to return, while Gutenberg appears to have gone no farther than Eltville, a few miles downstream and on the opposite bank of the Rhine. He, too, soon returned to Mainz, where in 1465 Archbishop Adolf awarded him court clothing (so that he could "present himself like one of our noblemen") and, more usefully perhaps, a yearly supply of eighty bushels of grain and some 2,500 bottles of wine.[8]

The importance of 1462 for the spread of printing is easy to exaggerate. The case for the 1462 Mainz diaspora is difficult to prove

given that so little is known about the assistants and associates of Gutenberg as well as of Fust and Schöffer. Moreover, the first printing presses—with one notable exception—would not operate in cities beyond the German lands for the better part of a decade following the "Fall of Mainz." Paris and Venice would have to wait until 1470, Naples until 1471, Lyon and Louvain until 1473, and Krakow until 1474. All of this suggests a leisurely progress on the part of these fabled Mainz refugees seeking their fortunes in friendlier latitudes.

The exception was Subiaco, forty miles east of Rome, and home to the cave where Saint Benedict, the father of Western monasticism, took his refuge soon after 500 AD. Sometime in 1464, around the time of Paul II's election, a pair of German clerics arrived at the Benedictine monastery of Santa Scolastica. Konrad Sweynheym and Arnold Pannartz were, in effect, commercial travelers, employees of Fust and Schöffer whose mission was to distribute and sell the books printed in Mainz. However, they arrived at the monastery furnished with the know-how to begin printing themselves and perhaps also with the necessary tools and equipment: printing presses were held together with pegs, which made for relatively easy dismantling, transportation, and reassembly. By the end of 1464 or early 1465, in any case, they were operating their own press, assisted by the Benedictines and functioning, it appears, independently of their erstwhile employers in faraway Mainz.

Why Sweynheym and Pannartz chose Subiaco remains unclear. It is no doubt significant that the majority of the Benedictines at Santa Scolastica were German, or at least transalpine, with only two Italian monks and the rest from places such as Swabia, Saxony, Austria, Switzerland, Alsace, and France.[9] Whatever the reason, at Santa Scolastica the two Germans benefited from a rich library from which to choose their exemplars, as well as a location relatively close to Rome—the obvious market for their wares—yet also remote and secluded enough for them to pursue their venture in secrecy. They also had, with the monks, a team of helpers who could be trained to work for them.

The ecclesiastical setting of a monastery, Sweynheym and Pannartz's training as clerics, a location not too distant from Rome: all

might have suggested plans for a venture in liturgical publishing and the production of religious treatises. Their first publication, possibly ready by late 1464 or early 1465, was instead an elementary Latin grammar (of which no copies survive). For their next offering, finished before the end of that September, they printed 275 copies of that classic of humane letters, Cicero's *De Oratore* (of which 17 copies still survive). The primary market for this treatise on rhetoric was clearly humanist scholars rather than monks and priests—exactly the sort of clients, in other words, who bought manuscripts from Vespasiano. This choice of such a classic of humane studies was different from anything hitherto printed north of the Alps, where the major publications of both Gutenberg and Fust had been Bibles and Psalters. However, Fust and Schöffer, back in business in Mainz, quickly came to exactly the same conclusion regarding the potential market for printed copies of the Latin classics. At some point, likewise in 1465, they printed a Latin edition of Cicero's work on moral philosophy, *De Officiis*—their first foray beyond religious works and political polemics.

Two more works rolled off the press in Subiaco over the next eighteen months: a volume of works by the early Christian author Lactantius in the autumn of 1465 and then, even more ambitiously, 275 copies of Saint Augustine's *The City of God*, completed by the summer of 1467. Around the time of the latter's completion, Sweynheym and Pannartz moved their base of operations from Subiaco to Rome, setting up near the Campo de' Fiori in premises owned by two brothers, the merchants Pietro and Francesco Massimo. Descended from a family of wealthy landowners, Pietro and Francesco had branched out into trade and commerce, importing lead, tin, antimony, and paper (all necessary materials, as it happened, for typography and printing). The Massimo brothers may have spotted in printed books another potentially lucrative commodity. They might even have been responsible for luring the printers from Subiaco to Rome, for the first Roman edition of Sweynheym and Pannartz, Cicero's *Letters to Friends*, printed in 1467, bore a colophon giving credit to the family: *In domo Petri de Maximis . . . iuxta Campum Florae* ("In the house of Pietro Massimo . . . near the Campo de' Fiori"). Later books would include Francesco's name as well.

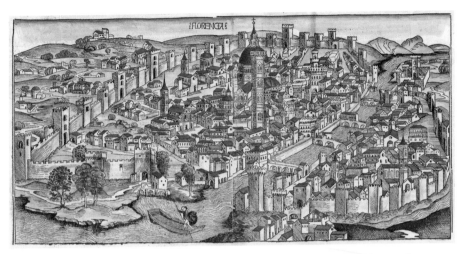

A view of Florence published in 1493 in Hartmann Schedel's *Nuremberg Chronicle*. The sturdy walls of the city encompassed a population of around fifty thousand people.

Papyrus, made from a plant cultivated in the Nile delta, was the favored writing material in the ancient world.

The parchment codex, made from animal skins, began supplanting papyrus scrolls as the most prevalent support for writing by the fourth century AD. This new format, adopted by Christians, was more durable and could hold a greater amount of information.

Cosimo de' Medici (left) with his oldest son, Giovanni, on the right. Both men were among Vespasiano's most important clients. This fresco by Benozzo Gozzoli was painted in the private chapel in the family palazzo.

The library in the Dominican convent of San Marco was funded by Cosimo de' Medici, built by Michelozzo, endowed with Niccolò Niccoli's books, and graced by the frequent services of Vespasiano.

Cardinal Bessarion was, Vespasiano wrote, "a man of great authority in the Church." He worked tirelessly to end the division between the Greeks and the Latins and to preserve the knowledge of antiquity by means of his extensive manuscript collection. This portrait was painted by Pedro Berruguete after a design by Justus van Gent.

An illuminated letter Q in one of the Cicero manuscripts prepared by Vespasiano
for William Grey. The design features an ultramarine blue background with gold
leaf and the elegant, encircling tendrils of white vine-stem decoration.

The conqueror of Constantinople in 1453, Mehmed is said to have wept when he witnessed the devastation of the ancient city. For the next three decades he would terrify and mesmerize the West. His portrait was painted in 1480 by Gentile Bellini.

The fall of Constantinople to the Ottoman Turks in May 1453 was regarded by many scholars in the West, such as Cardinal Bessarion, as a dire threat to ancient culture and learning.

The greatest soldier of the age, Federico da Montefeltro was one of
Vespasiano's best customers thanks to his ambition to create a library "so
vast, and so select, / As to supply each intellect and taste."

Melozzo da Forlì's fresco reveals two of Pope Sixtus IV's great passions, the Vatican Library (here the kneeling Platina becomes his librarian) and the promotion of his many family members (four of his nephews, including Girolamo Riario, far left, group around his throne).

Francesco del Chierico's illustration for Exodus in the Urbino Bible, prepared for Federico da Montefeltro, shows Moses leading a procession of fashionably dressed Israelites into a verdant, well-tended wilderness.

"Our Plato today has emerged onto our thresholds," Marsilio Ficino proudly announced when his Latin translation emerged from the press of San Jacopo di Ripoli. With its two columns of Gothic type, the edition was deliberately designed to look like a Bible.

Vespasiano's country retreat outside Florence, the Casa Il Monte, which he called his "sweet and lovely place."

NSTITVENTI michi . Q . frater eũ fermonẽ referre & mandare huic tertio libro quẽ poſt anthomii diſputatione craſſus habuiſſet: acerba ſane recordatio: ueterẽ animi curã moleſtiamq̃ renouauit. Nam illud imortalitate dignũ ingeniũ: illa humanitas: illa uirtus. L. craſſi morte exticta ſubito eſt: uixit diebus decem poſt eũ diem q̃ hoc et ſuperiore libro cõtineẽt. Vt eni romam rediit extremo ſcenicoꝝ ludoꝝ die uehemẽter cõmotus: ea oratione que ferebaẽt habita eſſe i cõcione a philippo quẽ dixiſſe conſtabat uidendũ ſibi eſſę aliud cõſiliũ: illo ſenatu ſe rẽ. p. regere nõ poſſe: mane idibꝰ ſeptembris. et ille et ſenatus frequẽs uocatu druſi in curiam uenit. Ibi cũ druſus multa de philippo queſtus eſſet: retulit ad ſenatũ de illo ipõ quod in eũ ordinẽ conſul tam grauiter in cõcione eſſet iuectus. Hic ut ſepe inter hoies ſapiẽtiſſimos conſtare uidi quãq̃ hoc craſſo: cũ aliquid accuratius dixiſſet ſemp fere cõtigiſſet: ut nũq̃ dixiſſe melius putareẽt: tamẽ omniũ conſenſu ſic eſſe tum iudicatũ audiui ceteros a craſſo ſemp omnes illo autẽ die etiã ipm a ſeſe ſupatũ. Deplorauit eni caſum atqꝫ orbitatẽ ſenatus cuius ordinis a conſule qui quaſi parẽs bonus aut tutor fidelis eſſe deberet: tanq̃ ab aliquo nefario predone diripereẽt patrimoniũ dignitatis. Neqꝫ uero inqt eſſe mirãdum ſi tum ſuis conſiliis rem. p. ꝓflegaſſet. conſiliũ ſenatus rei. p. repudiaret. Hic cum homini et uehemẽti et diferto et in ꝑmis forti ad reſiſtendum philippo quaſi quaſdã uerboꝝ faces admonuiſſet: nõ tulit ille: et grauiter exarſit pignoribuſqꝫ ablatis craſſũ iſtituit cohercere.

Sweynheym and Pannartz's 1465 edition of Cicero's *De Oratore*.

Sweynheym and Pannartz brought with them to Rome some of the books printed in Subiaco. In November 1467 Leonardo Dati purchased a copy of the Subiaco edition of *The City of God*. He wrote in this book that he purchased it from "the Germans themselves now living in Rome, who are accustomed not to writing but 'printing' books of this sort without number."[10]

The "books without number" printed by Sweynheym and Pannartz, especially the two editions of Cicero, were presented in a format familiar to readers of manuscripts such as those produced by Vespasiano. It is easy to understand why Leonardo Dati and Leon Battista Alberti should have approved of the art of printing. The transition from handwritten manuscripts to printed books was, for the reader, much less of an adjustment than the roll-to-codex changeover must have been a thousand years earlier. The first printed books were designed to look as much as possible like the handwritten manuscripts on which they were modeled. Printed books shared virtually all of the same artistic features, including in many cases rubrication and hand-painted decorations—borders, illuminated capitals, various illustrations—added by an illuminator to individualize the book. At least one copy of the 1467 Subiaco edition of *The City of God* featured the white vine-stem border decorations familiar from so many of Vespasiano's deluxe manuscripts. The identity of the original owner who purchased this book and then commissioned the artwork is unknown, but he or she must have owned or at least seen manuscripts—even perhaps ones by Vespasiano and his team—decorated in this style.

Printed books also resembled manuscripts in their physical makeup. Unlike in the papyrus-to-parchment changeover, the support materials remained the same. The transition from scribes to printers did not entail any kind of dramatic parchment-to-paper conversion. Just as scribes sometimes copied manuscripts on paper, so too printers produced books on parchment. Of the forty-eight surviving copies of the *Gutenberg Bible*, thirty-six were printed on paper (including ones with hand-painted letters and decorations) and a dozen on parchment. Assuming this 3:1 paper-to-parchment ratio held for the entirety of the print run, Gutenberg likely printed some forty of his

Bibles on parchment. So much did the *Gutenberg Bible* look like a regular manuscript, in fact, that legend claims Johann Fust had billed his wares as handwritten manuscripts.[11] Francesco Filelfo, for one, could easily have been fooled. Seeing copies of the books printed in Rome by Sweynheym and Pannartz, he supposedly enthused that "they might be thought to come from the hand of the most accurate copyist."[12]

The 1467 Rome edition of Cicero's *Letters to Friends* would have looked very much like a manuscript from one of Vespasiano's scribes—hence the kind of confusion felt even by as experienced a reader as Filelfo. Not only did Sweynheym and Pannartz choose works by Cicero, stealing the clothes, so to speak, of someone like Vespasiano; they also formatted them in a style that in every respect imitated that of producers of humanist manuscripts. The set of type used in Subiaco might best be described as semi-Gothic, since, despite making concessions to the humanist style, it betrayed its Germanic origins in slightly thicker and pointier letterforms. Once in Rome, however, Sweynheym and Pannartz cut a new set of type, producing punches and matrices of more authentically "antique" letters, almost certainly using a humanist manuscript as their model. Gutenberg's pieces of movable metal type, designed by Schöffer, imitated *textura*, the Gothic script of medieval German monks. However, the goldsmith who created the matrices in Rome in 1467 reproduced the elegant letters pioneered by Poggio Bracciolini and practiced by notaries and men of letters such as Ser Antonio di Mario, Gherardo del Ciriagio, and Piero Strozzi. Printers south of the Alps were about to commit themselves to the "antique letters" of the Florentine lovers of wisdom. In homage to Poggio and to Vespasiano's many scribes, this elegant style of type could easily (and perhaps more justifiably) have been called "Florentine." Instead, in reference to Sweynheym and Pannartz's stylistic choice, it later became known as "roman."

A casual glance at Sweynheym and Pannartz's 1467 edition of *Letters to Friends* would therefore not necessarily have betrayed the book as anything other than a handwritten manuscript produced by a talented scribe with a crisp, clear, and highly legible script. At the end of the book, however, the two printers proudly (and for the first time) added their names in the colophon: "This wonderful work Konrad Sweynheym produced together with Arnold Pannartz."

Many readers agreed that this new method of producing books was wonderful, even miraculous. This new art showed, as an Italian cardinal exclaimed, "that man does not need a feather; there is no use for it. He prints in one day what cannot be written in a year."[13] Over the next few years, various bishops, scholars, teachers, doctors, and friars would proclaim printing a "holy art," a "new and almost divine way of writing," something "descended from heavenly cloisters," a "miracle unheard of in all previous ages."[14] The speed with which books could be produced, the quantity of them, and their relative cheapness in comparison to manuscripts—all of these things meant, they believed, that knowledge could spread far and fast, with everyone, even the poor, able to own libraries. Darkness would be dispelled and there would come, a friar would write in 1476, *salutem in medio terre*—salvation on earth.[15]

Chapter 17

The Finest Library Since Antiquity

By the time of Cosimo de' Medici's death in the summer of 1464, Vespasiano was more or less finished supplying the two hundred manuscripts for the Badia in Fiesole. Some work still remained to be done, such as a beautifully illuminated *Natural History* by Pliny the Elder, copied by a scribe named Hubertus. But the majority of the manuscripts for the library had been furnished by his team in, as Vespasiano's legend stated, some twenty-two months of work.

The deaths within a year of both Cosimo and his son Giovanni robbed Vespasiano of two of his most valuable clients. Even so, his shop would remain as busy as ever thanks to commissions from several new patrons. As a scribe and friend of Vespasiano observed around this time, such was his reputation for passing on the wisdom of the Greeks, Romans, and Hebrews that all lovers of learning—"popes in Rome, ecclesiastics, kings, princes and all learned men"—made tracks to his door.[1]

One of these princes was Borso d'Este, the ruler of Modena and Ferrara. Borso had hitherto collected only hounds and birds of prey, and his favorite pastime involved cavorting through the countryside with a party of carefree companions and his cheerful jester Scoccola. Determined, however, to cultivate an image more in keeping with other "magnificent men," he began expanding the collection of 276 books inherited from his father.

Vespasiano also catered to humbler and more earnest clients. He provided books for a German scholar named Johannes Tröster, a canon of Regensburg Cathedral and friend of Pius II. For him Vespasiano produced an edition of Cicero on paper rather than parchment, though the work still cost three florins. Tröster proudly wrote

on the wooden binding that he had purchased the work in Florence from Vespasiano.[2]

Vespasiano's other clients included a Spanish bishop as well as a cardinal named Bartolomeo Roverella, who purchased a splendid manuscript of Strabo for fifty-three florins: one of the most expensive codices Vespasiano had ever produced. He also continued to do business with Jean Jouffroy, who first bought manuscripts from him twenty years earlier. "He is both learned and knowledgeable about antiquity," Giovanni Aurispa grudgingly observed of Jouffroy, "even though he is French."[3] Appointed bishop of Albi in 1462, Jouffroy once placed a single order with Vespasiano for fourteen manuscripts. However, Vespasiano's dealings with Bishop Jouffroy prove that, whatever the price of a manuscript, the margin of profit could be disappointingly slender, barely covering expenses. "I expected your lordship to send me a little payment or gift for my pains over and above the cost of the books," Vespasiano wrote to him in a letter of complaint, "but indeed I have received neither this, nor even the cost price."[4]

Cosimo had been a far prompter and more generous patron. Surviving accounts for 111 of the manuscripts produced for the Badia in Fiesole show that he paid Vespasiano a total of 1,566 florins.[5] This sum means the codices cost Cosimo an average of 14 florins each, somewhat lower than the prices at which many of Vespasiano's manuscripts changed hands, though around a dozen cost more than 30 florins. Cosimo's payments, spread across two years, did not of course amount to pure profit for Vespasiano. He needed to purchase his materials as well as to pay his scribes and illuminators. Even so, he made an average profit of $3\frac{1}{2}$ florins per book—a total, over the two years, of 400 florins. Though the profits were shared with his partners, the sons of Michele Guarducci, his 37.5 percent stake in the bookshop meant these 111 manuscripts alone earned him 75 florins per year between 1462 and Cosimo's death in 1464. This sum compares favorably with the wages of schoolteachers and most employees of international banking firms such as that of the Medici, all of whom earned between 40 and 60 florins per year. However, it is worth reflecting that Vespasiano's 75 florins would not have allowed him to purchase the two most expensive manuscripts done for the Badia

in Fiesole, a volume of the works of Saint John Chrysostom (37 florins) and a collection of Saint Jerome's letters (39 florins).

The profit of $3\frac{1}{2}$ florins per manuscript that Vespasiano made thanks to Cosimo probably represented the peak of his margins. It was difficult to produce a large volume of, say, three hundred leaves of parchment for much less than 20 florins. Even a volume costing 50 florins did not guarantee a higher margin than one costing a fraction of the price, because of the increased expense of labor and materials. And as the example of Bishop Jouffroy shows, Vespasiano was to some extent financially reliant on the whims, generous or otherwise, of his wealthy clients.

Vespasiano suffered few if any financial difficulties at this point, but his problem from an economic point of view was that manuscripts, from the outset, had not been planned or designed as commercial propositions. Copied for centuries by monks in their cloisters, often from materials manufactured on site—inks, pigments, the hides of animals—they were artifacts blissfully produced without consideration of profit and loss. Their migration from scriptoria to bookshops introduced the profit ledger and the need to find a supply of customers beyond the walls of the monastery library. A reclusive scholarly activity had become a business like any other, with a manuscript, no matter how exalted its contents, a commodity to be produced and exchanged on the market.

More manuscripts than ever were being produced and exchanged at this time. The decade of the 1460s witnessed a higher production of manuscripts in Europe than at any point in history. During the first half of the 1400s, just under a million manuscripts were copied all across Europe, an average of some 190,000 per decade. During the decade of the 1460s, however, a total of 457,000 manuscripts were copied—a massive increase that appeared to indicate that, ten years after Gutenberg's invention, the manuscript book and the job of the scribe were both viable and secure.[6] Italians were the largest producers, as indeed they had been for more than a century. The bibliographer Victor Scholderer once speculated that the printing press was invented and perfected in Germany because manuscripts were scarcer and less easily accessible in northern Europe than in Italy, prompting Gutenberg to contemplate a new and different means

of producing books.[7] Vespasiano was one of the reasons for the wide availability of manuscripts in Italy, able as he was to supply with both speed and skill the various needs of his many clients.

Unlike two of his recent predecessors, Nicholas V and Pius II, the new pope, Paul II, took little interest in the Vatican Library. Like both of them, however, he was committed to a crusade against the Turks. Following his election in the summer of 1464 he had assured the Western princes of his zeal for "the defense of the Christian Faith against the fury of the Turks."[8] The two stumbling blocks were, as usual, a lack of money and various disagreements, divisions, and mutual suspicions among the crusading parties. To solve the first problem, Paul assigned the income from indulgences and tithes to be handed directly to a special commission, the Commissaries General of the Holy Crusade, consisting of Bessarion and two other cardinals. The Commissaries General and the Venetians then came up with a scheme whereby the various Italian states were to contribute large sums to fund a crusade: Venice and the papacy were to donate 100,000 florins each, Naples 80,000, Milan 70,000, and Florence 50,000. Even the tiny March of Montferrat was prevailed upon to find 5,000 florins for the cause.

No one in Italy apart from the pope and the Venetians proved eager to expend these sums, believing yet again that the crusade would only serve the commercial interests of the Venetians. In Naples, King Ferrante even threatened to side with the Turks, claiming that Mehmed had offered him 80,000 florins to stir up troubles in Italy (a generous sum, to be sure, for something so easily done). Not even intelligence in 1465 of the equipping of an enormous Turkish fleet, followed by reports the following year of a 200,000-strong army on the march toward Albania, managed to concentrate Western minds. Pope Paul therefore took the bizarre and rather desperate expedient of sending an agent to Constantinople to convert the sultan to Christianity.

Paul's predecessor, Pius II, had already contemplated the idea of turning Mehmed into a good Christian. In 1461 Pius wrote *Epistula ad Mahumetem* (Letter to Mehmed) in which he invited the sultan to

convert to Christianity in return for recognition as Roman Emperor of the East. The historical precedent was the conversion to Christianity of Constantinople's founder, the Roman emperor Constantine. The letter never found its way to Constantinople, as Pius ultimately dedicated himself to a crusade rather than interfaith reconciliation.

Valid reasons existed for believing that Mehmed might be a candidate for conversion. According to the Greek historian Theodore Spandounes, who spent part of his boyhood under the care of his great-aunt, Mehmed's stepmother, the sultan had been baptized a Christian by his mother, a convert to Islam, and, though raised as a Muslim, adhered "more to the Christian faith than any other."[9] Mehmed's son Bayezid was later to claim his father did not follow the teachings of Mohammed. As a young man Mehmed had certainly been a reluctant student of the Koran: his tutors could persuade him to memorize passages only by means of the strap. Later, his deference for Byzantine relics, as well as commissions such as a Madonna and Child from the Venetian painter Gentile Bellini, hinted strongly at his great sympathy for the Christian religion.

In the summer of 1465, Pope Paul's agent set off from Rome for Constantinople. He was none other than Paul's former Latin tutor, the bellicose humanist and Aristotelian zealot, George of Trebizond. George was even more optimistic than Pius II about the chances of Mehmed converting. In 1453 he had written a treatise, *On the Truth of the Faith of Christians to the Emir*, arguing that little separated Christianity and Islam, and that at the time of the apocalypse—which George believed had finally arrived—a world emperor would arise and unify all men under one scepter and one religion. He hoped to have the treatise translated into Turkish and presented to Mehmed, whom he regarded as the emperor in question, and whom he hailed as "the king of all the earth and heavens."[10] After Pius II and King Ferrante both spurned his offers to embark on his divine mission to Constantinople, Pope Paul finally assented, paying his way to the East and arranging for him to send back messages in cipher.[11]

George sailed for Constantinople armed with a manuscript of his own translation of Ptolemy's *Almagest*. Composed in Greek around the year 150, the *Almagest* was the greatest surviving astronomical treatise from the ancient world, an attempt to describe the motions of

the stars and planets through geometry and mathematics. Cardinal Bessarion scorned George's translation as riddled with errors (he and his friends often gleefully gathered in his palace at the foot of the Quirinal Hill to discuss the defects of George's various translations). Even so, Ptolemy's work made a wise choice for a gift in view of Mehmed's interest in astronomy and astrology, especially insofar as they revealed his own providential destiny. However, George failed in his attempts to get an audience with the sultan. He remained undaunted, and on his tempest-tossed return voyage he composed *On the Eternal Glory of the Autocrat and His World Empire.* This treatise reiterated his view that Mehmed was destined to conquer Rome and rule the world, which would therefore fall under "one universal kingdom, one church, and one faith."[12]

George discovered himself in difficulties when he arrived back in Rome with the manuscript of this latest treatise. The work was scrutinized for heresy by a number of theologians, including Cardinal Bessarion. Not surprisingly, George soon found himself contemplating life from the inside of a prison cell, from which, as a Milanese ambassador reported, "he continues to commend the Turk grandly and to believe that he must become the Universal Lord of the World."[13] In fact, George took the opportunity of his enforced isolation in the Castel Sant'Angelo to pen yet another prophetic work, *On Divine Manuel, Shortly to be the King of the Whole World.* This treatise explained how George was bestowing on Mehmed II the name Manuel because he was the fulfilment of biblical prophecies. "The last days are upon us," he wrote. "Not only have you come to unite all the peoples as David prophesied, but also the great final Apostasy has begun at Rome which Paul the Apostle prophesied." This apostasy he blamed on "the followers of Plato."[14] The differences between Christianity and Islam might fade with the final blast of heavenly trumpets, but those between Plato and Aristotle were, for George, forever entrenched.

At almost exactly the same time that Sweynheym and Pannartz began printing books in the Palazzo Massimo in Rome, Vespasiano found yet another generous patron, one whose ambitions for a library—what

Vespasiano called "the finest library since antiquity"[15]—would keep a team of some forty scribes, together with rubricators and illuminators, all arranged by Vespasiano, occupied for the better part of the next decade.[16]

Federico da Montefeltro was the hereditary ruler of Urbino, a city-state of seven thousand inhabitants a zigzagging 125-mile journey from Florence through the hills and valleys of the Apennines. Federico was almost exactly the same age as Vespasiano. Born in 1422, the illegitimate son of Guidantonio da Montefeltro, Count of Urbino, he was at first welcomed by his father since the count's twenty-five-year marriage had failed to produce a legitimate heir. However, he found himself shunted aside when Guidantonio's first wife died and his second marriage resulted, in 1427, in a legitimate son, Oddantonio. Federico was educated in Venice and then Mantua, and as an adolescent he distinguished himself with a series of narcissistic poems celebrating his amorous achievements. Federico's true destiny, however, involved conquests of a different sort. At the age of fifteen he entered the service of the warlord Niccolò Piccinino, commanding a cavalry of eight hundred horses and proving himself a brilliant warrior through such feats as capturing a hitherto impregnable fortress from the ferocious Sigismondo Malatesta.

Federico's fortunes changed with the death of his younger half-brother, Oddantonio, who had become Count of Urbino on his father's death in 1443. After the seventeen-year-old made himself unpopular through high taxes and predatory sexual behavior, his corpse was discovered in the street in July 1444, his severed penis between his teeth. Federico quickly took control, making himself as popular with the inhabitants as Oddantonio had been reviled. His enormous fees as the most sought-after mercenary in Italy brought tremendous prosperity to the city, making Urbino, as was said, *una città in forma di palazzo*—a city in the shape of a palace. "Not a beggar was to be seen in all the land," marveled Vespasiano.[17] Indeed, Federico employed almost four hundred people at his court. His retainers encompassed everyone from various knights and gentlemen to clerks, teachers, chaplains, cooks, waiters, grooms, pages, dancing masters, and a keeper for his giraffe. Federico's career and the prosperity of Urbino were briefly threatened in 1450 when he was badly

injured in a joust in Milan, his opponent's lance breaking his nose and gouging out his right eye (he had disdained a visor). He survived to fight another day—and to pose for portraits showing not only his mutilations but also the large wart, the result of a childhood skin affliction, that became his trademark.

Later in life, Federico would commission a portrait of himself in which, accompanied by his young son and heir, he is seated on a gold-knobbed throne and dressed in an ermine-trimmed cloak draped over a suit of armor, a sword on his hip and a visored helmet at his feet. With his one good eye he reads a large leather-bound book. The painting shows the image Federico carefully cultivated and wished to project: a ruler, a warrior, and, above all, a reader.

Federico's image as a scholar-warrior was further burnished in a 26,000-line poem composed in his honor by his resident poet and court painter, Giovanni Santi, the future father of Raphael. Despite being "laden with the laurels" from the battlefield, Federico devoted himself, Santi wrote, to "mental discipline" and "elevating themes": he tucked into Aristotle, applied himself to algebra, studied the heavens with the finest astrologers, and, as he ate his frugal repasts, listened to ancient histories and tales of martial deeds. His court included no fewer than five men whose duty it was to read aloud to him during his meals.[18]

Federico was indeed a voracious bookworm. Like King Alfonso, he preferred Roman histories and treatises on warfare—Livy, Caesar, and Plutarch. His study of history was, in Vespasiano's view, one of the reasons why he proved so successful in battle. "A commander who knows Latin," Vespasiano claimed, "holds an advantage over one who does not."[19] During Lent he had theological works read to him, and he also enjoyed philosophy. Vespasiano claimed he was "the first warlord to study philosophy"[20] (though his old antagonist Sigismondo Malatesta was, as his exhumation of Pletho demonstrated, a devoted follower of Plato). He was especially fond of disputing the knottier passages of Aristotle's *Nicomachean Ethics*, a treatise in which he, like Cosimo and King Alfonso before him, could have learned about the virtue of "suitable expenditure on a great scale."

Federico certainly spent money on a great scale. He collected manuscripts from about 1460, but not until 1465, when his architects

began adding a new wing to his palace, did he think about lavishing his money on a library. And what a library it would be—one "so vast, and so select, / As to supply each intellect and taste," according to Giovanni Santi.[21] As Vespasiano wrote, "He alone had the spirit to do what no one had done for a thousand years or more"—that is, the spirit to put together the world's finest collection of books. Vespasiano claimed Federico spared no expense, sending for codices from around Europe and keeping a team of "thirty or forty scribes" busy copying manuscripts.[22]

Vespasiano was essential to this project. He was valuable, in the first place, because he knew where the finest exemplars could be found. On one occasion he went to Urbino equipped with the catalogues of the libraries of the Vatican, of the castle in Pavia (which held a thousand manuscripts), "and even," he boasted, "of Oxford University, which I had sent to me from England."[23] He also knew well the contents of the magnificent library in Naples thanks to his relations with King Alfonso and then Ferrante, as well as, of course, libraries in Florence such as those of Cosimo de' Medici, the convent of San Marco, the Badia in Fiesole, and the abbey across the street from his bookshop. He was further essential to Federico's ambitions because, more than anyone else in Europe, he was able to coordinate the team of scribes as well as the illuminators who would illustrate manuscripts for the collection in Urbino. Federico's colossal ambitions for his house of learning would require the full extent of Vespasiano's thirty-five years of experience in the manuscript industry.

Besides enlarging his palace and building a library and an intimate *studiolo* for reading his prized books and showing off his erudition, Federico da Montefeltro continued to occupy himself with the pressing business of warfare. The Florentines were his latest clients. In the summer of 1467, as Vespasiano began work for him, Count Federico rode north toward Bologna to intercept a 16,000-strong army marching on Florence. At the head of the invasion force was the feared Venetian commander, Bartolomeo Colleoni; somewhere in its ranks was a small band of Florentine exiles dedicated to overthrowing the Medici.

Since his father's death in 1464, Piero de' Medici had done his best to maintain his family's preeminent position in Florence. According to a chronicler, Piero enjoyed "great authority, many friends, wealth, and a power similar to his father's."[24] By 1466, however, Piero, at fifty years old, was increasingly disabled by gout. As a result, government meetings and ambassadorial receptions were held not in the Palazzo della Signoria but in the Palazzo Medici, which increasingly served as the seat of government. Moreover, Piero lacked his father's shrewdness and experience, and his power and grandeur soon provoked indignation among the citizens. His father had faced similar crises due to rivals and malcontents, most recently in 1458. On that occasion, the Medici maintained their power thanks to Cosimo's longtime ally, the duke of Milan, Francesco Sforza, who sent troops to quell an insurrection. As mercenary troops poured into the city, Cosimo took the opportunity to arrest 150 opponents, torture a few others, and strengthen his grip on power. However, the death of Sforza in March 1466 robbed Piero, so soon after losing his father, of this reliable supplier of military might.

Piero's authority was soon challenged. In May 1466 a petition signed by four hundred citizens demanded a return to a "government of the many."[25] Among the signatories were men who once had been Cosimo's closest allies in helping him to rig elections and maintain power. Though they claimed to want a restoration of ancient freedoms and a return to a republican form of government, in some cases they were motivated by perceived slights over marriages and political appointments. The ringleader of these malcontents was a sixty-eight-year-old wool merchant and veteran political operator named Luca Pitti, a vain and ambitious man whose enormous palace on the south side of the Arno became a rival center of power. Another of Piero's most prominent opponents was Agnolo Acciaiuoli, an older cousin of Donato and Piero. Vespasiano, who knew him well, claimed Agnolo had grown indignant over Piero's conduct. Vespasiano dined with him in 1466 and found him "deeply upset" by Piero's high-handed control of government.[26]

By the summer of 1466 the two factions were prepared for battle. Appeals went out for military assistance—to Milan from the Medici and to Borso d'Este, ruler of Ferrara, from Pitti and his fellow rebels.

Piero retreated to the Medici villa at Careggi and rallied the peasants in the tough hinterlands of the Mugello, the family power base. Escorted by these pickax-wielding ruffians, whose fathers and uncles had once finished off Rinaldo degli Albizzi's hopes of defeating Cosimo, he marched back into Florence with a fabricated tale of the perfidious conspirators trying to murder him. Then, as the city exploded in violence, he barricaded himself inside the family palazzo, plentifully stockpiled with food, weapons, and wine.

Events soon turned in Piero's favor as, at the end of August, the government officials drawn for service all proved to be Medici loyalists. In a show of strength, Piero flooded the Piazza della Signoria with three thousand infantry; at their head was his seventeen-year-old son Lorenzo, on horseback and in armor, shouting *Viva il popolo* (the "people" of whom the Medici saw themselves as protectors and defenders). Luca Pitti quickly made his peace, accepting the offer of the marriage of his daughter to someone Piero said he "held most dear" (which Pitti assumed would be Lorenzo but instead, disappointingly, turned out to be Piero's brother-in-law).[27]

Many of the other rebels, including Agnolo Acciaiuoli, fled into exile. Agnolo went south to Naples while others escaped to Venice, where their agitations continued. The rebels took themselves to Bartolomeo Colleoni's castle near Bergamo, a visit that resulted (following successful overtures to the warlord) in the huge army descending on Florence. Colleoni commanded these troops in his own name, rather than in that of the Republic of Venice, but the Venetians were secretly hoping Florence could be detached from its alliance with Milan. The rebels had even persuaded Colleoni—a grizzled sixty-six-year-old warrior with many decades of battle behind him—that he could become duke of Milan. To do so, he would need to kill the new duke, Francesco Sforza's twenty-two-year-old son Galeazzo Maria, who at that moment was in Florence, a guest in the Medici palazzo. In his army Colleoni counted the lords of Forlì, Faenza, and Pesaro, along with troops from Ferrara, led by Ercole d'Este.

The ruler of Pesaro marching on Florence was Alessandro Sforza, brother of the late Francesco and the hero of a 1462 battle against the Angevins in the Kingdom of Naples—the victory at Troia, which Vespasiano called "one of the greatest feats of arms seen in Italy

for many years."[28] Alessandro also happened to be another of Vespasiano's clients. After coming to power in 1444 he had started assembling what Vespasiano described as "a magnificent library . . . sending to Florence to buy all the manuscripts he could find, and having others copied for him regardless of the cost"—nearly five hundred volumes in total. According to Vespasiano, Alessandro was "one of the two great captains of the age who combined military skill with a love of books."[29] The other great captain was marching through the Apennines to do battle with him: Federico da Montefeltro, who, in the tangled web of Italian politics, was Alessandro Sforza's son-in-law.

Several of the most renowned mercenary captains in Italy therefore met on July 25 in the fields near Molinella, twenty miles northeast of Bologna. Ever scornful of mercenaries, Niccolò Machiavelli later claimed that after eight hours of battle not a single soldier had been killed, only a few horses wounded and a handful of prisoners taken. In fact, hundreds of soldiers were killed on both sides, Colleoni and his troops were forced back, and Borso d'Este's half-brother Ercole had two horses killed under him, suffered wounds from artillery, and would limp for the rest of his life. As Colleoni retreated north with his army, Piero de' Medici was once again, thanks to Count Federico, safe in his Florentine palazzo, enjoying power and authority. Vespasiano's two faithful clients survived to fight another day.

The conspiracy against Piero de' Medici put Vespasiano in an awkward position, and not simply because two of his best customers clashed at Molinella. Vespasiano's problem concerned the Medici. He had, of course, done much business with the family, Piero included. But he was also close friends with the Acciaiuoli—so close, indeed, that he had dined with Agnolo virtually on the eve of the rebellion, listening to him vent his frustrations with Piero. Despite many years of selling manuscripts to the Medici, Vespasiano suddenly had reason to feel uneasy about his relations with the family, commercial and otherwise.

This disquiet was behind a remarkable letter that King Ferrante wrote to Piero de' Medici in April 1467, following the failed conspiracy but before the Battle of Molinella. The king informed Piero that

he, Ferrante, enjoyed the devotion of "the most excellent Vespasiano," to whom he was indebted for his "information and experience." Likewise, he wrote, "we know that he is most devoted to you and your house, for we have heard of him speaking of you in the most reverential terms." He went on to praise Vespasiano's "virtue and merit," and finished by saying he hoped this recommendation would be of assistance to the bookseller.[30]

Vespasiano had appealed to King Ferrante for this letter of reference. Ferrante's assurances went beyond merely a recommendation to Piero for Vespasiano's abilities as a bookseller, which Piero already knew very well. Rather, Vespasiano needed Ferrante to vouch for his loyalty to the Medici regime. This loyalty had been brought into question not only through his close friendship with the Acciaiuoli family but also, perhaps, through his bookshop's reputation as a place where powerful men gathered for discussion, and where news and opinions were exchanged thanks to Vespasiano "collecting all the daily happenings." A historian has recently argued that by the 1460s Vespasiano's bookshop was "a political nexus . . . and even a listening post for the subversive, the disaffected, or the potentially so."[31] A few years earlier his bookshop was said to have "Aragonese doors" whose threshold Angevin supporters dared not darken (though in fact many Angevin supporters, such as Piero de' Pazzi, freely came and went). By 1466 there was a danger that the bookshop could have been perceived as a site of anti-Medici activity. Once again, as in the Angevin-Aragon dispute over the throne of Naples, when he had friends on both sides, Vespasiano needed to tread a careful path between Florence's rival factions. The measure of his eminence is that he was able to call upon one of Piero's closest allies, and one of the most powerful men in Italy, to vouch for him.

This request for a good reference was not the only letter to pass from Vespasiano to King Ferrante. Unfortunately, these revealing documents were destroyed along with many thousands of others during World War II. On September 30, 1943, as reprisal for the killing of one of their number in the village square in San Paolo Bel Sito, fifteen miles outside of Naples, a squad of Nazi soldiers set fire to the

nearby Villa Montesano, to which the Royal State Archives of Naples had been evacuated. Seven hundred years of history were lost—thirty thousand manuscripts and fifty thousand documents. The destruction left, as the archive's director, Count Riccardo Filangieri, later despaired, "an immense void in the historical sources of European civilization."[32]

Among the tens of thousands of documents lost in the blaze was a series of letters Vespasiano wrote to Ferrante in 1467 and 1468, including the one asking for the character reference to be sent to Piero de' Medici. Some of the king's replies to Vespasiano, composed by his secretary, do survive, and they prove that in these years the bookseller was providing Ferrante with intelligence on the political situation in Florence. Vespasiano was, as Ferrante told Piero de' Medici, someone on whom the king relied for "information and experience." Though Ferrante may not have initiated these reports, he certainly welcomed and encouraged them once they started arriving. In November 1467 he wrote Vespasiano to thank him for a letter sent ten days earlier, saying he was gratified to receive his news and urging Vespasiano to be diligent in reporting "the things happening there."[33] In another letter written a few weeks later, Ferrante thanked Vespasiano for supplying "a great deal of diverse news," then wrote of making a great effort against "those who have disturbed the peace of Italy"—a reference to the Venetians and the ruler of Ferrara, Borso d'Este, who supported the Angevin claim to the throne of Naples, and who was, like so many other involved parties, Ferrante included, one of Vespasiano's customers.

The information may have been passed to Ferrante through the Neapolitan ambassador Antonio Cincinello, a wily and unscrupulous character whom Vespasiano came to know well. His biography of Cincinello was careful to stress the ambassador's virtue ("he was held in great reputation everywhere because of his many laudable actions") but also blithely noted that Cincinello was willing to resort to any means necessary to serve King Ferrante: "It seemed to him that for the sake of his lord he must do whatever was needed."[34]

Vespasiano recounted Cincinello's underhanded tactics—obtaining information through bribery, threats, and controlled violence—with a thinly disguised admiration. Cincinello's missions at

this time involved foiling the efforts of Borso d'Este. On one occasion when he served as ambassador in Ferrara, he noted the comings and goings at Borso's court of an envoy from Jean of Anjou. Determined to uncover these secret dealings, he made subtle inquiries into the envoy's household and, after learning which barber the man used, began summoning the fellow for his own morning shave. He won the barber's confidence by tipping generously and then asked if he knew where the envoy kept his official documents—because, if he did, and if he had the courage to remove them, Cincinello would make it worth his while. The barber readily agreed, purloining the documents and bringing them to Cincinello, "who, having read them, understood the many secrets of Jean of Anjou, among them a planned invasion of the Kingdom of Naples."[35]

Where the rattle of ducats failed to produce a result, Cincinello deployed other, more drastic means. When he was ambassador to Rome he arranged for the kidnapping of one of Ferrante's enemies who was slipping in and out of the kingdom on some nefarious business. Determined to "get his hands on him," Cincinello lured his victim beyond the gates of Rome, where he had him seized and gagged by a band of horsemen, then bundled to Naples and hauled before Ferrante. The king enjoyed taking his vengeance through such baleful whimsies as strangling his enemies and then embalming them for display in a museum of mummies in the Castelnuovo. This latest enemy did not, apparently, become the latest exhibit, because as Vespasiano, in a statement that strains the bounds of credulity, claimed, Ferrante was "a most clement man who had no wish to do violence," and the offender was released with a caution. Vespasiano did admit that Cincinello's actions, here and elsewhere, raised certain uncomfortable moral questions. "Now in this case," he wrote of the kidnapping, "whether I agree or not, I pass no judgment, knowing Antonio to be a man of good conscience."[36]

Cincinello's schemes did finally come disastrously unstuck when he served Ferrante in L'Aquila, whose people were, in Vespasiano's opinion, "a rough and rowdy bunch," much like the beasts they tended in the surrounding hills. He reported Cincinello's violent death—hacked to pieces by an angry mob, his house looted and his butchered corpse tossed into the street. "Such was the end and the

reward of Messer Antonio, after such a long service. Almighty God, your judgments are marvellous," he wrote with no discernible irony, "and your ways inscrutable!"[37]

Vespasiano was hardly required to do "whatever was necessary" for Ferrante's sake, but he could have provided useful intelligence. He was close to Angevin supporters such as the Pazzi, who had been behind the attempt on the king's life, and Ferrante was no doubt hoping for—and Vespasiano may have been supplying—information on any other such plots. In any case, the bookseller was conveying the political weather in Florence in the wake of the city's recent divisions, information that, as a trusted intimate of so many powerful Florentines, and as someone privy to so many conversations, he could easily obtain. As Ferrante ended one of his letters to Vespasiano, "For all of this, we thank you."[38]

King Ferrante was not a "magnificent man" of the same stamp as his father. He was a cultured man, certainly, who loved music, and in 1465 he expanded the university in Naples such that it boasted a faculty of twenty-two professors. Though he was interested in architecture, carrying out renovations on the Castelnuovo, such were his views on art that he allowed the destruction, during these refurbishments, of frescoes by Giotto. He shared little of his father's enthusiasm for classical studies. Rather than Latin, he favored works in the local Neapolitan dialect. And rather than books on history or philosophy, he preferred more practical political and military treatises.

The royal library in the Castelnuovo continued to expand during these first years of Ferrante's reign and, as in the days of Alfonso the Magnificent, Vespasiano was kept busy producing manuscripts that went south to Naples. In fact, when another client complained that a manuscript of Suetonius's *The Twelve Caesars* being prepared by Vespasiano was taking too long to arrive, his agent explained that the famous bookseller placated him "with words and promises," but that he was busy having manuscripts copied for King Ferrante.[39]

During these years Vespasiano became friendly with the young man that Ferrante, in a letter to the bookseller, referred to as *Illustrissimo nostro Primogenito*—"our Most Illustrious Firstborn."[40] Ferrante's

nineteen-year-old son and heir, Alfonso, Duke of Calabria, spent much of 1467 and early 1468 in Florence, where he and Vespasiano came to know each other well. He was among the soldiers who in the summer of 1467 rode out with Federico da Montefeltro to do battle with Bartolomeo Colleoni and Alessandro Sforza. Alfonso had launched his military career at the age of fourteen, fighting in Calabria against the barons who supported the Angevin claim to the throne, and giving ample proof of his precocious abilities on the battlefield.

Just as his father's nascent military talents had been supplemented with lessons in humane letters, so too young Alfonso was put through his paces in Latin literature, no doubt with the aim of turning him into the combination of warrior and scholar exemplified by Federico da Montefeltro and Alessandro Sforza. Like his father and grandfather before him, he became a regular client of Vespasiano, and over the next few years he would commission at least twenty-six manuscripts from him.[41] And when Alfonso departed from Florence in the early spring of 1468, he too began receiving missives from Vespasiano. Addressed to "Most Illustrious Prince and Dearest Lord," they featured news and opinions on the state of Italy.

Chapter 18

The Second Coming

Johannes Gutenberg died in 1468 after enjoying for only a few short years his court clothing and the yearly allowances of grain and wine granted to him by Archbishop Adolf. He was interred in a church in Mainz with an inscription declaring him "the inventor of the art of printing and deserver of the highest honors from every nation and tongue."[1]

Gutenberg was certainly lauded in Italy. "Oh, that good German who invented this admirable art! He should be honored with praise fit for the gods," wrote a Venetian physician. "For through means of his discovery, the whole of the study of letters can easily be got hold of or learned."[2] One scholar attested that the printing press was a divine gift bestowed on the Christian world during Paul II's pontificate. Another confidently informed the pope: "Your pontificate, most glorious already, will never be forgotten because this art has been taken up to your Throne."[3] This flattery was not misplaced. Paul was neither a scholar nor a lover of humanist learning like his predecessors, Nicholas V and Pius II. He was, however, a great advocate of printing. He eagerly adopted the new technology and soon set to work a German printer newly arrived in Rome, Sixtus Riessinger, printing papal bulls. He even made frequent visits to Riessinger's printing office to inspect this new invention and its wares, evidently appreciating its enormous possibilities for spreading religious ideas.

The production of printed books was steadily gathering momentum. By the end of 1468, more than 120 titles had been printed across Europe in the years since Gutenberg produced his first works in Mainz. The vast majority, almost one hundred, originated in Ger-

many. Most of the German printers used Gothic type, but in 1468 a printer in Augsburg named Günther Zainer began using the "antique" or "roman" letters to which Sweynheym and Pannartz had also recently switched in imitation of Italian scribes such as those used by Vespasiano. That duo continued operations in the Palazzo Massimo, while yet another German, a priest named Ulrich Han, had set up his own press in Rome and begun printing books in 1467.

The year 1469 witnessed even greater advances in printing. More than forty new titles appeared in that year alone, but now the majority, twenty-four of them, were printed in Italy. The arrivals of Riessinger and Ulrich Han meant Rome now had three printing presses. Meanwhile, in Venice a German goldsmith named Johann de Speier received a patent from the Senate granting him a monopoly on printing books for five years (though, as luck would have it, he died after only a few months). He produced two titles in the summer of 1469, both Latin classics: Pliny the Elder's *Natural History* and Cicero's *Letters to Friends*. In some ways, 1469 was the year of Cicero, for Sweynheym and Pannartz printed three of his works: *On Duties, Brutus,* and *Letters to Friends.* Meanwhile, Han produced his own edition of *On Duties* as well as the editio princeps (first printed edition) of the *Tusculan Disputations.*

The year 1469 also marked the beginning of an important collaboration. Anyone printing classical texts such as those of Cicero or Pliny needed to contend with the same problems faced by Vespasiano: how to find a trustworthy exemplar and then exert quality control over the finished product by checking the completed text for human errors. To edit and emend their classical texts, Sweynheym and Pannartz therefore engaged an indefatigable fifty-two-year-old humanist scholar named Giovanni Andrea Bussi, since 1466 the bishop of Aleria in Corsica. He became an early advocate for the printing press, claiming in 1468 that thanks to this "admirable art" even the poorest could afford to create libraries, since a printed book cost a fifth of the price of a manuscript. He paid tribute to the Germans for the invention, although as he admitted, "you will smile at the rough Teutonic surnames."[4] More smiles were no doubt raised over the next few years as émigrés named Bartholomaeus Guldinbeck and Theobaldus Schencbecher set up their presses in Rome.

Bishop Bussi went enthusiastically to work with Sweynheym and Pannartz, assisted by Pope Paul, who allowed him access to the manuscript collection assembled by Nicholas V. Bussi helped the Germans with passages of text in Hebrew, Arabic, and Greek, hunted down codices for comparison, and consulted his notes from the long-ago lectures of former professors. In 1469 the texts edited by Bussi began flowing from the Sweynheym and Pannartz press: Cicero's *Letters to Friends*, Livy's *Ab Urbe Condita*, Strabo's *Geography*, Lucan's *Pharsalia*, Virgil's *Aeneid*, and another humanist favorite, Aulus Gellius's *Attic Nights*. Little wonder that Bussi described himself as living during this time "as if locked up in a prison of papers."[5]

Sweynheym and Pannartz printed another book in 1469, though this particular text required no attentions from Bishop Bussi. Following some ten years of work, Cardinal Bessarion had finally completed *Adversus calumniatorem Platonis*, his defense of Plato against the attacks of George of Trebizond. He originally wrote the treatise in Greek and then translated it into Latin himself, completing it in 1466 only to realize that his Latin was stilted and therefore, no doubt, woefully vulnerable to mockery and criticism. After he hired Niccolò Perotti to perform a more elegant job of translation, the result was a 474-page volume that served as an introduction to Plato's thought and revealed, according to a recent scholar, Bessarion's "amazingly powerful urge to answer George immediately and overwhelmingly."[6]

The desire for an immediate and overwhelming response was no doubt the reason why Cardinal Bessarion chose to distribute this thundering counterblast in the new medium of print. Sweynheym and Pannartz produced three hundred copies, twenty-five more than their usual print run. This surplus was to provide copies that Bessarion cannily sent free of charge (complete with a cover letter) to friends and fellow scholars, ensuring a widespread readership. To further this pro-Plato propaganda, Perotti gathered the comments and letters of thanks from these scholars and printed them in a dossier, thereby producing a collection of endorsements that amounted to the book world's first review-led publicity campaign. Perotti even doctored some of the comments in order to make them appear more enthusiastic.[7]

If in 1462 the printing press was deployed in the factional dispute in Mainz, in 1469 Bessarion drew on the resources of this new

technology in his propaganda battle with George of Trebizond. The virtues of Plato and the reputation of Pletho would be saved from the calumnies of the Aristotelians thanks to the hundreds of copies of a printed book.

Besides refuting the pugnacious George of Trebizond, Cardinal Bessarion had also been eager, as he put it, to "gather and preserve almost all the works of the Greek wise men."[8] For fifteen years his manuscript hunters had been scouring the occupied or endangered lands of the East in search of these works. No expense was spared, and reports of Bessarion's spending vary from 15,000 to 30,000 ducats. By 1468 his library encompassed 746 manuscripts, of which 482 were in Greek—the largest and finest collection of Greek literature in Europe at the time.[9] But having reached his late sixties, Bessarion was forced to consider what should become of these treasures following his death. Florence would have been a natural beneficiary given its many scholars with their devotion to Greek letters, as well as its public library and sympathetic patrons such as the Medici. Likewise, the Vatican Library in Rome might have made a worthy repository due to the presence of the three printers, especially Sweynheym and Pannartz. Their campaign to print the classics would have ensured that in time the manuscripts were turned into printed books and widely disseminated, thus ensuring their survival.

But Cardinal Bessarion chose neither, instead selecting Venice and donating his manuscripts to the Basilica of San Marco. He made his choice not because of the caliber of Venice's scholars (in the 1460s the republic was still an intellectual hinterland compared to Florence, Rome, and Naples) but rather for its geographical position between East and West and, perhaps most important, for what he regarded as its political stability. He was also, as Vespasiano pointed out, "on the friendliest of terms with the Venetians."[10] Bessarion was evidently undeterred by the fate of Petrarch's collection, the remains of which, a century after his bequest, were, despite various promises from the Venetian government of a purpose-built library, decaying and crumbling in a neglected chamber under the roof of San Marco.

In May 1468 Bessarion wrote a letter to the doge, Cristoforo Moro, justifying his gift with an eloquent plea for learning. He pointed out that "there is no more worthy or honorable possession, no more dignified and valuable treasure," than a book. "They live, they converse and speak with us, they teach us, educate us, console us," he wrote. Books bring the past to life and place it before our eyes, they offer examples to emulate, they tell us of things both human and divine. Without them, he wrote, we are rendered "barbarous and unlettered." After referring to "the fall of Greece and the pitiful capture of Byzantium" he described how, having gathered these works together, he now wished to ensure that "they would never be scattered about or lost ever again."[11] In keeping with his humanist beliefs, Bessarion insisted that these manuscripts should be—like those in the library of San Marco in Florence—accessible to the public, with the constant presence of two custodians to safeguard them.

The Venetian Senate graciously accepted this bequest, promising to lodge the books in a part of the ducal palace to be called the "Library of San Marco." No facilities yet existed in which to store or display the manuscripts, but that was a minor detail, and so in the spring of 1469 the first crates of Bessarion's manuscripts left Rome. On arrival in Venice they were stored in the ducal palace until suitable arrangements could be made. These arrangements would, in the end, take almost a century, during which time Bessarion's precious manuscripts would molder behind a wooden partition in the Sala dello Scrutinio, ill-attended and occasionally pillaged by borrowers, who sold them or otherwise failed to return them. Altogether, twenty-two manuscripts would disappear (a miraculously low casualty rate given the level of neglect). By 1515 its custodian would refer to the collection, ruefully, as the "buried library"—and Bessarion's manuscripts would not find a home for almost another fifty years.[12]

But all of that was in the future. For a happier apparition we may imagine a fine spring day in 1469. A young student lingering near Trajan's Column watches Roman porters carrying the crates, each weighing two hundred pounds,[13] from Bessarion's palazzo in preparation for their 325-mile journey to Venice in a convoy of pack mules. He is a twenty-year-old from the countryside outside Rome who, in 1469, goes to the Roman Studium to hear the lectures of Domizio Calderini,

a close friend of Bessarion. Named Aldo Mannuccio, this young man will later move to Venice, adopt the Latin appellation Aldus Manutius and—with some limited access to the boxed-up treasures of the Sala dello Scrutinio—begin using a printing press to ensure that, through the beautiful editions of what would become the Aldine Press, the wisdom of the Greeks will never be "scattered about or lost ever again."[14]

One of the scholars to whom Cardinal Bessarion sent a copy of his newly published *Adversus calumniatorem Platonis* was Cosimo de' Medici's former protégé Marsilio Ficino. When the book arrived in Florence at the end of the summer in 1469, Ficino had completed his epic task of translating Plato's dialogues into Latin and composing commentaries for each.

Any qualms Ficino suffered about Plato's supposed impiety had long since evaporated. Like Ambrogio Traversari before him, he found to his relief that the Greek philosophers were in harmony with the truths of Christianity. "The whole philosophy of the ancients," he wrote to a friend, "is simply religion united with wisdom."[15] Religion and wisdom came together most profoundly in Plato, who was, Ficino believed, "indisputably divine," a savior who could reform and renew religious life by showing how philosophy might "purify the soul" and help Christians to "see the divine light and worship God."[16] In a letter to a friend he went so far as to compare the death of Socrates to the last hours of Christ. "What about the wine-cup and the blessing at that same hour," he asked, "and the mention made of the cock at the very time of his death?" He furthermore noted that the many words and deeds of Socrates were recorded not by Socrates himself but, rather, "his four disciples"—words and deeds "which mightily confirm the Christian faith."[17] If earlier generations of scholars had awaited the Second Coming of Cicero and Quintilian, for Ficino the promised messiah would be Plato.*

*Ficino's equation of Christ and Socrates connects the chalice of wine at the Last Supper to the wine cup in which the poison is served to Socrates; the cock that crows after Peter's third denial of Christ to the cock that Socrates, with his last words, says he wishes to sacrifice to Asclepius; and the writers of the four Gospels to Socrates's four "disciples" (Plato, Xenophon, Aristotle, and Aristophanes).

However, Ficino was not ready to broadcast his dialogues to the world in either script or print—the times were not yet propitious to release the Platonic genie. Instead, he began gathering friends at his home outside Florence for informal discussions on Plato's philosophy. Cosimo had given him the house and farm as a reward for his work translating the *Corpus Hermeticum* and then taking on the complete works of Plato. Halfway up the side of a hill known as Montevecchio, the property boasted a vineyard, an olive grove, and, to the south, commanding views of Florence. Bounded by a pine forest, it stood conveniently near the Medici villa at Careggi, where Ficino visited his patron in the weeks before his death, reading aloud to him from some of the newly translated dialogues.

Ficino came to treasure this little farm at Montevecchio as a welcome retreat from the bustle of Florence. It was a place to which, free from the cares of life, he could withdraw for meditation and country walks. It was also the place to which he invited his friends to participate in intellectual and spiritual activities. He called the site of these philosophical retreats his *Academiola*, or Little Academy, a clear reference to the spot outside the walls of Athens where Plato had lived and taught. Plato's property had stood in a grove named for the ancient Greek hero Academus, which meant it came to be called the Academy. Since he was reviving Plato, Ficino likewise needed to revive Plato's Academy—and his little farm outside Florence seemed to mirror perfectly Plato's modest Athenian abode.[18]

Ficino and his friends knew that Plato had died on November 7, 347 BC, his eighty-first birthday, though the sources were divided over whether he died at a wedding feast (Diogenes Laertius) or "pen in hand" (Cicero in *On Old Age*). For many centuries Plato's followers had faithfully observed November 7 with solemn feasts, but commemorations had lapsed since the third century AD. Ficino therefore revived the tradition, gathering together his father and his friends at his house, addressing them as "beloved in Plato," and celebrating the life of the great philosopher whose bust presided over the festivities. He likewise began observing the feast day of Cosimo's patron saints, Cosmas and Damian. He had been urged to do so by the spirit of Cosimo himself, which spoke to him from an old oak tree near Careggi—

or so he informed Cosimo's grandson, Lorenzo, from whom he hoped further generous patronage might come.

By the end of 1469 Lorenzo de' Medici had become the new *de facto* ruler of Florence. His father, Piero, died on December 2, 1469, following his long and ghastly infirmity. Lorenzo was still a month shy of his twenty-first birthday and therefore far too young to hold public office: the Florentines believed that young men lacked the gravity necessary for political office and so the minimum age for participation was twenty-

Lorenzo de' Medici (1449–1492): poet, politician, "artist in expenditure."

nine. As his father faded that autumn and he saw the family's power slipping from his grasp, Lorenzo had appealed for military support to the duke of Milan, Galeazzo Maria Sforza, son of Duke Francesco, the staunch ally of his grandfather Cosimo. Within days of Piero's death, however, the promised Milanese muscle became superfluous. Hundreds of Medici partisans gathered at a Florentine convent and then sent a delegation to Lorenzo, recognizing him as Piero's political heir. Lorenzo claimed that he only unwillingly accepted this task, due to his "young age and the great responsibilities and dangers," but that he accepted "for the sake of our friends and supporters, because in Florence rich men fare poorly without the help of the state."[19]

Lorenzo was therefore poised to continue the Medici tradition of ruling the Republic of Florence as first among equals. He likewise seemed ready to extend the Medici tradition of sponsorship and philanthropy. His mother, Lucrezia Tornabuoni de' Medici, was a cultivated woman who befriended humanist scholars and wrote elegant poems about saints and Old Testament heroines. Such were

her leadership qualities and decision-making abilities that her father-in-law, Cosimo, once ruefully called her "the only man in the family."[20] She and Piero ensured that Lorenzo received a fine education in humane letters, which included studies under John Argyropoulos. But thanks to Ficino, Lorenzo would turn from Aristotle to Plato. In the summer of 1468 he attended discussions on Plato's philosophy hosted by Ficino in the rotunda designed by Brunelleschi for Ambrogio Traversari's former convent of Santa Maria degli Angeli.

These discussions with Ficino were crucial for the formation of Lorenzo's own thought. Later, in a long philosophical poem, "The Supreme Good," he would describe his conversion to Ficino's version of Platonism. Written in the vernacular, the poem celebrates "Marsilio of Montevecchio" as "he in whom heaven poured its every grace / that he might be a mirror to all men." Lorenzo describes meeting Marsilio in his "delightful haunt" outside the city—clearly his property on the slopes of Montevecchio—where Marsilio offers advice on how to find happiness. After much discussion Marsilio reveals that the only source of true happiness is God, and so the question becomes how to approach and understand him. What follows is a love-versus-knowledge debate. The investigations of philosophers such as Aristotle, who use the intellect, will ultimately fail to discover God and therefore to deliver happiness. God hides from wise scholars who try to analyze his nature, Marsilio explains, but reveals himself to the simple men who love him. "Love opens the gates of paradise: / the loving soul will never err, whereas / the search for knowledge often leads to death."[21]

It was a succinct summing-up of Ficino's thought. For all its bottomless erudition and high-flying metaphors, his philosophy was concerned above all with contemplation and love. While Aristotle gave analytical tools to study the natural world, Plato offered Ficino a spiritual experience. Aristotelian fact-finding in the external world of particulars was to be replaced by meditation on eternal verities. In works such as the *Phaedo* Plato had argued against "the foolhardiness of the body"—that is, against the evidence of the senses, as well as the body's needs and passions, all of which "contaminated" the soul and prevented it from discovering truth. The true philosopher, declared Plato, needed to escape from the "chains of the body."[22] Such

was Ficino's aim. He believed the soul could withdraw from the body through contemplation, an act by which it discovered not only its own divinity but also, through its gradual upward ascent, direct knowledge of God himself—a knowledge to which love, and not the furrowed brows of analytical study, gave access, and which was (unlike for Plato in *The Republic*) available to everyone. As he put it, he wished us to "cast off the bonds of our terrestrial chains" so that, "uplifted on Platonic wings and with God as our guide, we may fly unhindered to the ethereal abode."[23]

Ficino's excursions in the countryside outside the walls of Florence played a part in this philosophy of truth revealed and happiness gained through contemplative retreat. Arguments about how best to achieve happiness, whether through vigorous action or withdrawn contemplation, ran from Greek philosophy and Christian theology down through Dante and Petrarch. In Book 10 of the *Nicomachean Ethics* Aristotle had declared the contemplative life to be our highest pursuit—higher even than a life of virtuous political activity. Even so, buttressed by arguments in works by Cicero and the Pseudo-Aristotle, Florentine humanists such as Coluccio Salutati and Leonardo Bruni had celebrated instead the active life of the politically and commercially engaged citizen immersed in the hustle and bustle of the republic.

Plato offered a different perspective on man's place in society and goal in the world. In the *Phaedo,* worldly efforts such as the prosecution of wars and the acquisition of money were irritating distractions from the pursuit of truth. Ficino agreed, believing happiness and truth to be found not by speechmaking or moneygrubbing in the political arenas and commercial warehouses of Florence but, rather, through meditating in the "delightful haunt" of his little Academy in Careggi.

The intellectual divide in Florence by this time was, in some respects, not one between Aristotle and Plato, then, so much as between Cicero and Plato. Cicero had been the ancient writer *par excellence* for the earlier generation of Florentine humanists who admired what Bruni called his "political activities, his speeches, occupations, and struggles."[24] But high culture in Florence was detaching itself from occupations and struggles. The Ciceronian ideal of combining

scholarship with patriotism and civic virtue, so cherished by the earlier scholars, found little purchase in Ficino's translations of the *Corpus Hermeticum* or in the Platonic dialogues. For Ficino, who steered clear of politics, earthly action was less desirable than the ability to ascend, through mystical contemplation, into a divine realm of light and love. It is not difficult to see why a philosophy with such a mystical turn should have endeared itself to Lorenzo, who was in the process of tampering with the republican statutes in order to maintain his political authority.

Ficino offered another reason for Lorenzo to embrace Plato. In Book 5 of *The Republic* Plato wrote that there could be "no respite from evil in the state . . . nor, in my view, even in the human race," unless political leadership fell upon philosophers.[25] His prescription for a healthy state was for philosophy and political power to fuse together in a single figure, the philosopher-king (or-queen). Ficino did not need to cast his gaze very far to discover such a figure in Florence: he informed Lorenzo that he had achieved what Plato "looked for above all else among the great men of antiquity: you have combined the study of philosophy with the exercise of the highest public authority."[26]

Like Marsilio Ficino, Vespasiano was hoping to garner from Lorenzo de' Medici favors similar to those he had enjoyed thanks to both Lorenzo's father, Piero, and his grandfather Cosimo. After Lorenzo came to power Vespasiano wrote to him, reminding him of the "singular affection" in which he held the House of Medici and urging him to begin a project the pair of them had, his letter pointed out, already discussed: the creation of a private Medici library. He claimed he had mentioned this project to three of his other clients, Duke Alfonso, Federico da Montefeltro, and Alessandro Sforza, "who delight in the prospect. I know they will praise it very much." He then gave Lorenzo a gentle nudge: "The more I think about it, the more I feel it to be worthy of you."[27]

Name-dropping his three great clients suggests that Vespasiano's intention was to procure or produce the manuscripts for this princely library himself, exactly as he had done for Cosimo and his sons Piero and Giovanni. Lorenzo was certainly becoming an avid collector and

patron of the arts. "Lorenzo takes delight in rare things," commented a friend.[28] He would add to the splendors of the family palazzo with stunning arrays of tapestries, majolica, gems, vases, marbles, and ancient medals and coins. A visit to Naples in 1466 had led to a keen interest in antiquities. Visitors with letters of introduction showed up at the door of the Palazzo Medici requesting permission to see its treasures—the beautiful and valuable "books, jewels, and figures" (as one of them exulted) that became one of the sights of Florence.[29] Lorenzo even owned a ring that was said to hold prisoner a genie whose magical powers he was believed to control. However, Lorenzo showed little interest in Vespasiano's project. Having inherited the manuscript treasures of his father, uncle, and grandfather, he may have considered himself, at least for the time being, amply supplied.

Vespasiano, in any case, was as busy as ever with his other clients. He was still working on dozens of manuscripts for Federico da Montefeltro as well as, on commission from Cardinal Bessarion, a ten-volume set of the works of Saint Augustine. Though Bessarion entrusted his own treatise on Plato to the new technology of Sweynheym and Pannartz, for these editions of Saint Augustine, destined for his collection in Venice, he chose the reliable combination of Vespasiano, parchment, and scribes. These volumes would be among the most deluxe manuscripts ever produced by Vespasiano and his team, with each volume costing almost fifty florins—the annual salary of the average schoolmaster. They were large in format, beautifully inscribed, and finely illuminated.

Vespasiano's team would work on Cardinal Bessarion's manuscripts for some two years. The final volume was to be Saint Augustine's masterpiece, *The City of God*, but by the time this manuscript was completed many hundreds of other copies of Saint Augustine's masterpiece had suddenly become available in cities around Europe—a stark illustration of the commercial threat that Vespasiano now faced. Sweynheym and Pannartz first produced printed copies of *The City of God* in Rome in 1467, followed by a second edition in 1468. That same year, in Strasbourg, Johannes Mentelin printed an edition of several hundred copies, complete with woodcut illustrations. Then, in 1470, Johann de Speier and his brother Wendelin printed hundreds more copies of their own edition in Venice.

These printed editions of *The City of God* were significantly cheaper than the manuscript for which Vespasiano charged fifty florins. Printed books could be offered for sale for a fraction of the price of equivalent manuscripts. Bishop Bussi exulted that works costing more than one hundred florins in manuscript were now, thanks to the printing press, only twenty florins; those costing twenty florins in manuscript could be had in print for only four florins.[30] As it happens, Bussi's claim of a printed book costing a fifth of the price of a manuscript held true in the case of *The City of God*. Mentelin charged nine florins for one copy of his 1468 edition, which had been rubricated by a scribe and illuminator from Augsburg named Johannes Bämler. The edition produced by Sweynheym and Pannartz in 1470 was even less expensive: it sold for five florins.[31] Needless to say, it would have been impossible for Vespasiano to produce a manuscript of a work as voluminous as *The City of God*—which required hundreds of pages of parchment as well as hundreds of hours of work by a scribe—for anything close to this price.

Printed books cost less than manuscripts because, obviously, they could be produced far more swiftly and in greater numbers and because they primarily used paper rather than parchment. As early as 1458, according to a chronicler, Mentelin was able to print three hundred pages of text per day, which made his press some thirty times faster than the average scribe.[32] The trajectory of Mentelin's career offered a cautionary tale to the scribes of the period still copying manuscripts. He worked in the 1440s as a scribe and illuminator only to abandon the profession in the 1450s after learning the art of printing through one of Gutenberg's assistants (and possibly even from Gutenberg himself during the latter's years in Strasbourg). Mentelin went on to produce Bibles as early as 1460, then editions of the theological writings of Saint John Chrysostom, Saint Jerome, and Saint Thomas Aquinas. In 1469, he diversified into classical literature, printing an edition of Leonardo Bruni's translation of Aristotle's *Nicomachean Ethics* and then, in 1470, Terence's *Comedies* and an edition of the works of Virgil—exactly the kinds of books with which Vespasiano, in manuscript form, supplied his many clients.

Each year, ever more presses appeared issuing ever more books. While some 165 titles had been printed in the fifteen years from the appearance of the *Gutenberg Bible* to the end of 1469, at least that number was printed in the year 1470 alone, doubling in the space of twelve months the entire quantity of printed books available across Europe.[33] Besides Mainz and Strasbourg, presses operated north of the Alps in Nuremberg, Cologne, Augsburg, Paris, and in the Swiss cities of Basel and Beromünster.

The new technology began spreading most steadily and rapidly throughout Italy. Besides Rome, printers were operating in Venice and Naples, to the latter of which Sixtus Riessinger migrated even as another German printer, Georg Lauer, arrived in Rome. In 1470 yet another German, Johann Reinhard, began printing in the tiny Umbrian hill town of Trevi, while that same year in nearby Foligno a printer named Johann Neumeister (who teamed up with a local goldsmith) produced an edition of one of Leonardo Bruni's histories. In 1470 the local authorities in Ferrara entertained an offer to have no fewer than eight printing presses brought to the city from Rome.[34] Though they turned down the proposal, in early 1471 an émigré French printer calling himself Andreas Belfortis, a former scribe who had come to Ferrara seeking work as a copyist, set up shop and began printing books.

The year 1470 marked the moment, too, when Italians started operating printing presses. The first appears to have been a Sicilian nobleman from Messina named Giovanni Filippo del Legname (who adopted the Latin moniker Philippus de Lignamine). In 1470 he arrived in Rome by way of Naples, set himself up in a grand house near the Palazzo di San Marco, became equerry to Pope Paul II, bought a press from Ulrich Han, and produced an edition of Quintilian's *Institutio Oratoria*—the first appearance in print of this classic of humanist learning. Meanwhile, in October of that year the Senate in Lucca voted thirty-eight to eight to bring back to the city a priest, scribe, and teacher of calligraphy named Clement of Padua. A year or two earlier, Clement had gone to Venice with the express purpose of learning "the art of printing letters," which, according to one of the authors he printed, he figured out "by intelligent observation."[35]

Printing presses also began operating in Bologna, run by two brothers named Annibale and Scipio Malpighi, and in Milan, where a priest named Antonio Zarotto set up shop with Panfilo Castaldi, a Venetian physician. An interesting legend surrounds Castaldi. His wife, Caterina, was descended from Marco Polo and supposedly gave Castaldi as part of her dowry a set of movable type that the explorer brought back from China in 1295. In 1681 a Franciscan named Antonio Cambruzzi claimed (on the basis of highly dubious evidence) that in about 1440 Castaldi showed his experiments with this type to a friend visiting from Germany, a certain Fausto Conesburgo, who took the secret back to Mainz and—under the more familiar name Johann Fust—stole the credit for the invention.

If we discount a Marco Polo connection, one mystery about these early Italian printers is how they learned their trade. Who constructed their presses, cast their type, and prepared their ink? Ironically, no instruction manual on how to build or to operate a press is known to have been printed during the fifteenth century. The earliest written description of how a printing press functioned comes from as late as 1534, the better part of a century after Gutenberg's first publication. Appearing in a private letter rather than a printed book, it was meant to enlighten a Frisian scholar who, probably like most people, had no inkling of how printed books were created.[36] The knowledge required to cast movable type remained a trade secret for even longer. An even more difficult process than assembling and operating a press, it involved making a special alloy of lead, tin, and antinomy. The earliest published instructions would not appear until 1540, when a book on metallurgy, Vannoccio Biringuccio's *De la Pirotechnia*, appeared in Venice.

The process of manufacturing and operating a printing press therefore seems to have been transmitted by word of mouth and through practical workshop demonstrations—and, indeed, Panfilo Castaldi picked up the trade not through a Marco Polo connection but thanks to working in Venice with the expatriate Germans Johann and Wendelin de Speier. Castaldi's case was typical. Italian printers either witnessed the technique firsthand in the office of a German printer willing to divulge proprietary information, or else they bought their equipment secondhand, like Philippus de Lignamine or the no-

tary Evangelista Angelini, who in 1471 purchased a press and type from another printer.

Acquiring the press and the know-how was only part of the problem. Would-be printers also needed to raise start-up capital and then cover their running costs. "The expense needed to carry out the art of printing is very great," declared Bishop Bussi.[37] According to one estimate, the equipment essential for outfitting a printing office for a single publication—the case of type, reams of paper, a supply of ink, a small furnace for smelting, as well as the printing press itself—would have cost a minimum of thirty-five florins,[38] a good deal more than the annual rent of a typical workshop.

Besides these start-up costs, printers needed operating capital to cover the expenses for successive titles. A large-format book printed in an edition of many hundreds of copies could entail high production costs. The paper and labor for a Bible printed in Venice in an edition of 930 copies cost between 450 and 500 florins.[39] Even that sum was dwarfed by the *Gutenberg Bible*, which required around five thousand calfskins for the parchment editions and fifty thousand sheets of paper for the rest. According to Peter Schöffer, the print run of Bibles (a maximum of 180 copies) had consumed more than 4,000 florins,[40] which meant each copy cost at least 22 florins to produce—roughly the same cost price as many of Vespasiano's manuscripts. The *Gutenberg Bible* was, however, an exception, and most books cost far less both to produce and to purchase.

Printers could face overheads and running costs of a magnitude unknown to a producer of manuscripts. Vespasiano's ten-volume set of Saint Augustine cost Cardinal Bessarion 500 florins, which, assuming a margin of 20 percent, could have resulted in a profit of 100 florins. Vespasiano had therefore been required to fund the cost price of 400 florins—a substantial sum, to be sure, but the surviving accounts for the bookshop do not indicate any dealings with bankers or other financial backers. The slower pace of scribal production, which stretched out a large commission over a number of years, complete with piecemeal payments and few exorbitant upfront costs, was a different proposition than printing hundreds of copies of a book in a matter of a few short months on the speculation that all would sell.

In the case of many printers, therefore, a third party entered the relationship between producer and consumer: the capitalist. Printing offices were organized along the same lines as most other commercial enterprises that involved credit, loans, and risk.[41] However lofty its contents, a book was still, after all, an object to be manufactured and exchanged, earning profits or incurring losses like any other commodity. Gutenberg had borrowed large sums from Fust, and Italian printers likewise entered into financial partnerships. Ulrich Han's enterprise was supported by a merchant from Lucca based in Rome. Contracts such as the one Antonio Zarotto signed with his partners in Milan, after parting with Castaldi, were increasingly common. Each of Zarotto's partners undertook to invest a hundred ducats over a period of three years. As executive partner, Zarotto was to receive a third of the profits minus the cost of the presses, fonts, and matrices, all of which would belong to him after three years. This partnership produced some fine early volumes (including work by George of Trebizond) and might have proved successful had not the two partners—in a reprise of Gutenberg and Fust—fallen out. One of them, a humanist scholar named Cola Montano, began circulating insulting epigrams about his erstwhile business partner, who promptly had him clapped in prison.

By 1470 printing presses had come to Rome, Naples, Venice, Bologna, Milan, and even to the towns of Trevi and Foligno. These rapid developments around Europe may have caused Vespasiano some small disquiet, for in 1469 he claimed the value of his bookshop had declined "because of the hard times."[42] It remains unclear whether these conditions (on which he failed to elaborate) were related to the encroachments of printers or, perhaps more likely, other factors such as the successive deaths of faithful clients such as Cosimo de' Medici and his two sons. He had also, in 1468, lost his older brother Jacopo, the distinguished doctor. Following a long illness, Jacopo died exactly one year and a day after their mother, Mona Mattea, and was interred in the nave of the Basilica of Santa Croce. His epitaph proudly proclaimed: JACOBO BISTICCIO MEDICO CELEBERRIMO.

Jacopo's death was a blow to the Bisticci family, for he earned far more money from doctoring than Vespasiano, despite his excellence and expertise, ever did from selling manuscripts.[43] Even so, in 1470 there was still little cause for despair. Not only did Vespasiano still enjoy the patronage of his wealthy clients, but also there was still one Italian city that, though known for books, scholars, readers, and enterprising merchants with spare capital to invest, still lacked a printing press. For no printers had arrived to chance their fortunes in Florence.

Chapter 19

Florentinis Ingeniis Nil Ardui Est

Lorenzo de' Medici may have cherished contemplating the supreme good with Marsilio Ficino in the delightful haunts of the Tuscan countryside. However, important business required his presence and attention in Florence.

Pope Paul II died in the Vatican at the age of fifty-four in the summer of 1471, suffering a fit of apoplexy after a hearty dinner in which he overindulged his appetite for melons. There were rumors of poison and of a magic spell gone wrong—for the pope delighted in experimenting with stones and other methods of divination.[1] He was replaced by a learned Franciscan theologian, fifty-seven-year-old Francesco della Rovere, who took the name Sixtus IV. Lorenzo had reason to hope for benevolence from the new pope, who earlier in his career had been supported by funds from the Medici bank in Rome. That October, Lorenzo's embassy to Rome, on which he was accompanied by Donato Acciaiuoli, proved a great success. Sixtus made him the gift of two antique marble busts and also let him purchase, at an advantageous price, some of the gems and cameos from Paul II's magnificent collection (the late pope's trove of pearls alone was valued at 300,000 ducats). Even better, Sixtus appointed the Medici as his papal bankers—a post Paul had given to one of his relatives. So well disposed toward the Medici did the new pope seem that Lorenzo soon began contemplating a cardinal's hat for his eighteen-year-old brother, Giuliano.

However, matters closer to home soon caused Lorenzo grave concern. One of the many business concerns of the Medici was a mining concession for alunite, a mineral used in the manufacture of alum. This magic and essential ingredient for dyeing textiles was tra-

ditionally sourced from mines at Phocaea (present-day Foça) on the Aegean coast of Anatolia. However, the Ottoman capture of the region in 1455 meant that the West, by importing alum from Phocaea, was handing over to the Turks some 300,000 ducats annually. The discovery of alunite in early 1461 in the mountains near Tolfa, in the Papal States some forty miles north of Rome, was therefore a cause for celebration. "Today I bring you victory over the Turk," the discoverer, Giovanni da Castro, announced to Pope Pius II.[2] Mines quickly went into production, and alum was declared a papal monopoly (overseen by a three-man committee featuring the ubiquitous Cardinal Bessarion) whose profits were dedicated to a crusade.

Further alunite deposits were then discovered in 1470, this time in Tuscany, twenty-five miles south of Volterra. Once again, mines were developed to exploit the precious mineral. As at Tolfa, the Medici bank helped to finance and administer the concession through a private consortium in which other wealthy Florentines—friends and supporters of the Medici—shared an interest. This arrangement proved unpopular in Volterra. For the previous century Florence had dominated the city, and Medici control of the alum mines was one further and, for some, increasingly intolerable example of their exploitation of the city's resources. Volterra was divided, rather like Florence itself, into pro- and anti-Medici factions, and early in 1472 the latter, seeing a chance to deal a blow to their rivals, seized control of the mines. The perpetrators were exiled to Florence, where Lorenzo was called upon to arbitrate the dispute. Before he could pronounce his verdict, two members of the pro-Medici faction were murdered in Volterra, their houses plundered and burned. Ambassadors from Volterra quickly arrived in Florence, pledging loyalty to both the city and Lorenzo. But with his own factions in Florence to worry about, and with other subject towns throughout Tuscany watching the proceedings with eager interest, Lorenzo decided to teach the people of Volterra the sternest of lessons. He hired the services of Federico da Montefeltro, his godfather, and set aside a million florins for the assault. By the end of May 1472, Federico's army of twelve thousand men were at the gates of Volterra.

Despite its imposing mountaintop location and sturdy circuit of walls, Volterra was ill-equipped to repel Federico, whom another

warlord called "the stormer of cities."[3] In the middle of June, the citizens negotiated their surrender. Federico agreed to their terms that the city should not be sacked, but his soldiers, having breached the walls, soon entertained other ideas. Hundreds of Volterrani were slain and their possessions looted. Machiavelli later wrote that for a whole day the city "suffered the greatest horrors, neither women nor sacred places being spared."[4] Vespasiano later exculpated Federico from responsibility for these atrocities, claiming that he did his best to prevent looting but that "great disorders" arose—violence and rapine of such fury that afterward Federico "could not contain his tears."[5] Regardless, Federico indulged in some looting of his own: he made off with a bronze lectern shaped like an eagle and, still more irresistible, a haul of seventy-one Hebrew manuscripts from the collection of a recently deceased Jewish banker. Included among them was a thirteenth-century Hebrew manuscript of the Old Testament, a volume that was a foot thick—almost a thousand leaves of heavy parchment—and that required two people to lift it.

These precious manuscripts were added to Federico's library in Urbino. Vespasiano and his scribes were still producing manuscripts for this collection. Despite his warfaring duties, Federico still managed to take an active role in commissioning these works. Shortly before departing on his mission to Volterra, he wrote to Vespasiano asking for a commentary on Aristotle's *Politics* to go with the one on the *Nicomachean Ethics* composed by Donato Acciaiuoli. Aristotle's *Ethics* was a particular favorite of Federico's. Vespasiano had produced a lavishly decorated manuscript of the translation by Giannozzo Manetti that Federico carried everywhere, including on his military campaigns. At intervals during the battles, Federico enjoyed hearing passages from it read aloud.[6]

Vespasiano put Donato forward to compose the commentary on the *Politics*. During these months he was also having the dialogues of Plato prepared for Federico's library. The reliable Gherardo del Ciriagio copied out translations done by Leonardo Bruni, including *Crito, Phaedrus, Gorgias,* and *Phaedo.* Gherardo appears to have retired five years earlier, or at least no other works of his date from between 1467 and 1472. Vespasiano must have lured him back to assist with the massive task of stocking Federico's library.

"*Florentinis ingeniis nil ardui est,*" a goldsmith named Bernardo Cennini boasted: "To Florentine ingenuity, nothing is difficult." Like another Italian, Clement of Padua, who supposedly used "intelligent observation," Cennini claimed to have puzzled out the secrets of printing all on his own. He thus perhaps removed any reservations about this foreign technology imported from the barbarian lands north of the Alps, making it possible for the printing press to be viewed as a home-grown invention.

Then in his mid-fifties, Cennini may well have been able to work out the finer details of printing on his own. He had worked as an assistant to the great Lorenzo Ghiberti on the "Gates of Paradise," the bronze doors for the east side of Florence's baptistery. He had also worked with another goldsmith: Vespasiano's older brother Jacopo, before he turned to medicine. In the early 1430s, Jacopo and Cennini entered into a partnership that was dissolved around 1446 with the latter owing the former (who had by this time successfully switched careers) a debt of 102 florins.[7] In any case, Cennini would certainly have understood the technique of casting movable type, and some of the logistics of laying out books may have been explained to him by his twenty-seven-year-old son, Pietro, who for much of the previous decade had worked as a scribe. However, like Clement of Padua, Cennini could have seen one of these German machines in action given the number of printing presses operating in Italy by 1471.

To fund his new enterprise, Cennini sold a house owned by his wife, mortgaged the family home, and contracted a debt of 200 florins with another goldsmith. In early November 1471 the first of three parts of his printed edition of a Latin commentary on Virgil appeared, complete with his triumphant boast about Florentine ingenuity.

Cennini soon found himself with a competitor, since by 1472 another printer had begun work in the city. Though known from his colophons as Johannes Petri, he also appears in documents as Giovanni di Pietro, as Giovanni Tedesco (John the German), and, after his hometown, as Giovanni da Magonza (John of Mainz), a place of origin that no doubt linked him to either Gutenberg or Fust. In the space of about a year, Johannes printed four works, all in the

vernacular, including works by some of Florence's most celebrated literary sons, Petrarch and Boccaccio. He printed an edition of the latter's novel *Il Filocolo*, originally composed in the 1330s, that appeared in November 1472. He evidently anticipated a wide readership for these works, especially for Boccaccio, whose writings were so popular that for many decades readers with no professional scribal training produced manuscripts of his works for their own reading pleasure.[8]

Two printers, then, Bernardo Cennini and Johannes of Mainz, published five titles in Florence in 1471 and 1472.[9] However, after this short burst of activity both presses ground to a halt. Cennini would print nothing more, running into financial difficulties in part because two other editions of the same commentary on Virgil had been printed (one in Strasbourg, the other in Venice) by the time his own edition appeared. He attempted to relieve his debts by offering unsold copies in pledge to one of his creditors, the goldsmith who had loaned him 200 florins. He ultimately unloaded some of his stock, a total of forty-four copies, on an itinerant peddler from Lombardy.[10]

Bernardo Cennini and Johannes of Mainz were far from alone among printers in suffering economic woes at this time. Despite the proliferation of the printing press, manuscript production had peaked in 1470: more manuscripts were copied in that year across Europe than in any other year in history, in keeping with the upward trend in production in each decade since the turn of the century. However, the manuscript-to-printed-book changeover was fast approaching. Already by 1472, north of the Alps at least, more books were printed than manuscripts copied.[11]

In Italy, the surge in the number of presses meant the supply of books far outstripped the demand. Many of these early printers published editions of the Latin classics for which there was, at best, a limited market, even with printed books costing a fraction of the price of manuscripts. Johannes of Mainz had been atypical in printing works in the vernacular, because Latin was the language of the printing press. Between 1465 and 1472, 85 percent of all books printed in

Italy were in Latin, a proportion that rose even higher across Europe as a whole: 91 percent.[12] Anyone wishing to find a book in his or her own language would have a difficult time of it. Before 1472, only thirty-six titles had been printed in German and thirty-one in Italian. Not a single book had yet been published in French.[13]

Sweynheym and Pannartz's average print run was 275 copies, but not enough readers or buyers existed to sustain this level of production for works such as Pliny the Elder's *Natural History* or Suetonius's *The Twelve Caesars*, especially since other presses were producing their own editions of these same works. Printed books were certainly, on the whole, cheaper than manuscripts. Even so, a number of Sweynheym and Pannartz's volumes could be costly. Their 1470 edition of Pliny's *Natural History* was listed at eight ducats and their edition of Aquinas's commentary on the Gospels at ten, while their 1469 *De Oratore* cost a hefty sixteen ducats[14]—the equivalent of the annual rent on a workshop or the yearly salary of a poor craftsman. Sales of this expensive tome were no doubt hampered by the fact that not only had Sweynheym and Pannartz already produced an edition of *De Oratore* in 1465, but so too, in 1468, had Ulrich Han, likewise in Rome, while in 1470 two separate editions appeared in Venice.

These factors meant that Sweynheym and Pannartz managed to sell only a fraction of their output. By 1472, following some five years in Rome, they had printed, according to their inventory, 12,475 copies, the vast majority of which—some 10,000 books—remained unsold. They complained to Pope Sixtus IV that after much labor, difficulty, and expense, their house was "full of unsold books, but empty of the necessities of life."[15]

Other printers running into trouble at this time included Johann Neumeister, the printer in Foligno: he found himself in prison for unpaid debts. In 1472 he produced the first printed edition of Dante's *Divine Comedy*, but his livelihood suffered when within months printers in Mantua and Venice followed with editions of their own, flooding the market. The first two printers to operate in Venice, Nicolas Jenson and Wendelin de Speier, likewise ran into trouble. In 1472 alone, the two presses published some thirty titles between them before both were forced to check their production and seek to stay afloat by attracting financial backers in Germany. In 1472 Verona had

two printers, one of whom published a treatise on warfare embellished with dozens of woodcuts. Before the end of the year, however, both had either gone broke or left town. In Milan, Panfilo Castaldi's career as a printer likewise came to an abrupt end. He returned to Venice, bringing with him all his tools as well as his plentiful supply of unsold books.

The recession in the trade in printed books corresponded with opposition to the printing press from a number of writers who feared this technology would harm knowledge by propagating errors. In 1471, as the first printed volumes appeared in Florence, the poet and scholar Angelo Poliziano—Lorenzo de' Medici's librarian and tutor to his children—complained: "Now the most stupid ideas can, in a moment, be transferred into a thousand volumes and spread abroad."[16]

The danger certainly existed that any errors introduced into texts could now be disseminated in many hundreds of copies. A number of printers took the precaution of collaborating with scholars to find exemplars and to reproduce them accurately in critical editions. In some cases, humanist scholars became partners in printing firms. Ulrich Han, in Rome, was assisted by a professor of rhetoric from the university in Perugia. The Malpighi brothers in Bologna worked in concert with a scholar named Francesco Puteolano, who once claimed to have corrected three thousand errors in an edition of Statius's *Silvae*—a work rediscovered by Poggio in 1418—that had been printed in Padua.[17] However, even these conscientious efforts sometimes failed. Sweynheym and Pannartz worked closely with Giovanni Andrea Bussi, whom Sixtus IV appointed to the position of *bibliothecarius*, or papal librarian, in 1471. One of the books whose publication Bussi supervised was a 1470 edition of Pliny the Elder's *Natural History*. It had a print run of three hundred copies and a preface composed by Bussi praising the art of printing with the sonorous declaration: "Had the ancients possessed this art, we should not now be wanting the many other wonderful works of Pliny. As things are now, the monuments of the sages of old will never perish."[18]

This edition of Pliny was bitterly attacked by Cardinal Bessarion's protégé Niccolò Perotti, who claimed to have discovered twenty-two errors in the text. In a letter to another humanist, Perotti wrote that initially he had entertained high hopes for "the new art of writing lately brought to us from Germany," but that these expectations had been dashed thanks to the sloppiness of printers and what he regarded as incompetent editors such as Bishop Bussi. He recognized the danger that a printed text, no matter how filled with errors, could easily become the standard edition of a work, shunting aside older and more accurate manuscript versions. To remedy the situation, he advocated a system of press regulation by which "someone or other charged by papal authority" would closely supervise the printing of all books, ensuring the highest possible standard of accuracy. "The task," he declared, "calls for intelligence, singular erudition, incredible zeal, and the highest vigilance." Little attention was paid to Perotti's proposal, and in any case it would have been infeasible: a single person, even one possessing "incredible zeal," could never have overseen the large number of classical texts that printing presses from all around Europe had begun producing.[19]

Others objected to printed books for a different reason. While Bishop Bussi exulted that poorer people could now afford to keep libraries, the decline in the price of books had disturbing consequences for others. A Venetian scholar named Giorgio Merula found a copy of Sweynheym and Pannartz's 1470 edition of Pliny's *Natural History* in the shop of a Venetian *cartolaio* (a good indication of Sweynheym and Pannartz's distribution beyond Rome). The sudden and wide availability of Pliny was, for Merula, no cause for rejoicing. Snobbishly, he lamented that books were suddenly available to people who "in happier times" possessed no access to them. Thanks to the printing press, works that had once been "remote and hidden and unknown to those of average learning" were now "repeated at cross-roads and among the lower classes as common knowledge."[20]

Even more vociferous in his attack on printing was a scribe and Benedictine monk in Venice named Filippo da Strada. In 1473 he wrote a poem in Latin urging the doge of Venice to "curb the printers" and "lay low the printing press" for the sake of public morality.

For Filippo, the German printers were uncouth, drunken interlopers who filled people's minds with "abominable vices." They eagerly printed at low cost volumes "suggestive of sexuality" that would be consumed by impressionable young people such as "tender boys and gentle girls"—for which reason the printshop was no better than a brothel. Some special pleading was included in his diatribe since Filippo noted that one undesirable result of the printing press was that reputable scribes such as himself had been driven from their homes and were dying of hunger.[21]

Filippo's last claim cannot be taken any more seriously than his complaints about drunken Germans encouraging incorrigible behavior among impressionable youngsters. Few scribes during these first years voiced any concerns about artificial letters putting them out of business. In fact, the printing press was introduced around Europe almost entirely without political protests, civil unrest, or economic upheaval. No scribes took to the streets in the 1470s; no printing presses were smashed or printshops ransacked in a foreshadowing of handloom weavers attacking Lancashire textile mills or Luddites breaking stocking frames in the early days of the Industrial Revolution.*

One of the reasons for this acquiescence is that the printing press actually provided a good deal of work for scribes and illuminators, who rubricated printed books and decorated them with pen flourishes and illuminated capitals. One of the books printed in Venice by Nicolas Jenson left thousands of one- and two-line spaces blank for initials to be added by hand. Virtually all surviving copies are fully rubricated and feature four thousand to five thousand initials added by decorators in red and blue ink. Many of the copies are

* The situation in the Ottoman Empire was different. Since Arabic was the sacred language of the Koran, its mechanical reproduction was forbidden by the Ottoman authorities. The printing press was furthermore opposed by the powerful guilds of the scribes and illuminators. In 1514 the Venetian Gregorio de' Gregori produced the first work to be printed in Arabic, *Kitab Salat as-Sawai*, a collection of Catholic prayers translated into Arabic. The Koran first appeared in print in 1537, but the printers were two Venetians, Paganino Paganini and his son Alessandro. The first printing press to operate in the Islamic world was that of Athanasius Dabbas, the patriarch of Antioch, who printed an edition of the Gospels in Aleppo in 1706, followed two years later by a Psalter. No printing press would operate in Istanbul until 1728.

also illuminated in gold and other colors—every bit as beautifully and conscientiously as if they had been handwritten manuscripts.[22]

And, of course, illuminated manuscripts were still being produced. North of the Alps, in particular, a kind of golden age of manuscript production was beginning as wealthy rulers and aristocrats—Philip the Good, Charles the Bold, Margaret of York, the Flemish courtier Louis de Gruuthuse—commissioned deluxe editions for their libraries. So prolific were the commissions and so beautiful the manuscripts that one historian has written that "the great period of southern Netherlandish illuminated book production and patronage is the second half of the fifteenth century"—the half-century, in other words, that followed Gutenberg's invention.[23]

Filippo da Strada made one further complaint about the printing press, one that, unlike the others, was both accurate and prescient. In October 1471 Wendelin de Speier published the first Bible in Italian, translated by Niccolò Malerbi with the assistance of two other scholars, one a Franciscan, the other a humanist. Filippo regarded this work as especially dangerous because it was, he believed, inaccurately done and therefore liable to lead to heresy. Moreover, the Word of God was now (as Merula might have said) available as common knowledge among the lower classes, who would no longer need the guiding hands or selective sermons of the clergy.

Italian printers published other works besides Bibles, religious treatises, texts of the Greek and Roman classics, and the more modern classics of Dante, Petrarch, and Boccaccio. The earliest presses in Mainz had been closely linked to current political events, publishing indulgences and papal bulls, recording in alarmist tones the threat of the Ottoman Turks, and producing broadsides on behalf of the rival bishops, Diether and Adolf. By the early 1470s printers in Italy likewise saw the opportunity to disseminate current information in the raucous service of political ends.

As in Mainz, so in Italy, the ever-present Turkish threat proved a reliable source of business for printers. In the summer of 1470 Mehmed II's galleys captured Negroponte, a Venetian possession in the Eastern Mediterranean. News reached Venice almost three weeks

later when a shipwrecked sailor fetched up with a water-damaged bundle of letters reporting celebratory bonfires along the Turkish coast. Negroponte (present-day Chalcis in Greece) was vital as a commercial entrepôt and military base. Its loss was a frightful blow to all of Europe. The Turks now controlled mainland Greece, the Peloponnese, and large chunks of the Balkans from Macedonia through to Bosnia and Bulgaria. The capture of Negroponte gave the sultan virtually unassailable control of the Aegean, with his westward advance seemingly unstoppable. "The Turkish navy will soon be at Brindisi, then Naples, then Rome," despaired Cardinal Bessarion, who bore, among other ecclesiastical titles, that of Bishop of Negroponte.[24]

The conquest of Negroponte set the printing presses of Italy chattering and clanking. In the years 1471 and 1472, presses in Milan, Naples, and Venice all published editions of anonymous poems lamenting Negroponte's capture. Undoubtedly easier and more lucrative to print than, say, editions of Pliny or Dante, these were short works quickly produced with a small expenditure of capital and sold cheaply in the streets to a reading public eager for news about the latest Ottoman aggression. Since the fall of Negroponte coincided almost exactly with the spread of printing throughout Italy, the conquest was one of the first events in history to be recorded and widely disseminated more or less immediately to an eager and anxious reading public.[25]

Besides the many anonymous poems, another printed work deplored the fall of Negroponte. In the weeks following the conquest, Cardinal Bessarion wrote frantic letters to Italian princes and delivered speeches calling—yet again—for a crusade. He collected these works together and sent them in manuscript to the doge of Venice and various friends, two of whom, one in Venice, the other in Paris, spotting the opportunity to disseminate them more widely, saw them through to print. *Orations Against the Turks* therefore appeared in two separate editions in 1471, with copies urgently dispatched across Christendom.[26]

Soon afterward, Cardinal Bessarion himself embarked on an urgent mission. In the spring of 1472, as Vespasiano was completing the ten-volume set of manuscripts of Saint Augustine's works destined for Bessarion's library, the cardinal set off on vital papal business.

Though he was, as Vespasiano pointed out, "old, infirm and cruelly afflicted by the stone,"[27] he left Rome in April on an arduous journey to France on behalf of Pope Sixtus. His assignment was to broker a peace between King Louis XI and the dukes of Brittany and Burgundy, then in the process of forming an anti-French alliance with King Edward IV of England—a conflict highly detrimental to the prospects of a crusade.

After two months, Bessarion reached Lyon in June, but his mission proved a dismal failure due to what Vespasiano called the "hostile disposition and erratic behavior" of King Louis. Bessarion's refusal to excommunicate the two dukes, as Louis insisted, led to such a heated argument that the king pulled him by the beard. The episode left Bessarion horrified and humiliated. He set off on his return journey—in Vespasiano's words, "old and sick and unhappy"—but failed to reach the sanctuary of Rome, dying in November in Ravenna, fittingly, the most Byzantine of Italian cities. He was buried a fortnight later in the basilica of Santi Apostoli in Rome, in a tomb he himself had prepared. It featured inscriptions in both Latin and Greek, as well as a cross supported by a pair of hands representing the Greek and Latin churches: an emblem of the ill-fated union of the faiths for which he had toiled so long.

Chapter 20

For the Advantage of All Scholars

Federico da Montefeltro enjoyed a tremendous reception in Florence in the summer of 1472 following his brutal conquest of Volterra. "For days on end there was feasting," reported Vespasiano. Federico was given free lodging for himself and his entourage in the fine palace occupied during the Council of Florence by the Patriarch of Constantinople. Beautiful gold textiles and bowls worth a thousand ducats were offered to him as gifts. He also received as a present from the grateful citizens a beautiful house on Florence's hilly southern outskirts, the Villa Rusciano, on which Filippo Brunelleschi had once worked. "Never was anyone honored so highly," Vespasiano noted approvingly.[1]

Vespasiano paid his own homage to Federico. In the manuscript of Ptolemy's *Geography* that he was preparing for the library in Urbino—an edition beautifully decorated by the artist Francesco Rosselli—he added a double-page bird's-eye view of Volterra. This illustration showed Volterra's imposing hilltop position, its rugged circuit of walls punctuated by sturdy gates and tall defense towers, and its cannons perched on rocky outcrops around the city. All gave a sense of the city's impregnability and therefore of Federico's tremendous martial abilities. Federico "accomplished the impossible," Vespasiano declared, "considering the difficulty of the position and the evil nature of the people of Volterra."[2]

Federico presently enjoyed esteem beyond the borders of Tuscany. In 1474 he married one of his six daughters, twelve-year-old Giovanna, to Giovanni della Rovere, the seventeen-year-old nephew of Pope Sixtus IV. Giovanni was made lord of the papal fiefdoms of Senigallia and Mondavio. Federico, in recognition of his new kinship

with the pope, was upgraded from a count to a duke in a ceremony that required him to prostrate himself before Sixtus, swear an oath of fidelity, and kiss his foot.

These new ties to the pope caused a strain between Federico and Lorenzo de' Medici, whose relations with Sixtus, in the meantime, had badly soured. The pope's ambitions for his nephew Giovanni extended beyond Senigallia and Mondavio. He hoped to offer him Città di Castello, nominally part of the Papal States but ruled without a legal title from the pope by the warlord Niccolò Vitelli. Determined to take the city back into his orbit, the pope dispatched troops headed by another of his nephews, Giovanni's brother, Cardinal Giuliano (later to become famous as the "Warrior Pope," Julius II). Sixtus appealed to Florence for assistance in the affair. Having no desire to see the pope establish a stronghold so close to the Florentine borders, Lorenzo refused to help and, indeed, actively frustrated the papal troops by cutting off their supply lines. His troublemaking proved in vain, for Città di Castello fell to the papal troops following a two-month siege in the summer of 1474.

Lorenzo also tried to thwart Sixtus's dynastic ambitions for yet another nephew, thirty-one-year-old Girolamo Riario, who had worked in a butcher shop in Savona before his uncle became pope. In 1473 Sixtus had married Riario to the illegitimate ten-year-old daughter of Galeazzo Maria Sforza, the duke of Milan. Now he pursued an audacious plan of carving out a domain for his nephew in the Romagna, a patchwork of principalities spread along central Italy between the Adriatic Sea and the Apennine Mountains. Technically owned by the papacy since 1278, these lands (which included cities such as Rimini, Ravenna, and Imola) had long since been alienated to petty warlords and become prey to violent feuds and intermittent massacres.

Fearing Florence could become isolated if the pope and his nephew took the region under control, Lorenzo began negotiating with the duke of Milan the purchase of Imola, which occupied a strategic location between Florence and the Adriatic, along the trade route to Venice. Sixtus likewise coveted Imola, which he hoped to offer Riario as a wedding present. The pope managed to acquire the city from his new kinsman, Galeazzo Maria, for 40,000 florins despite

the fact that Lorenzo had earlier agreed to pay the duke 100,000. A dilemma arose for Lorenzo when Sixtus appealed to him, as the papal banker, for a loan to pay the 40,000 florins. When Lorenzo refused the request, Sixtus angrily responded by removing the Medici from their post as papal bankers. This honor he promptly conferred on their longtime rivals: the Pazzi.

Like his predecessor, Paul II, Pope Sixtus embraced the new technology of the printing press. He issued both bulls and indulgences in print, favoring the Roman press of Georg Lauer for the former and those of Adam Rot and Theobaldus Schencbecher for the latter. In 1471, the first year of his papacy, he even commissioned Ulrich Han to print editions of two of his own scholarly treatises.

Sixtus appreciated the value of books for the defense of the Church and of the Catholic faith. His nephew Pietro Riario, a cardinal (believed by some to be the pope's son), had been an even greater bibliophile. Thanks to the lucrative posts lavished on him by the pope, the young cardinal plunged, in the words of a nineteenth-century historian of Rome, "into the wildest sensuality."[3] Amid his orgiastic pleasures he found time for collecting books, and a library—"without which," he sighed, "a house seems empty"[4]—was to be among his mighty feats of prodigality. He contacted more than sixty booksellers across Italy to locate manuscripts for him. Though no correspondence has been discovered to link Vespasiano to this project, Cardinal Riario must surely have turned to the king of the world's booksellers to meet some of his needs.

Riario's death in 1474 at the age of twenty-eight (thanks to a vial of Venetian poison, so went the rumor) meant his plans for his palace and its library went unfulfilled. However, the next year, in June 1475, Sixtus resuscitated the ambitions for a worthy book collection, issuing one of his most important bulls, *Ad decorem militantis Ecclesie* ("For the adornment of the Church Militant")—the birth certificate, so to speak, of the Vatican Library.

Pope Nicholas V had already collected many hundreds of books for the Vatican. Even if his successor, Calixtus III, did not dispose of most of them, as Vespasiano claimed, the collection was little re-

spected or augmented by subsequent popes. By 1475 the library put together by Nicholas was, according to one scholar of the day, "languishing in squalor."[5] Sixtus therefore decided to give the books a commodious home, a sound organization, and a trustworthy custodian. (The former *bibliothecarius*, Giovanni Andrea Bussi—the great collaborator of Sweynheym and Pannartz—had died earlier in the year.) The pope had no doubts about the benefits of a well-stocked and easily accessed collection: the library, his bull proclaimed, would adorn the Church Militant, increase the Catholic faith, benefit learned men, and honor the people of Rome. It was to be *pro communi doctorum virorum comodo*—"for the advantage of all scholars."[6]

Sixtus's bull also named as his new chief librarian the nemesis of two former popes, Calixtus III and Paul II: none other than Bartolomeo Platina. The combative humanist went to work putting chaos into order. That summer he hired a carpenter to begin constructing desks for the rooms in which the collection was kept. He had the entrance adorned with a marble doorway featuring Sixtus's coat of arms. He improved the lighting by opening a new window into the Cortile del Papagallo. And he ensured that the volumes were dusted with fox tails, the floor carefully swept, and the rooms fumigated with juniper.

Rules and regulations were put in place to protect the volumes. Borrowing privileges were revoked if readers argued with each other, failed to restore the books to their proper places, or clambered over the benches rather than walking around them. Platina ordered chains—no fewer than 1,728 of them—to tether the most valuable volumes to the desks. Manuscripts could be borrowed, but readers were required to enter their names in a register book that contained a stern warning: "Whoever writes his name here in acknowledgment of books received on loan out of the pope's library will incur his anger and his curse unless he return them uninjured."[7]

The pope's anger was sincere and his curse serious. Sixtus noted in his bull that certain borrowers evidently entertained no fear of the Almighty, having taken books "which they presume rashly and maliciously to hide and secretly to detain." Indeed, since Nicholas's death in 1455 at least twenty manuscripts had disappeared from the collection.[8] Perpetrators were given forty days to return the volumes. If the

manuscripts did not reappear after that period elapsed, the culprits, Sixtus declared, would be excommunicated.

After the recession of the early 1470s, printing presses in Italy gradually resumed their operations. Dozens of new ones multiplied up and down the peninsula. In the years 1475 and 1476, some 570 titles were printed in Italy: more than half the total published across the whole of Europe.[9] Germany accounted for only 265 titles in these years, France for 101. By the beginning of 1476, twenty-four Italian towns and cities had printing presses compared to only thirteen in Germany and six in France.[10] By 1476 at least a hundred printers were operating in Italy, three times as many as in Germany.[11] To be sure, the majority of printers in Italy were still transplanted Germans, but a dozen years after the arrival of Sweynheym and Pannartz the Italians could be said to have supplanted the Germans as the people of the printed book.

North of the Po, east of the Tiber, on either side of the Apennines, right down to Reggio di Calabria in the toe of Italy, the presses rattled and champed. Works of philosophy, religion, medicine, and poetry, papal bulls and indulgences, psalters and grammars, summonses for the payment of excise, orations against the Turks, advertisements for booksellers—all were published, on both paper and parchment, as printing shops became an ever more common sight in Italian towns and cities.

Nowhere did they appear more plentifully than in Venice, with a population of 100,000, where eighteen printers were at work by 1476. No other city in Europe came close. Paris, with a population of 120,000 people and a prestigious university, could boast only five. Ten presses operated in Cologne, while Mainz, from which so many printers had come, was left with only two, including that of Peter Schöffer (Johann Fust had died in 1466 of the plague while on a business trip to Paris). Upstream along the Rhine, Strasbourg was home to half a dozen.

Next after Venice came Rome, where by 1476 thirteen printing presses were churning out liturgical books, philosophical treatises, and papal bulls. Konrad Sweynheym retired from printing after 1473,

but Arnold Pannartz continued the operations until his death in 1476. Meanwhile Padua had also become an important city for publishing, home to ten printing presses. Unsurprisingly, given the prestige of its medical school, a number specialized in medicine, printing classic works by medieval experts as well as more up-to-date treatises on pediatrics and pleurisy.

Then came Naples with nine printers, among them the pioneer Sixtus Riessinger, who had managed to weather the recession. Milan could boast eight printing presses, while Bologna had seven, and Vicenza and Ferrara each had six. Genoa, Parma, Pavia, Piacenza, Trento, Treviso, Turin: all had printers too. Even the remote towns of Cagli and Iesi had printers. The tiny hilltop town of Mondovì in Piedmont was home to two, one of whom in 1476 published an edition of *Aesop's Fables*.

There were a number of absences from this roster of printing presses, such as Pisa, Siena, Lucca, and Arezzo. The most glaring anomaly was Florence, where in 1475 not a single printer was operating. No books had been published in the city since the printer from Mainz known as Johannes Petri brought out his edition of Petrarch's *Triumphs* in February 1473. Over the following three years, as dozens of presses were founded and thousands of books printed all around Italy, Florence still produced books in the old-fashioned way, with scribes scratching with their goosequills on sheets of parchment.

That Florence should have been so reluctant to embrace this new technology—Florence, which for decades had been at the forefront of artistic, literary, intellectual, and technological change—is simply astonishing. The city enjoyed a perfect combination of a high literacy rate, esteemed teachers, and an affluent class of citizens with an appetite for learning. It could boast well-stocked libraries and discriminating collectors, as well as a street lined with booksellers and stationers. Florentines furthermore possessed (as Bernardo Cennini had pointed out) an ingenuity in technology and design. The modern book with its title page and its clear, round "antique" script—the script adopted for their presses by many printers both north and south of the Alps—was a Florentine invention. The city had been, for many decades, the place where scholars, from William Grey and Janus Pannonius to Cardinal Bessarion, came to find manuscripts, and

where bookhunters such as Poggio Bracciolini and Giovanni Aurispa knew they could find buyers for the precious wares they discovered in the monasteries of Germany or Constantinople. It is paradoxical that many early printers specialized in publishing texts of the humane letters that Florentine scholars had championed for decades, and yet Florence was one of the few important European cities where these classics had not been propagated in print.

One reason for the slow inroads of the printing press in Florence may have been Lorenzo de' Medici's apparent lack of interest in this new technology. While Pope Paul II and the Venetian Senate had embraced the printing press, Lorenzo preferred his books in manuscript form, continuing to have works of his favorite authors copied by scribes long after printed editions became available. Another reason was the lack of a university of the stature of those in Bologna (where the Malpighi brothers deliberately marketed their wares to lecturers and students) and Padua (whose legal and medical students were likewise targeted by both Paduan and Venetian printers). Lorenzo had reorganized the Studio Fiorentino at the end of 1472, combining it with the university in Pisa (founded in 1343) such that pupils pursued humanistic studies in Florence but went to Pisa—a rival city under Florentine control since 1406—for disciplines such as law and medicine. Florence therefore had no need for the hefty legal, medical, and theological works published in centers with major universities, and even Pisa remained a city of manuscripts.

Another reason why printing failed to take hold in Florence in the 1470s was the prominence of Vespasiano. His scribes could not work nearly as fast as a printer, but after forty years in the bookselling business he was able to provide his clients with both deluxe bespoke manuscripts of whatever they might wish to possess, as well as less expensive secondhand books and cheaper versions copied on paper. In 1469 a scholar in Genoa had pointed out what no doubt all Vespasiano's clients felt, that the "king of the world's booksellers" could easily find all the works he wanted. If printers such as Cennini and Johannes of Mainz went under because they overproduced works for which only a limited market existed, Vespasiano succeeded because he assembled most of his manuscripts specifically on request from his clients. Those wishing to find copies of the Greek or Latin classics

could easily procure them from Vespasiano, assured of both the beauty and the accuracy of the end product.

Vespasiano's book-buying public was so well served by his team of scribes and illuminators that the necessity and usefulness of the printing press—not to mention its economic viability—must have been less obvious to them than it was in, say, Mainz or Venice. Establishing a printing firm involved, as Cennini and others had discovered, a substantial outlay of capital and the acceptance of a good deal of risk. The famously shrewd Florentine merchants may well have given sober second thoughts to investing their surplus capital in the precarious enterprise of a printing firm in a city dominated by the activities of the king of the world's booksellers. The scale and reach of Vespasiano's business may even help explain why no printing presses had appeared in nearby cities such as Pisa (despite its university), Lucca, Siena, Arezzo, and Volterra.

Some Florentines may well have regarded printing as a foreign innovation (hence Cennini's "reinvention") that produced an inferior product in terms of both aesthetics and—as Poliziano believed—textual accuracy. Vespasiano maintained that no printed book could ever match the beauty and quality of a manuscript copied by a scribe such as Gherardo del Ciriagio and illuminated by an artist of the skill of Francesco del Chierico. The books he was preparing for the library in Urbino were a case in point. In this library, he wrote, all the books were of the highest quality, all were elegantly illuminated, all were on parchment, and all were perfect and complete, with no pages missing. And all were, as he boasted, "written by hand, for a printed volume would have been ashamed to be among them."[12] Or as a poet wrote in praise of Federico's collection, these books had not been printed in small letters that would soon fade, but rather they had been "painted" by a skilled hand.[13] The manuscript book was, in other words, not only more beautiful but also more durable than a printed one.

At least four printed books would find their way into Federico's magnificent library. However, the duke appears to have shared Vespasiano's contempt for printed books, since these works were not allowed a place among his treasured manuscripts. Rather, they were kept in a different room, one that stored codices awaiting binding and incomplete manuscripts earmarked for recopying.[14] Given this

location, they may well have been books that Federico intended to
have reverse-engineered and turned into manuscripts.

At least one scholar in Florence, Marsilio Ficino, was prepared to em-
brace the new technology of print. Ficino's reputation had increased
since the death of Cosimo de' Medici a dozen years earlier. He had
been ordained as a priest in 1473, but his unique talents were as
widely and prolifically distributed as ever. He continued to strum his
lyre and sing hymns, and to deliver lectures on Plato at his house in
Careggi and in the monastery of Santa Maria degli Angeli in Flor-
ence. He claimed to be able to understand "the language of angels,"
who spoke to him in prophecies when he visited them in heaven,
to which he was transported by spirits.[15] He also performed exor-
cisms, and on one occasion he drove a demon from the home of his
shoemaker.

 Around the time of his ordination in 1473, Ficino had completed
his latest work, *On the Christian Religion.* This treatise rehearsed many
of Ficino's favorite themes, such as the chain of theologians running
from Hermes Trismegistus and Moses down through Plato and Chris-
tianity. If the latter was in danger of declining into empty ritual in a
spiritually vacuous Iron Age, a new Golden Age awaited with the antici-
pated return of a philosopher-king in the model of Hermes or Moses—
someone who could unite under his command both the spiritual and
the political worlds. Ficino no doubt had in mind the dedicatee of his
treatise, Lorenzo de' Medici.

 Ficino had spent much time courting Lorenzo in a fierce com-
petition for patronage with Luigi Pulci, the leader of a rackety gang
of young aristocrats (Pulci's mother was a Bardi) who had begun
gathering around Lorenzo in the 1460s, meeting under the Roof of
the Pisans. Ficino and Pulci were two opposites fighting for the soul
of Lorenzo. Ficino was scholarly and pious, Pulci (known as Gigi)
boisterously scandalous, famous for his insults, invective, and sarcas-
tic humor; he also had an unblushing fondness for taverns, brothels,
and black magic. He lived up to his surname (Pulci means "fleas")—a
maddenly irritating parasite. As one Florentine frantically complained
in a letter to Lorenzo, "Gigi is annoying, Gigi has a bad tongue, Gigi

is crazy, Gigi is arrogant, Gigi spreads scandal, Gigi has a thousand faults." Ficino triumphed when Gigi wrote a series of sonnets scorning pilgrims, miracles, preachers, and the doctrine of the immortality of the soul—and, in so doing, Ficino declared, made himself "odious to God" because of his "poisonous tongue and pen." He was duly condemned from the pulpits and bounced from Lorenzo's charmed inner circle, over which, at least for the time being, Ficino would preside.[16]

In 1475 Ficino decided to have *On the Christian Religion* printed. Though neither Bernardo Cennini nor Johannes of Mainz was still active, Ficino managed to find a printer newly starting up in Florence. He was an immigrant from Breslau in Silesia (Wrocław in modern Poland) known from his colophons as "Nicolaus Laurentii, Alamanus," though various documents Italianize him as Niccolò di Lorenzo, Niccolò Tedesco, and sometimes Niccolò della Magna (a corruption of "Alamanus"—the reference to his supposedly German origins). The Anglophone world often calls him Nicholas of Breslau.[17]

Nicholas appears to have arrived in Florence in the mid-1460s after apparently working in the book trade in Silesia. Niccolò Machiavelli's father, Bernardo, a book lover, called him "Niccolò Tedesco, priest and astrologer," though by the 1470s, priest or not, he had a son, named Gianni.[18] Earlier in his career he worked as a scribe or calligrapher, possibly in association with a scriptorium at a convent in Breslau. In the early 1470s he served as a roving consultant for start-up printers, traveling to places such as Mantua and Lendinara, a small town twenty-five miles southwest of Padua, where in 1471 documents described him as "Niccolò Tedesco, compositor in the art of printing books."[19] He continued working as a scribe and illuminator, including for Lorenzo de' Medici. Two Ptolemy manuscripts in Lorenzo's collection announce that they were inscribed "by the hand of Niccolò Tedesco"[20]—a good indication of both Lorenzo's preference for manuscripts and the peaceful hybridization of the professions of scribe and printer.

Nicholas did not make an especially adept or professional job of *On the Christian Religion*. Despite his reputation as a "compositor in the art of printing books," Nicholas's inexperience is revealed by the fact that he made no use of a title page or colophon, nor of

signatures, pagination, or running headers. Further, one page was printed twice and typographical errors are found throughout. In one place, the letter *n* is even printed upside down. Surviving copies reveal numerous interlinear notes and corrections—most by Ficino himself. The publication nonetheless marked the moment when one of Florence's leading intellectuals chose to distribute his work in the medium of print.

Chapter 21

Apud Sanctum Iacobum de Ripoli

Nicholas of Breslau was not the only printer setting up shop in Florence. The same month that his Latin edition of Marsilio Ficino's *On the Christian Religion* was published, in November 1476, another work also came off a Florentine press. Considerably more modest than Ficino's opus, it was so inexpensive and ephemeral that not a single book survives from the print run of four hundred copies. It was a *Donatus*, one of the Latin grammars intended for use in schools. Rather than a German immigrant, the press was operated by a pair of Italian friars based in a Dominican convent on the edge of the city.

This convent, San Jacopo di Ripoli, was home to a community of forty-seven Dominican nuns.[1] It stood on the western outskirts of Florence, in Via della Scala, close to the Porta al Prato and a ten-minute walk from the great Dominican basilica of Santa Maria Novella. It had occupied premises here since 1292, when violence and warfare in the countryside forced the nuns to forsake their home three miles outside Florence, in the hamlet of Ripoli, and take refuge within the city walls. Here the nuns were safely sequestered in a sprawling complex completely surrounded by walls. Theirs quickly became the most populous convent in Florence, housing more than a hundred sisters by 1300 and boasting a giant wooden crucifix painted by the great Cimabue and a series of frescoes showing scenes from the life of the Virgin Mary.

Numbers at the convent dropped catastrophically with the Black Death in 1348, when all but three nuns died from the plague. The community struggled to reach a population of twenty nuns over the following decades, even when the amount of the "spiritual dowry"— the sum a family paid the convent to take their daughter as a "bride

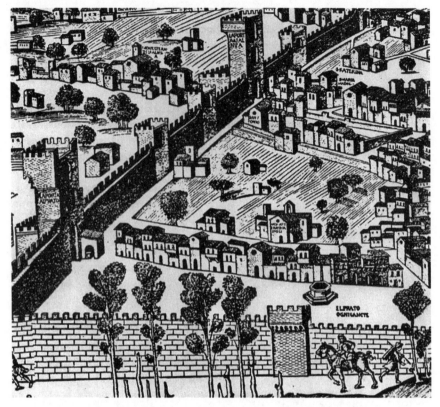

Detail from the "Chain View" of Florence by Cosimo Rosselli showing
the neighborhood of San Jacopo di Ripoli.

of Christ"—was generously reduced. San Jacopo was, at least, one of
the city's wealthier convents, drawing a few daughters from Florence's
most distinguished families. Such families might need to pay 2,000
florins for a daughter's dowry, and therefore marrying the girl to
Christ—for whom a dowry cost only a tenth of the average paid for a
Florentine husband—made good economic sense, especially for a
father with multiple daughters.[2] Of the slightly more than 10 percent
of Florence's female population who entered convents, the vast ma-
jority, as many as 80 percent, came from the city's wealthier families.[3]

A convent was not merely a place of prayer and seclusion. It also
operated as a business enterprise—and, in the case of San Jacopo di
Ripoli, a thriving one whose assets had steadily been built up over
the course of the previous century through shrewd investments,

mostly in property. In the 1470s the convent owned some ten houses in Florence that it rented to a variety of tenants, including woolworkers, a butcher, a sawyer, a kiln worker, and a chicken seller. It owned a workshop rented out to a linen merchant, two mills, nine farms, as well as various fields, orchards, and vineyards scattered around the countryside. The impressive portfolio included an eel pond—eels were a luxury food—and a herd of swine. Tenants paid their rent not only in cash but also in chickens, geese, firewood, and bundles of straw.[4]

The man charged with overseeing these various activities was a Dominican friar named Domenico da Pistoia. Fra Domenico had been appointed procurator in 1474, a role giving him control of San Jacopo's commercial affairs. Almost nothing is known of his earlier life apart from the fact that he evidently came from Pistoia and served in various positions, including procurator, in the monastery of San Domenico in Fiesole (which a few decades earlier had launched the religious and artistic careers of Fra Angelico). Fra Domenico was clearly a practical and efficient man of business. His tasks at San Jacopo included negotiating with the convent's various tenants as well as dealing with all those involved in its commercial ventures—everyone from bishops to bricklayers and swineherds. Soon after arriving at San Jacopo he embarked on an ambitious building project, the conversion of an old granary next to the monastery into a pair of houses to be used as rental properties. The enterprise witnessed him bulk-ordering bricks, tiles, and lime, and arranging for windows, gutters, and a well. All of the transactions he dutifully recorded in his squiggly *mercantesca*, the loopy handwriting used by Florentine merchants.[5]

Fra Domenico also decided that the convent should invest in another business: a printing press. What experience he possessed, if any at all, is a mystery. He was unlikely to have puzzled out the intricacies of a printing press on his own, as Bernardo Cennini claimed to have done. His time in Pistoia and Fiesole, neither of which had a press, could have offered no exposure to the technicalities of the process.

Nevertheless, Fra Domenico must have known something about composing and preparing books. He had worked at times as a scribe,

copying out not religious texts but, rather, manuscripts of Cicero's works.[6] Soon after arriving in Florence he may have come into contact with either Bernardo Cennini or one of the German émigré printers. In any case, in 1476 Fra Domenico became one of the many scribes who turned his hand from pen to print.

First of all, Fra Domenico needed to purchase or manufacture a press with all its working parts, and to furnish himself with other equipment such as matrices and type.

The press itself may have been among the least of his expenses. The materials for manufacturing a press—the lengths of wood, the spindle, the press stone—would have cost about five florins, while a used press could be purchased for roughly the same amount.[7] Fra Domenico may have bought his press secondhand from one of the Germans, such as Johannes of Mainz, who ceased activity after printing works by Boccaccio and Petrarch. In fact, a few months after printing his *Donatus* Fra Domenico realized that he needed to improve the quality of his type, or what he called his "abbici," or ABCs.[8] He therefore negotiated to purchase Johannes's matrices, from which he would cast his own letters. The German had obviously fallen on hard times: he exchanged his set of "antique-style letters" for a bushel of wheat and a pair of shoes.[9]

Like any start-up printer, Fra Domenico also needed to raise funds for his enterprise, some thirty-five or forty florins.[10] His expenses included a small furnace for smelting type and a ladle for pouring the molten metal into the matrices. He purchased tools such as anvils, files, drills, emery stones, and a vice, along with the various ingredients for his ink. Paper may have been cheaper than parchment, but it nonetheless represented his greatest single expense. Two reams, or one thousand sheets, of chancery paper, the smallest size (approximately $12'' \times 18''$), cost almost a florin. Printing 250 copies of a book one hundred pages long would therefore have required twenty-five reams of paper, or an outlay of more than twelve florins, roughly a third of his total start-up costs.

Like all early printers, Fra Domenico needed to be resourceful in raising capital. He proceeded through a variety of means: loans, a

financial partnership, and small donations. The prioress of San Jacopo di Ripoli, Sister Agnesa, loaned him twenty florins, while a woman at the hospital next door, the Ospedale della Scala, one Mona Margherita, extended him three more. In the tradition of early Italian printers, he took on a business partner, a financial backer (about whom almost nothing is known) named Don Ippolito. And in the tradition of early Italian printers, the two partners quickly fell out. Details of the dispute are lost, but so serious was the matter that it needed to be settled—ultimately in Don Ippolito's favor—by a representative of the archbishop of Florence. "To Don Ippolito," read Fra Domenico's terse account, "one florin as ordered by the vicar of the archbishop."[11] He enjoyed much happier relations with the priest-confessor at San Jacopo di Ripoli, Fra Piero di Salvatore da Pisa. Fra Piero donated money he earned from saying Masses for the nuns as well as money he received from his office as chamberlain of the Ospedale della Scala.[12] He served as Fra Domenico's partner in the enterprise, though what experience he possessed is likewise a mystery.

One of Fra Domenico's other expenses was labor—salaries for the workers who helped operate the press. Three or four workers were always required, including a number with specialized skills. Someone was needed, first of all, to set the type, that is, to choose the "abbici" from the wooden case in which they were kept (with capital letters at the top—hence "uppercase" and "lowercase") and compose the page. This box, which Fra Domenico ordered from a carpenter named Francesco, held not only the entire alphabet in both upper- and lowercase but also all the punctuation marks and other typographical characters, including small blocks of blank type for the spaces between words. The type case therefore featured as many as one hundred compartments, each filled with at least a dozen pieces of type, with considerably more for letters such as *e* and *i*, each of which could easily appear one hundred times on a single page. The earliest known description of printing—the aforementioned 1534 letter—claimed the letters were "arranged in their boxes according to the alphabet," which suggests the compartments ran consecutively from *A* to *Z*. However, this same letter stressed the need for speed and accuracy, and so most type cases would surely have been laid out ergonomically.[13]

The typesetter or compositor, as he was known, prepared the type from a copy text or exemplar, whose pages, removed from their binding, were secured above the case in a vertical support. This apparatus, known as a *visorium*, featured a line-by-line slider to help the typesetter keep his place as he continually glanced up from the case to the copy text. He laid out his type on a composing stick, a hand-held instrument adjusted to the width of the page to be printed. Because the metal letters were reversed, vigilance was needed since certain pieces of type, such as *b* and *d* or *p* and *q*, could easily become confused (hence "mind your *p*'s and *q*'s"). Further, a piece of type might have been replaced in the wrong compartment or letters such as *u* and *n* mixed up. The line endings needed to be "justified" with the help of hyphenation or careful spacing—for the latter of which the compositor used "slugs," blank pieces of type placed between the words. Adding to the typesetter's difficulties was the fact that not only were the pieces of metal type backward but the words and sentences needed to be added to the composing stick upside down.

The compositor then transferred the type into a metal tray, later known in English as a galley because of its resemblance to the shallow-hulled ship. He repeated this process, filling the composing stick with text and then sliding the type onto the galley until an entire page had been set. This galley would be secured with a string and then set aside as the typesetter began preparing the next galley. Multiple galleys were needed simultaneously because all books were made by printing several blocks of text together on a large sheet of paper that the printer then folded, sometimes multiple times depending on the size of the volume. For a folio, the paper was folded once down the middle, giving two leaves or four printed pages, front and back. In a quarto the paper was folded twice, producing four leaves ("quarto" comes from the Latin *quartus*, meaning a fourth) and a total of eight pages, front and back. An octavo (from *octavus*, an eighth) required three folds to give eight leaves or sixteen pages of text.

For a folio, the typesetter composed four galleys, two for each side of the paper. The ordering and disposition of these galleys—the process known as *imposizione* (imposition)—needed to be such that the pages would run in the correct sequence once the paper was

folded and cut. For instance, if pages 1 and 2 were printed on one side of the paper and 3 and 4 on the other—as might seem natural—the final result would be an arrangement by which pages 1 and 4 shared front and back of the same leaf, making orderly pagination impossible. Instead, pages 1 and 4 needed to be printed on one side, facing each other, pages 2 and 3 on the reverse. The *imposizione* for a quarto was even more complex. It required four galleys for each side of the paper, each carefully positioned in relation to the others so the correct sequence was revealed once the paper was folded twice and then cut. This operation called for pages 1 and 8 to occupy half of one page, pages 4 and 5 the other half, albeit upside down in relation to 1 and 8, the top margins of their texts aligned with the middle of the page. Small wonder that very occasionally upside-down pages appeared in early printed books.

Once the galleys for an entire sheet were properly ordered, the compositor fixed them in a rectangular frame known as the chase, which, together with the galleys of type, became known as the form. The compositor placed the form in a shallow wooden box later known in English, with a touch of the macabre, as the coffin. One end of the coffin was hinged to the *timpano* (tympan), a parchment-covered iron frame whose opposite end was hinged to a second frame known as the *fraschetta* (frisket), made from either parchment or heavy paper. The sheet of paper was dampened with a wet cloth, the better to absorb the ink, and then placed on the bed of the tympan. The frisket—which featured cut-out windows—was then closed over it.

At this point the two pressmen (*torcolieri*) took over the operation. One was the beater (*battitore*), the other the puller (*tiratore*). The beater would ink the letters locked in the form with a pair of inkballs, bundles of wool covered in leather and fixed with a wooden handle. He was called a beater because, after rubbing the surfaces of the inked balls together to get the same amount on each, he struck them repeatedly over the form in a rocking motion, covering the surfaces of all the letters evenly with ink. He also had to be careful not to knock the pieces of type from the form and, if he did so, to replace them correctly. Once he finished with the inkballs for the day, he soaked them overnight in urine so the leather coverings remained supple and smooth.[14]

Finding the right ink recipe for printing on movable type was one of Gutenberg's great achievements. The water-based ink used by scribes was far too thin to be used in a press, which called for a greater viscosity so the ink did not simply wash over the type. Gutenberg invented an oil-based ink, mixing lampblack with linseed oil, the ingredient which for several decades—coincidentally or not—painters in Northern Europe had been using to suspend their pigments. He also introduced copper and lead into his mixtures, which helped produce the famous glossy black of his Bibles.[15] For his part, Fra Domenico mixed his ink from a variety of ingredients, including linseed oil and various resins, varnishes, turpentine, pitch, and lampblack—a recipe he could only have learned from someone trained in the art.[16]

Once the form was properly inked by the beater, the letters were ready for printing. The purely mechanical aspects of the press were the least novel of Gutenberg's system. The ancient Romans had crushed grapes for wine with wooden presses that exerted pressure by means of wooden screws; a fresco from a dyer's shop in Pompeii shows a screw-driven press for felt and cloth. The concept and its mechanisms were easily adaptable to printing. The plunger that crushed the grapes or cloth became the flat plate, known as the platen, that pressed the paper onto the inky surface of the form when the puller turned the screw. He lowered the platen by tugging a horizontal bar on a spindle connected to the screw, leaving the platen pressed against the tympan for a few seconds before raising it by pushing the bar back into its original position. After the tympan and frisket were raised with a sticky slurp, the printer removed the sheet of paper with its inked impressions. This first "proof" was carefully checked for errors, sometimes by the author himself—a process one author later lamented as "this devouring and unworthy labor of correcting characters."[17] The necessary adjustments were made to the type before, finally, hundreds of prints were taken. The form was dismantled and its ink-stained components scrubbed clean and then carefully replaced in their compartments, ready for reuse. The leaves were hung on a string and left to dry (rather like photographs developing in a darkroom) until, when the time came, the next side came to be printed.

Fra Domenico paid monthly salaries to two employees at his press, a pair of brothers named Matteo and Giovanni Ferretti, whom

he simply called "our workers."[18] They probably acted as beater and puller, but they might also have offered know-how based on previous firsthand experience with a printing press. They could have worked as compositors, too, in the early stages. However, Fra Domenico soon found other workers able to perform this vital, demanding, but often tedious task that required patience, concentration, and manual dexterity: the nuns of San Jacopo di Ripoli.

Aut mas aut murus, as the saying had it: "a husband or a wall"—that is, a convent. Such were the choices for a woman, or rather a girl, because by sixteen or seventeen most girls in Florence had either married or entered a convent. Sometimes girls were cloistered much earlier: in 1450 San Jacopo di Ripoli accepted a three-year-old named Marietta, daughter of a certain Jacopo Bellaci.

There were worse fates for a girl than to spend her days behind a convent wall, especially since most women in Florence, even married women, enjoyed extremely limited liberties. Preachers held up the Virgin Mary as an example of how all women, not just nuns, should be shut away from society. "Let's talk of where the Angel found the Virgin," declared the Franciscan Bernardino of Siena in one of his sermons. "Where do you think she was? At the windows or engaging in some other sort of vanity? Oh, no! She was enclosed in a room, reading, to give an example to you, girls, so that you will never be tempted to stay either at the doorway or the window, but that you will remain inside the house, reciting Ave Marias and Our Fathers."[19] An archbishop of Florence, Antonino, likewise wrote that women "should not go leaping about the piazza, nor stand telling stories and murmuring in the doorway, nor talking at the window."[20] They should set foot outside, he declared, only to go to church. Even here the women were segregated: the cathedral of Santa Maria del Fiore, for example, featured a coarse cloth separating them, both physically and visually, from the men.

Giving up on a husband was not necessarily that much of a hardship. Enough women in Florence were victimized by their violent or shiftless husbands (one preacher had to implore husbands not to beat their wives when they were pregnant) that they sought refuge

Veiling ceremony of a Florentine nun.

in institutions for the *malmaritate,* the "badly married." Marriages in Florence were seldom love matches. A girl's parents chose and, through the dowry, paid for her husband, who was generally interested in the financial rather than the sentimental rewards of marriage. Besides the size of her dowry, he concerned himself with the size of her hips, because he wanted children, the more the better. (A woman named Cecca, wife of one Antonio Masi, amply fulfilled her duties by giving birth to thirty-six children.)[21] The husband was usually much older, too, often over thirty—double the age of his bride—which meant she might easily be widowed at twenty-five or thirty, after which, as a preacher stressed, she was expected to "go about very much veiled."[22] And if marriage separated a girl from her family, in a convent she often joined her sisters, cousins, or aunts. One-third of the nuns in San Jacopo di Ripoli were related by blood, and when little Marietta entered the convent she was reunited with her older sister Tommasa.[23]

A girl taking the veil would be escorted to the convent by the relatives who paid her spiritual dowry. The prioress blessed the girl's habit and draped a veil over her head before placing a ring on her finger, an obvious allusion to a secular marriage. In a clear indication of her new life—and of a break with her old self—she received a name chosen for her by the convent, one intended to invoke heavenly patronage. In time, months or perhaps even years later, she took her vows, swearing her oath of poverty, chastity, and obedience, as well as her compliance to the rules of her order. Her family might stage a small celebration on this occasion, offering gifts of wine and candles to the convent—for this ritual was a social occasion and, for the relatives, a proud moment to be observed and treasured.[24]

One of the first things a girl did on entering a convent was to renounce all her worldly possessions. A rule book for nuns stressed that the girls must turn over "all their things, no matter how small."[25] The convent undertook to provide for their needs for the rest of their lives—food, clothing, furniture, bedding. A prosperous convent such as San Jacopo di Ripoli was not without its comforts. The nuns donned fur-lined cloaks in winter and occupied common rooms heated by braziers. Anyone falling ill was allowed special treats and delicacies, even meat.

Dominican friars went out among the people, preaching in piazzas and begging for alms. Dominican nuns, on the other hand, lived completely withdrawn from the world, forbidden to interact with the public or even to leave the convent. They did have a special place in the society from which they were shut away: that of praying for the success of the friars as well as for the safety and well-being of the government and the city. The prayers of nuns were believed to be more effective than those of ordinary people—more useful to the city, as a Florentine nun once boasted, "than two thousand horses."[26]

Nuns also served the economic interests of the city. Florentine nuns embroidered and knitted, they made ribbons, yarn, pillows, and purses, they prepared herbal concoctions, and they took in vulnerable young girls as boarders. The best eyeglasses in Europe could be obtained from the Benedictine nuns at Santa Brigida al Paradiso,

just outside Florence.[27] One of the industries practiced at San Jacopo di Ripoli was the manufacture of gold thread, a delicate task that involved winding strips of gold leaf around silk thread that was woven into the sort of gorgeous brocade given as a gift to Federico da Montefeltro in 1472. Though profits from these enterprises supposedly went to the convent, the nuns were often allowed to keep at least some of the money for themselves. More than half the sisters at San Jacopo di Ripoli enjoyed private incomes from outside sources.[28]

These private revenue streams were essential for keeping the institution financially viable and the nuns comfortably appointed. The income of the nuns at San Jacopo di Ripoli also proved vital to Fra Domenico's printing press: he took advantage of them to fund his new project. Not only did he borrow the substantial sum of twenty florins from Sister Agnesa, but to purchase the matrices from Johannes of Mainz he appealed to another nun, Sister Gostanza, to provide the bushel of wheat to feed the indigent German.[29]

Another way nuns throughout Europe earned money for themselves and their convents was by working as scribes and illuminators. Dominican nuns were especially prolific, and throughout the 1400s San Jacopo di Ripoli was home to what the historian Sharon Strocchia has called "a flourishing scriptorium."[30] Like nuns in the other convents, the sisters copied or decorated liturgical books mainly for their own use or for that of the nearby Dominican basilica of Santa Maria Novella, though occasionally they produced work for clients outside the convent.[31] Thanks to Fra Domenico, these nuns were, like so many other scribes around Europe, about to turn their hands from goosequills to composing sticks.

Chapter 22

A Reversal of Fortune

By 1476 Vespasiano had been selling manuscripts in the Street of Booksellers for more than forty years. Old friends and mentors— such as Niccolò Niccoli, Cosimo de' Medici, Cardinal Cesarini, Giannozzo Manetti, Tommaso Parentucelli—were long gone. Some of his best customers, too, were dead. John Tiptoft, the duke of Worcester, had lost his head in London in 1470. Andrew Holes died the same year, albeit more peacefully among his library of books in a beautiful house in the shadow of Salisbury Cathedral. Borso d'Este died in his castle in Ferrara in the summer of 1471 and Cardinal Jouffroy at his abbey in France in 1473. Alessandro Sforza also died in 1473: he fell from a window in his palace, broke his ribs, punctured a lung, and succumbed to pneumonia.

Of particular sadness to Vespasiano had been the fate of Janus Pannonius. In 1459 the young poet and scholar became bishop of Pécs and one of the most powerful men in Hungary, which, after the splendors of Italy, he deplored as "this barbarian country."[1] He was a close ally of the Hungarian king, Matthias Corvinus, but after plotting against him in 1472—he opposed Matthias's conciliatory overtures to Mehmed II—he fled for Venice only to fall ill after taking refuge at a castle near Zagreb. As Vespasiano sorrowfully recorded, he "died in great misery" at the age of thirty-seven.[2] He composed his own epitaph: "Here lies Janus, the first to bring the laurel-bedecked muses from the heights of Mount Helicon to the banks of the Danube."

Vespasiano still had important clients, such as the duke of Urbino. In Pesaro, Costanzo Sforza replaced his father, Alessandro, as

ruler. The young man was, according to Vespasiano, "a literary man and an expert soldier" who expanded Alessandro's library with many more volumes.[3] Vespasiano also continued to do work for both King Ferrante and his son Duke Alfonso. He had recently produced for Alfonso a manuscript of Claudius Ptolemy's *Geography*, an atlas of the Roman world originally composed in Alexandria around the middle of the second century and translated from the Greek by one of Manuel Chrysoloras's students. Vespasiano prepared a deluxe edition with dozens of maps showing lands stretching from "Insula Britanica" in the west to "Taprobana" (modern-day Sri Lanka) in the east. The manuscript included numerous maps of cities: Alexandria, Cairo, Jerusalem, Damascus, and Constantinople, along with Rome, Venice, Milan, and Florence.

The map of Florence, a bird's-eye view from the north, shows the city embraced by a diamond-shaped circuit of walls and split in half by the River Arno, spanned by its four bridges. Many of Florence's churches and various other monuments are shown inside the walls, all identified by inscriptions helpfully added by a scribe in reddish ink. The artist, Piero del Massaio, even included the copper ball that in 1471 Andrea del Verrocchio added to the lantern at the top of Brunelleschi's dome. The map also shows, on the south side of the Arno, between the Ponte Rubaconte and the Ponte Vecchio, a handsome private home. The reddish ink clearly identifies the occupant: *Domus Vespasiani*—the house, that is, of Vespasiano. The inclusion of Vespasiano's home in Via de' Bardi indicates his friendship with Duke Alfonso, who must have appreciated this little in-joke, and who may have been a visitor to Vespasiano's house during his stay in Florence. It also gives proof of Vespasiano's eminence: his house, like that of Niccolò Niccoli many years earlier, had become one of the sights of Florence.

Vespasiano received an even greater tribute around this same time. He enjoyed the admiration of a younger generation of scholars, foremost among them a prodigy named Angelo Ambrogini. Angelo came from Montepulciano, a hilltop town south of Florence where in 1464, when he was ten, his magistrate father was murdered by the relatives of a man he had sent to prison. His widowed mother,

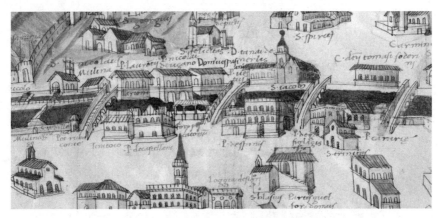

"*Domus Vespasiani*" marked on the map of Florence produced for the manuscript of Ptolemy commissioned by the Duke of Calabria.

with five children to feed, sent Angelo, her eldest, to seek his fortune in Florence. He lived with relatives above a stonecutter's workshop in a poor neighborhood on the south side of the Arno, so poverty-stricken, according to legend, that his toes poked through his worn-out shoes. He distinguished himself as a precocious poet and brilliant scholar, studying Greek with Marsilio Ficino and translating four books of the *Iliad* into Latin hexameters by the time he was sixteen. His talents reached the ears of Lorenzo de' Medici, who, in 1473, took him into his palace and provided him with access to its library. Angelo assumed the humanistic appellation Poliziano, from the Latin name of Montepulciano (Mons Politianus). He would become the greatest classical scholar of his generation, indeed of the century, and his poetry would inspire the sculpture of Michelangelo and the painting of Botticelli.

Around 1475 Poliziano wrote what he called "a glorious poem" that sang the praises of life and thought in Florence. He celebrated Lorenzo, "who rules the city with the mastery of Jupiter governing the motions of the starry heavens," before proceeding through a roll call of the city's distinguished poets and scholars (with due reverence toward "the great Marsilio"). He then paid a stirring tribute to one of his favorite places in the city: Vespasiano's bookshop. He heaped

Vespasiano with praise for bringing ancient texts and cultures back
to life:

> For if the god of Epidaurus, thanks to the herbs of Crete,
> Returned to his father the deceased Androgeon,*
> You, Vespasiano, give back to the great men of the ancient world
> The vitality of which the decaying years had robbed them.
> Thanks to you the Greeks banish the forgetful waves of Lethe,
> And no longer does the Latin language fear the god of the Styx.
> Happy is the man who has plucked the names of the divine poets
> From the pyre's devouring flames.[4]

In later years, looking back, Vespasiano came to regard these
early years of Lorenzo's reign as a time when the city of Florence en-
joyed what he called "a better standing than it had for many years."
But the good times, Vespasiano believed, always portended the bad.
Whenever princes, republics, or private citizens reached the height
of their happiness and believed themselves invincible, they needed
to "fear a reversal of fortune, which never fails to occur." The Flo-
rentines were, he believed, like the people before the Flood or the
residents of Sodom, wallowing in "earthly pleasures and sensual pur-
suits," blindly refusing to accept that calamity could befall them. But
just as the Flood overtook the world, and just as fire and brimstone
rained down on Sodom, "a scourge fell on Florence, utterly unex-
pected, causing the ruin of the city."[5]

Vespasiano was writing with the benefit of hindsight. Even so, by 1476
clues to this tragic reversal of fortune were increasingly apparent. Lo-
renzo de' Medici's relations with Pope Sixtus had been steadily dete-
riorating. Lorenzo believed he knew who was to blame for this
lamentable situation: his own relations and longtime business rivals,

* Poliziano's allusion is to the line about resurrection found in the *Elegies* of the Roman poet
Sextus Propertius: "The god of Epidaurus by his Cretan herbs restored the lifeless Andro-
geon to his father's hearth." Androgeon was the son of King Minos of Crete. The famous
sanctuary of Asclepius, the god of healing, was found at Epidaurus.

the Pazzi. The 1459 marriage of Lorenzo's sister Bianca with Guglielmo de' Pazzi—a childhood friend of Lorenzo—had failed to mitigate the tensions between the two families. In 1475 Lorenzo wrote to his staunchest and most powerful ally, Galeazzo Maria Sforza, the duke of Milan, blaming "these Pazzi relatives of mine" for their incessant troublemaking. He lamented that through their ill nature "they are seeking to harm me as much as they can, and are doing so against all right."[6]

Vespasiano's friend and client Piero de' Pazzi, head of the family, had died in 1464. The patriarch of the clan was now Piero's fifty-three-year-old brother, Jacopo, who, with the help of his many nephews, had begun usurping Medici privileges. Not only had the Pazzi supplanted the Medici as papal bankers, but Guglielmo and his brothers, Giovanni and Franceschino, managed to gain from the pope the alum monopoly previously administered by the Medici. Further, in 1474 Sixtus appointed Francesco Salviati—a cousin of these three Pazzi brothers and a man whom Lorenzo rightly regarded as a creature of the rival clan—as archbishop of Pisa. The appointment went contrary to Lorenzo's wishes, but Sixtus stubbornly asserted his authority, pointing out that Lorenzo "is a citizen and we are the pope, because thus has it pleased God."[7]

Lorenzo's position was soon made more perilous as Galeazzo Maria Sforza was removed from the scene. The duke was perhaps the most extreme embodiment of a distinguishing Renaissance type that combined cultural refinement and religious piety with obscene ostentation and murderous savagery. He was a bibliophile, a music lover, and a patron of the arts as well as a doting father to his young son and heir, whose birth he facilitated by seeking out the relics of Mary Magdalene. However, he made himself unpopular in Milan with a profligate lifestyle that required heavy taxation: he once visited Florence with an entourage of thousands of horses and hounds, falcons, a dozen carriages, and an enormous fleet of velvet-clad servants and courtiers. Worse still was the duke's licentious and brutal behavior, which included seducing the wives of his courtiers and subjecting both criminals and political enemies to cruel and unusual punishments such as being buried alive in an iron coffin. Like King Ferrante of Naples, the

duke reveled in depraved amusements. One of his favorite pastimes was viewing corpses, the sight of which caused him to rejoice with what a disconcerted historian called an "insane excitement."[8]

On December 26, 1476, the thirty-two-year-old duke set off for the church of Santo Stefano in Milan to listen to the choir. He was met on the church steps by three men dressed in red and white—the colors of Brutus but also, ironically, of Galeazzo Maria himself, who had made it illegal for anyone else to dress in his personal colors without his written permission.[9] The trio soon committed a far more serious transgression, leaping at the duke and stabbing him fourteen times. The assassins had been motivated not only by Galeazzo Maria's seduction of their womenfolk but also by the republican teachings of Cola Montano, the humanist professor and pioneer printer. Montano's philosophical opposition to the duke's autocratic and absolutist rule was joined to a personal antipathy that developed following several stints in prison and a humiliating barebuttocked public flogging. He had left Milan for Bologna in 1475 but not before inspiring anti-Sforza sentiments in some of his most zealous acolytes, for whom he arranged with the warlord Bartolomeo Colleoni lessons in dagger-wielding that witnessed the three men rehearsing their assault on a wooden model of the duke. Their attack proved successful, but their triumph was short-lived. The trio were swiftly apprehended and butchered by Sforza henchmen, then dragged through the streets before being impaled on lances and displayed on a bell tower, from which for the next two decades they would grimly survey the city.

Having lost his friend and protector, Lorenzo de' Medici suddenly found himself with a new and extremely dangerous enemy. Galeazzo Maria's son, Gian Galeazzo, was only seven years old, and so the question of who would rule Milan became a matter of much political vexation far beyond its borders. A dangerous fault line divided Florence and Venice from the pope and King Ferrante. The loyalty of Milan, a longtime Florentine ally, was now up for grabs.

The matter of who would protect and influence the young duke was therefore a vital one. Federico da Montefeltro put himself forward for the task, claiming he had no interest but "the good and honor of the duchy."[10] He would have been a natural choice given

that, ten years earlier, following the death in 1466 of Francesco Sforza, the duke's widow summoned Federico to Milan and tasked him with overseeing the peaceful succession of Galeazzo Maria, whose first cousin happened to be Federico's beloved wife, Battista. Federico's role was not to be reprised. Though the pope and King Ferrante of Naples supported him, Lorenzo opposed this regency since he could not risk the prospect of Federico usurping Medici influence and interests in Milan. Federico was furious when he learned of Lorenzo's opposition. Lorenzo, he grimly predicted, was plunging headlong "into the abyss."[11]

Despite the tensions between Lorenzo de' Medici and Federico da Montefeltro, Vespasiano's work preparing manuscripts for the library in Urbino continued unabated. The library was found on the ground floor of the new palace's north wing. This room had been vaulted, carpeted, and furnished with a bronze lectern as well as with benches for the manuscripts. All were carefully arranged by subject: geography, poetry, and history to the left of the entrance; theology, law, and philosophy to the right. The collection included not only Greek and Latin works (as well as the Hebrew volumes pillaged from Volterra) but also more modern writings by Petrarch, Poggio Bracciolini, and Leonardo Bruni. All were bound in scarlet and decorated with rich silver fittings—"adorned / And bound with wond'rous beauty," in the words of Federico's resident painter and poet, Giovanni Santi. Distinguished visitors were allowed to feast their eyes on the collection. "I've seen / Men of the finest taste in wonder lost / Before them," wrote Santi.[12] However, Federico's librarian observed strict instructions to keep at bay the *inepti et ignoranti, immundi et stomacosi*—anyone who was "foolish, ignorant, filthy, or angry."[13]

By 1476 Vespasiano had labored for almost five years on the magnificent collection, his team of scribes and illuminators producing roughly half of the nine hundred manuscripts that would grace the ducal palace. Though his favorite scribe, Gherardo di Ciriagio, died around 1473, Vespasiano had found a new copyist to whom he assigned his most prestigious manuscripts, a Frenchman named Hugues Commineau (or Hugo de Comminellis, as he styled himself).

From Mézières in northeast France, on the banks of the Meuse, he was yet another of Vespasiano's highly educated scribes, holding a master's degree from the University of Paris and capable of exquisitely beautiful humanist handwriting. In 1476 Hugo received his most important commission yet from Vespasiano, a work of surpassing elegance that would be one of the most beautiful manuscripts ever produced by his workshop.

Federico da Montefeltro needed a Bible to adorn his magnificent library. He could, of course, have purchased a printed edition. Though a Bible in folio size (16½″ × 11½″) was a large and costly proposition, a good number of printers—in Germany, France, Switzerland, and Italy—had risen to the challenge. Indeed, a half-dozen folio Bibles had been printed in the first decade after the appearance of Gutenberg's in 1454. Sweynheym and Pannartz published a two-volume Latin edition in 1471, the same year that Wendelin de Speier, in Venice, produced a folio edition in, as the text proudly announced, the *lingua volgare*. Five years later, also in Venice, Nicolas Jenson published a Latin edition on parchment. Like so many of these other folio Bibles, it was an expensive luxury item that, as one bibliographer observed, "cost the price of a farm."[14]

Federico imagined a different style of Bible for his library—something more in keeping with the one produced for Borso d'Este in Ferrara between 1455 and 1461. The "Bible of Borso d'Este," as it became known, had been copied on parchment by a scribe and richly decorated with more than a thousand illustrations by a team of talented artists. However, the scribe wrote out the biblical verses in a Gothic script, the standard style—so redolent of monks hunched over parchment in their scriptoria—in printed editions such as Gutenberg's with its *textura* letters. Even Nicolas Jenson, who used "antique letters" in his classical publications, printed his Bible, which appeared in 1476, in a Gothic-style typeface (often used in liturgical books in Italy) known as *rotunda*, so called because the letterforms were rounder and less angular than in Gothic script. Vespasiano, in choosing Hugo as his scribe, ensured that the Bible for Urbino would appear, by contrast, in the beautiful and legible "antique letters" that were the hallmark of his Latin classics.

Hugo copied out the text of Saint Jerome's translation in his steady, immaculate script—240 leaves of parchment altogether, running from Jerome's preface and the Book of Genesis through the Book of Job. Vespasiano then arranged for dozens of illustrations, likewise done in the new Florentine style by Francesco del Chierico. Francesco produced a series of paintings to accompany the text while a team of other miniaturists worked on the illuminated capitals and decorative borders—not the stylish but austere white vine-stem pattern but colorful, intricate embellishments featuring putti, birds, insects, and other animals such as deer disporting themselves among the stems, buds, and petals that sprouted from classical urns in rich and dizzying profusions.

As attractive and eye-catching as these decorations were, the real masterpieces in Vespasiano's Bible were Francesco del Chierico's illustrations. Twenty-one in number, they begin each new book, from God the Father creating the world—a globe that rests on his lap—to a naked, pox-ridden Job praying on a hillside. Francesco's illustrations reveal the Holy Land to have been a lush, hilly terrain dotted with steeples and castles, and carved up by winding roads. This topography perfectly reflects the rolling landscape of Tuscany, celebrated for its beauty and fecundity. Francesco captured its well-tilled prosperity in his miniatures, with the illustration for Exodus, for example, depicting a determined Moses leading a snaking procession of Israelites into the wilderness—a verdant, well-tended agricultural countryside.

Francesco's miniatures are as finely detailed and charged with narrative incident and expressive gesture as any Florentine fresco or altarpiece. He peopled his biblical scenes with dozens of elegant figures, the men in doublets and bright hose, the women in their billowing gowns looking like dainty Botticelli maidens. These figures might have adorned Federico's dazzling court, later commemorated in a handbook for courtiers for its *sprezzatura*, a style of elegant nonchalance. Francesco lavished particular care on the costumes of his figures. The illustration for Leviticus is especially striking, showing the Israelites in stunning robes of shot silk, the green tones of the fabrics shading to orange, the pinks to blues—an iridescent effect,

known as *colore cangiante,* or changing color, achieved by silk weavers using warp and weft threads of two different hues.

Francesco created compelling and up-to-date architectural settings as enthusiastically anachronistic as his landscapes and costumes. The Temple of Jerusalem is envisioned as a beautiful domed structure with oculus windows—a shrunken version of Brunelleschi's dome for Santa Maria del Fiore—while the Feast of Booths described in the Book of Nehemiah takes place on a Renaissance-style loggia overlooking a broad sweep of river. Federico da Montefeltro would have appreciated these touches, a succession of architects well-versed in the classical style having constructed his palace in Urbino.

While Vespasiano's team worked on the Bible for the library in Urbino, Fra Domenico's ambitions for his press were growing. No copies survive of any of the six titles produced by the press in its first four months, among them short religious tracts featuring the speeches of figures such as Saint Sebastian and Saint Gregory. In the spring of 1477, however, a costlier and more enterprising book rolled off the convent's press: *The Legend of Saint Catherine.*

This treatise gave the life of Saint Catherine of Siena as told by her confessor, Raymond of Capua. A mystic who died in 1380 at the age of thirty-three, Saint Catherine would become a popular subject for printers over the next century. Her letters and biography featured in sixty-one different editions produced across Europe in the decades following her canonization in 1461.[15] However, Fra Domenico's 1477 publication was the editio princeps of Raymond of Capua's biography—its first appearance in print. Dated March 24, 1477, the colophon proudly declared: "This Legend was printed in Florence at the Monastery of San Jacopo di Ripoli by two friars, Brother Domenico from Pistoia and Brother Piero from Pisa. DEO GRAZIAS."

Unlike the convent's first six titles, *The Legend of Saint Catherine* still survives. Libraries in Italy, France, Britain, Austria, Germany, Denmark, Sweden, and the United States altogether hold more than twenty copies. Bibliographers are virtually unanimous in disparaging the quality of the text. The type, a curious hybrid of gothic and roman, has been described as "crudely made," "irregular," and "un-

Alnome digefu crifto crucifixo
edimaria dolce. Comincia elpro
lago della infrafcripta legenda
dellamirabile uergine . Beata
chaterina dafiena fuora dellape
nitentia difanto domenicho

Aquila fpirituale laquale uolo
in fino alla fumita delcielo difo
pra e cheriuelo alla chiefa milita
nte lifecreti deldiuino configlio
Dice cofi neluigefimo capitulo
dellefue reuelatione io uidi uno
angelo difcendere dicielo elqua
le auena lachiaue delloabiffo z

ffi laprofõ
ntia amolti
uia della f
role z cõ e)
quale elde
loro chella
uero accio
mente laco
ngelo chec
tendiamo
nde config
del quale
fcefediciel
uiera quefl
tro propo
fono quefc
ifino dal p
figlioli ecã
mini electi
Elli e que
dice laqu
aue di da
niuno pu

The Ripoli Press edition of *The Legend of Saint Catherine* with its
"ungainly" type.

gainly," and the overall effect of the pages as "unpleasantly undulant."[16] To his credit, Fra Domenico no doubt entertained the same low opinion of his type, since shortly after printing the book he purchased the matrices for more elegant "antique letters" from Johannes of Mainz.

The ungainly typeface was far from the only problem with the book. *The Legend of Saint Catherine* is a quarto that runs through more than 320 pages of text, with two columns on each page. The complexities of putting together hundreds of copies of this edition obviously challenged the abilities of Fra Domenico and his team, exposing their inexperience, inattention, and even incompetence. At times the books were sloppily printed, the pages in some copies as much as eight millimeters, or a third of an inch, out of alignment. Part way through the print run Fra Domenico remedied the situation by commissioning a blacksmith to make him a set of press points for the tympan, or what were later known in English as "duckbills"—triangular pins to perforate the paper and stop it from slipping on the tympan.[17] A worse problem was negligent collation: more than forty copies were missing as many as twenty pages of text. An even unhappier fate apparently befell numerous others, since Fra Domenico regretfully reported in his diary that a large number were *guasti*—"spoiled."[18]

What this edition lacked in technical expertise it made up for, in certain copies at least, in artistic appeal. Like so many other early books, some copies of *The Legend of Saint Catherine* were hand-decorated. A customer wanting a copy with no decoration could purchase one for two lire and ten soldi—roughly the same price as a bushel of grain or forty bottles of wine. A copy embellished with decorations could be had for almost double that price, four lire and ten soldi.[19] Fra Domenico hired rubricators to add red lettering to the pages, but he also produced more elaborate and deluxe copies by hiring miniaturists to add decorations. Fra Domenico was far from alone in this practice, which had become so prevalent by the 1470s that many early printed books can be described as "illuminated"— bedecked with ornate decorations (including gold leaf) by miniaturists who had spent the earlier parts of their careers festooning handwritten parchment manuscripts.

Fra Domenico approached a number of miniaturists in Florence to perform these tasks. Fourteen copies of *The Legend of Saint Catherine* were illuminated in the shop of three brothers, Gherardo, Bartolomeo, and Monte, whose father, the sculptor Giovanni del Fora, had been a collaborator of Donatello. Gherardo del Fora in particular was a skilled, multi-talented artist who apprenticed with Domenico Ghirlandaio—the future master of Michelangelo. Fra Domenico also turned to another artist with an equally stellar reputation: Francesco del Chierico.[20] Francesco and an assistant illuminated fifteen copies of *The Legend of Saint Catherine*, adorning Fra Domenico's somewhat crude production at the same time that Francesco painted his miniature masterpieces for the Bible destined for Federico's library. The striking contrast between Fra Domenico's clumsy edition and his own gorgeous manuscripts may have been behind Vespasiano's comment that a printed book "would have been ashamed" to trespass in the library in Urbino.

Fra Domenico's mass production of copies meant that—like any other merchant with goods to unload—he needed to find commercial outlets. Florence's *cartolai* offered promising opportunities for sales, but copies of *The Legend of Saint Catherine* could also be bought at the convent itself. Fra Domenico dutifully recorded these purchases, which offer a fascinating insight into Florence's book-buying public. Unsurprisingly, a good number of friars and priests purchased copies, a total of forty-four of them, as did four nuns. Also recorded among the purchasers are a cabinetmaker, a weaver, a hosier, a blacksmith, and a bricklayer. The latter pair even paid extra to have their copies rubricated. Their purchases testify not only to their piety but also to both the financial status (for even a printed book required a certain disposable income) and the high literacy rate among Florence's artisans.

Fra Domenico worked extremely hard to sell his books. Much of the spring and summer of 1477 he spent crisscrossing Florence with his wares, lugubriously noting the discouraging outcomes in his account book. He recorded that one of the *cartolai* took a copy to San Benedetto—a small church near the cathedral—to inquire if they

wished to buy it: "They said no." Fra Domenico himself gave a copy to the prioress of Santa Lucia to see if she could sell it: "We got this back." He then took this same copy to the prioress of San Giuliano: "She returned it." The same went for a copy offered to the prior of Santa Maria degli Angeli: "This *Legend* was returned." As for the one in the shop of the *cartolaio* Bartolomeo Tucci: "Returned," wrote Fra Domenico in the sad refrain that runs through the pages of his account books.[21] Indeed, so sluggish were sales that copies of *The Legend of Saint Catherine* languished unsold in the convent as late as 1781, more than three centuries after its first appearance.[22]

Fra Domenico was as shrewd and enterprising as any other Florentine man of business. He bartered unsold books for services, at one point trading copies of *The Legend of Saint Catherine* for a supply of firewood. Copies also paid for the services of a doctor and the leeches to bleed one of the workmen. Another copy Fra Domenico exchanged for cuttings from a mulberry tree to be planted in the monastery garden—part of a scheme to raise money for the convent through silk production. He also gave a book to the shoemaker Jacopo del Cavalieri as partial payment for providing the impoverished Johannes of Mainz with a pair of shoes. A book was therefore turned into a pair of shoes, and the pair of shoes, in reverse alchemy, into the matrices for making type for still more books.

"Today peace in Italy is dead," Pope Sixtus IV had remarked upon learning of the assassination of the duke of Milan in 1476.[23] War was indeed not long in coming.

In the spring of 1477 the Ottoman Turks blockaded Lepanto and began besieging Krujë, in Albania, both under Venetian control. Worse still, the Turks made incursions into Venetian territory on the Italian mainland, raiding Friuli and carrying off captives and livestock. A veteran Umbrian mercenary in the pay of the Venetians, fifty-six-year-old Carlo Fortebracci, fought them off but abandoned the campaign when Lorenzo de' Medici urged him to return to Umbria to claim what Fortebracci believed was his birthright—the city of Perugia, which the pope claimed for himself. Mayhem followed as Fortebracci and his troops raided the area around Città di Castello

(held by the pope's nephew and Federico da Montefeltro's son-in-law, Giovanni della Rovere) before making their way into Sienese territory; here they captured various castles as well as several thousand head of cattle. When Federico's thirty-two-year-old illegitimate son, Antonio, arrived to assist the Sienese, Fortebracci's men drove him back. Federico himself then arrived to attack Fortebracci's hilltop stronghold of Montone, some twenty-five miles north of Perugia. Aided by Neapolitan troops, Federico captured the town after an eight-week bombardment, enhancing his reputation as the "stormer of cities" and forcing Fortebracci to flee to Florence, where, as a notary enthused, "all the people ran to see him." This rebel against the pope was accommodated in a palazzo close to Lorenzo's, fêted by government officials and, as the notary observed, given a "beautiful gift."[24]

In Rome, a Milanese agent wrote home describing the dangerous outcome of Lorenzo's actions. "The attitude of King Ferrante toward Lorenzo is not good," he reported, "and that of the Duke of Urbino is not any better. They do not think of anything else but giving him a severe beating."[25]

Assassination of the Amalekite from the Urbino Bible:
"How the mighty are fallen."

Several of Francesco del Chierico's illustrations for Federico da Montefeltro's Bible catered to the duke's tastes and vanities. The illustration for the Book of Joshua depicts a battle scene in which armored knights on caparisoned steeds do battle with lances beneath the walls of a besieged and burning medieval castle. Flattering reference was made, no doubt, to Federico's renowned prowess at capturing impregnable fortresses, with Montone only his most recent feat.

Yet another illustration looked to the future. The illustration in 2 Samuel shows a swift and brutal assassination watched by an implacable ruler. After receiving news of the death of King Saul, the enthroned David looks on as one of his henchmen plunges a dagger into the neck of the Amalekite who dispatched the Lord's anointed. *Quomodo ceciderunt robusti*, Hugo wrote in his meticulous script: "How the mighty are fallen."

On the final page of the manuscript Hugo would write that this first part of Jerome's translation of the Bible was prepared for "the Illustrious Prince, Federico da Montefeltro, captain-general of the forces of King Ferdinand and the Holy Roman Church." These were the armies that, as work on this first volume neared completion, Federico was preparing to unleash on Florence.

Chapter 23

How the Mighty Are Fallen

According to the great nineteenth-century German historian Ferdinand Gregorovius, Pope Sixtus IV was a man "filled with sensuality, avarice, ostentation and vanity."[1] Soon after his election as pope, he had moved his sisters Bianca and Luchina from Genoa to Rome. Thereafter began his flagrant campaign of nepotism (the Italian word *nipote* means "nephew," "niece," or "grandchild") as he promoted so many of his nephews to high ecclesiastical office that the Vatican hierarchy came increasingly to resemble the Della Rovere family tree. Giuliano della Rovere and Pietro Riario (a son of Bianca) had been appointed cardinals in 1471, followed in 1477 by two more nephews, Cristoforo della Rovere and Girolamo Basso della Rovere, along with a great-nephew, the sixteen-year-old Raffaele Riario Sansoni. When Cristoforo died early in 1478, Sixtus quickly replaced him in the College of Cardinals with yet another nephew, Cristoforo's young brother Domenico.

These promotions formed part of an ambitious political project that witnessed Sixtus carving out a power base for the family in central Italy as he gave Giovanni della Rovere the lordship of Senigallia and Mondavio, and Girolamo Riario the lordship of Imola. These dynastic plans were challenged at each turn by Lorenzo de' Medici, whom the enraged pope denounced as "a villain and an evil man."[2] By 1477 Sixtus had decided that Florence required what he called "a change of government."[3] Though he made clear he would not countenance the killing of Lorenzo, friends and allies pointed out that such a regime change could hardly be accomplished without the deaths of both Lorenzo and his younger brother, twenty-five-year-old Giuliano. "No one's life is to be taken," the pope insisted.

His nephew Girolamo Riario and Francesco Salviati, the archbishop of Pisa and a member of the Pazzi clan, soothed him: "Holy Father, be content to let us steer this bark."[4]

Sixtus left matters at that, apparently believing Lorenzo would merely be toppled and imprisoned along with Giuliano. Girolamo Riario, a man described by Vespasiano as hot-headed, reckless, and violent,[5] contemplated a harsher chastisement. He had begun his career as a butcher, and a butcher he remained. Among his fellow conspirators was Jacopo de' Pazzi, head of the clan, along with Jacopo's nephew Franceschino. Military backup would come from Federico da Montefeltro and his son Antonio commanding Sienese troops. The bloody deed itself was to be carried out by the mercenary captain Giovanni Battista da Montesecco, a loyal warrior on the pope's behalf.

The conspirators gathered in various palaces and taverns, mooting plans such as dispatching Lorenzo during a proposed trip to Rome in 1478. But when Lorenzo canceled his trip—perhaps having sniffed out the plot—the conspirators realized they would need to strike in Florence. They therefore required a ruse by means of which their agents and actors, including Montesecco and his troops, could enter Florence without raising suspicions.

An outbreak of plague in Pisa provided the cover. Early in March 1478 the pope's great-nephew, Cardinal Raffaele Riario Sansoni, a student at the University of Pisa, escaped the contagion by making his way to Florence with his tutor, Jacopo Bracciolini, the son of Poggio, who also served as secretary to Archbishop Salviati. The thirty-six-year-old Jacopo had received an impeccable education in the classics, studying under both Guarino da Verona and Marsilio Ficino, with the latter of whom he remained good friends. As befit the son of Poggio, pioneer of "antique letters," he wrote with one of the crispest and most polished scribal hands of the century. But whereas his father had been one of Cosimo de' Medici's closest friends, Jacopo was part of the plot against Lorenzo and Giuliano—despite having served between 1469 and 1471 as Lorenzo's secretary.

Unlike his tutor, young Cardinal Raffaele was unaware of the conspiracy, though he may have questioned why his trip to Florence required an escort from a well-seasoned warrior like Montesecco and

his eighty-strong force of armed men. Jacopo de' Pazzi invited him to stay at La Loggia, his country villa in Montughi, some two miles from the center of Florence. This villa featured on its facade the monumental terracotta plaque with René of Anjou's coat-of-arms quartered with the frolicking Pazzi dolphins, a reminder of an earlier dispute between the Medici and the Pazzi when Jacopo's older brother Piero hosted the Angevin pretender to the kingdom of Naples. Piero's plot against King Ferrante had failed, but now Jacopo and his kinsmen prepared themselves for their own deadly stratagem.

The arrival in Florence of an ecclesiastic such as Cardinal Raffaele required Lorenzo to lay on some official hospitality. Six weeks after the cardinal's arrival, in the middle of April, Lorenzo arranged a suitably splendid banquet at the Medici villa in Fiesole. Montesecco and his men were poised to strike, but the slaughter was called off when Giuliano, apparently indisposed, failed to appear. The conspirators were forced to delay their plot until an opportunity arose on Ascension Sunday, April 26. Cardinal Raffaele had expressed a strong desire to see both the cathedral of Santa Maria del Fiore and the Medici's Florentine palazzo with its many exquisite treasures. Lorenzo invited him to the Easter Mass in the cathedral to be followed by yet another banquet. "No one," wrote Vespasiano's friend, the poet and scholar Angelo Poliziano, "suspected fraud of any sort."[6] Plans quickly needed changing when the conspirators learned early Sunday morning that once again Giuliano would miss the dinner. But since both brothers would be present at the Mass, the setting for the double murder switched from the palace to the cathedral.

This change of venue did not sit well with the conscience of Montesecco, who balked at the idea of such butchery in a sacred place. Further, charmed by Lorenzo's hospitality, he was fast losing his appetite for the savage mission. With new assassins needing urgently to be found, the conspirators settled upon a number of men with grievances against the Medici, including a financially embarrassed fifty-six-year-old merchant named Bernardo Bandini de' Baroncelli. Also among the killers were two priests, Antonio Maffei, a vicar from Volterra, and Stefano da Bagnone, who doubled as the Latin tutor for Jacopo de' Pazzi's illegitimate daughter.

The choice of killers left much to be desired, but their signal to strike at Lorenzo revealed an unerring sense of the theatrical: the moment when the officiating priest elevated the Host. At this point midway through the Mass the sanctuary bell was rung and, according to the Milanese ambassador, Lorenzo and Giuliano, "as was their custom," began strolling around the cathedral, "well separated one from another."[7] Giuliano was attacked first, stabbed in the chest by Baroncelli and then, after collapsing, violently set upon by Franceschino de' Pazzi, who in his frenzy managed to knife himself in the thigh. As Giuliano lay dying on the floor from nineteen stab wounds, the two priests assaulted Lorenzo, though they were repelled after wounding him in the neck. He fled into the sacristy, where a young friend sucked at the wound in case the dagger had been poisoned. "We were all struck with astonishment," one churchgoer later wrote, "people flying now here, now there, while the church resounded with loud shouts."[8] Meanwhile, the priests slipped away, heading for the Street of Booksellers.

Later that day, Lorenzo de' Medici appeared at a window in the family palace, still wearing his bloodstained robe. "Control yourselves and let justice be done," he urged the crowd below in Via Larga. "Do not harm the innocent."[9]

Justice was already taking its swift and ruthless course. Minutes after the attack in the cathedral, Jacopo de' Pazzi had ridden into the Piazza della Signoria on horseback shouting "*Popolo e libertà!*" ("The people and liberty!")—the rallying cry for republicans who believed the Medici had stolen their political freedoms. The people of Florence failed to rise up to reclaim these lost republican liberties. Instead, throngs of armed Medici partisans took to the streets chanting pro-Medici slogans as the bell of the Palazzo della Signoria tolled to summon hundreds more. Jacopo and his nephew Renato, son of Piero, fled into the countryside where, a day later, disguised as peasants, they were captured in a hamlet some thirty miles northeast of Florence. Jacopo offered his captors money to allow him to commit suicide, but he and Renato were beaten and returned to

Florence, where they were tortured and—still dressed in their peasant garb—hanged.

By this time retribution had claimed Archbishop Salviati and his cousin Franceschino. The former was captured along with Jacopo Bracciolini as they tried to enter and seize the seat of government, the Palazzo della Signoria; the latter in the Palazzo Pazzi in the Street of Booksellers, from which, still bleeding from the thigh, he was dragged through the streets. The three of them were hanged from the windows of the Palazzo della Signoria, Archbishop Salviati in his ecclesiastical robes, the others stripped naked. One eyewitness, Poliziano, made the astonishing claim ("it will, I grant, seem incredible to all") that as they swung from their ropes the archbishop viciously sank his teeth into the bare chest of Franceschino.[10]

Bloody reprisals against the other conspirators followed in the ensuing days and weeks. Vespasiano claimed that more than five hundred people were slaughtered in punishment for the "wicked crime" in the cathedral. "It is not for me to describe such cruel excesses," he wrote.[11] Others were not so reticent. Poliziano described seeing corpses "which the people mocked and abused most cruelly." Another eyewitness recounted how a priest in Archbishop Salviati's entourage was killed in the Piazza della Signoria, "his body being quartered and the head cut off, and then the head was stuck on top of a lance and carried about Florence the whole day." The priest's disembodied legs and an arm were dragged through the streets to the Palazzo Medici to cries of "Death to the traitors!"[12] Niccolò Machiavelli, then a few days short of his ninth birthday, would later recount the "relentless cruelty" against the Pazzi and their followers, reporting that even outside Florence the roads were strewn with "fragments of human bodies."[13]

One of the attackers, Bernardo Bandini de' Baroncelli, the murderer of Giuliano, managed to escape. He made his way to a distant city where he felt he would surely be beyond the reach of the vengeful Medici: Constantinople.

Vespasiano witnessed many of the horrifying acts of violence in the days after the murder. The narrow street outside his shop played host

to a series of particularly macabre spectacles. Two days after the murder of Giuliano, anyone venturing along the Street of Booksellers would have been treated to the sight of eight of Giovanni Battista da Montesecco's soldiers standing in the windows of the notaries near the Badia. Hanged a day earlier, they had been stripped naked and, like sinister mannequins, placed upright in the windows, "left to lean," according to one witness, "so that they looked like men depicted or portrayed to look alive . . . stiff and naked as the day they were born."[14]

A few days later, on May 3, the street erupted in tumult when the two priests, Maffei and Bagnone, were apprehended where they had taken sanctuary with the Benedictine monks in the Badia. As they were dragged through the doors and into the street, a furious mob gathered outside Vespasiano's shop, baying for the blood of the monks who sheltered them. One day later, on the other side of the street, the two priests received their rough justice. Their ears and noses were cut off before they were hanged from the windows of the Palazzo del Podestà, the palace of justice across the narrow Via del Palagio from Vespasiano's shop. Their bodies were then cut down and stripped naked as a mob robbed them of their doublets and hose. The following evening Montesecco, captured as he fled Florence, was decapitated under the loggia of the Palazzo del Podestà; his head, like a dreadful trophy, was stuck on its door.

An even more harrowing display came in the middle of May when a group of boys appeared in the Street of Booksellers dragging the putrefying corpse of Jacopo de' Pazzi. Jacopo had been buried in the family crypt in Santa Croce, but his corpse was disinterred on May 15 after heavy rains persuaded the authorities that the burial of such a wicked man in consecrated ground had incurred the wrath of God. He was therefore exhumed and reburied—the rope still encircling his neck—in unconsecrated ground beside the city wall. Two days later, on their own initiative, the gang of youths dug up the corpse and toured it through the streets, making "great sport all through the town." Conducting their ghastly captive past Vespasiano's shop to the nearby Palazzo Pazzi, they suspended him by the rope from the doorknob and urged: "Knock at the door!" Finally tiring of their amusements, they dragged the corpse to the Ponte di

Rubaconte and, merrily singing songs, dumped it into the Arno. People crowded onto the bridges to watch it bob downstream where, one day and almost six miles later, at Brozzi, another group of boys fished it from the water, hung it in a willow tree, and flogged it with sticks. Then they, too, tossed the body into the Arno. It was last seen passing under the bridges of Pisa on its way to the sea. The indignities continued in song. "*Messer Jacopo giù per Arno se ne va,*" children sang in the streets: "Messer Jacopo goes away down the Arno."[15]

"How the mighty are fallen," Vespasiano's scribe Hugo wrote in Federico da Montefeltro's Bible. That human affairs were always prey to grim and swift reversals had long been one of Vespasiano's most steadfast convictions. "Oh, vain hopes of mortals," he once wrote regarding the misfortunes of the powerful Strozzi family. "Who would have believed that the happiest house in Florence in so short a time should undergo such a change? Everyone should beware, for however happy their condition may be, their destruction will come quickly. Such is the state of human affairs."[16] The downfall of the Pazzi—a family whom he called "the most fortunate in the city"[17]— offered still more evidence of the precariousness of life and the caprices of fortune. But the bad times, Vespasiano would later maintain, were only just beginning.

"Messer Jacopo Goes Away Down the Arno" was not the only song to be heard in the streets of Florence in the weeks after what came to be known as the *Congiura de' Pazzi*, the Pazzi Conspiracy. Within a few weeks of Giuliano de' Medici's death a ballad appeared in print recounting the "atrocious betrayal" and maligning the perpetrators. It was clearly intended to be recited or sung because at various points the poet breaks off to voice his sorrow: "I cry with my eyes and my heart bursts to have to recite my verses." Or again: "Here let me stop for a while with tears and sobs and sighs."[18]

The poem was pro-Medici propaganda, extolling the virtues of Lorenzo and Giuliano while viciously castigating the assassins and their accomplices. These "treacherous traitors" were listed and condemned one by one, their reputations savagely torn apart in verse. Jacopo de' Pazzi was identified as a blasphemer, an enemy of virtue

and kindness, an "angry man with a feeble brain." His nephews were "fools, full of madness . . . traitors and rebels." The poem also hinted at other nefarious participants—"men of greater status whose names I had best not mention." The poet was no doubt alluding to Federico da Montefeltro, King Ferrante, and probably even Pope Sixtus. He was happy, however, to linger on the executions, the men dangling from ropes and those "cut to pieces."

Though the poem is anonymous, the identity of the printer is secure. In 1478 Fra Domenico's press at San Jacopo di Ripoli produced a libretto "on the death of Giuliano" for a stationer named Giovanni di Nato, whose shop was found by the Porta al Prato, the city gate nearest San Jacopo.[19] The edition was probably commissioned by Giovanni, who shrewdly spotted an appetite for information about the Pazzi Conspiracy—the more shrill, biased, and sensational, the better. Fra Domenico's partnership with a stationer made sound business sense, since Giovanni, by stocking the librettos in his shop, saved Domenico the effort of traipsing around the city with an armful of chapbooks, hoping to make sales to skeptical customers.

Some of Giovanni di Nato's customers for this poem were balladeers who recited the verses on street corners—"with tears and sobs and sighs"—and then sold copies of the chapbook to passersby. The city's streets had long been used by itinerant entertainers such as the *cantimbanchi*, or "bench singers," who performed in the streets and piazzas. The *ciarlatani* likewise plied their trade in the streets—men who removed teeth and sold miraculous remedies (and who gave us the word "charlatan"). Peddlers were another a familiar sight, selling from baskets hung round their necks such wares as religious trinkets and other cheap souvenirs. Many were blind and begged in front of churches, and some of them, too, became popular street performers, entertaining crowds by singing songs—often bawdy ones—and reciting prayers and orations.

The arrival of the printing press gave these peddlers and songsters another commercial opportunity to exploit, and street hawkers in turn provided Fra Domenico with people to sell his wares. In December 1477 his account book recorded sales of newly printed religious pamphlets to two peddlers, "Angelo *cieco*" (Blind Angelo) and

"Chola *cieco*" (Blind Chola).[20] Among the first purveyors of print in Florence, they bought (and sometimes commissioned) copies of pamphlets containing the texts of the prayers and songs they performed. Blind Chola, for instance, purchased two hundred copies of *Prayer on the Blood of Christ*, a work he probably ordered directly from Fra Domenico. He would have recited this oration in the streets and then, with any luck, sold copies to passersby. He was unable to return any unsold stock to the printer.

These inexpensive little tracts and flyers probably represented the first experience many people had—the poor especially—of the printed page. Almost none of the works has survived, not simply because they were so cheaply produced but also because of how the buyers used them: they stuck them onto the walls of their homes or else folded them into amulets and used them as charms. Devotional texts were believed by the faithful to have magical powers similar to the unguents and potions sold by the *ciarlatani* (who sometimes sold books and pamphlets too). Words inscribed on paper had long served as amulets, from the magical papyri the ancient Egyptians rolled up and placed in leather pouches strung around their necks, to the special talisman (known as a *vefk*) worn by Mehmed II's grand vizier, Karamani Mehmed Pasha. After Gutenberg, a whole industry developed in Germany of printing cards whose texts supposedly kept the purchaser safe from the plague and other afflictions. Words produced mechanically on paper in print runs of three hundred copies appear to have enjoyed powers every bit as potent as those inscribed by a quill on a piece of parchment.[21]

In its first year of operation, the press at San Jacopo di Ripoli produced a dozen of these texts, including ones intended to coincide with the feast days of Saint Gregory and Saint Sebastian. They also printed copies of the Lord's Prayer to be sold by another itinerant peddler, "Giovanmichele *zoppo*" (Lame Giovanmichele).[22] Many of the first people in Florence to buy printed material were therefore pilgrims seeking poems and religious charms in the piazzas from the blind and the lame.

Chapter 24

The Land of Oblivion

The fate of Florence in the months following the Pazzi Conspiracy was a grim one. Furious about the ignominious execution of Archbishop Salviati and the two priests, as well as the imprisonment of Cardinal Raffaele Riario—an innocent party in the affair—Sixtus IV placed Florence under interdict. This punishment denied holy sacraments to the dying and church burials to the dead. Sixtus then excommunicated Lorenzo de' Medici, with the bull *Ineffabilis et summi patris providentia* issuing from the Roman press of Johannes Bulle. It denounced Lorenzo as a "son of iniquity and perdition," enumerating his many offences and declaring that they had been inspired by the devil.

War broke out between the two parties in the summer of 1478, the drawn-out contest known as the "Pazzi War." Sixtus used all means at his disposal, ecclesiastical as well as military, offering indulgences and a plenary remission of sins to anyone who took up arms against the Florentines. Hoping to gain territories for himself in southern Tuscany, King Ferrante put his army, commanded by his son, Duke Alfonso, at the service of the pope. The Neapolitan troops were assisted by Federico da Montefeltro. In the middle of July the armies of the two men crossed into Florentine territory and began attacking the fortresses with devastating new weapons, Alfonso with arrows dipped in poison, Federico with cannons bearing fearsome nicknames such as "the Cruel" and "the Desperate," capable of discharging stones weighing almost four hundred pounds and requiring the efforts of one hundred pairs of buffalo to tow them through the hilly terrain. Farmers and villagers from the Chianti countryside fled inside the walls of Florence in panic. Florentine forces were led by

Ercole d'Este of Ferrara, who spent much time debating his course of action with his astrologers before reaching the conclusion that the enemy was best countered with him, the commander, dithering at a safe distance. His reluctance to engage may have had something to do with the fact that he and Alfonso were brothers-in-law.

Marsilio Ficino received divine messages, which he dutifully passed along to King Ferrante ("Be wholly content with the territories you have") and the pope ("O our Sixtus, stop this great conflict now").[1] He warned the pope that his war against Florence meant the "utter destruction of the world is imminent, a universal and final calamity overwhelming the human race by war, pestilence and famine. Many leaders from every nation will be overthrown, and then a new heresy under a false prophet will arise."[2] The great men failed to pay any heed, and the conflict wore on—complete with pestilence and famine—through the summer and into the autumn.

Vespasiano found himself faced, not for the first time, with some of his best customers taking to the field of battle against Florence. He was still doing business with both Duke Alfonso and King Ferrante, for the latter of whom an illuminated manuscript of Livy's Third Decade was in production.[3] Further, he had completed the second manuscript of the two-volume Bible for Urbino—with exquisitely unfortunate timing—on the eve of the war. On June 12 the scribe, Hugo, composed his colophon on the final page of the second volume, recording that "this elegant Bible," as he modestly called it, had been prepared for the "Illustrious Prince, Duke Federico da Montefeltro of Urbino, captain of the Holy Roman Church." It was written, he noted, "by the hand of Hugo de Comminellis" with everything managed by Vespasiano di Filippo, "Florentino Librario." He tactfully refrained from adding any topical references, as Vespasiano's scribe Ser Antonio di Mario had been prone to do in times of plague or warfare.

Vespasiano immediately sent word to Federico that this second volume was complete and ready to be dispatched to Urbino. However, Federico's involvement in the Pazzi Conspiracy, as well as his alliance with Sixtus, made the matter of delivering this precious

manuscript a ticklish one. Though Federico had sent Lorenzo a let-
ter deploring the "horrendous and despicable attack" in the cathe-
dral,[4] Lorenzo was fully aware of the duke's complicity, thanks to the
confession Giovanni Battista da Montesecco made before his execu-
tion. Vespasiano needed to tread carefully, remembering that his
friend Giannozzo Manetti had once been accused of treason for ded-
icating *On the Dignity and Excellence of Man* to King Alfonso, Ferran-
te's father, at a time when Florence was at war with Naples. Federico
was equally aware of the delicacy of his position in claiming his prized
new possession, for the hostilities between him and Lorenzo meant
the volume might never leave Florence.

Vespasiano intervened with Lorenzo, asking him to ensure the
Bible's untroubled passage to Urbino. To his credit, Lorenzo assented,
and the manuscript was dispatched with no further ado, together with
a letter from Vespasiano to the duke reporting his intercession. Once
the manuscript arrived—remarkably, little more than a week after
Hugo penned his colophon—Federico wrote to Lorenzo thanking
him for his generosity. No evidence exists that the duke's advisors cau-
tioned him about the possibility of poison (as had King Alfonso's phy-
sicians many years earlier when he received his codex of Livy from
Lorenzo's grandfather). Whatever the case, Federico wrote to Lor-
enzo, addressing him as "dearest brother" and describing how Vespa-
siano informed him that Lorenzo "promptly and with good will offered
every help and favor in sending the Bible which I had made in Flor-
ence, for which I thank Your Magnificence."[5]

The pleasantries continued with Lorenzo a few days later writ-
ing to Federico expressing his happiness in hearing that the beauti-
ful volume had safely reached Urbino and assumed its place in the
library. Then this peaceful, bookish interlude of mutual good will
came to an end as Federico's mighty guns began preparing to wreak
havoc on the Florentines.

In August, news reached Florence of the papal troops led by Duke
Alfonso rampaging through the Tuscan countryside, capturing live-
stock and, at one point, carrying off a blacksmith. "Such a terror was
never seen," reported one Florentine, "everyone being utterly dis-

mayed."[6] Yet despite the poison arrows and heavy bombardments, Florence had suffered few casualties during the first weeks of the Pazzi War. An apothecary in Florence delivered a cynical but by no means flawed judgment on Italian warfare: "The rule for our Italian soldiers seems to be this: 'You pillage there, and we will pillage here; there is no need for us to approach too close to one another.'"[7] Indeed, one of Federico da Montefeltro's earlier campaigns, on behalf of Pius II, resulted in nothing more deadly than the capture of twenty thousand chickens.

One of the few casualties of the war that summer proved to be Vespasiano's great friend Donato Acciaiuoli. As Florence's ambassador to Rome at the time of the Pazzi Conspiracy, Donato found himself the victim of Girolamo Riario, the most ruthless and vengeful of the papal nephews. Furious at the failure of the plot and at the imprisonment of his young nephew, Cardinal Raffaele, Girolamo burst into Donato's Roman residence with thirty armed ruffians. He treated the distinguished scholar with such highhanded contempt—"like a thief or a traitor," claimed Vespasiano[8]—that Donato afterward complained to the pope of the terrible affronts to both himself and, by extension, to Florence. Sixtus denied sanctioning Girolamo's conduct, but Donato could not be mollified. Appalled by the insults and injuries, he asked to be recalled to Florence. The Florentine government agreed, but even before Donato arrived back in the city—which he did in the middle of August, passing through the war-torn Chianti countryside—he found himself appointed to another vital post, ambassador to France. He was charged with gaining the support for the Florentine cause of King Louis XI, the "universal spider" to whom, almost two decades previously, he had presented the copy of his biography of Charlemagne prepared by Vespasiano.

Vespasiano visited Donato upon his return to Florence, offering a poignant eyewitness account of the sad decline of the great scholar and statesman as he contemplated the terrible dangers faced by his city—the scourge, as Vespasiano called it, that had fallen on Florence. "He fell into a deep depression," wrote Vespasiano, "unable either to eat or sleep, or to take happiness in anything."[9] Among his sorrows must have been the distressing fate of the Pazzi clan. His wife, Marietta, was the sister of Renato, the niece of Jacopo, and the

cousin of Franceschino, all now dead. Four of Marietta's brothers languished in chains in the tower in Volterra, condemned to life imprisonment. Meanwhile the Pazzi dolphins had been chiseled from their buildings, including the one done for their Florentine palazzo by Donatello and another at the villa in Montughi by Luca della Robbia. Even the Pazzi name was banned, for Lorenzo was determined to expunge the family from history.

Despite his marital connections to the Pazzi, Donato was above all suspicion. Devoted as ever to Florence, he bid a sad farewell to Marietta, his children, and friends such as Vespasiano, then set off for France in the blistering August heat. Before the month was out he reached Milan, where he was received with the "greatest honors" but where, inevitably, he fell ill. His doctors diagnosed him as *tutto pieno d'umori malinconici*—"full of melancholy humours."[10] He died soon afterward at the age of fifty. Vespasiano wrote that he was universally mourned not only in Florence but also by men such as Federico da Montefeltro and Duke Alfonso of Calabria, the latter telling the former, according to Vespasiano, that "all Italy must grieve for the loss of this man who was without equal."[11]

Few grieved Donato's death more than Vespasiano, his dear friend of almost forty years. The loss led to a further darkening of his vision of life. "O vain desires of men!" he wrote in his biography of Donato. "How false and uncertain our hopes in this miserable and fragile life!"[12]

Donato Acciaiuoli's death came about in part, Vespasiano claimed, because the people caring for him in his house in Milan fell ill and therefore became incapable of offering him the attention he needed. No doubt at least some of them were suffering from the plague, for pestilence returned to Italy in the terrible summer of 1478. Florence was especially badly hit. By September as many as ten or more people were dying each day at the Ospedale della Scala, next door to San Jacopo di Ripoli; others dropped dead in the street outside.[13] And less than a week after Donato's death, Vespasiano was dealt another terrible blow.

The grand house on Via de' Bardi was slowly emptying of inhabitants. Following the deaths of his mother and brother, Vespasiano's sister Marietta, the wife of a shoemaker, had been next to go, in 1476. She left behind a son, Giovanfrancesco Mazzinghi, who continued to live in the house. Vespasiano also shared his home with his brother Lionardo, with Jacopo's widow, Andrea, and with Andrea's son, Lorenzantonio, now in his mid-twenties and qualified as a doctor. Also in residence, after 1477, was Lorenzantonio's new bride, Maria Giducci, a girl from a prominent and respectable Florentine family. She arrived in the house in Via de' Bardi bringing a handsome dowry of 1,200 florins.

Tragedy struck the household when in September 1478 Lorenzantonio died of the plague at the age of twenty-seven. His young widow returned to her family, leaving Vespasiano legally obliged to repay her dowry. The big house must have seemed cheerless following Lorenzantonio's death, and so, despite the danger of warfare and the threat of invasion, Vespasiano began spending more and more time at the farmhouse near Antella, a few miles outside Florence. Here in the Casa Il Monte, among checkered hillsides shaded by olive trees and enlivened by the chattering cicadas and the fluty descant of the hoopoe, his spirits drooped. A few months later, aged fifty-six, he wrote to one of his scribes in Florence: "It appears, dear friend, that the world is not only old but also decrepit, and everything is winding down." He was living, he claimed, in *tera oblivionis*—the land of oblivion.[14]

At San Jacopo di Ripoli the plague was also taking its toll. The contagion did not ravage the community as it had in 1348, when all but three nuns died. This time the damage was economic, a threat to business rather than to life.

The convent had recently undergone a successful commercial expansion. In the summer of 1477, thanks to loans from some of the nuns, Fra Domenico had added shares in its third mill and its tenth farm to the convent's collection of properties in and around Florence. The following spring Fra Domenico invested in another herd

of swine. But the ravages of war and plague now threatened these burgeoning commercial affairs. "Here we are abandoned by everyone due to war and plague," wrote Fra Domenico. The location of the convent—next to a hospital treating many of the victims—made it especially vulnerable. "We can't earn anything more," he wrote to the government officials, "because the shops don't want to send us anything on account of the plague, which lies right outside our door."[15] He claimed that, if matters continued, the nuns would be forced to beg for alms in the street.

Fra Domenico was probably exaggerating: his letter was a plea for a reduction in taxes. Certainly the convent's printing press was still operating. By the summer of 1478 the Ripoli Press had published almost thirty titles, an average of a new book roughly every three weeks, usually in a print run of between two hundred and three hundred copies. Capital investments in the press continued. In the summer of 1477 Fra Domenico hired a new assistant from Venice, a young man named Lorenzo di Alopa, who began working as a compositor and errand boy. The following year a goldsmith provided Fra Domenico with "*tre abbici*," three new sets of ABCs, two antique-style and one "modern," or Gothic.[16] The new types were used to print not only the lament on the death of Giuliano de' Medici but also a number of more impressive classical works. During the summer of 1478 the Ripoli Press published, in Latin, an edition of two ever-popular works by the Roman historian Sallust, *The Conspiracy of Catiline* and *The Jugurthine War*. They also brought out, likewise in Latin, the collection of biographies by a later Roman historian, Sextus Aurelius Victor's *Lives of Illustrious Romans* (albeit attributing the work, as other printers had done before them, to a more famous author, Pliny the Younger).

The purchase of the new ABCs as well as the production of this classic literature were made possible in part by Fra Domenico's entry into a partnership in 1478 with a *cartolaio*, a man named Bartolo di Domenico. Fra Domenico referred to him as "Bartolo *miniatore*," which indicates that at some point in his career he worked as an illuminator, decorating manuscripts—another crossover artist who seems to have gone seamlessly from manuscript to print production. Bartolo became a publisher, agreeing to purchase and sell quantities

of books that he and Fra Domenico decided to print. He assumed the burden of paying the salaries of the press's employees, such as Lorenzo di Alopa (who had previously received his salary in the form of a doublet, a winter cloak, and a work apron). He also made capital investments, not only in the new sets of type but also in the convent's herd of swine, for the latter of which he offered up ten florins.[17]

The employees whose salaries Bartolo paid included the nuns whom Fra Domenico was still using as compositors. In the spring of 1478 Bartolo contributed ten florins toward the "*salario delle monache nostre che componghano allo stampare*" ("the salary of our nuns who work as compositors at the press").[18] Ten florins was a considerable amount, which suggests the sisters were performing a great deal of work. The historian Melissa Conway has estimated that compositors at the Ripoli Press could set two and a half pages in the course of a fourteen-hour workday.[19] The sixty-four pages comprising the *Lives of Illustrious Romans* would therefore have required some 358 hours of typesetting. The nuns must have been as relieved as any scribe to reach the final page and add their colophon: IMPRESSUM FLORENTIAE APUD SANCTUM IACOBUM DE RIPOLI ("Printed in Florence at San Jacopo di Ripoli"). One of the compositors used by Fra Domenico was Sister Marietta, the nun who entered San Jacopo di Ripoli as a three-year-old in 1450 and was now in her early thirties. Fra Domenico's account book records that he paid "suor Marietta" two florins for her work.[20]

Though meticulous in his record keeping, Fra Domenico made no mention whatsoever in his accounts of these Latin works by Sallust and Aurelius Victor. He was possibly trying to conceal from the ecclesiastical authorities, to whom he was accountable, the new direction his printing press was taking. These latest books were secular and "pagan" rather than religious works such as the biography of Saint Catherine of Siena, and he may therefore have feared the response of his superiors.[21]

The Ripoli Press would continue to print inexpensive prayers and orations, but these Latin works revealed a widening of Fra Domenico's ambitions. He published these classics in an "antique" type mimicking the handwriting of humanist scribes such as those used

by Vespasiano. Two other works, printed even before the Sallust and
the Aurelius Victor, revealed the true nature and scale of the threat
that the Ripoli Press posed to Vespasiano. Early in 1478 Bartolo di
Domenico commissioned from Fra Domenico an edition of Bartolo-
meo della Fonte's *In Persium explanatio,* a commentary on the satires
of the first-century Roman poet Aulus Persius Flaccus. More interest-
ing than the commentary was the identity of the author. Bartolomeo
della Fonte was a thirty-one-year-old Florentine poet and scholar who
once studied under Vespasiano's friend "Messer Giovanni," the Greek
scholar John Argyropoulos. Through Messer Giovanni he became
friends with Donato Acciaiuoli, who encouraged his studies and, in
1473, took him on a legation to the king of France. Bartolomeo was
almost certainly known to Vespasiano. His brother Niccolò was a
scribe who may well have done work for Vespasiano.[22] In any case,
Bartolomeo's learned commentary on a classical author was precisely
Vespasiano's stock-in-trade.

Another work testified even more insistently to the printing
press's incursions among Vespasiano's circle of humanist friends.
Early in 1478 the Ripoli Press published its most ambitious and impor-
tant work to that point, an edition of Donato Acciaiuoli's commentary
on Aristotle's *Nicomachean Ethics.* Donato had based his commentary
on lectures delivered in Florence by Messer Giovanni. Vespasiano
knew the treatise well, having been present at Messer Giovanni's lec-
tures and then produced a manuscript of Donato's work for the
library of Federico da Montefeltro. He would later conclude his bi-
ography of Donato with the proud claim that this commentary was "a
most esteemed work now found in all of the universities in Italy."[23]
He must have known that the copies stocked by the universities and
read by the students were from the edition printed at San Jacopo di
Ripoli—the handiwork of Fra Domenico and his team rather than of
Vespasiano.

The Pazzi War dragged on through the autumn of 1478 and into the
winter. The Florentines finally received reinforcements from Venice
and Milan commanded by a mercenary captain from Rimini, thirty-
seven-year-old Roberto Malatesta, the son of Sigismondo. Roberto

had begun the war in the service of Duke Alfonso but after bickering with him over his share of the booty from Monte Sansovino, which the pair had captured, he promptly transferred his services, with the carefree conscience of a soldier of fortune, to Florence. Though he defeated papal troops led by Girolamo Riario outside Perugia, the enemy's depredations of Tuscan territories continued. Fortresses changed hands, mills were burned, and livestock captured. Rain fell steadily through December, causing the Arno to flood. "It pleased God to chastise us," wrote the Florentine apothecary Luca Landucci in his diary. "And at this Christmas-time, what with terror of the war, the plague, and the papal excommunication, the citizens were in sorry plight. They lived in dread, and no one had any heart to work."[24]

Raging throughout the winter and spring of 1479, and then into the summer, the plague claimed ever more victims. Anyone who could retreated, like Vespasiano, to the countryside, fearing the plague more than the marauding soldiers despite tales of burning hamlets and kidnapped villagers. Marsilio Ficino took himself off to his farm at Careggi, where he began writing a book on how to survive the plague. He came up with a sage piece of advice: "*Fuggi presto & dilungi & torna tardi*"—"Escape early & linger & come back late." Even the government left town, departing to the Badia in Fiesole. At the end of June the city's biggest festival, the Feast of San Giovanni, was a subdued affair with no tents and few ceremonies. In July a priest tried to poison Lorenzo de' Medici. Supposedly an agent of Girolamo Riario, he was hanged in a window of the Palazzo del Podestà—yet another corpse twisting above the Street of Booksellers.

The fear and pessimism of the times were reflected in one of the books printed by the Ripoli Press early in 1479, the *Prophecies* of Saint Bridget of Sweden. The pious founder of a religious order who died in 1373, Bridget had recorded a series of visions that scholars quickly translated from Swedish into Latin and various European vernaculars. Her revelations became so popular by the fifteenth century that many bogus prophecies circulated under her name, foretelling cataclysmic events such as the rise of a wicked tyrant and the destruction of Rome. The Ripoli edition does not survive, so we cannot know if Fra Domenico stuck faithfully to her actual writings or if—perhaps more likely—he was adding to the fire-and-brimstone

pseudo-Brigittine literature. But since her visions concerned, among other things, the coming of the Antichrist "at a time . . . when iniquity will abound beyond measure and there will be an immense increase of impiety," there was plenty of scope to capture the dire, fearful, and recriminatory mood of the times.[25] Fra Domenico failed to record who commissioned these prophecies, but they would have been sung or declaimed in the piazza by a *cantimbanco*—no doubt suitably unnerving a public already anxious about the future.

Vespasiano likewise took the plague and the war as signs of God's displeasure. He reported in June that some of his neighbors in the country had died from the pestilence: a youngster and an old man. He knew what was to blame. "It must be because of our deeds, because of our sins and failures, that so much persecution is visited upon us," he wrote to one of his scribes. "May God keep us and not look upon our sins and iniquities, but rather turn his usual mercy toward us." He had entered, he wrote, "a labyrinth from which, I pray God, I can escape with body and soul, although I very much doubt it."[26]

By the end of 1479 Florence was in an increasingly desperate plight. In September the Florentine troops under Ercole d'Este had suffered a shameful defeat at Poggio Imperiale, whose magnificent fortress Federico da Montefeltro and Duke Alfonso captured in a single day. Peace negotiations with the pope had failed despite the mediation of King Louis of France, mainly because Sixtus demanded that Lorenzo de' Medici travel to Rome to beg for absolution for his involvement in the deaths of Archbishop Salviati and the other ecclesiastics. Lorenzo refused for reasons of his own safety and security. Even his seven-year-old son, Piero, smelled a rat: "We beseech you, we your children," he wrote, "to have the more care for yourself the more you see that the enemy rather lays hidden snares than dares open warfare."[27]

The heavy taxes imposed to finance the faltering campaign raised mutinous murmurs in Florence. Facing threats to his rule both at home and abroad, Lorenzo decided upon a bold and dangerous gambit: he would go to Naples to begin peace negotiations with King Ferrante—the man who displayed in his castle the embalmed corpses

of his enemies. "God help him," wrote one Florentine politician in his journal.[28]

The fate of someone else who trusted to the mercy of King Ferrante should have given Lorenzo pause for chastening reflection. The warlord Jacopo Piccinino had supported the Angevin claim to Naples, fighting with Jean of Anjou against Ferrante's forces before, in 1463, following a defeat, he transferred his loyalty to Ferrante. His switch of allegiance came thanks to a plot woven by none other than Antonio Cincinello, the man willing to do "whatever was needed" to defend his king. The devious Cincinello promised the warlord a large sum of money as well as lands in the Kingdom of Naples. In the spring of 1465, after many entreaties and reassurances, he convinced Piccinino to come to Naples. King Ferrante rode a half mile out of Naples to bid his old foe a friendly welcome and personally escort him into the city as a guest of honor. Piccinino enjoyed warm hospitality for several days before, on the pretext of getting a tour of the royal treasure house in the Castelnuovo, he was lured into a dungeon and strangled. His corpse was carried to the top of the castle and unceremoniously dumped from a window. The warlord, it was given out, had slipped and fallen to his death after peering out a window to inspect the ships docked in the harbor. Vespasiano noted that Piccinino had been warned to stay away from Naples. "Men are blind to so many things," he observed, "and from this blindness comes their punishment."[29]

Lorenzo, like Piccinino, saw fit to ignore the warnings he received. Ominously, the treacherous Cincinello was still active and laying his deadly snares, not yet having met his gory fate at the hands of the mob in L'Aquila. Lorenzo did take the precaution of dispatching agents to negotiate with Ferrante in Naples and to sound out Duke Alfonso at his winter quarters near Siena. Filippo Strozzi, who had for many years operated a bank in Naples, traveled south with an escort of seventeen horsemen to deal with Ferrante. Another agent was sent to Siena. That mission fell to Vespasiano.

During a ceasefire, Vespasiano found himself making his way through the wintry, war-ravaged Tuscan countryside, past the burned-out mills,

battered castles, and plundered farms. He did not receive the kind of send-off given to Florence's more usual ambassadors, members of wealthy and ancient families such as the Acciaiuoli or the Pandolfini. As these honored delegates left the city for Venice or Milan they would be escorted through the streets by the citizens in a solemn procession, laden with gifts for the foreign ruler and dressed in squirrel-trimmed scarlet robes. Vespasiano's mission was a humbler affair. He was, in effect, to spy on the enemy camp, possibly using as a pretext the delivery of yet another manuscript to Duke Alfonso.

In many respects Vespasiano was well suited to his mission, having once been described as *tutto ferandino* ("all for Ferrante"). He had maintained close relations not only with Ferrante—to whom, despite the hostilities, he had recently sent a new manuscript of Livy—but also with Alfonso, whom he knew from the duke's youthful sojourn in Florence a dozen years earlier. Over the ensuing years Vespasiano had supplied Alfonso with more than twenty manuscripts, including the copy of Ptolemy's *Geography* showing the location of his house. He also maintained fellowship with various Neapolitan ambassadors, not only the ruthless Cincinello but also Matteo Malferito, about whom he wrote a biography sprinkled with anecdotes gained from close personal acquaintance. And the appointment made all the more sense given that likewise present in Siena, as Alfonso's ally in the war against Florence, was an even closer acquaintance and greater client: Federico da Montefeltro.

The mission was not without peril. Alfonso was capable of savagery well beyond the predictable skulduggery of murderous Italian princes. He devised for the barons who rebelled against his father tortures so hideous that at the end of his life, decades hence, he would be haunted by their ghosts. "Never was man more cruel than Alfonso," wrote one horrified ambassador, "nor more vicious, nor more wicked, nor more poisonous, nor more gluttonous."[30]

Vespasiano eventually reached Buonconvento, fifteen miles south of Siena, and here, in the tiny walled town surrounded by army tents and swarming with bored crossbowmen, he met one of the men on whom the fate of Lorenzo depended. Alfonso was now in his early thirties, the father of three children by his wife (the daughter of Francesco Sforza) and one by his mistress (another bastard would make

an appearance in due course). A portrait medal struck the following year would show him with a long nose, beady eyes, thin lips, and—as the wages of gluttony—plump cheeks and a double chin. Though one of the most redoubtable warriors in Italy, he did not allow his martial endeavors to distract him from, according to legend, the pursuit of local Tuscan beauties.

The other man holding the key to Lorenzo's fate, Federico da Montefeltro, had based himself in Siena. Lavishly accommodated in the archbishop's palace, he enjoyed gourmet meals of veal, stingray, almond cakes, and fowl of every feather. He had added to his luster with his capture of Poggio Imperiale, but his battlefield antics were hampered by an incident that took place shortly before the outbreak of the war. He had been recounting some of his famous victories to an appreciative audience at his palace in Urbino when the balcony on which he was standing gave way and he toppled to the ground, breaking his ankle and gashing his leg. Now, unable to walk or ride, the great warrior needed to be carried about in a litter like a gout-stricken valetudinarian. In December 1479 he took himself off to dip his afflicted limb in the mineral baths at Viterbo. At some point, however, he met with Vespasiano and Alfonso, for this must have been the occasion when the bookseller heard the one duke telling the other that all of Italy must mourn for Donato Acciaiuoli—an anecdote that places Vespasiano in the presence of these two formidable enemies of Lorenzo.

Florentine officialdom eagerly awaited Vespasiano's reports. The ambassador to Milan at this time was Pierfilippo Pandolfini, a former student of both John Argyropoulos and Marsilio Ficino. He was also a close friend of Vespasiano, who had helped stock his impressive library. Pandolfini wrote to a mutual friend in December, soon after arriving in Milan on his embassy: "Tell Vespasiano to write me when he returns from Siena, because he will have much news." Then, a few weeks later: "Vespasiano will return. I await some good news from him." Finally, two weeks after that, in the middle of January: "Now that Vespasiano has returned, I await his letters so that he can free us from worries and make us wiser in the future."[31]

Vespasiano's letters to Pandolfini have been lost to history along with any other reports he provided. But his stature as a newsgatherer

is indicated by the fact that his information and advice were sought by someone as well connected and well traveled as Pandolfini, a man who had just returned from embassies to Venice and Rome, and who was such a prolific and indefatigable diplomat that in Florence he was known simply as "*L'Ambasciatore*," the Ambassador.

Vespasiano's mission to Siena meant he missed the action in the Street of Booksellers at the end of December 1479. The escaped assassin, Bernardo Bandini de' Baroncelli, was apprehended the previous summer in Constantinople following more than a year on the run. The secretary to the Florentine government exulted that the "most glorious prince," Mehmed II, had vowed "to do with him whatever we may want—a decision certainly in keeping with the love and great favor he has always shown toward our republic and our people."[32]

The Florentines urged the sultan to keep the traitor alive as an envoy was dispatched to Constantinople to fetch him back to Florence. After a long journey, Baroncelli arrived, as a gift to the Medici, two days before Christmas. A few days later he was thrown from the window of the Palazzo del Podestà with a rope around his neck.

The execution of Baroncelli caught the attention of a twenty-eight-year-old artist whose father, Ser Piero, an eminent notary, worked in Via del Palagio, a few doors down from Vespasiano's shop.[33] Leonardo da Vinci took the sketchbook that he always kept on his belt and made a drawing of the dangling assassin, complete with notes giving details of his clothes. He recorded that the dead man was clad in a tan-colored skullcap, serge doublet, black hose, black jerkin with velvet collar, and a blue coat lined with fox fur.

Leonardo da Vinci's sketch of Bernardo Bandini de' Baroncelli, hanged beside Vespasiano's bookshop.

Leonardo was probably hoping to obtain the commission to paint Baroncelli's portrait—his *pittura infamante*, or "ignominious picture"—

on the wall of the Palazzo del Podestà. Besides having their severed heads stuck on doors or impaled on pikes and paraded through the streets, those who rebelled against the Medici appeared in fresco, in posthumous portraits, on a "wall of shame" in the Street of Booksellers. The wall of the Palazzo del Podestà, across Via del Palagio from Vespasiano's shop, still bore the handiwork of Andrea del Castagno, who in 1440 frescoed portraits of the eight members of the Albizzi family executed for conspiring against Florence at the Battle of Anghiari. So famous were these images that, although he went on to paint frescoes in the Vatican, Andrea thereafter became known as "Andreino *degli Impicchati*"—Little Andrea of the Hanged Men.

In the summer of 1478 Sandro Botticelli had been paid forty florins to add to the wall images of eight of the Pazzi conspirators swinging at the end of their ropes, Archbishop Salviati included. Soon all those who made their way into the Street of Booksellers were greeted by these gruesome effigies to which Leonardo evidently hoped to add his own handiwork with a portrait of Baroncelli. He failed to get the commission but was soon busy with other projects. Leonardo must have been a familiar sight in the Street of Booksellers, not merely on account of his father's nearby shop but also because he was a regular customer of the *cartolai*, buying reams of paper for his writings and drawings. *Cartolai* were indispensable to artists, who, a short time earlier, had pioneered the technique of using large sheets of heavy-grade paper, *cartone*, to make templates ("cartoons") for their frescoes. Some thirty years hence, when he planned a mural, a magnificent battle scene for an assembly room in the Palazzo della Signoria, Leonardo would purchase 950 sheets of this large-format heavy-grade paper.

Leonardo had recently completed a portrait of a young woman named Ginevra de' Benci, the adolescent daughter of a Florentine banker. However, in 1479 he dreamed of things other than portraits and altarpieces, for he was making sketches on paper for inventions such as a water-driven sawmill, an automated loom, and a propeller-powered roasting spit. Almost every single realm of human endeavor could be improved, he believed, by the ingenious application of worm screws and cogwheels, all of which he laboriously but elegantly worked out on sheets of paper.

Leonardo's design for a printing press.

With such improvements in mind, Leonardo had recently drawn a design for a new kind of printing press. He was in little doubt about the enormous importance of Gutenberg's invention. The design for an automated loom (found on the reverse of his drawing for the printing press) was accompanied by a bold statement: "This instrument is second only to printing." Yet he believed that even Gutenberg's brilliant invention could be improved. Leonardo's version of the press would be equipped with a system of wheels and pulleys that, once the puller tugged the lever, simultaneously slid the tympan horizontally along the carriage and forced the platen downward. This redesign offered the advantage of allowing a single person to operate the press, while his sophisticated arrangement of gears ensured the frictionless running of its components.[34]

No instruction manual on how to construct or operate a press appeared during the fifteenth century. The earliest illustration of a press in operation, a "dance of death" printed in Lyons in 1499, was

a simple woodcut showing two devils running amok in a printshop—hardly intended to offer an accurate description. Know-how for this new technology could only be gained hands-on and through visual inspection, which meant that to create his design Leonardo must have seen a printing press at first hand. An expert on Leonardo's technological designs, Ladislao Reti, states that this drawing indicates that Leonardo clearly possessed an advanced knowledge of contemporary printing practice.[35] But where he saw a press is unknown. He could have come into contact with printers such as Nicholas of Breslau or Johannes of Mainz, though more likely, given his training under a goldsmith, Andrea del Verrocchio, he may have come across Bernardo Cennini and his prototype. Or perhaps, having heard of the invention, he puzzled out the details himself, as Cennini and Clement of Padua both claimed to have done. For, as Cennini had declared, *Florentinis ingeniis nil ardui est.* And to the genius of Leonardo, certainly, nothing was difficult.

Leonardo never constructed his printing press, nor was his design published during his lifetime. In fact, none of Leonardo's thousands of pages of writings and drawings saw print during his lifetime or, indeed, for centuries afterward. In an unhappy irony, a man so wedded to ideas of technological advancement neglected to disseminate his works by means of what he recognized as history's greatest invention. The result is that many of his discoveries and designs have vanished. Only six thousand pages of Leonardo's notes survive out of an estimated total of twenty-four thousand pages, a loss rate of 75 percent.[36]

Vespasiano's mission to Siena evidently gave a good report of Duke Alfonso's intentions toward Lorenzo de' Medici: the ceasefire held, Lorenzo made his way to Naples, and a peace treaty with King Ferrante was finally ratified. When Lorenzo arrived back in Florence in the middle of March 1480, bonfires were lit and bells rung in joyous celebration.

Lorenzo had pulled off a stunning coup de théâtre. Even so, the celebrations may have been premature. Despite the peace, Duke Alfonso remained with his army in Siena, in whose town hall he now

appeared prominently in a fresco depicting his troops at Poggio Imperiale putting flight to the cowardly Florentines. Siena was a self-governing republic, and Alfonso's continued presence was supposedly to calm the discord among its citizens (some of whom had recently tried to topple the government). However, many in the city suspected less beneficent motives. His governance in Siena became so draconian, with such a profligate recourse to banishment, imprisonment, and execution, that soon both the Sienese and the Florentines alike suspected that, with the connivance of his father, Alfonso planned to make himself master of Siena and, therefore, a dangerous neighbor for the Florentines. Part of Vespasiano's mission had perhaps been to discover Alfonso's intentions.

Anxiously observing events, the apothecary Landucci noted in his diary that Duke Alfonso was hoping to subdue the Florentines as he did the Sienese. But he was suddenly foiled in these plans by a "great miracle."[37]

Chapter 25

Lament for Otranto

On Sunday, August 1, 1480, four horsemen arrived in Naples after a desperate 270-mile ride north from the heel of Italy. They brought with them the shocking and terrible news that an armada of more than a hundred ships flying the Crescent flag had landed at Otranto, and that the city was under attack from an army of eighteen thousand men.

Mehmed the Conqueror had struck on Italian soil. Over the next few days further reports reached Naples, clarifying, exaggerating, and terrifying. The number of ships swelled to 350, while one ambassador in Naples claimed the Turks were "burning villages, taking prisoners, and killing little children as though they were dogs."[1] King Ferrante immediately ordered Duke Alfonso to return with his army from Siena to defend his realm—unexpectedly delivering Florence from the lingering Neapolitan threat.

Alfonso was too late to save Otranto. The city fell following a two-week siege led by Gedik Ahmed Pasha, grand admiral of the Ottoman Fleet. Vespasiano described what happened next. The Turks, he claimed, "murdered the populace with great cruelty. Some of the wives and virgins they killed, others they violated with great infamy." Not only that, but they entered the cathedral, where the archbishop had gathered with his clergy as well as with "virgins, pious young women, and many worthy men, all in prayer." The Turks killed the archbishop, cut off his head, then did the same to the priests. "Afterward they killed the poor girls in front of their fathers and mothers." Other women, Vespasiano wrote, were sold into slavery and forced to work in brothels.[2]

Other early reports recounted similar stories: of churches destroyed, statues smashed, virgins raped on altars, and the head of the

slain archbishop, Stefano Agricoli, making the rounds of Otranto impaled on a lance. However, neither Vespasiano's nor any of the other early reports mention what, according to legend, took place on August 14 on the Hill of Minerva. On that day 800 men were taken to this scrubby knoll outside the city and given a stark choice: convert to Islam or die. All chose the latter, displaying such brave devotion that the scimitar-wielding executioner converted to Christianity on the spot—and was promptly executed by his comrades, bringing the tally of martyrs to 801. Much later, in 1771, they would be canonized as the Holy Martyrs of Otranto.

How many people died in Otranto, and under what circumstances, is a matter of historical debate. But casualties of the Turkish conquest of Otranto also included manuscripts from one of the West's greatest storehouses of Greek literature and philosophy.

The Basilian monastery of San Nicola di Casole stood on high ground overlooking a bare plain some two miles south of Otranto. The monastery was a link between the Greek and Italian worlds, founded sometime shortly before 1100 by a community of Greek-speaking Basilian monks. However, the monastery was built over a preexisting structure that went back many centuries. The library was, in fact, one of the oldest Christian libraries in the West.[3]

San Nicola di Casole certainly held Greek manuscripts in great number. It featured a flourishing scriptorium and a stable of learned monks—"men absolutely worthy of veneration," according to a local humanist scholar, Antonio Galateo, "all educated in the knowledge of Greek letters, and many in Latin as well."[4] Over the centuries the monastery had been home to scholars, poets, and philosophers determined to preserve and disseminate the historical and literary heritage of Greece. The monastery reached its peak in the first half of the 1200s under the abbot Nektarios, who stocked the monastic library with treasures brought back from his visits to Constantinople. Galateo reported that the monastery had a library "with all kinds of books, as many as could be found throughout Greece."[5] It held copies of both *The Iliad* and *The Odyssey*, and its collection stretched to works on astrology, on the interpretation of dreams, and on the healing power of stones.

San Nicola di Casole operated a system whereby these manuscripts could be borrowed by readers: borrowers merely needed to sign a form in the presence of two monks, who served as guarantors for its return. A document dating from the second half of the twelfth century—several decades before the arrival of Nektarios and his trove of manuscripts—records the loan of sixty-eight volumes. Priests and other ecclesiastics made up the vast majority of the borrowers, though two local notaries and a magistrate also took out manuscripts. Gospels and psalters were the most popular, but works by Aristotle and the comedies of Aristophanes also went out on loan. As one of the entries reads, "The notary Michele di Pietro received from me, the monk Biagio, the Aristophanes and the *Sophistical Refutations* of Aristotle, on orders from the abbot."[6]

A borrower from a much later period was Cardinal Bessarion, who came to San Nicola di Casole on his quest to recover and preserve Greek letters. As Galateo later wrote, Bessarion transferred "no small quantity of manuscripts to Rome." These volumes, which he failed to return, soon merged into his personal collection and, in the fullness of time, made their way to Venice. However, the purloining of these manuscripts from San Nicola di Casole proved fortunate because, as Galateo recorded, in August 1480 the library was "looted and destroyed by the Turks," with the building going up in flames, destroying the manuscripts "gathered from all over Greece."[7] Galateo did manage to rescue a volume or two, albeit ones of little worth. A few others appear to have been saved by a young priest named Sergio Striso, who removed them from the library before the attack. Unlike the dozens of priests and monks massacred by the Ottomans in 1480, Striso survived. Years later he could be found near Otranto in "a little old house falling into ruin"—what remained of the library— diligently poring over his cache of ancient manuscripts.[8]

The devastating assault on Otranto gained Mehmed a foothold in Italy from which he appeared ready to launch an attack on Rome, of whose conquest he had dreamed for almost three decades.

The invasion stunned King Ferrante. Besides dispatching Duke Alfonso to the south, he pleaded for assistance from the other Italian

powers, warning that unless they came to his rescue he would side with the sultan—a threat he had made on a previous occasion—and help wreak destruction on them. Pope Sixtus, at least, was mounting a vigorous response in Rome, where, as a humanist scholar and poet observed, "the alarm was as great as if the enemy had been already encamped before her very walls."[9] He began preparing to flee for Avignon in the event of the Ottoman advance on Rome while also taking bold measures to counter any such invasion. He levied taxes on each household in the Papal States as well as tithes on the clergy, putting these funds toward building and outfitting ships for a crusading fleet. He granted a plenary indulgence to anyone who enlisted in the fight against the Turks, stating that if the faithful wished to preserve their lands, houses, wives, and children, not to mention the faith into which they had been baptized, "let them take up their arms and fight."[10]

The need for Christian concord in the face of the Muslim threat led Sixtus to one final step: he raised the interdict on Florence and reconciled himself with Lorenzo de' Medici. After more than three years of hostilities, Florence and the papacy were finally at peace. The "miracle" of the Ottoman attack on Otranto was complete.

Though the sultan's invasion of the Kingdom of Naples conveniently removed the military threats and interdicts, most Florentines felt deep sympathy for the enslaved and slain of Otranto. As the notary Giusto Giusti wrote in his diary, the conquest was "bad news for Christianity."[11] The invasion became a topic of conversation in the piazzas in the weeks that followed, with "much talk," as another Florentine wrote, "about the loss of Otranto."[12]

The tragedy of Otranto was also performed in song and rhyme in Florence's piazzas. Several months after the fall of the city, in November, Fra Domenico recorded that *uno cerretano* commissioned the Ripoli Press to print five hundred copies of a pamphlet about the assault.[13] A *cerretano* (or *ciarlatano*) was a "charlatan," one of the street vendors who pulled teeth, sold remedies, and often juggled, sang, or played an instrument to attract attention and sell his wares. Fra Domenico failed to record the details of this particular peddler, but he

would have been similar to Blind Angelo or Blind Chola—someone hoping to sell copies of the pamphlets whose words he sang or recited in the streets. The text that the Ripoli Press produced for him was entitled *Lament for Otranto*.

No copies of this particular work have survived, but the fall of Otranto provided street singers—and, by extension, printers such as Fra Domenico—with a good deal of business, and not merely in Florence. A chronicler in Lombardy claimed there were "many laments" on the subject that "everywhere are sung in the streets in front of the people and put up for sale."[14] He reproduced one in his chronicle, a tale full of references to the cruel rage of the Turks, the bitter tears of the captives bound in chains, and the glorious victory soon to be won by God in heaven—with help from the pope as well as Ferrante, the duke of Milan, and "beautiful Florence."

In addition to pamphlets, the Ripoli Press was persevering with its ventures into the humanist classics. In the autumn of 1480, for example, Fra Domenico printed one hundred copies of Statius's *Silvae* to coincide with lectures on the Roman poet that Angelo Poliziano was delivering at the Florentine Studio. However, Fra Domenico also continued printing chapbooks of prayers and orations as well as small religious works such as psalters, most in much larger editions than the volume of Statius's poems. In the spring of 1480, a street hawker named Antonio Lombardo—the same man who several years earlier bought forty-four copies of Bernardo Cennini's commentary on Virgil—commissioned Fra Domenico to print five hundred copies of a devotional work known as *Epistola della Domenica* (Sunday Epistle). Several months later he was back for more: a reprint of eight hundred copies.

The books from the Ripoli Press were therefore reaching a wide readership.[15] The convent sold its wares to educated clients such as doctors, notaries, and numerous priests and friars, as well as to Poliziano's students at the university. However, readers from many other trades and professions purchased books from the press. Carpenters, flax-makers, weavers, goldsmiths, hosiers, masons, and blacksmiths (one of whom bought a copy of the life of Alexander the Great): all appear in Fra Domenico's records. Other names are found too (Ugo, Cenni, Conissino) but without either surnames or mention of their

jobs or trades. A number of them were probably street hawkers because, besides Blind Andrea, Blind Chola, and Antonio Lombardo, Fra Domenico sold books to another blind peddler, "Giovanni *Cieco*," who lived beside the Porta al Prato, a short walk from the convent.

Women likewise bought books from the Ripoli Press: not only nuns and prioresses from other convents, but also clients identified in the accounts as "Monna Lorenza" and "wife of Lenzone." Another client was the widow of Donato Acciaiuoli, a woman well known to Vespasiano, who described seeing husband and wife tenderly holding hands.[16] Fra Domenico also recorded how one copy of *The Legend of Saint Catherine* was bound and decorated so it could be shown to "a woman who wishes to buy it." In the end she decided against the purchase. "*Renduta*," Fra Domenico wrote: "given back."[17]

The purchases appearing in Fra Domenico's account book do not include the buyers who got their copies from the many *cartolai* who stocked them. Nor do they count those tempted by the antics and offerings of the peddlers such as Blind Andrea as they wandered the city with copies of *Prayer on the Blood of Christ* or the laments for the death of Giuliano de' Medici or the fall of Otranto. These works no doubt attracted an even wider and more varied readership than the hosiers, masons, and blacksmiths who bought their books directly from Fra Domenico.

Around the time the Ripoli Press printed its edition of *Lament for Otranto*, another work on the subject was in preparation. This particular lament did not, however, appear in print. Instead, it was produced the old-fashioned way—inscribed on parchment with a goosequill. The author was none other than Vespasiano.

A few weeks after the fall of Otranto, on September 5, 1480, the monks of the Badia in Florence summoned their notary, Ser Piero da Vinci, whose office in Via del Palagio stood only a few steps from Vespasiano's shop. Ser Piero proceeded to draw up a new lease for what the monks called "our workshop beside the Palazzo del Podestà," that is, the premises rented by Vespasiano. Ser Piero recorded that Vespasiano (whom he described as a *librarius*) consented to the transaction: the transfer of the lease to a new tenant, a *cartolaio* named

Andrea di Lorenzo. Andrea would occupy the shop on the same terms: fifteen florins per year plus a pound of wax for candles. He soon assumed a much more distinguished name: Andrea di Vespasiano. His adoption of this name suggests not only that he had worked as an assistant for Vespasiano (apprentices sometimes took the name of their masters) but also that, for his own commercial reasons, he wished to keep alive the famous bookseller's name.[18]

Vespasiano was retiring from the book trade. His tax return for 1480 stated that he was fifty-eight years old, and that the shop he used to operate *non va più a fare nulla*—"is no longer in business."[19] An era had come to an end.

Vespasiano's economic situation seems never to have recovered following his brother Jacopo's death more than a decade earlier. The sudden and premature death of his nephew Lorenzantonio—which caused him grief as well as the financial hardship of repaying his widow's dowry—compounded his problems. The sad fact is that despite his great eminence in the field, Vespasiano, like many subsequent publishers and booksellers, failed to make very much money. As he bleakly observed, "Most of those who busy themselves with books, with no other means of support, are poor in possessions."[20]

Vespasiano believed the times were no longer profitable or auspicious for men of wisdom, whom he later called "these singular men of whom there is now such a scarcity."[21] He came to believe that by the 1480s, for want of sympathetic and supportive patrons, scholarship was declining. Alfonso the Magnanimous and Pope Nicholas V belonged to what he called "the time of happy memory"—an era when books were translated and studied, and scribes and scholars amply rewarded "in the highest degree." Federico da Montefeltro continued this noble tradition, but "neither the court of Rome nor that of any other prince" followed him in providing a refuge for bookworms and men of wisdom. The result was that "the profession of letters perished as scholars, finding no favor or esteem, turned to other pursuits."[22]

Certainly no patron of the caliber of Cosimo de' Medici and his sons, or of Federico da Montefeltro and King Alfonso, came heaving into view in 1480. Still, Vespasiano's judgment was harsh on popes, princes, and men of letters. Scholarship certainly did not perish in

the last decades of the fifteenth century thanks to, in Florence alone, the erudite enterprises of Angelo Poliziano and Marsilio Ficino, both in the entourage of a "magnificent man," Lorenzo de' Medici. Lorenzo would become an even greater collector of manuscripts than his father and grandfather combined, eventually assembling a library of around a thousand codices, including five hundred Greek manuscripts, the largest such collection in Italy after the Vatican and the treasure trove of Cardinal Bessarion.[23] In 1491 Poliziano would write to Lorenzo that "the favors you bestow on the learned brings you so much favor and universal good will as no man has enjoyed for many years."[24] In the summer of 1480, though, all of this was in the future. For many years Lorenzo had failed to commission work from Vespasiano and to build the library of which the bookseller dreamed. In 1476 Vespasiano had written to Lorenzo that the House of Medici "always provided for my just and honest needs."[25] Four years later these needs were, it seemed, destined to go unfulfilled.

There was one other important factor in Vespasiano's retreat from the business of bookselling. Florence already had two established printing presses, those of Fra Domenico and Nicholas of Breslau. Since Marsilio Ficino's *On the Christian Religion* in 1476, Nicholas had printed some twenty books, including *Monte Santo di Dio* (Holy Mountain of God), a religious text embellished with—in an impressive technological and artistic feat—three copperplate engravings. He had also printed the *Nicomachean Ethics*, a commentary on Aristotle's *On the Soul*, works on agriculture and medicine, and poems by Luigi Pulci.

In 1480, other entrepreneurs began setting up shop in Florence. Johannes of Mainz became active again, and his edition of Petrarch's poems was due to appear in November. Fra Domenico's former business partner, Don Ippolito, teamed up with a *cartolaio* to print a work by Antonino, the late archbishop of Florence. A certain Bartolommeo di Libri had set up a printing office in 1479, bringing out an edition of a poem by Boccaccio as well as a book on grammar by Vespasiano's friend and client Niccolò Perotti. And arriving in town at the end of 1480 was the most ambitious and accomplished printer of them all: Antonio Miscomini. After going into business in Venice in 1476, Antonio, a native of Modena, had printed everything from

an edition of Niccolò Malerbi's translation of the Bible and Saint Augustine's *City of God* to Livy's history of Rome and the complete works of Virgil. Forsaking the overcrowded Venetian market, Miscomini wisely set his sights on printing and distributing his books in Florence.

Competing with printed books had become increasingly difficult for Vespasiano. As one of Ulrich Han's colophons boasted in 1470, "For what a quill can write the whole year through, / This in a day, and more, his press will do."[26] Such speed was appreciated by the English merchant and printer William Caxton, who in about 1473 recounted the travails of writing out a manuscript: "my penne is worn," he lamented, "myn hande wery and not stedfast, myn eyen dimmed with overmoche lokyng on the whit paper." He therefore undertook to learn, "at my grete charge and dispense," the art of printing—through which means he produced copies of his English translation of Raoul Lefèvre's *History of Troy* in a single day ("begonne in oon day and also fynysshid in oon day").[27]

Vespasiano refused to embrace printing as so many other booksellers and scribes had done, from Peter Schöffer to Caxton. He even refused to stock printed books despite the fact that many other Florentine *cartolai* now supplied them in greater quantities than manuscripts and at a cheaper price. Vespasiano undoubtedly financed his deluxe manuscripts—the illuminated codices that he sold for fifty florins—by producing or selling secondhand cheaper works such as handwritten grammars and psalters. However, the market for such wares eventually collapsed with the arrival of print. The day after Vespasiano signed the deed of transfer in the office of Ser Piero da Vinci, the Ripoli Press put out a reader for schoolchildren known as a *Salteruzzo*. Printed in an edition of several hundred copies, it sold for much less than one of Vespasiano's equivalent manuscripts, even one copied on paper or the cheapest parchment. And the Ripoli Press was capturing the higher end of the market, too, intruding on Vespasiano's territory by printing works such as Donato Acciaiuoli's commentary on Aristotle's *Nicomachean Ethics*.

Almost two decades earlier, thanks to the largesse of Cosimo, Vespasiano had been able to earn at least seventy-five florins per year. Even then his margins had been slight, his income often dependent

on the generosity of a patron willing to reward him with (as he once pleaded to Bishop Jouffroy) "a little payment or gift for my pains." Anyone in the manuscript trade certainly faced fierce competition and a loss of earnings. In his tax declaration for 1480 a Florentine scribe named Antonio Sinibaldi wrote: "My only business is copying manuscripts for money. This has been cut in half by printing and I'm losing my shirt."[28] Antonio may have been exaggerating his plight, for tax declarations in Florence were often heavily fictionalized tales of poverty and woe (and in fact Antonio continued to find work as a scribe). But printers certainly boasted in their colophons, not without cause, that scribes were now obsolete: "Let rest the tired hand, let rest the reed pen," ordered an edition of Pliny the Elder printed in Venice in 1469. Or as the same printer declared a year later, "Who dares glorify the pen-made book, / When brass-stamped letters so much fairer look?"[29]

Vespasiano was one of the few who glorified the pen-made book. He was quite exceptional in his aversion to the printed book, regarding it as an inferior product unworthy of sharing space in a library such as the one he had furnished in Urbino. He held reservations about the content as well as the style of printed books, dismissing publications in the vernacular aimed—as Fra Domenico's cheaper publications certainly were—at a much less refined and erudite readership than his own. His occasional scathing comments about "the dregs of the people"[30] suggest he had little wish to diversify and expand his clientele to encompass readers such as the bricklayers and blacksmiths who bought books produced at San Jacopo di Ripoli. Instead, turning over his keys to the bookshop, he turned to other pursuits.

Vespasiano was not merely retiring from business; he was also moving house. In 1479 he and his nephew Giovanfrancesco Mazzinghi, the shoemaker's son, sold some of their possessions to a prominent physician, raising twenty-seven florins. Included in the sale was a collection of damascene bowls and a set of knives with jasper handles. Soon afterward, they divested themselves of another piece of property, a woodland outside Florence. Finally, after relinquishing his shop Vespasiano arranged for the house in Via de' Bardi to be rented

out on a five-year lease to a wealthy widow. He was repairing to the country. Here he intended to pursue a different career, a new one that he admitted was "alien to my profession."[31] He was going to become a writer.

The farmhouse to which Vespasiano retired, Casa Il Monte, the old family home, stood alone on a wooded hill outside the village of Antella, a two-hour walk southeast from Florence. He called the property "this sweet and lovely place,"[32] emphasizing its beauty in order to lure his Florentine friends for visits. Here he lived in what he called "pleasant solitude"[33] among his fig and olive trees, his fields of wheat and barley, his grapevines and ramshackle outbuildings. And here he kept his small collection of books, including a manuscript of Petrarch that included a map showing the relative positions of the houses in Avignon of the poet and his beloved Laura. Another was a translation into the vernacular of the writings of Saint Jerome; the manuscript had been copied by a scribe whose colophon stated with surprising candor that he was working in prison.[34]

Vespasiano was also taking out books on loan. The day after he gave up his shop he borrowed a manuscript from Lorenzo de' Medici: John Argyropoulos's translation of the works of Aristotle. This manuscript must have brought back fond memories of those long-ago days spent at the Castello di Montegufoni with Messer Giovanni and the Acciaiuoli brothers, discussing the relative merits of Plato and Aristotle.

It was not Aristotle, though, who exercised Vespasiano's pen in the weeks and months following his retirement. Instead, he set about work on the topical subject of the conquest of Otranto and what he regarded as the decline of Italy. *The Lament for Italy for the Fall of Otranto to the Turks* is a gloomy and indignant work that castigates the Italians for their sins, including usury and sodomy, and that sees the tribulations of Italy—pestilence, war, civil discord, the Turkish attack on Otranto—as God's wrathful vengeance on a wicked and unrepentant people. Urging people to mend their ways, he adopted the voice of Old Testament prophets such as Jeremiah and Ezekiel, whom he frequently quoted, finding parallels between the destruction of Jerusalem and the havoc wreaked on Italian cities, especially Otranto. His appraisal of the state of the world was a bleak one: "No one speaks

truthfully anymore," he writes. "Everything is deceit, lies, cunning, theft, sodomy, wickedness, with no fear of God or concern for the world. O miserable Christians, worse than beasts, where are you headed?"[35]

These bitter reflections may offer further clues as to Vespasiano's reasons for giving up the bookshop. He had spent most of his life disseminating the wisdom of classical literature with its teachings on how to become a worthy citizen and build a better society—on how to "live well and honorably," as Francesco Barbaro once wrote. In his letter to Poggio in 1417 Barbaro had enthused that the unearthing of the works of "wise men" of the ancient world such as Quintilian and Cicero would "bring the human race more benefit." Vespasiano had been crucial to this project, making the works of these wise men available to scholars and princes all across Europe, from England to Hungary. "All evil is born from ignorance," as he once wrote. "Yet writers have illuminated the world, chasing away the darkness."[36]

By the late 1470s, if not earlier, Vespasiano seems to have lost faith in the ability of the classics to illuminate the world, to chase away the darkness and reform society. Plague, wars, the Pazzi Conspiracy and, perhaps most of all, the unstoppable advances of the Turks: all these events called into question his belief in the advancement of society through the application of reason, or what in his *Lament for Italy* he called the misguided devotion to *senno umano*—human wisdom. The answers to Italy's problems lay, rather, in books of a different sort: the Holy Scriptures. *The Lament for Italy* is therefore a rejection of the affluent, worldly culture of the fifteenth century that we have come to associate with aspects of the Italian Renaissance, and that Vespasiano, through his manuscripts, did so much to promote.

The text opens with a quotation from Jeremiah 9:1: "Oh that my head were waters, and mine eyes a fountain of tears, that I might weep day and night for the slain of the daughter of my people!" Vespasiano then explores one of his favorite themes, the sudden and unexpected striking down of those at the peak of their power and glory. Their calamitous downfalls come, he believed, as divine chastisement for their iniquities, on which he elaborates at length. He offers a quotation he claims comes from the prophet Jeremiah: "*Abundantia panis et superfluitas vitae destruxerunt Jerusalem.*" (In fact,

it appears to be an allusion to Ezekiel 16:49, which states that Sodom fell because of its "fulness of bread, and abundance of idleness.") From this abundance, he believed, comes pride, then divine displeasure, and consequently "so much war, pestilence and adversity; and yet we do not know, nor do we wish to understand, that it proceeds from our iniquities. And therefore we refuse to change or to show a single sign of penitence. Instead, benighted and blinded, we turn to luxuries and every kind of foolishness."

The Florentines, with their wealth and abundance, were especially guilty of luxuriating in material pleasures—the sort of "delightful things" that, by contrast, Vespasiano's friend Giannozzo Manetti had celebrated in *On the Dignity and Excellence of Man*. Worse still, many of these luxuries had been amassed through the sin of usury. Vespasiano pointedly alludes to the prescription *Mutuum date, nihil inde sperantes* ("lend, expecting nothing in return"), which the Florentines, "unbelieving and impious," conveniently ignored. "O city of Florence," he wails, "full of usury and ill-gotten gains which have caused you to destroy each other."

This text, with its laments about impiety and the need for repentance, hardly ploughed a new furrow. One of the manuscripts in Vespasiano's library in Antella was a collection of sermons (filled, tellingly, with his marginal notations) delivered by Bernardino of Siena. Declared a saint in 1450, only six years after his death, Bernardino was a Franciscan who spent his long career traveling throughout Italy and, in inflammatory rhetoric, promoting morality and condemning vice. "He illuminated the whole world," wrote Vespasiano, "which at this time was blinded and benighted, no longer knowing God."[37] Vespasiano was too young to have seen the legendary bonfire that Bernardino lit in the Piazza Santa Croce in Florence in April, 1424, a conflagration of wigs and other frivolous possessions that preceded by more than seven decades Girolamo Savonarola's more famous bonfires. But he met the friar on at least one occasion when Bernardino ventured into the bookshop to debate with the great Manetti. "In no one else," an awestruck Vespasiano later wrote, "were so many talents combined."[38]

Bernardino had preached his fiery sermons at exactly the same time that Poggio, Niccoli, and Leonardo Bruni were seeking out the

wisdom of the ancients. It might be tempting to see this fire-and-brimstone preacher as the flip side of the classical pursuits of the humanists. The nineteenth-century historian Jacob Burckhardt once wrote that preachers such as Bernardino were "criticized and ridiculed by a scornful humanism" and "scoffing Florentines." In actual fact, Bernardino encountered little conflict from the humanists. Manetti, for example, cordially conceded to his arguments in Vespasiano's bookshop. Poggio called Bernardino "a learned and prudent man" who brought to his sermons "the greatest moderation, the greatest diligence in speaking," while another humanist praised him as a "Christian Cicero." Higher praise in Florence at that time is difficult to imagine. Bruni once wrote fulsomely to the friar, hoping to lure him back to Florence for another set of fire-breathing sermons: "There is no need to tell you what great devotion and what immense love the people of Florence bear for you . . . The ears of our citizens are still overflowing with your divine and mellifluous eloquence."[39] Bruni was skilled in the arts of flattery, to be sure, but no doubt his letter was sincere. After all, Bernardino was, like the devotees of humane letters, committed to a moral reform of society conducted by means of eloquent and inspiring oratory.

For Vespasiano, if humanism was the light that failed, its counterpart, Christian faith, still could bring salvation. Though the Italians had fallen into the hands of the "cruellest barbarians," God's vengeance was not yet complete. "The cruel persecution is not done, nor will it end until we have mended our ways. We must put an end to our infinite errors and make penitence, firmly vowing not to sin again, so that the Almighty God lifts his harsh and bitter sentence." He ended with a flourish: "Let us return along the road of repentance, if we wish the Almighty God to pardon and deliver us from our cruel punishment."

Chapter 26

Pardon and Deliver Us

At the end of May 1481, bells were rung, cannons fired, and bonfires lit in cities all across Italy. Word had arrived confirming the death of the man who for the better part of three decades had terrorized and mesmerized Europe. Pope Sixtus ordered processions of thanksgiving and wrote letters to the princes of Europe exulting that God had freed them "from that peril which for years past has struck the Christian commonwealth with so many calamities."[1]

Mehmed the Conqueror had died in suspicious circumstances in early May, a few days after setting off from Constantinople on a military expedition whose destination—Rhodes, Hungary, the Mamluk Sultanate of Egypt—remained anybody's guess. He may even have been marching to the provincial capital of Amasya to do battle against his eldest son, Bayezid, whom he disliked and distrusted. But after suffering severe abdominal pains, the sultan died in his tent at the age of forty-nine. He was succeeded by Bayezid, the man most likely responsible for his death, rumored to have been by poison. Bayezid then outmaneuvered his younger half-brother and rival, Cem. The grand vizier, Karamani Mehmed Pasha, who supported Cem's claim to the throne, accidentally smudged the inscription on his *vefk*, the talisman giving him special powers. Obliged to hand the charm to a dervish for repair and, as a result, left exposed and powerless, the grand vizier was promptly murdered by Bayezid's janissaries.[2]

Galvanized by the fall of Otranto, the pope had spent the previous few months preparing for a crusade against the Turks, raising both money and ships. He himself undertook to provide twenty-five galleys, even melting down some of his silver plate to meet the costs.

King Ferrante offered forty warships, with Genoa, Bologna, Ferrara, and Siena all providing a few more and the Florentines donating 40,000 florins. The unexpected death of Mehmed dampened what little fervor and resolve the various rulers possessed, with those in Bologna, for example, hastily retracting their offer. Just the same, a fleet was ready to sail from Rome by the end of June. In a solemn ceremony in the basilica of Saint Paul Outside the Walls the sea captains received the sign of the Cross and kissed the papal foot. Then Sixtus took himself down to the Tiber, where the galleys bobbed at anchor. He boarded each of them in turn, offering apostolic blessings as the soldiers saluted, pounded their shields, and chanted the pontiff's name. "It was a feast for both eye and ear," wrote one chronicler.[3]

The galleys sailed from the Tiber docks and, after joining forces with Ferrante's warships in the Bay of Naples, shaped a course for Otranto, on which Duke Alfonso was marching overland with his army. Finally, on September 10, after a short siege, Ferrante was able to report to the pope the happy news that Otranto was back in Christian possession. "This is the time of deliverance," Sixtus wrote, "of glory, of victory."[4]

Little more than a week after the reconquest of Otranto, Vespasiano wrote to Duke Alfonso, praising him for the victory over the Turks.[5] Addressing him as "Most Illustrious and Excellent Lord," he went on to describe the rejoicing in Florence, where "one could not have made greater celebrations." He proceeded to offer Alfonso a number of illuminating historical parallels, examples in which valiant attacks overcame robust defenses. Alfonso's reconquest of Otranto, he believed, topped them all, for "never was there made a more worthy defense than this, nor a more powerful offense." The exploits of legendary mercenaries such as Francesco Sforza and Niccolò Piccinino paled in comparison, as did those of Scipio Africanus the Younger at the Siege of Numantia in 133 BC. Not even Alexander the Great, Vespasiano reckoned, came close to matching Alfonso's feat at Otranto.

Alfonso must hardly have believed such flattery. Though the Turks certainly put up a stiff defense during the summer of 1481, cir-

cumstances within the Ottoman Empire—notably the contest between Bayezid and Cem—forced them to lay down their arms and negotiate a retreat to Albania. Vespasiano soon came to the point of his enthusiastic blandishments. "Whoever writes of what happened in this siege . . . will show it to be, by comparison, inferior neither to the deeds of the ancients nor to those of the moderns." Vespasiano was clearly hoping to become the historian of this episode, and to have Alfonso, the hero of the story, as his patron. His history would have been an expansion of his *Lament for Italy*, albeit with a happy ending. He signed off: "Your distinguished Lordship's servant, Vespasiano."

Alfonso appears not to have taken the hint and commissioned the history. Vespasiano nonetheless persisted with his career as a writer, composing a work concerned with domestic rather than foreign affairs. Vespasiano and his older brother Lionardo had remained bachelors well into their fifties. However, in what must have come as a surprise to those who knew him, in 1480 Lionardo, at the age of sixty, married a thirty-year-old named Maria, who went on to give birth to two children.[6] Vespasiano would never marry, but that did not stop him from maintaining strong views on the subject, especially on the role and conduct of brides, and indeed of women in general. He decided to pass on the benefit of his wisdom to a young newlywed: not his new sister-in-law but rather a woman of much higher status named Caterina de' Portinari.[7]

Caterina came from the same family that two centuries earlier had produced Dante's Beatrice. She had recently married into another old and distinguished Florentine family, the Pandolfini. Vespasiano was friends with Pierfilippo Pandolfini ("The Ambassador") and also with his brother, Pandolfo, father of the thirty-year-old groom, Agnolo. Vespasiano prevailed upon this intimacy to compose his "exhortation" (as he called it) for the nuptial ceremony known as *dì dell'anello*, or "ring day"—Agnolo's presentation of a ring to his bride. He claimed to be moved by his "singular love" for the Pandolfini family, who lived down the block from Vespasiano's shop and had their family tombs in the Badia. He would use his position as Agnolo's faithful friend to remind Caterina of those things befitting a "modest and honest girl."

Modesty and honesty are the keynotes of Vespasiano's advice. He uses the words *pudicitia* or *pudicissima* (modesty or virtue) eleven times, *honestà* or *honestissima* five times, and *continentia* (by which he meant self-restraint and abstinence) three times. He warns Caterina against dressing elaborately or wearing jewelry—for such things are "offensive to purity." He goes on to note that "most women of our times" take the figure God has given them and then try to change it by "adorning the body or the face." Rather than such vanities, women should observe the dictates of honesty, purity, and piety.

The exhortation continues with stories of virtuous women that Vespasiano held up as exemplars to the young bride: her own mother as well as her mother-in-law, Gostanza Pandolfini, "always a mirror of honesty and self-control." A few figures from recent history are offered, such as Battista Malatesta, who became a nun following her husband's death, and Cecilia Gonzaga of Mantua, who was "more gorgeous in appearance than any of her age," despite which she scorned marriage and went into a monastery, "estimating the future life more than the present."

Further shining examples follow as Vespasiano continues with a roll call of saints and martyrs, such as Saint Lucy, who plucked out her eyes when a suitor admired them, and Saint Cecilia, "who endured so many pains to keep herself inviolate and immaculate," and was ultimately burned by her pagan persecutors and then decapitated. Old Testament heroines such as Judith and Susannah are evoked, as is Portia, "daughter of Cato and wife of Brutus," as Vespasiano reminds her, "avenger of the Roman Republic." He urges the young Caterina: "Put before your eyes her purity and humility, her self-restraint, her inviolable faith and integrity." He then recounts with admiration how "this constant woman," learning of the death of her husband, "immediately rushed to the fire, scooped up hot coals, and swallowed them."

After these edifying examples of chastity and fidelity, Vespasiano returns to the subject of vanities and ornaments. Many would encourage Caterina to wear armbands, necklaces, and finger rings—but these are "mortal and fading things. These lessons that I have set before you shall be your ornaments. They are pearls, rubies, topaz, emeralds and diamonds." He ends his treatise with a stirring injunc-

tion: "Take upon yourself the perpetual and true, and forget the mortal and the fleeting. In doing so, you will find yourself blessed and happy in the present life, and you will be heir to higher things, together with the immaculate virgins and the modest and holy women."

Vespasiano was voicing the concerns of the men of his time regarding their womenfolk. In a male-dominated society such as Florence, family honor was assessed by the behavior of wives and daughters. The Florentines took special measures to curb the sort of adornment deplored by Vespasiano. Sumptuary laws (from *sumptus*, Latin for "expense") regulated the colors, fabrics, dyes, and dimensions of clothing in general and, increasingly, of female dress in particular, including their jewelry and headgear. These laws dated back to Dante's time, but naturally they were flouted, with one fourteenth-century chronicler cursing that "in spite of all these strong ordinances, outrages remain."[8] Fines were imposed on offenders by the Officers of the Women, a special fashion police who patrolled Florence's streets and piazzas. Concerned citizens could even drop the name of culprits into one of the many *tamburi*—denunciation boxes—scattered throughout the city.

Vespasiano had the manuscript elegantly copied and illuminated, then delivered to Caterina. He had not yet, however, exhausted all he had to say on the subject of women. Far from it, he began planning another work—a treatise in praise of women. But first another task beckoned. He was lured out of retirement to supervise the production of an important new manuscript for an old client who needed a favor.

At some point in the spring of 1482, Vespasiano traveled to Urbino. What exactly took him on the 125-mile journey through hills, valleys, and forests to the Marches is unclear. He may have been hoping for the kind of commission with which he tried to tempt Duke Alfonso, that of writing a flattering history of Federico da Montefeltro's deeds and battles. He certainly regarded "the invincible Federico," as he called him, as a fit subject for an inspiring biography: the man who united in one person the soldier and the scholar, who had proved himself, Vespasiano believed, "the best and wisest of rulers," and who

had put together what Vespasiano regarded as the finest library since antiquity.[9]

Vespasiano took the opportunity of his visit to inspect the library in the ducal palace in the company of Federico himself. He was impressed with what he saw, declaring it superior even to the libraries of San Marco, the Vatican, the castle of Pavia, and Oxford University (whose collections he knew either firsthand or from catalogues). "The singular thing about this library," he wrote, "is that all of the works, whether sacred or profane, whether in the original or in translation, are perfect and complete." Vespasiano summed up the feat with praise that was as much for himself as for Federico: "Such perfection is an achievement of the highest worth."[10]

And yet the library was still not quite perfect and complete. A decade earlier Vespasiano had overseen the copying of Plato's dialogues for the library. These dialogues had been the translations of Leonardo Bruni, whereas Marsilio Ficino had produced more recent and authoritative versions. Ficino claimed that Federico asked him "in person and in writing, both with great vehemence," for a copy of his translations. He also asked for the production of the manuscript to be overseen by Vespasiano.[11] This codex was, naturally, to be handwritten: Vespasiano believed a printed volume could not possibly share space in the library with so many beautiful manuscripts.

The sun was setting on Federico da Montefeltro's remarkable career. As Vespasiano prepared his manuscript of Plato for the library in Urbino, Federico set off on what would be his final excursion into battle. Still the most famous warrior in Italy, capable of fielding a battle-hardened army of thousands of soldiers and horses, he was nonetheless, at sixty years of age, feeling the burden of his years. Too heavy to ride a horse, he still carried the injury suffered in his tumble from the balcony in Urbino. And in the summer of 1482 he found himself, in the words of one of his scribes, "*intra incudine e martello*": between the anvil and the hammer.[12]

No sooner had the threat from the Ottomans disappeared than another war broke out in Italy, the *Guerra del Sale*, or Salt War—a dis-

mayingly familiar mixture of political ambition and territorial expansion played out against a backdrop of family dramas and fluctuating alliances. The dispute began in the brackish lagoons of the Duchy of Ferrara, a domain ruled by the fifty-year-old Ercole d'Este. Though the Venetians enjoyed a monopoly extracting salt from the marshes around Comacchio, Duke Ercole had begun encroaching on their privilege. He was supported by his father-in-law, King Ferrante, as well as by Ludovico Sforza of Milan, both of whom resented Venetian power and influence on the peninsula. The Venetians enjoyed the backing of Pope Sixtus, whose nephew, the power-hungry Girolamo Riario, had turned his covetous attentions to Ferrara. Federico needed to decide whom to support: his kinsmen Sforza and the pope, or his longtime ally Ferrante. He found himself, as the scribe claimed, lost in a labyrinth.

Federico signed a contract, in the end, to fight for Duke Ercole and his allies, his head having been turned, perhaps, by the remarkable sum of 165,000 florins. Hostilities commenced in May, with his opposite number in the Venetian camp, Roberto Sanseverino, tauntingly sending him the gift of a fox in a cage: a message that Federico, despite his cunning, was about to be trapped.

Warfare in the scorching, mosquito-bitten lowlands of the Po River delta was an unhealthy proposition, and many of Federico's soldiers quickly fell ill. Some twenty thousand soldiers on both sides would die of fever through the course of the summer, their bodies cast into the rivers that veined the landscape. Vespasiano reported that Federico too came down with a fever due to "endless hardships and the bad disposition of the air." His friends urged him to retire to Bologna, where the air was fresher. However, Federico refused to leave Ferrara undefended, believing it a crucial bulwark in the defense against Venetian aggression. The result was that on September 10, 1482, he died from what Vespasiano called "marsh fever."[13]

Federico's death created problems for Vespasiano and great anxieties for Marsilio Ficino. A few months after the duke's death, Ficino wrote to a friend describing his bitter feelings over what had transpired after he gave Vespasiano his Plato translations, which he called his "children of the mind." (One of Ficino's favorite puns

involved playing on the words *libri*, Italian for books, and *liberi*, Latin for children.) "So Vespasiano handed them over for copying to scribes engaged for a fee," he explained. "Yet since the scribes received the books but no fee, they have, alas, now held them captive for a long time. Meanwhile, I am burning with a most ardent longing for my children and daily I fear a thousand dangers for them."[14]

Ficino's worries are understandable. It is entirely possible that Vespasiano's scribes had been given Ficino's sole copy of his complete translation of Plato: a manuscript, almost twenty years in the making, that included not only translations of the dialogues but also his introductions for and commentaries on them. When Cosimo died in 1464, Ficino had translated only ten of the dialogues. Over the following two years he produced thirteen further translations, finally completing his enormous task by about 1469. Yet he refused to have his translations and commentaries copied for circulation because he planned to make revisions, which he finalized only in 1482—the year in which he handed the manuscript to Vespasiano.

Federico's death and the suspension of work on the Urbino manuscript meant Ficino fearfully contemplated the loss of his many years of precious labor. One of Vespasiano's German scribes, moreover, caused him problems. In a letter to a friend he bemoaned the fellow's shocking behavior. "Our holy Plato," he explained, "was being copied out recently by a certain unholy German who has now spilled sacred blood before the very altar with his sacrilegious hands. That brigand, that destroyer of the sacred, hacked the priest to pieces and immediately fled."[15] In the 1950s Ficino's French translator and biographer took this statement quite literally, suggesting that one of Vespasiano's scribes had actually murdered a priest as he officiated at the altar. More likely Ficino was speaking allegorically, alluding to the fact that the scribe had somehow damaged the manuscript. He urged his friend to ensure that "our Plato" should no longer risk the harsh fate "of being defiled at any time by the polluted hands of that wicked man."[16]

In the end, the scribes were paid, the copy for the library in Urbino completed, and Ficino's manuscript released from what he called "a long imprisonment and harsh fetters."[17] But the experience convinced Ficino that further steps were needed to ensure the wider

dissemination of his beloved Plato so that never again should his life's work be so threatened. No sooner did he receive the manuscript back from Vespasiano, therefore, than he began preparations to have it reproduced again: not in a single manuscript by a team of scribes but, rather, in more than a thousand copies. The Plato manuscript was then sent to the convent of San Jacopo di Ripoli.

Chapter 27

The Grand Conjunction

After more than five years of operation, the Ripoli Press remained as busy as ever. Between 1481 and 1483, Fra Domenico purchased some three hundred pounds of ingredients for his inks and went through seventy thousand sheets of paper.[1] He also traipsed around Florence trying to unload copies of 150 of his earlier publications, all too often recording the sad refrain: "Said books were returned."[2] He continued to barter whenever he could, at one point trading four books for a stack of firewood. On another occasion he struck a different sort of deal. He printed five hundred copies of an operetta about King Herod for a client whom he simply called *il Pigro Ciermatore*—"the Lazy Beggar." When the Lazy Beggar was tardy in settling his bill, Fra Domenico held back the final consignment. The song sheets were released only when he received a linen tablecloth as compensation.[3]

Besides his fugitive pieces—the prayers and ballads for peddlers and street singers—Fra Domenico continued to produce his more exalted and expensive titles. In 1482 the press printed *Morgante*, Luigi Pulci's epic poem about the knights of Charlemagne—some twenty-five thousand lines of verse in twenty-three cantos. Sister Marietta was paid two florins for her work as a compositor on Pulci's rollicking tale. Pulci was still a notorious figure in Florence, having been condemned by preachers for denying miracles, for questioning the immortality of the soul, and for calling the afterlife nothing more than a *barato oscuro*, a huge dark hole. In 1477 he composed his *Confession*, a poetic treatise retracting his scandalous attacks on religion. That and his various other protestations of faith were not enough to see him admitted back into Lorenzo de' Medici's inner circle. Nor would they satisfy the clergy in Padua when, in 1484, Pulci

died in their city while on his way to Venice. They refused to give him a religious funeral and interred his body outside the walls of the churchyard.

The publication of *Morgante* was an impressive feat. The printed edition quickly made Pulci's work accessible to a wide readership. Soon its verses were sung in the streets of Florence, a preacher ruefully noting that "even the women sang the *Morgante* all day long"[4]—a lament that offers a glimpse of the literacy and irreverent humor of Florentine women, as well as the wide reach of the Ripoli Press.

In 1483 the Ripoli Press brought forth, after difficult labors, an even more ambitious production. Composed between 1349 and 1353, Giovanni Boccaccio's *Decameron* was a collection of one hundred stories (the work was often known as the *Cento Novelle*) told by three men and seven women sheltering in a villa outside Florence during the Black Death of 1348. Begun in the spring of 1482, the Ripoli Press's massive project, which involved setting some 250,000 words, consumed thirteen months of work and required, according to one estimate, 4,298 man-hours of typesetting.[5] Most of the work was done by Lorenzo di Alopa, the young Venetian who had arrived in the workshop as a lowly assistant to Fra Domenico in the summer of 1477. Over the course of forty days in the summer of 1482 Lorenzo set and printed fifty-four pages, a merciless pace so prejudicial to his health that Fra Domenico sent him to recover at the thermal baths at Petriolo (once a favorite of Pope Pius II and the haunt of women hoping to become pregnant). In the autumn, for further assistance on the *Decameron* and other titles, Fra Domenico hired Lorenzo's older brother Antonio. He paid him a generous salary of five florins per month only to have Antonio walk off the job a short time later following a demand for increased wages. Fra Domenico replaced him with a delivery boy named Baccino, whom he borrowed from the stationer Giovanni di Nato.

The edition of the *Decameron* finally appeared in May 1483. Fra Domenico was no doubt hoping the work would prove a financial success. For more than a century the *Decameron* had been an extremely popular title, so in demand that over the decades enthusiastic amateurs, many from the merchant class, made their own handwritten copies. One of them, copying out the entire text on paper in around

1450, inscribed his colophon: "Filippo d'Andrea da Bibbiena wrote out this *Cento Novelle* for his relatives and friends."[6] However, the Ripoli edition was not a success, with a print run of a mere 105 copies and, after four months, only a single recorded sale from the convent—to a goldsmith named Benvenuto.[7] Other copies were no doubt sold through the *cartolai*, but the circulation of so many handwritten manuscripts may have impeded sales. Even more damaging was the fact that numerous other presses had brought out their own editions. The *Decameron* had already been printed twice in Venice (in 1471 and 1481) as well as in Naples, Mantua, Bologna, Milan, and Vicenza. Fra Domenico was a victim of Boccaccio's success.

Like Luigi Pulci's *Morgante*, the *Decameron* was a highly unusual book to emerge from a convent that used nuns as compositors and otherwise issued pious prayers and orations as well as learned humanistic texts. Boccaccio's hundred stories are full of pungent incidents: people falling into latrines, sharing tombs with corpses, or having their severed heads planted in pots of basil. So racy are parts of the *Decameron* that English editions published as late as 1896 and 1903, to spare the blushes of their readers, modestly left the spicier passages untranslated. These qualms cannot merely be chalked up to scandalized Victorian prudery. When Pier Paolo Pasolini brought out his film adaptation in 1971, he claimed to be exploring "the new explosion of liberty,"[8] only to find, as charges of obscenity were laid against him, that Italian society was still not quite liberal enough for fullfrontal Boccaccio. Especially controversial was Pasolini's graphic portrayal of Filostrato's story from Day Three, in which nuns enjoy sexual relations with Masetto, their convent's handsome young gardener.

Fra Domenico evidently had no qualms about using Sister Marietta as a compositor for text by the scandalous Luigi Pulci, but neither Sister Marietta nor any of the other nuns appear in the accounts for the *Decameron*. The work certainly raised moral questions about female readers. Boccaccio mischievously claimed his stories were specifically for women—for what he called "ladies with time on their hands."[9] The stories were aimed, in other words, at exactly the idle young women over whose reading habits and materials monks and

other moralists sweated and fretted. A treatise on female education written around the time of the *Decameron* urged women to "flee from all books and stories, songs and treatises of love," in short, from works such as the *Decameron*.[10] Boccaccio himself eventually recognized the problem: his epilogue allowed that he may have mentioned topics or used phrases "which are not very suitable to be heard or said by virtuous women."[11] Some twenty years after he finished the work he even urged a friend not to allow the "illustrious women" of his household to read the work, since "many matters therein are less than decent and contrary to respectability."[12]

Fra Domenico and his ecclesiastical superiors may have been perturbed about these less than decent matters, particularly those stories involving nuns. Filostrato's story on Day Three begins with the assertion that "there are a great many men and women who are so dense as to be firmly convinced that when a girl takes the white veil and dons the black cowl, she ceases to be a woman or to experience feminine longings." The tale enthusiastically debunks this illusion, showing eight nuns as well as their abbess merrily abandoning their vows of chastity ("We are constantly making Him promises that we never keep!" one of them reasons) to explore the truth of the maxim that "all other pleasures in the world are mere trifles by comparison with the one experienced by a woman when she goes with a man."[13] The Church tolerated the *Decameron* throughout the fourteenth and fifteenth centuries, but after 1573, at the height of the Counter-Reformation, only expurgated editions could be printed—ones that, as the license from the Inquisition insisted, "in no way speak ill or scandalously of priests, friars, abbots, abbesses, monks, nuns, bishops and other sacred matters."[14]

Along with lecherous friars and corrupt priests, saucy nuns were stock figures in comedy from the Middle Ages onward. However, the civic and ecclesiastical authorities in Florence took nuns and their vows of celibacy extremely seriously. Their behavior was closely monitored because they had the power, it was believed, to corrupt and destroy a city. In 1435, for instance, the city fathers blamed "the evils of wars, disorders, epidemics and other calamities and troubles" on the "many nuns" who, "through carnal desire, have failed in their reverence" to God.[15] The whole point of shutting away the nuns behind

convent walls was to separate them from men and thereby remove, as a papal bull declared in 1298, "occasions for lasciviousness."[16]

All too often these walls proved minor impediments. Court records in Tuscany describe how men secretly entered convents to satisfy what one document called their "libidinous desires." Included among them was a man who in 1419 managed to live for five months in a Dominican convent in Pisa, and a priest who, two years later, entered a convent of Poor Clares thirty miles west of Florence "and stayed many days, knowing carnally day and night one of the recluses who wore the nun's habit."[17] The most notorious convent in Florentine territories was undoubtedly Santa Margherita in Prato, scene in the 1450s of the love affair between an Augustinian novice and a Carmelite friar: Sister Lucrezia Buti and the amorous painter Fra Filippo Lippi (the painter Filippino Lippi would be the result of the liaison).

Morality and celibacy were strictly enforced at San Jacopo di Ripoli. Fra Domenico's business activities, not least his printing press, meant that various men—the beaters and pullers, helpers such as Lorenzo di Alopa and Baccino, and indeed Fra Domenico himself—needed regular access to the premises. However, visitors were only allowed inside with a trio of elderly nuns as their chaperones and a license from a special commission established in 1432, the Officers of the Night and Preservers of Morality in the Monasteries. A nun breaking the rules of enclosure and contact at San Jacopo di Ripoli faced harsh chastisement: she would be stripped bare to the waist and whipped at the feet of each of the sisters. To complete the humiliation, she was then forced to eat her meals off the floor in the middle of the refectory.[18]

Such anxieties about moral behavior make Sister Marietta and the other nuns unlikely compositors on the *Decameron*. Their absence from the printing press might account in part for the slow production of the work as well as for the breakdown in the health of Lorenzo di Alopa as he struggled to set the pages without the usual team of helpers.

Despite the mangled Treviso edition of the *Corpus Hermeticum*, Marsilio Ficino remained committed to the new technology of printing.

During the first two decades of the printing press he became, in fact, one of the most prolifically published of all living authors—"one of the first early modern intellectuals," according to a Ficino scholar, "to enjoy the accelerated Europe-wide exposure made possible by the invention of the printing press."[19] By the early 1480s editions of four of his books had been printed by seven publishers in four different Italian cities, besides which he had composed introductions for two lavish publications, including an edition of Dante's *Divine Comedy*.

The Ripoli Press was among Ficino's hard-working cluster of publishers. In the summer of 1481 Fra Domenico bought rosin, pitch, and varnish to make ink, as well as five thousand sheets of paper. He then set about printing 375 copies of Ficino's latest work, *Advice Against the Plague*, which, as Ficino wrote on his first page, was aimed at *ogni persona thoscana*—everyone in Tuscany. He had been inspired to compose the work following the terrible recurrence of the plague of 1478 and 1479. He himself had fallen so desperately ill at this time that not even the attentions of three of Florence's most eminent physicians proved effective. His life was spared only thanks to divine intervention—further proof, he realized, of his providential mission to restore Plato to the world.[20]

For lesser mortals, Ficino drew on his medical training to offer prescriptions, precautions, and practical advice: fumigating the house with sweet-smelling herbs, washing twice a day in vinegar, holding a wet sponge to the nose, and making potions and remedies from myrtle, juniper, rosewater, and camphor. "Never forget turpentine," he urged his readers. He also speculated about the causes of the plague, reasoning that it was an airborne poison infecting the "vital spirits," the harbinger of life emanating from the heart and carried in the blood.

Advice Against the Plague was a small book, only one hundred pages long. Fra Domenico did his best to distribute the work beyond the walls of Florence: the *cartolaio* Giovanni di Nato shipped ten copies for sale in Milan, while Giovanni's wife, Mona Mea, acting as a kind of commercial traveler, took twenty-seven books to Bologna and fifty to Pistoia. However, Ficino turned to another publisher in 1482 for his next work, what he called his "massive volume,"[21] *Platonic Theology*, which ran to a hefty 648 pages. The printer was Antonio

CONSILIO DI Marsilio ficino fioréti
no, contro la peftilentia ,

 A carita inuerfo la patria
 mia mi muoue a fcriuere
 qualche configlio contro
 la peftilentia, & accioche
 ogni perfona thofcana la i
 tenda & poffi coneffo me
dicare pretermettero le difputationi fottili
& lunghe, & etiamdio fcriuerro in lingua
thofcana, bafti fapere che qualunque cofa io
aprcuerro, benche per breuita nõ narri mol
to, niente dimeno , e . approuata con molte
ragioni & auctorita di tutti edoctori antichi
e moderni, & fperientie di molti, & fpetial
mente del noftro padre maeftro Ficino me
dico fingulare, ilquale lamaggiore parte de
gli morbati fanaua , preghiamo iddio dona
tore della uita & riuelatore delle medicine
uere et falutifere , checci riueli fufficiéti ri
medii contro alla pefte, & conferui anoi el
dono fuo uitale ad fua laude & gloria
Che chofa e peftilentia , Capitolo primo ,

I A peftilentia e uno uapore uelenofo
 concreato nellaria inimico dello fpiri
 ai

The Ripoli Press edition of Ficino's *Advice Against the Plague*.

Miscomini, recently arrived in Florence after producing his impressive list of titles in Venice.

The product of five years of labor, *Platonic Theology* was the fifteenth century's most ambitious and visionary philosophical work. Ficino wrote that he wished "to paint a portrait of Plato as close as possible to the Christian truth"[22]—to do for Plato, in other words, what Aquinas had done for Aristotle two hundred years earlier. To those skeptical about whether Plato could be palatable for good Christians, Ficino pointed out that "anyone who reads very carefully the works of Plato that I have translated" would not fail to reach the conclusion that "whatever subject he deals with, he quickly brings it round, in a spirit of utmost piety, to the contemplation and worship of God."[23]

Platonic Theology is fascinating because of the way that Ficino brings matters round to the contemplation and worship of man. For Ficino, man does not languish in the fallen condition stressed in medieval times but is, rather, a privileged being at the center of the universe, placed there by God as lord and master thanks to his ability and intelligence. These abilities are best manifested and admired, Ficino believed, in man's various arts and crafts: disciplines ranging from poetry to astronomy and statecraft—creative efforts that make man into what Ficino calls "a sort of God." Man's use of astronomy to understand the heavens, for instance, demonstrates how he possesses an intelligence "nearly the same as the very Author of the Heavens." Man's use of language indicates that he has a *divinam quandam mentem* ("a divine sort of mind").[24] These statements are remarkable and even shocking in light of the Lateran Council's declaration of the distance and dissimilarity between God and man. Ficino was certainly alert to the possibility of theological objections to his claims. "In all I discuss, either here or elsewhere," he wrote in a disclaimer, "I wish to maintain only what meets with the approval of the Church."[25]

Claims about man's godlike powers look back to the insights Ficino discovered in the *Corpus Hermeticum* as well as forward to writers such as Shakespeare ("What a piece of work is man"). They are also no doubt informed, as was Giannozzo Manetti's treatise on the dignity of man, by the wondrous creations on show in "the famous city of Florence." The monuments raised by architects and artists such

as Filippo Brunelleschi, Lorenzo Ghiberti, and Donatello, as well as the scrutiny of the heavens by astronomers such as Paolo Toscanelli: all undeniable proof of man's soaring intellect and divine creative powers.

Ficino believed that anyone who read his Plato translations would easily become convinced of the philosopher's piety. In 1482, however, very few people could have read Ficino's translations for the simple reason that they existed only in manuscript (and very few at that) in places such as Federico da Montefeltro's library in Urbino. To circulate Plato's ideas more widely—and to safeguard his own efforts against the malicious vagaries of damage and loss—he decided the time had come to have these translations printed. He may not have been entirely happy with Miscomini's production of *Platonic Theology* because, as in the case of Nicholas of Breslau's edition of *On the Christian Religion*, the text was marred by misprints. When it came to printing Plato, he therefore put the commission out to tender, hoping to find an accurate and reliable publisher.

Whether either Miscomini or Nicholas of Breslau made bids is unknown,[26] but late in 1483 Fra Domenico and Lorenzo di Alopa ceased all other work in order to create what was known as a *campione*, a sample of their merchandise. Lorenzo even went to Lucca to purchase a new set of type: not the "antique" ABCs they had used for much of their recent work but, rather, a Gothic font, for the Plato translations were to be printed, according to Ficino's wishes, in "modern letters."[27]

Such an ambitious edition meant Ficino needed to find a sponsor to underwrite the production. He had dedicated *Platonic Theology* to the "great-souled Lorenzo de' Medici,"[28] but Lorenzo provided little if anything toward its publication. Relations between the two men had cooled since the Pazzi Conspiracy in 1478. Ficino was certainly not involved in planning or executing the plot, nor would he have stood to gain from its success. Even so, his close links with some of the principals raised the question of whether he possessed any foreknowledge. A modern historian of the conspiracy suggests that Ficino "came close to involvement."[29] He was certainly close to many

members of the Pazzi clan, in whose palace, among Piero de' Pazzi's books, he had commenced his scholarly career working as a tutor to Piero's sons—four of whom were imprisoned following the plot, another exiled, and Renato brutally executed. One of his other friends and former students, Jacopo Bracciolini, had been hanged from the Palazzo della Signoria, while Francesco Bandini, who hosted some of Ficino's Platonic gatherings at his home in Florence, and who was, in Ficino's words, "a man of extraordinary magnificence," had been forced by Lorenzo into exile.[30] Ficino had furthermore been a mentor of sorts to young Cardinal Riario Sansoni, dedicating to him a treatise composed in the months before the Pazzi Conspiracy.

With Lorenzo de' Medici an unlikely prospect, Ficino approached another wealthy Florentine merchant, Bernardo Rucellai, to whom he announced a matter of "Platonic *gravitas*" (a typically Ficinian pun meaning both "seriousness" and "pregnancy"). He informed Rucellai that he was "to give birth within days to a Latin Plato, long ago conceived with Greek seed. But it can be no easy birth without the hand of an obstetrician; therefore, dear Bernardo . . ."[31] Rucellai declined the opportunity, but another sponsor came forward in the person of one of Ficino's former students, twenty-seven-year-old Filippo Valori. The wealthy and aristocratic Valori family had supported Ficino's scholarly efforts for more than twenty years, with Bartolomeo, the head of the household and Filippo's father, having financially assisted Ficino from the earliest days of his Platonic studies in the 1450s. Filippo joined forces with another of Ficino's disciples, Francesco Berlinghieri, then in his early forties and likewise from a wealthy family. He had studied philosophy under John Argyropoulos and attended sessions of Ficino's Platonic Academy in Careggi. He served in various public offices but was an author in his own right, composing a series of speeches on religious themes before, in 1482, he produced his bizarre masterpiece, a poetic rendering of Ptolemy's *Geography*.

The Ripoli Press's *campione* evidently impressed Ficino and his two investors. In January 1484 Fra Domenico signed a contract to print 1,025 copies of "certain of Plato's works" in "small modern letters."[32] This modest description belied the magnitude of the project, one of the most formidable printings ever attempted anywhere. The

fact that the Ripoli Press landed such a prestigious and potentially lucrative commission indicates its high standing among Florence's most erudite and influential humanists.

Under the terms of the contract Valori and Berlinghieri undertook to pay for the entire paper supply: almost six hundred thousand sheets, an investment requiring an outlay of 240 florins.[33] The contract further stipulated that these two partners would pay for the services of someone to make corrections and, in order to expedite the process, for a second printing press. Fra Domenico stood to make a handsome profit. He was to be paid by the quire—four florins for each one in the edition. Since the edition ran to seventy-four signatures, he was to receive a total of 296 florins, of which at least 100 florins would be clear profit for the press.[34]

Throughout the spring Fra Domenico recorded various payments to the nuns.[35] He failed to specify whether any of these disbursements involved work at the press, but given the scale of the task it would only have made sense to employ practiced compositors such as Sister Marietta. Since Ficino's text was laid out in two columns of forty-six lines, and since each line was set with as many as thirty to forty "small modern letters," a page could easily require the compositor to set more than three thousand pieces of type, an increase of more than a third over each page of the *Decameron*. Two years earlier Lorenzo di Alopa typeset little more than a page of Boccaccio's text each day, a pace that, in the heat of the Florentine summer, clearly taxed his physical and also perhaps his mental well-being. Further, while Lorenzo and the pressmen printed only 105 copies of each page of the *Decameron*, with Ficino's *magnum opus* they faced a tenfold increase in their labors.

Waiting in the wings, too, was a proofreader who, as the contract insisted, would *fare correggere*—make corrections. After bad experiences with previous printers, Ficino clearly wished to assert control over the quality of the text. Each page was presumably submitted to the scrutiny of this eagle-eyed corrector (and possibly to Ficino himself). A few typographical errors on a page meant the compositor was obliged to make adjustments to his (or her) 3,000-piece puzzle.

For Ficino, speed was of the essence: hence the purchase by Fra Domenico of the second printing press mentioned in the contract. He was determined that his Plato translations should appear in 1484 because that year was, he knew, a most important and auspicious one—an astrological turning point, the "Grand Conjunction" in which Jupiter and Saturn would meet in the sign of Scorpio. Power and wisdom, the active and contemplative, would come together in a heavenly alliance. Mighty changes were bound to come about in the Christian religion, ushering in a new Golden Age, and Ficino was determined that Plato should be part of these celebrations. As Ficino wrote at the end of his Plato translations, "Jupiter is lord; Saturn the philosopher. Surely unless these be conjoined nothing either great or stable may be established."[36] Plato foretold a time, he wrote, when "power and wisdom came together in the same man"—the much longed-for philosopher-king.[37] That time was finally at hand.

Past conjunctions of these two planets had witnessed such momentous events as Noah's Flood and the birth of Christ. Ficino's friend Paul of Middelburg, the court astrologer in Urbino and a lecturer in astronomy at the University of Padua, predicted that in 1484 this rare alignment would see the arrival of a prophet—described by Paul as a creature of great intellect with red hair and an ugly body covered in black and brown spots. He would interpret the Bible in an "exceptional and wonderful way," and evil spirits would flee before him.[38]

A prophet duly appeared in Rome on Palm Sunday in 1484. Wearing a silk robe and scarlet boots, he rode through the streets on a donkey, surrounded by disciples laying palm branches in his path. In his hands he held a basket, and in the basket was a human skull. He wore a crown of thorns topped by a silver ornament in the shape of a crescent moon bearing the inscription: *Hic est puer meus Pimander, quem ego elegi* ("This is my son Pimander whom I have chosen"). His message—intoned as he drummed on the skull with his staff—was of the need for repentance and reform, and the coming of a new world religion.

This bizarre messiah made his way unopposed to Saint Peter's, from whose altar he delivered to the startled congregation an oration in which he declared himself the reincarnation of the angel of

wisdom, Pimander. In fact, he was a thirty-three-year-old father of five from Bologna named Giovanni da Correggio. His career as Pimander—whom he encountered thanks to Ficino's translation of the *Corpus Hermeticum*—would encompass an audience with Pope Sixtus as well as, in the months that followed, prosecutions for heresy, stints in prison, and episodes of self-harm. "He desperately beat his head against the block," came a report from Florence, where Lorenzo de' Medici had him imprisoned on his arrival, "and ripped all the flesh from it."[39]

Giovanni da Correggio's dramatic appearance indicates the diffusion of Ficino's ideas, thanks to the printing press, in environments beyond the lofty philosophical realms of the Studio Fiorentino, Ficino's *Academiola*, or Vespasiano's reading groups. But this skull-toting oddball did not represent the change desired by Ficino, for whom it was Plato rather than Pimander whose rebirth was required in 1484. His hopes for this great event during the *annus mirabilis* rested on the compositors and pressmen at San Jacopo di Ripoli.

For many people, 1484 seemed anything but the *annus mirabilis* foretold by the heavens. Poor crops meant the price of food rose, with "everything dearer," as one Florentine lamented.[40] The Salt War dragged on. In Rome, the Colonna and Orsini clans resumed their violent feud. Palaces were pulled down, stables burned, churches sacked. "Never did I see such confusion," wrote one ambassador. "The whole of Rome was in arms."[41] Plague returned in the summer. So deadly was the contagion in some cities that the authorities took the drastic step of forbidding prostitutes—the "greatest cause of infection," according to one outraged moralist—from entering private homes.[42]

One victim of the plague may have been Pope Sixtus, who died in Rome in the middle of August following a short illness. The anxious cardinals who gathered for the conclave signed a pledge that whoever among them was elected pope should be so generous as to allow the others a country property "whither they may freely betake themselves . . . for the purpose of evading the plague."[43] As soon as

he became pope, Sixtus's successor, who assumed the name Innocent VIII, took the precaution of building himself a summer residence, the Villa Belvedere, on a breezy hill overlooking Saint Peter's.

Another possible victim of the plague that summer was Fra Domenico. At this point, midway through his printing of Ficino's Plato, he disappears from both San Jacopo di Ripoli and the historical record.[44] At the end of July a new procurator, Fra Vincenzo, arrived at the convent. Though Fra Domenico might have been transferred to another Dominican institution, no further records about him have ever been found, and so most likely he died that summer in Florence. If not the plague, then the frantic pace and monumental task of publishing Ficino's Plato could have contributed to the collapse of his health and, ultimately, his death.[45]

The Ripoli Press had certainly been overwhelmed by the Plato commission ever since printing began in February. Between February and July, Fra Domenico and his team typeset and printed almost two-thirds of the work: some twenty-four dialogues consuming more than 350 leaves of text, front and back. At this pace, the team was typesetting and printing four or five pages each day—an astonishing rate that would seem to imply the participation of at least some of the nuns as compositors.

Fra Domenico's death or departure must have put the Plato project in jeopardy and Ficino in a lather about whether his book would be ready for the much-anticipated conjunction of Jupiter and Saturn, forecast for the end of November, some four months hence. The entirety of *The Republic* still needed to be typeset and printed, as did important dialogues such as *Phaedo* and *Phaedrus*, as well as Ficino's biography of Plato and his commentary on the *Symposium*.

Ficino need not have fretted. Fra Vincenzo began dipping into a bag in "the writing desk of Fra Domenico" for gold florins to pay Lorenzo di Alopa—now in sole charge of production—and to meet other expenses.[46] The reams of paper kept arriving: six thousand sheets on August 23; then, three weeks later, six thousand more. Printing continued at a slightly slower rate, perhaps two and a half pages per day, as the last two hundred leaves were typeset and printed. Filippo Valori made a final payment to Fra Vincenzo in the middle

of September, and within a month or two the edition was finished. Ficino's Plato was ready for the planetary conjunction of Jupiter and Saturn.

"Our Plato today has emerged onto our thresholds," Ficino happily announced to a young philosopher, Giovanni Pico della Mirandola, newly arrived in Florence.[47] An erudite and dedicated humanist, Pico may have been surprised by the sight of Plato's *Opera* ("Works"), as the edition of Ficino's translations was entitled. The book was assuredly very different in style from the manuscript prepared by Vespasiano for the library in Urbino. Vespasiano's manuscript featured his usual elegant touches: the opulent title page, the capital letters decorated with pink and blue flowers, the "antique letters" making their precise and lucid progress across the page. The *Opera* printed by the Ripoli Press, on the other hand, with its two columns of cramped Gothic type, looked like a much older production—like something out of a previous century, reminiscent of berobed monks in dim cloisters scratching their quills on parchment. Rather than a humanist text of the sort produced by Vespasiano and then copied in style by so many printers, the *Opera* resembled a Bible, or at least a theological text, most of which, in contrast to works of humane letters, were still copied or printed in two columns of Gothic type (as, for example, the *Gutenberg Bible* had been). The *Opera* had none of the ancient or "pagan" touches, the whiffs of classical antiquity, self-consciously evoked by so many of the classical texts copied or printed throughout the course of the fifteenth century.

Ficino's choice of this oldfangled style was deliberate. Plato's *Opera* was, for him, quite literally a bible. The dialogues were, in his opinion, theological as well as philosophical works, and Plato a religious figure who occupied a central place in the Christian story. Ficino's introduction even advanced the remarkable idea that "almighty God sent down from on high the divine soul of Plato at the appointed time so that by his life, genius, and marvellous eloquence he might cast the light of holy religion among all peoples."[48]

Equally deliberate may have been Ficino's choice of San Jacopo di Ripoli, where a Dominican friar operated a printing press staffed

in part by nuns. Though the Ripoli Press had published the *Decameron* and Pulci's *Morgante*, those like George of Trebizond who believed Plato to be guilty of "wicked impiety" may have been reassured by a colophon announcing the book's origins in a sanctified Dominican space. In any event, Ficino must have regarded a convent a fitting place for the messiah of "holy religion" to make his appearance.

At first, Ficino celebrated the completion of the printing. On further inspection, he found himself disappointed. In a letter to a friend he praised "the devoted care and generous hand of Filippo Valori," but lamented that the printing "was rather less than accurate." Despite the presence of the proofreader who was to *fare correggere*, Ficino held the printers responsible for Plato having come to light "in a rough condition." Any mistakes he blamed on "the carelessness of the printers, or rather misprinters." He felt it necessary to insert into the volume a long section listing the errors and their corrections. Yet such a state of affairs was, Ficino allowed, only to be expected. He compared Plato to a prisoner who, after a long incarceration in the "deep darkness," appears "grimy and emaciated." After having spent so many lifetimes in darkness, Plato had at last "risen from the dead."[49]

In the decades and centuries that followed, Ficino's "Grand Conjunction" yielded spectacular results. The intellectual historians James Hankins and Ada Palmer state that "by far the most important achievement" of fifteenth-century scholarship was "the gradual recovery and translation of the Platonic corpus into Latin."[50] This decades-long undertaking had involved the arrival in Florence of wise men from the East such as Manuel Chrysoloras, George Gemistos Pletho, and Cardinal Bessarion, the intervention of Cosimo de' Medici, and the scholarly efforts of Leonardo Bruni, Cardinal Bessarion, and Marsilio Ficino. Finally came the printing press in San Jacopo di Ripoli— the magic lantern from which the awakened Platonic genie was released into the world.

The Ripoli Press's publication of 1,025 copies of Ficino's translation of Plato marked, according to Paul Oskar Kristeller, "a major event in the history . . . of Western thought."[51] The billows and swells

of the Platonic revival generated in Florence soon became a deluge that washed across the European intellectual landscape. Plato would so dominate the Western philosophical tradition for the next half-millennium that in 1927 the British philosopher A. N. Whitehead could famously declare in a lecture in Edinburgh: "The safest general characterization of the European philosophical tradition is that it consists of a series of footnotes to Plato."[52]

Plato advanced into domains far vaster and more exotic than merely the pipe-smoke-garlanded realms of university philosophy departments. His ideas shaped countless cultural and intellectual trends: ideas of love, of magic and the occult, of art and imitation, of creativity through the divine frenzy of the "mad poet." His theories on the structure of the cosmos influenced such pioneers of the Scientific Revolution as Johannes Kepler (who used the Platonic solids described in the *Timaeus* to determine the number of the planets and their distances from the Sun) and Galileo (who credited Plato with the theory of the common origin of the planets). His theories of the soul have been said to prefigure Sigmund Freud's understanding of the psyche, while Friedrich Nietzsche argued in *The Birth of Tragedy* that Plato's dialogues inspired the novel.

Few things in heaven and earth were not dreamt of in Plato's philosophy. His writings have played a pivotal role in what has been called the "construction of modernity,"[53] including ideas of power, justice, gender, and the self. He has been seen as a proto-Communist and a proto-Nazi, as an inspiration for quantum mechanics, and as both an opponent and a supporter of women's rights. The *Apology* has come to be seen as a supreme example of speaking truth to power, with Socrates revealing implacable courage as he goes to his death challenging ignorance and prejudice, and accusing his judges of caring for wealth and reputation but showing "no interest or concern for wisdom and truth."[54]

Ficino's translations were the means by which for many centuries readers across Europe gained access to Plato. His complete Latin translation was republished twenty-four times over the following century.[55] The result was that far more scholars came to know Plato's philosophy through Ficino and the Ripoli Press edition than via the original Greek (not printed until 1513). And when Plato finally ap-

peared in languages such as French and Italian, the translators used Ficino's Latin version rather than the original Greek. Copies of Ficino's translations were owned by Ben Jonson, John Milton, and Samuel Taylor Coleridge in England, by Jean-Jacques Rousseau and Jean Racine in France, by Bishop Berkeley in Ireland and Baruch Spinoza in the Netherlands, and by Gottfried Wilhelm Leibniz and Immanuel Kant in Germany.[56] The Ripoli Press's 1484 edition is recorded at Harvard in 1735, at Yale in 1742, and even, by 1623, in China.[57] More than 120 copies have survived into the twenty-first century: thirty-six in Italy, the remainder scattered from Malta, Slovakia, and Sweden to libraries in California, Kansas, Oregon, and the Rare Book Division of the Library of Congress.

Despite the magnitude of this achievement, the printing press at San Jacopo di Ripoli never produced another book. Fra Vincenzo evidently possessed little desire to continue Fra Domenico's ambitious enterprise. Nor did Lorenzo di Alopa keep the Ripoli Press alive. He skillfully ushered the last third of the Plato through to completion, and rather than the usual *Impressum Florentiae apud Sanctum Iacobum de Ripoli* the colophon of Ficino's Plato reads: *Impressum Florentiae per Laurentium Venetum*. Though "Lorenzo the Venetian" appeared poised to establish himself as a successful printer, he mysteriously vanished for almost a decade before reemerging in Florence in the summer of 1494—though not at San Jacopo di Ripoli—and publishing works in Greek. In 1496 he printed two more of Ficino's Greek-to-Latin translations, an indication, perhaps, that Ficino did not hold him personally responsible for the "rather less than accurate" printing of the *Opera*. As for Ficino, the great scholar would die three years later, in 1499, at the age of sixty-five, at his precious villa in Careggi. By that time more than forty editions of his writings and translations had been published in fourteen different cities, including by five printers in Paris and ten in Venice.

San Jacopo di Ripoli continued as a convent for another three hundred years until in 1781 it was suppressed by the Grand Duke of Tuscany, Pietro Leopoldo, as part of his campaign to reduce the power of the Church and abolish what he regarded as socially useless institutions. For the next century the premises served as a girls' school before in 1886 the Italian government purchased and deconsecrated

the site, then gave it to the Italian Army for use as a barracks. The buildings were briefly requisitioned in 1945 to serve as a refuge for displaced persons; many were Jewish survivors of the Holocaust. The site reverted back to the army, taking the name of a hero of the First World War, Simone Simoni. Today it continues as the Caserma Simoni, home of the army's administration directorate. Restoration completed in 2018 brought to light, in a room used by the nuns as their refectory, a long-hidden cycle of frescoes showing scenes from the life of Jesus and Mary.

Of the printing press operated by Fra Domenico, Lorenzo di Alopa, and nuns such as Sister Marietta, no traces remain. A battered plaque mounted outside in Via della Scala gestures briefly toward the earlier incarnation of the premises as a convent and place of learning. It states that San Jacopo di Ripoli was where one of Europe's first printing presses was set up in 1476 by Bernardo Cennini.

Epilogue

Chasing Away the Darkness

An April morning in 1490: Vespasiano is leaving Antella for the Florentine convent of Santa Brigida del Paradiso, a one-hour journey on the back of a mule that will carry him past fields spattered red with poppies and through spring air perfumed with bedstraw. His retirement among his books and papers in the "pleasant solitude" of the Casa Il Monte these past ten years has been a busy one, though sporadic work for the library of San Marco occasionally calls him back along this twisting road. Old clients such as King Ferrante still come calling. The library founded by the king's father, Alfonso the Magnanimous, continues to grow at an impressive rate thanks to various purchases and gifts as well as Ferrante's habit of confiscating the books of his vanquished enemies.[1]

Another customer, too, has appeared. By 1490 Vespasiano is once again working for the Medici—indeed, for Lorenzo himself. Long ago Vespasiano proposed a new library to Lorenzo, who, despite the occasional nudge, showed scant interest. However, his insatiable appetite for collecting now finally encompasses manuscripts. He is enthusiastic, in particular, about Greek codices procured from points east. His disdain for printed books remains such that copies of Marsilio Ficino's books are reverse-engineered for him, turned from printed pages into beautifully illuminated leaves of parchment.[2] Lorenzo plans to install and display these manuscripts in the family palazzo, in a library beautifully decorated with marble busts.[3] Since Lorenzo wishes to include the writings of Church Fathers such as Saint Augustine and other early Christians, he turns to Florence's scribes and, inevitably, to Vespasiano.[4]

Vespasiano therefore makes his way on muleback to Santa Brigida del Paradiso, where the librarian, Brother Gregorio, carefully records that his visitor has been "sent by Lorenzo." Here Vespasiano is greeted by two friends. One is Angelo Poliziano, who almost twenty years earlier paid extravagant homage to Vespasiano for having brought back to life "the great men of the ancient world." He is soon to embark on Lorenzo's behalf on a manuscript hunt through the libraries of Bologna, Padua, and Venice. The other is Pico della Mirandola, Marsilio Ficino's friend and fellow Plato enthusiast: a tall, green-eyed intellectual virtuoso who can read, among other languages, Aramaic and Chaldean, and who can recite the entirety of Dante's *Divine Comedy* both forward and backward. The awestruck Ficino regards him as a member of "a superhuman race."[5] "They wanted to see everything in our library," Brother Gregorio later notes of his distinguished visitors.[6]

On a mission from the Medici, mixing with the greatest minds of the age, hunting down old manuscripts in the hush and must of a library . . . Vespasiano must feel on this spring day as if the Golden Age has returned. But it is not to be. Vespasiano will find illuminators for Lorenzo, including some who worked with him on the Urbino Bible. But the collaboration ends with Lorenzo's death in April 1492, at the age of forty-three, followed two years later by those of Pico and Poliziano, both from poison. Then, with the ousting of Lorenzo's sons from Florence in November 1494 following a French invasion of Italy and a popular uprising, the precious manuscripts in the Palazzo Medici are boxed up and moved for safekeeping to the monastery of San Marco. Here they join in quiet seclusion the collection assembled by Niccolò Niccoli in what, as the century draws to its close, seems like another lifetime.

After the expulsion from Florence of Lorenzo's sons in 1494, the city fell under the spell of Girolamo Savonarola, a Dominican from Ferrara who in 1491 became prior of San Marco. The long and hopeful project of reconciling paganism with Christianity reached an abrupt end. "The difference between Plato and a Christian is as great as that between sin and virtue," Savonarola thundered from the pulpit, "and

the difference between Plato's doctrine and the doctrine of Christ is as great as that between darkness and light."[7] In his sermons he denounced the "useless and shameful books" of ancient authors who "teach a thousand lascivious things." Ominously, he cited precedents for destroying books: "Saint Paul had many books and other curious things burned," he declared from the pulpit. "Saint Gregory had the beautiful statues of Rome smashed and the *Decades* of Livy burned."[8]

Savonarola took these examples to heart. He sent his followers into the streets, teams of boys and young men in sober dress and close-cropped hair who aggressively enforced morality by hounding and harassing gamblers, prostitutes, sodomites, and women in immodest attire. The patrols confiscated baskets of cakes and pastries and, on Savonarola's orders, went from door to door collecting "vanities": playing cards, masks, mirrors, chess sets, wigs, cosmetics, musical instruments, and paintings with (as Savonarola distastefully observed) "ugly images" and "figures with bare breasts." He burned a collection of them on Shrove Tuesday in 1497 and again in 1498, transporting them on a carriage to the Piazza della Signoria and stacking them into a ninety-foot-high pyramid topped by the figure of Satan. The pyramid was arranged in seven tiers, one of which, according to an eyewitness, was entirely devoted to books and manuscripts—not merely the "lascivious" ancients but also copies of Boccaccio's *Decameron* and (a particular bugbear to Savonarola) Luigi Pulci's *Morgante*. Then, as trumpets sounded and bells rang, the gigantic pyre was set alight. Savonarola "shouted with joy."[9]

Savonarola was a complex figure responding to intricate social, political, and spiritual conditions in Florence and abroad. He was not simply, as he is so often presented, a relic of the "Dark Ages" who snuffed out the brilliance of the Florentine Renaissance with (as one textbook states) "a spasm of medieval piety."[10] "Medieval" piety ran throughout fifteenth-century Florence. Even a dyed-in-the-wool humanist such as Coluccio Salutati had believed the plague to be the righteous vengeance of God. The contrast between Savonarola and the humanists was by no means as stark or as vivid as might appear.[11] They shared many of the same aspirations, especially the moral reform of a society they believed to be politically corrupt, morally bankrupt,

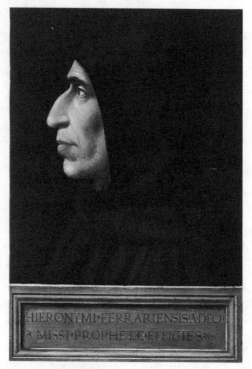

Girolamo Savonarola (1452–1498):
"Socrates from Ferrara."

and spiritually vacuous. Savonarola simply voiced from the pulpit
what Vespasiano and his humanist friends discussed in their rarefied
reading circles, taking much the same message beyond the realms
of Latin speakers and into (as one of Savonarola's admirers put it)
"the highways and byways," in a language "not reeking of the lamp-
light and affectation."[12]

Savonarola's message appealed to many humanists. Both Poliz-
iano's students and members of Ficino's academy, not least Pico della
Mirandola, flocked to the preacher's side. Nor was Savonarola im-
mune to the charms of humanism. In 1497 a professor at the Studio
Fiorentino hailed him because of his learning as the "Socrates from
Ferrara"—granting him the name and prestige of the philosopher
so recently identified with Ficino. Savonarola was careful to ensure
that Cicero and Virgil were spared his bonfires, and the convent of
San Marco became a leading institution of humanist learning where

philosophy was taught in an "Accademia Marciana." If Savonarola acted out in public the role of fierce scourge of worldly wisdom, taunting philosophers from his pulpit for "the greatest ravings you've ever heard," in private, with colleagues such as Pico, he was far more open to the potential compatibility of Plato or Aristotle with Christian doctrine.[13]

Vespasiano should have been responsive to Savonarola's message. After all, in his *Lament for Italy* he called for repentance and reform, and for an end to "luxuries and every kind of foolishness"— the same sorts of "vanities" incinerated in the friar's bonfires. But the destructive activities and populist message of Savonarola and his followers, whom Vespasiano called "the dregs of the people," were too much. Savonarola spread his message in print as well as from the pulpit, and in the first half of the 1490s Florence's printing presses churned out his speeches and sermons by the score. Though Johannes of Mainz printed a number of his titles, Savonarola's busiest presses were those of Antonio Miscomini (who issued five of his works in 1492 alone) and Bartolommeo di Libri (at least a dozen in 1495). If many Florentine humanists were happy enough for philosophy to descend from the ivory tower and go forth into the "highways and byways," Vespasiano, whatever his commitment to the humanist project, remained too much of a high-brow—as hidebound as one of his beautiful manuscripts. He lamented Savonarola's power in a letter to a friend in the spring of 1497. "See where we are led!" he wrote in despair. "Woe to the city that falls into the hands of the people."[14]

Savonarola's regime in Florence was not to last. On May 12, 1497, Pope Alexander VI's bull of excommunication was issued from a printing press operated in Florence by Francesco di Dino. The friar was pronounced a heretic, tortured and, in May 1498, hanged from a gallows built in the middle of the Piazza della Signoria. His corpse was burned at the stake and stoned by boys before his ashes were thrown into the Arno.

Vespasiano died two months later in Antella, at the age of seventy-six. His body was brought to Florence where, on July 27, 1498, he was lowered into the family tomb in the floor of Santa Croce that bore the name of his brother Jacopo. The bills of mortality simply recorded him as "Vespasiano *cartolaio.*"

Much of Vespasiano's time at Antella had been spent composing his biographies of "illustrious men." He must have been planning this collection for many decades, since in 1458, soon after the death of King Alfonso, he sought an interview with one of the men present at the deathbed, Alfonso's confessor, Ferrando da Cordova. So eager was Vespasiano in his research that he arrived at Ferrando's lodgings when the priest, who had arrived in Florence a day earlier, was still in bed, "exhausted from his travels." But Ferrando proved happy to enlighten Vespasiano. He told him the remarkable story of how Alfonso was preparing to confess his sins when a hermit from Ferrara turned up and told him that, in fact, he was not about to die. Alfonso was only too delighted to forestall his confession ("Great princes commit great sins," Ferrando gravely confided to Vespasiano). However, Ferrando cleverly spotted that the hermit had been sent by the devil in hopes of ensnaring Alfonso's immortal soul. The diabolical plot uncovered and the hermit banished from Naples, Alfonso made his confession, commended his soul to God, and peacefully passed into the next life.

Vespasiano sought out various other witnesses to episodes in the lives of his many subjects. He once interviewed a Dominican friar present at the execution in London of John Tiptoft. He learned how the duke had asked the executioner on Tower Hill to take his head off with three blows of the ax in honor of the Holy Trinity. "The scoundrel was happy to oblige," Vespasiano reported.[15]

Most of the lives were completed by 1493, when Vespasiano began presenting manuscript copies to various of his friends. His inspiration came from the historians who, he noted, preserved the fame of heroes whose great deeds would otherwise be forgotten. "I have often considered," he wrote in his introduction, "how much light writers both ancient and modern have cast on the works of illustrious men, and how the fame of many others has been lost to history because no one preserved their deeds." He was uniquely positioned to celebrate the deeds of many of his own remarkable contemporaries. "I was born into this age and encountered many illustrious men, about whom I have a good deal of information," he noted. "I

have therefore set down in brief commentaries all that I learned about them so as to preserve their memory."[16]

A terrible irony befell Vespasiano's project. As well he knew, the fame of illustrious men was sometimes lost to history not because "no one preserved their deeds" but because the manuscripts that celebrated these deeds had perished or been lost. Such could have been the fate of Vespasiano's manuscript. Since his presentation copies were all copied by hand, their readership was circumscribed, and his praises of illustrious men, as the decades passed, went largely unheard. A few more handwritten copies were made from his manuscripts in the centuries that followed, but all quickly disappeared into libraries or simply vanished from sight in a sorry reprise of the loss of knowledge during the "Dark Ages" that he had done so much in his lifetime to reverse. True, a number of excerpts did see print. His biography of Cardinal Cesarini was published in Rome in 1647, those of Eugenius IV and Nicholas V in Milan in 1751, and in 1788 he made a brief appearance as "Vespasian of Florence" in the footnotes to Edward Gibbon's *History of the Decline and Fall of the Roman Empire*.[17] However, the lives and deeds of Vespasiano's illustrious men were not truly safe for posterity until, in 1839, Cardinal Angelo Mai published the manuscript he discovered in the Vatican Library. Nor were the deeds of Vespasiano himself known to history: a handwritten note on the cover of the Vatican manuscript, copied a century after his death, simply reported that the author was a Florentine who lived during the time of John Argyropoulos.

Vespasiano occupied a tenuous and unenviable position, straddling as he did two different technologies. He brought to the height of perfection a means of production rapidly superseded, indeed engulfed, by another that—however smooth and relatively uneventful the transition for so many others—he adamantly refused to embrace. He was the most accomplished, prolific, and influential producer of manuscripts during the fifteenth century. He must personally have been responsible for the creation of a thousand manuscripts, possibly considerably more; untold others, both ancient and modern, passed through his hands. He had been fortunate to live and work in a golden age for manuscripts, which appeared more abundantly in his lifetime than at any other point in history, turned out in their millions to feed

the appetites of a growing population of the literate and learned, and of princes and potentates founding great libraries in imitation of the ancients. In the thousand years between the fall of the Roman Empire and the year 1500, some 10.8 million manuscripts were produced in Western Europe. Almost half of those—4.9 million—were copied during the 1400s alone, of which 1.4 million, or 29 percent, were handwritten in Italy.

This surging wave that carried Vespasiano to great heights through so much of his career inevitably broke on the shoals of a new technology. During the last five decades of the fifteenth century the arrival of the printing press meant the steady accumulation of manuscripts was dramatically eclipsed as between 1454 and 1500—the so-called incunabular period*—some 12.5 million printed books appeared. While presses operated in 19 European cities in 1470, by 1500 the number had risen to 255. Italy once again took the lead, with 56 cities operating presses before the turn of the sixteenth century and at least 4.5 million books printed.

The gradual changeover from script to print meant that between 1400 and 1500 the price of books fell by two thirds.[18] By the last decades of the fifteenth century, printed books therefore reached the hands of readers—such as the bricklayers and blacksmiths who bought books from the Ripoli Press—who could never have afforded manuscripts. Even so, printed books were not available or accessible to all. By 1500 printing presses were found in only 11 percent of European cities with populations above five thousand, and forty of Europe's one hundred largest cities still did not have printing houses.[19] Cities without a press included Frankfurt, with its population of ten thousand people and significance as the place where in 1454 Gutenberg first displayed his wares.[20] It is easy to speak of the "dissemination" of knowledge and information by the printing press, but those towns and cities without a printer—more than 1,500 urban centers across Europe—found it difficult to provision themselves with books given relatively high transport costs that, even on a short journey of two hundred miles, could raise the price of a book by 20 percent. As

*Books printed in these decades are known as incunables, from the Latin *incunabula*, literally "cradle" and, more figuratively, "swaddling clothes"—a reference to the "infancy" of printing.

an economist of the period has observed, "supply-side constraints limited technology diffusion."[21]

The social and political consequences of print are therefore easy to exaggerate. Latin remained the language of the printing press throughout the last decades of the fifteenth century: 70 percent of all books published before 1500 were in Latin.[22] Furthermore, the effects of printing on literacy are not straightforward. Though the spread of literacy certainly required the availability of inexpensive texts, stationers and booksellers had amply supplied schoolmasters and their students with primers and grammars long before the arrival of print. The "eight to ten thousand" boys and girls that a chronicler estimated were learning to read in Florentine schools in the late 1330s had been untroubled by any lack of reading material. Moving forward two centuries, into the era of print, the story changes, for evidence suggests that literacy levels in Tuscany actually declined over the course of the sixteenth century.[23] The economic prosperity and political liberties of the fourteenth and fifteenth centuries did more for Florence's literacy than the printing press could muster during the economic decline and repressive measures presided over by the grand dukes of Tuscany in the city's "forgotten centuries."[24]

The influence of the printing press on the Protestant Reformation, often presented as a "print event," the result of a large-scale "media campaign," is far from straightforward. Print undoubtedly played an important role. Even before Martin Luther, the Church began censoring the Bible's translation into the vernacular languages, while Pope Leo X—the second son of Lorenzo de' Medici—bemoaned the printing press's abilities to make evil "grow from day to day."[25] Luther himself made full use of the press, becoming an astonishingly prolific propagandist, responsible for 20 percent of all pamphlets published in German-speaking lands in the first thirty years of the sixteenth century and making Wittenberg (in which no printing press had operated before 1502) into Germany's largest printing center.[26] Low levels of literacy across these regions, though, meant a circumscribed reading public even in those towns where presses operated. In the first decades of the sixteenth century, in German-speaking towns and cities, only one person in three could read; in rural areas the rate was drastically lower: less than 5 percent. According to one

estimate, the reading public of the Holy Roman Empire, with a population of 16 million, was around 400,000, which meant only one person in forty-three could read Luther's message. Nor did the printing press put ownership of books in reach of everyone: Luther's 1534 German Bible cost the equivalent of a month's wages for an unskilled worker.[27]

Such circumstances have led the authors of a classic study of the history of the printing press to brand the idea of the Reformation as its offspring a "ridiculous thesis."[28] Even so, the Reformation could hardly have unfolded as it did without the printing press. A recent study has found that cities with at least one printing press by 1500 were 30 percent more likely to be Protestant by 1600 than those without.[29] Other studies have shown how the printing press led to economic growth, which led in turn to Protestantism because of the causal link between the "Protestant ethic" and the market-driven "spirit of capitalism" (to give the famous formulation of the German sociologist Max Weber).[30]

The printing press does appear to have played a significant but largely unheralded role in another enterprise, one even more earth-shattering than Luther's. If Vespasiano was not the most famous and important bookseller of the fifteenth century, the only other candidate was an Italian who turned up in Córdoba in 1486 to run a bookshop. An acquaintance described him as "*un hombre de tierra de Génova, mercader de libros de estampa*"—"a man from Genoa, merchant of printed books." The people of Córdoba knew this tall, red-haired, deeply religious, "marvellously articulate" thirty-five-year-old Genoese as Cristóbal Colón. He was, noted his friend, an ingenious man "knowledgeable in the art of cosmography and the layout of the world."[31]

Christopher Columbus stocked many maps and marine charts in his Córdoba shop, along with books such as a Latin translation of Marco Polo's writings printed a year earlier in Antwerp. In Córdoba he was licking his wounds and biding his time, disappointed that the king of Portugal, John II, had recently declined his offer to sail for Zipangu—mentioned by Marco Polo as a land paved in gold—in return for expenses, the title of admiral, and the right to wear gold spurs.

Many things inspired Columbus's ambition to sail to the West in search of a sea route to the East, including flotsam and jetsam such as the two drowned men with broad, Asian faces fished from the sea off an island in the Azores who had floated, he surmised, from China. Columbus had been fired, too, by a religious zeal that impelled him to launch a quest for gold and spices whose vast profits could be used on, as he wrote excitedly in his diary in 1492, "the conquest of Jerusalem."[32]

Columbus's imagination received its first eager promptings, however, from books. A decade before arriving in Córdoba, following voyages to places as far-flung as Chios and Iceland, he joined his younger brother Bartolomeo in Lisbon, where Bartolomeo ran a cartography shop. Here among his brother's compasses and charts Columbus devoured volumes on geography in whose margins he penned more than 2,500 notes. One of those books was Enea Silvio Piccolomini's *Historia Rerum Ubique Gestarum*, composed while he was pope and printed in Venice in 1477. Another was a Venetian edition of Pliny the Elder's *Natural History*, with its compelling tales of strange people in faraway lands—all of which became, according to one historian, part of his "imaginative landscape."[33] His passion for books was inherited by his son, Hernando Colón. Hernando sailed with his father on his fourth and final voyage to the Americas but gave up exploration for the world of books, becoming the greatest collector of the sixteenth century, with a library of fifteen thousand volumes.[34]

Few traces of Vespasiano remain in Florence. His bookshop across from the Badia has become a pizzeria and the tomb slab on the floor of Santa Croce bears the name and timeworn effigy of his brother Jacopo. In 1898, four hundred years after his death, Florence honored him with a small plaque in the basilica, giving him a modest but fitting presence in the building that—with the tombs of Leonardo Bruni, Lorenzo Ghiberti, Niccolò Machiavelli, and Michelangelo—has become the last resting place of some of the greatest titans of the Italian Renaissance.

Vespasiano's manuscripts are widely diffused across Europe, as indeed they were during his lifetime. Just as his volumes once graced

the palaces of the greatest collectors of the age, so too many of the world's finest libraries now hold them, from London and Oxford to Paris, Copenhagen, Munich, Vienna, and Budapest. In Italy they can be found in collections in Rome, Florence, Venice, and Ferrara; and, in Spain, in libraries in Barcelona, Valencia, and León. In the United States, Harvard Library holds a manuscript of Leonardo Bruni's writings copied in an elegant humanistic hand. The scribe has penned on the flyleaf the proud notice that it was sold by "Vespasianus Librarius Florentinus."

These manuscripts are only the survivors, a fraction of what Vespasiano produced in his forty-year career. The fates of many others present sobering examples of the fragility and perishability of knowledge. Federico da Montefeltro's librarian in Urbino was ordered to keep at bay the foolish, the ignorant, the filthy, and the angry. But in 1502 Cesare Borgia and his soldiers arrived, stripped the manuscripts of their precious bindings—the scarlet covers and silver fittings of which Vespasiano was so proud—and carted the volumes off to Forlì. The survivors, including Federico's two-volume Bible, are now in the Vatican Library, one of the greatest repositories of Vespasiano's handiwork (it also holds his manuscript of Ficino's Plato). Dismal fates awaited many others, victims of violence, plunder, and disaster. The manuscripts created for Alessandro Sforza and his son Costanzo were consumed in a fire in Pesaro in 1514. The library assembled at Pécs by Janus Pannonius was expropriated after his death by Matthias Corvinus only for Corvinus's magnificent library in Buda Castle to fall victim to Turkish soldiers following the Battle of Mohács in 1526, with the loss of thousands of volumes, Vespasiano's among them.

Vespasiano's legacy is greater, though, than the sum of his surviving manuscripts. Nor was his achievement simply that, as he modestly put it, he was "born into this age and encountered many illustrious men"—though his biographies did reveal to his distant posterity that the Florentine Renaissance consisted of something more than anatomical accuracy in painting and sculpture, round arches in churches, and the conquest of three-dimensional space. They revealed its sweeping horizons, which, through the discovery and study of writers such as Quintilian, Cicero, and Plato, have stretched across the centuries and into our own age. Vespasiano was an active collaborator

in the dream to recapture the wisdom of the past and bring it back to life for the sake of the present, for the good of the people who, as Petrarch's grandchildren believed, might learn a better and happier way to live.

"All evil is born from ignorance," as Vespasiano wrote. "Yet writers have illuminated the world, chasing away the darkness." This darkness he and his friends hoped to dispel by casting onto their fractured and unhappy times the pure radiance of the past, one scribe and one manuscript at a time.

Acknowledgments

It is a pleasure to thank the many people who gave me help with research, writing, and, ultimately, publication. First of all, I must thank two friends and colleagues with each of whom I've been lucky enough to work for more than two decades: my editor at Grove Atlantic in New York, George Gibson, and my literary agent in London, Christopher Sinclair-Stevenson. Christopher was as enthusiastic and encouraging as always, and George, as usual, astute with his editorial suggestions, tireless in his many efforts on my behalf, and endlessly patient with my progress on the manuscript. I also thank Morgan Entrekin at Grove Atlantic, as well as Emily Burns for her logistical support and, not least, her assistance with tracking down many of the images. I was also fortunate to have the help and support of Becky Hardie, Greg Clowes, and the rest of the team at Chatto & Windus in London. I also wish to thank my longtime editor at Garzanti in Milan, Paolo Zaninoni, and Kristin Cochrane and Amy Black and their team at Penguin Random House in Toronto.

For their work on the physical aspects of the book, I have many people to thank: Gretchen Mergenthaler and Sal Destro for producing and designing the American edition, for which Rebeca Anaya created the beautiful script for the cover; Stephen Parker, who brilliantly adapted the format of some of Vespasiano's scribes and illuminators for the cover of the UK edition; and John Gilkes for creating the map of Florence. My thanks also to Alicia Burns for her diligent copyediting and to Nicole Balant for reading the proofs. Jen Burton compiled the index.

As for the content of the book, I was extremely fortunate in having experts in several disciplines reading the manuscript either in whole or in part. Anne Leader read the manuscript in full, offering insight and advice and providing much information about, among other things, the Street of Booksellers. Crucially, she also deciphered

Fra Domenico's squiggles for me in the Archivio di Stato di Firenze. Likewise, I am very grateful to Valery Rees for keeping me on the straight and narrow with Marsilio Ficino, and to Angie Hobbs for her generous assistance with key sections on Plato and Aristotle. Nancy Goldstone helped with the history of the Angevins and Aragonese in Naples. Whatever mistakes or misinterpretations that might remain are, unfortunately, all my own.

A number of other scholars answered my queries when information eluded me. I thank Jeremiah Dittmar, Oren Margolis, David Marsh, Peter Stoicheff, and David Womersley. My debt to the work of a multitude of other scholars is, I hope, adequately reflected in the endnotes. However, I owe a special thanks to a number of experts whose writing and research have been of such value to me: Melissa Conway, Arthur Field, James Hankins, Margaret Meserve, John Monfasani, Brian Richardson, and Sharon T. Strocchia. Most of all I am indebted to the tremendous scholarly legacy of the late Albinia de la Mare, without whose decades of research on Vespasiano this book could simply not have been possible.

Two friends assisted me with translations: Robert-Louis Liris with Latin (in particular, with Poliziano's verses about Vespasiano), and Sergio Porrini with the finer points of some Italian expressions. I owe a special thanks to another friend, Bob Craine, a fellow enthusiast for Florence who went beyond the call of duty in reading several versions of the manuscript and offering much sound advice.

In a book about libraries it is a pleasure to thank the many librarians who provided assistance. David Speranzi at the Biblioteca Nazionale Centrale in Florence gave me permission to see Fra Domenico's "Diario" of his printing press. The staff of the Archivio di Stato di Firenze allowed me to access the account books of the convent of San Jacopo di Ripoli. For assistance with acquiring permission for images—much of it during the COVID-19 pandemic, when libraries and museums were closed—I am grateful to many other librarians: Lauren Dolman, Bethany Hamblen, and Seamus Perry at Balliol College, Oxford; Christopher Skelton-Foord at New College, Oxford; Julianne Simpson and Angie McCarthy at the John Rylands Library in Manchester; Kimberley Stansfield and Yvette Dickerson from the London Library; Sabina Fiorenzi at the Biblioteca Casan-

atense in Rome; Giovanna Pecorilla at the Uffizi; Eugenia Antonucci at the Biblioteca Medicea Laurenziana; and Rossella Giovannetti at the Biblioteca Riccardiana.

And in a book about the "king of the world's booksellers" it would be remiss not to pay tribute to some of the kings and queens of bookselling in the United Kingdom, United States, and Canada with whom I've had the pleasure of working over the years: Gail and Laurie Greenwood, Vivien Jennings and Roger Doeren, Mitchell Kaplan, René Martin, Ben McNally, Elaine Petrocelli, and Rachel Phipps. I've had the great privilege of touring Florence and other parts of Italy with Mary Gay Shipley, Barbara Theroux, Sally Jordan, and Sally Ruggles. All would agree with Cardinal Bessarion that there is no more valuable treasure than a book.

One of the many benefits of my visits to Florence is the companionship of the friends I always meet up with. For many years of stimulating conversation in and about Florence I'm grateful to Bill Cook, Bill Wallace, Elaine Ruffolo, Rocky Ruggiero, and Paola Vojnovic (who first showed me Vespasiano's tomb in Santa Croce). David Battistella and Rima Stubbs have provided not only good company and conversation but also generous hospitality that even includes a bedroom with a view of Brunelleschi's dome. I thank David, too, for taking photographs for the book.

I am profoundly thankful, as always, to my wife, Melanie, a fellow writer and book lover, for her enthusiasm, patience, and love. This book is dedicated to our dear friend, the ultimate "Friend of Florence," Simonetta Brandolini d'Adda, in recognition of everything she does to preserve and protect the splendors of Florence, ensuring that it has not only a rich and storied past but also a vibrant future.

Image Credits

Credits for the insert images are as follows: Page 1, image A: Nuremberg Chronicle, via Wikimedia Commons. Page 1, image B: the Heracles Papyrus (Oxford, Sackler Library, Oxyrhynchus Pap. 2331), via Wikimedia Commons. Page 2, image A: Codex Vaticanus, photographed by Leszek Jańczuk, via Wikimedia Commons. Page 2, image B: Scala / Art Resource, NY. Page 3, image A: Vsatinet, via Wikimedia Commons. Page 3, image B: © RMN-Grand Palais / Art Resource, NY. Page 4: Balliol 248C, folio 12r. Courtesy of Balliol College, Oxford University. Page 5, image A: © National Gallery, London / Art Resource, NY. Page 5, image B: Bibliothèque nationale de France MS Français 2691, folio 254v. Page 6: Wikimedia Commons. Page 7, image A: Scala / Art Resource, NY. Page 7, image B: Courtesy of the Vatican Library. Page 8, image A: Bayerische Staatsbibliothek (Munich). Page 8, image B: © David Battistella.

Credits for the images running throughout are as follows: Pages xii–xiii: © John Gilkes. Page 3: © David Battistella. Page 6: Granger Historical Picture Archive. Page 11: Biblioteca Medicea Laurenziana, Florence. Ms. Plut. 73.7, c. 3r. Courtesy of MiBACT. Any further reproduction by any means is forbidden. Page 17: Courtesy of the Uffizi Gallery. Page 21: Pinacoteca Ambrosiana, Milan, Italy © Veneranda Biblioteca Ambrosiana / Mondadori Portfolio / Bridgeman Images. Page 33: Poggio Bracciolini, engraved by Philips Galle (Rijksmuseum). Page 42: New College Library, Oxford, MS 288, folio 4v © Courtesy of the Warden and Scholars of New College, Oxford. Page 45: © RMN-Grand Palais / Art Resource, NY. Page 61: By permission of Saint Catherine's Monastery, Sinai, Egypt. Page 68: Wikimedia Commons. Page 107: MS 248E, folio 1vb. Courtesy of Balliol College, Oxford. Page 109: Latin Bible from 1407, on display in Malmesbury Abbey, Wiltshire, England, via Wikimedia Commons.

Selected Bibliography

Alexander, Jonathan J. G. *Medieval Illuminators and Their Methods of Work.* New Haven: Yale University Press, 1992.

Allen, Michael J. B., and Valery Rees, with Martin Davies, eds. *Marsilio Ficino: His Theology, His Philosophy, His Legacy.* Leiden: Brill, 2002.

Barbier, Frédéric. *Gutenberg's Europe: The Book and the Invention of Western Modernity.* Translated by Jean Birrell. Cambridge: Polity Press, 2017.

Bisticci, Vespasiano da. *Vite di Uomini Illustri del Secolo XV.* Edited by Paolo d'Ancona and Erhard Aeschlimann. Milan: Hoepli, 1951.

——. *Vite di Uomini Illustri del Secolo XV.* Edited by Ludovico Frati. 3 vols. Bologna: Romagnoli-Dall'Acqua, 1892.

Black, Robert. *Education and Society in Florentine Tuscany: Teachers, Pupils and Schools, c. 1250–1500.* Leiden: Brill, 2007.

Brown, Judith C. "Monache a Firenze all'Inizio dell'Età Moderna." *Quaderni storici,* new series, 29 (April 1994): pp. 117–52.

Cagni, Giuseppe M., ed. *Vespasiano da Bisticci e il suo epistolario.* Rome: Edizioni di Storia e Letteratura, 1969.

Conway, Melissa, ed. *The "Diario" of the Printing Press of San Jacopo di Ripoli.* Florence: Olschki, 1999.

Conway, Melissa. "The Early Career of Lorenzo de Alopa." *La Bibliofilía* 102 (January–April 2000): pp. 1–10.

Davies, Martin. "Humanism in Script and Print." In *The Cambridge Companion to Renaissance Humanism,* edited by Jill Kraye, pp. 47–62. Cambridge: Cambridge University Press, 1996.

De la Mare, A. C. *The Handwriting of Italian Humanists.* Oxford: Printed at the University Press for the Association internationale de bibliophilie, 1973.

——. "Messer Piero Strozzi, a Florentine Priest and Scribe." In *Calligraphy and Palaeography: Essays Presented to Alfred Fairbank on His 70th Birthday,* edited by A. S. Osley, pp. 55–68. London: Faber & Faber, 1965.

——. "New Research on Humanistic Scribes in Florence." In *Miniatura fiorentina del Rinascimento, 1440–1525: Un primo censimento,* 2 vols., edited by Annarosa Garzelli, vol. 1, pp. 395–600. Florence: Giunta regionale toscana, 1985.

———. "Vespasiano da Bisticci and Gray." *Journal of the Warburg and Courtauld Institutes* 20 (January–June 1957): pp. 174–76.

———. "Vespasiano da Bisticci as a Producer of Classical Manuscripts in Fifteenth-Century Florence." In *Medieval Manuscripts of the Latin Classics: Production and Use,* edited by Claudine A. Chavannes-Mazel and Margaret M. Smith, pp. 166–207. Los Altos Hills, CA: Anderson-Lovelace, 1996.

———. "Vespasiano da Bisticci, Historian and Bookseller." 2 vols. PhD diss., London University, 1965.

Eisenstein, Elizabeth L. *The Printing Press as an Agent of Change: Communications and Cultural Transformations in Early-Modern Europe.* 2 vols. Cambridge: Cambridge University Press, 1979.

Febvre, Lucien, and Henri-Jean Martin. *The Coming of the Book: The Impact of Printing, 1450–1800.* Translated by David Gerard. London: Verso, 1958.

Ficino, Marsilio. *The Letters of Marsilio Ficino.* 10 vols. Translated by the members of the Language Department of the School of Economic Science. London: Shepheard-Walwyn, 1981.

Field, Arthur. *The Intellectual Struggle for Florence: Humanists and the Beginnings of the Medici Regime, 1420–1440.* Oxford: Oxford University Press, 2017.

———. *The Origins of the Platonic Academy of Florence.* Princeton: Princeton University Press, 1988.

Flannery, Melissa C. "San Jacopo di Ripoli Imprints at Yale." *Yale University Library Gazette* 63 (April 1989): pp. 114–31.

Flannery, Melissa C., Roger S. Wieck, and Frank H. Ellis. "Marginalia," *Yale University Library Gazette* 63 (October 1988): 71–77.

Ganz, Margery A. "A Florentine Friendship: Donato Acciaiuoli and Vespasiano da Bisticci." *Renaissance Quarterly* 43 (1990): pp. 372–83.

Hankins, James. "Cosimo de' Medici and the 'Platonic Academy.'" *Journal of the Warburg and Courtauld Institutes* 53 (1990): pp. 144–62.

———. *Humanism and Platonism in the Italian Renaissance.* 2 vols. Rome: Edizioni di Storia e Letteratura, 2003–4.

———. "The Myth of the Platonic Academy of Florence." *Renaissance Quarterly* 44 (Autumn 1991): pp. 429–75.

———. *Plato in the Italian Renaissance.* 2 vols. Leiden: Brill, 1990.

Hankins, James, and Ada Palmer. *The Recovery of Ancient Philosophy in the Renaissance: A Brief Guide.* Florence: Olschki, 2008.

Hofmann, Heinz. "Literary Culture at the Court of Urbino During the Reign of Federico da Montefeltro." *Humanistica Lovaniensia: Journal of Neo-Latin Studies* 57 (2008): pp. 5–59.

Howlett, Sophia. *Marsilio Ficino and His World.* New York: Palgrave Macmillan, 2016.

Kapr, Albert. *Johann Gutenberg: The Man and his Invention.* Translated by Douglas Martin. Aldershot, UK: Scolar Press, 1996.

Kristeller, P. O. "The First Printed Edition of Plato's Works and the Date of Its Publication (1484)." In *Science and History: Studies in Honor of Edward Rosen,* edited by Pawel Czartoryski and Erna Hilfstein, pp. 25–39. Wrocław: Polish Academy of Sciences Press, 1978.

Leader, Anne. *The Badia of Florence: Art and Observance in a Renaissance Monastery.* Bloomington: University of Indiana Press, 2012.

Margolis, Oren J. "The 'Gallic Crowd' at the 'Aragonese Doors': Donato Acciaiuoli's *Vita Caroli Magni* and the Workshop of Vespasiano da Bisticci." *I Tatti Studies in the Italian Renaissance* 17 (2014): pp. 241–82.

———. *The Politics of Culture in Quattrocento Europe: René of Anjou in Italy.* Oxford: Oxford University Press, 2016.

Marsh, David. *Giannozzo Manetti: The Life of a Florentine Humanist.* Cambridge, MA: Harvard University Press, 2019.

Martines, Lauro. *April Blood: Florence and the Plot Against the Medici.* London: Jonathan Cape, 2003.

Meserve, Margaret. "News from Negroponte: Politics, Popular Opinion, and Information Exchange in the First Decade of the Italian Press." *Renaissance Quarterly* 59 (Summer 2006): pp. 440–80.

Monfasani, John. *George of Trebizond: A Biography and a Study of His Rhetoric and Logic.* Leiden: Brill, 1976.

———. "The Pre- and Post-History of Cardinal Bessarion's 1469 *In Calumniatorem Platonis.*" In *"Inter graecos latinissimus, inter latinos graecissimus": Bessarion zwischen den Kulturen,* edited by Claudia Märtl, Christian Kaiser, and Thomas Ricklin, pp. 347–66. Berlin: Walter de Gruyter, 2013.

Najemy, John N. *A History of Florence, 1250–1575.* Oxford: Blackwell, 2008.

Nuovo, Angela. *The Book Trade in the Italian Renaissance.* Translated by Lydia G. Cochrane. Leiden: Brill, 2013.

Pius II: Commentaries. Edited by Margaret Meserve and Marcello Simonetta. 2 vols. Cambridge, MA: Harvard University Press, 2003 and 2007.

Poncet, Christophe. "Ficino's Little Academy of Careggi." *Bruniana & Campanelliana* 19 (2013): pp. 67–76.

Rees, Valery. "Ficino's Advice to Princes." In *Marsilio Ficino: His Theology, His Philosophy, His Legacy,* edited by Michael J. B. Allen and Valery Rees, with Martin Davies, pp. 339–57. Leiden: Brill, 2002.

Reeve, Michael D. "Classical Scholarship." In *The Cambridge Companion to Renaissance Humanism,* edited by Jill Kraye, pp. 20–46. Cambridge: Cambridge University Press, 1996.

Richardson, Brian. "The Debates on Printing in Renaissance Italy." *La Bibliofilía* 100 (May–December 1998): pp. 135–55.

———. *Printing, Writers and Readers in Renaissance Italy.* Cambridge: Cambridge University Press, 1999.

Rouse, Mary A., and Richard H. Rouse. *Cartolai, Illuminators, and Printers in Fifteenth-Century Italy.* Los Angeles: UCLA Research Library, 1988.

———. "Nicolaus Gupalatinus and the Arrival of Print in Italy." *La Bibliofilía* 88 (September–December 1986): pp. 221–51.

Simonetta, Marcello. *The Montefeltro Conspiracy: A Renaissance Mystery Decoded.* New York: Doubleday, 2008.

Strocchia, Sharon T. "Naming a Nun: Spiritual Exemplars and Corporate Identity in Florentine Convents, 1450–1530." In *Society and the Individual in Renaissance Florence,* edited by William J. Connell, pp. 215–50. Berkeley: University of California Press, 2002.

———. *Nuns and Nunneries in Renaissance Florence.* Baltimore: Johns Hopkins University Press, 2009.

———. "Savonarolan Witnesses: The Nuns of San Jacopo and the Piagnone Movement in Sixteenth-Century Florence." *Sixteenth Century Journal* 38 (Summer 2007): pp. 393–418.

Two Renaissance Book Hunters: The Letters of Poggius Bracciolini to Nicolaus de Niccolis. Edited and translated by Phyllis Walter Goodhart Gordan. New York: Columbia University Press, 1974.

Uhlendorf, B. A. "The Invention of Printing and Its Spread till 1470: With Special Reference to Social and Economic Factors." *Library Quarterly: Information, Community, Policy* 2 (July 1932): pp. 179–231.

Ullman, Berthold L. *The Origin and Development of Humanistic Script.* Rome: Edizioni di Storia e Letteratura, 1960.

Ullman, Berthold L., and Philip A. Stadter. *The Public Library of Renaissance Florence: Niccolò Niccoli, Cosimo de' Medici and the Library of San Marco.* Padua: Editrice Antenore, 1972.

Weddle, Saundra. "Identity and Alliance: Urban Presence, Spatial Privilege, and Florentine Renaissance Convents." In *Renaissance Florence: A Social History,* edited by Roger J. Crum and John T. Paoletti, pp. 394–412. Cambridge: Cambridge University Press, 2006.

Witt, Ronald. "What Did Giovannino Read and Write? Literacy in Early Renaissance Florence," *I Tatti Studies in the Italian Renaissance* 6 (1995): pp. 83–114.

Wittschier, Willy. "Vespasiano da Bisticci und Giannozzo Manetti." *Romanische Forschungen* 79 (1967): pp. 271–87.

Woodhouse, C. M. *George Gemistos Plethon: The Last of the Hellenes.* Oxford: Clarendon Press, 1986.

Notes

Chapter 1

1 See Robert Black, "Literacy in Florence, 1427," in David S. Peterson and Daniel E. Bornstein, eds., *Florence and Beyond: Culture, Society and Politics in Renaissance Italy: Essays in Honor of John M. Najemy* (Toronto: Center for Renaissance and Reformation Studies, 2008), pp. 195–210; and idem, *Education and Society in Florentine Tuscany: Teachers, Pupils and Schools, c.1250–1500* (Leiden: Brill, 2007), vol. 1, pp. 1–42. For literacy elsewhere in Europe: R. C. Allen, "Progress and Poverty in Early Modern Europe," *Economic History Review*, vol. 56 (2003), p. 415.

2 John N. Najemy, *A History of Florence, 1250–1575* (Oxford: Blackwell, 2008), pp. 45–46. Regarding the demand for works on the vernacular, see Ronald Witt, "What Did Giovannino Read and Write? Literacy in Early Renaissance Florence," *I Tatti Studies in the Italian Renaissance*, vol. 6 (1995), pp. 83–84, to which I am also indebted for information on schools and literacy.

3 Giovanni Morelli, quoted in Witt, "What Did Giovannino Read and Write?" p. 105.

4 Anne Leader, "The Tomb of a Bookseller in Early Renaissance Florence." I am grateful to Dr. Leader for sharing her draft of this article with me before its publication, and for supplying information on the Badia's tenants. For information on the Badia and the Street of Booksellers, I am also indebted to another of her works, *The Badia of Florence: Art and Observance in a Renaissance Monastery* (Bloomington and Indianapolis: Indiana University Press, 2012), especially p. 27.

5 The documents unfortunately contradict the myth, first propagated by a 1928 guidebook, that Vespasiano's shop occupied today's Via del Proconsolo n° 14: the lovely building with *pietra serena* quoins and the entablature featuring an open book at its apex. In fact, these premises, next door to what had actually been Vespasiano's shop, were occupied much later by Giunti, the publishers.

6 I am grateful to Anne Leader for supplying this detail (personal email communication, February 5, 2019).

7 Quoted in A. C. de la Mare, "New Research on Humanistic Scribes in Florence," in Annarosa Garzelli, ed., *Miniatura fiorentina del Rinascimento, 1440–1525: Un primo censimento*, 2 vols. (Florence: Giunta regionale toscana, 1985), vol. 1, p. 403.

8 The most comprehensive source for Vespasiano's biographical details, and the one from which I have taken the information in the following paragraphs, is Giuseppe M. Cagni, *Vespasiano da Bisticci e il suo Epistolario* (Rome: Edizioni di Storia e Letteratura, 1969), pp. 11–46. For evidence regarding the year of Vespasiano's birth, see p. 13.

9 On these debts, see ibid., p. 19; and Raymond de Roover, *The Rise and Decline of the Medici Bank, 1397–1494* (Cambridge, MA: Harvard University Press, 1963), p. 183. For salaries, see Richard A. Goldthwaite, *The Economy of Renaissance Florence* (Baltimore: The Johns Hopkins University Press, 2009), pp. 86–87.

10 This percentage is based on Giovanni Villani's estimate in his fourteenth–century chronicle: see his *Nuova Cronica*, ed. Giuseppe Porta (Milan: Guanda editore, 1991), vol. 3, p. 198. See the skeptical response of Paul F. Grendler in "What Piero Learned in School: Fifteenth-Century Vernacular Education," in Grendler, ed., *Renaissance Education Between Religion and Politics* (Aldershot, Hants: Ashgate, 2006), IV, note 6, pp. 2–3. For more optimistic appraisals: Gene Brucker, *Renaissance Florence* (Berkeley and Los Angeles: University of California Press, 1969), p. 223; Christopher Kleinhenz, ed., "Education," in *Medieval Italy: An Encyclopedia* (Abingdon, Oxon.: Routledge, 2004), pp. 354–55; and Witt, "What Did Giovannino Read and Write?" pp. 87–89.

11 See Piero Lucchi, "La Santacroce, il Salterio e il Babuino: Libri per imparare a leggere nel primo secolo della stampa," *Quaderni Storici*, vol. 13 (May–August, 1978), pp. 593–630.

12 Quoted in Eric Cochrane, *Florence in the Forgotten Centuries, 1527–1800: A History of Florence and the Florentines in the Age of the Grand Dukes* (Chicago: University of Chicago Press, 1973), p. 67.

13 Vespasiano da Bisticci, *Vite di Uomini Illustri del Secolo XV*, ed. Paolo d'Ancona and Erhard Aeschlimann (Milan: Hoepli, 1951), p. 83. Unless otherwise indicated, all quotations are from this edition. The incident described by Vespasiano almost certainly took place in 1439, when Cardinal Cesarini was in Florence for the Council of Ferrara-Florence.

14 Phyllis Walter Goodhart Gordan, ed. and trans., *Two Renaissance Book Hunters: The Letters of Poggius Bracciolini to Nicolaus de Niccolis* (New York: Columbia University Press, 1974), p. 85. For Poggio's complaints about the Roman Curia, see pp. 39 and 51.

15 *Vite di Uomini Illustri*, p. 443. Vespasiano met Niccoli before Cosimo de' Medici returned to Florence in October 1434, for he describes an incident with Niccoli that took place in the bookshop during Cosimo's exile.

16 Gordan, ed., *Two Renaissance Book Hunters*, p. 21.

17 *Vite di Uomini Illustri*, p. 438.

18 Ibid., p. 442.

19 Giannozzo Manetti, *Biographical Writings*, ed. and trans. Stefano U. Baldassarri and Rolf Bagemihl (Cambridge, MA: Harvard University Press, 2003), p. 129.

20 Quoted in Berthold L. Ullman and Philip A. Stadter, *The Public Library of Renaissance Florence: Niccolò Niccoli, Cosimo de' Medici and the Library of San Marco* (Padua: Editrice Antenore, 1972), p. 89.

21 *Vite di Uomini Illustri*, p. 439.

22 *Two Renaissance Book Hunters*, p. 93.

23 *Vite di Uomini Illustri*, p. 435.

24 Ibid., p. 295.

25 Ibid., p. 2.

26 Ibid., p. 340.

27 Cagni, *Vespasiano da Bisticci e il suo Epistolario*, p. 162.

Chapter 2

1 Ugolino Verino, "To Andrea Alamanni: In Praise of Poets and on the Splendor of His Time," in Stefano Ugo Baldassarri and Arielle Saiber, eds., *Images of Quattrocento Florence: Selected Writings in Literature, History, and Art* (New Haven: Yale University Press, 2000), p. 93.

2 Leonardo Bruni, "Panegyric of Florence," in Baldassari and Saiber, eds., *Images of Quattrocento Florence*, p. 40.

3 "Panegyric of Florence," in Baldassari and Saiber, eds., *Images of Quattrocento Florence*, p. 42.

4 Dante makes his comment in Book 1, chapter 3 of his *Convivio*.

5 Verino, "To Andrea Alamanni," in *Images of Quattrocento Florence*, p. 94.

6 *Vite di Uomini Illustri*, p. 3. Mai published the work as *Vitae CIII virorum illustrium, qui saeculo XV exiterunt*. Another dozen biographies were subsequently discovered in further manuscripts.

7 Jacob Burckhardt, *The Civilization of the Renaissance in Italy*, trans. S. G. C. Middlemore (Vienna: Phaidon Press, n.d.), p. 306, note 273.

8 Ibid., p. 89.

9 Thomas Albert Howard, "Jacob Burckhardt, Religion, and the Historiography of 'Crisis' and 'Transition,'" *Journal of the History of Ideas*, vol. 60 (January 1999), p. 150.

10 Quoted in Ludwig von Pastor, *Tagebücher—Briefe—Erinnerungen*, ed. Wilhelm Wühr (Heidelberg: F. H. Kerle, 1950), p. 275. Burckhardt described the importance of Vespasiano to Pastor, a fellow historian, who then recorded the comments in his diary.

11 Jules Michelet, *The Witch of the Middle Ages*, trans. L. J. Trotter (London: Woodfall and Kinder, 1863), p. 9.

12 Pierre de Nolhac, *Pétrarque e l'humanisme*, 2 vols. (Paris: Librairie Honoré Champion, 1907), vol. 1, p. 2. Nolhac attributes the phrase to the nineteenth-century scholar Ernest Renan.

13 *Petrarch: A Critical Guide to the Complete Works*, ed. Victoria Kirkham and Armando Maggi (Chicago: University of Chicago Press, 2009), p. 135.

14 Petrarch, *On His Own Ignorance*, in *The Renaissance Philosophy of Man*, ed. Ernst Cassirer, Paul Oskar Kristeller, and John Herman Randall (Chicago: University of Chicago Press, 1948), p. 115.

15 For Petrarch as the author of the phrase "Dark Ages," see Theodor E. Mommsen, "Petrarch's Conception of the 'Dark Ages,'" *Speculum*, vol. 17 (April 1942), pp. 226–42.

16 See Damasus Trapp, "'Moderns' and 'Modernists' in the MS Fribourg Cordeliers," *Augustianum*, vol. 26 (July 1965), pp. 241–70.

17 Fernand Braudel, *Civilization and Capitalism, 15th–18th Century*, vol. 3, *Perspective of the World*, trans. Siân Reynolds (London: Fontana, 1984), pp. 15–16.

18 Jean M. Grove and Roy Switsur, "Glacial Geological Evidence for the Medieval Warm Period," *Climatic Change*, vol. 30 (1994), pp. 1–27; and idem, *Little Ice Ages: Ancient and Modern*, 2 vols. (London: Routledge, 2004), vol. 1, p. 401.

19 Barbara Tuchman, *A Distant Mirror: The Calamitous 14th Century* (New York: Alfred A. Knopf, 1978).

20 See Grove, *Little Ice Ages: Ancient and Modern*; and idem, "The Onset of the 'Little Ice Age,'" in P. D. Jones et al., eds., *History and Climate: Memories of the Future?* (New York: Kluwer Academic/Plenum Publishers, 2001), pp. 153–85.

21 Jan Huizinga, *The Waning of the Middle Ages: A Study of the Forms of Life, Thought and Art in France and the Netherlands in the Fourteenth and Fifteenth Centuries* (Harmondsworth: Penguin, 1922).

22 Quoted in Edward Muir, *Ritual in Early Modern Europe* (Cambridge: Cambridge University Press, 2005), p. 120.

23 Quoted in Robert Coogan, "Petrarch's *Liber sine nomine* and a Vision of Rome in the Reformation," *Renaissance and Reformation/Renaissance et Réforme*, New Series, vol. 7 (February 1983), p. 5.

24 Quoted in Ernest Hatch Wilkins, *Life of Petrarch* (Chicago: University of Chicago Press, 1961), p. 201. For the laws regarding wolves, arrows, and feces, see Robert Brentano's amusing list of fourteenth-century statutes in *Rome Before Avignon: A Social History of Thirteenth-Century Rome* (Berkeley: University of California Press, 1990), pp. 130–31.

25 See Neal Gilbert, trans., "A Letter of Giovanni Dondi dall'Orologio to fra' Guglielmo Centueri: A Fourteenth Century Episode in the Quarrel of the Ancients and the Moderns," *Viator*, vol. 8 (1977), pp. 299–346.

26 Quoted in Mommsen, "Petrarch's Conception of the 'Dark Ages,'" p. 240 (translation slightly modified).

27 Manetti, *Biographical Writings*, p. 129.

28 James Hankins, *Plato in the Italian Renaissance*, 2 vols. (Leiden: Brill, 1990), vol. 1, p. 95.

29 *Vite di Uomini Illustri*, p. 249.

30 Aulus Gellius, *Attic Nights*, vol. 1, Books 1–5, trans. J. C. Rolfe, Loeb Classical Library 195 (Cambridge, MA: Harvard University Press, 1927), p. xxvii.

31 Ibid., p. 267.

32 Quoted in A. C. Clark, "The Reappearance of the Texts of the Classics," *The Library* (1921), pp. 20–21.

33 Quoted in Quintilian, "General Introduction," *The Orator's Education*, vol. 1, ed. and trans. Donald A. Russell, Loeb Classical Library 124 (Cambridge, MA: Harvard University Press, 2002), p. 2.

34 *The Orator's Education*, vol. 1, p. 51.

35 Ibid., p. 101.

36 Ibid., p. 57.

37 Ibid., p. 197.

38 Cicero, *On the Orator, Books 1–2*, trans. E. W. Sutton and H. Rackham, Loeb Classical Library 348 (Cambridge, MA: Harvard University Press, 1942), p. 23.

39 Quoted in Ronald G. Witt, *Coluccio Salutati and His Public Letters* (Geneva: Librairie Droz, 1976), p. 62.

40 *Le "Consulte" e "Pratiche" della Repubblica fiorentina nel Quattrocento*, ed. Elio Conti (Florence: Università di Firenze, 1981), vol. 1, p. 309.

41 Quoted in *Renaissance Debates on Rhetoric*, ed. and trans. Wayne A. Rebhorn (Ithaca: Cornell University Press, 2000), p. 19.

42 Quoted in C. Joachim Classen, "Quintilian and the Revival of Learning in Italy," *Humanistica Lovaniensia*, vol. 43 (1994), p. 79.

43 Quoted in Cornelia C. Coulter, "Boccaccio's Knowledge of Quintilian," *Speculum*, vol. 22 (October 1958), p. 491.

44 Quoted in Gordan, ed., *Two Renaissance Book Hunters*, p. 192.

45 For an excellent historical overview of how books were made, see Peter Stoicheff, "Materials and Meanings," in Leslie Howsam, ed., *The Cambridge Companion to the History of the Book* (Cambridge: Cambridge University Press, 2015), pp. 73–89.

46 For the myth, as well as what can be adduced from the available historical evidence, see Richard R. Johnson, "Ancient and Medieval Accounts of the 'Invention' of Parchment," *California Studies in Classical Antiquity*, vol. 3 (1970), pp. 115–22.

47 Martial, *Epigrams*, ed. and trans. D. R. Shackleton Bailey, Loeb Classical Library 94 (Cambridge, MA: Harvard University Press, 1993), p. 43.

48 Eusebius, *The Life of the Blessed Emperor Constantine* (London: Samuel Bagster and Sons, 1845), Book IV, pp. 203–4.

49 Propertius, *Elegies*, ed. and trans. G. P. Goold, Loeb Classical Library 18 (Cambridge, MA: Harvard University Press, 1990), p. 343; and Martial, *Epigrams*, p. 171.

50 Quoted in Thomas M. Tanner, "A History of Early Christian Libraries from Jesus to Jerome," *The Journal of Library History (1974–1987)*, vol. 14 (Fall 1979), p. 415.

51 Clement of Alexandria, "The Stromata, or Miscellanies," in Jason L. Sanders, ed., *Greek and Roman Philosophy After Aristotle* (New York: The Free Press, 1966), p. 306.

52 Quoted in Arthur Field, *The Intellectual Struggle for Florence: Humanists and the Beginnings of the Medici Regime, 1420–1440* (Oxford: Oxford University Press, 2017), p. 104.

Chapter 3

1 Manetti, *Biographical Writings*, p. 127. For Poggio's warnings, see Gordan, ed., *Two Renaissance Book Hunters*, p. 47. The monk friend was Ambrogio Traversari—who was happy to comply.

2 Niccoli's list can be found in Rodney P. Robinson, "The Inventory of Niccolò Niccoli," *Classical Philology*, vol. 16 (July 1921), pp. 251–55.

3 The friend was Cencio Rustici: see Gordan, ed., *Two Renaissance Book Hunters*, p. 188.

4 *Vite di Uomini Illustri*, pp. 250–51.

5 *Two Renaissance Book Hunters*, p. 26.

6 *Vite di Uomini Illustri*, p. 292.

7 Quoted in Clark, "The Reappearance of the Texts of the Classics," p. 14.

8 Quoted in Alison I. Beach, *Women as Scribes: Book Production and Monastic Reform in Twelfth-Century Bavaria* (Cambridge: Cambridge University Press, 2004), p. 14.

9 Quoted in ibid.

10 For this figure, see Bernhard Bischoff, *Manuscripts and Libraries in the Age of Charlemagne*, ed and trans. Michael Gorman (Cambridge: Cambridge University Press, 1994), p. 116.

11 *Poetry of the Carolingian Renaissance*, ed. and trans. Peter Godman (Norman: University of Oklahoma Press, 1985), pp. 192–93.

12 Poggio's friend Cencio Rustici reports seeing the book written on bark (*Two Renaissance Book Hunters*, p. 188). Unfortunately he fails to tell us what it contained. For the number of scribes at Saint Gall, see Walter Horn and Ernest Born, *The Plan of Saint Gall: A Study of the Architecture and Economy of, and Life in, a Paradigmatic Carolingian Monastery*, 3 vols. (Berkeley and Los Angeles: University of California Press, 1979), vol. 1, p. 151.

13 Quoted in Courtney M. Booker, *Past Convictions: The Penance of Louis the Pious and the Decline of the Carolingians* (Philadelphia: University of Pennsylvania Press, 2009), pp. 5–6.

14 *Two Renaissance Book Hunters*, p. 188.

15 *Vite di Uomini Illustri*, p. 292.

16 Ibid., p. 292.

17 *Two Renaissance Book Hunters*, p. 192.

18 For Barbaro's letter, see ibid., pp. 197–201.

19 *Vite di Uomini Illustri*, p. 293.

Chapter 4

1 *Vite di Uomini Illustri*, p. 9.

2 For this story, see ibid., p. 8.

3 Ibid.

4 *Two Renaissance Book Hunters*, p. 46.

5 *Vite di Uomini Illustri*, p. 291.

6 Ibid., pp. 165 and 166.

7 Quoted in Witt, "What Did Giovannino Read and Write?" p. 104. For the works on morality and patriotism, see ibid., pp. 103–4.

8 *Vite di Uomini Illustri*, p. 259.

9 On the possibility of Manetti serving as Vespasiano's tutor, see Heinz Willy Wittschier, "Vespasiano da Bisticci und Giannozzo Manetti," *Romanische Forschungen*, 79. Bd., H. 3 (1967), pp. 271–87.

10 *Vite di Uomini Illustri*, p. 439.

11 See A. C. de la Mare, "Vespasiano da Bisticci, Historian and Bookseller," 2 vols. (PhD diss., London University, 1965), vol. 2, p. 301.

12 *Vite di Uomini Illustri*, p. 349.

13 Ibid., p. 316.

14 Antonio de Ferraris (Il Galateo), quoted in Mattia Cosimo Chiriatti, "Lo Scriptorium di San Nicola di Casole (Otranto, Lecce) e il suo *Typikon* (Codex Taurinensis Graecus 216): Un'Analisi Storico-Letteraria," *Hortus Artium Medievalium*, vol. 23 (January 2017), p. 428.

15 Barry Baldwin, "Greek in Cicero's Letters," *Acta Classica*, vol. 35 (1992), p. 1.

16 Quoted in Avi Sharon, "A Crusade for the Humanities: From the Letters of Cardinal Bessarion," *Arion: A Journal of Humanities and the Classics*, Third Series, vol. 19 (Fall 2011), p. 163.

17 Giovanni Aurispa, quoted in George J. Kovtun, "John Lascaris and the Byzantine Connection," *The Journal of Library History (1974–1987)*, vol. 12 (Winter 1977), p. 20; and Leonardo Bruni, quoted in Hans Baron, *The Crisis of the Early Italian Renaissance: Civic Humanism and Republican Liberty in an Age of Classicism and Tyranny*, 2 vols. (Princeton: Princeton University Press, 1955, revised edition 1966), p. 193.

18 *Two Renaissance Book Hunters*, p. 141; Manetti, *Biographical Writings*, p. 121.

19 Quoted in Field, *The Intellectual Struggle for Florence*, pp. 195–96.

20 *Vite di Uomini Illustri*, p. 351.

21 Quoted in Andrea Rizzi, "Violent Language in Early Fifteenth-Century Italy," in Susan Broomhall and Sarah Finn, eds., *Violence and Emotions in Early Modern Europe* (London: Routledge, 2016), p. 145.

22 Quoted in Diana Robin, *Filelfo in Milan: Writings 1451–1477* (Princeton: Princeton University Press, 1991), pp. 19–20.

23 *Vite di Uomini Illustri*, pp. 294 and 388.

24 For the early history of the family, see Gene Brucker, "The Medici in the Fourteenth Century," *Speculum*, vol. 32 (January 1957), pp. 1–26.

25 For this story, see *Vite di Uomini Illustri*, p. 437.

26 Ibid., p. 437.

27 Quoted in Najemy, *A History of Florence*, p. 275.

28 *Vite di Uomini Illustri*, p. 408.

29 Quoted in Najemy, *A History of Florence*, p. 277.

30 *Vite di Uomini Illustri*, p. 409.

31 Ibid., p. 419.

32 Cagni, ed., *Vespasiano da Bisticci e il suo Epistolario*, p. 159.

33 Respectively, Cagni, *Vespasiano da Bisticci e il suo Epistolario*, p. 19; and De La Mare, "Vespasiano da Bisticci, Historian and Bookseller," vol. 1, p. 16.

34 *Vite di Uomini Illustri*, p. 422.

35 Ibid., p. 406.

36 Ibid., p. 418.

37 Eltjo Buringh, *Medieval Manuscript Production in the Latin West: Explorations with a Global Database* (Leiden: Brill, 2011), pp. 416 (for the cardinals) and 216 (for the German monasteries).

38 *Vite di Uomini Illustri*, p. 444.

39 Ibid., p. 12.

40 *Pius II: Commentaries*, ed. Margaret Meserve and Marcello Simonetta, 2 vols. (Cambridge, MA: Harvard University Press, 2003), vol. 1, p. 317.

41 "The Sacred Exchange between Saint Francis and Lady Poverty," *Francis of Assisi: Early Documents*, vol. 1, ed. Regis J. Armstrong, J. A. Wayne Hellmann, and William J. Short (New York: New City Press, 1999), p. 536.

42 Quoted in Daniela Da Rosa, *Coluccio Salutati: Il cancelliere e il pensatore politico* (Florence: La Nuova Italia, 1980), p. 38.

43 Quoted in Hans Baron, *In Search of Florentine Civic Humanism* (Princeton: Princeton University Press, 1988), vol. 1, p. 231.

44 *Nicomachean Ethics*, trans. Harris Rackham, Loeb Classical Library 73 (Cambridge, MA: Harvard University Press, 1926), pp. 205–7.

45 Quoted in Peter Howard, "Preaching Magnificence in Renaissance Florence," *Renaissance Quarterly*, vol. 61 (Summer 2008), p. 352.

46 *Vite di Uomini Illustri*, p. 410.

47 Ibid.

48 Quoted in Laura Jacobus, *Giotto and the Arena Chapel: Art, Architecture and Experience* (London: Harvey Miller, 2008), p. 8.

49 Quoted in Ullman and Stadter, *The Public Library of Renaissance Florence*, p. 4.

Chapter 5

1 *Vite di Uomini Illustri*, p. 15.

2 Ibid., pp. 13–14.

3 Quoted in Joseph Gill, *The Council of Florence* (Cambridge: Cambridge University Press, 1959), p. 184. For a discussion of his costume and the influence of his impressive bearing, see Rosamond E. Mack, *Bazaar to Piazza: Islamic Trade and Italian Art, 1300–1600* (Berkeley and Los Angeles: University of California Press, 2002), p. 154.

4 Quoted in Gill, *The Council of Florence*, p. 189.

5 Alessandro d'Ancona, *Origini del teatro italiano* (Turin: Loescher, 1891), vol. 1, p. 248 (my translation). Abraham of Souzdal's description of the two performances is given on pp. 248–53.

6 *Pero Tafur: Travels and Adventures, 1435–1439*, ed. and trans. Malcolm Letts (London: George Routledge & Sons, 1926), p. 227.

7 C. M. Woodhouse, *George Gemistos Plethon: The Last of the Hellenes* (Oxford: Clarendon Press, 1986), p. 154.

8 Quoted in Joseph Gill, *Personalities of the Council of Florence* (Oxford: Blackwell, 1964), p. 105.

9 Quoted in Eugenio Garin, *History of Italian Philosophy*, ed. and trans. Giorgio Pinton, 2 vols. (Amsterdam: Rodopi, 2008), vol. 1, p. 222.

10 For Pletho's possession of this manuscript, see James Hankins, "Cosimo de' Medici and the 'Platonic Academy,'" *Journal of the Warburg and Courtauld Institutes*, vol. 53 (1990), p. 157.

11 Quoted in Serge-Thomas Bonino, O.P., "Aristotelianism and Angelology According to Aquinas," in Gilles Emery, O.P., and Matthew Levering, eds., *Aristotle in Aquinas's Theology* (Oxford: Oxford University Press, 2015), p. 33.

12 Dante, *Il Convivio*, trans. Richard H. Lansing (New York: Garland, 1990), IV, 6.16.

13 *On His Ignorance*, in *The Renaissance Philosophy of Man*, p. 102.

14 Marsilio Ficino, quoted in Sophia Howlett, *Marsilio Ficino and His World* (New York: Palgrave Macmillan, 2016), p. 40.

15 See James Hankins, "Plato in the Middle Ages," in Joseph Strayer, ed., *Dictionary of the Middle Ages* (New York: Charles Scribner's Sons, 1987), vol. 9, pp. 694–704.

16 John Whittaker, "*Parisinus Graecus 1962* and the Writings of Albinus," *Phoenix*, vol. 28 (Autumn 1974), p. 321.

17 Plato, *Euthyphro. Apology. Crito. Phaedo*, trans. Chris Emlyn-Jones and William Preddy, Loeb Classical Library 36 (Cambridge, MA: Harvard University Press, 2017), p. 181.

18 Quoted in Hankins, "Cosimo de' Medici and the 'Platonic Academy,'" p. 157.

19 Quoted in ibid., p. 150.

20 Diogenes Laertius, *Lives of Eminent Philosophers*, vol. 1, p. 445.

21 For Aristotle's criticisms of Plato, see Harold F. Cherniss, *Aristotle's Criticism of Plato and the Academy* (Baltimore: Johns Hopkins University Press, 1944). I am also indebted to the summary of the history of the "bipolar" philosophical debate given by John Monfasani; see "Marsilio Ficino and the Plato-Aristotle Controversy," in Michael J. B. Allen and Valery Rees with Martin Davies, eds., *Marsilio Ficino: His Theology, His Philosophy, His Legacy* (Leiden: Brill, 2002), pp. 179–83.

22 Aristotle, *Metaphysics*, vol. 1: Books 1–9, trans. Hugh Tredennick, Loeb Classical Library 271 (Cambridge, MA: Harvard University Press, 1933), p. 69. For Aristotle, form could exist without matter in one case, that of God, whom Aristotle conceived as "pure active thought thinking itself." My thanks to Angie Hobbs for her help in clarifying some of the issues in these paragraphs.

23 James Hankins, *Humanism and Platonism in the Italian Renaissance* (Rome: Edizioni di Storia e Letteratura, 2003), vol. 1, p. 21.

24 Quoted in Charles L. Stinger, *Humanism and the Church Fathers: Ambrogio Traversari (1386–1439) and Christian Antiquity in the Italian Renaissance* (Albany: State University of New York Press, 1977), p. 75.

25 Diogenes Laertius, *Lives of Eminent Philosophers*, vol. 1, pp. 276–79.

26 Quoted in Field, *The Intellectual Struggle for Florence*, p. 160.

27 Diogenes Laertius, *Lives of Eminent Philosophers*, vol. 1, p. 451.

28 Bruni's more flattering approach to Aristotle is given in Gary Ianziti, "Leonardo Bruni and Biography: The *Vita Aristotelis*," *Renaissance Quarterly*, vol. 55 (Autumn 2002), pp. 805–32.

29 Quoted in Field, *The Intellectual Struggle for Florence*, p. 163.

30 Plato, *The Republic*, ed. and trans. Chris Emlyn-Jones and William Preddy, Loeb Classical Library 237 (Cambridge, MA: Harvard University Press, 2013), vol. 1, p. 479.

31 Quoted in Garin, *The History of Italian Philosophy*, vol. 1, p. 170.

32 Xenophon, *Memorabilia. Oeconomicus. Symposium. Apology*, trans. E. C. Marchant and O. J. Todd, revised by Jeffrey Henderson, Loeb Classical Library 168 (Cambridge, MA: Harvard University Press, 2013), p. 9.

33 Plato, *The Republic*, vol. 2, p. 117.

34 For the anxious reception of Plato in the first half of the twentieth century, see William Chase Green, "Platonism and Its Critics," *Harvard Studies in Classical Philology*, vol. 61 (Cambridge, MA: Harvard University Press, 1953), pp. 39–71.

35 *The Republic*, vol. 1, pp. 475–76, 549, and 551. For the "philosopher-queen," see Susan Moller Okin, "Philosopher Queens and Private Wives: Plato on Women and the Family," *Philosophy and Public Affairs*, vol. 6 (Summer 1977), pp. 345–69.

36 For a summary of Pletho's criticisms, see John Wilson Taylor, *Georgius Gemistus Pletho's Criticism of Plato and Aristotle* (Menasha, WI: George Banta, 1921), p. 29.

37 Quoted in Woodhouse, *George Gemistos Plethon*, p. 213.

38 Galileo Galilei, *Dialogue Concerning the Two Chief World Systems*, trans. Stillman Drake (Berkeley and Los Angeles: University of California Press, 1962), p. 108.

39 Gennadios Scholarios, quoted in Woodhouse, *George Gemistos Plethon*, p. 166. For possible candidates, see pp. 162–64.

40 *Vite di Uomini Illustri*, p. 145.

41 Quoted in *The History of the Council of Florence*, trans. Basil Popoff, ed. J. M. Neale (London, 1861), pp. 144–45.

42 See *The History of the Council of Florence*, pp. 93–96.

43 Quoted in ibid., pp. 98–99.

44 Quoted in John Monfasani, "A Tale of Two Books: Bessarion's 'In Calumniatorem Platonis' and George of Trebizond's 'Comparatio Philosophorum Platonis et Aristotelis,'" *Renaissance Studies*, vol. 22 (February 2008), p. 3, note 15.

Chapter 6

1 Cécile Caby, "Lettere e raccolte epistolari di Girolamo Aliotti († 1480): Pratiche dis-
 corsive e strategie sociali di un monaco umanista," *Nuovi territori della lettera tra XV e
 XVI secolo Atti del Convegno internazionale FIRB 2012* (Venice, November 11–12, 2014),
 ed. Filippo Bognini, *Filologie medievali e moderne*, vol. 11 (2016), p. 109.

2 Pliny the Younger, *Letters*, trans. Betty Radice, vol. 1, Books 1–7, Loeb Classical Li-
 brary 55 (Cambridge, MA: Harvard University Press, 1969), p. 175.

3 Pliny the Younger, *Letters*, p. 179.

4 For Pliny the Younger's description of his uncle's last expedition, see *Letters*, pp.
 427–33.

5 Pliny the Elder, *Natural History*, 10 vols., trans. H. Rackham, vol. 1, books 1–2, Loeb
 Classical Library 330 (Cambridge, MA: Harvard University Press, 1938), p. 9.

6 *Natural History*, Loeb Classical Library 352, vol. 2, books 3–7, p. 521.

7 Quoted in Albert Derolez, "The Script Reform of Petrarch: An Illusion?" in John
 Haines and Randall Rosenfeld, eds., *Music and Medieval Manuscripts: Paleography and
 Performance* (Abingdon: Routledge 2016), p. 5.

8 Quoted in Susan Rankin, *Writing Sounds in Carolingian Europe: The Invention of Musical
 Notation* (Cambridge: Cambridge University Press, 2018), p. 346.

9 See Chiriatti, "Lo Scriptorium di San Nicola di Casole," p. 432.

10 Winifred Marry, "The Mediaeval Scribe," *Classical Journal*, vol. 48 (March 1953), p. 210.

11 Quoted in A. C. de la Mare, "Vespasiano da Bisticci as a Producer of Classical Manu-
 scripts in Fifteenth-Century Florence," in Claudine A. Chavannes-Mazel and Marga-
 ret M. Smith, eds., *Medieval Manuscripts of the Latin Classics: Production and Use* (Los
 Altos Hills, CA: Anderson-Lovelace, 1996), p. 182.

12 De la Mare, "Vespasiano da Bisticci, Historian and Bookseller," vol. 2, p. 301.

13 For the rent of a house in Florence, see Gene Brucker, ed., *The Society of Renaissance
 Florence: A Documentary Study* (Toronto: University of Toronto Press, 1998), p. 2. For
 the wages of errand boys: Patricia Lee Rubin, *Images and Identity in Fifteenth-Century
 Florence* (New Haven: Yale University Press, 2007), p. 72. For Vespasiano's sale to Jouf-
 froy: De la Mare, "Vespasiano da Bisticci, Historian and Bookseller," vol. 2, p. 300.

14 The scholar was Angelo Poliziano: see Peter E. Knox and J. C. McKeown, eds., *The
 Oxford Anthology of Roman Literature* (Oxford: Oxford University Press, 2013), p. 408.

15 De la Mare, "Vespasiano da Bisticci, Historian and Bookseller," vol. 1, p. 93.

16 See Leader, *The Badia of Florence: Art and Observance in a Renaissance Monastery*, p. 90.

17 Gordan, ed., *Two Renaissance Book Hunters*, pp. 98–99.

18 *Vite di Uomini Illustri*, p. 145.

19 Quoted in John L. Flood and David J. Shaw, *Johannes Sinapius (1505–1560): Hellenist
 and Physician in Germany and Italy* (Geneva: Librairie Droz, 1997), pp. 10–11.

20 *Vite di Uomini Illustri*, p. 163. All quotations are from this biography by Vespasiano,
 pp. 163–64. A. C. de la Mare dates Grey's first visit to Florence to 1442: "Vespasiano da
 Bisticci and Gray," *Journal of the Warburg and Courtauld Institutes*, vol. 20 (January–
 June 1957), p. 174.

21 Roy Martin Haines, "Gray, William (c. 1388–1436)," *Oxford Dictionary of National Biog-
 raphy*, online edition.

22 Quoted in Raoul Morçay, "La Cronaca del Convento Fiorentino di San Marco: La parte più antica, dettata da Giuliano Lapaccini," *Archivio Storico Italiano*, vol. 71 (1913), p. 14.

23 Quoted in Allie Terry-Fritsch, "Florentine Convent as Practiced Place: Cosimo de' Medici, Fra Angelico, and the Public Library of San Marco," *Bowling Green State University, Art History Faculty Publications*, vol. 1 (2012), p. 237.

24 Plutarch, *Lives*, vol. 2, trans. Bernadotte Perrin, Loeb Classical Library 47 (London: W. Heinemann, 1914), p. 605.

25 Pliny the Younger, *Natural History*, vol. 10, Books 33–35, Loeb Classical Library 394, p. 267.

26 Quoted in Matthew Nicholls, "Roman Libraries as Public Buildings in the Cities of the Empire," in Jason König, Katerina Oikonomopoulou, and Greg Wolff, eds., *Ancient Libraries* (Cambridge: Cambridge University Press, 2013), p. 261.

27 Aulus Gellius, *Attic Nights*, vol. 3, trans. J. C. Rolfe, Loeb Classical Library 212 (Cambridge, MA: Harvard University Press, 1927), pp. 363–65.

28 John Willis Clark, *The Care of Books: An Essay on the Development of Libraries and Their Fittings, from the Earliest Times to the End of the Eighteenth Century* (Cambridge: Cambridge University Press, 1901), pp. 206–7.

29 For these stipulations, see Ullman and Stadter, *The Public Library of Renaissance Florence*, pp. 12–13. The desks and benches have long since disappeared from San Marco. My description is based on the similar furnishings in the Biblioteca Malatestiana, undoubtedly based on those at San Marco.

30 Ullman and Stadter, *The Public Library of Renaissance Florence*, p. 61.

31 *Vite di Uomini Illustri*, p. 412.

32 Ibid., pp. 23 and 27.

33 Quoted in De la Mare, "Vespasiano da Bisticci, Historian and Bookseller," vol. 2, p. 399.

34 Ibid., p. 298.

35 Giuseppe Carlo di Scipio, "Giovanni Sercambi's Novelle: Sources and Popular Traditions," *Merveilles & contes*, vol. 2 (May 1988), p. 26.

36 Seneca, *De Tranquillitate Animi*, in *Moral Essays*, vol. 2, trans. John W. Basore, Loeb Classical Library 254 (Cambridge: Harvard University Press, 1932), p. 249; and Petrarch, *Petrarch: Four Dialogues for Scholars*, ed. and trans. Conrad H. Rawski (Cleveland: Press of Western Reserve University, 1967), p. 31.

37 See Michael von Albrecht, *Cicero's Style: A Synopsis, Followed by Selected Analytic Studies* (Leiden: Brill, 2003), p. 156.

38 Cassius Dio, *Roman History*, vol. 5: Books 46–50, trans. Earnest Cary and Herbert B. Foster, Loeb Classical Library 82 (Cambridge, MA: Harvard University Press, 1917), pp. 131–33.

39 For the changing views of Cicero, see Hans Baron, "The Memory of Cicero's Roman Civic Spirit in the Medieval Centuries and in the Florentine Renaissance," in *In Search of Florentine Civic Humanism*, vol. 1: *Essays on the Transition from Medieval to Modern Thought* (Princeton: Princeton University Press, 1998), pp. 94–133.

40 Quoted in ibid., p. 116.

41 *Vite di Uomini Illustri*, p. 165.

42 Balliol College, Oxford, MS 248E, folio 251r. This is the first dated work in the five-volume set, though it may not have been the first of the manuscripts to be completed. The five volumes are Balliol MS 248A–E.

43 Quoted in Christopher Celenza, *The Intellectual World of the Italian Renaissance: Language, Philosophy and the Search for Meaning* (Cambridge: Cambridge University Press, 2018), p. 138.

Chapter 7

1 See *The Opera of Bartolomeo Scappi (1570): L'arte et prudenza d'un maestro cuoco (The Art and Craft of a Master Cook)*, trans. Terence Scully (Toronto: University of Toronto Press, 2008).

2 Margaret M. Smith, "The Design Relationship Between the Manuscript and the Incunable," in *A Millenium of the Book: Production, Design & Illustration in Manuscript & Print*, ed. Robin Myers and Michael Harris (Winchester, DE: Oak Knoll Press, 1994), p. 31.

3 Quoted in Leila Avrin, *Scribes, Script, and Books: The Book Arts from Antiquity to the Renaissance* (London: The British Library, 1991), p. 224.

4 A. C. de la Mare, "New Research on Humanistic Scribes in Florence," p. 410. A florin was worth roughly eighty soldi in the first half of the fifteenth century: see Brucker, ed., *The Society of Renaissance Florence: A Documentary Study*, p. 2.

5 John Henderson, *Piety and Charity in Late Medieval Florence* (Chicago: University of Chicago Press, 1997), p. 267.

6 De la Mare, "Vespasiano da Bisticci, Historian and Bookseller," vol. 1, p. 207.

7 De la Mare writes that the rates went from as low as twenty-five soldi to one florin per quire: "New Research on Humanistic Scribes in Florence," p. 419.

8 See Modesto Fiaschini and Roberto Rusconi, eds., *Pagine di Dante: Le edizioni della Divina Commedia dal torchio al computer* (Perugia: Electra, 1989), pp. 52–53.

9 De la Mare, "New Research on Humanistic Scribes in Florence," p. 421.

10 De la Mare, "Vespasiano da Bisticci, Historian and Bookseller," vol. 1, p. 165.

11 For Ser Antonio's manuscripts, see B. L. Ullman, *The Origin and Development of Humanistic Script* (Rome: Edizioni di Storia e Letteratura, 1960), pp. 99–104.

12 William Jerome Wilson, "Manuscript Cataloguing," *Traditio*, vol. 12 (1956), p. 479.

13 Oxford, New College MS 121, fol. 376v, quoted in M. B. Parkes, *English Cursive Book Hands, 1250–1500* (Oxford: Clarendon Press, 1969), p. xiii (my translation).

14 Quoted in Alfred W. Pollard, *An Essay on Colophons with Specimens and Translations* (Chicago: The Caxton Club, 1905), p. xv.

15 Quoted in Brian Richardson, *Women and the Circulation of Texts in Renaissance Italy* (Cambridge: Cambridge University Press, 2020), p. 100.

16 For these colophons, see Ullman, *The Origins and Development of Humanistic Script*, pp. 99–100.

17 *The Book of the Art of Cennino Cennini: A Contemporary Practical Treatise on Quattrocento Painting*, trans. Christiana J. Herringham (London: George Allen, 1899), pp. 9 and 11.

18 Mary Philadelphia Merrifield, ed., *Original treatises, dating from the XIIth to XVIIIth centuries on the arts of painting, in oil, miniature, mosaic, and on glass; of gilding, dyeing, and the preparation of colors and artificial gems* (London: J. Murray, 1849), p. 590.

19 Quoted in H. J. Chaytor, *From Script to Print: An Introduction to Medieval Vernacular Literature* (Cambridge: Heffer & Sons, 1945), p. 14.

20 Derolez, "The Script Reform of Petrarch," p. 5.

21 Quoted in Martin Davies, "Humanism in Script and Print," in Jill Kraye, ed., *The Cambridge Companion to Renaissance Humanism* (Cambridge: Cambridge University Press, 1996), p. 48.

22 Quoted in Davies, "Humanism in Script and Print," p. 48. The manuscript is Bibliothèque nationale de France, Lat. 1989.

23 *Letters to Atticus*, vol. 2, ed. and trans. D. R. Shackleton Bailey, Loeb Classical Library 8 (Cambridge, MA: Harvard University Press, 1999), p. 171. Davies writes that it is an "open question" whether the early humanists truly believed the ancient Romans had written in this script ("Humanism in Script and Print," p. 49).

24 Teresa De Robertis, "I primi anni della scrittura umanistica: Materiali per unaggiornamento," in Robert Black, Jill Kraye, and Laura Nuvoloni, eds., *Palaeography, Manuscript Illumination and Humanism in Renaissance Italy: Studies in Memory of A. C. de la Mare* (London: Warburg Institute, 2016), p. 62.

25 A. C. de la Mare, *The Handwriting of Italian Humanists* (Oxford: Printed at the University Press for the Association internationale de bibliophilie, 1973), pp. 69–70; De Robertis, "I primi anni della scrittura umanistica," p. 69.

26 *Two Renaissance Book Hunters*, pp. 96, 119, and 134.

27 See the list compiled by De Robertis, "I primi anni della scrittura umanistica," pp. 65–74.

28 Francis Ames-Lewis, "The Inventories of Piero di Cosimo de' Medici's Library," *La Bibliofilia*, vol. 84 (1982), p. 106.

Chapter 8

1 For these possibilities, see De la Mare, "Vespasiano da Bisticci, Historian and Bookseller," vol. 1, p. 116.

2 Quoted in ibid., p. 117.

3 Quoted in Margery A. Ganz, "A Florentine Friendship: Donato Acciaiuoli and Vespasiano da Bisticci," *Renaissance Quarterly*, vol. 43 (1990), p. 372.

4 Quoted in De la Mare, "Vespasiano da Bisticci, Historian and Bookseller," vol. 1, p. 41.

5 De la Mare, "New Research on Humanistic Scribes in Florence," p. 403, note 60.

6 *Vite di Uomini Illustri*, p. 32.

7 Ibid., pp. 30 and 31.

8 Ibid., pp. 33 and 34.

9 Ibid., p. 35.

10 Quoted in Edward Gibbon, *The History of the Decline and Fall of the Roman Empire*, vol. 8, ed. William Smith (Boston: J. Murray, 1855), pp. 267 and 268. For the scavenging of stone, see Roberto Weiss, *The Renaissance Discovery of Classical Antiquity* (Oxford: Basil Blackwell, 1969), p. 9.

11 Quoted in Gibbon, *The History of the Decline and Fall*, vol. 8, p. 281.

12 *Pero Tafur: Travels and Adventures*, p. 36.

13 *Vite di Uomini Illustri*, p. 35.

14 Quoted in Eugène Müntz and Paul Fabre, *La Bibliothèque du Vatican au XVe siècle* (Paris, 1887), pp. 47–48.

15 *Vite di Uomini Illustri*, p. 39.

16 Quoted in Gaetano Milanesi, *Nuove indagini con documenti inediti per servire alla storia della miniatura italiana* (Florence, 1850), pp. 327–28.

17 Jonathan J. G. Alexander, *Medieval Illuminators and Their Methods of Work* (New Haven and London: Yale University Press, 1992), pp. 56 and 59.

18 See *The Book of the Art of Cennino Cennini*, p. 54.

19 Quoted in Zoltán Haraszti, "Medieval Manuscripts," *The Catholic Historical Review*, vol. 14 (July 1928), p. 242.

20 *The Book of the Art of Cennino Cennini*, pp. 47 and 50.

21 Ibid., p. 50.

22 For an example of cobalt blue used in a medieval manuscript, see Debbie Lauwers, Vincent Cattersel et al., "Pigment identification of an illuminated mediaeval manuscript *De Civitate Dei* by means of a portable Raman equipment," *Journal of Raman Spectroscopy*, vol. 45 (2014), pp. 1266–71.

23 Spike Bucklow, "The Trade in Colors," in Stella Panayotova, ed., *Color: The Art & Science of Illuminated Manuscripts* (London: Harvey Miller, 2016), p. 61.

24 *The Book of the Art of Cennino Cennini*, p. 40.

25 Quoted in Alixe Bovey, *Monsters and Grotesques in Medieval Manuscripts* (London: British Library, 2002), p. 42.

Chapter 9

1 De la Mare, "Vespasiano da Bisticci, Historian and Bookseller," vol. 1, p. 221.

2 Ibid., p. 118.

3 *Vite di Uomini Illustri*, p. 95.

4 "Lamento di'Italia per la Presa d'Otranto fatta dai Turchi nel 1480," in Ludovico Frati, ed., *Vite di Uomini Illustri del secolo XV*, 3 vols. (Bologna: Romagnoli-Dall'Acqua, 1892), vol. 3, p. 310.

5 Quoted in Kenneth M. Setton, *The Papacy and the Levant, 1204–1571*, vol. 2, *The Fifteenth Century* (Philadelphia: American Philosophical Society, 1978), p. 130.

6 Franz Babinger, *Mehmed the Conqueror and His Time*, trans. Ralph Manheim, ed. William C. Hickman (Princeton: Princeton University Press, 1978), p. 96.

7 Quoted in Setton, *The Papacy and the Levant*, vol. 2, p. 150.

8 Quoted in James Hankins, "Renaissance Crusaders: Humanist Crusade Literature in the Age of Mehmed II," *Dumbarton Oaks Papers*, vol. 49, *Symposium on Byzantium and the Italians, 13th–15th Centuries* (1995), p. 122.

9 Quoted in Sharon, "A Crusade for the Humanities: From the Letters of Cardinal Bessarion," p. 165.

10 See Mustafa Soykut, "Note sui rapporti tra Italia, Islam e impero ottomano (secoli XV–XVII)," *Archivio Storico Italiano*, vol. 169 (April–June 2011), pp. 227–28.

11 Quoted in Terence Spencer, "Turks and Trojans in the Renaissance," *The Modern Language Review*, vol. 47 (July 1952), p. 331. The authenticity of this letter, now lost, is in doubt.

12 Quoted in Johannes Koder, "Romaioi and Teukroi, Hellenes and Barbaroi, Europe and Asia: Mehmed the Conqueror—Kayser–i Rum and Sulṭān al-barrayn wa-l-bahrayn," in *Athens Dialogues E-Journal*, available online at http://athensdialogues.chs.harvard .edu/cgi–bin/WebObjects/athensdialogues.woa/wa/dist?dis=21.

13 Quoted in Soykut, "Note sui rapporti tra Italia, Islam e impero ottomano," p. 229. For Pliny: *Natural History*, vol. 2, p. 377.

14 See Kenneth M. Setton, *Western Hostility to Islam and Prophecies of Turkish Doom* (Philadelphia: American Philosophical Society, 1992), p. 1.

15 *Pius II: Commentaries*, vol. 1, p. 211.

16 See Dimitri Gutas, *Greek Thought, Arabic Culture: The Graeco-Arabic Translation Movement in Baghdad and Early Abbasid Society* (London: Routledge, 1998), and Jonathan Lyons, *The House of Wisdom: How the Arabs Transformed Western Civilization* (London: Bloomsbury, 2010).

17 Adam Mez, *Die Renaissance des Islams* (Heidelberg: C. Winter, 1922); and Joel L. Kraemer, *Humanism in the Renaissance of Islam: The Cultural Revival During the Buyid Age* (Leiden: Brill, 1992).

18 Robert Hillenbrand, "'The Ornament of the World,' Medieval Córdoba as a Cultural Center," in Salma Khadra Jayyusi and Manuela Marín, eds., *The Legacy of Muslim Spain* (Leiden: Brill, 1994), pp. 120–21. I have calculated the cost of the sale from the value of the dinar given in Rodney J. Phillips, *The Muslim Empire and the Land of Gold* (New York: Eloquent Books, 2008), p. 61.

19 See Aby Warburg, *The Renewal of Pagan Antiquity: Contributions to the Cultural History of the Italian Renaissance*, trans. David Britt (Los Angeles: Getty Research Institute, 1999), p. 489.

20 Quoted in Babinger, *Mehmed the Conqueror and His Time*, p. 66.

21 Quoted in Setton, *The Papacy and the Levant*, vol. 2, p. 133.

22 *Pero Tafur: Travels and Adventures*, p. 145.

23 For evidence of the possible holdings at this time, see Nigel G. Wilson, "The Libraries of the Byzantine World," *Greek, Roman and Byzantine Studies*, vol. 8 (1967), pp. 55–57; and Julian Raby, "Mehmed the Conqueror's Greek Scriptorium," *Dumbarton Oaks Papers*, vol. 37 (1983), pp. 15–34.

24 Quoted in Sharon, "A Crusade for the Humanities," p. 166.

25 For this figure, see Gülru Necipoğlu, "Visual Cosmopolitanism and Creative Translation: Artistic Conversations with Renaissance Italy in Mehmed II's Constantinople," *Muqarnas*, vol. 29 (2012), p. 9. Evidence comes from a recently discovered 1502 inventory, and Necipoğlu notes that the "majority of books listed in the inventory had been collected by Mehmed II."

26 Quoted in Warburg, *The Renewal of Pagan Antiquity*, p. 489.

27 Quoted in Koder, "Romaioi and Teukroi," sec. 2.2.

28 Quoted in Warburg, *The Renewal of Pagan Antiquity*, p. 489.

29 Quoted in Setton, *The Papacy and the Levant*, vol. 2, p. 140.

30 See Hankins, "Renaissance Crusaders," p. 142.

31 "Lamento d'Italia," in Frati, ed., *Vite di Uomini Illustri*, p. 324.

32 Ibid., pp. 309–10.

Chapter 10

1 Edward Schröder, Gottfried Zedler, and Heinrich Wallau, "Das Mainzer Fragment vom Weltgericht," in *Veröffentlichungen der Gutenberg-Gesellschaft* (Mainz, 1904), p. 1.

2 See the estimates given in Janet Ing, "The Mainz Indulgences of 1454/5: A Review of Recent Scholarship," *The British Library Journal*, vol. 9, no. 1 (Spring 1983), p. 19 and note 19, pp. 29–30.

3 Quoted in Paul Needham, "The Paper Supply of the Gutenberg Bible," *The Papers of the Bibliographical Society of America*, vol. 79 (3rd quarter, 1985), p. 309. Written by Piccolomini in March 1455, the letter is a follow-up to an earlier (lost) letter to Carvajal written during Piccolomini's stay in Frankfurt in October 1454. The letter from March 1455 responds to the cardinal's request for both more information and a copy.

4 For the two cases, see "A Suit for Breach of Promise Against Johann Gutenberg," in *The Gutenberg Documents, with translations of the texts into English, based on the compilation by Dr. Karl Schorbach*, ed. Douglas McMurtrie (New York: Oxford University Press, 1941), pp. 83–92.

5 See Kurt Köster, "Gutenbergs Straßburger Aachenspiegel-Unternehmen von 1438–1440," *Gutenberg-Jahrbuch*, vol. 58 (1983), pp. 24–44.

6 The documents have been published by Otto W. Furhmann, *Gutenberg and the Strasbourg Documents of 1439: An Interpretation by Otto W. Fuhrmann, to which has been Appended the Text of the Documents in the Original Alsatian, the French of Laborde, and Modern German and English Translations* (New York: Kredel, Press of the Woolly Whale, 1940), p. 188.

7 According to Henri-Jean Martin, *The History and Power of Writing*, trans. Lydia G. Cochrane (Chicago: University of Chicago Press, 1995), p. 221.

8 Quoted in Needham, "The Paper Supply of the Gutenberg Bible," p. 309.

9 For the history of the fair, see Mathilde Rovelstad, "The Frankfurt Book Fair," *Journal of Library History, Philosophy, and Comparative Librarianship*, vol. 8 (July–October 1973), pp. 113–123. For the African elephant: Donald F. Lach, *Asia in the Making of Europe*, vol. 2: *A Century of Wonder* (Chicago: University of Chicago Press, 1970), p. 133.

10 David Landau and Peter Parshall, *The Renaissance Print, 1470–1550* (New Haven and London: Yale University Press, 1994), p. 1.

11 Paul Needham, "Prints in the Early Printing Shops," *Studies in the History of Art*, vol. 75, Symposium Papers LII: *The Woodcut in Fifteenth-Century Europe* (2009), p. 41. For an excellent overview, see Frédéric Barbier, *Gutenberg's Europe: The Book and the Invention of Western Modernity*, trans. Jean Birrell (Cambridge: Polity Press, 2017), pp. 88ff.

12 Wolfgang Brücker, quoted in Peter Schmidt, "The Multiple Image: The Beginnings of Printmaking, Between Old Theories and New Methods," in Peter Parshall, Rainer Schoch et al., *Origins of European Printmaking: Fifteenth-Century Woodcuts and Their Public* (Washington, DC: National Gallery of Art, 2006), p. 41.

13 Henri-Jean Martin, *The History and Power of Writing*, p. 225; and Hee-Jae Lee, "Korean Typography in 15th Century," International Federation of Library Associations and Institutions, Seoul, 2006, available online at https://archive.ifla.org/IV/ifla72/papers/085–Lee–en.pdf.

14 Stephan Füssel, *Gutenberg and the Impact of Printing*, trans. Douglas Martin (Aldershot: Ashgate, 2005), pp. 17–18.

15 I have taken these century-by-century figures from Jan Luiten Van Zanden, *The Long Road to the Industrial Revolution: The European Economy in a Global Perspective, 1000–1800*

(Leiden: Brill, 2009), p. 77, Table 3; and from Eltjo Buringh and Jan Luiten Van Zanden, "Charting the 'Rise of the West': Manuscripts and Printed Books in Europe, a Long-Term Perspective from the Sixth Through Eighteenth Centurie," *The Journal of Economic History*, vol. 69 (June 2009), pp. 416–17, tables 1 and 2. The statistic for the 326 percent increase in manuscript production in Italy comes from John Monfasani, "The Rise and Fall of Renaissance Italy," *Aevum*, Anno 89, Fasc. 3 (September–December 2015), p. 470, table 2. The decade-by-decade figures for the fifteenth century I have calculated from the statistics given in Needham, "Prints in the Early Printing Shops," p. 42.

16 Quoted in Leor Halevi, "Christian Impurity versus Economic Necessity: A Fifteenth-Century Fatwa on European Paper," *Speculum*, vol. 83 (October 2008), p. 917.

17 Verner W. Clapp, "The Story of Permanent/Durable Book-Paper, 1115–1970," in Margaret Holben Ellis, ed., *Historical Perspectives in the Conservation of Works of Art on Paper* (Los Angeles: Getty Conservation Institute, 2014), p. 4.

18 See Halevi, "Christian Impurity Versus Economic Necessity," pp. 917–45.

19 Quoted in Carmen C. Bambach, "The Purchases of Cartoon Paper for Leonardo's 'Battle of Anghiari' and Michelangelo's 'Battle of Cascina,'" *I Tatti Studies in the Italian Renaissance*, vol. 8 (1999), p. 113.

20 For this argument of Marco Mostert, a historian at the University of Utrecht, see Martin Wainwright, "How Discarded Pants Helped to Boost Literacy," *The Guardian*, July 12, 2007.

21 Charles Van Doren, *A History of Knowledge: Pivotal Events, People and Achievements of World History* (New York: Ballantine, 1991), p. 152.

22 Quoted in C. A. Spinage, *Cattle Plague: A History* (New York: Kluwer Academic/Plenum Publishers, 2003), p. 95. For the cattle plagues during the 1300s, see ibid., pp. 94–95. For falling herds, see William Chester Jordan, *The Great Famine: Northern Europe in the Early Fourteenth Century* (Princeton: Princeton University Press, 1996), p. 36. For livestock suffering from the bubonic plague: Judith R. Gelman, *The English Economy Following the Black Death* (Washington, DC: Bureau of Economics, Federal Trade Commission, 1982), p. 23.

23 Needham, "Prints in the Early Printing Shops," p. 41.

Chapter 11

1 *Vite di Uomini Illustri*, p. 160.

2 Cagni, *Vespasiano da Bisticci e il suo Epistolario*, p. 131.

3 For this and other examples, see De la Mare, "Vespasiano da Bisticci, Historian and Bookseller," vol. 2, pp. 388–94.

4 Quoted in Sara Bischetti, "Codicologia dei manoscritti in scrittura umanistica su carta (conservati nelle biblioteche storiche di Roma)," (PhD diss., Università degli Studi di Roma "Sapienza," 2013), p. 84, note 171.

5 For the ancient sources, see *Homeric Hymns. Homeric Apocrypha. Lives of Homer*, ed. and trans. Martin L. West, Loeb Classical Library 496 (Cambridge, MA: Harvard University Press, 2003).

6 Ibid., p. 399.

7 Eric A. Havelock, "The Alphabetization of Homer," in *The Literate Revolution in Greece and Its Cultural Consequences* (Princeton: Princeton University Press, 1982), p. 166.

8 Quintilian, *The Orator's Education*, vol. 4, p. 279.

9 Pliny the Elder, *Natural History*, vol. 2, p. 577.

10 Quoted in Robin Sowerby, "Early Humanist Failure with Homer (I)," *International Journal of the Classical Tradition*, vol. 4 (Summer 1997), p. 57.

11 For these efforts, see Sowerby, "Early Humanist Failure with Homer (I)," pp. 58, 59, 60, and 63.

12 Marsuppini's letter describing his depression with the task is given in Remigio Sabbadini, "Briciole Umanistiche," *Giornale Storico della Letteratura Italiana*, vol. 17 (1891), p. 214.

13 For Perotti's letter, see Cagni, *Vespasiano da Bisticci e il suo Epistolario*, pp. 130–31.

14 For Vespasiano's clients at this time, see De la Mare, "Vespasiano da Bisticci, Historian and Bookseller," pp. 310ff.

15 Quoted in Zweder von Martels, "Ubbo Emmius, the Eternal Edict, and the Academy of Groningen," in Alasdair A. MacDonald et al., eds., *Christian Humanism: Essays in Honor of Arjo Vanderjagt* (Leiden: Brill, 2009), p. 411.

16 Quoted in Jerry H. Bentley, *Politics and Culture in Renaissance Naples* (Princeton: Princeton University Press, 1987), p. 52.

17 Quoted in Alan Ryder, *Alfonso the Magnanimous: King of Aragon, Naples and Sicily, 1396–1458* (Oxford: Clarendon Press, 1990), p. 306. Ryder fully discusses Alfonso's patronage in Chapter 8, "A Renaissance King."

18 De la Mare, "Vespasiano da Bisticci: Historian and Bookseller," vol. 1, p. 158, note 42.

19 *Vite di Uomini Illustri*, p. 53.

20 Ibid., p. 58.

21 This episode is discussed in B. L. Ullman, "The Post-Mortem Adventures of Livy," in *Studies in the Italian Renaissance* (Rome: Edizioni di Storia e Letteratura, 1973), pp. 54–58.

22 *History of Rome*, vol. 1, trans. B. O. Foster, Loeb Classical Library 114 (Cambridge, MA: Harvard University Press, 1919), pp. 3 and 4.

23 Pliny the Younger, *Letters*, vol. 1, p. 87.

24 Suetonius, *Lives of the Caesars*, vol. 1, trans. J. C. Rolfe, introduction by K. R. Bradley, Loeb Classical Library 31 (Cambridge, MA: Harvard University Press, 1914), p. 469.

25 Martial, *Epigrams*, Book xiv, p. 190.

26 B. L. Ullman, "Poggio's Manuscripts of Livy and Other Authors," in *Studies in the Italian Renaissance*, pp. 308–9. Ullman disputes the "universal assumption" that Beccadelli purchased Poggio's copy.

27 See William Roscoe, "Some Account of the Manuscript Library at Holkham, in Norfolk, belonging to T. W. Coke, Esq.," in *Transactions of the Royal Society of Literature of the United Kingdom* (1834), pp. 366–67. Roscoe appears to be the source for the story about Cosimo, Alfonso, and the supposedly poisoned manuscript, which he saw (among six other manuscripts of Livy) at Holkham Hall in Norfolk. See *The Life of Lorenzo de' Medici, called The Magnificent*, 2 vols. (London, 1825), vol. 1, p. 34. Roscoe mistakenly believed that Holkham Hall MS 344 was the codex in question. For this story, see also Ryder, *Alfonso the Magnanimous*, p. 320.

28 For information on Serragli and his dealings I am indebted to Gino Corti and Frederick Hartt, "New Documents Concerning Donatello, Luca and Andrea della Robbia, Desiderio, Mino, Uccello, Pollaiuolo, Filippo Lippi, Baldovinetti, and Others," *The Art Bulletin*, vol. 44 (June 1962), pp. 155–67; and Francesco Caglioti, "Fifteenth-Century

Reliefs of Ancient Emperors and Empresses in Florence: Production and Collecting," *Studies in the History of Art*, vol. 70 (2008), pp. 66–109.

29 For Piero Strozzi, see De la Mare, "Vespasiano da Bisticci as a Producer of Classical Manuscripts," p. 180, note 43; and in idem, "New Research on Humanistic Scribes," p. 417. I am also indebted to De la Mare, "Messer Piero Strozzi, a Florentine Priest and Scribe," in A. S. Osley, ed., *Calligraphy and Palaeography: Essays Presented to Alfred Fairbank on his 70th Birthday* (London: Faber & Faber, 1965), pp. 55–68.

30 Barbier, *Gutenberg's Europe*, p. 205.

31 I am indebted in these paragraphs to the discussion in Margaret M. Smith, *The Title-Page: Its Early Development, 1460–1510* (London: The British Library, 2000), especially (regarding manuscripts) pp. 25–34.

32 For this codex as the inspiration for Vespasiano's title pages, see De La Mare, "Vespasiano as Producer of Classical Manuscripts," p. 188. For a more recent discussion of the conservation of the codex of Josephus, see Antonio Manfredi, "Finalità e significato del restauro dei manoscritti nel secolo XV: Appunti e proposte," *Studi di archivistica, bibliografia, paleografia*, vol. 4 (2018), pp. 123–34.

33 For Vespasiano's Neapolitan enterprise I am indebted to Luca Boschetto, "Una Nova Lettera di Giannozzo Manetti a Vespasiano da Bisticci: Con alcune considerazioni sul commercio librario tra Firenze e Napoli a metà Quattrocento," in *Medioevo e Rinascimento*, vol. 18 (2004), pp. 175–206. See also De la Mare, "New Research on Humanistic Scribes in Florence," p. 404, note 63, and p. 411; and idem, "Vespasiano da Bisticci, Historian and Bookseller," vol. 1, p. 94, and vol. 1, pp. 316–17.

34 The link between Vespasiano's exports and Alfonso's literary interests is pointed out by Boschetto: see "Una Nova Lettera," p. 193.

35 *Vite di Uomini Illustri*, p. 543.

Chapter 12

1 *Vite di Uomini Illustri*, p. 47.

2 For these estimates, see Ludwig von Pastor, *History of the Popes from the Close of the Middle Ages*, ed. Frederick Ignatius Antrobus, 6 vols. (London: Kegan Paul, Trench, Trubner & Co., 1899), vol. 2, p. 211.

3 *Vite di Uomini Illustri*, p. 45.

4 Ibid., p. 96.

5 *Pius II: Commentaries*, vol. 1, p. 141.

6 Quoted in Setton, *The Papacy and the Levant*, p. 163.

7 Quoted in ibid., p. 164.

8 *Vite di Uomini Illustri*, p. 167.

9 The origins of the legend and the evidence against it were first presented by Johann Stein in *Calixte III et la Comète de Halley* (Rome: Specola Astronomica Vaticana, 1909), pp. 5–39. Stein's pamphlet was then helpfully summarized in English by William F. Rigge in "An Historical Examination of the Connection of Calixtus III with Halley's Comet," *Popular Astronomy*, vol. 18 (1910), pp. 214–19.

10 Quoted in Pastor, *History of the Popes*, vol. 2, p. 348.

11 Quoted in ibid., p. 346.

12 Quoted in Setton, *The Papacy and the Levant*, p. 167.

13 Quoted in ibid., p. 168.

14 Machiavelli, *History of Florence and of the Affairs of Italy* (London: H. G. Bohn, 1851), p. 299.

15 Quoted in Paul Botley, "Giannozzo Manetti, Alfonso of Aragon and Pompey the Great: A Crusading Document of 1455," *Journal of the Warburg and Courtauld Institutes,* vol. 67 (2004), pp. 132–33.

16 *Vite di Uomini Illustri,* p. 283.

17 *Two Views of Man: Pope Innocent III, On The Misery of Man, Giannozzo Manetti, On the Dignity of Man,* trans. Bernard Murchland (New York: Frederick Ungar Publishing Co., 1966), p. 4. All quotations from the two texts are from this edition. See also the excellent discussion in David Marsh, *Giannozzo Manetti: The Life of a Florentine Humanist* (Cambridge, MA: Harvard University Press, 2019), pp. 86–95.

18 *Readings in Medieval History,* ed. Patrick J. Geary (Toronto: University of Toronto Press, 2010), p. 50; *The Imitation of Christ,* trans. Ronald Knox and Michael Oakley (New York: Sheed and Ward, 1960), p. 75.

19 Étienne Gilson, *Humanisme et Renaissance* (Paris: Vrin, 1983), p. 28.

20 Richard C. Trexler, "Florentine Religious Experience: The Sacred Image," *Studies in the Renaissance,* vol. 19 (1972), p. 7.

21 On this ambition, see Timothy Verdon, "Introduction," *Christianity and the Renaissance: Image and Religious Imagination in the Quattrocento,* ed. Timothy Verdon and John Henderson (Syracuse: Syracuse University Press, 1990), p. 28.

22 *Vite di Uomini Illustri,* p. 166.

23 Ibid., p. 284.

24 Francesco Guicciardini, quoted in Alfred von Reumont, *Lorenzo de' Medici, The Magnificent,* 2 vols. (London: Smith, Elder & Co., 1876), vol. 1, p. 130.

25 For Manetti's uneasy relations with Cosimo and other powerful Florentines at this time, see Marsh, *Giannozzo Manetti,* pp. 110–12.

26 Cagni, *Vespasiano da Bisticci e il suo Epistolario,* pp. 133–35.

27 Quoted in Amanda Lillie, "Fiesole: *Locus amoenus* or Penitential Landscape?" *I Tatti Studies in the Italian Renaissance,* vol. 11 (2007), p. 25.

28 Ames-Lewis, "The Inventories of Piero di Cosimo de' Medici's Library," pp. 106–7.

29 Quoted in De la Mare, "Vespasiano da Bisticci, Historian and Bookseller," vol. 1, p. 79.

30 This deterioration is noted in Ames-Lewis, "The Inventories of Piero di Cosimo de' Medici's Library," p. 110.

31 *Pius II: Commentaries,* vol. 1, p. 151.

32 Ibid., p. 153.

33 Quoted in Setton, *The Papacy and the Levant,* p. 170.

Chapter 13

1 Angelo Decembrio, quoted in Anthony Grafton, *Commerce with the Classics: Ancient Books and Renaissance Readers* (Ann Arbor: University of Michigan Press, 1997), p. 40.

2 Quoted in De la Mare, "New Research on Humanistic Scribes in Florence," p. 403.

3 *Vite di Uomini Illustri,* pp. 173–74.

4 For Vespasiano's biography, see ibid., pp. 226–28.

5 Ludovico Carbone, "Oratio habita in funere . . . Guarini Veronensis," in Eugenio Ga-
 rin, ed., *Prosatori latini del Quattrocento* (Milan: Riccardo Ricciardi, 1952), p. 400.

6 Quoted in Benjamin G. Kohl, "Tiptoft [Tibetot], John, first earl of Worcester (1427–
 1470)," *Oxford Dictionary of National Biography*, online edition.

7 William Caxton, quoted in Horace Walpole, *A Catalogue of the Royal and Noble Authors of
 England* (Strawberry Hill, 1758), p. 65.

8 Jacopo da Bisticci is listed in the tax records as a goldsmith in 1442 but a doctor
 ("Maesto Jachopo Medicha") in 1451: see Cagni, *Vespasiano da Bisticci e il suo Episto-
 lario*, p. 22, note 3. Cagni discusses the relationship with Galileo de' Galilei Buonaiuti
 on p. 22, but notes that Galileo's influence on Jacopo's career change is "only an
 hypothesis."

9 De la Mare, "Vespasiano da Bisticci: Historian and Bookseller," vol. 1, p. 11.

10 Ibid., vol. 2, p. 424.

11 Quoted in Cagni, *Vespasiano da Bisticci e il suo Epistolario*, p. 23.

12 Quoted in ibid., p. 23, note 7. My thanks to Anne Leader for information on the word
 triste.

13 Franco Sacchetti, *I Sermoni Evangelici: Le lettere ed altri scritti inedit o rari di Franco Sac-
 chetti*, ed. Ottavio Gigli (Florence, 1857), p. 94.

14 Quoted in Iris Origo, "The Domestic Enemy: The Eastern Slaves in Tuscany in the
 Fourteenth and Fifteenth Centuries," *Speculum*, vol. 30 (July 1955), p. 335.

15 Anthony Molho, *Marriage Alliance in Late Medieval Florence* (Cambridge, MA: Harvard
 University Press, 1994), pp. 216 and 219–20.

16 Quoted in Field, *The Intellectual Struggle for Florence*, p. 303.

17 Cagni, *Vespasiano da Bisticci e il suo Epistolario*, p. 25, note 1.

18 Plague struck Florence and Tuscany in 1436, 1437, 1438, 1439, 1448, 1449, 1450, 1456,
 and 1457. See Arthur White, *Plague and Pleasure: The Renaissance World of Pius II* (Wash-
 ington, DC: The Catholic University of America Press, 2014), p. 375.

19 *Vite di Uomini Illustri*, pp. 431 and 432.

20 *Vite di Uomini Illustri*, p. 319.

21 For theories of the plague in fifteenth-century Florence, see Ann G. Carmichael,
 "Plague Legislation in the Italian Renaissance," *Bulletin of the History of Medicine*, vol. 57
 (Winter 1983), pp. 508–25.

22 Saladino Ferro, quoted in ibid., p. 522.

23 See Ganz, "A Florentine Friendship: Donato Acciaiuoli and Vespasiano da Bisticci,"
 p. 376; and De la Mare, "Vespasiano da Bisticci, Historian and Bookseller," vol. 2,
 p. 307.

24 *Vite di Uomini Illustri*, p. 297.

25 On these biographical difficulties, see John Monfasani, "The Averroism of John Argy-
 ropoulos and His 'Quaestio utrum intellectus humanus sit perpetuus,'" *I Tatti Studies
 in the Italian Renaissance*, vol. 5 (1993), pp. 157–61.

26 Quoted in ibid., p. 162, note 21.

27 *Vite di Uomini Illustri*, p. 425.

28 Ibid., p. 324.

29 See Roberta Panzanelli, "Compelling Presence: Wax Effigies in Renaissance Flor-
 ence," in Roberta Panzanelli, ed., *Ephemeral Bodies: Wax Sculpture and the Human Figure*
 (Los Angeles: Getty Research Institute, 2008), pp. 13–39.

30 William Chillingworth, *The Religion of Protestants: A Safe Way to Salvation* (Oxford, 1638), preface.

31 *The Basic Writings of Thomas Aquinas*, ed. Anton C. Pegis (Indianapolis, IN, and Cambridge, MA: Hackett, 1997), vol. 1, pp. 492 and 496.

32 Quoted in De la Mare, "Vespasiano da Bisticci as Historian and Bookseller," vol. 1, p. 22.

33 Quoted in N. G. Wilson, *From Byzantium to Italy: Greek Studies in the Italian Renaissance* (London: Duckworth, 1992), p. 87.

34 For Filelfo's warning, see Arthur Field, *The Origins of the Platonic Academy of Florence* (Princeton: Princeton University Press, 1988), p. 124, note 57.

35 Quoted in ibid., p. 123.

36 Marsilio Ficino, quoted in Howlett, *Marsilio Ficino and His World*, p. 7.

37 Hankins, "Cosimo de' Medici and the 'Platonic Academy,'" p. 157, note 41. This manuscript of Plato is now in the National Library in Prague, known after the buyer, the Bohemian nobleman Bohuslav Hasištejnský z Lobkovic, as the Lobcovicianus. On its history (but without the price given by Hankins), see Nigel G. Wilson, "The Prague Manuscript of Plato," *Studi Classici e Orientali*, vol. 44 (December 1995), pp. 23–32.

38 Quoted in Hankins, "Cosimo de' Medici and the 'Platonic Academy,'" p. 150.

39 See John Henderson, *The Renaissance Hospital: Healing the Body and Healing the Soul* (New Haven and London: Yale University Press, 2006), pp. 302–3, 316–17.

40 *The Letters of Marsilio Ficino*, trans. by the members of the Language Department of the School of Economic Science (London: Shepheard-Walwyn, 1981), vol. 3, p. 23.

41 Quoted in Hankins, *Plato in the Italian Renaissance*, vol. 1, p. 273.

42 Christiane Klapisch-Zuber gives the infant mortality rate in Florence as 23.8 percent: *Women, Family, and Ritual in Renaissance Italy*, trans. Lydia Cochrane (Chicago: University of Chicago Press, 1985), p. 105. She notes that Richard C. Trexler gives a rate at the foundling hospital, the Spedale degli Innocenti, as 26.6 percent during good years and more than 50 percent during bad (p. 151).

43 Quoted in Hankins, *Plato in the Italian Renaissance*, vol. 1, p. 279.

44 Quoted in ibid., p. 168.

45 Ibid., p. 236.

46 See John Monfasani, *George of Trebizond: A Biography and a Study of His Rhetoric and Logic* (Leiden: Brill, 1976), p. 159. For this anti-Plato diatribe, see ibid., pp. 158–59.

47 *The Letters of Marsilio Ficino*, vol. 7, p. 22.

Chapter 14

1 For the starting date of 1446, see Isabelle Hyman's convincing argument in "Notes and Speculations on S. Lorenzo, Palazzo Medici, and an Urban Project by Brunelleschi," *Journal of the Society of Architectural Historians*, vol. 34 (May 1975), pp. 101–2. The Brunelleschi legend is found in the sixteenth-century *Il Libro di Antonio Billi*, ed. Karl Frey (Berlin, 1892), p. 48. It is repeated in *Il Codice Magliabecchiano*, ed. Karl Frey (Berlin, 1892), p. 89.

2 Niccolò de' Carissimi da Parma, quoted in Rab Hatfield, "Some Unknown Descriptions of the Medici Palace in 1459," *The Art Bulletin*, vol. 52 (September 1970), p. 233.

3 *Vite di Uomini Illustri*, pp. 424–25.

4 Quoted in Hatfield, "Some Unknown Descriptions," pp. 233 and 236.

5 Biondo Flavio, *Italy Illuminated*, ed. and trans. Jeffrey White (Cambridge, MA: Harvard University Press, 2005), vol. 1, p. 73.

6 Cagni, *Vespasiano da Bisticci e il suo Epistolario*, p. 153.

7 De Roover, *The Rise and Decline of the Medici Bank*, p. 391.

8 Angelo Poliziano, quoted in Amanda Lillie, "Fiesole: *Locus amoenus* or Penitential Landscape?" *I Tatti Studies in the Italian Renaissance*, vol. 11 (2007), p. 35.

9 Quoted in ibid., p. 25.

10 *Vite di Uomini Illustri*, p. 413.

11 Ibid., p. 430.

12 Ibid., p. 414.

13 Ibid.

14 De la Mare, "New Research on Humanistic Scribes in Florence," p. 444.

15 See *Vite di Uomini Illustri*, pp. 521–23; and Jean Leclercq, "Un traité de Jérome de Matelica sur la vie solitaire," in *Rivista di storia della Chiesa in Italia*, vol. 18 (1964), pp. 13–22.

16 See De la Mare, "Vespasiano da Bisticci as a Producer of Classical Manuscripts," p. 181.

17 For the respective contributions, see De la Mare, "New Research on Humanistic Scribes in Florence," pp. 441–42.

18 Quoted in Oren J. Margolis, "The 'Gallic Crowd' at the 'Aragonese Doors': Donato Acciaiuoli's *Vita Caroli Magni* and the Workshop of Vespasiano da Bisticci," *I Tatti Studies in the Italian Renaissance*, vol. 17 (2014), p. 257.

19 Quoted in ibid., p. 243.

20 All of these details are given in Vespasiano's life of Piero de' Pazzi; see *Vite di Uomini*, pp. 500–506.

21 Quoted in Pastor, *History of the Popes*, vol. 2, pp. 470–71.

22 Quoted in Robert Black, *Benedetto Accolti and the Florentine Renaissance* (Cambridge: Cambridge University Press, 1985), pp. 262–63.

23 Quoted in Necipoğlu "Visual Cosmopolitanism and Creative Translation," p. 16.

24 Quoted in Pastor, *History of the Popes*, vol. 3, p. 9.

25 Quoted in ibid., pp. 11–12.

26 *Pius II: Commentaries*, vol. 1, p. 185.

27 Quoted in Oren J. Margolis, *The Politics of Culture in Quattrocento Europe: René of Anjou in Italy* (Oxford: Oxford University Press, 2016), p. 161. For the terracotta, see ibid., pp. 176–77.

28 *Vite di Uomini illustri*, p. 505. Vespasiano does not specifically identify himself as Piero de' Pazzi's auditor. A case for him being the friend to whom Piero confides is convincingly made by Margolis: see "The 'Gallic Crowd' at the 'Aragonese Doors,'" *passim*, but especially p. 282. See also idem, *The Politics of Culture in Quattrocento Europe*, p. 162.

29 Quoted in De la Mare, "Vespasiano da Bisticci, Historian and Bookseller," vol. 2, p. 340.

30 *Vite di Uomini Illustri*, p. 505.

31 Quoted in Margolis, *The Politics of Culture in Quattrocento Europe*, p. 161.

32 Quoted in Margolis,"The 'Gallic Crowd' at the 'Aragonese Doors,'" p. 264.

33 Quoted in De la Mare, "Vespasiano da Bisticci, Historian and Bookseller," vol. 1, p. 30.

Chapter 15

1 I have taken the description of Ficino's playing and singing from the translation of Poliziano's poem in James K. Coleman, "Furor and Philology in the Works of Angelo Poliziano," in Andrea Moudarres and Christiana Purdy Moudarres, eds., *New Worlds and the Italian Renaissance: Contributions to the History of European Intellectual Culture* (Leiden: Brill, 2012), p. 256.

2 Quoted in Hankins, "Cosimo de' Medici and the 'Platonic Academy,'" p. 149.

3 *Vite di Uomini Illustri*, p. 425.

4 Quoted in Field, *The Origins of the Platonic Academy of Florence*, p. 108.

5 Diogenes Laertius, *Lives of Eminent Philosophers*, vol. 1: Books 1–5, tran. R. D. Hicks, Loeb Classical Library 184 (Cambridge, MA: Harvard University Press, 1925), p. 283.

6 For an excellent introduction to the *Corpus Hermeticum*, see Frances A. Yates, *Giordano Bruno and the Hermetic Tradition* (London: Routledge and Kegan Paul, 1964), pp. 1–19.

7 *The City of God*, vol. 3, Loeb Classical Library 413, trans. David S. Wiesen (Cambridge, MA: Harvard University Press, 1968), p. 111.

8 Quoted in Brian Copenhaver and Charles B. Schmitt, *Renaissance Philosophy* (Oxford: Oxford University Press, 1992), p. 147.

9 Quoted in E. N. Tigerstedt, "The Poet as Creator: Origins of a Metaphor," *Comparative Literature Studies*, vol. 5 (December 1968), p. 468.

10 Quoted in ibid., p. 473.

11 *The Letters of Marsilio Ficino*, vol. 1, p. 51.

12 *Reject Aeneas, Accept Pius: Selected Letters of Aeneas Sylvius Piccolomini (Pope Pius II)*, trans. Thomas M. Izbicki et al. (Washington, DC: Catholic University of America Press, 2006), p. 160.

13 *Pius II: Commentaries*, vol. 1, p. 209.

14 See Isotta Nogarola, *Complete Writings: Letterbook, Dialogue on Adam and Eve, Orations* (Chicago: University of Chicago Press, 2003).

15 Quoted in Setton, *The Papacy and the Levant*, vol. 2, p. 233.

16 See ibid., p. 238.

17 Quoted in ibid., p. 261. For Pius's treatments at Petriolo, see *Pius II: Commentaries*, vol. 2, p. 257.

18 Ibid., vol. 1, p. 329.

19 Ibid.

20 *Vite di Uomini Illustri*, p. 430.

21 The ten dialogues were *Hipparchus, Amatores, Theages, Meno, Alcibiades I* and *II, Minos, Euthyphro, Parmenides,* and *Philebus*. See Paul Oskar Kristeller, "Marsilio Ficino as a Beginning Student of Plato," *Scriptorium*, vol. 20 (1966), p. 45.

22 Plato, *Statesman, Philebus, Ion*, Loeb Classical Library 164, trans. Harold North Fowler and W. R. M. Lamb (Cambridge, MA: Harvard University Press, 1925), p. 203.

23 Quoted in Hankins, *Plato in the Italian Renaissance*, vol. 1, pp. 267–68.

Chapter 16

1 Bartolomeo Platina, *The Lives of the Popes*, ed. William Benham (London: Griffth, Farran, Okeden & Welsh, 1888), pp. 278–79.

2 Quoted in Anthony Grafton, *Leon Battista Alberti: Master Builder of the Italian Renaissance* (Cambridge, MA: Harvard University Press, 2002), p. 331. Niccolò Galimberti dates this conversation to "not later than 1464": "Il 'De componendis cyfris' di Leon Battista Alberti tra crittologia e tipografia," in Mario Segatori, ed., *Subiaco, la culla della stampa* (Subiaco: Iter Edizioni, 2010), p. 206.

3 *Pius II: Commentaries*, vol. 2, p. 31.

4 Quoted in Albert Kapr, *Johann Gutenberg: The Man and His Invention*, trans. Douglas Martin (Aldershot: Scolar Press, 1996), p. 237.

5 *Pius II: Commentaries*, vol. 2, p. 29.

6 Quoted in Kapr, *Johann Gutenberg*, p. 242.

7 Quoted in B. A. Uhlendorf, "The Invention of Printing and Its Spread till 1470: With Special Reference to Social and Economic Factors," *The Library Quarterly: Information, Community, Policy*, vol. 2 (July 1932), p. 200.

8 Kapr, *Johann Gutenberg*, pp. 259–60.

9 Lotte Hellinga, *Texts in Transit: Manuscript to Proof and Print in the Fifteenth Century* (Leiden: Brill, 2014), p. 165, note 16. The transalpine cardinal and scholar Nicholas of Cusa is often seen as the key advocate for the printing press in Italy. However, his death on August 11, 1464, around the time the two Germans arrived at Subiaco, removed him and his influence from the scene.

10 Quoted in Martin Davies, "Humanism in Script and Print in the Fifteenth Century," in Kraye, ed., *The Cambridge Companion to Renaissance Humanism*, p. 61.

11 The legend is mentioned in Haraszti, "Medieval Manuscripts," p. 243.

12 Quoted in Brian Richardson, "The Debates on Printing in Renaissance Italy," *La Bibliofilía*, vol. 100 (May–December 1998), p. 143.

13 Quoted in Mary Kay Duggan, *Italian Music Incunabula: Printers and Type* (Berkeley: University of California Press, 1992), p. 80.

14 For these quotes, see Richardson, "The Debates on Printing in Renaissance Italy," p. 136.

15 Quoted in ibid., p. 141.

Chapter 17

1 Zembino da Pistoia, quoted in De la Mare, "Vespasiano da Bisticci, Historian and Bookseller," vol. 1, p. 109, and vol. 2, p. 291.

2 De la Mare, "Vespasiano da Bisticci, Historian and Bookseller," vol. 1, p. 403. For Borso d'Este, see ibid., vol. 2, p. 347.

3 *Carteggio di Giovanni Aurispa*, ed. Remigio Sabbadini (Rome: Tipografia del Senato, 1931), p. 119.

4 De la Mare, "Vespasiano da Bisticci, Historian and Bookseller," vol. 2, p. 327.

5 See ibid., vol. 1, p. 219.

6 Uwe Neddermeyer, "Why Were There No Riots of the Scribes? First Results of a Quantitative Analysis of the Book-Production in the Century of Gutenberg," *Gazette du livre médiéval*, no. 31 (Autumn 1997), p. 4, Table 1.

7 Victor Scholderer, "Printers and Readers in Italy in the Fifteenth Century," in Robert Black, ed., *Renaissance Thought: A Reader* (London: Routledge, 2001), p. 120.

8 Quoted in Pastor, *History of the Popes*, vol. 4, p. 79.

9 Theodore Spandounes, *On the Origin of the Ottoman Emperors*, ed. and trans. Donald M. Nicol (Cambridge: Cambridge University Press, 1997), pp. 52–53.

10 Quoted in Monfasani, *George of Trebizond*, p. 132.

11 For information on this mission I am indebted to ibid., pp. 184–94.

12 Quoted in ibid., p. 132.

13 Quoted in ibid., p. 192.

14 Quoted in ibid., p. 133.

15 *Vite di Uomini Illustri*, p. 210.

16 Vespasiano's team of forty scribes is confirmed by De la Mare, "New Research on Humanistic Scribes in Florence," p. 449; and idem, "Vespasiano da Bisticci as a Producer of Classical Manuscripts," p. 90.

17 *Vite di Uomini Illustri*, p. 217.

18 Quoted in James Dennistoun, *Memoirs of the Dukes of Urbino*, ed. Edward Hutton, 3 vols. (London: The Bodley Head, 1909), vol. 1, pp. 231–32. For the readers, see p. 150.

19 *Vite di Uomini Illustri*, p. 206.

20 Ibid., p. 207.

21 Quoted in Dennistoun, *Memoirs of the Dukes of Urbino*, vol. 1, p. 164.

22 *Vite di Uomini Illustri*, p. 210.

23 Ibid., pp. 213–14.

24 Marco Parenti, *Ricordi storici, 1464–1467*, ed. Manuela Doni Garfagnini (Rome: Edizioni di Storia e Letteratura, 2001), p. 57.

25 Quoted in Najemy, *History of Florence*, p. 302.

26 *Vite di Uomini Illustri*, p. 496.

27 *The Memoir of Marco Parenti: A Life in Medici Florence*, ed. and trans. Mark Phillips (Princeton: Princeton University Press, 1987), p. 195.

28 *Vite di Uomini Illustri*, p. 230.

29 Ibid., p. 229.

30 De la Mare, "Vespasiano da Bisticci: Historian and Bookseller," vol. 2, p. 339.

31 Margolis, "The 'Gallic Crowd' at the 'Aragonese Doors,'" p. 282.

32 Riccardo Filangieri, "Report on the Destruction by the Germans, September 30, 1943, of the Depository of Priceless Historical Records of the Naples State Archives," *The American Archivist*, vol. 7 (October 1944), p. 255.

33 Cagni, *Vespasiano da Bisticcio e il suo Epistolario*, p. 154.

34 *Vite di Uomini Illustri*, pp. 362 and 365.

35 Ibid., pp. 363–64.

36 Ibid., p. 365.

37 Ibid., pp. 374 and 375. Cincinello's death occurred in September 1485.

38 Cagni, *Vespasiano da Bisticcio e il suo Epistolario*, pp. 154–55.

39 Quoted in De La Mare, "Vespasiano da Bisticci, Historian and Bookseller," vol. 1, p. 82.

40 Cagni, *Vespasiano da Bisticcio e il suo Epistolario*, pp. 155–56.

41 De la Mare, "New Research on Humanistic Scribes in Florence," pp. 451–52.

Chapter 18

1 Quoted in Kapr, *Johann Gutenberg*, p. 265.

2 Quoted in Mary A. Rouse and Richard H. Rouse, "Nicolaus Gupalatinus and the Arrival of Print in Italy," *La Bibliofilía*, vol. 88 (September–December 1986), p. 233.

3 See Pastor, *History of the Popes*, vol. 4, pp. 72 and 68.

4 Quoted in Pollard, *An Essay on Colophons*, p. 88. For Bussi's positive appraisal of the printing press, see Richardson, "The Debates on Printing in Renaissance Italy," pp. 136 and 138.

5 Quoted in Massimo Miglio, "Giovanni Andrea Bussi," *Dizionario Biografico degli Italiani*, online edition.

6 John Monfasani, "The Pre- and Post-History of Cardinal Bessarion's 1469 *In Calumniatorem Platonis*," in Claudia Märtl, Christian Kaiser, and Thomas Ricklin, eds., "*Inter graecos latinissimus, inter latinos graecissimus*": *Bessarion zwischen den Kulturen* (Berlin: Walter de Gruyter, 2013), p. 352.

7 See Jeroen De Keyser, "Perotti and Friends: Generating Rave Reviews for Bessarion's *In Calumniatorem Platonis*," *Italia Medioevale e Umanistica*, vol. 52 (2011), pp. 103–37; and Martin Davies, "Some Bessarion Owners," *La Bibliofilía*, vol. 115 (January–April 2013), pp. 41–52.

8 Quoted in Sharon, "A Crusade for the Humanities," p. 165.

9 See Henri Omont, *Inventaire des manuscripts Grecs et Latins donnés à Saint-Marc de Venise par le Cardinal Bessarion en 1468* (Paris, 1894).

10 *Vite di Uomini Illustri*, p. 96.

11 The full translation of this letter is given in Sharon, "A Crusade for the Humanities," pp. 164–65.

12 For the sorry fate of Bessarion's manuscripts in Venice, see M. J. C. Lowry, "Two Great Venetian Libraries in the Age of Aldus Manutius," *Bulletin of the John Rylands Library*, vol. 57 (1974), pp. 135–37. Lowry gives 1565 as the *terminus ante quem* for the arrival of Bessarion's manuscripts in their permanent home (p. 137, note 3).

13 Chiriatti, "Lo Scriptorium di San Nicola di Casole," p. 437.

14 For the possibility of Manutius using Bessarion's manuscripts, see Lowry, "Two Great Venetian Libraries," pp. 138–39.

15 *The Letters of Marsilio Ficino*, vol. 6, p. 33.

16 Marsilio Ficino, *Platonic Theology*, vol. 1, trans. Michael J. B. Allen, ed. James Hankins with William Bowen (Cambridge, MA: Harvard University Press, 2001), p. 9.

17 *The Letters of Marsilio Ficino*, vol. 7, p. 14.

18 For a good overview of Ficino's patterning of his farm on Plato's Academy, see Christophe Poncet, "Ficino's Little Academy of Careggi," *Bruniana & Campanelliana*, vol. 19 (2013), pp. 67–76.

19 Lorenzo de' Medici, *Opere*, ed. Tiziano Zanato (Torino: Einaudi, 1992), p. 39.

20 Quoted in Maria Grazia Pernis and Laurie Schneider Adams, *Lucrezia Tornabuoni de' Medici and the Medici Family in the Fifteenth Century* (New York: Peter Lang, 2006),

p. 124. For a study of Lucrezia's writings, see *Lucrezia Tornabuoni de' Medici: Sacred Narratives*, ed. and trans. Jane Tylus (Chicago: University of Chicago Press, 2001).

21 I have used the translation given in *Lorenzo de' Medici: Selected Poems and Prose*, ed. John Thiem (University Park, PA: Penn State University Press, 1991).

22 Plato, *Euthyphro. Apology. Crito. Phaedo*, pp. 325–31.

23 Ficino, *Platonic Theology*, vol. 1, p. 15.

24 Quoted in Baron, "The Memory of Cicero's Roman Civic Spirit," p. 122.

25 Plato, *The Republic*, vol. 1, p. 541.

26 Quoted in Howlett, *Marsilio Ficino and His World*, p. 55.

27 Cagni, *Vespasiano da Bisticci e il suo Epistolario*, pp. 158–59.

28 Quoted in F. W. Kent, *Lorenzo de' Medici and the Art of Magnificence* (Baltimore: Johns Hopkins University Press, 2004), p. 33.

29 Quoted in Richard C. Trexler, *Public Life in Renaissance Florence* (Ithaca: Cornell University Press, 1980), p. 446. Trexler describes Lorenzo's magic ring on pp. 446 and 458.

30 Henry B. Wheatley, *Prices of Books* (London, 1898), p. 79.

31 For Mentelin's price, see Henry Noel Humphreys, *A History of the Art of Printing, from its invention to its widespread development in the middle of the 16th century* (London, 1868), p. 99. For Sweynheym and Pannartz's: Konrad Burger, *Buchändlerzeigen des XV Jahrhunderts* (Leipzig: K. W. Hiersemann, 1907), Table 6a.

32 E. Gordon Duff, *Early Printed Books* (Cambridge, 1893), p. 40.

33 The British Library's *Incunabula Short Title Catalogue* records 335 titles published before 1471.

34 For this offer, see David McKitterick, "What Is the Use of Books Without Pictures? Empty Space in Some Early Printed Books," *La Bibliofilía*, vol. 116 (January–December 2014), p. 70.

35 Rouse and Rouse, "Nicolaus Gupalatinus and the Arrival of Print in Italy," pp. 228 and 233.

36 See Johan Gerritsen, "Printing at Froben's: An Eye-Witness Account," *Studies in Bibliography*, vol. 44 (1991), pp. 144–63.

37 Quoted in Brian Richardson, *Printing, Writers and Readers in Renaissance Italy* (Cambridge: Cambridge University Press, 1999), p. 25.

38 See Melissa Conway, ed., *The "Diario" of the Printing Press of San Jacopo di Ripoli* (Florence: Olschki, 1999), p. 21. For salaries of bank employees: Goldthwaite, *The Economy of Renaissance Florence*, p. 565.

39 See Richardson, *Printing, Writers and Readers in Renaissance Italy*, p. 25.

40 Barbier, *Gutenberg's Europe*, p. 120.

41 See Luigi Balsamo, "Tecnologia e capitali nella storia del libro," in Berta Maracchi Biagiarelli and Dennis E. Rhodes, eds., *Studi offerti a Roberto Ridolfi* (Florence: Olschki, 1973), pp. 77–94.

42 Quoted in De la Mare, "Vespasiano da Bisticci, Historian and Bookseller," vol. 2, p. 344.

43 As De la Mare writes: "Vespasiano shows no signs of ever having made much money from his business" (ibid., vol. 1, p. 226).

Chapter 19

1 Anna Modigliani, "Paolo II, papa," *Dizionario Biografico degli Italiani*, online edition.

2 Quoted in Setton, *The Papacy and the Levant*, p. 239.

3 Quoted in Pastor, *History of the Popes*, vol. 4, p. 298.

4 Machiavelli, *The History of Florence*, p. 344.

5 *Vite di Uomini Illustri*, p. 202.

6 Heinz Hofmann, "Literary Culture at the Court of Urbino During the Reign of Federico da Montefeltro," *Humanistica Lovaniensia: Journal of Neo-Latin Studies*, vol. 57 (2008), pp. 12–13.

7 Giuseppe Ottino, *Di Bernardo Cennini e dell'Arte della Stampa in Firenze nei Primi Cento Anni dall'Invenzione di Essa* (Florence, 1871), pp. 23–24.

8 Vittore Branca, "Copisti per passione, tradizione caratterizzante, tradizione di memoria," in *Studi e problemi di critica testuale: Convegno di studi difilologia italiana nel centenario della commissione per i testi di lingua, 7–9 aprile 1960* (Bologna: Commissione per i testi di lingua, 1961), pp. 69–83.

9 A third printer may have been at work in Florence around this time, a mysterious figure known to historians only as the "Printer of the Terentius," a reference to his Latin edition of Terence's *Comedies*, done as early as 1471. Scholars disagree as to whether his edition of the *Comedies* was printed in Florence or Naples. The edition and its associated printer is assigned to Florence by Piero Scapecchi in "Scava, scava, vecchia talpa! L'oscuro lavoro dell'incunabulista," *Biblio teche oggi*, vol. 2 (1984), pp. 37–50, and to Naples by Paolo Trovato in "Il libro toscano nell'età di Lorenzo: Schede ed ipotesi," in Luigi Beschi, ed., *La Toscana al Tempo di Lorenzo il Magnifico* (Pisa: Pacini editore, 1996), pp. 530–32. Whoever this mysterious printer was, he went on to produce a number of other titles in the early 1470s, including the first printed edition of Boccaccio's *Decameron*.

10 Lorenz Böninger, "Ricerche sugli inizi della stampa fiorentina," *La Bibliofilía*, vol. 105 (September–December 2003), p. 226.

11 For these statistics, see Neddermeyer, "Why Were There No Riots of the Scribes?" p. 2 and p. 3, Diagram 2.

12 Figures calculated from the *Incunabula Short Title Catalogue* maintained by the British Library: 462 out of 541 titles in Italy, and 817 out of 901 for Europe as a whole.

13 The *Incunabula Short Title Catalogue* lists the earliest book in Middle French to be a translation of part of the Old Testament printed in Lyons "about 1473–75."

14 For these prices, see Burger, *Buchändlerzeigen des XV Jahrhunderts*, Table 6a.

15 Quoted in Mary A. Rouse and Richard H. Rouse, *Cartolai, Illuminators, and Printers in Fifteenth-Century Italy* (Los Angeles: UCLA Research Library, 1988), p. 65, note 92.

16 Quoted in Will Durant, *The Story of Civilization*, 5: *The Renaissance* (New York: Simon and Schuster, 1953), p. 315.

17 Michael D. Reeve, "Classical Scholarship," in *The Cambridge Companion to Renaissance Humanism*, p. 30.

18 Quoted in Martin Davies, "Making Sense of Pliny in the Quattrocento," *Renaissance Studies*, vol. 9 (1995), p. 246.

19 For a discussion, see John Monfasani, "The First Call for Press Censorship: Niccolò Perotti, Giovanni Andrea Bussi, Antonio Moreto, and the Editing of Pliny's *Natural*

History," *Renaissance Quarterly,* vol. 41 (Spring 1988), pp. 1–31. All quotes are taken from Monfasani's translation of Perotti's letter.

20 Quoted in Richardson, "The Debates on Printing," p. 147.

21 For the translated text, see Shelagh Grier, *Polemic Against Printing* (Birmingham, UK: Hayloft Press, 1986).

22 See Lilian Armstrong, "Problems of Decoration and Provenance of Incunables Illuminated by North Italian Miniaturists," *The Papers of the Bibliographical Society of America,* vol. 91, *Marks in Books: Proceedings of the 1997 BSA Conference* (December 1997), p. 470.

23 Hanno Wijsman, "Patterns in Patronage: Distinction and Imitation in the Patronage of Painted Art by Burgundian Courtiers in the Fifteenth and Early Sixteenth Centuries," in Steven Gunn and Antheun Janse, eds., *The Court as a Stage: England and the Low Countries in the Later Middle Ages* (Woodbridge, Suffolk: Boydell Press, 2006), p. 57.

24 Quoted in Margaret Meserve, "News from Negroponte: Politics, Popular Opinion, and Information Exchange in the First Decade of the Italian Press," *Renaissance Quarterly,* vol. 59 (Summer 2006), p. 441, note 3.

25 On this connection, see the discussion in ibid., p. 443 and *passim.*

26 See ibid., pp. 469–70; and idem, "Patronage and Propaganda at the First Paris Press: Guillaume Fichet and the First Edition of Bessarion's 'Orations against the Turks,'" *The Papers of the Bibliographical Society of America,* vol. 97 (December 2003), pp. 521–88.

27 *Vite di Uomini Illustri,* p. 98.

Chapter 20

1 *Vite di Uomini Illustri,* p. 202.

2 Ibid.

3 Ferdinand Gregorovius, *History of the City of Rome in the Middle Ages,* trans. Annie Hamilton (London: George Bell & Sons, 1900), vol. 7, part 1, p. 247.

4 Quoted in Egmont Lee, *Sixtus IV and Men of Letters* (Rome: Edizioni di Storia e Letteratura), p. 121, note 154.

5 Quoted in Eugène Müntz, *Les arts à la cour des papes,* vol. 3, *Bibliothèque des écoles françaises d'Athènes et de Rome* (Paris, 1882), p. 118.

6 The full text of the bull is given in José Ruysschaert, "Sixte IV, fondateur de la Bibliothèque vaticane (15 juin 1475), *Archivum historiae pontificiae,* vol. 7 (Rome: Pontificia Universitas Gregoriana, 1969), pp. 523–24. Ruysschaert reports (p. 517) that no copies of the original bull exist, either in manuscript or print.

7 Quoted in Clark, *The Care of Books,* p. 230.

8 Maria Bertòla, "Codici latini di Niccolò V perduti o dispersi," *Mélanges Eugène Tisserant* (Vatican City: Biblioteca Apostolica Vaticana, 1964), pp. 129–40.

9 I have compiled the information that follows from a search for the years 1475 and 1476 in the British Library's *Incunabula Short Title Catalogue.*

10 Italian towns and cities with printing presses by the beginning of 1476: Bologna, Brescia, Cagli, Faenza, Ferrara, Genoa, Iesi, Mantua, Milan, Modena, Mondovi, Naples, Padua, Parma, Pavia, Perugia, Piacenza, Reggio di Calabria, Rome, Trento, Treviso, Turin, Venice, and Vicenza. In Germany: Augsburg, Blaubeuren, Burgdorf, Cologne, Esslingen, Lübeck, Mainz, Marienthal, Nuremberg, Reutlingen, Rostock, Speyer, and Ulm. In France: Albi, Angers, Lyon, Paris, Strasbourg, and Toulouse.

11 There were thirty-two printing presses operating in Germany in 1475–76.

12 *Vite di Uomini Illustri*, p. 213.

13 Quoted in Hofmann, "Literary Culture at the Court of Urbino," p. 21.

14 Ibid.

15 See *The Letters of Marsilio Ficino*, vol. 6, p. 23.

16 For the dispute, see Edoardo A. Lebano, "Luigi Pulci and Late Fifteenth-Century Humanism in Florence," *Renaissance Quarterly*, vol. 27 (Winter 1974), pp. 489–98; Paolo Orvieto, "Uno 'scandalo' del 400: Luigi Pulci ed i sonetti di parodia religiosa," *Annali d'Italianistica*, vol. 1 (1983), pp. 19–33; and Michael J. Maher, "Luigi Pulci and Laurentian Florence: '*Contra hypocritas tantum, pater, dissi*'" (PhD diss., University of North Carolina at Chapel Hill, 2013).

17 On Niccolò Tedesco, see Roberto Ridolfi, "Contributi sopra Niccolò Tedesco," *La Bibliofilía*, vol. 58 (1956), pp. 1–14; and Böninger, "Ricerche sugli inizi della stampa fiorentina (1471–1473)," pp. 227–31.

18 For Gianni, see Ridolfi, "Contributi sopra Niccolò Tedesco," p. 3 and note 3. For Bernardo Machiavelli's comments, see *Libro di Ricordo*, ed. Cesare Olschki (Florence: Felice Le Monnier, 1954), p. 35.

19 Quoted in Ridolfi, "Contributi sopra Niccolò Tedesco," pp. 3–4.

20 Quoted in ibid., p. 4.

Chapter 21

1 Archivio di Stato di Firenze, San Jacopo di Ripoli, vol. 27, Campione segnato A, 1476–1607, folio 1r. My thanks to Anne Leader for guiding me through this volume in the archives.

2 For the dowry paid by Piero de' Pazzi for his daughter Caterina, see Julius Kirschner, *Marriage, Dowry, and Citizenship in Late Medieval and Renaissance Italy* (Toronto: University of Toronto Press, 2015), p. 65. Giovanni Tornabuoni paid 3,000 florins for his daughter Ludovica (ibid., p. 88). For the relative costs of spiritual dowries, see Judith C. Brown, "Monache a Firenze all'Inizio dell'Età Moderna," *Quaderni storici*, new series, vol. 29 (April 1994), p. 128.

3 See Richard Trexler, "Le celibat à la fin du Moyen Age: Les religieuses de Florence," *Annales*, vol. 27 (1972), pp. 1337–38; and R. Burr Litchfield, "Demographic Characteristics of Florentine Patrician Families, Sixteenth to Nineteenth Centuries," *Journal of Economic History*, vol. 29 (1969), pp. 191–205.

4 ASF, San Jacopo di Ripoli, vol. 27, folios 1v–9v.

5 Ibid., folio 12r and ff.

6 Pietro Bologna, "La Stamperia Fiorentina del Monastero di S. Jacopo di Ripoli e le sue Edizioni," *Giornale Storico della Letteratura Italiana*, vol. 20 (Turin: Ermanno Loescher, 1892), p. 350.

7 See Richardson, *Printing, Writers and Readers in Renaissance Italy*, p. 26.

8 Conway, ed., *The "Diario" of the Printing Press of San Jacopo di Ripoli*, p. 163.

9 Ibid., pp. 108 and 113.

10 For Fra Domenico's start-up expenses, see Conway's breakdown in ibid., pp. 20–26.

11 Ibid., p. 96. For Fra Domenico's methods of financing his start-up, see pp. 26–28.

12 Ibid., p. 99.

13 See Gerritsen, "Printing at Froben's," p. 149.

14 For this practice, see Colin H. Bloy, *A History of Printing Ink, Balls and Rollers, 1440–1850* (London: Adams & Mackay, 1967), p. 53.

15 See Richard N. Schwab et al., "New Evidence on the Printing of the Gutenberg Bible: The Inks in the Doheny Copy," *The Papers of the Bibliographical Society of America*, vol. 79 (Third Quarter, 1985), pp. 375–410; and Philip M. Teigen, "Concurrent Printing of the Gutenberg Bible and the Proton Milliprobe Analysis of Its Ink," *The Papers of the Bibliographical Society of America*, vol. 87 (December 1993), pp. 437–51.

16 See Conway, ed., *The "Diario,"* Appendix VI, pp. 333–35.

17 Quoted in Barbier, *Gutenberg's Europe*, p. 138.

18 Conway, ed., *The "Diario,"* p. 92.

19 Quoted in Saundra Weddle, "Women's Place in the Family and the Convent: A Reconsideration of Public and Private in Renaissance Florence," *Journal of Architectural Education*, vol. 55 (2001), p. 65.

20 Quoted in Natalie Tomas, "Did Women Have a Space?" in Roger J. Crum and John Paoletti, eds., *Renaissance Florence: A Social History* (Cambridge: Cambridge University Press, 2006), p. 313.

21 F. W. Kent, "Florence, 1300–1600," in Francis Ames-Lewis, ed., *Florence* (Cambridge: Cambridge University Press, 2012), p. 12.

22 Girolamo Savonarola, quoted in Allison Levy, *Re–membering Masculinity in Early Modern Florence: Widowed Bodies, Mourning and Portraiture* (Aldershot: Ashgate, 2006), p. 76.

23 ASF, Compagnie Religiose Soppresse da Pietro Liepoldo, San Jacopo di Ripoli, vol. 23, folio 179r.

24 For overviews and examples, see Sharon T. Strocchia, *Nuns and Nunneries in Renaissance Florence* (Baltimore: Johns Hopkins University Press, 2009), pp. 16–17; and idem, "Naming a Nun: Spiritual Exemplars and Corporate Identity in Florentine Convents, 1450–1530," in William J. Connell, ed., *Society and the Individual in Renaissance Florence* (Berkeley: University of California Press, 2002), pp. 215–50; Silvia Evangelisti, "Monastic Poverty and Material Culture in Early Modern Italian Convents," *The Historical Journal*, vol. 47 (March 2004), pp. 1–20; Brown, "Monache a Firenze all'Inizio dell'Età Moderna," pp. 117–52.

25 Quoted in Evangelisti, "Monastic Poverty and Material Culture in Early Modern Italian Convents," p. 4.

26 Quoted in Saundra Weddle, "Identity and Alliance: Urban Presence, Spatial Privilege, and Florentine Renaissance Convents," in Roger J. Crum and John T. Paoletti, eds., *Renaissance Florence: A Social History*, p. 400.

27 Vincent Ilardi, "Florence's Leadership in the Development of Eyeglasses in the Fifteenth Century," in *Arte Lombarda*, new series, No. 105/107, "Metodologia della Ricerca Orientamenti Attuali: Congresso internazionale in onore di Eugenio Battisti," Part One (1993), pp. 159–62.

28 See Strocchia, *Nuns and Nunneries in Renaissance Florence*, p. 88.

29 Conway, ed., *The "Diario,"* p. 108.

30 Sharon T. Strocchia, "Savonarolan Witnesses: The Nuns of San Iacopo and the Piagnone Movement in Sixteenth-Century Florence," *The Sixteenth Century Journal*, vol. 38 (Summer 2007), p. 397. For nuns working as scribes, see Richardson, *Women and the Circulation of Texts in Renaissance Italy*, pp. 96–125. He discusses San Jacopo di Ripoli on p. 100.

31 Strocchia lists San Jacopo di Ripoli as one of the monasteries in Florence supplying books for the market: see *Nuns and Nunneries in Renaissance Florence*, p. 144.

Chapter 22

1 Quoted in Ilona Berkovits, *Illuminated Manuscripts from the Library of Matthias Corvinus*, trans. Susan Horn (Budapest: Corvina Press, 1964), p. 14.

2 *Vite di Uomini Illustri*, p. 172.

3 Ibid., p. 232.

4 Angelo Poliziano, "Bartholomaeo Fontio," in Ida Maïer, *Ange Politien: La formation d'un poète humaniste, 1469–1480* (Geneva: Librairie Droz, 1966), p. 60. I am grateful to Robert-Louis Liris for his assistance in translating this poem.

5 *Vite di Uomini Illustri*, p. 339.

6 Quoted in Lauro Martines, *April Blood: Florence and the Plot Against the Medici* (London: Jonathan Cape, 2003), p. 104.

7 Quoted in ibid., p. 100.

8 Francesco Malaguzzi Valeri, *La Corte di Lodovico il Moro: La Vita Privata e l'Arte a Milano nella Seconda Metà del Quattrocento* (Milan: Hoepli, 1913), p. 119.

9 Evelyn S. Welch, *Art and Authority in Renaissance Milan* (New Haven and London: Yale University Press, 1995), p. 7.

10 Quoted in Marcello Simonetta, *The Montefeltro Conspiracy: A Renaissance Mystery Decoded* (New York: Doubleday, 2008), p. 53.

11 Quoted in ibid., p. 54.

12 Quoted in Dennistoun, *Memoirs of the Dukes of Urbino*, vol. 1, p. 164.

13 Quoted in Joseph Connors and Angela Dressen, "Biblioteche: L'architettura e l'ordinamento del sapere," in Donatella Calabi and Elena Svalduz, eds., *Il Rinascimento Italiano e l'Europa*, vol. 6, *Luoghi, spazi, architetture* (Treviso: Costabissara, 2010), p. 210.

14 Henry Stevens, *The Bibles in the Caxton Exhibition, MDCCCLXXVII, or, A Bibliographical Description of Nearly One Thousand Representative Bibles* (London, 1878), p. 29.

15 Ruth Mortimer, "Saint Catherine of Siena and the Printed Book," *The Papers of the Bibliographical Society of America*, vol. 86 (March 1992), p. 12.

16 Melissa C. Flannery, "San Jacopo di Ripoli Imprints at Yale," *The Yale University Library Gazette*, vol. 63 (April 1989), pp. 119 and 120; and Flannery et al., "Marginalia," *The Yale University Library Gazette*, vol. 63 (October 1988), p. 71.

17 Conway, ed., *The "Diario,"* p. 94. See also Flannery's discussion in "San Jacopo di Ripoli Imprints at Yale," p. 120.

18 Conway, ed., *The "Diario,"* p. 182.

19 Flannery, "San Jacopo di Ripoli Imprints at Yale," p. 129.

20 Rouse and Rouse, *Cartolai, Illuminators, and Printers in Fifteenth-Century Italy*, p. 51–52.

21 Ibid., pp. 45–46.

22 Flannery, "San Jacopo di Ripoli Imprints at Yale," p. 120.

23 Quoted in Simonetta, *The Montefeltro Conspiracy*, p. 35.

24 *I Giornali di Ser Giusto Giusti d'Anghiari (1437–1482)*, ed. Nerida Newbigin (Rome: Moxedano, 2002), p. 196.

25 Quoted in Simonetta, *The Montefeltro Conspiracy*, p. 77.

Chapter 23

1 Gregorovius, *History of the City of Rome in the Middle Ages*, vol. 7, part 1, p. 284.

2 Quoted in Pastor, *History of the Popes*, vol. 4, p. 305.

3 Quoted in ibid.

4 Quoted in ibid., p. 306.

5 *Vite di Uomini Illustri*, p. 341.

6 *Della Congiura de' Pazzi dell'Anno 1478: Commentario di Angelo Poliziano*, trans. from Latin into Tuscan by Alessandro de Mandato, available online: https://www.liberliber.it /mediateca/libri/p/poliziano/della_congiura_de_pazzi_etc/pdf/della__p.pdf.

7 Quoted in Pastor, *History of the Popes*, vol. 4, p. 513.

8 Filippo Strozzi, quoted in Janet Ross, ed. and trans., *The Lives of the Early Medici as Told in Their Correspondence* (London: Chatto & Windus, 1910), p. 190.

9 Quoted in Miles J. Unger, *Magnifico: The Brilliant Life and Violent Times of Lorenzo de' Medici* (New York: Simon and Schuster, 2008), p. 320.

10 *Della Congiura de' Pazzi dell'Anno 1478*.

11 *Vite di Uomini Illustri*, p. 340.

12 Luca Landucci, *A Florentine Diary from 1450 to 1516*, trans. Alice de Rosen Jarvis (London: J. M. Dent & Sons, 1927), p. 16.

13 Machiavelli, *The History of Florence*, p. 362; and *Vite di Uomini Illustri*, p. 202.

14 Quoted in Martines, *April Blood*, p. 126.

15 Gian-Paolo Biasin, "'Messer Iacopo Giù Per Arno Se Ne Va . . .'" *MLN*, vol. 79 (January 1964), p. 11.

16 *Vite di Uomini Illustri*, p. 564.

17 "Lamento d'Italia per la presa d'Otranto fatta dai Turchi," in *Vite di Uomini Illustri*, ed. Frati, vol. 3, p. 311.

18 The text is given in F. Flamini, "Versi in Morte di Giuliano de' Medici (1478)," *Il Prupugnatore*, ed. Giosuè Carducci (Bologna, 1889), vol. 2, part 1, pp. 318–30.

19 Conway, ed., *The "Diario,"* p. 125.

20 Ibid., p. 141. For information on the links between street performers, blind beggars, and cheap print, see Laura Carnelos, "Street Voices: The Role of Blind Performers in Early Modern Italy," *Italian Studies*, vol. 71 (2016), pp. 1–13; and, in the same volume, Blake Wilson, "The *Cantastorie/ Canterino/ Cantimbanco* as Musician," pp. 154–70. See also Rosa Salzberg, "In the Mouths of Charlatans: Street Performers and the Dissemination of Pamphlets in Renaissance Italy," *Renaissance Studies*, vol. 24 (November 2010), pp. 638–53; and Angela Nuovo, *The Book Trade in the Italian Renaissance*, trans. Lydia G. Cochrane (Leiden: Brill, 2013), pp. 315–28.

21 See Don C. Skemer, *Binding Words: Textual Amulets in the Middle Ages* (University Park, PA: Penn State University Press, 2006). For his discussion of the amuletic qualities of the productions of the Ripoli Press, see pp. 228–29.

22 Conway, ed., *The "Diario,"* p. 175. The Ripoli edition of Paternosters sold by Giovanmichele was printed in the spring of 1477 (ibid., p. 105).

Chapter 24

1 Quoted in Valery Rees, "Ficino's Advice to Princes," in *Marsilio Ficino: His Theology, His Philosophy, His Legacy*, pp. 354 and 355.

2 *The Letters of Marsilio Ficino*, vol. 5, p. 15.

3 De la Mare, "Vespasiano da Bisticci, Historian and Bookseller," vol. 2, p. 367.

4 See Simonetta, *The Montefeltro Conspiracy*, p. 124.

5 De la Mare, "Vespasiano da Bisticci, Historian and Bookseller," vol. 2, p. 362.

6 Landucci, *A Florentine Diary*, p. 23.

7 Ibid., p. 22.

8 *Vite di Uomini Illustri*, p. 341.

9 Ibid., p. 343.

10 Ibid., p. 344.

11 Ibid., p. 346.

12 Ibid., p. 345.

13 Landucci, *A Florentine Diary*, pp. 24 and 25.

14 Cagni, *Vespasiano da Bisticci e il suo Epistolario*, pp. 161–62.

15 Quoted in Strocchia, *Nuns and Nunneries in Renaissance Florence*, p. 106.

16 Conway, ed., *The "Diario*," p. 163.

17 For Bartolo, see ibid., p. 37.

18 Ibid., p. 156.

19 Ibid., p. 29, note 65.

20 Ibid., p. 225.

21 On this matter, see Flannery, "San Jacopo di Ripoli Imprints at Yale," p. 125.

22 De la Mare, "New Research on Humanistic Scribes in Florence," p. 460–61.

23 *Vite di Uomini Illustri*, p. 348.

24 Landucci, *A Florentine Diary*, p. 26.

25 *The Revelations of St. Birgitta of Sweden*, vol. 3: *Liber Caelestis*, trans. Denis Searby, introduction and notes by Bridget Morris (Oxford: Oxford University Press, 2012), p. 140.

26 Cagni, *Vespasiano da Bisticci e il suo Epistolario*, pp. 162–63.

27 *The Lives of the Early Medici*, ed. and trans. Ross, p. 218.

28 *I Giornali di Ser Giusto Giusti*, ed. Newbigin, p. 212.

29 *Vite di Uomini Illustri*, p. 484. Vespasiano does not mention Cincinello's involvement in the plot against Jacopo Piccinino. For details, see Franca Petrucci, "Cicinello, Antonio," *Dizionario Biografico degli Italiani*, online edition.

30 Quoted in J. A. Symonds, *Renaissance in Italy: The Age of the Despots* (London: Smith, Edler & Co., 1912), p. 448.

31 De la Mare, "Vespasiano da Bisticci, Historian and Bookseller," vol. 2, pp. 368–89. For Pandolfini's library, see Armando Verde, "Nota d'archivio: Inventario e divisione dei beni di Pierfilippo Pandolfini," *Rinascimento*, vol. 9 (1969), pp. 307–24.

32 Quoted in Setton, *The Papacy and the Levant*, p. 337.

33 For the location of Ser Piero's shop, see Anne Leader, "'In the Tomb of Ser Piero': Death and Burial in the Family of Leonardo da Vinci," *Renaissance Studies*, vol. 31 (2016), p. 328.

34 See Giuseppe Aliprandi, "Leonardo da Vinci e la Stampa," *Gutenberg Jahrbuch* (Mainz: Gutenberg Gesellschaft, 1955), pp. 315–20; Carlo Pedretti, "L'Arte della Stampa in Leonardo da Vinci," *Studi Vinciana: documenti, analisi e inediti leonardeschi* (Geneva: Librairie Droz, 1957), pp. 109–17; and Ladislao Reti, "Leonardo da Vinci and the Graphic Arts: The Early Invention of Relief-Etching," *Burlington Magazine*, vol. 113 (April 1971), pp. 188–95.

35 Reti, "Leonardo da Vinci and the Graphic Arts," p. 188.

36 For this calculation, see Ladislao Reti, "The Leonardo da Vinci Codices in the Biblioteca Nacional of Madrid," *Technology and Culture*, vol. 8 (October 1967), p. 437.

37 Landucci, *A Florentine Diary*, p. 30.

Chapter 25

1 Quoted in Setton, *The Papacy and the Levant*, vol. 2, p. 344.

2 "Lamento d'Italia per la Presa d'Otranto," in Frati, ed., *Vite di Uomini Illustri*, vol. 3, pp. 313–14.

3 So, at least, was the claim of Ferdinand Gregorovius; see *Nelle Puglie*, trans. Raffaele Mariano (Florence: Barbera, 1882), p. 374.

4 Quoted in Chiriatti, "Lo Scriptorium di San Nicola di Casole," p. 428.

5 Quoted in ibid.

6 Quoted in ibid., p. 436.

7 Quoted in ibid., p. 428.

8 See Francesco G. Giannachi, "Learning Greek in the Land of Otranto: Some Remarks on Sergio Stiso of Zollino and His School," in Federica Ciccolella and Luigi Silvano, eds., *Teachers, Students, and Schools of Greek in the Renaissance* (Leiden: Brill, 2017), pp. 222–23.

9 Quoted in Pastor, *History of the Popes*, vol. 4, p. 334.

10 Quoted in ibid., pp. 335–36.

11 *I Giornali di Ser Giuto Giusti*, ed. Newbigin, p. 216.

12 Landucci, *A Florentine Diary*, p. 31.

13 Conway, ed., *The "Diario,"* p. 199.

14 *Cronica gestorum in partibus Lombardie et reliquis Italie*, ed. Giuliano Bonazzi (Città di Castello: Lapi, 1904), p. 84. For the poem reproduced in the chronicle, see pp. 85–89.

15 See Conway, ed., *The "Diario,"* Appendix VIII, pp. 345–53.

16 *Vite di Uomini Illustri*, p. 346.

17 Conway, ed., *The "Diario,"* p. 209.

18 For Ser Piero's document, see De la Mare, "Vespasiano da Bisticci, Historian and Bookseller," vol. 2, p. 371. For "Andrea di Vespasiano," see Conway, ed., *The "Diario,"* p. 337.

19 Quoted in Cagni, *Vespasiano da Bisticci e il suo Epistolario*, p. 36.

20 *Vite di Uomini Illustri*, p. 422.

21 Ibid., p. 155.

22 Ibid., pp. 2–3.

23 See Richard Stapleford, ed. and trans., *Lorenzo de' Medici at Home: The Inventory of the Palazzo Medici in 1492* (University Park, PA: Penn State University Press, 2013), p. 9; and E. B Fryde, *Humanism and Renaissance Historiography* (London: Hambledon Press, 1983), pp. 159–61.

24 Quoted in Fryde, *Humanism and Renaissance Historiography*, p. 183.

25 Cagni, ed., *Vespasiano da Bisticci e il suo Epistolario*, p. 159.

26 Quoted in Pollard, *An Essay on Colophons*, p. 89.

27 *Caxton's Own Prose*, ed. N. F. Blake (London: André Deutsch, 1973), p. 100.

28 Quoted in De la Mare, "New Research on Humanistic Scribes in Florence," p. 460 (my translation).

29 Quoted in Pollard, *An Essay on Colophons*, pp. 36–37 (translations slightly modified).

30 Cagni, ed., *Vespasiano da Bisticci e il suo Epistolario*, p. 175.

31 *Vite di Uomini Illustri*, p. 3. For Vespasiano's transactions, see De la Mare, "Vespasiano da Bisticci, Historian and Bookseller," vol. 2, pp. 367–68 and 372.

32 Cagni, *Vespasiano da Bisticci e il suo Epistolario*, p. 180.

33 Quoted in ibid., p. 42.

34 For Vespasiano's library, see De la Mare, "Vespasiano da Bisticci, Historian and Bookseller," vol. 2, Appendix VI.

35 For Vespasiano's work, see Aulo Greco, "Il 'Lamento d'Italia per la presa d'Otranto' di Vespasiano da Bisticci," in Cosimo Damiano Fonseca, ed., *Otranto 1480: Atti del Convegno Internazionale di Studio promosso in occasione del V centenario della Caduta di Otranto ad opera dei Turchi* (Otranto, 19–23 May 1980), 2 vols. (Lecce: Congedo, 1986), vol. 1, pp. 343–59.

36 *Vite di Uomini Illustri*, p. 441.

37 Ibid., p. 137.

38 Ibid., p. 136.

39 Quoted in Franco Mormando, *The Preacher's Demons: Bernardino of Siena and the Social Underworld of Early Renaissance Italy* (Chicago: University of Chicago Press, 1999), p. 5. For Bernardino's relations with the humanists, see also John W. Oppel, "Poggio, San Bernardino of Siena, and the *Dialogue On Avarice*," *Renaissance Quarterly*, vol. 30 (Winter 1977), pp. 564–87 (especially pp. 567–69, from which I have taken the Poggio quote).

Chapter 26

1 Quoted in Setton, *The Papacy and the Levant*, p. 371.

2 For this episode, see John J. Curry, *Transformation of Muslim Mystical Thought in the Ottoman Empire: The Rise of the Halveti Order, 1350–1650* (Edinburgh: Edinburgh University Press, 2010), pp. 68–69.

3 Quoted in Pastor, *History of the Popes*, vol. 4, p. 343.

4 Quoted in Setton, *The Papacy and the Levant*, p. 373.

5 See Cagni, *Vespasiano da Bisticci e il suo Epistolario*, pp. 169–71.

6 Ibid., pp. 33–34.

7 For the text, see ibid., pp. 164–68. The original manuscript is in the Biblioteca Nazionale in Florence, MS. Naz. II.XI.34, ff. 1–10v.

8 Quoted in Carole Collier Frick, *Dressing Renaissance Florence: Families, Fortunes, and Fine Clothing* (Baltimore: Johns Hopkins University Press, 2002), p. 180. I am indebted to Frick's discussion on pp. 180–84.

9 *Vite di Uomini Illustri*, p. 189.

10 Ibid., p. 213.

11 *The Letters of Marsilio Ficino*, vol. 6, p. 47.

12 Matteo Contugi da Volterra, quoted in Gino Benzoni, "Federico da Montefeltro," *Dizionario Biografico degli Italiani*, online edition.

13 *Vite di Uomini Illustri*, pp. 221–22 and 223.

14 *The Letters of Marsilio Ficino*, vol. 6, p. 47.

15 Ibid., p. 38.

16 Ibid., p. 38. For the supposed murder, see Raymond Marcel, *Marsile Ficin (1433–1499)* (Paris: Société d'Édition "Les Belles Lettres," 1958), pp. 460–61.

17 *The Letters of Marsilio Ficino*, vol. 7, p. 4.

Chapter 27

1 Conway, ed., *The "Diario,"* p. 64.

2 Ibid., p. 241.

3 See Rouse and Rouse, *Cartolai, Illuminators and Printers*, p. 85.

4 Girolamo Savonarola, *Prediche sopra Ezechiele*, 2 vols., ed. Roberto Ridolfi (Rome: A. Belardetti, 1955), vol. 2, p. 262.

5 Conway, ed., *The "Diario,"* pp. 56–57.

6 Quoted in Rhiannon Daniels, *Boccaccio and the Book: Production and Reading in Italy, 1340–1520* (London: Legenda, 2009), p. 85 (my translation). The "copyists for passion" are discussed in Vittore Branca, "Copisti per passione, tradizione caratterizzante, tradizione di memoria," in S*tudi e problemi di critica testuale: Convegno di studi di filologia nel centario della Commissione per i testi di lingua* (Bologna: Commissione per i testi di lingua, 1961), pp. 69–83.

7 Conway, ed., *The "Diario,"* pp. 58–61 and 351.

8 Kenneth Pearson, "News in the Arts," *Sunday Times*, December 6, 1970, p. 31.

9 *The Decameron*, trans. G. H. McWilliam (London: Penguin, 1995), p. 801.

10 Quoted in Judith Serafini-Sauli, "The Pleasures of Reading: Boccaccio's *Decameron* and Female Literacy," *MLN*, vol. 126 (January 2011), p. 34.

11 *The Decameron*, p. 798.

12 Quoted in Serafini-Sauli, "The Pleasures of Reading," p. 30.

13 *The Decameron*, III.1.

14 Quoted in Cormac Ó Cuilleanáin, *Religion and the Clergy in Boccaccio's Decameron* (Rome: Edizioni di Storia e Letteratura, 1984), p. 19.

15 Quoted in Strocchia, *Nuns and Nunneries in Renaissance Florence*, p. 174.

16 Quoted in Elizabeth Makowski, *Canon Law and Cloistered Women: Periculoso and Its Commentators, 1298–1545* (Washington, DC: Catholic University of America Press, 1997), p. 135.

17 Quoted in Samuel K. Cohn Jr., *Women in the Streets: Essays on Sex and Power in Renaissance Italy* (Baltimore: The Johns Hopkins University Press, 1996), pp. 108–9. See also Strocchia, *Nuns and Nunneries in Renaissance Florence*, pp. 178–80.

18 Strocchia, *Nuns and Nunneries in Renaissance Florence*, p. 163

19 Michael J. B. Allen, "Introduction," *Marsilio Ficino: His Theology, His Philosophy, His Legacy*, p. xv.

20 See Cesare Vasoli, "Marsilio Ficino," *Dizionario Biographico degli Italiani*, online edition.

21 *Platonic Theology*, vol. 6, p. 221.

22 *The Philosophy of Marsilio Ficino*, vol. 1, pp. 10–11.

23 *Platonic Theology*, vol. 1, p. 9.

24 For an excellent discussion, see Tigerstedt, "The Poet as Creator," pp. 471–72.

25 Quoted in Howlett, *Marsilio Ficino and His World*, p. 53.

26 Conway observes that the attention Fra Domenico gave to this sample task "suggests that other Florentine printers were also bidding on a large and significant commission" (*The "Diario,"* p. 46).

27 See ibid., p. 268.

28 *Platonic Theology*, vol. 6, p. 221.

29 Leandro Perini makes the statement in his edition of Angelo Poliziano's *Coniurationis commentarium: Commentario alla Congiura dei Pazzi* (Florence: University of Florence, 2012), p. 11, note 13.

30 Quoted in James Hankins, "The Myth of the Platonic Academy of Florence," *Renaissance Quarterly*, vol. 44 (Autumn 1991), p. 460 (my translation).

31 Quoted and translated in Hankins, "Cosimo de' Medici and the 'Platonic Academy,'" p. 153.

32 Conway, ed., *The "Diario,"* p. 268.

33 Ibid., p. 46.

34 Ibid.

35 Ibid., p. 273.

36 Quoted in Hankins, *Plato in the Renaissance*, vol. 1, p. 304.

37 Quoted in Howlett, *Marsilio Ficino and His World*, p. 10.

38 See Gustav-Adolf Schoener, "The Coming of a 'Little Prophet': Astrological Pamphlets and the Reformation," in *Esoterica: The Journal*, vol. 6 (2004), pp. 29–30.

39 Quoted in Eugenio Garin, *Ermetismo del Rinascimento* (Rome: Editore Riuniti, 1988), p. 57.

40 Landucci, *A Florentine Diary*, p. 40.

41 Quoted in Pastor, *History of the Popes*, vol. 4, p. 380.

42 Quoted in Ann G. Carmichael, *Plague and the Poor in Renaissance Florence* (Cambridge: Cambridge University Press, 1986), p. 123.

43 Quoted in White, *Plague and Pleasure: The Renaissance World of Pius II*, p. 299.

44 The absence of a death record for Fra Domenico could be explained by the fact that he probably died, and then was interred, in the convent of San Jacopo di Ripoli. Deaths in Florence had been recorded since 1385 by the Board of the Grascia, an agency that provisioned the city, and since 1450 by the Arte Medici e Speziali, the Guild of Physicians and Apothecaries. Both got their information from Florence's

gravediggers, who reported the names of all those they buried. However, if someone died and was buried within a religious community, there was no need to transport the body and, therefore, to engage the services of a gravedigger. On the shortcomings of these records, see C. M. Cipolla, "The 'Bills of Mortality' of Florence," *Population Studies*, vol. 32 (November 1978), pp. 543–48.

45 For this possibility, see Melissa Conway, "The Early Career of Lorenzo de Alopa," *La Bibliofilía*, vol. 102 (January–April 2000), p. 9.

46 Conway, ed., *The "Diario*," p. 274.

47 Quoted in Hankins, "Cosimo de' Medici and the 'Platonic Academy,'" p. 151. For the dating of the work, see P. O. Kristeller, "The First Printed Edition of Plato's Works and the Date of Its Publication (1484)," in Pawel Czartoryski and Erna Hilfstein, eds., *Science and History: Studies in Honor of Edward Rosen* (Wrocław: Polish Academy of Sciences Press, 1978), pp. 25–39; and idem, "Ficino and his Work After Five Hundred Years," in *Marsilio Ficino e il ritorno di Platone*, ed. Gian Carlo Garfagnini (Florence: Olschki, 1986), vol. 1, p. 128.

48 Quoted in Allen and Rees, eds., *Marsilio Ficino: His Theology, His Philosophy, His Legacy*, p. 85.

49 *The Letters of Marsilio Ficino*, vol. 7, p. 24.

50 James Hankins and Ada Palmer, *The Recovery of Ancient Philosophy in the Renaissance: A Brief Guide* (Florence: Olschki, 2008), p. 10.

51 Kristeller, "The First Printed Edition of Plato's Works," p. 138.

52 See A. N. Whitehead, *Process and Reality: An Essay in Cosmology*, ed. D. R. Griffin and D. W. Sherburne (New York: Free Press, 1978), p. 39.

53 Tom Cohen, "P.S.: Plato's Scene of Reading in the *Protagoras*," in *Anti-Mimesis from Plato to Hitchcock* (Cambridge: Cambridge University Press, 1994), p. 45.

54 Plato, *Euthyphro. Apology. Crito. Phaedo*, Loeb Classical Library 36, p. 153.

55 P. O. Kristeller, "L'état présent des études sur Marsile Ficin," *XVIe Colloque International de Tours: Platon et Aristote à la Renaissance* (Paris: Librarie Philosophique J. Vrin, 1976), pp. 66 and 75, note 54.

56 Hankins, *Humanism and Platonism in the Italian Renaissance*, vol. 2, p. 441.

57 Kristeller, "The First Printed Edition of Plato's Works," p. 137.

Epilogue

1 For King Ferrante's continued patronage, see De la Mare, "Vespasiano da Bisticci, Historian and Bookseller," vol. 2, p. 376A.

2 Fryde, *Humanism and Renaissance Historiography*, pp. 184–85.

3 For this library, see Kent, *Lorenzo de' Medici and the Art of Magnificence*, p. 7.

4 See Fryde, *Humanism and Renaissance Historiography*, pp. 183–84.

5 Quoted in Howlett, *Marsilio Ficino and His World*, p. 23.

6 De la Mare, "Vespasiano da Bisticci, Historian and Bookseller," vol. 2, p. 377.

7 Girolamo Savonarola, *Prediche sopra l'Esodo*, ed. Pier Giorgio Ricci, 2 vols. (Rome: Belardetti, 1956), vol. 2, p. 291.

8 Quoted in Michel Plaisance, "Florence: Carnival in the Time of Savonarola," in Nicole Carew-Reid, ed. and trans., *Florence in the Time of the Medici: Public Celebrations, Politics,*

and Literature in the Fifteenth and Sixteenth Centuries, (Toronto: Center for Reformation and Renaissance Studies, 2008), p. 65, note 63, and p. 67.

9 Quoted in ibid., p. 66, note 68; p. 68, note 80; and p. 81. For the burning of Dante, Petrarch, Boccaccio, and Pulci, see p. 69, note 81.

10 Lawrence S. Cunningham et al., eds., *Culture & Values: A Survey of the Humanities*, 8th edition (Boston: Wadsworth, 2014), p. 384.

11 For a succinct appraisal, see Roberto Weiss, "Savonarola and the Renaissance," *Black-friars*, vol. 34 (July–August 1953), p. 320.

12 Quoted in Peter Godman, *From Poliziano to Machiavelli: Florentine Humanism in the High Renaissance* (Princeton: Princeton University Press, 1998), p. 135.

13 Quoted in Godman, *From Poliziano to Machiavelli*, p. 140. For "Socrates from Ferrara," see p. 134.

14 Cagni, ed., *Vespasiano da Bisticci e il suo Epistolario*, pp. 42–43.

15 *Vite di Uomini Illustri*, pp. 67–68 and 228.

16 Ibid., pp. 1 and 3.

17 Gibbon used not one of Vespasiano's manuscripts but Lodovico Muratori's 1751 publication, *Rerum Italicarum Scriptores*, which included the lives of Eugenius and Nicholas. "Vespasian of Florence" appears in the sixth volume of the first quarto edition, first published in 1788 as part of the final installment of three quarto volumes. I am grateful to David Womersley for this information.

18 Jeremiah E. Dittmar, "Information Technology and Economic Change: The Impact of the Printing Press," *The Quarterly Journal of Economics*, vol. 126 (August 2011), p. 1133.

19 Ibid., p. 1144, Table 1; and p. 1155.

20 For Frankfurt's population: Carl-Ludwig Holtfrerich, *Frankfurt as a Financial Center: From Medieval Trade Fair to European Financial Center* (Munich: C. H. Beck, 1999), p. 49. For Frankfurt's lack of a printing press in 1500 I am grateful for information provided by Dr. Jeremiah Dittmar, personal e-mail communication, April 25, 2020.

21 Dittmar, "Information Technology and Economic Change," p. 1134.

22 The *Incunabula Short Title Catalogue* gives a percentage of 69.9 for books published before 1500.

23 Leandro Perini, "Libri e lettori nella Toscana del Cinquecento," *Firenze e la toscana dei Medici nell'Europa del Cinquecento* (Florence: Olschki, 1983), pp. 109–31. For the Florentine students, see Giovanni Villani, *Nuova Chronica*, vol. 3, p. 198.

24 On which, see Cochrane, *Florence in the Forgotten Centuries*, for example p. 67.

25 Quoted in Elizabeth L. Eisenstein, *The Printing Press as an Agent of Change: Communications and Cultural Transformations in Early-Modern Europe* (Cambridge: Cambridge University Press, 1979), p. 347.

26 See Mark U. Edwards Jr., *Printing, Propaganda, and Martin Luther* (Minneapolis: Fortress Press, 1994); and Andrew Pettegree, *Brand Luther: 1517, Printing, and the Making of the Reformation* (New York: Penguin, 2016).

27 For these figures and their sources, see Allyson F. Creasman, *Censorship and Civic Order in Reformation Germany, 1517–1648: "Printed Poison & Evil Talk"* (Abingdon: Routledge, 2016), p. 31.

28 Lucien Febvre and Henri-Jean Martin, *The Coming of the Book: The Impact of Printing, 1450–1800*, trans. David Gerard (London, Verso, 1958), p. 288. Supporters of the thesis include—besides Eisenstein, Edwards, and Pettegree, all cited earlier—Arthur Geoffrey Dickens, *Reformation and Society in Sixteenth Century Europe* (New York: Harcourt,

Brace, & World, 1968); and many of the historians published in Jean-François Gilmont, ed., *The Reformation and the Book* (Aldershot: Ashgate, 1998).

29 Jared Rubin, "Printing and Protestants: An Empirical Test of the Role of Printing in the Reformation," *The Review of Economics and Statistics*, vol. 96 (May 2014), pp. 270–86.

30 Max Weber, *The Protestant Ethic and the Spirit of Capitalism*, trans. Talcott Parsons (New York: Scribner's, 1930). On the links between the printing press and economic growth, see Joerg Baten and Jan Luiten van Zanden, "Book Production and the Onset of Modern Economic Growth," *Journal of Economic Growth*, vol. 13 (2008), pp. 217–35.

31 "Testimonios," in Pedro Voltes, *Cristóbal Colón* (Barcelona: Salvat Editores, 1987), p. 180.

32 See Carol Delaney, "Columbus's Ultimate Goal: Jerusalem," in *Comparative Studies in Society and History*, vol. 48 (2006), pp. 260–92 (quoted at p. 261).

33 Valerie I. J. Flint, *The Imaginative Landscape of Christopher Columbus* (Princeton: Princeton University Press, 1992).

34 See Edward Wilson-Lee, *The Catalogue of Shipwrecked Books: Young Columbus and the Quest for a Universal Library* (London: William Collins, 2018).

Index

Note: *Italic* page numbers indicate illustrations.